Bits & Pieces Put Together to Present a Semblance of a Whole: Walker Art Center Collections

Walker Art Center, Minneapolis

Published with the assistance of the Getty Grant Program.

Bits & Pieces Put Together to Present a Semblance of a Whole: Walker Art Center Collections

Joan Rothfuss and Elizabeth Carpenter

Contributors

Elizabeth Alexander
Max Andrews
Elizabeth Armstrong
Graham Beal
Doug Benidt
Philip Bither
Andrew Blauvelt
Peter Boswell
A. S. Byatt
Steve Cannon
Elizabeth Carpenter
Aimee Chang
Sylvia Chivaratanond
Doryun Chong
Joshua Clover
Arthur C. Danto
Deepali Dewan
Lynn Dierks
Steve Dietz

Robin Dowden
Dave Eggers
Alisa Eimen
Siri Engberg
Darby English
Richard Flood
Douglas Fogle
Martin Friedman
Mildred S. Friedman
Rosemary Furtak
Gary Garrels
Diana Gaston
Marge Goldwater
Jorie Graham
Kathy Halbreich
John G. Hanhardt
Charles R. Helm
Irene Hofmann
Bill Horrigan

Olukemi Ilesanmi
Bruce Jenkins
Eungie Joo
Toby Kamps
John R. Killacky
Clara Kim
Diana Kim
Wayne Koestenbaum
Richard Koshalek
Philip Larson
James Lingwood
Elizabeth Mangini
Elizabeth Wright Millard
Sheryl Mousley
Linda Nochlin
Dean Otto
Richard Peterson
Jennifer Case Phelps
Francesca Pietropaolo

Jenelle Porter
Annie Proulx
J. Fiona Ragheb
Lawrence Rinder
Joan Rothfuss
Sarah Schultz
David Shapiro
Charles Simic
Howard Singerman
Daniel Smith
Rochelle Steiner
Claire Tancons
Elizabeth Thomas
Jan van der Marck
Philippe Vergne
Jill Vetter
Hamza Walker
Suzanne Weil

Bits & Pieces Put Together to Present a Semblance of a Whole: Walker Art Center Collections is published on the occasion of the opening of the newly expanded Walker Art Center, April 2005.

Major support for Walker Art Center programs is provided by the Minnesota State Arts Board through an appropriation by the Minnesota State Legislature, The Wallace Foundation, the Doris Duke Charitable Foundation through the Doris Duke Fund for Jazz and Dance and the Doris Duke Performing Arts Endowment Fund, The Bush Foundation, Target, General Mills Foundation, Best Buy Co., Inc., The McKnight Foundation, Coldwell Banker Burnet, the Institute of Museum and Library Services, the National Endowment for the Arts, American Express Philanthropic Program, The Regis Foundation, The Cargill Foundation, 3M, Star Tribune Foundation, U.S. Bank, The Andrew W. Mellon Foundation, and the members of the Walker Art Center.

Library of Congress Cataloging-in-Publication Data

Walker Art Center
 Bits & pieces put together to present a semblance of a whole : Walker Art
Center collections.-- 1st ed.
 p. cm.
 Includes index.
 ISBN 0-935640-78-9 (hardcover : alk. paper)
 1. Walker Art Center--Catalogs. 2. Arts--Minnesota--Minneapolis--Catalogs. 3. Walker Art Center--History. I.
Title: Bits and pieces put together to present a semblance of a whole. II.
Title: Walker Art Center collections. III. Title.
 N583.A53 2005
 709'.04'0074776579--dc22
 2004031088

**Available through D.A.P./Distributed Art Publishers
155 Sixth Avenue, New York, NY 10013**

Every reasonable attempt has been made to identify owners of copyright. Errors or omissions will be corrected in subsequent editions.

Wayne Koestenbaum, "Jackie and Repetition," from *Jackie Under My Skin: Interpreting an Icon* (New York: Farrar, Straus and Giroux, 1995), © by permission of the author.

Publications Manager
Lisa Middag
Editors
Pamela Johnson, Kathleen McLean
Designers
Andrew Blauvelt, Chad Kloepfer
Production Specialist
Greg Beckel

Printed and bound in Belgium by Die Keure.

Cover art
Lawrence Weiner

Contents

Prologue
Collection: A Semblance of a Whole

Collecting is something we all do and from early on. Our secret caches and open displays mark the passage of time, the accumulation of experience, and the approach of connoisseurship. Each of us knows the introspective joy of chasing the tides to find the perfect shell to add to the shelf back home, or the meander of a childhood journey made possible by an amassing of small tin cars. Collecting is about holding something dear and elevating its value through lavish attention. The contemplation of something outside ourselves first allows for the loss of self, and then, the projection of self onto something other.

Ordering the world occupies the collector. From big to small, popular to rare, permanent to ephemeral, handmade to natural, bits and pieces of the world often seem to be there for our taking and for shaping into our own definition of a whole. But soon we realize that the urge to make a chronology complete or a collection comprehensive is an impossible conceit given how swiftly minuscule shifts in understanding are multiplied by an infinity of minutes. Since there is no secure history of human endeavor or absolute end of time, it would be a mistake to confuse classification with truth. This is both liberating and sad.

Labeling, as well as love, prompt the desire to possess something, at least temporarily. "This is mine" or "It's perfect" or "It's unique" are but some of the descriptions collectors use to identify their objects. Sometimes, however, ownership (or knowing something intimately enough to name it) tames the romantic flame, and soon the beloved is ignored, stored, discarded, or forgotten. The story is then rewritten to obscure the sequence of mistaken affections; what we knew and didn't know about the loved one is recast, suggesting our reluctance to confess to the seductive thrill of, say, superficial beauty. Sometimes we call this growing up, a process that, like collecting, we happily imagine involves a refinement of taste and a loss of innocence.

Loss can also be accompanied by mourning for the thing missed. All collectors have stories about the object that got away (as if it ran from their embrace). While the loss can be devastating, leaving them to wonder why they weren't worthy, some collectors enjoy the chase more than the possession. The collector is like a detective, tracking mysteries of all sorts, including research, rationales, relationships, rebukes, and rapture. Luck plays no favorites and sometimes a collector arrives too late for the assignation; another has made off with the inamorata. This experience often increases the value of the vanished thing in the loser's mind, and lust for it escalates.

Excellence cannot be universally understood. Great artists know this instinctively, even as they are judged by those who often resort to familiar lexicons and formal relationships in attributing value to an artistic treasure or translating what is experienced into words as well as across cultures. In his ravishing novel *My Name Is Red*, Turkish author Orhan Pamuk exhibits the Byzantine tension between East and West by staging a mystery involving a competition among the best miniaturists of the day. While skilled at rendering in great complexity the flatness of a singular Islamic vision, they are secretly urged by their sultan to forsake tradition and break taboos in order to learn how to paint lifelike portraits using the recessive space and multiple perspectives of Renaissance art. (Isn't the fluidity of history a hopeful thing? Isn't it pleasing that the seemingly retrograde flatness of traditional miniatures later becomes an emblem of the avant-garde in critic Clement Greenberg's taste for Color-Field painting?) Perhaps unconsciously reflecting his landscape of Istanbul, Pamuk recently said, "I want to be a bridge in the sense that a bridge doesn't belong to any civilization, and a bridge has a unique opportunity to see both civilizations and be outside of it. That's a good, wonderful privilege." Perhaps the ideal collector of contemporary art would inhabit that bridge. Any universal definition of quality—one that ignores the specific history, texture, ritual, and habits of place—would need to be twisted into shape and fixed by some critical mumbo jumbo.

Calibrating equal, if different, values can be a joy of promise. Although such deliberations often are attacked as promiscuously relativistic, they in fact require a discriminating curiosity; those calculations aid in searching for alternatives to a modern (and mostly Western) idea of progressive development (allegedly leading to something better, not just different—a hierarchy the powerful, paradoxically, seem to need more than the weak). This journey has fewer geographic boundaries as well as aesthetic absolutes; the good collector knows there's no escaping one's own baggage and plans accordingly. The best compass is a tolerance for ambiguity, the most compelling company a new voice, and the most lasting inoculation one against the status quo.

Too often collectors are so infatuated by their own vision that they begin to think in singular and sanctimonious terms. How can "mine is the best" be true in any absolute? An artist makes another masterpiece representing another moment in his emotional life; the roughness of a Japanese tea bowl challenges the delicacy of a Sevres teacup; and the bronze hero on the horse is just another old guy to the kid who skateboards by. So often collectors who tell you what to think have listened too much to others and, unlike the rampant questions that break out when faced with the eccentricities of a collector driven by mad passion, there's no fun or intellectual reward in seeing a cold-blooded collection that only reminds you of better ones. This, of course, is different from the treasury

assembled by a collector who prefers to find the most perfect example of what is already accepted and precious; walking through these collections can be a calming, luminous, and exhilarating experience. But they may not provide the best model for those involved in collecting the art of the present. A combination of distance and contrasting examples is needed in order to create an approximation of the ideal, even if it is a personal one; when collecting young artists, neither luxury may exist, so one is acquiring something other than a refined idea or technique. Fascinating, forward-looking, and provocative collections often are composed by those who are teased by the new and challenged by riding the wave as it develops; these collectors often enjoy the company of artists, one of the true luxuries of living in the present tense. While conversations with an artist may range from chaos theory to Internet porn, from breaking horses to raising children, from presidential politics to media manipulation, it's wise to ask an artist how he or she made something rather than what something means. A frustrated curator once asked, "Why don't people understand that the real beauty of art is that there is no fixed meaning? Art demands you give it your own meaning." But most of us were never taught to trust our own feelings or to elaborate our own questions; we're more comfortable leaping to easy conclusions, which the unfamiliar or new rarely provide. A good collector must learn how to levitate. (By the way, artists always remember who acquired their first work and what they paid for it. Collecting institutions depend on these memories.)

It is said that institutions, being stewards of the public trust, have a greater responsibility when assembling a collection. But just what does that responsibility consist of? Disinterest, certainly, but it's impossible to pretend that the stories told through a collection aren't a compilation of personal narratives. People make decisions and, all too often, even the best mistake their preferences for expertise. (That being said, preferences tempered by erudition and first-hand experience make a firm foundation for a collector's judgments. And, occasionally, what appears to be a mistake can later become a triumph of insight; mistakes are not necessarily to be avoided, especially if a team of curators is recommending work to be acquired, a sane way to proceed as varying opinions often result in more complex conversations among the objects in a collection.) Inclusivity is a fundamental responsibility, but it's also impossible to be all things to all people. Though we all want to be liked, it's dangerous—knowing that mediocrity springs from a lack of definition—to pretend that the encyclopedic, in its attempt to be exhaustive, is in and of itself inclusive. An institution of contemporary art has a particular responsibility to support living artists who may present a less than beautiful picture of a less than beautiful moment. What happens when those images create conflict between the institution's responsibility to audience and to artist? Sometimes someone screams that certain pictures don't represent a community's values, forgetting that the community also consists of those without megaphones. What offends one person may comfort another. Sometimes visitors think they are obliged to like everything they see, but choosing only the "likeable" is not a good institutional or artistic mission. So with responsibilities come difficulties. Without ceding the delicacy of individual moral positions, an institution of contemporary ideas exists to give people choices. In truth, it's impossible to build a distinctive collection with modest means unless one is willing to take calculated risks, to break some canonical rules, and to jump ahead of the accepted. The exchange with one's public isn't so much about sampling masterpieces (although in time some of those early risks become influential cultural markers) as about expending the currency of innovation from down the street and around the globe. It's impossible to proceed as an institutional collector of contemporary art without a sense of humor, a will to educate, a delight in long-term thinking, a serious love for the material, and a taste for the wild (even if it turns into a wild goose chase).

Only an individual can elect to keep a collection locked away and private. The beauty of an institution is its public mission. The conversations regarding value (as well as the very definition of art and meaning and purpose and intention and beauty and appropriateness and technique and history and representation and on and on) that ping-pong between the public and the institutional team provide energy and insights for both. Nothing and everything is sacred.

Nothing is forever.

I always will cherish the amazing intellectual duels the curators and I have had over which works to acquire and why. While I often fell deeply under the spell of the object under discussion, my respect for those curators and interns, past and present, whose research, convictions, and discerning eye made the Walker's collection distinct, deliberate, and desirable is deeper still. This collection of individuals, in tandem with an extraordinary group of patrons who welcomed new ideas, has made my life, as well as the life of this institution and community, richer than it is possible to enumerate here. Martin Friedman, my predecessor, set a sterling example for those of us who followed. I imagine I express the thoughts of the collective in hoping this assembly of essays provides access to the artists' inner thoughts, to our public aspirations, and to the generosity of those who made it possible to share these endeavors with future generations.

Kathy Halbreich
Director

Introduction
A Museum of the Present

During the late 1930s Daniel Defenbacher, director of the Walker Art Galleries, imagined a completely new kind of arts institution. It would depart from the traditional museum model in which artworks were entombed in airless galleries and understood primarily as vehicles through which people could visit history. Instead, Defenbacher wanted the "average man" to discover that art was not part of some timeless realm outside daily life, but a vital force that was alive and in action, with the potential to energize every aspect of our lives.[1] Art, he believed, could be found everywhere in our environment: in architecture, graphic and industrial design, fashion, performance, music, dance, and literature, as well as visual art objects. If we were alert, our routine experiences would be enriched by the harmony, pleasure, artistry, and functionality inherent in the good art that was all around us.

To put his ideas to the test, Defenbacher renamed his institution the Walker Art Center, and wrote a new mission for it that privileged education and inclusiveness. He and his staff devised a menu of activities that included exhibitions, lectures, classes, workshops, performances, community activities, and outreach, with the goal of "ACTUAL PARTICIPATION in arts and crafts BY EVERYBODY."[2] He also reimagined the role of the permanent collection: rather than the inert center of an encounter with the past, he saw it as a rich and versatile asset that could support a variety of edifying agendas. "A permanent collection of art may be only a dull display of lifeless things or it may be a source of material for exhibitions to illustrate easily grasped art principles," he explained in an early catalogue. "The Center intends to use the T. B. Walker Art Collection in the latter manner."[3]

In 1940, when that statement was written, the collection consisted only of the objects that had been amassed by Thomas Barlow Walker, the institution's lumber-baron founder, and placed there on loan by the Walker family foundation. Among its treasures were numerous oil paintings from Europe and the United States, featuring fine examples from the Hudson River and Barbizon schools; Chinese jades, Japanese ivory netsuke, and Greek vases; ceramics and glassware from several continents and historical periods; Native American artifacts; and ancient Syrian stone carvings. It was, in other words, an eclectic, unfocused accumulation with great potential as a teaching tool, and the trio of shows that helped inaugurate the new facility used it in just that way.[4]

As he was inventing more active ways to use T. B.'s trove, Defenbacher also began a drive to make the collection more contemporary, beginning with the acquisition of important European and American paintings by Lyonel Feininger, Edward Hopper, George Luks, Franz Marc, and John Sloan.[5] Since Defenbacher's departure in 1951, that initiative has been continued under the careful watch of the Walker's three subsequent directors: H. Harvard Arnason, Martin Friedman, and Kathy Halbreich. Most of T. B.'s objects have been

sold or returned to the family, and the Walker's holdings have evolved into one of the premier collections of modern and contemporary art in this country, with more than thirteen thousand works in four main categories: the Visual Arts Permanent Collection; the Edmond R. Ruben Film and Video Study Collection; the Digital Arts Study Collection; and the artists' books and multiples that are held by the Library. Together they form a textured and idiosyncratic corpus with thematic areas of great depth, many impressive monographic concentrations, and a surprising number of artists appearing in two or more areas. It has never been what some might consider an ideal, "one of each" assortment that tells a sequential story about the history of art since 1900. Instead, the diversity of the collections supports the contemporary understanding that this One True History does not exist; rather, there are a thousand stories that overlap, intersect, and circle around one another.

Objects—the beautiful, the novel, and the rare as well as the utterly typical—have been at the center of the museum experience since the wonders of the Crystal Palace were presented to London audiences in 1851. This "visible past," as historian George Kubler described it,[6] is a vast profusion of things that offers tangible proof of human history and helps confirm and mark the passage of time. But if an object is, broadly speaking, anything external to oneself, then intangibles such as events, natural phenomena, relationships, and ideas might also qualify. Breaching the boundaries of media or disciplines is no longer a rarity among artists, and museums always (eventually) follow their lead. The Walker prefers to define its collections according to these expanded criteria, embracing not only the expected (painting, sculpture, drawing) but also the surprising: commissions of new work; projects realized in the community by artists-in-residence; and relationships between the institution and artists, some of which have developed over decades. This immaterial archive of experiments, opportunities, research, and shared experiences, combined with objects, makes a collection that is as complex and nuanced as contemporary art-making itself.

The highlights of these collections are numerous. Within the visual arts holdings of some eleven thousand objects, there are a couple dozen sublime Minimalist sculptures and paintings, including seven by Donald Judd, three by Dan Flavin, and two each by Carl Andre, Sol LeWitt, and Agnes Martin; these are augmented by drawings and prints in which the same artists explore their ideas on paper. There is a rich representation of the Italian Arte Povera movement, with works by eight of its major figures, and a concentration of paintings by the mid-century Japanese Gutai group—both unusual choices for an American museum. A large number of artists, including Matthew Barney, Robert Gober, Ellsworth Kelly, Sherrie Levine, Claes Oldenburg, and Andy Warhol, are represented in depth, offering viewers an extended assessment of each career. Editioned works are a strong focus: there are more than five hundred objects by the wide-ranging, international group known as Fluxus, five hundred multiples by the influential German artist Joseph Beuys, and concentrations of prints and

multiples by Katharina Fritsch, Sigmar Polke, and Rirkrit Tiravanija. The Walker has the only complete archives of graphic works by Jasper Johns and Robert Motherwell, as well as hundreds of prints from the archives of Tyler Graphics Workshop, which collaborated with such masters as Helen Frankenthaler, Joan Mitchell, and Frank Stella. The Visual Arts Study Collection contains models, working drawings, and other preparatory materials related to objects within the larger holdings. Within the Edmond R. Ruben Film and Video Study Collection one finds nearly eight hundred titles, including an unusually rich group of experimental films from the 1960s and 1970s by Kenneth Anger, Stan Brakhage, Bruce Conner, Paul Sharits, and many others, as well as the complete catalogue of films by William Klein and a clutch of rare, early twentieth-century films from the Soviet Union. The Walker holds more than twelve hundred artists' books and multiples as well as äda'web, an early and historically significant archive of Internet-based art. In the performing arts, choreographers Trisha Brown, Merce Cunningham, and Bill T. Jones together account for twenty-one residencies and thirty-eight performances over five decades, and have been commissioned to make eleven new works—a significant contribution to the development of contemporary dance and an immeasurable enrichment of this community's cultural life. In recent years, the Walker has tended to collect around the edges of the obvious, distinguishing itself by embracing hybrid or otherwise unclassifiable works that might fall between the cracks in more traditional institutions.

Setting aside such uncontrollable factors as the vagaries of the marketplace and the unsolicited donation, the focused nature of the collections can be attributed to a mix of discipline and strategic planning. Not all gifts can be accepted and not all passions pursued; the kindnesses of strangers and the enthusiasms of staff must be balanced with the job of constructing a cohesive and elastic whole. During the past decade the Walker's visual arts curators, and the Board of Directors committee that oversees acquisitions, have maintained a long-range plan that identifies major pieces to be pursued according to a carefully determined set of criteria. A work must fit within the Walker's mission and have the potential to amplify or expand the "conversations" that are already taking place in the collections. Some of these are historical works that are deemed critically necessary; others strengthen monographic concentrations already in place or build new ones with artists who are just beginning their careers. It has been a priority to acquire objects that have been included in temporary exhibitions or present works developed during residencies and commissions; this allows the collections to reflect programmatic history and long-term relationships with artists. Walker curators certainly have the discretion to pursue unexpected opportunities and are expected to take risks on works by young artists, but the broad strokes outlined by these guidelines help ensure that the visual arts collection is shaped purposefully rather than randomly. When practical, acquisitions in other departments—digital arts, library, film and video, performing arts—overlap those in visual arts, so that an artist's work may be represented in as complete a way as possible across the institution.

The task of a public collection is not only to accumulate, but also to preserve and present what has been gathered. With collections of new art, there are manifold challenges associated with fulfilling these

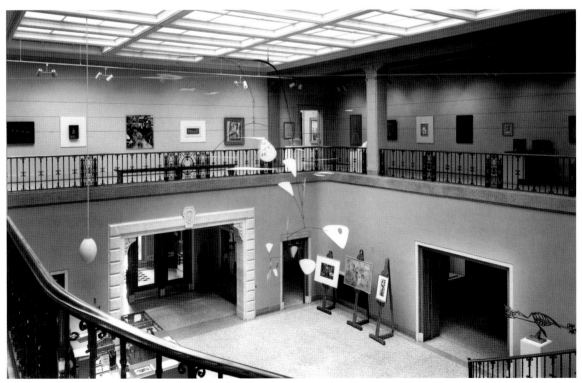

Walker Art Galleries, installation view of the exhibition *Reality and Fantasy, 1900–1954*, 1954

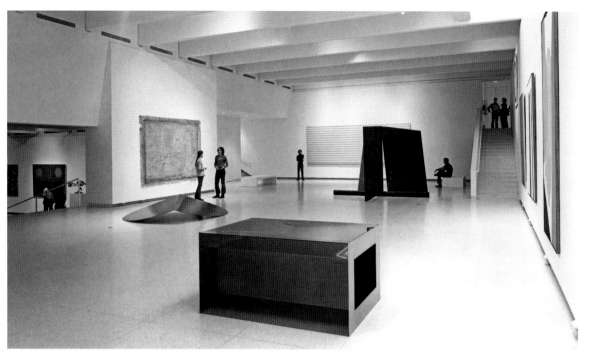

Installation view of the first permanent collection exhibition in the Walker Art Center's Barnes building, 1971

mandates. First, the hybrid nature of many contemporary works renders old taxonomies meaningless, and sometimes it is even difficult to know what you have. A useful case study is Matthew Barney's *Cremaster* series, whose five segments include elements recognizable as sculpture, photography, drawing, performance, music, film, and video. But the *Cremaster* works—a version of each is in the Walker collection—also seem far greater than the sum of their parts. The old standby designations "mixed media" and "installation" don't quite describe them. Is it then useful to discuss the *Cremaster* works as an amalgam of traditional classifications? If not, has Barney found a new form? Or does his innovation lie instead in closing the gap between what used to be called "high" and "low" culture? If that's true, can his work be situated within any art-historical tradition, or is it part of another history, say that of popular cinema? Should the films be shown as DVDs in a gallery setting, or as 35mm prints in a traditional cinema space?

These questions are daunting enough, but Barney's work raises other challenges. Full access to his art depends on technology, which changes rapidly. How should the institution plan for the day when the laser disks, DVDs, and films that were the original formats of the *Cremasters* can no longer be projected or played, either because they have deteriorated or because the projection equipment is outmoded and unavailable? What is the safest way to handle and store objects made with organic, chemically unstable, or unusual materials—such as Barney's "self-lubricating plastic"—so that they will be available to as many people as possible for as long as possible? How can gallery spaces designed for static, quiet objects be practically adapted for work that requires darkened spaces with sound control and seating in order to be experienced in an optimum way?

Maintaining accessibility for media-based works has been an issue since the advent of video art in the 1960s, and technological advances continue to present new challenges. Internet-based and digital works, which are basically intangible and often depend on interactivity, are particularly perplexing. How does a collector preserve a work with no physicality? Is preservation actually an act of violence against a work if, like Internet-based art, it exists properly only when it is available for interaction? Must a digital work be "frozen" in order to exist as a historical document, or is it possible to rethink the notion of the digital archive so that it allows for continued activity while also functioning as a record of the moment? While it is sometimes difficult to move forward without a map, contemporary collections—if they aspire to truly represent their times —must do their best, adjusting along the way. The answers to these questions will become clear over time, until they become muddy again; if we are lucky, artists will continue to explore the edges, bringing collectors with them.

Along with gathering, preserving, and presenting works of art, the collecting institution has the job of contextualizing it, and this catalogue is meant to do some of that work. It is the second comprehensive publication on the Walker's holdings, and builds on the work done in the first—*Walker Art Center: Painting and Sculpture from the Collection* (1990)—which was overseen by former director Martin Friedman. Since that book appeared, the collections have grown dramatically both in number and breadth, and the opening of an expanded facility seemed the right moment for a fresh look at the Walker's holdings. The scholarly research done for the 1990 book is the basis for the current catalogue, which would have been impossible without it. But history, as all historians know, is not a set of fixed

Installation view of the exhibition *Art in Our Time: 1950 to the Present*, 1999

or finished narratives. It is continually being reassessed and adjusted in response to new information and changing points of view, a process that keeps it alive. Art objects, too, benefit from periodic reexamination. It is in that spirit that this catalogue is offered.

The book's organization takes its cue from the Walker's multidisciplinary approach to collecting and programming. Instead of focusing only on painting and sculpture, this volume, like the institution itself, embraces all of the forms that art takes, implicitly arguing for the value of inclusiveness over hierarchy. Its title—taken from a work by Lawrence Weiner in the collection—is BITS & PIECES PUT TOGETHER TO PRESENT A SEMBLANCE OF A WHOLE, a perfect linguistic sketch of this dual act of deconstruction and reconstitution.[7] The heart of the book is a series of entries on artists rather than objects, a choice that allows each career to be explored holistically and objects to be placed in the context of a larger whole. At the same time, the Walker's specific relationship with each artist is explored in detail, often through new information provided by the artist or unearthed in the institutional archives.

The 350 artists included in the book were selected for a range of reasons. Some have an established role in the history of twentieth- or twenty-first-century art and are represented in the collection by a significant work (Lee Bontecou, Maya Deren, Edward Hopper, Franz Marc). Others have a long relationship with the Walker or are represented in the collection in great depth (Siah Armajani, Merce Cunningham, Sherrie Levine, Claes Oldenburg). The Walker's dedication to emerging artists is reflected in the inclusion of many younger practitioners (Lee Bul, Julie Mehretu, Jason Moran). Artists and works new to the collection since the publication of the previous catalogue were given some priority. A fair

number of the entries do not include an essay, an arrangement that is not meant to imply a hierarchy but was simply a way to include as many artists as possible. If an entry lacks a text, it is often because that object was treated in detail in the previous catalogue.

Typically, books of this type are written by an institution's curatorial staff, who are understood to be the experts of record on the artists and works in question. This book does include texts by all current Walker curators in each collecting department: Visual Arts, Film/Video, Performing Arts, New Media Initiatives, and Library/Archives. In addition, thirty-three former Walker curators from those departments have contributed an essay on one artist with whom they had a special connection. Finally, the mix was seasoned by sixteen special contributors (novelists, poets, scholars) who were asked to choose one object and offer a personal reflection on its significance for them. Overall, the inclusion of seventy-five authors in this book could be understood as a proposition: for any given work, there are an infinite number of correct answers to the question "What does it mean?" The lavish number of Walker alumni who appear—we were fortunate that so many responded to our invitation—reminds us that collections are, in great measure, shaped by the individuals who pass through an institution.

In addition to the alumni voices, several other elements of this book tie it closely to Walker history. The evolution of each of the eight programming departments is told in a scrapbooklike assortment of pictures and short texts. Two essays explore the institution's beginnings as the private collection of Thomas Barlow Walker and its later connection with the Work Projects Administration (WPA). Finally, each entry includes specific information about that artist's involvement with the Walker, including exhibitions, performances,

screenings, commissions, residencies, and complete collection holdings. This "hard data"—which has not previously been gathered and published—is a detailed description of the relationships that support and animate many of the objects in the collection.

In 1940, Daniel Defenbacher's ambitious goal was for the Walker to become "a 'museum' of the present for the people of today."[8] He surely meant to emphasize the (assumed) discordance between the words "museum" and "present," but only in order to deny its validity. The Walker's collections are living documents of our own time, and as such they can help us to a fuller understanding of ourselves as a culture. Such objects, physical and otherwise, are meant to be treasured.

Joan Rothfuss
Curator, Permanent Collection

Notes
1. Daniel S. Defenbacher, "Art in Action: A Survey of Purpose and Program," *Walker Art Center of the Minnesota Arts Council* (Minneapolis: Walker Art Center, 1940), 7.
2. Walker Art Center membership brochure, 1939, unpaginated (Walker Art Center Archives).
3. Defenbacher, "Art in Action," 11–12.
4. The three exhibitions were: *Parallels in Art*, which found similarities between works from different historical periods; *Trends in Contemporary Painting*, which offered seven paintings exemplifying seven different stylistic approaches; and *Ways to Art*, which explained how to separate an object's formal qualities from its subject matter (demonstrating, for example, how formal means contribute to an object's affective power). See *Walker Art Center of the Minnesota Arts Council*.
5. The paintings are Marc's *Die grossen blauen Pferde* (*The Large Blue Horses*) (1911), acquired in 1942; Feininger's *Barfüsserkirche II* (*Church of the Minorites II*) (1926), acquired in 1943; Hopper's *Office at Night* (1940) and Sloan's *South Beach Bathers* (1907–1908), both acquired in 1948; and Luks' *Breaker Boy of Shenandoah, Pa.* (1921), acquired in 1949.
6. Kubler used the phrase in his influential book *The Shape of Time: Remarks on the History of Things* (New Haven, Connecticut: Yale University Press, 1962), 10.
7. This work by Weiner, which exists as a linguistic phrase that can be configured for a variety of situations, has been installed on the facade of the Walker's Barnes building since 1992. For this publication, Weiner was commissioned to reformat the work for the book's cover.
8. Defenbacher, "Foreword," *Walker Art Center of the Minnesota Arts Council*, 5.

T. B. Walker's Gift to the Future

The Walker Art Center's collections have their beginnings in 1874, when one of lumber magnate Thomas Barlow (T. B.) Walker's eight children, Julia, requested a drawing to decorate her bedroom walls. He obliged her with a portrait of a monk by Italian artist Tambourine, purchased while on a business trip to New York, and from there he began to educate himself in the art of collecting. He eventually amassed an eclectic group of works—ranging from Chinese jades and French landscape paintings to Native American artifacts—that became one of the most important collections in the Midwest and was the seed for the institution that bears his name.

Walker was born in Ohio in 1840 and came west to Minnesota in 1862. He quickly saw an opportunity to make money in lumber and became one of the wealthiest men of his era. When his business empire was well established, Walker turned his energy to collecting. In 1879, out of a feeling of civic pride and a desire to share his treasures, he opened the Walker Art Gallery. Occupying several rooms of his Minneapolis home, it was reported to be the first public gallery west of the Mississippi.[1] By 1915, additions built to accommodate his growing collections totaled fourteen rooms. Each had a different theme, such as the Jade, Miniature, and Jean-Charles Cazin rooms, and was decorated with paintings hung in traditional salon style from floor to ceiling, sculptures, antique furniture, and rare Oriental rugs.[2]

In 1916 Walker purchased the land just south of downtown Minneapolis that is today known as Lowry Hill. The expansive site adjoined several city parks, and Walker intended to move his home and galleries there so that he and his wife, Harriet, could enjoy the quiet of this secluded area in their old age. Unfortunately, Harriet died in 1917, just prior to the move; T. B., likely feeling his own mortality, refocused his attention on creating a permanent public space for his art collection. He offered the Lowry site to the City of Minneapolis in 1918, but after five years of negotiations finally withdrew his offer and decided to build his own museum instead. In 1925 he established the T. B. Walker Foundation and hired local architects Long & Thorshov to design the building. Two years later, on May 22, 1927, the Walker Art Galleries opened on the present site of the Walker Art Center. Its Moorish-style facade featured intricate detail work in terra-cotta and stone, and the interior included a grand staircase that swept up dramatically from the lobby to the second floor. Walker had accomplished his goal, but he did not have long to enjoy his success: he died in July 1928.

Despite the economic depression of the 1930s, which destroyed the lumber business, the T. B. Walker Foundation managed to keep the museum open. In the mid-1930s Hudson and Louise Walker, both art collectors like their grandfather, took on the arduous task of reexamining every object, artwork, and artifact in T. B.'s vast collection. Their research had important implications for the direction the Walker Art Galleries would take in the coming decades and laid the groundwork for its transition from an art gallery to an art center in 1940.

J.V.

Notes

1. See *Walker Art Center: A History* (Minneapolis: Walker Art Center, 1985), 3.

2. For more on T. B. Walker's collection, see Martin Friedman, ed., *Walker Art Center: Painting and Sculpture from the Collection* (Minneapolis: Walker Art Center; New York: Rizzoli International Publications, 1990), 8–30. An analysis of T. B. Walker's paintings is included in Janet L. Whitmore, *Painting Collections and the Gilded Age Art Market: Minneapolis, Chicago and St. Louis, 1870–1925*, PhD dissertation, University of Minnesota, 2002.

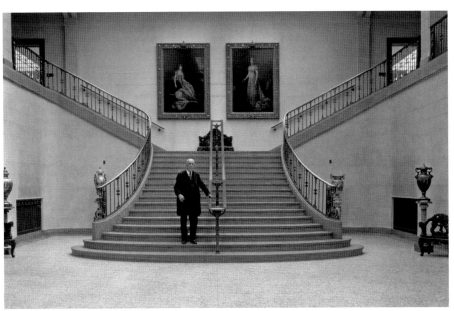

T. B. Walker at the opening of the Walker Art Galleries, Minneapolis, 1927

An American Legacy: The WPA Collection

In 1933, during the height of the Great Depression, President Franklin Delano Roosevelt established the Works Progress Administration (WPA),[1] one of his New Deal initiatives, in an attempt to stimulate an economic recovery and alleviate the scourge of unemployment sweeping the nation. The 1935 Federal Art Project (FAP), which operated under the auspices of the WPA, was a work-relief program for musicians, actors, and writers as well as visual artists who, among other things, were commissioned to create paintings, sculptures, murals, photographs, prints, or drawings in order to embellish newly constructed federal buildings, post offices, and courthouses. According to Holger Cahill, national director of the FAP since its inception, the goals of the program were as follows: "Through employment of creative artists it is hoped to secure for the public outstanding examples of contemporary American art; through art teaching and recreational art activities to create a broader national art consciousness and work out constructive ways of using leisure time; through services in applied art to aid various campaigns of social value; and through research projects to clarify the native background in the arts. The aim of the project will be to work toward an integration of the arts with the daily life of the community and an integration of the fine arts and practical arts."[2] In keeping with the program's main objective to lift people out of the depths of poverty by providing them with opportunities to work, one of its divisions called for the establishment of community arts centers (which would be staffed by relief workers) in both rural areas and urban centers, where art could become part of the cultural experience of any American who was interested, not just the wealthy elite.

The stately Walker Art Galleries, which housed the extensive private collection of lumber baron Thomas Barlow Walker, was not immune to the financial difficulties brought on by the Depression. The T. B. Walker Foundation that had been formed after Walker's death in 1928 was, for all intents and purposes, out of money. The doors of the Galleries remained open and the lights were on, but all other expenses had to be kept to a minimum. Having successfully launched myriad smaller-scale art centers across the country, the WPA administrators were looking for an opportunity to establish a major art center that would become a significant museum of modern art with a life beyond the period of its federal funding. The Walker Art Galleries was a prime candidate. Both Daniel Defenbacher, director of the FAP in Washington, D.C., and Clement Haupers, director of the FAP in Minnesota, took notice of its potential and swiftly arranged for meetings with Walker family members who managed the foundation.

In 1938, Defenbacher presented "A Proposal of Federal Art Project Sponsorship for an Art Center at the Walker Art Galleries," which laid out the alliance between the foundation and the center, specifying its democratic mission to be custodians of the building and collection, to use these assets to present temporary and circulating contemporary art exhibitions, and to provide workshops, lectures, symposia, and art instruction for adults and children in the Twin Cities community. In 1939, the foundation consented to the FAP proposal, as it was clear that federal assistance would guarantee the continued existence of T. B. Walker's legacy without hardship to the family coffers. It was also decided that Defenbacher would leave his post in Washington, D.C. to become the first director, a position that he readily accepted due to his strong feeling that the Walker "was the culmination of the whole art center program."[3] On January 4, 1940, the new Walker Art Center triumphantly opened its doors.

In 1939, the federal government began the process of lending works of art produced under various WPA art projects to museums, art centers, government and state institutions, and other nonprofit public agencies. Many of these works were created as a result of the mandate issued by the easel and graphic divisions of the FAP, which obligated artists to submit a certain percentage of their output for allocation. The Walker was a recipient and is one of twenty-nine other arts institutions (including the Art Institute of Chicago and the Metropolitan Museum of Art, New York) that continues to house a collection of WPA material on long-term loan from the General Services Administration of the U.S. Government. The eighty-three prints and two paintings in the Walker's collection represent a range of imagery in keeping with the American Scene tradition of the day by local artists such as Syd Fossum and Mac LeSueur as well as such luminaries from the period as Mabel Dwight, Jacob Kainen, Louis Lozowick, Elizabeth Olds, Isaac Soyer, and Raphael Soyer.[4]

With the onset of World War II, the FAP program was scaled back due to improved economic conditions. Many positions were phased out as enlistments in the armed forces increased and the rolls of eligible relief recipients diminished. All WPA activity was halted in December 1942 upon an order by President Roosevelt. By March 1943, its involvement with the Walker Art Center ceased entirely.

E.C.

Notes

1. In July 1939, President Roosevelt placed the WPA under the Federal Works Agency—changing the title to Work Projects Administration, thereby stressing its tangible results rather than its relief aspects. See Francis V. O'Connor, *Federal Support for the Visual Arts: The New Deal and Now* (Greenwich, Connecticut: New York Graphic Society, Ltd., 1969): 27.

2. Holger Cahill quoted in O'Connor, *Federal Support for the Visual Arts*, 28.

3. John Franklin White, "The Walker Art Center: A Crowning Achievement," in John Franklin White, ed., *Art in Action: American Art Centers and The New Deal* (Metuchen, New Jersey; London: The Scarecrow Press, Inc., 1987), 15.

4. For a complete list of works and inventory of arts institutions, see *WPA Artwork in Non-Federal Repositories*, May 1996, (Washington, D.C.: U.S. General Services Administration, Public Buildings Service, Cultural and Environmental Affairs Division, Fine Arts Program).

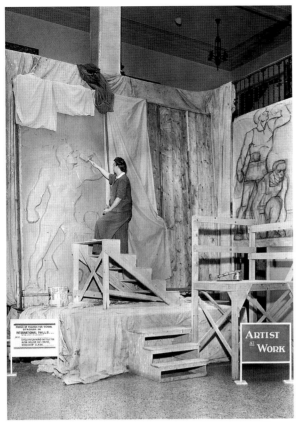

FAP artist and Walker instructor Evelyn Raymond sculpting a frieze for a
stadium in International Falls, Minnesota, in the Walker Art Center lobby, 1942

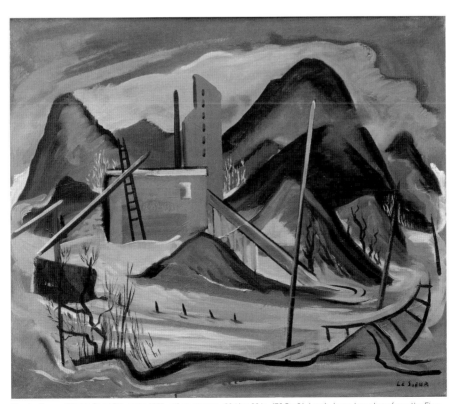

Mac LeSueur *Winter Sand Pit* circa 1935 oil on canvas 30 1/8 x 36 in. (76.5 x 91.4 cm) Long-term loan from the Fine
Arts Collection, Public Buildings Service, U.S. General Services Administration

Visual Arts

Since the Walker Art Center's founding in 1940, special exhibitions have been a cornerstone of its program, and they are, along with stewardship of the collections and management of commissions and artists' residencies, the principal responsibilities of the Visual Arts Department. These three activities are interwoven in a way that makes each stronger, and they also reinforce the department's goals to present and acquire the strongest work by the most compelling artists of the day; to make that art more accessible to audiences; to offer young artists support in a variety of ways; and to contribute to scholarship in the fields of art and cultural history. While aesthetic emphases have shifted with changes in taste and personnel, the goal of the Visual Arts program has remained remarkably true to the Walker's founding tenet: to make clear the nourishing connection between contemporary art and contemporary life.

The exhibition program is a mix of contemporary, historical, group, monographic, thematic, and media-specific shows. The vitality of the moment has been on view in such presentations as *London: The New Scene* (1965) and *Let's Entertain* (2000). Dozens of artists have had their first major museum exposure in Walker exhibitions, among them Joseph Cornell, Frank Gehry, Julie Mehretu, Mario Merz, and Kara Walker. Important scholarly work has been done in exhibitions that looked at under-explored groups (Arte Povera, De Stijl, Fluxus) or applied new critical lenses to the work of established artists (Chantal Akerman, Lucio Fontana, Bruce Nauman). The introduction of new technologies and experimental media—an inescapable part of the contemporary experience—has been the focus in *Light/Motion/Space* (1967) and *The Last Picture Show: Artists Using Photography, 1960–1982* (2003). The Walker's multidisciplinary mission has led to cross-departmental collaboration in exhibitions such as *Graphic Design in America: A Visual Language History* (1989, with Design) and *Art Performs Life: Merce Cunningham/Bill T. Jones/Meredith Monk* (1998, with Performing Arts). Often, disciplines are blended within the space of the gallery itself, with performances and film screenings presented side-by-side and in dialogue with objects.

Since the 1940s, Visual Arts has consciously positioned its exhibition program as an international one, but in recent years it has attempted to embrace even more of the world, a change that reflects broad political, economic, and cultural shifts as well as demographic changes that have radically transformed the Twin Cities. Early exhibitions such as *New Art of Brazil* (1962) and *New Art of Argentina* (1964) have been augmented by *Tokyo: Form and Spirit* (1986), which looked at historical and contemporary aspects of life in Japan; *Hélio Oiticica* (1993), a retrospective of a key Brazilian artist of the postwar period; and the multidisciplinary, cross-departmental *How Latitudes Become Forms: Art in a Global Age* (2003), which identified emerging trends in art from five continents. A parallel effort has been made to place more Walker-organized shows on the road, sharing the art with a much broader public

and extending the life of each project. To date, more than one hundred fifty Walker exhibitions have been presented in dozens of cities on four continents. In 2005 alone, seven travelling shows will be seen by audiences in Arizona, California, Florida, North Dakota, Ireland, Mexico, Spain, and Switzerland.

Since the 1960s, Visual Arts exhibitions have been enriched by specially commissioned new works. Commissions give emerging artists an opportunity to define themselves and challenge established artists to take their work in new directions; often, they also bring those artists into the community for extended periods of time to fabricate or install their pieces. In recent years, some have taken part in a formal program of community-based artist residencies, which offer small groups of participants the chance for close interaction with an artist. Resident artists have the chance to work directly with the public, and participants gain a new understanding of what the experience of art can be. Visual artists-in-residence—who have included Robert Irwin, Glenn Ligon, Barry McGee, Catherine Opie, Lorna Simpson, and Nari Ward, among many others—may be featured in exhibitions, commissioned to produce new work, asked to curate a project from the Walker's collections, or invited to install their work in the Minneapolis Sculpture Garden.

In many ways, the Visual Arts Permanent Collection is thoroughly integrated with the institution's history. After 1958 (when Martin Friedman was hired as a curator), exhibitions, commissions, and acquisitions were pursued at a much faster pace; as a result, the collections—though they encompass the whole of the twentieth and twenty-first centuries—are strongest after 1960. Similarly, working with living artists became a priority during Friedman's tenure as curator and director (1961 to 1990); many of the works in the collection were exhibited, commissioned, or discovered during studio visits. Some relationships with artists—for example, Matthew Barney, Robert Gober, Jasper Johns, Ellsworth Kelly, Sherrie Levine, and Claes Oldenburg—have extended over many years and encompassed multiple projects, and the collection often reflects that commitment through deep holdings that follow the shifts and turns of a whole career. In 1991, Kathy Halbreich assumed the directorship, and under her leadership the mission to support living artists remains central, but she has also directed the expansion of the collection to include groups who have remained outside the traditional artistic canon. These "alternative modernisms" include Japanese Gutai, Viennese Actionism, Italian Arte Povera, and Fluxus, all of which developed during the 1950s and 1960s, and all of which are underrepresented in public collections in the United States. This somewhat "left of center" position has formed a collection with a unique shape. The Walker's holdings are the basis for many special exhibitions, and they are made available to scholars and students, which ensures their continual revitalization within new contexts and critical discourses as well as for new generations of viewers.

Exhibitions Organized by the Walker 1940–2005

* denotes traveling exhibitions

1940
Ways to Art
Parallels in Art
Trends in Contemporary Art
Stanford Fenelle
Letters, Words and Books
Elof Wedin
Frontiers of American Art
Artistry in Glass from Dynastic
 Egypt to the Twentieth Century
Syd Fossum
Answers to Questions
Edwin Holm
Josephine Lutz
Exhibition of Student Work
Cameron Booth
Portraits of Indians and their Arts
Mac Le Sueur
Paintings and their X-Rays
Unpopular Art

1941
Children's Portraits
Accessories for the House
Exhibition of Student Work
American Houses Today
Art of the Print
City Planning
Three Women Sculptors
Idea House I
Gopher Camera Club
John Huseby
America Builds for Defense
L. G. Le Sueur "Modern
 Illustrations for Mother Goose"

1942
Miriam Ibling
Art of the Print
June Corwine
Chinese Paintings
Faculty and Student Show
2nd Annual Gopher Camera
 Club Salon
Indian Portraits
From the Halls of Montezuma

1943
Local Artists
92 Artists
3rd Annual Gopher Camera
 Club Salon
Definitions*

1944
First Annual Minnesota
 Sculpture Exhibition
Le Sueur So Far
110 American Painters of Today*
Exhibition of Student Work
The New Spirit: Le Corbusier—
 Architect, Painter, Writer*

1945
American Watercolor and
 Winslow Homer*
Silk Screen Portraits of 13
 Artists by Harry Sternberg
Reproductions: Own Your
 Favorite Painting
Second Annual Regional
 Sculpture Exhibition
Eleanor Harris
The Story of Jade
Paintings by Philip Evergood
Races of Mankind

1946
Man and Clay
Recent Purchases and Gifts
Ideas For Better Living
Alonzo Hauser
Furniture and Fabrics
Nine Minnesota Artists
Watercolor—U.S.A.*
Paintings by June Corwine
5 Minnesota Painters
Third Regional Sculpture
 Exhibition
Exhibition of Student Work
136 American Painters
Sculpture by Dustin Rice
Painting by Lenore Erik-Alt
Useful Gifts
Paintings by Fridtjof Schroder
Painting by Agnes Sims
Photographs by Clarence Laughlin

1947
Lithographs by William Norman
Ethel Schochet
Vanguard Group
Arthur Kerrick
Sectional Furniture
Warsaw Lives Again
Made in Scandinavia
John Marin: A Retrospective
 Exhibition
Paintings by Everet McNeal
Plastics in the Home
Fourth Annual Six-State
 Sculpture Exhibition
First Biennial Exhibition of
 Paintings and Prints*
Idea House II
82 Drawings by William Bushman
Designs for Idea Houses III
 through VIII
Christmas Exhibition
Useful Gifts

1948
Sculpture by Evelyn Raymond
Children's Fair
Modern Jewelry Under
 Fifty Dollars*
Paintings to Know and Buy
Man and Clay
Everyday Art Outdoors

Walker Director Daniel Defenbacher (seated right) with (left to right): designer Arthur Carrara, artist Alonzo Hauser, educator Carol Kottke, and curator William Friedman, circa 1949

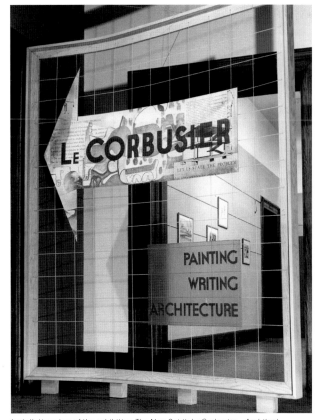

Installation view of the exhibition *The New Spirit: Le Corbusier—Architect, Painter, Writer,* 1944

Second Christmas Exhibition Sale
Useful Gifts
Modern Art in Advertising:
 Designs for Container
 Corporation of America
1949
Modern Textiles
A New Direction in Intaglio*
Modern Painting in Minnesota
Lamps and Lighting
Recent Paintings by
 Cameron Booth
Photographs by John Szarkowski
Textiles and Ceramics
John T. Baxter Memorial
 Collection of American
 Drawings
Made in Minnesota
Alfred H. Maurer 1868–1932*
Christmas Exhibition Sale
Second Biennial Exhibition of
 Paintings and Prints*
Useful Gifts
1950
Jerome Liebling
Alvin Lustig
New Minneapolis Painters
The Tradition in Good Design
 to 1940
Pictures for the Home
Aristide Pappas
The Tradition in Good Design,
 1940–1950
Mobiles and Constructions
Seeing Pictures
Contemporary American
 Painting: Fifth Biennial
 Purchase Exhibition*
Useful Gifts
1951
Knife / Fork / Spoon*
Phyllis Downs Paintings
Pastels by Geraldine Frise
Fifth Six-State Sculpture
 Exhibition
Paintings, Drawings, and
 Collages by John Anderson
Minnesota Paintings and
 Sculptures
Painting by Lenore Erik-Ault
Third Biennial Exhibition of
 Paintings and Prints from the
 Upper Midwest*
Useful Gifts
Christmas Sale
1952
Paintings and Drawings by
 Birney Quick
California Crafts
Gilbert and Susan Walker
 Collection
Murray Turnbull

Joan Miró
Robert Kilbride
C. S. Price Memorial Exhibition
David Smith Sculpture
Architects Workshop
Marianna Pineda Sculpture
Made in Sweden
Charles Sheeler
Contemporary American
 Painting and Sculpture:
 Collection of Mr. and
 Mrs. Roy R. Neuberger
Artists Equity Exhibition
W. Dean Warnholtz
Cameron Booth
Rufino Tamayo
John Anderson
Floyd and Margareth Brewer
Photography by Clark Dean
Drawings by Richard Burgess
Drawings by Walter Quirt
Artists Workshop
Goya and Twentieth Century Art
Christmas Sale
Lowenthal Collection of
 American Art
Useful Gifts
1953
Visitors From Minnesota*
Julia Pearl
Classical Art from the
 T. B. Walker Collection
Textiles
19th Century American
 Landscape Paintings from the
 T. B. Walker Collection
Sculpture by Saul Baizerman
Mobile Prints from Paul La Porte
Art in Modern Ballet
Architects Workshop 1934
Purcell and Elmslie Architects*
Mobiles by Alexander Calder
Ben Nicholson
John Wylie
The Classic Tradition in
 Contemporary Art
Prints and Paintings by
 Malcolm Myers
Cameron Booth
Syd Fossum
Joseph Cornell
Ethel Christensen
Elof Wedin
Harold Tovish
Olivetti: Design in Industry
Gerhard Marcks
Kurt Pinke: The Farbenspiel
Christmas Sale
Book Corner Holiday Exhibition
Useful Gifts
Second Annual Sales and
 Rental Exhibition

1954
Fourth Biennial of Paintings
 and Prints*
Classical Art From the
 T. B. Walker Collection
Morgan Russell: Paintings
Jean Arp
Reality and Fantasy, 1900–1954
Photographs of Robert Doisneau
Religious Art from the
 T. B. Walker Collection
Sculpture and Drawings by
 John Rood
Photographs of Sabine Weiss
The Sculpture of Jacques Lipchitz
Useful Gifts
Children's Holiday Workshop
1955
Babette
Paintings by Franklin Sampson
Design Review 1955
Marcel Breuer's Design for
 St. John's Abbey
Richard Sussman
The Sculpture of Ann Wolfe,
 1954–1955
Vanguard 1955
People in Motion by Walter Quirt
Annual Book Fair
Useful Gifts
1956
Sculpture by Paul Granlund
Expressionism 1900–1955*
Second Annual Exhibition of
 Art by the Mentally Ill
Biennial of Paintings, Prints
 and Sculpture from the
 Upper Midwest
Paintings by Hazel Moore
Southdale Artists
Pacific Coast Art
Annual Book Fair
Paintings and Drawings by
 Phyllis Downs
Useful Gifts
Theodore Roszak
1957
The Artist's Studio
Recent Acquisitions:
 Sculpture and Prints
Philip Morton
Paintings by Stuart Davis*
Third Annual Exhibition of Art
 by the Mentally Ill
Recent Work by Elsa Jemne
Drawings by Picasso
Religious Prints
Early American Glass
First Annual Collectors Club
 Exhibition
Portraits by Walter Gramatté
Third Annual Book Fair
Useful Gifts

Paintings by Jack Tworkov
1958
Kraushaar Galleries Exhibition
Paintings by Wilfred Zogbaum
Bittan Valberg Rugs
1958 Biennial of Paintings, Prints
 and Sculpture*
Faces of Minnesota
Paintings and Drawings by
 Kurt Seligmann
Paintings by Byron Burford
Prismatic Sculpture by
 Fred Dreher
Recent Work by Herbert Bayer
Sculpture by Germaine Richier
Little Magazines
Fourth Annual Book Fair
Sculpture by Paul Manship
Useful Gifts
Recent Paintings by Urban Couch
Second Annual Collectors
 Club Exhibition
Prints by Georges Braque
1959
Paintings by Byron Bradley
Painting by Walter Quirt
Watercolors by Gordon Holler
Paintings by Josephine
 Lutz Rollins
Paintings by Melvin Geary
School of Paris 1959:
 The Internationals
Paintings from the Stedelijk
 Museum, Amsterdam*
Recent Paintings by
 Louis Schanker
John T. Baxter Memorial
 Exhibition
Recent Sculpture by
 Katherine Nash
Paintings by Phyllis Downs
Fifth Annual Book Fair
American Prints Today
Paintings by Carol Hoorn Fraser
Paintings by Cameron Booth
Toys Old and New
Art Fair
1960
Sculpture by Dorothy Berge/
 Paintings by Tony Urquhart
The John and Dorothy Rood
 Collection
Paintings by Tseng Yu-Ho
Paintings, Prints and Drawings
 by Rudy Pozzatti
60 American Painters: Abstract
 Expressionist Painting of
 the Fifties
Paintings and Drawings by
 William Saltzman
16 Younger Minnesota Artists
Japan: Design Today

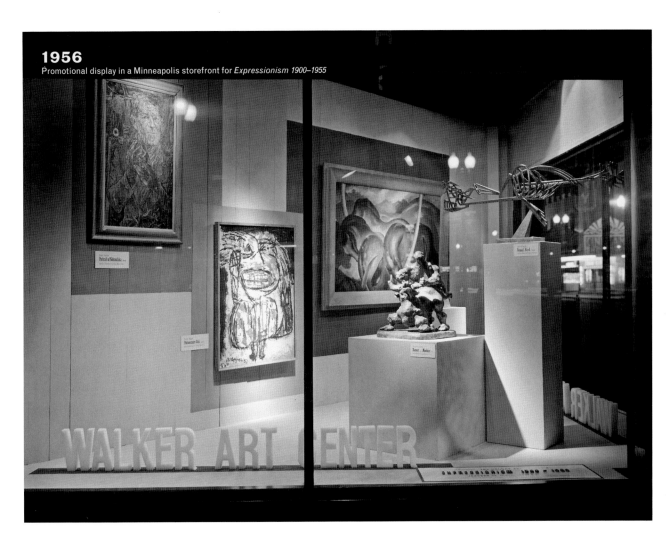

1956
Promotional display in a Minneapolis storefront for *Expressionism 1900–1955*

left to right: Richard Smith, John Kazmin, and David Hockney at the opening for *London: The New Scene*, 1965

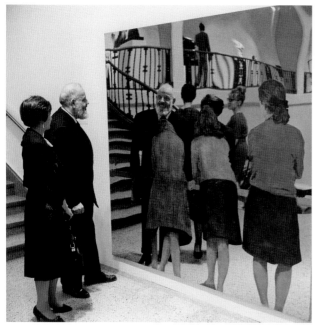

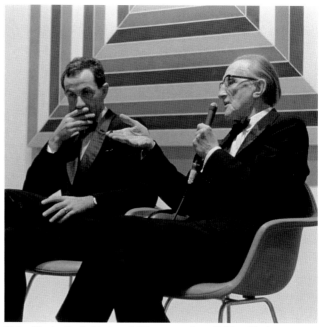

Visitors mirrored in Michelangelo Pistoletto's *Three Girls on a Balcony* (1962–1964) in the exhibition *Michelangelo Pistoletto: A Reflected World*, 1966

Walker Director Martin Friedman (left) in conversation with Marcel Duchamp, 1965

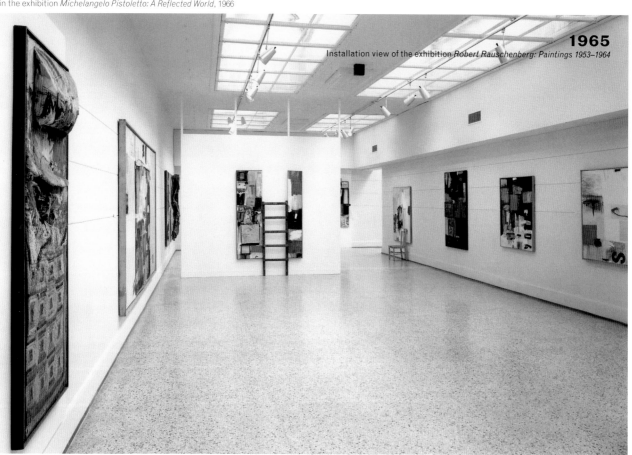

1965

Installation view of the exhibition *Robert Rauschenberg: Paintings 1953–1964*

Martin Friedman on Commissions at the Walker

Martin Friedman, Walker Art Center director from 1961 to 1990, in conversation with curator Joan Rothfuss, New York City, August 6, 2004

Joan Rothfuss: During the 1960s, the Walker had an active and really rather daring exhibition program, but the practice of commissioning new works from artists didn't pick up steam until the late 1960s. How did you approach this risky part of the program?

Martin Friedman: I never thought of it as a risk. It just seemed to me that giving artists opportunities to make new work was something the museum should do. I never knew how things were going to work out—I was just as curious as the next person, and it was an adventure for all of us.

JR: Why did you start when you did?

MF: We began commissioning pieces in earnest while the Barnes building was under construction. One of our first exhibitions outside the museum was *14 Sculptors: The Industrial Edge*, which we installed in the old Dayton's [department store in downtown Minneapolis] eighth-floor auditorium. We were glad to have access to that great space, between the flower shows and all the other special events! There were some wonderful works. I remember especially Robert Grosvenor's very commanding piece, which was made from aluminum tubing suspended from the ceiling, and Robert Morris' series of aluminum-mesh structures.

The next year we organized *Figures/Environments*, which included several commissioned works. One of the most ambitious was Red Grooms' *The Discount Store*. It was based on drawings Red made at one of the first Target stores in the area, and it was built, from start to scratch, in a space we set up in the old State Theatre Building on Hennepin Avenue, where we had temporary offices. When it was finished, it was a walk-in cartoon version of a Target store, complete with a tire department, a popcorn lady, and a gun shop.

JR: After that came *9 Artists/9 Spaces*, which was a very different experience, I understand.

MF: Yes indeed. That was also done in 1970, but it was an entirely commissioned works show, and everything was installed outdoors, around the area. Those were tense, anarchic days, with protests, riots, and bombings all over the country. Somehow, in this atmosphere, the show's works were viewed as provocative by some, and I'm sorry to say that practically everything was destroyed in one way or another by the public.

For example, the piece Richard Treiber installed in front of the State Capitol in St. Paul was a huge pile of brush that echoed the dome of the building. The authorities must have viewed it as an incitement to burn down the Capitol, because it suddenly disappeared. Bill Wegman painted a huge billboard of one of Minneapolis' cherished icons, the Foshay Tower, but the tower was shown on its side with the legend, "What goes up must come down." You can imagine how that was received. It had been sited just across the Mississippi River from the University of Minnesota, and was up for maybe a day or so, and then it, too, vanished. How does a billboard disappear? It had been removed during the night and hidden, but where? After a frantic search, our staff found it stashed away in a University storage place. There's more! Ron Brodigan made a huge snakelike metal piece that seemed to go in and out of the ground, which he carefully sited in the park across from the Minneapolis Institute of Arts. It was stomped and flattened by a group of young vagrants, who resented its presence in "their" park. One of the few pieces that survived was Barry Le Va's series of wooden platforms, maybe because no one could find it. It was somewhere around Prior Lake.

Every time something happened to a work, Richard Koshalek, the show's curator, would cross out the number on the poster. *9 Artists/9 Spaces* shrank to 8, then 7, then 6 . . . you get the idea. We were apprehensive about what new horrors each day might bring.

JR: All these stories are interesting because they add up to a kind of uneasy relationship between the museum, the artist, and the community. Bringing a work out of the institution entirely changes the way it functions.

MF: No question about it. Once we left the confines of the museum, we encountered a great variety of reactions. We certainly never thought of what we were doing as confrontational, but those were difficult times. We believed in all the works that we presented in public settings, but we were clueless as to how the public might react to them.

JR: And yet, as soon as the Barnes building opened, you did it all over again. Everything in your very first show, *Works for New Spaces*, was commissioned.

MF: Well, I was somewhat more toughened by then, more annealed, you could say. And don't forget, we were now safely back indoors!

JR: I understand that while the building was in the planning stages you spent a lot of time in New York, visiting artists and getting suggestions about what ideal gallery spaces might look like.

MF: That's true. All of the artists said, "Keep it simple, keep it big." So that's what Mickey [Mildred Friedman] and I talked about with Ed [architect Edward Larrabee Barnes]. He got the message, and we

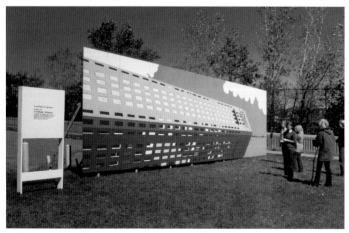

William Wegman's *What Goes Up Must Come Down* (1970) in the exhibition *9 Artists/9 Spaces*, University of Minnesota, Minneapolis, 1970

Lynda Benglis' *Adhesive Products* (1971) in the exhibition *Works for New Spaces*, 1971

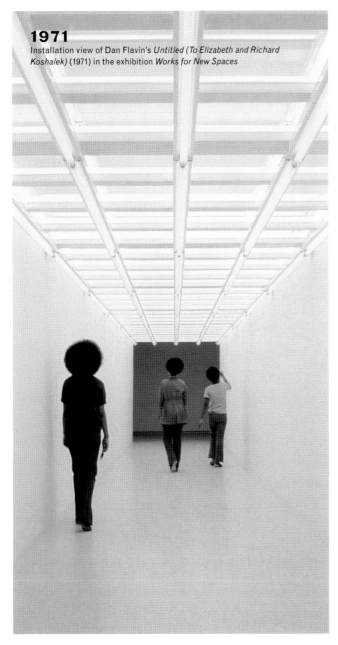

1971
Installation view of Dan Flavin's *Untitled (To Elizabeth and Richard Koshalek)* (1971) in the exhibition *Works for New Spaces*

nical help from a physicist; the idea was to find the exact point where forces of attraction and repulsion would cancel one another. Somehow they managed to do it. I remember Siah saying, with great delight, "If I were in Persia, I would be a prophet!" There was a little problem, however. Every time an admiring visitor would try to photograph it, the flash broke the magnetic field and the thin, bent metal foil that composed the piece would crash to the ground.

The artists in that opening exhibition put an indelible stamp on the building. The Walker became not just a place to exhibit art, but also one to make it, and from then on commissioning was a way of life for us.

JR: By the 1980s, you'd made this into an art form on its own with huge commission projects such as the exhibitions *Tokyo: Form and Spirit*, *Hockney Paints the Stage*, and *The Architecture of Frank Gehry*.

MF: I think the 1980s could be called our period of high delirium.

JR: A period that culminated with probably your largest project of the type—the Minneapolis Sculpture Garden.

MF: Yes, and there were marvelous works commissioned for it. We asked Martin Puryear to create an entrance to the Garden off Vineland Place. The result was *Ampersand*, two granite columns, one the inverted version of the other. Together, they express the idea of being and becoming—each column was left rough and unfinished on one end, and turned smooth on the other. It was the first time Martin had worked with stone. Then, of course, there is the *Spoonbridge and Cherry*.

JR: What was the assignment you gave Claes Oldenburg and Coosje van Bruggen?

MF: It was the most general brief imaginable. Essentially we gave them what was then a large sector of the north end of the Garden to work with. We knew that we wanted water there, but that was it. At first, Claes made all sorts of drawings that might allude to Minnesota—Viking ships, Indian canoes—but in the end they settled on this simple but rather surreal image of a spoon and cherry that really has nothing much to do with the region. Why a cherry? And why a spoon, for that matter? Well, why not? A great deal is left to the imagination, but that makes the work. The *Spoonbridge and Cherry* fountain is a benign, if improbable, alien presence, which is a large part of its success with the public.

JR: Another major statement out there is Armajani's Irene Hixon Whitney Bridge. How did you settle on him for the commission?

MF: He was the logical choice for a few reasons. First, he had designed many bridges, which we had seen and admired. We'd worked successfully with him many times before, and he's an honored presence in the area.

During the course of the planning, he and I looked carefully at an old steel bridge over the Mississippi slated for destruction. We hoped that one of its immense arches might be salvaged for his project. After climbing up and crawling along hilly embankments, it was evident to us that the rusted arch was far too big to incorporate into his design, but the impression of its graceful curves stayed with him, and they appear in the bridge he eventually designed, which is like a giant handshake across the busy highway. Its parabolic curves and trestle shapes connect it historically to nineteenth-century industrial-age forms, which he alludes to in his work so often.

JR: And you were there observing the creative process—that truly is one of the pleasures of our work, don't you think?

MF: Absolutely. And I never really felt it necessary to try to influence the outcome: once an artist was asked to make a work and a proposal was accepted—for its budget as well as its design—I would generally stand back and watch things happen. I never really knew what we would get, but that's the exciting part. And I must say, we were very fortunate.

ended up with simply built, commodious galleries that echoed the large lofts we had visited. Suddenly, we had all this space and I thought, "What are we going to do with it?" For many reasons—not the least being that we didn't have enough large-scale paintings and sculptures in the collection to fill the new galleries—the first show had to be of specially commissioned works.

The artists we invited to make pieces could hardly wait to attack the building, and they did, in the most amazing ways. Dan Flavin bisected a large gallery by constructing a long tunnel he filled with radiant multicolored light. Lynda Benglis' poured pieces looked like creatures from a science-fiction film boring their way through the exterior walls into the galleries. Don Judd made a spectacular series of blue galvanized metal boxes, and Robert Irwin made a scrim piece that glowed like a huge wedge of light.

Siah Armajani's piece, *Fifth Element*, was strange and compelling. Through the magic of magnetism, it hung a few inches below the ceiling with no visible means of support. He made it with tech-

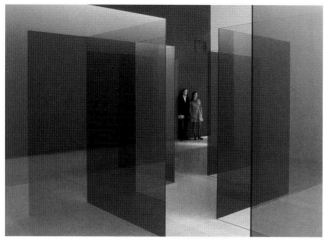

Larry Bell's *No Title* (1969) in the exhibition *14 Sculptors: The Industrial Edge*, Dayton's Auditorium, 1969

Installation view of Stan VanDerBeek's *Telephone Mural* (1970) at First National Bank of Minneapolis, 1970

1972
Marisa (left) and Mario Merz in the galleries of the exhibition *Mario Merz*

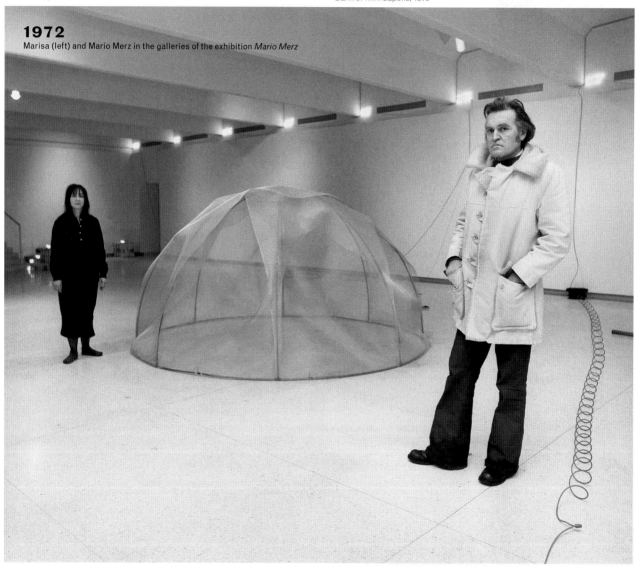

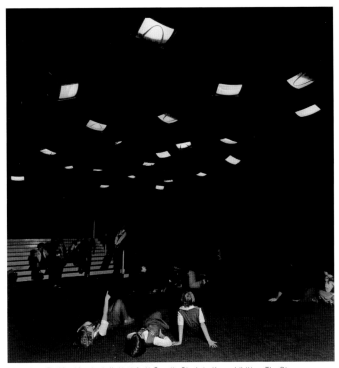

Nam June Paik's video installation *Anti-Gravity Study* in the exhibition *The River: Images of the Mississippi* 1976

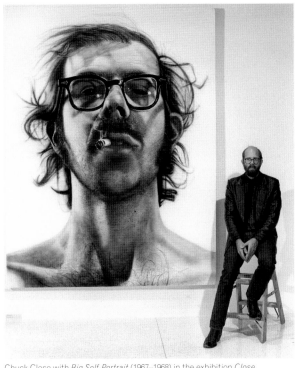

Chuck Close with *Big Self-Portrait* (1967–1968) in the exhibition *Close Portraits*, 1980

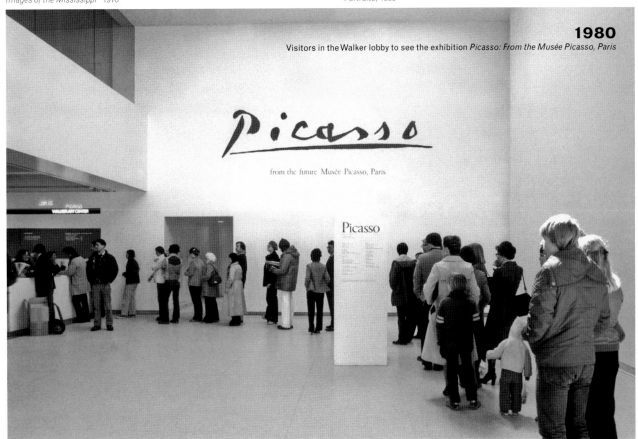

1980

Visitors in the Walker lobby to see the exhibition *Picasso: From the Musée Picasso, Paris*

Hock E Aye Vi Edgar Heap of Birds with his installation *Building Minnesota* (1990)
on West River Parkway, Minneapolis

Installation view of the exhibition *In the Spirit of Fluxus*, 1993

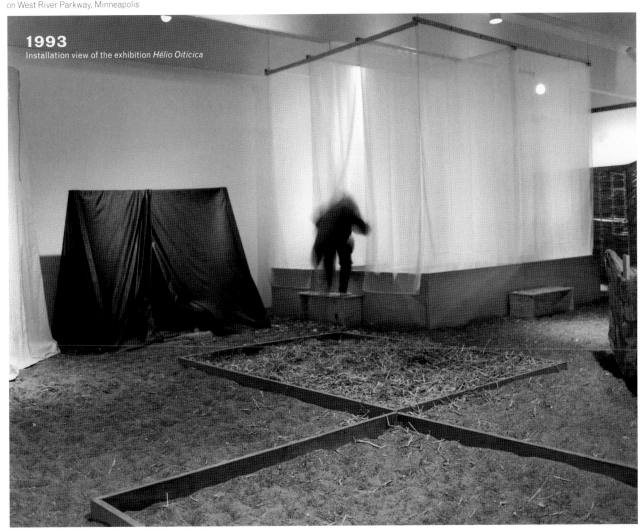

1993
Installation view of the exhibition *Hélio Oiticica*

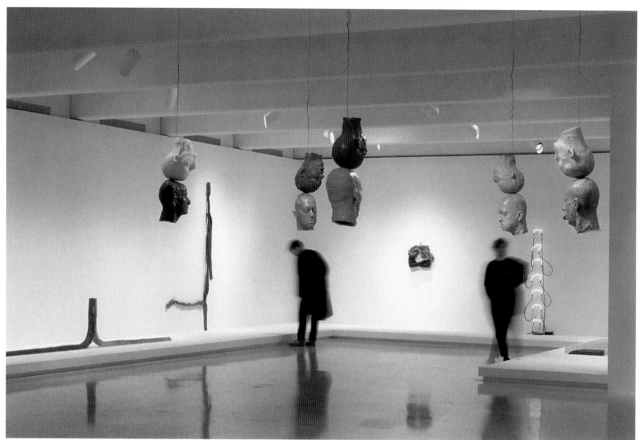

Installation view of the exhibition *Bruce Nauman*, 1994

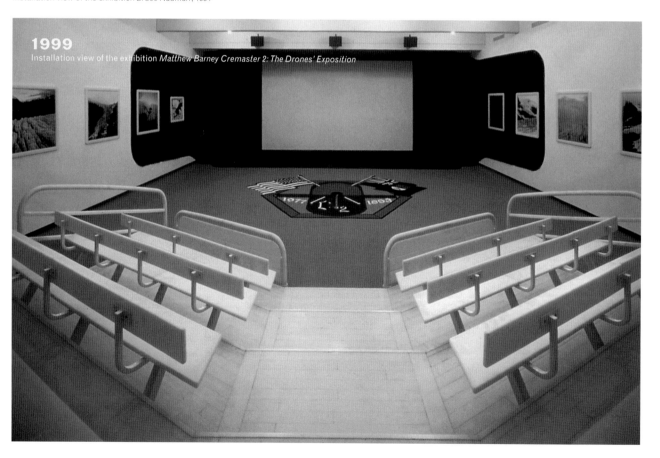

1999
Installation view of the exhibition *Matthew Barney Cremaster 2: The Drones' Exposition*

1990

The Persistent Figure

Jasper Johns: Printed Symbols*

David Hockney: Fax Prints

Architecture Tomorrow:
 Geological Architecture:
 The Work of Stanley Saitowitz*

Viewpoints—Mel Chin*

Art Into Life: Russian
 Constructivism 1924–1932*

1991

Architecture Tomorrow:
 Tourisms: suitCase Studies:
 An Installation by Elizabeth
 Diller and Ricardo Scofidio*

The Legacy of Surrealism:
 Permanent Collection

Architecture Tomorrow: Edge of
 a City: An Installation by
 Steven Holl*

Material Matters: Permanent
 Collection Sculpture
 Since 1980

Viewpoints—Alan Rath*

Viewpoints—Jac Leirner

1992

Portraits, Plots, and Places:
 The Permanent Collection
 Revisited

Photography in Contemporary
 German Art: 1960 to the
 Present*

Ann Hamilton/David Ireland

The Once and Future Park

Viewpoints—John Snyder

Brice Marden: Cold Mountain*

Claes Oldenburg: In the Studio*

Magdalena Abakanowicz: An
 Installation in the Minneapolis
 Sculpture Garden

Viewpoints—Guillermo Gómez-
 Peña and Coco Fusco: The
 Year of the White Bear*

Public Address: Krzysztof
 Wodiczko*

Robert Motherwell: The Spanish
 Elegies

Viewpoints—Malcolm X:
 Man, Ideal, Icon*

1993

In the Spirit of Fluxus*

Viewpoints—Michael Sommers/
 Susan Haas: The Question
 of How

The Permanent Collection:
 Recent Acquisitions

Craigie Horsfield*

Lee Friedlander: Letters from
 the People

1994

The Garden in the Galleries

The Sublime Is Now: The Early
 Work of Barnett Newman

Bruce Nauman*

Selections from the Permanent
 Collection and The Listening
 Project

Ellsworth Kelly: The Process
 of Seeing

The Edmond R. and Evelyn Halff
 Ruben Bequest: Twentieth
 Century Masterworks

Duchamp's Leg*

1995

Economies: Hans Accola and
 Rirkrit Tiravanija

Sigmar Polke: Illumination

Sigmar Polke: Editions,
 1966–1995*

Joel Shapiro: Outdoors

Bordering on Fiction: Chantal
 Akerman's "D'Est"*

Viewpoints—Paul Shambroom:
 Hidden Places of Power

Dawoud Bey: Portraits 1975–1995*

"Brilliant!" New Art from London*

Shu Lea Cheang: Bowling Alley

1996

Composing a Collection:
 Recent Gifts and Acquisitions

Willem de Kooning: The Late
 Paintings, the 1980s*

Robert Motherwell: Reality
 and Abstraction

Peter Fischli and David Weiss:
 In a Restless World*

Visitors' Voices: Recomposing
 the Collection

The Photomontages of
 Hannah Höch*

Selections from the Permanent
 Collection

Edward Hopper's "Office at
 Night:" Women at Work

1997

Dialogues: Todd Norsten/
 Kristin Oppenheim

On a Balcony: A Cinema
 (Mark Luyten)

no place (like home)

Dialogues: Mary Esch/
 Daniel Oates

The Art and Life of Anne Ryan

Frank Stella at Tyler Graphics*

Diana Thater: Orchids in the
 Land of Technology

Hot Art Injection (Hold Still)

Joseph Beuys Multiples*

Media Is the Message: Art
 of the 1960s

Stills: Emerging Photography
 in the 1990s

1998

100 Years of Sculpture: From
 the Pedestal to the Pixel

Dialogues: Sam Easterson/
 T. J. Wilcox

Sculpture on Site (S.O.S.)

Performance in the 1970s:
 Experiencing the Everyday

Art Performs Life: Merce
 Cunningham/Meredith Monk/
 Bill T. Jones

Regards, Barry McGee

Unfinished History*

Commission Possible: Walker
 Art Center, 1980–1998

1999

Robert Gober: Sculpture +
 Drawing*

Dialogues: Paul Beatty/
 Wing Young Huie

Scenarios: Recent Work by
 Lorna Simpson*

Hot Art Injection (may cause
 side effects)

Edward Ruscha: Editions
 1959–1999*

Matthew Barney Cremaster 2:
 The Drones' Exposition

Art in Our Time: 1950 to the
 Present

Artists at Work

2000 BC: THE BRUCE CONNER
 STORY PART II*

The Nature of Abstraction:
 Joan Mitchell Paintings,
 Drawings, and Prints

2000

Let's Entertain*

Artist-in-Residence:
 Glenn Ligon

The Home Show

Dialogues: Bonnie Collura/
 Santiago Cucullu

State of the Art: Recent Gifts
 and Acquisitions

The Cities Collect

Artist-in-Residence:
 Bill T. Jones

Coloring: New Work by
 Glenn Ligon

Herzog & De Meuron: In Process

2001

Painting at the Edge of the World

Franz Marc and the Blue Rider

Artist-in-Residence: Spencer
 Nakasako

Hot Art Injection III

The Essential Donald Judd

Zero to Infinity: Arte Povera
 1962–1972*

American Tableaux*

2002

Walk Around Time:
 Selections from the
 Permanent Collection

Alan Berliner: The Language
 of Names

Catherine Opie: Skyways and
 Icehouses

To/From: Rivane
 Neuenschwander

Things Not Necessarily Meant
 to be Viewed as Art (from
 the Permanent Collection)

Dialogues: Amy Cutler/
 David Rathman

2003

How Latitudes Become Forms:
 Art in a Global Age*

Elemental: Selections from the
 Permanent Collection

Julie Mehretu: Drawing into
 Painting*

Strangely Familiar: Design and
 Everyday Life*

The Squared Circle: Boxing in
 Contemporary Art

Pop³: Oldenburg, Rosenquist,
 Warhol

The Last Picture Show:
 Artists Using Photography,
 1960–1982*

Selections from the Permanent
 Collection

Past Things and Present:
 Jasper Johns since 1983*

2004

Shake Rattle and Roll:
 Christian Marclay

2005

Chuck Close: Self-Portraits
 1967–2005*

Kiki Smith*

Huang Yong Ping:
 A Retrospective*

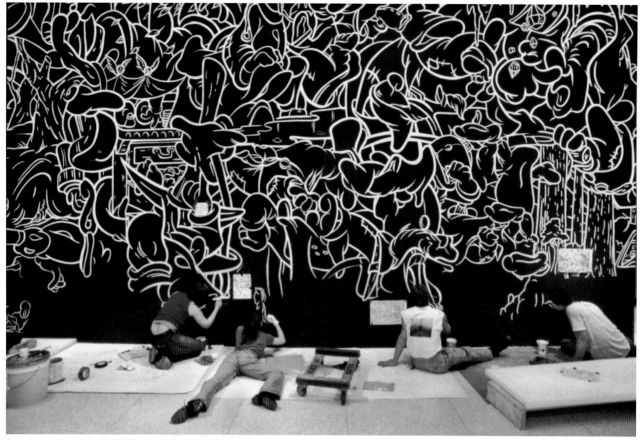

Arturo Herrera's *All I Ask* (1999/2001) installation in progress for the exhibition *Painting at the Edge of the World*, 2001

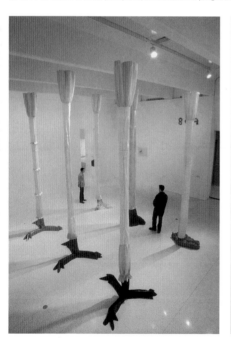

A selection of Luciano Fabro's *Piede (Foot)* (1968–1972) in the exhibition *Zero to Infinity: Arte Povera 1962–1972*, 2001

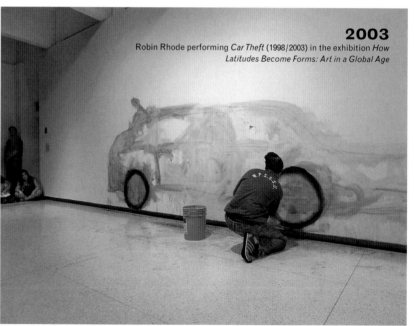

2003

Robin Rhode performing *Car Theft* (1998/2003) in the exhibition *How Latitudes Become Forms: Art in a Global Age*

Performing Arts

As a leading national force since its founding, the Walker Art Center's Performing Arts Department has been built successfully on a foundation laid by five visionary directors and a level of institutional commitment rare for a contemporary arts center.

The Walker began presenting local dance, poetry, and chamber music concerts in 1940. In 1953, the volunteer-staffed Center Arts Council (CAC) was formed to organize a wider range of performances and film screenings. Out of CAC grew the Center Opera Company (later the Minnesota Opera Company) in 1963, led by John Ludwig and dedicated primarily to contemporary American opera and unique collaborations between opera and visual artists. By the time it disbanded in 1970, the CAC had already presented Merce Cunningham's first Minnesota performance (1963) and established its first artist commission, Alwin Nikolais' *Vaudeville of the Elements* (1965). Performing Arts was officially designated as a department in 1970, with Suzanne Weil serving as coordinator until 1976.

Throughout the 1970s, the department sponsored events in a range of venues around the Twin Cities, increasing the visibility of contemporary dance, new music, jazz, and experimental theater and hosting an array of pop, rock, and folk concerts. Weil increased annual presentations from fewer than one hundred in the mid-1960s to more than two hundred annual presentations by the early 1970s. She launched significant program initiatives and established key relationships with a range of artists now considered masters— Cunningham, Mabou Mines, Philip Glass, Twyla Tharp, Meredith Monk, and many others—that continue today. Weil also designed elaborate residencies and laid the foundation for what would become an active commissioning program, both of which served as national models for the field.

Nigel Redden assumed the directorship in 1976 and further solidified the Walker's growing national reputation by producing major festivals such as the M-80: No Wave/New Wave rock festival (1979), New Music America (1980), and New Dance USA (1981). He helped establish the Twin Cities as a vital center for noncommercial composed, experimental, and avant-garde music through his collaboration with the Saint Paul Chamber Orchestra, which cosponsored the long-running Perspectives Series. His major commissions for Trisha Brown (*Glacial Decoy*, 1979) and Richard Foreman (*City Archives*, 1977) were early indicators of directions the program would take in the disciplines of dance and theater.

Commissioning activity and support of artist residencies grew during Robert Stearns' six-year tenure, which began in 1982. He launched a number of large-scale, nationally significant theatrical projects, including David Byrne/Robert Wilson's *The Knee Plays* (1984) and Lee Breuer/Robert Telson's epic *The Gospel at Colonus* (1983). He also began two long-standing collaborative series—Discover: New Directions in Performance (with Northrop Auditorium) and Out There in 1989 (with the Southern Theater)—and, with former Walker film curator Melinda Ward, helped develop the national public television program *Alive from Off Center* (1985–1997).

John Killacky assumed leadership of the department in 1988, and the following year his position was retitled curator of Performing Arts. Despite declines in national funding that began to negatively impact all arts organizations in the mid-1990s, Killacky's years marked a time of greater engagement with the local artistic community (Imp Ork, Patrick Scully, Shawn McConneloug), more international programming, and continued support for major artists of the Walker's history. A commitment to provocative, identity-based performance work, which was central to the times, included memorable (and controversial) evenings with Ron Athey, Diamanda Galás, Karen Finley, and Guillermo Gómez-Peña and Coco Fusco.

In 1997, Philip Bither became curator and focused departmental energies toward a renewed interest in contemporary music (jazz, avant-rock, and new music), experimental puppetry, and in-depth community-based artist residencies (Bill T. Jones, Liz Lerman, Joanna Haigood, and others). The department's global programming and the commissioning of large-scale theater and dance projects are further emphasized, including Builders Association/motiroti's *Alladeen* (2003); Improbable Theatre's *The Hanging Man* (2004); and Ralph Lemon's *Come home Charley Patton* (2005). In 1999, the Walker was awarded a $1.5 million program endowment grant from the Doris Duke Charitable Trust, dramatically increasing its ability to make long-range commitments and fund the early development of new works. In 2004, William and Nadine McGuire contributed $10 million in support of commissioning performing arts projects and for construction of a state-of-the-art theater that bears their name, ensuring a permanent home for contemporary performing artists at the Walker.

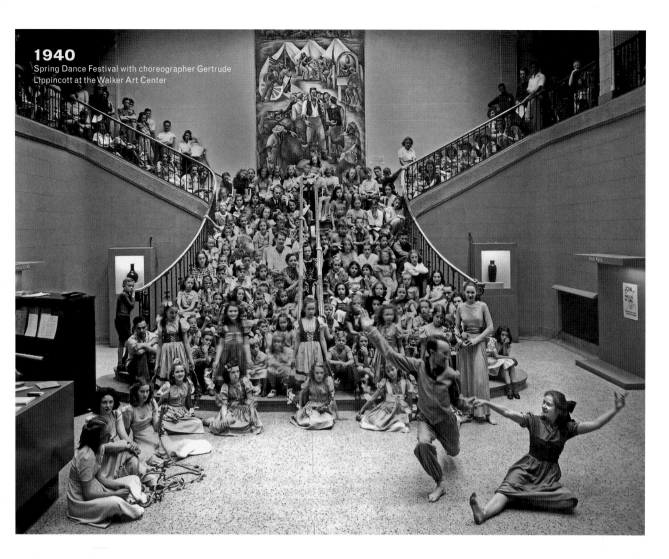

1940
Spring Dance Festival with choreographer Gertrude Lippincott at the Walker Art Center

Liberace at the Walker Art Center, 1950

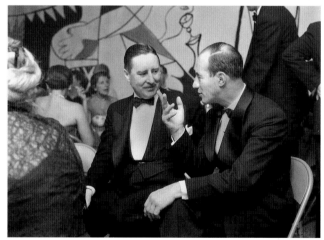

Walker Director H. Harvard Arnason (center) at the Center Arts Ball, 1954

1965

The ONCE Group's *Kittyhawk (An Antigravity Piece)*, Here [2] Festival, Walker Art Center

Miles Davis and Herbie Hancock at the Guthrie Theater, 1968

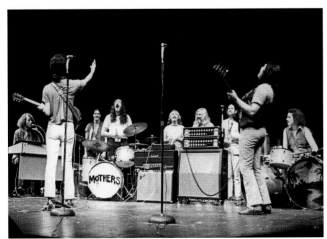

Frank Zappa and the Mothers of Invention at the Guthrie Theater, 1969

In the Beginning: Recollections from the Walker's First Performing Arts Coordinator

Before there was a Performing Arts Department (or a Guthrie Theater, for that matter), there was the Center Arts Council (CAC), a volunteer (but by invitation only) arm of the Walker Art Center. The CAC was a lively and disparate group of academics, homemakers, architects, and business types with a particular interest and expertise in jazz, opera, theater, or other art forms. The group received two thousand dollars from the Walker's budget and made things happen. In 1963, it sponsored Merce Cunningham's first Twin Cities performance at the Woman's Club—on a stage so small that it could maybe accommodate a meeting of the Board. By some kind of dumb luck I was there, and felt like Lewis & Clark when they sighted the mighty Mississippi. Nothing was ever the same again.

In 1968, I took over the program from John Ludwig. At the time, the National Endowment for the Arts played a major role in getting dance out of New York and into schools, local studios, wacko performance venues, and stages across the hinterlands. In the early days, dance, theater, music, and poetry were supported by rock, jazz, and folk concerts held at the Guthrie, as such events particularly were part of the robust art and political scenes that defined the late 1960s and early 1970s. My tenure began just as the original Walker building was torn down. For two years, our offices were at 807 Hennepin Avenue in Minneapolis (above the State Theatre). Being "homeless," we were forced to use the city and dozens of local institutions as venues and cosponsors. By the time I left the Walker in 1976 to become the director of the dance program at the National Endowment for the Arts, we were still "out there," literally and figuratively. Now, after almost thirty years, the Walker's constantly evolving performing arts program has moved into spectacular new spaces and is much more professional—and there's an actual staff. I'm proud to be its great-grandmother.

—Suzanne Weil

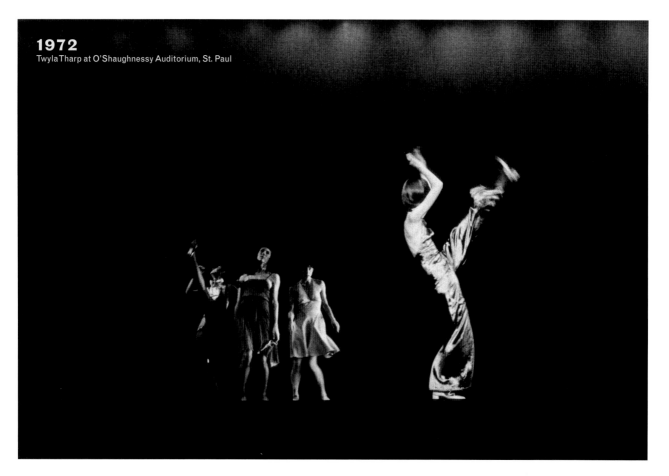

Selected Performing Arts Commissions 1964–2005

1964
Dominic Argento: *Masque of Angels* (Center Opera Company commission)
1965
Alwin Nikolais: *Vaudeville of the Elements*
1977
Richard Foreman: *City Archives*
1979
Trisha Brown Dance Company: *Glacial Decoy*
1983
Lee Breuer/Robert Telson: *The Gospel at Colonus*
1984
David Byrne/Robert Wilson: *The Knee Plays*
1987
Merce Cunningham Dance Company: *Fabrications*
David Gordon: *United States*
1988
Kronos Quartet: *Assembly Required*

1990
Stephen Petronio: *Close Your Eyes and Think of England*
Urban Bush Women: *Praise House*
John Jesrun: *Everything That Rises Must Converge*
Bill T. Jones: *The Promised Land*
1991
Meredith Monk: *ATLAS*
John Zorn/Arto Lindsay: *Houdini/de Sade*
Kei Takei: *24 Hours of Light*
The Wooster Group: *BRACE UP!*
Wim Vandekeybus/Ultima Vez: *Always the Same Lies*
1992
Ron Vawter: *Roy Cohn/Jack Smith*
Laurie Carlos: *White Chocolate: For My Father*
1993
Pauline Oliveros: *Njinga, The Queen King*
David Rousseve: *Urban Scenes/Creole Dreams*
1994
Diamanda Galás: *Schrei 27*
Bill T. Jones: *Still/Here*
1995
Ping Chong & Company: *Chinoiserie*

1996
Eiko & Koma: *River*
Ann Carlson: *Rodemeover*
1997
Jon Jang/James Newton: *When Sorrow Turns to Joy*
Elizabeth Streb/Ringside: *Fly*; *Across*
1998
Chris Aiken/Steven Paxton and Friends: *The Improvisation Project*
Michael Sommers: *Prelude to Faust*
1999
Dianne McIntyre/Lester Bowie: *Invincible Flower*
Robert LePage: *Geometry of Miracles*
Lee Breuer/Mabou Mines: *Red Beads*
Fred Ho/Scott Marshall/Paul Chan: *All Power to the People: The Black Panther Suite*
Bill Frisell: *Blues Dream*
2000
Joanna Haigood/Zaccho Dance Theatre: *Picture Powderhorn*
Chen Shi-Zheng/Akira Matsui/Eve Beglarian: *Forgiveness*

2001
Liz Lerman Dance Exchange: *Hallelujah Minneapolis: In Praise of Beauty and Disorder*
Shirin Neshat: *Logic of the Birds*
Basil Twist/The Elkina Sisters: *Petrushka*
William Kentridge/Kevin Volans/Handspring Puppet Company: *Zeno at 4 am*
Roger Guenveur Smith: *Iceland*
2003
Improbable Theatre: *The Hanging Man*
Matthew Shipp Trio: *Boxing & Jazz*
Rennie Harris: *Facing Mekka*
The Builders Association/motiroti: *Alladeen*
2005
Bill T. Jones: *Lord Buckley*
Ralph Lemon: *Come home Charley Patton* (*The Geography Trilogy*: Part 3)
Richard Maxwell: *Joe*
Sarah Michelson: *Daylight*
Jason Moran: *Milestone*

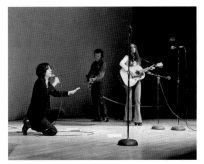

Patti Smith and Tony Glover, Walker Art Center Auditorium, 1972

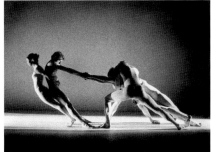

Pilobolus Dance Theatre, Walker Art Center Auditorium, 1973

Meredith Monk, Walker Art Center Auditorium, 1974

1979
Trisha Brown's *Glacial Decoy*, The Children's Theatre, Minneapolis

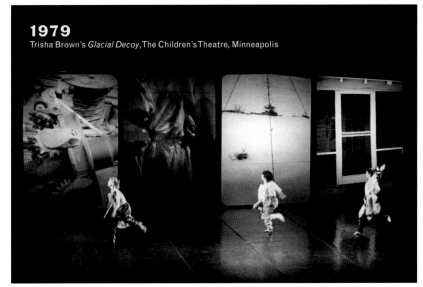

Douglas Dunn with the Grand Union, Walker Art Center lobby, 1975

Robert Wilson performs *I Was Sitting On My Patio This Man Came Up I Thought I Was Hallucinating* at Edyth Bush Theatre, St. Paul, 1977

Laurie Anderson performs excerpts from *United States of America*, New Music America, University of Minnesota, Minneapolis, 1980

David Byrne, Walker Art Center, 1984

Selected Performing Artists-in-Residence 1964–2005

1964
Shozo Sato Dance (through Center Arts Council)
1967
Merce Cunningham Dance Company
1969
Merce Cunningham Dance Company
1970
Murray Louis
1971
The Grand Union
Murray Louis
Stratford Theater
1972
Dance Theater of Harlem
James Cunningham
Merce Cunningham/John Cage
Morton Subotnick
Twyla Tharp
1973
Mabou Mines
Pilobolus Dance Theatre
Valda Setterfield/David Gordon/ Douglas Dunn
1974
Trisha Brown Dance Company
Meredith Monk/The House
Moulton Soulton
1975
Merce Cunningham/John Cage
The Grand Union
Mabou Mines
Pilobolus Dance Theatre

Yvonne Rainer
Twyla Tharp
1976
Trisha Brown Dance Company
Laura Dean and Dance Company
Jim Self
1977
Manuel Alum
Andy DeGroat
Douglas Dunn
Meredith Monk
Kathryn Posin
Rotante
Twyla Tharp
1978
John Cage
Merce Cunningham Dance Company
Kei Takei
1979
Trisha Brown Dance Company
Laura Dean
Steve Reich and Musicians
1980
JoAnne Akalaitis
Lee Breuer
David Gordon
1981
Merce Cunningham/John Cage
Bill T. Jones
1982
Lee Breuer/Robert Telson
Trisha Brown Dance Company
1983
David Gordon
1984
David Byrne/Robert Wilson
Douglas Dunn and Dancers

Matthew McGuire and the Creation Company
1985
Trisha Brown Dance Company
Meredith Monk
1986
Suzusetzu and Suzushi Hanayagi
1987
Sarah Brumgart
Susan Marshall and Company
Stephen Petronio Company
Yen Lug Wrong and Shi-Me
1988
Art Bridgman and Myrna Packer
Contraband
Daniel West Dancers
Urban Bush Women
1989
Ann Carlson
Merce Cunningham Dance Company
Eiko & Koma
1990
Molissa Fenley
Margaret Jenkins
Bill T. Jones/Arnie Zane Dance Company
Steve Kreikhaus
Steven Petronio Company
Relache
1991
John Malpede/LAPD
Kei Takei
1992
Keith Antar Mason
Jonathan Stone
1993
Merce Cunningham Dance Company

Eiko & Koma
Karen Finley
Joanna Haigood
Spiderwoman Theater
Urban Bush Women
1994
Axis Dance Theater
Chuck Davis
Keith Antar Mason/ The Hittite Empire
Robbie McCauley
New Performance Group: Morton Subotnick, Joan La Barbara, Mark Coniglio, Dierdre Murray, Stuart Dempster
Stuart Pimsler/David Dorfman/ Sam Costa/Craig Harris/ Sekou Sundiata
1995
California EAR Unit
Robbie McCauley
David Rousseve
1996
Ronald K. Brown
Ann Carlson
Eiko & Koma
Silesian Dance
1997
Paul Boesing
Jon Jang/James Newton
Ralph Lemon
Jin Hi Kim
Liz Lerman Dance Exchange
David Soldier
Elizabeth Streb/Ringside
Pearl Ubungen
1998
Yoshiko Chuma

Everett Dance Theater
Bill T. Jones/Arnie Zane
 Dance Company
Hot Mouth/Grisha Coleman
Meredith Monk
Butch Morris with Imp Ork
Michael Sommers
Meg Stuart/Ann Hamilton

1999
Eric Bass
Lee Breuer/Mabou Mines
Fred Ho
Jon Jang/James Newton
Bill T. Jones/Arnie Zane
 Dance Company
Diane McIntyre/Lester Bowie

Urban Bush Women/
 David Murray Octet

2000
Chen Shi-Zheng
Joanna Haigood/Zaccho
 Dance Theatre
Bill T. Jones
Ralph Lemon

2001
Bill T. Jones/Arnie Zane
 Dance Company
Liz Lerman Dance Exchange
Shirin Neshat
Roger Guenveur Smith
Basil Twist
White Oak Dance Project

2002
Big Dance Theater
Improbable Theatre
Kronos Quartet
Ralph Lemon
Meredith Monk/Ann Hamilton

2003
Eiko & Koma
Rennie Harris
Robin Holcomb
Improbable Theatre
Ralph Lemon
Kronos Quartet

2004
33 Fainting Spells
Big Dance Theater

Ralph Lemon
Christian Marclay
Jennifer Monson Dance
Jason Moran
Ranee Ramaswamy/Joko
 Sutrisno/I Dewa Putu Berata

2005
Builders Association/dbox
Joe Chvala/Ruth MacKenzie
Ornette Coleman
Bill T. Jones
Ralph Lemon
Richard Maxwell
Sarah Michelson
Jason Moran

1988
Urban Bush Women, St. Paul Student Center, St. Paul

John Cage at the Walker Art Center, 1980

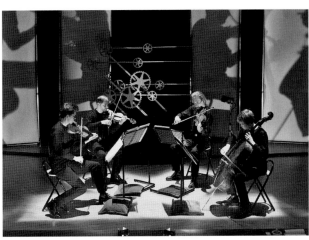
Kronos Quartet, *Assembly Required*, Walker Art Center Auditorium, 1988

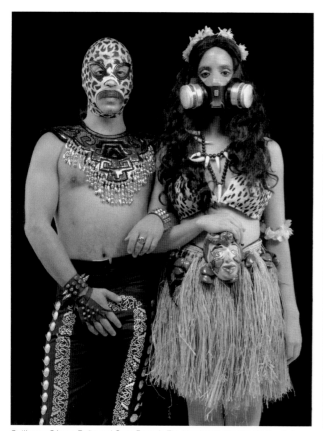

Guillermo Gómez-Peña and Coco Fusco's *The New World (B)order*, Walker Art Center, 1992

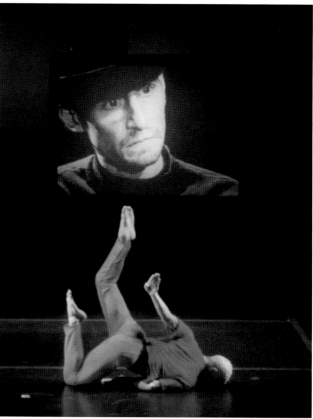

Bill T. Jones' *Still/Here*, University of Michigan, Ann Arbor, 1995

1998
dumb type's *[OR]*, Theater Kampnagel, Hamburg, Germany

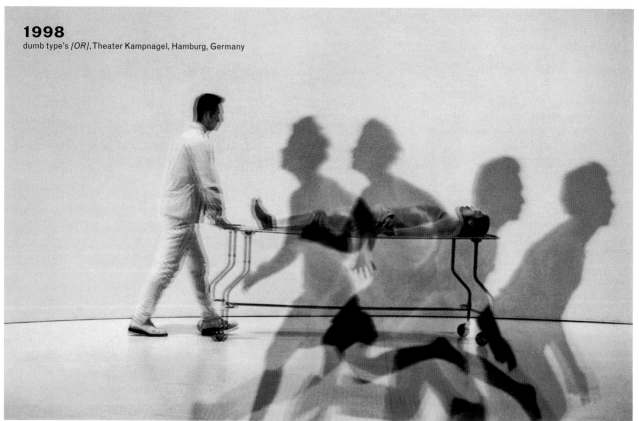

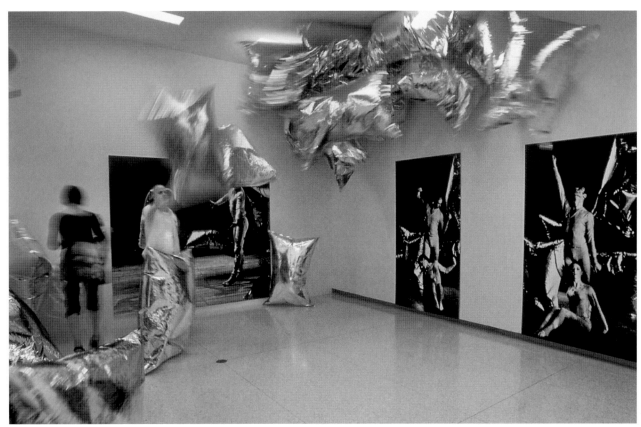

Merce Cunningham's *Rainforest* (1968) as documented in the exhibition *Art Performs Life: Merce Cunningham | Meredith Monk | Bill T. Jones*, 1998

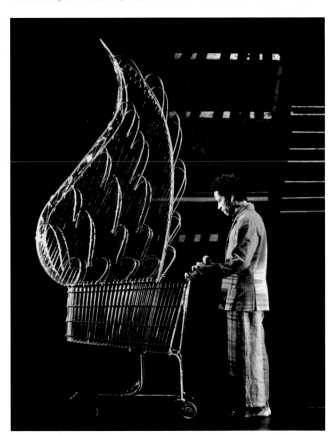

Ralph Lemon's *Tree* (*The Geography Trilogy*: Part 2), Yale Repertory Theatre, New Haven, Connecticut, 2000

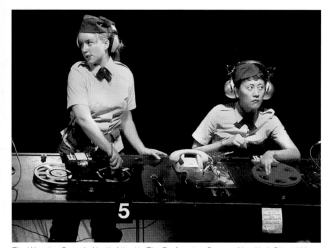

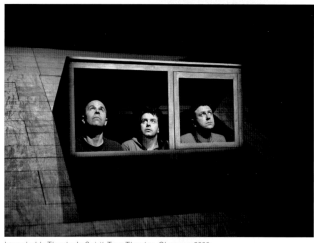

The Wooster Group's *North Atlantic*, The Performing Garage, New York City, 1999

Improbable Theatre's *Spirit*, Tron Theatre, Glasgow, 2000

2004
Ragamala Music and Dance Theater's *Sethu* (*Bridge*) in the Minneapolis Sculpture Garden

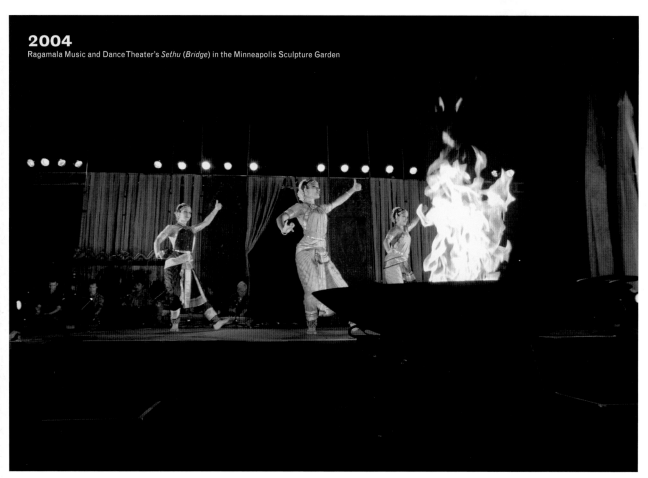

Film/Video

Widely recognized for presenting a full-range of moving-image art forms, the Walker Art Center's film and video programs feature both contemporary and historical works. In the 1940s, the Walker quickly identified moving images (mostly movies, but also experimental films) as integral to contemporary life. Artists of that time were experimenting with film's formal properties, such as light, motion, and sound, while also separating film art from conventional narrative cinema. The Walker recognized the importance of these developments and made a commitment to the presentation of both experimental and classic cinema as essential to its core mission—a philosophy that continues today.

Early film programs took place at the Women's Club Assembly and included contemporary works such as *Five Abstract Film Exercises* (1943–1947) by John and James Whitney and *Ritual in Transfigured Time* (1946) by Maya Deren. The volunteer-run Center Arts Council began to present films as early as 1953, including those by accomplished Hollywood directors such as Alfred Hitchcock, Ernst Lubitsch, and Billy Wilder as well as works from abroad, such as Akira Kurasawa's *Rashomon* (1950) and Satyajit Ray's *Pather Panchali* (*Song of the Road*) (1955). Film classes for Walker members screened contemporary works like Jean Cocteau's *Orphée* (*Orpheus*) (1951) and Sidney Meyers' *The Quiet One* (1948).

During the 1960s, a bi-monthly program featured works that critiqued contemporary culture, such as Robert Frank and Alfred Leslie's *Pull My Daisy* (1958) and Ron Rice's *The Flower Thief* (1960), which were balanced with classics such as Carl Theodore Dreyer's *La Passion de Jeanne d'Arc* (*The Passion of Joan of Arc*) (1928) and Sergei Eisenstein's *Oktyabr* (*October: Ten Days That Shook the World*) (1927). In 1966, this program began to be curated thematically and included series such as Italian Neo-Realism; Expanded Cinema, which featured underground protest films such as those by Stan VanDerBeek; and the Experimental Film Series, featuring the avant-garde work of Ed Emshwiller, Kenneth Anger, and Bruce Baillie.

In 1973, the Film/Video Department was officially formed and John Hanhardt was named as the first full-time film coordinator. That same year, the Walker's Edmond R. Ruben Film and Video Study Collection was established, along with an endowment to fund the development of the archive. Ruben, a leading figure in film exhibition in the Upper Midwest, and his wife Evelyn believed in collecting films as a way of preserving the art form. Today, with more than eight hundred fifty titles, the Ruben Collection brings together classic and contemporary cinema as well as documentaries, avant-garde films, and video works by artists. It is distinctive for its holdings by visual artists that range from classics by Salvador Dali, Marcel Duchamp, and Fernand Léger to extensive contemporary work by William Klein, Derek Jarman, Bruce Conner, Marcel Broodthaers, Nam June Paik, and leading experimental artists who challenged the form and content of film, such as Paul Sharits and Stan Brakhage.

In 1974, Melinda Ward began her five-year term as film curator and quickly instituted the exhibition structure that is still used today. She expanded the annual screening program to more than two hundred fifty different presentations of narrative, documentary, avant-garde, and animated films organized into series by filmmaker, historical periods, and stylistic themes. Some popular programs begun at that time continue today, including Summer Music & Movies and Live Music/Silent Films. Richard Peterson succeeded Ward when she went on to create the Walker's Learning Museum Program. He presented a broad range of films with a focus on contemporary avant-garde. He added a significant number of these to the Ruben Collection.

Bruce Jenkins, who began his thirteen-year tenure in 1986, produced ambitious screening programs that embraced all genres. In 1990, he initiated the prestigious Regis Dialogue series, which showcases the work of distinguished directors and actors, and features onstage dialogues between artists and noted critics. During the 1990s, moving images were increasingly incorporated into exhibitions, as artists from all disciplines explored the possibilities of the medium. The Film/Video department played a major role in exhibitions such as 2000 B.C.: THE BRUCE CONNER STORY PART II (1999), *Bordering on Fiction: Chantal Akerman's "D'Est"* (1995), and *In the Spirit of Fluxus* (1993).

Over the years, the department has organized a number of seminars and panel discussions, including two major national conferences focused on the democratization of media production and the aesthetic of the new moving image: Media Arts in Transition, held in 1983; and its 1999 sequel, Media Arts in Transition, Again, which explored changes in the field within a rapidly expanding global, multidisciplinary, and technological context. (The latter was a collaboration with the New Media Initiatives, Design, Visual Arts, and Education departments.)

A key component to the department is the Film/Video artist-in-residence program, which has supported such projects as Cheryl Dunye's screenwriting workshops conducted inside a prison and Spencer Nakasako's filmmaking classes with teens. Long-term residencies have also resulted in new commissions, including Shu Lea Cheang's *Bowling Alley* (1995–1996), Alan Berliner's *The Language of Names* (2001–2002), and Ericka Beckman's *Frame-UP* (2004–2005).

The presentation of contemporary world cinema was expanded through the Walker's Bush Global Initiative by Cis Bierinckx, who served as curator from 2001 to 2002. Building on a long history of programming, the department, now headed by Sheryl Mousley, continues to present film, video, and new forms of media inside and outside the cinema and examine ways that filmmakers and artists alike use moving images to explore our contemporary age.

Maya Deren *Ritual in Transfigured Time* 1946 16mm film (black and white, sound)
15 minutes Edmond R. Ruben Film and Video Study Collection

Jean Cocteau *Orphée* (*Orpheus*) 1951 16mm film (black and white, sound)
112 minutes Edmond R. Ruben Film and Video Study Collection

1958
Robert Frank and Alfred Leslie's *Pull My Daisy* (1958)

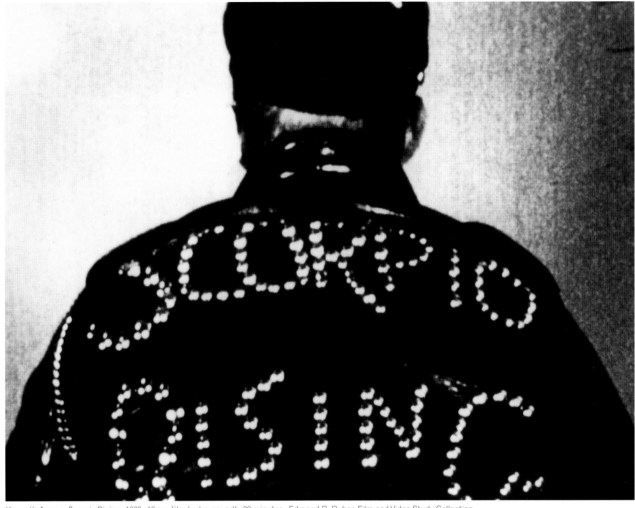

Kenneth Anger *Scorpio Rising* 1963 16mm film (color, sound) 29 minutes Edmond R. Ruben Film and Video Study Collection

Selected Film/Video Screenings

1940s

Maya Deren: *Ritual in Transfigured Time* (1946)

John and James Whitney: *Five Abstract Film Exercises* (1943–1947)

Sidney Peterson and James Broughton: *Potted Palms* (1946–1947)

Douglas Crockwell: *Glen Falls Sequence* (1940)

Norman McLaren: *Fiddle-de-de* (1947)

1950s

John Huston: *The Treasure of the Sierra Madre* (1948)

Fritz Lang: *M* (1931)

Arthur Weegee: *Weegee's New York* (1951)

Jean Vigo: *Zéro de Conduite (Zero for Conduct)* (1933)

Roberto Rossellini: *Roma, Città Aperta (Open City)* (1945)

1960s

Vittorio De Sica: *Ladri di biciclette (The Bicycle Thief)* (1948)

Ingmar Bergman: *Det Sjunde Inseglet (The Seventh Seal)* (1957)

François Truffaut: *Jules et Jim (Jules and Jim)* (1962)

Shirley Clarke and Irving Jacoby: *Skyscraper* (1960)

Bruce Conner: *A Movie* (1958)

1970s

Stan Brakhage: *Eyes* (1971)

Luchino Visconti: *Il Gattopardo (The Leopard)* (1963)

Maggi Carson: *Punking Out* (1978)

Rainer Werner Fassbinder: *Wildwechsel (Jail Bait)* (1972)

Charles and Ray Eames: *A Computer Glossary* (1967)

1980s

Abel Gance: *Napoleon* (1927)

Sally Potter: *The Gold Diggers* (1983)

Ernie Gehr: *Serene Velocity* (1970)

Max von Sydow: *Ved vejen (Katinka)* (1988)

Dennis Hopper: *Colors* (1988)

1990s

Krzysztof Kieslowski: *Dekalog (The Decalogue)* (1989)

Joel Cohen: *Barton Fink* (1991)

Julie Taymor: *Fool's Fire* (1992)

Hal Hartley: *Flirt* (1995)

Harry Smith: *Early Abstractions* (1987)

2000s

Errol Morris: *Mr. Death: The Rise and Fall of Fred A. Leuchter, Jr.* (1999)

Zacharias Kunuk: *Atanarjuat (The Fast Runner)* (2001)

Samira Makhmalbaf: *Panj é asr (At Five in the Afternoon)* (2003)

Rodney Evans: *Brother to Brother* (2004)

Jessica Yu: *In the Realms of the Unreal* (2004)

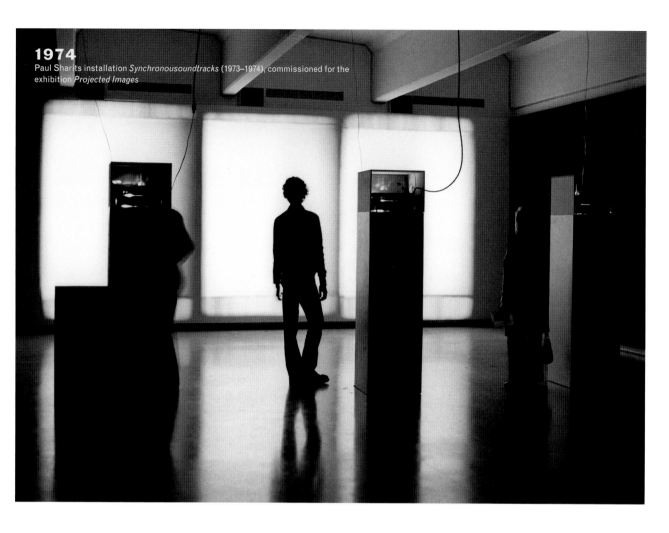

1974
Paul Sharits installation *Synchronousoundtracks* (1973–1974), commissioned for the exhibition *Projected Images*

Selected Film/Video Visiting Artists 1948–2004

Chantal Akerman
Macky Alston
Kenneth Anger
Emile de Antonio
Gregg Araki
Charles Atlas
Scott and Beth B
Bruce Baillie
Betsy Baytos
Les Blank
Jim Blashfield
Peter Bogdanovich
Robert Breer
Charles Bonnett
David Byrne
Kitty Carlisle Hart
Joel Coen
Bruce Conner
Martha Coolidge
David Cronenberg
Jonathan Demme
Raymond Depardon
Maya Deren

Ernest Dickerson
Sara Driver
Atom Egoyan
Kimberly Elise
Rob Epstein
Rodney Evans
Valie Export
Milos Forman
Bill Forsyth
Hollis Frampton
Carl Franklin
Marlon Fuentes
Samuel Fuller
Laura Gabbert
Abel Gance
Ernie Gehr
Jean-Luc Godard
Jill Godmilow
Bette Gordon
Spalding Gray
William Greaves
Red Grooms
Philip Haas
Barbara Hammer
Hal Hartley
Dennis Hopper
Ann Hui

Ken Jacobs
Henry Jaglom
Derek Jarman
Joan Jonas
Chuck Jones
Larry Jordan
William Klein
Ken Kobland
Al Kraning
Peter Kubelka
George Landow
David Lynch
Dusan Makavejev
Louis Malle
Babette Mangolte
Ron Mann
John Maybury
Don McKellar
Jonas Mekas
Tracey Moffatt
Errol Morris
Paul Morrissey
Gunvor Nelson
Stanley Nelson
Pat O'Neill
Ondine
Yoko Ono

Nam June Paik
Ed Pincus
Michael Powell
Vincent Price
Yvonne Rainer
Marlon Riggs
Patricia Rozema
Alan Rudolph
Nancy Savoca
Julia Scher
Thelma Schoonmaker
Peter Sellars
Paul Sharits
Jonathan Stack
Hans-Jürgen Syberberg
Russ Tamblyn
Julien Temple
Leslie Thornton
Rose Troche
Christine Vachon
Stan VanDerBeek
King Vidor
David Warrilow
William Wegman
Yvonne Welbon
Fay Wray
Mai Zetterling

Bruce Conner, Visiting Filmmakers Series, 1978

Stan Brakhage, Filmmakers Filming Series, 1981

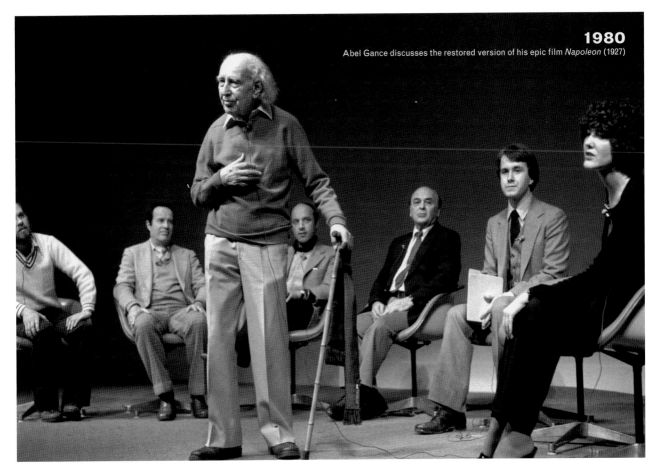

1980
Abel Gance discusses the restored version of his epic film *Napoleon* (1927)

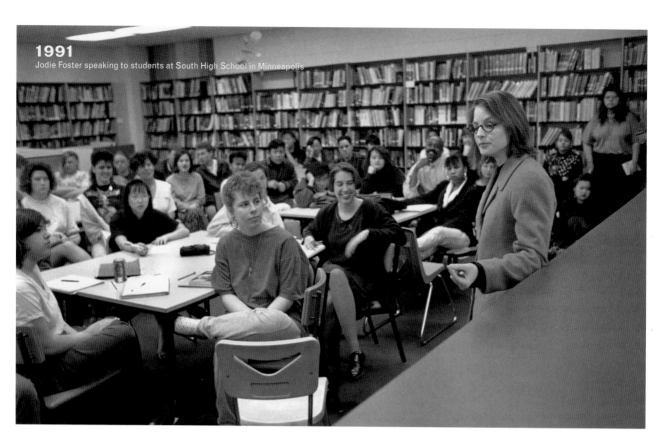

Clint Eastwood, Regis Dialogue, 1990

Spike Lee, Regis Dialogue, 1996

Regis Dialogues and Retrospectives 1990–2004

1990

Clint Eastwood Directs
 Dialogue: Clint Eastwood with Richard Schickel
 Regional Premiere: *White Hunter, Black Heart*
Merchant Ivory Productions Re-viewed
 Dialogue: James Ivory with David Sterritt
 Benefit Preview: *Mr. & Mrs. Bridge*

1991

Jodie Foster: Growing Up on Screen
 Dialogue: Jodie Foster with B. Ruby Rich
 Regional Premiere: *The Silence of the Lambs*
Produced by Pressman
 Dialogue: Edward R. Pressman with Julie Salamon
 Regional Premiere: *Paris by Night*
Keith Carradine: In Retrospect
 Dialogue: Keith Carradine with Phil Anderson
 Regional Premieres: *The Bachelor* and *The Ballad of the Sad Café*
John Sayles: From Alligators to Agitators
 Dialogue: John Sayles with Jay Carr
 Regional Premiere: *City of Hope*
Ken Burns: Imaging America
 Dialogue: Ken Burns with Terrence Rafferty
 Regional Premiere: *Empire of the Air: The Men Who Made Radio*
Wim Wenders: In the Course of Fame
 Dialogue: Wim Wenders with J. Hoberman
 Preview Screening: *Bis ans Ende der Welt* (*Until the End of the World*)

1992

Danny Glover: In Retrospect
 Dialogue: Danny Glover with Armond White
Robert Altman: An American Maverick
 Dialogue: Robert Altman with David Bordwell
 Preview Screening: *The Player*

Marcel Ophuls: A Course in Resistance
 Dialogue: Marcel Ophuls with Phillip Lopate
 Regional Premiere: *Novembertage: Stimmen und Wege* (*November Days*)

1993

Liv Ullmann: From Actor to Auteur
 Dialogue: Liv Ullmann with Molly Haskell
 Regional Premiere: *Sofie*
American Playhouse: A Tribute
 Dialogue: Julie Dash with Lindsay Law
Chen Kaige: Fifth Generation Filmmaker
 Dialogue: Chen Kaige with Amy Taubin
 Regional Premiere: *Ba wang bie ji* (*Farewell My Concubine*)

1994

On the Road with Jim Jarmusch
 Dialogue: Jim Jarmusch with Jonathan Rosenbaum

1995

Passion in Perspective: The Films of Jane Campion
 Dialogue: Jane Campion with Richard Peña
Assertions of Resistance: The Films of Haile Gerima
 Dialogue: Haile Gerima with Arthur Jafa
 Regional Premiere: *Sankofa*
Agnieszka Holland: In Retrospect
 Dialogue: Agnieszka Holland with Amy Taubin
 Regional Premiere: *Total Eclipse*

1996

The Brothers Quay: Alchemists of Animation
 Dialogue: Timothy and Stephen Quay with Bruce Jenkins
 Regional Premiere: *Institute Benjamenta*
Gordon Parks: In Retrospect
 Dialogue: Gordon Parks with Susan Robeson
Tom Hanks: In Retrospect
 Dialogue: Tom Hanks with Richard Schickel
Spike Lee: In Retrospect
 Dialogue: Spike Lee with Elvis Mitchell

1997

G Is for Greenaway
 Dialogue: Peter Greenaway with Peter Wollen
 Regional Premiere: *The Pillow Book*

Jessica Lange: In Retrospect
 Dialogue: Jessica Lange with Molly Haskell
 Regional Premiere: *Cousin Bette*

1998

Abbas Kiarostami: In Retrospect
 Dialogue: Abbas Kiarostami with Richard Peña
 Regional Premiere: *Ta'm e guilass* (*Taste of Cherry*)
À propos de Denis
 Retrospective: Claire Denis
 Regional Premiere: *Nénette et Boni* (*Nénette and Boni*)
And Now for Something Completely Different: The Films of Terry Gilliam
 Dialogue: Terry Gilliam with Stuart Klawans

1999

Stan Brakhage: The Art of Seeing
 Dialogue: Stan Brakhage with Bruce Jenkins
 World Premiere: *The Earth Song of the Cricket*
 U.S. Premiere: *Birds of Paradise*
The Great Ecstasy of the Filmmaker Herzog
 Dialogue: Werner Herzog with Roger Ebert
 Regional Premiere: *Julianes Sturz in den Dschungel* (*Wings of Hope*)
 Special Publication: Declaration of Minnesota Manifesto

2000

John Waters: Shock Value
 Monologue: John Waters
Léos Carax: L'amour fou
 Dialogue: Léos Carax with Kent Jones
 Regional Premiere: *Pola X*
Doris Dörrie: Straight through the Heart
 Dialogue: Doris Dörrie with Klaus Phillips
 U.S. Premiere: *Erleuchtung garantiert* (*Enlightenment Guaranteed*)

2001

Agnès Varda, cine-writer
 Dialogue: Agnès Varda with Bérénice Reynaud
 Regional Premiere: *Les Glaneurs et la glaneuse* (*The Gleaners and I*)
Tales of the City: Hanif Kureishi's Rough Guide to London
 Dialogue: Hanif Kureishi with A.O. Scott
 Regional Premiere: *Intimacy*

2002

Filming to the Heart: Film Works by Heddy Honigmann
 Dialogue: Heddy Honigmann with Michael Tortorello
 Regional Premiere: *Goede man, leve zoon* (*Good Husband, Dear Son*)

2003

Gus Van Sant: On the Road Again
 Dialogue: Gus Van Sant with Scott Macaulay
 Regional Premiere: *Gerry*
Matthew Barney: Cremaster Cycle
 Dialogue: Matthew Barney with Richard Flood
 Regional Premiere: *Cremaster Cycle*
Frederick Wiseman: A Sense of Place
 Dialogue: Frederick Wiseman and Jim McKay
 Regional Premiere: *La dernière lettre* (*The Last Letter*)

2004

Guy Maddin: Pages from a Filmmaker's Diary
 Dialogue: Guy Maddin and Elvis Mitchell
 Regional Premiere: *The Saddest Music in the World*
Apichatpong Weerasethakul: New Language from Thailand
 Dialogue: Apichatpong Weerasethakul and Chuck Stephens
 Regional Premiere: *Sud pralad* (*Tropical Malady*), *Sud Sangeha* (*Blissfully Yours*)

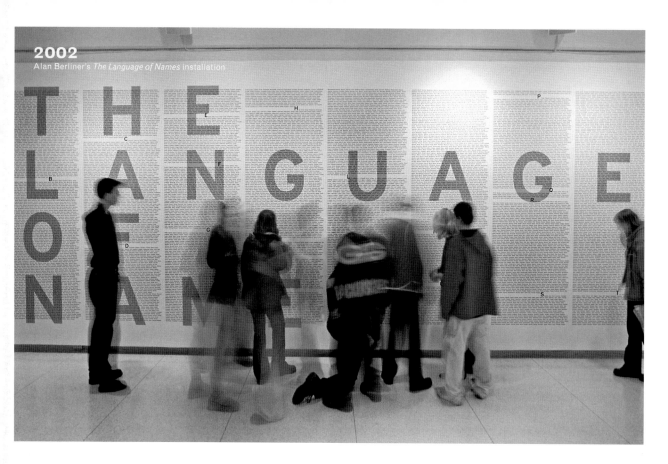

2002
Alan Berliner's *The Language of Names* installation

Film/Video
Artists-in-Residence
1973–2004

John Akomfrah
Craig Baldwin
Ericka Beckman
James Benning
Sadie Benning
Alan Berliner
Shu Lea Cheang
Wendy Clarke
Nick Deocampo
Arthur Dong
Cheryl Dunye
Richard Foreman
Suzan Pitt-Kraning
Tom Kalin
Christian Marclay
Victor Masayesva
Cara Mertes
Antonio Muntades
Spencer Nakasako
Susan Robeson
Fatimah Tobing Rony
Wang Jian Wei

Spencer Nakasako (second from left) with teen workshop participants in Walker on Wheels, 2001

Wang Jian Wei *Movable Taste* installation for the exhibition *How Latitudes Become Forms: Art in a Global Age*, 2002

Education and Community Programs

Innovative educational activities and a commitment to providing access to art for all people have been at the heart of the Walker Art Center's mission since its inception as a public institution. In 1940, it opened with a roster of offerings that included free art classes and lectures, a children's newspaper, a student council and exhibitions, statewide extension activities, and free meeting space for community groups. Its civic-minded spirit is illustrated in such early programs as The Inquisition, a lively weekly event in which audience members were invited to "stump the experts" on a panel of specialists with their questions about art. In 1942, classes ranging from painting and sculpture to industrial and interior design were codified into a formal art school that remained active until 1950.

During the 1950s, under the stewardship of Director H. Harvard Arnason, an emphasis was placed on helping audiences interpret rather than make art. While at the Walker, Arnason continued as chair of the art department at the University of Minnesota, which created a stronger working relationship between the two institutions. His desire to extend the museum experience into the classroom furthered the Walker's partnerships with the Minneapolis Public Schools. The program focus also expanded from visual arts to other forms, including dance, film, poetry, design, and architecture. The creation of educational exhibitions for children during this period, such as Weather and Art, The Artist's Studio, and Seeing into Space, set a precedent for future experiential and gallery-based projects.

During his thirty-year tenure as director (1961 to 1990) Martin Friedman championed creative risk-taking and nontraditional approaches to education. His ability to leverage new sources of federal and local funding fostered the development of innovative programs such as the 1968 Walker-Bryant Art Workshop, the Walker's first community-based outreach program for teens. New Learning Spaces and Places, an ambitious 1974 exhibition accompanied by an issue of Design Quarterly, examined new contexts and spaces for learning, including a prescient exploration of ways that computer technology would impact the classroom. In 1979, with major support from the National Endowment for the Humanities, the Walker launched a three-year, interdisciplinary initiative entitled The Meanings of Modernism, which formalized its commitment to fostering adult education programs by inviting artists, musicians, choreographers, filmmakers, writers, art critics, and scholars to discuss contemporary art.

"Participatory," "experiential," and "artist-driven" are words that describe much of the programming of the 1980s. In 1984, the citywide ArtFest celebrated the opening of new educational spaces that included the Walker's Art Lab, a multipurpose studio classroom. The department soon began commissioning artists to create playful, interactive installations for the space, a practice that continues in the enhanced Art Lab designed by Herzog & de Meuron. The department frequently works with national and local artists on residency projects and commissions. The opening of the Minneapolis Sculpture Garden in 1988 literally provided an expanded field on which to engage visitors of all ages.

When Director Kathy Halbreich arrived in 1991, she made a commitment to expand the Walker's engagement with diverse audiences. Programs such as Free First Saturday and Free Thursday encourage visitors to participate in the institution's full spectrum of offerings. Explore Memberships make it possible for people with limited incomes to receive complimentary member benefits and event tickets. In 1994, the Walker became the first art museum in the country to devote staff solely to creating programs for teenagers. Its cornerstone is the Walker Art Center Teen Arts Council (WACTAC), a rotating group of twelve young people who develop activities of particular interest to their peers. Teens are frequent participants in artist-in-residence projects, which for more than a decade have brought prominent visual, performing, and media artists together with the public in the creation of new works. Further outreach happens with Walker on Wheels, a commissioned mobile art lab that travels throughout the area and provides a flexible space for activities and gatherings.

Walker educators and curators have continued to experiment with interpretive programs that reflect changing artistic practices and encourage active engagement with the art and artists of our time. The Andersen Window Gallery, a focused study space within the galleries, invited visitors to take a closer look at contemporary art and culture. Early installations explored the collection decade by decade, beginning with Edward Hopper's Office at Night (1940), while later iterations showcased the work and processes of artists-in-residence such as filmmaker Spencer Nakasako in 2001, whose in-gallery video booth allowed visitors to record their own stories. For children and families, the WAC Packs filled with interpretive tools and the Artwork of the Month brochures encourage in-gallery learning. The advent of the Internet led to such pioneering projects as ArtsConnectEd, a Web site for teachers, students, and parents developed with the Minneapolis Institute of Arts.

With the Walker's building expansion, the possibilities for direct participation in creative processes have been multiplied. Dialog, an interactive table, provides visitors with information about artworks on display through media resources drawn from the collections and archives. The Best Buy Arcade, a space for changing installations, offers visitors immersive experiences with art. For its debut, it hosts Dolphin Oracle II (2004), a work by Piotr Szyhalski and Richard Shelton that uses digital animation and artificial intelligence to answer questions posed by visitors.

More than fifty years ago, then-Walker Director Daniel Defenbacher declared, "An Art Center is a 'town meeting' in a field of human endeavor as old as man himself." That idea finds renewal in Halbreich's vision: "The metaphor for the museum is no longer a church or temple, but a lively forum or town square." The twenty-first century Walker Art Center is a place of celebration, challenge, and refuge at the heart of the community.

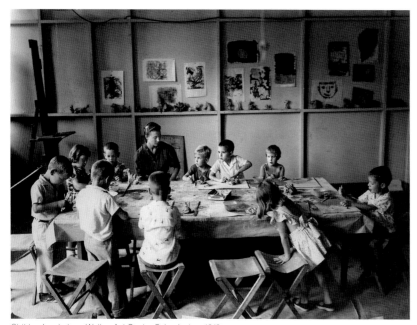

Children's art class, Walker Art Center School, circa 1942

Brochure for Magnet Master, a toy created by Daniel Defenbacher and Arthur Carrara, 1949

1940

Director Daniel Defenbacher (center) quizzes panelists during an "inquisition," Walker Art Center lobby

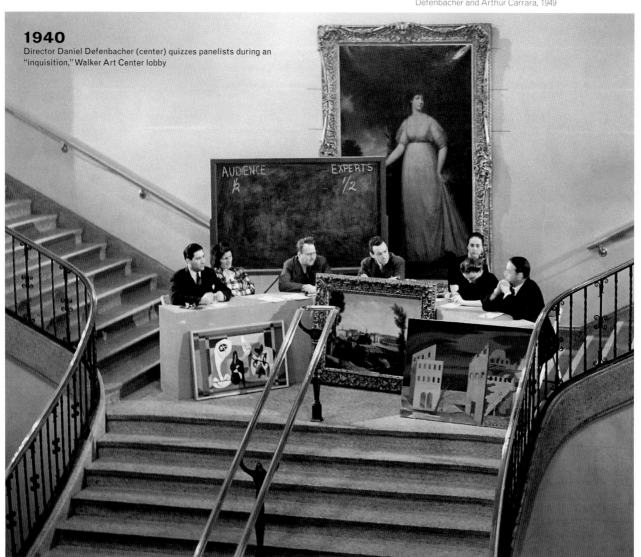

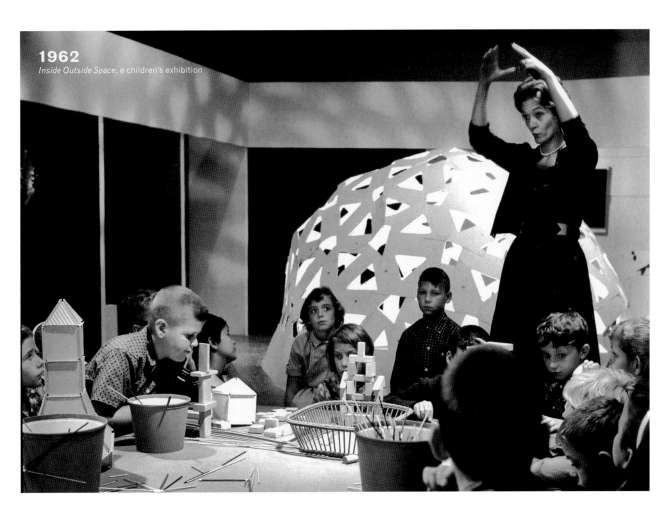

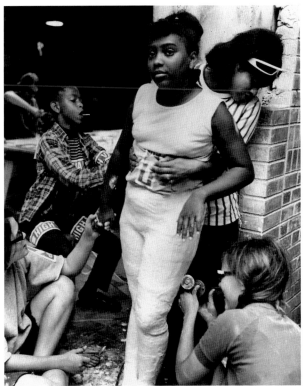

Walker-Bryant Summer Program, 1968

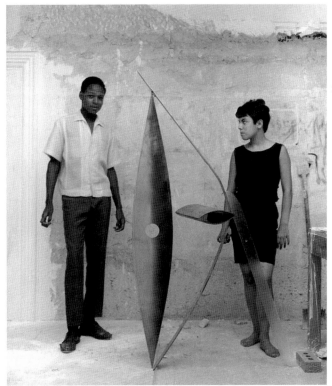

Walker-Bryant Summer Program, 1969

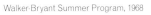

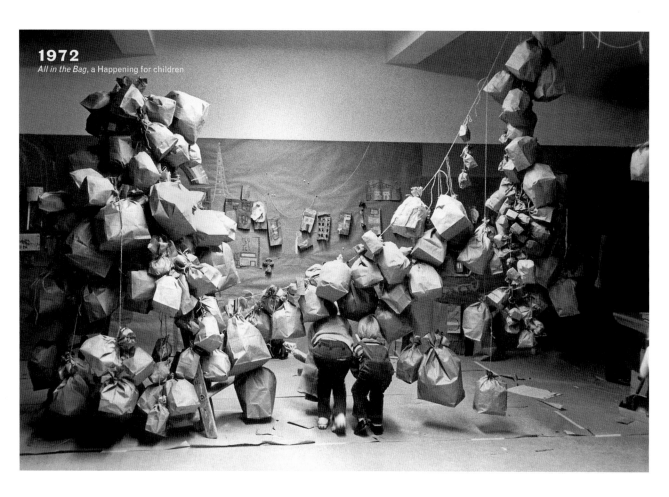

1972
All in the Bag, a Happening for children

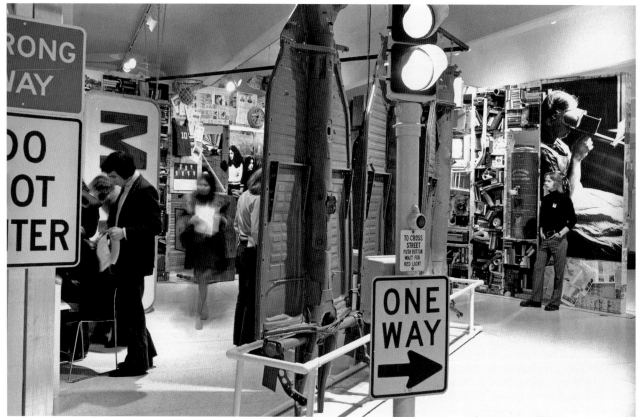

Installation view of *New Learning Spaces and Places*, 1974

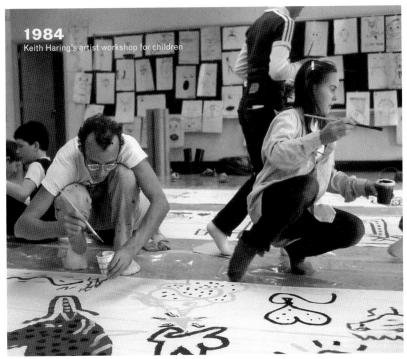

1984
Keith Haring's artist workshop for children

September calendar celebrating new Art Lab, 1984

ART ON THE AIR

WALKER ART CENTER is pleased to announce the inauguration of Art on the Air®, a new feature presented in collaboration with WNYC/New York Public Radio's live children's program **Kids America**®. From October 1987 through May 1988, commissioned works by contemporary composers will be broadcast nationally to twenty-four cities.

Once a month **Kids America** will broadcast Art on the Air compositions during its "Radiovision®" segment at 7:30 pm eastern standard time. Children can then call 1-800-235-KIDS to discuss their impressions with the program hosts. Each composer will be in the WNYC studio during the call-in session or will provide taped remarks to be aired during the segment. Tune in **Kids America** on your local public radio station for details.

A curriculum packet based on the Art on the Air compositions will be available in 1989 through museums nationwide.

Art on the Air is supported by funding from Spunk Fund, Inc. Funding for Kids America is made possible by major grants from the Corporation for Public Broadcasting and by Kool-Aid Koolers®. Walker Art Center's children's programs are supported in part by grants from The Pillsbury Company Foundation and The Cargill Foundation.

Brochure for the radio program *Art on the Air*, 1987

Frank Gehry (center right) at the Architecture Adventure workshop, 1986

Art Lab Installations
1985–2001

1985
Wendy Clark: *Video Rotation*

1986
Kinji Akagawa: Installation for the exhibition *Tokyo: Form and Spirit*

1988
Owen Morrell: *Catawampus Classroom*
Rodney Alan Greenblat: *Design Your Own Future with Rodney Alan Greenblat*

1989
Jan Jancourt and Scott Makela: *360°– A Small World of Big Messages for Graphic Design in America*

1990
University of Minnesota architecture students: *Constructivist Inspired Work Space for Kids*

1991
Ta-coumba Aiken: *Crosses, Crosses We Bear, Crisscrosses*

1993
Yoshi Wada: *What's the Matter with Your Ear?*

1994
Steven Woodward with David Culver and Kate Hunt: *Key to the Garden*

1995
Dorit Cypis: *Backstage at the Walker*

1996
Melvin Smith: *Homage to Hannah Höch*

1997
The Cunningham Group: *Disney's Lands: From Mainstreet to Your Street*

1998
Joep van Lieshout: *The Good, the Bad, and the Ugly*
May Sun: *Monumental Minnesota: The Sculpture Garden 10 Years Later*

1999
Karen Wirth: *IF not THIS*

2000
Ta-coumba Aiken: *Open Face*

2001
Julie Snow Architects: *Zero to Infinity: Arte Povera Lab*

Dorit Cypis' *Backstage at the Walker* Art Lab installation, 1995

In-gallery Information Office, *Joseph Beuys Multiples*, 1997

7000 Oaks, Minnesota finale in the Minneapolis Sculpture Garden, coordinated by the Walker Art Center Teen Arts Council, 1997

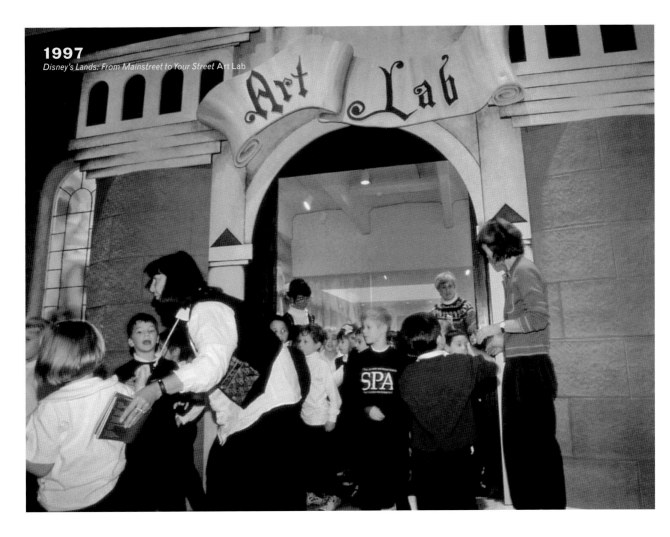

Participants in Spencer Nakasako's teen video workshop, 2001

Picture Powderhorn teen workshop with Joanna Haigood (right), 2000

School tour of the exhibition *Painting at the Edge of the World*, 2001

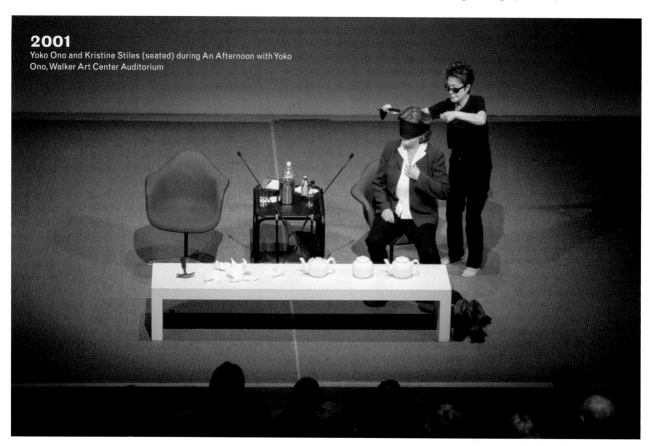

2001
Yoko Ono and Kristine Stiles (seated) during An Afternoon with Yoko Ono, Walker Art Center Auditorium

Hip-Hop Workshop at Free First Saturday, 2002

2003
Below the Belt: Battle of the Underage, Walker Art Center Auditorium

Design

The Walker Art Center's design legacy can trace its roots to its earliest days as a public art center. Daniel Defenbacher, its first director and an architect by training, initiated several pioneering projects to educate the public about the virtues of modern design. Among these initiatives were Idea Houses I and II (1941, 1947), the first museum exhibition homes to display the latest innovations in domestic architectural, product, and interior design. The Everyday Art Gallery, which opened in 1946 with Hilde Reiss as curator, became one of the first museum spaces in the United States dedicated to modern design. The Gallery offered an ambitious program of exhibitions, including special shows such as *Well-Designed Articles from Minneapolis Stores*, which underscored one of its primary purposes—educating the consumer about the benefits of modern design, an objective that would become a precursor of the "good design" movement of the 1950s. Another equally important goal was for design to act as a bridge for the public between the more practical and therefore accessible products of modern living and the unfamiliar, often abstract, world of modern art.

The Walker began publication of *Everyday Art Quarterly* in 1946, the first design journal issued by a museum. Through the *Quarterly*, audiences were introduced to the work of now-legendary designers. In 1954, the publication was renamed *Design Quarterly*, focusing on in-depth explorations of singular topics—an editorial practice that would continue until the 1990s. During the 1960s and 1970s, under the direction of Peter Seitz and later Mildred Friedman, the journal increasingly embraced topics that examined design's impact on society. A range of subjects were explored that reflected the changing currents of design thinking: the visionary architecture of Archigram and Superstudio; issues of ecology and product obsolescence; the development of mass transit and urban renewal strategies; the ergonomics of everyday objects; and the impact of technology on design. The list of writers and contributors from this period reads as a who's who of contemporary design.

Mildred Friedman, design curator from 1979 to 1991, sometimes in collaboration with Walker Director Martin Friedman, organized a series of groundbreaking exhibitions such as *Sottsass/Superstudio: Mindscapes* (1973); *New Learning Spaces and Places* (1974); *Nelson/Eames/Girard/Propst: The Design Process at Herman Miller* (1975); *De Stijl, 1917–1931: Visions of Utopia* (1982); *The Architecture of Frank Gehry* (1986), the architect's first major museum exhibition; *Tokyo: Form and Spirit* (1986), featuring the work of Japanese designers such as Arata Isozaki, Tadanori Yokoo, Toyo Ito, Tadao Ando, and Eiko Ishioka; *Architecture Tomorrow* (1988–1991), a series of installations undertaken by Frank Israel, Morphosis, Todd Williams/Billie Tsien, Stanley Saitowitz, Diller+Scofidio, and Steven Holl; and *Graphic Design in America: A Visual Language History* (1989), the first large-scale museum survey of the field in the United States. The Walker continues to host and organize exhibitions of design, including *Herzog & de Meuron: In*

Process (2000), *The Home Show* (2000), and *Strangely Familiar: Design and Everyday Life* (2003). Two popular annual lecture series, which began in the 1980s, present architects and designers of international renown: the Summer Design Series, in collaboration with the American Institute of Architects Minnesota; and Insights, organized with the American Institute of Graphic Arts Minnesota.

The department not only originates design-related exhibitions and lectures, but also produces the institution's graphic identity and publications program. An in-house staff of editors and designers produces a complete range of materials, encompassing printed ephemera, environmental graphics, and exhibition catalogues. Throughout the 1970s and 1980s, the Walker's graphic identity served as a de facto model for modern art museums worldwide. In 1987, the American Institute of Graphic Arts presented its Design Leadership Award to the Walker—placing it in the company of IBM, MIT, Apple, the *New York Times*, Nike, and Herman Miller. In the 1990s, the institution began to focus on new art forms and new audiences, which created an opportunity to reexamine its graphic identity. Laurie Haycock Makela, design director from 1991 to 1996, commissioned typographer Matthew Carter to develop a new typeface to reflect the multivalent character of a multidisciplinary arts center. This innovative font formed the basis of a visually dynamic identity. Under the direction of Haycock Makela, Matt Eller (1996 to 1998), and Andrew Blauvelt (1998 to present), the department developed a more flexible direction, shifting the Walker's identity to less rigidly modernist style. Such an approach reflects the institution's varied programs, the diversity of its changing audiences, and the increasing fragmentation of the marketplace.

Since the 1990s, the Walker has been the recipient of more than seventy-five design awards and has been featured in numerous design publications and exhibitions worldwide. Today, the Walker's graphic identity is widely admired for its progressive approach and is frequently cited as a model for other contemporary art museums by extending the notion of institutional identity to a more comprehensive understanding of the complete museum experience. In 2001, the department was nominated for the prestigious Chrysler Award for Design Innovation and its work was exhibited at the Design Museum, London.

The Walker has published more than one thousand exhibition guides and books to date. This ambitious program gained strength in the 1980s, and evolved its distinctive approach in the ensuing decades. Whether an artist's monograph, a catalogue raisonné, or for a thematic group exhibition, Walker catalogues eschew formulaic approaches to uniquely reflect the intrinsic character of their subject matter. In the late 1990s, the program issued a new form of catalogue that not only documented artists' work, but also contextualized it from multidisciplinary perspectives. These reader-style volumes—*Let's Entertain* (2000), *Painting at the Edge of the World* (2001), and *The Last Picture Show* (2003), for example—reinforce the Walker's commitment to publishing new scholarly research.

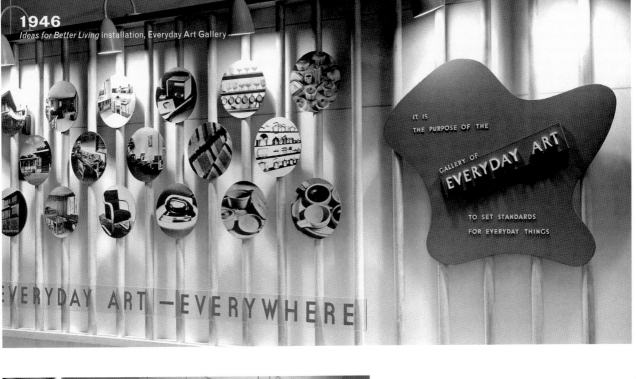

1946
Ideas for Better Living installation, Everyday Art Gallery

EVERYDAY ART — EVERYWHERE

IT IS
THE PURPOSE OF THE

GALLERY OF
EVERYDAY ART

TO SET STANDARDS
FOR EVERYDAY THINGS

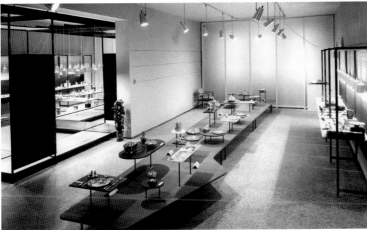

Fifty Years of Danish Silver, Design Gallery, 1955

Idea House II under construction, 1947

Selections from *Design Quarterly*, 1965–1993

Light and Color
Guest editor: Gyorgy Kepes
Nos. 69/70: The Expression of
Gio Ponti
1968
No. 71: Mass Transit: Problem
and Promise
No. 72: The Future: Space &
Technology
1969
No. 73: Form in: Architecture,
Design, Art
Nos. 74/75: Process and
Imagination
1970
No. 76: Ephemera:
Disposable Goods
Guest editor: Daniel Solomon;
Guest designer: Barbara
Stauffacher Solomon
No. 77: Public Spaces, Public Art
No. 78/79: Conceptual Architecture
Guest editors: Peter Eisenman,
Ant Farm, Archigram,
Archizoom, Craig Hodgetts,
John Margolies, Ed Ruscha,
Tony Smith, Superstudio
1971
No. 80: Making the City
Observable
Guest editor and designer:
Richard Saul Wurman
No. 81: Edward Larrabee Barnes
Walker Art Center
Nos. 82/83: Urban Renewal
1972
No. 84: Finnish Architecture
No. 85: Urban Renewal in
America, 1950–1970
Guest editors: Peter Wolf,
Denise Scott Brown, Richard
Saul Wurman
Nos. 86/87: International Design
Conference in Aspen
1973
No. 88: Human Systems in
Industrial Design
Guest editors: Niels Diffrient,
Jay Doblin, Charles Owen,
Robert Propst
No. 89: Sottsass Superstudio:
Mindscapes
1974
Nos. 90/91: New Learning Spaces
and Places
Guest editors: Hardy Holzman
Pfeiffer Associates
No. 92: Signs
Guest editors: Alvin Eisenman,
Inge Druckery, Ken Carbone
No. 93: Film Spaces
1975
Nos. 94/95: Design and

Architecture for the Federal
Government
Guest editors: Lois Craig,
John Massey, Harry Weese,
Lawrence Halprin, Dietmar
Winkler, Arthur Polos, Edward
D. Stone
No. 96: Human Experience in
Designed Environment
Guest editors: Niels Diffrient,
Nicholas Polites
No. 97: Ornament in Architecture;
Five and Dime Architects
Guest editor: Daniel Solomon
Nos. 98/99: Nelson/Eames/Girard/
Propst: The Design Process
at Herman Miller
1976
No. 100: The Architecture of
James Stirling: Four Works
Nos. 101/102: The River: Images
of the Mississippi River
1977
No. 103: Architecture as Energy
Guest editor: Marguerite
Villecco
No. 104: Julia Child's Kitchen
Guest editors: Bill Stumpf,
Nicholas Polites
1978
No. 105: Projects for
Handicapped Accessibility
Guest editors: David Niland,
Stanley Tigerman
Nos. 106/107: Noguchi's Imaginary
Landscapes
No. 108: Vacant Lots
1979
No. 109: Rooms
Guest editors: Susana Torre,
Stanley Tigerman
No. 110: Ivan Chermayeff
Nos. 111/112: Eight Artists:
The Elusive Image
1980
Nos. 113/114: City Segments
No. 115: Maps
Guest editor: Marc Treib
No. 116: WGBH, Boston:
A Design Anatomy
Guest editors: Rosemarie
Bletter, Christopher Pullman
1982
No. 117: Hennepin Avenue
Guest editor: Denise
Scott Brown
Nos. 118/119: Meanings of
Modernism: Form, Function
and Metaphor
No. 120: Green Architecture:
Notes on the Common Ground
Guest editor: Barbara
Stauffacher Solomon

1983
No. 121: Robots and Robotics
No. 122: The Meaning of Place
in Art and Architecture
1984
No. 123: A Paul Rand Miscellany
No. 124: Joe D'Urso
No. 125: Center City Profile
(Minneapolis, Minnesota)
Guest editors: Rem'Koolhaas,
Joseph Giovannini
No. 126: A Serious Chair
Guest editors: William
Houseman, Bill Stumpf
1985
No. 127: LA 84: Games of the
XXIII Olympiad
Guest editor: Joseph Giovannini
No. 128: Urban Circumstances
Guest editor: J. B. Jackson
No. 129: Skyways
No. 130: Formal Principles of
Graphic Design
Guest editors: Armin Hofmann,
Wolfgang Weingart
1986
No. 131: Unvernacular Vernacular:
Contemporary American
Consumerist Architecture
No. 132: Suburbs
Guest editor: Lois Craig
No. 133: Does It Make Sense?
Guest editor and designer:
April Greiman
No. 134: Japan From the Inside
No. 135: The Corporate Villa
Guest editor: Fred Koetter
No. 136: The City in Film
Guest editor: Michael Webb
1987
No. 137: The Flower Gardens
of Gertrude Jekyll
Guest editor: Michael R. Van
Valkenburgh
No. 138: House and Home
1988
No. 139: Within the City:
Phenomena of Relations
Guest editor: Steven Holl
No. 140: Skyscraper View
No. 141: Minneapolis Sculpture
Garden
Guest designer: Nancy Skolos
1989
No. 142: Computers and Design:
Massachusetts Institute
of Technology
Guest editor: Muriel Cooper
No. 143: Ephemeral Places:
Here Today—Gone Tomorrow
Guest editor: Grady Clay
No. 144: Images in Motion:
R/Greenberg Associates

No. 145: Hats
Guest editor: Richard Saul
Wurman
No. 146: Autoeroticism
Guest editors: Karal Ann
Marling, Donald J. Bush
1990
No. 147: Celebrations: Urban
Spaces Transformed
Guest editors: Christine Macy,
Sarah Bonnemaison
No. 148: The Evolution of
American Typography.
No. 149: Design to Grow With
1991
No. 150: The Fourth Coast:
An Expedition on the
Mississippi River
Guest editor: Design
Center for American Urban
Landscape, University of
Minnesota
No. 151: Framing American Cities
Guest editor: Mark Robbins
No. 152: Architecture Tomorrow:
Elizabeth Diller and Richard
Scofidio, Steven Holl, Frank
Israel, Thom Mayne and
Michael Rotondi, Stanley
Saitowitz, Tod Williams and
Billie Tsien
No. 153: Beyond Style: The
Designer and Society
1992
No. 154: Karl Friedrich Schinkel,
Disneyland, Shaker design
No. 155: Frank Lloyd Wright, the
Tuileries, Frank Gehry furniture
No. 156: Alvaro Siza, Guggenheim
Museum, U.S. currency design,
suburbs, David Hockney
Turnadot
No. 157: Lauretta Vinciarelli,
Museum of 1980s Design,
public housing, Calvin Klein
advertising, South Central
Los Angeles
1993
No. 158: infrastructure design,
digital displays, new
typefaces, Levittown
No. 159: film technology, Louis I.
Kahn, Mall of America, street
fashion, virtual reality

Issues 1–28 were published under
the original title *Everyday Art
Quarterly* between 1946 and 1953.
The Walker Art Center ceased its
affiliation with *Design Quarterly*
in 1993, with issue 159.

Stanley Abercrombie
Dean Abbott
Janet Abrams
Aesthetic Apparatus
Lauralee Alben
Emilio Ambasz
Charles S. Anderson and
 Laurie DeMartino
Dana Arnett
Richard Arnold
George Baird
Diana Balmori
Shigeru Ban
Reyner Banham
Julie Bargmann
Kent Barwick
Thomas Beeby
Aaron Betsky
Michael Bierut
Christine Binswanger
Gunnar Birkerts
Andrew Blauvelt
Rosemarie Haag Bletter
Carol Bly
Yve-Alain Bois
Lawrence O. Booth
Jorge Luis Borges
Paul Boyer
Constantin Boym
Sam Brody
Denise Scott Brown
Scott Bukatman
Robert Campbell
Donald Canty
Ralph Caplan
James Carpenter
Matthew Carter
John Casbarian
Matthew Causey
Adele Chatfield-Taylor
Walter Chatham
Ivan Chermayeff
Peter Chermayeff
Brad Cloepfil
Elizabeth Close
Harry Cobb
Stuart Cohen
Peter Conrad
Patricia Conway
Muriel Cooper
Judy Corcoran
Lois Craig
Denise Gonzales Crisp
Arthur Danto
Lewis Davis
Michael Dennis
Elizabeth Diller and
 Ricardo Scofidio
Steven Doyle

Arthur Drexler
Joe Duffy
Anthony Dunne and Fiona Raby
Joe D'Urso
Charles and Ray Eames
Elliott Peter Earls
Peter Eisenman
Richard Etlin
Thomas Fisher
Richard Foreman
Bernardo Fort-Brescia
Cheryl Fosdick
Harrison Fraker
Kenneth Frampton
Robert Frasca
Ed Frenette
Carol Frenning
Alice T. Friedman
Mildred Friedman
Stephen Frykholm
Martin Fuller
Paul Gapp
Joel Garreau
Lynn Geesman
Frank Gehry
Arthur Gensler
Brendan Gill
Joseph Giovannini
Richard Gluckman
Keith Goddard
Peter Goode and Patrick
 McCaughey
Pat Gorman
Bruce Graham
Graphic Thought Facility
Dennis Grebner
Robert Greenberg
Stormi Greener
April Greiman
David Griswold
Diane Gromala
Graham Gund
Frances Halsband
Bruce Hannah
Hugh Hardy
Chester Hartman
Laurie Hawkinson and
 Henry Smith-Miller
Richard Heath
Jessica Helfand and
 William Drenttel
Steven Heller
Charles Herbert
Jacques Herzog
Allan Hess
Caroline Hightower
Grant Hildebrand
Kit Hinrichs
Thomas Hodne
Jonathan Hoefler and
 Tobias Frere-Jones
Steven Holl
Malcolm Holzman

William Innes Homer
Christain Huebler
Kent Hunter
Lawrence M. Irvin
Eiko Ishioka
Alexander Isley
Frank Israel
Barry Jackson
Kerrie Jacobs
Hugh Newell Jacobsen
Helmut Jahn
Vincent James
John Jay
Alicia Johnson and Hal Wolverton
E. Fay Jones
Wes Jones
Rick Joy
Tibor Kalman
Toshihiro Katayama
Gyorgy Kepes
William Kessler
Chip Kidd
Ralph L. Knowles
Fred Koetter
Rem Koolhaas
Spiro Kostof
Alex Krieger
Robert Kronenberg
Philip Larsen
Christopher Lasch
Maud Lavin
Tony Lawlor
Jean Leering
Maya Lin
LOT-EK
Weiming Lu
Ellen Lupton
Lust
John Maeda
Laurie Haycock Makela
P. Scott Makela
Fumihiko Maki
Robert Mangurian and
 Mary-Ann Ray
Ron Margolis
Karal Ann Marling
Judith Martin
Bruce Mau
Thom Mayne
Marlene McCarty
Katherine McCoy
Michael McCoy
Geoff McFetridge
Robert McGuire
Michael McKinnel
Herbert McLaughlin
Tom Meyer
Duane Michals
J. Abbott Miller
Samuel Mockbee
Andrea Moed
Clement Mok
Rafael Moneo

Charles W. Moore
Arthur Naftalin
James L. Nagle
Ralph Nelson and Raveevarn
 Choksombatchai
Peter Nobokov
J. P. Nordenson
Leonard Parker
William Pederson
Emily Oberman and
 Bonnie Siegler
Jayme Odgers
Judy Olausen
Aura Oslapas
Tom Oslund
John Pastier
Robert Peck
David Peters
Gene Peterson
Steven Peterson
Charles Pfister
Elizabeth Plater-Zyberk
John Plunkett and Barbara Kuhr
James Polshek
Monica Ponce De Leon
Peter Pran
Antoine Predock
Paul Prejza
Christopher Pullman
Rick Poynor
Samina Quraeshi
Brooke Kamin Rapaport
Hani Rashid
Alan Resnick
ReVerb
Todd Rhoades
Dennis Dun Rhodes
Terence Riley
Jaquelin Robertson
Michael Rock
Garth Rockcastle
Randall Rothenberg
Michael Rotundi
Witold Rybczynski
Sharon Lee Ryder
Moshe Safdie
Stanley Saitowitz
David Samela
Danny Samuels and
 Robert Timme
Jim Sandell
Joel Sanders
Paula Scher
Herbert Schiller
Robert Schmike
Martha Schwartz
Mark Scogin
Douglas Scott
J.otto Seibold
Peter Seitz
John Sheehy and Tom Larsen
Jennifer Siegal
Jilly Simmons

Nancy Skolos	Donald Stull	Mikon van Gastel	Fo Wilson
William Slayton	Bill Stumpf	Michael Van Valkenburgh	Cornel Windlin
Alden Smith	Lisa Strausfeld	Rudy Vanderlans	Bruce Wright
Elizabeth A. T. Smith	Sarah Susanka	James Victore	Gwendolyn Wright
Julie Snow	Piotr Szyhalski	Anthony Vidler	Richard Saul Wurman
David Solomon	Alan Temko	Tucker Viemeister	Susan Yelavich
Laurinda Spear	Lucille Tenazas	Massimo Vignelli	Jurjen Zeinstra
Art Spiegelman	Milo Thompson	Ken Walker and Beverly Russel	Charles Zucker
Bernard Spring	Thonik	Peter Walker	
James Stageberg	Stanley Tigerman	Wolfgang Weingart	
Carl Steinitz	Donald Torbert	Sue Weller	
Suzanne Stephens	Susana Torre	Allan Wexler	
Jennifer Sterling	Gael Towey	Why Not Associates	
Dugald Stermer	Steve Trimble	William H. Whyte	
Robert Stern	Nancy Troy	Mark Wigley	
Scott Stowell	Rick Valicenti	Lorraine Wild	

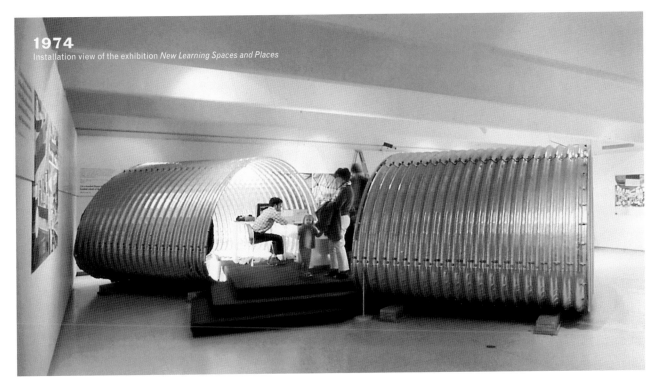

1974
Installation view of the exhibition *New Learning Spaces and Places*

Installation view of the exhibition *Nelson/Eames/Girard/Propst: The Design Process at Herman Miller*, 1975

Installation view of the exhibition *De Stijl: 1917–1931, Visions of Utopia*, 1982

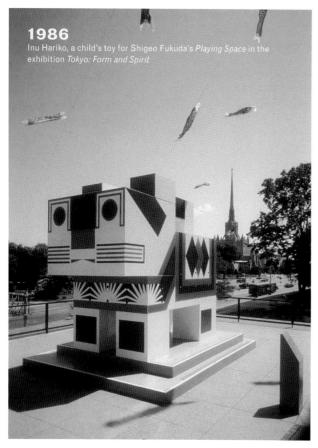

1986
Inu Hariko, a child's toy for Shigeo Fukuda's *Playing Space* in the exhibition *Tokyo: Form and Spirit*

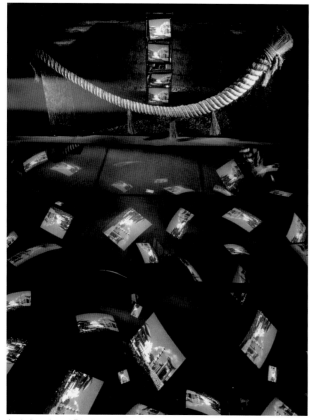

Arata Isozaki and Eiko Ishioka's *Performing Space* installation for *Tokyo: Form and Spirit*, 1986

Mildred Friedman on Design at the Walker

Mildred Friedman, editor of *Design Quarterly* from 1969 to 1991 and Walker Art Center design curator from 1979 to 1991, in conversation with curator Joan Rothfuss, New York City, August 6, 2004

Joan Rothfuss: When you began working at the Walker in the early 1970s, how did you define your role?

Mildred S. Friedman: I began by designing all of the office furnishings for the new building, working very closely with Ed [architect Edward Larrabee Barnes]. In the 1960s, I had worked as a designer for the architect Robert Cerny, so the Walker interiors were a natural project for me.

When the design of the building interiors was finished, it was necessary to develop other areas that were the Design Department's responsibility. The journal *Design Quarterly* already existed, so that was an essential part of my job. I did change it. We recruited a number of incredible writers from outside the immediate area, people like Richard Saul Wurman, Rem Koolhaas, and Bill Stumpf, who had written on ergonomics, urban planning, and various important topics. In the 1970s and 1980s, *Design Quarterly* became a catalogue for a number of Walker exhibitions such as *New Learning Spaces and Places*; *The Design Process at Herman Miller*; *The River: Images of the Mississippi*; and many others.

JR: These were groundbreaking exhibitions in many ways, but your curatorial activities took a dramatic leap with the Frank Gehry show.

MSF: In the early 1980s, I wanted to undertake a large-scale architecture exhibition. I didn't know Frank Gehry, but I had been reading about his work for a long time and I thought it was significant. His office is in Los Angeles, so one day I just called him and asked, "How would you like to do an exhibition at the Walker Art Center?" And he said, "Where?" We told him it was near Canada, because, you know, he was born in Toronto.

JR: I had no idea—I thought you must have been the best of buddies before you started working together.

MSF: No, but he and his great wife, Berta, did become our friends as the exhibition developed. When I went to Los Angeles, I stayed in their guest house, and spent time visiting his projects and talking with members of his then-small staff. I asked him to create five full-scale objects for the show in which we would then put drawings, models, and photographs of built works. He created a lead-coated wood fish, a cardboard enclosure for his cardboard furniture, a copper enclosure, a Finnish plywood snake house, and a series of wood trees.

It's hard to believe now, but at that point Frank had a reputation mostly among architects, few others had heard of him. The exhibition traveled to New York, Toronto, Atlanta, Los Angeles, and Houston. It was the first opportunity for a wide audience to see his work.

JR: Could you talk about the origins of the 1986 *Tokyo: Form and Spirit* exhibition?

MSF: Martin [Friedman] and I went to Tokyo because we were given a joint travel grant by the Japan Society. We went with Rand Castile, who was then head of the Japan House gallery, and Lily Auchincloss, who was his patroness. For almost a month, we traveled all over. Rand is an expert on Japan, as he had lived there for many years. We loved it. When we came back we said, "What are we going to do with all this information?" So we began thinking about an exhibition, but we didn't know what it would be. We had met Arata Isozaki—one of Japan's most prominent architects. He sat down with us and was incredibly helpful. To make a very long story a little shorter, he helped us arrive at the

idea of talking about the Edo period and today's Japan by comparing the two—in terms of the art that was produced, what it looked like, how it worked, and so forth. The concept was that we would look at major aspects of life, such as walking through the city, spirituality, working, playing—all the things that everybody does everyday. We would have objects to represent what each aspect looked like in the Edo period—for example, a tea house. Then we would ask a young architect (in that case Tadao Ando, of whom at that point almost no one in the United States was familiar) to design it. So throughout the show we would pair historical Edo objects with contemporary updates.

We borrowed most of the Edo-period material from American museums because it was difficult to get loans from Japan. Then we invited Fumihiko Maki, Tadao Ando, Shiro Kuramata, Eiko Ishioka, Hiroshi Hara, Toyo Ito, Tadanori Yokoo, and Shigeo Fukuda to participate. We were lucky—when we went there in 1982, they were all happy to participate because they wanted to make reputations in the United States. Isozaki helped by introducing us to the others. It wasn't that difficult. We had great fun with it.

JR: The exhibition had a sort of dry run in Tokyo, didn't it?

MSF: Yes. We wanted to see the work before we brought it to the United States. There was really no other way to see it. A good deal of it looked pretty terrible. The materials were wrong in many instances—not what you would expect from Japan. Martin and I brought one of the Walker's crew members over, and we did critiques. The projects needed some real materials and proper workmanship. It was a big success; parts of the show were shown in a Sapporo beer warehouse, an auditorium, the top floor of a fashion house, and so on. They sold tickets and had events at these various places. We finally got it all together and brought the whole thing back to the United States. We also had to bring over

some Japanese craftsmen to work with us. Our crew was so magnificent because they took many incomplete installations and finished them. At the Walker, the show picked up a real edge.

Organizing *Tokyo: Form and Spirit* was a real adventure. One of the funniest stories concerns a video we were using to raise money for the project. Not speaking Japanese, we took the video around with us. During one visit with the Kyocera Company, which produces cell phones, we couldn't make the video player work, so we asked for a technician to help. Two elderly gentlemen in snap-on bow ties came down. They looked like Maytag repairmen. We asked, "Could you please have this video played, so we could present it to the powers that be?" When they had it working, Martin said, "Now we are waiting for Mr. Nakamura and Mr. so-and-so…" And they said, "We are Mr. Nakamura and Mr.…." So, we sat there with red faces while this video played, and when it was all over Mr. Nakamura turned to Martin and said, "Now Friedman-san, would you be kind enough to tell me once again the name of your exhibition? Such interesting material you're showing us. So persuasive, so beautifully documented." So we told him, "We're calling it *Tokyo: Form and Spirit*." And he looked at his colleague and sort of smiled, and then he said, "But Friedman-san, this is Kyoto." Martin said, "Oh, couldn't we think of it as a working title?"

Needless to say, that story happened in many versions, but in the end we did get support from many generous people.

Frank Gehry in the exhibition galleries for *The Architecture of Frank Gehry*, 1986

View of the exhibition *Graphic Design in America*, 1989

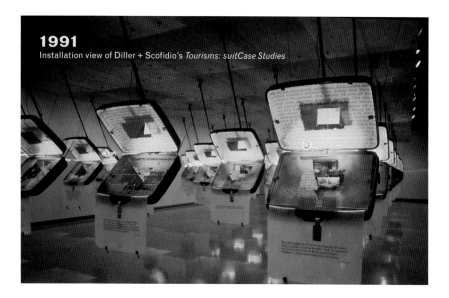

1991
Installation view of Diller + Scofidio's *Tourisms: suitCase Studies*

Fax to Laurie Haycock Makela, Walker Art Design, 612 375 7618

From Matthew Carter, Carter & Cone Type Inc, 617 354 4146

9 January 1995

Dear Laurie,

Having seen the calendar mock-up and the pages you faxed last week I agree with you about the informal appearance of the Vineland design. An alphabet of more monumental display capitals that can be used in much the same way as your present DIN sans seems like a better direction.

I'm glad you are still intrigued by the idea of snap-on serifs that I tried in Walker Sans; they provide a way to make the face distinctive and give it some variability—the typographic equivalent of the vocal inflection you mention. I have been experimenting with a few trial caps. They are necessarily fairly simple in their vanilla form. The weight matches the Heavy version of DIN.

HAHEHRHTH

Serifs can be attached at will to the vertical stems, on both sides, in any combination:

HHHHAAEE

A couple of warnings about this approach. Not every combination of serif and letterform will work ideally—although the misfits do at least have the charm of showing their means of construction:

A word or line of letters that combines unserifed, partially serifed and fully serifed characters will be hard to space evenly.

Because the serifs are themselves characters in the font, they will be influenced by tracking. It will be difficult, therefore, to use tracking to letterspace words to fill the line. I would have to include a number of fixed spaces of various widths in the font, as in metal days—en, thick, thin, hair, etc.

In general: a scheme like this has much greater variability than a conventional font, and makes greater demands on the designer/compositor who is using it. In practice, however, Matt and the other designers would probably find that certain flavors were used more than others. In this case I could make derivative fonts in which the combination of serif and capital were prefabricated to reduce the amount of time needed to set it.

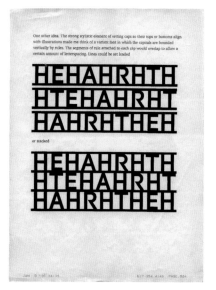

One other idea. The strong stylistic element of setting caps so their tops or bottoms align with illustrations made me think of a variant font in which the capitals are bounded vertically by rules. The segments of rule attached to each cap would overlap to allow a certain amount of letterspacing. Lines could be set leaded

or stacked

Fax from Matthew Carter to Design Director Laurie Haycock Makela regarding his newly commissioned Walker typeface, 1995

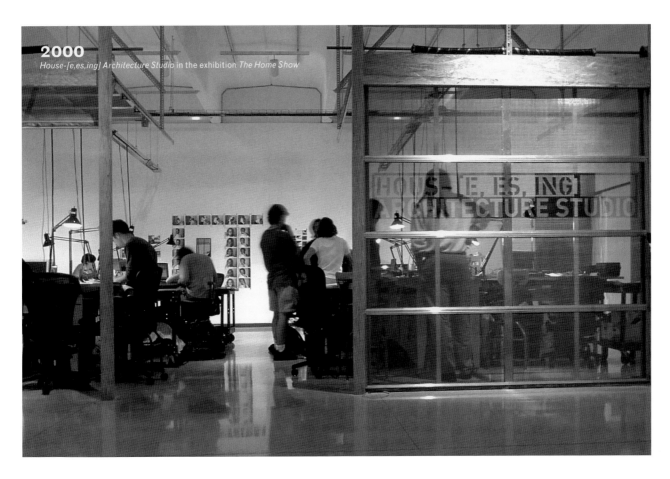

2000
House-[e,es,ing] Architecture Studio in the exhibition *The Home Show*

Installation view of *Strangely Familiar: Design and Everyday Life*, 2003

left to right: Christine Binswanger, Jacques Herzog, and Charles Stone of Herzog & de Meuron discuss architectural plans with Walker Director Kathy Halbreich, 2004

New Media Initiatives

In 1996, the Walker Art Center established the New Media Initiatives Department to advance its mission through the use of innovative forms of digital technologies, particularly the Internet, and to create new educational and artistic projects. Steve Dietz, the department's first director and curator from 1996 to 2003, developed a pioneering program that reflected the institution's historical commitment to contemporary arts and communication, and an unprecedented approach to the opportunities that Internet technology offered in the field of art and culture.

With a unique twofold mission to investigate the informational and aesthetic possibilities that new digital technologies offered, the Walker's New Media Initiatives department was quickly dubbed "a leader in high-tech cultural initiatives" by the *New York Times*. The 1998 acquisition of äda'web and the formation of the Digital Arts Study Collection put the Walker at the forefront of museums engaged in collecting and preserving new media. In the same year, with funding from the Jerome Foundation, the program was able to support new media as a viable and significant area of emerging artists' efforts through a series of projects and critical essays commissioned for the Walker's Gallery 9 (gallery9.walkerart.org) online exhibition space. Between 1997 and 2003, it became one of the most recognized online venues for the exhibition and contextualization of Internet-based art and presented the work of more than one hundred artists, including 0100101110101101.org, Mark Amerika, Margaret Crane and Jon Winet, Auriea Harvey, Lisa Jevbratt, Jennifer and Kevin McCoy, and Piotr Szyhalski.

In the field of information access, the Walker partnered with the Minneapolis Institute of Arts to build a shared technology infrastructure and the services needed to digitize and deliver resources on the Internet. In 1998, the two institutions launched ArtsConnectEd (www.artsconnected.org), a gateway to their combined collections and educational resources that has become the model for similar Internet-based educational initiatives. Under the auspices of ArtsConnectEd and the development of the Walker's institutional site (walkerart.org), New Media Initiatives implemented information systems that made it possible to deliver the Walker's archives, collections, and program information on the Web.

By early 2000, the Walker began to envision a multidisciplinary, global contemporary arts Internet portal, entitled the *Virtual Arts Network*, though it was not realized. Another pilot project—mnartists.org, developed with the McKnight Foundation and launched in 2001—demonstrated the potential for connecting artists, arts organizations, and their audiences in an online breadth of content and active community exchange.

Not only has the Walker created new models for online initiatives, but it has also sought innovative ways of using digital technologies on-site, in its public spaces. New Media Initiatives works closely with the Walker's Design and Education and Community Programs departments to develop new methods of visitor interaction using technology as a vehicle. In 2000, Antenna Design was commissioned to create an in-gallery display for an online exhibition. The resulting *Art Entertainment Network* gallery portal was a physical interface that combined wireless computing technology in a structure reminiscent of a revolving door. Other projects have led to public, multimedia presentations in the galleries through special installations, such as Raqs Media Collective and Atelier Bow-Wow's electronic sarai for *Translocations* (2003) and *Art on Call*, a new model for the museum audio guide that visitors can access using cell phones.

Key among these interdepartmental collaborations was the commission of an interactive, multimedia table through an invited international competition. Designed by Marek Walczak, Jakub Segen, Michael McAllister, and Peter Kennard, *Dialog* was included in the exhibition *Strangely Familiar: Design and Everyday Life* (2003) and later installed in the expanded Walker. The table has two stations that can serve several visitors simultaneously. Infrared video cameras mounted above it track participants' hand movements, which act as the cursor for the interface. This gesture-recognition and video-tracking software allows several people to interact concurrently with a variety of information appearing on the surface of the table. While conventional computer kiosks allow single users to obtain information, the shared space of *Dialog* is designed to promote social interactions among visitors, while providing access to the Walker's multidisciplinary collections and facilitating learning about the arts. Under the stewardship of Director Robin Dowden since 2003, New Media Initiatives demonstrates, with projects such as *Dialog* and others, its commitment to the ongoing investigation of new digital technologies as a means to assist, educate, and inspire visitors.

äda'web (1995–1998)

Vivian Selbo's *Vertical Blanking Interval* (1996)

ArtsConnectEd, a collaboration with the Minneapolis Institute of Arts, 2005

Gallery 9, 1997

Paul Vanouse and Peter Weyhrauch's *The Consensual Fantasy Engine* (1995)

Shu Lea Cheang's *Bowling Alley* (1995–1996)

New Media Commissions 1997–2004

1997

Piotr Szyhalski
Ding an sich (The Canon Series) (1997)
http://www.walkerart.org/gallery9/szyhalski/dingansich/
Harvest (1997)
http://ftp.mcad.edu/piotr2/harvest/entry.html

1998

Natalie Bookchin
Questions and Answers, Questions as Answers, Answers as Questions (1998)
http://www.walkerart.org/nmi/iim/bookchin.cfm
Janet Cohen, Keith Frank, and Jon Ippolito
The Unreliable Archivist (1998)
http://www.three.org/z/UA/
Carl DiSalvo
An Essay on Space (1998)
http://www.walkerart.org/salons/shockoftheview/space/disalvo/
Lisa Jevbratt
A Stillman Project (1998–1999)
http://www.walkerart.org/stillmanIndex.html
Marek Walczak and Remo Campopiano
VRML Minneapolis Sculpture Garden (1998)
http://www.walkerart.org/msg/vrml/0.html

1999

Mark Amerika
PHON:E:ME (1999)
http://phoneme.walkerart.org/launch.html
C5
16 Sessions (1999)
http://www.c5corp.com/walker/gateway.html
Jennifer and Kevin McCoy
Airworld (1999)
http://www.airworld.net
Beth Stryker and Sawad Brooks
DissemiNET (1999)
http://disseminet.walkerart.org

2000

0100101110101101.org
life_sharing (2000)
http://www.0100101110101101.org
Antenna Design
Art Entertainment Network Gallery Portal (2000)
interactive kiosk installation

Natalie Bookchin and Alexei Shulgin
Universal Page (2000)
http://www.universalpage.org
Claude Closky
Calendar 2000 (2000)
http://www.walkerart.org/gallery9/closky/2000/
Margaret Crane and Jon Winet
Democracy—The Last Campaign (2000)
http://dtlc.walkerart.org
Auriea Harvey
An Anatomy (2000)
http://ananatomy.walkerart.org/
Vivian Selbo
open_source (2000)
http://opensource.walkerart.org
Victoria Vesna
A Community of People with No Time (NoTime) (2000–2001)
http://notime.arts.ucla.edu
Marek Walczak and Martin Wattenberg
WonderWalker (A Global Online Wunderkammer) (2000)
http://wonderwalker.walkerart.org

2001

Ochen K.
Community (2001)
http://www.community.walkerart.org
Diane Ludin
Harvesting the Net:: MemoryFlesh (2001)
http://memoryflesh.walkerart.org

2002

r a d i o q u a l i a
Free Radio Linux (2002)
http://www.radioqualia.net/freeradiolinux

2003

Julie Mehretu and entropy8zuper!
The Twin Cities Are East African Cities (2003)
http://tceastafrica.walkerart.org
Raqs Media Collective and Atelier Bow-Wow
Architecture for Temporary Autonomous Sarai (2003)
mixed-media installation
Scott Paterson, Marina Zurkow, and Julian Bleecker
PDPal (2003)
http://pdpal.walkerart.org
Warren Sack and Sawad Brooks
Translation Map (2003)

http://translationmap.walkerart.org
tsunamii.net
alpha 3.8 (2003)
http://translocations.walkerart.org/tsunamii/
Marek Walczak, Michael McAllister, Peter Kennard, and Jakub Segen
Dialog (2003)
http://dialog.walkerart.org

2004

Ralph Lemon and John Klima
How can you stay in the house all day and not go anywhere? (2003–2004)
http://geography.walkerart.org/patton/

Online Exhibitions 1998–2003

1998

Beyond Interface: net art and Art on the Net (1998)
http://www.walkerart.org/gallery9/beyondinterface/
The Shock of the View: Artists, Audiences, and Museums in the Digital Age (1998–1999)
http://www.walkerart.org/salons/shockoftheview/

2000

Art Entertainment Network (2000)
http://aen.walkerart.org

2001

CrossFade: Sound Travels on the Web (2001)
http://crossfade.walkerart.org
Telematic Connections: The Virtual Embrace (2001)
http://telematic.walkerart.org

2003

Translocations (2003)
http://translocations.walkerart.org

New Media Artists-in-Residence

2002

Raqs Media Collective (Jeebesh Bagchi, Monica Narula, Shuddhabrata Sengupta)

2003

Andreja Kuluncic

Claude Closky's *Calendar 2000* (2000)

Jennifer and Kevin McCoy's *Airworld* (1999)

Sonicflux: Steve Reich (2000)

Marek Walczak and Martin Wattenberg's *WonderWalker (A Global Online Wunderkammer)* (2000)

Art Entertainment Network (2000)

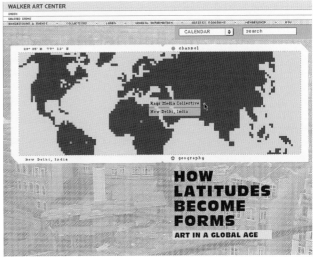

How Latitudes Become Forms: Art in a Global Age site (2002)

2000

Antenna Design's *Art Entertainment Network* Gallery Portal in the exhibition *Let's Entertain*

Installation view of Raqs Media Collective and Atelier Bow-Wow's *Architecture for Temporary Autonomous Sarai* in the exhibition *How Latitudes Become Forms: Art in a Global Age*, 2003

mnartists.org, 2002

Piotr Szyhalski performs at the mnartists.org launch, 2002

2003
Installation view of *Dialog* table, designed by Marek Walczak, Jakub Segen, Michael McAllister, and Peter Kennard

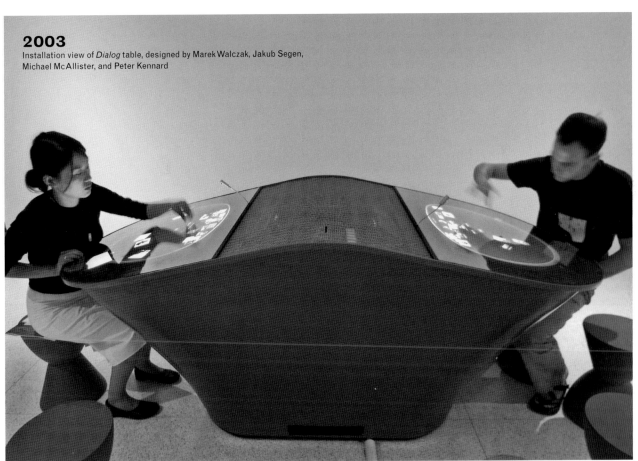

Library/Archives

The bibliographic heart of the Walker Art Center is Library/Archives. Although tucked behind the scenes, this department serves the entire museum staff and routinely makes its resources available to the public.

The Walker's John Rogers Shuman Memorial Library, focused solely on contemporary art, is dedicated to securing not only those resources necessary for documenting and interpreting works in the collection past and future, but also materials related to all curatorial concerns: architecture, design, film, new media, painting, performing arts, photography, sculpture, and video. The strongest aspect of the Library is undoubtedly the holdings of exhibition catalogues that chart the course of art since 1950 as well as the careers of thousands of artists worldwide.

Among the numerous volumes in the Library is a group of more than one thousand that bear the designation of artists' books. This cache, built over some twenty years, features works by artists represented in the Walker's collection, such as Dieter Roth and Edward Ruscha, as well as pieces by artists whose primary activity is making books, such as Carol Barton, Julie Chen, and Keith Smith. There have been several exhibitions of these works, notably *Artists' Books* (1981), *Artists/Books* (1989), which paired pieces from the permanent collection with book works by the same artists, and *Artists' Books: No Reading Required: Selections from the Walker Art Center Library Collection* (2004). Since then, many exhibitions have included books from this collection, including *Chris Marker/William Klein: Silent Movie/Moving Pictures* (1996), *Robert Gober: Sculpture + Drawing* (1999), and *Zero to Infinity: Arte Povera 1962–1972* (2001). The Walker has also commissioned book works: Siah Armajani's *Bridge Book* (1991), Laurie Simmons' *Laurie Simmons: Water Ballet/Family Collision* (1987), and Sol LeWitt's *Lines in Two Directions and in Five Colors on Five Colors with All Their Combinations* (1988).

Because contemporary art can sometimes be difficult and unusually challenging, it is vital that the Walker have resources available to contextualize works of art, aid in historical research, and help the audience better understand the nature of artistic practice, whether through a slide presentation or an in-gallery reading room as part of an exhibition. The Library, which began as little more than a few shelves of books in a curatorial office, stands ready to fill these needs with 125 active subscriptions to journals published worldwide; 35,000 books; 4,700 clip files; 1,200 artists' books; and thousands of exhibition catalogues documenting contemporary art all over the world. In addition, there is primary source material in the form of audiotapes recorded in the Walker Auditorium from 1956 to the present featuring artists, authors, and critics reading, speaking, or engaged in discussion.

The Archives is the institutional memory of the Walker. Founded in 1994 with support from the Lila Wallace-Reader's Digest Foundation, the Archives preserves and makes accessible documentation regarding the history of the Walker. The oldest records date from the 1860s and bring to life the creation of Thomas Barlow (T. B.) Walker's extensive and eclectic collection of paintings, jades, vases, and porcelains. The correspondence, photographs, and scrapbooks document the collecting practice of this nineteenth-century lumber baron and illuminate his commitment to philanthropy and the community, particularly in regard to the opening of the Walker Art Galleries in 1927.

The greatest quantity of archival materials relates to the operation of the Walker. In 1939, the Minnesota Arts Council (MAC) and the Work Projects Administration (WPA) took over the Walker Art Galleries from the T. B. Walker Foundation, which was run by the founder's heirs. In January 1940, the newly named Walker Art Center reopened, and for three brief but significant years it was the largest WPA art center in the country. The records and papers of Director Daniel S. Defenbacher capture the public spirit of the era and trace the institution's transformation from a static museum to a lively contemporary arts facility. The Walker's direction, growth, and mission are contained in the files of its four directors: Defenbacher (1939 to 1950), H. Harvard Arnason (1951 to 1960), Martin Friedman (1961 to 1990), and Kathy Halbreich (1991 to the present).

The program records document artistic developments in the visual, performing, and media arts for the past sixty-plus years, including artists' correspondence, drawings, and installation notes; sound and visual documentation of performances, lectures, exhibitions, dialogues, residencies, and workshops; and ephemera that include brochures, newsletters, annual reports, and invitations. This documentation provides valuable insight into understanding the art of our time. Among the highlights are Joseph Cornell's correspondence from 1953 in which he describes how his films are created; Mario Merz's drawings for his first solo exhibition in the United States in 1972, which was held at the Walker; and video footage of Charles Ray discussing the creation of *Unpainted Sculpture* (1997) in 1999. Several artists who have had a long history with the Walker are well-represented in recordings and images, including Trisha Brown, John Cage, Chuck Close, Merce Cunningham, Claes Oldenburg, Yoko Ono, and Nam June Paik. Extensive residency activities in recent years have generated more valuable documentation.

The Archives' special collections include the set elements to Ron Vawter's performance *Roy Cohn/Jack Smith* (with chaise longue by Elizabeth Murray), a work co-commissioned by the Walker; extensive photographic documentation of Ben Vautier's installation at the 1962 Festival of Misfits in London; the Reza Abdoh Video Collection; and the Richard Hegelberger Collection of Bruce Conner Correspondence, 1955–1981.

The Minneapolis Sculpture Garden

Since its opening in 1988, the Minneapolis Sculpture Garden has acquired a comfortable patina befitting the well-loved and well-tended public space it has become. Its gravel paths, lined with mature linden trees, are firmly tamped; its perennial garden blooms lush in late summer, and ivy now creeps thickly over its stone walls. More than five million people have strolled the Garden to date, making it one of the most-visited attractions in the area. It is, in short, a lovely and thriving success, confirmation of former Walker Art Center Director Martin Friedman's hunch that the Twin Cities needed just such a gathering place.

The Garden occupies eleven acres of parkland directly across from the Walker that had been undeveloped since the formal flower beds and hedges of the Armory Gardens were removed in 1966. Thanks to Friedman's tenacity and vision, the site is once again a garden, one that unites two of Minnesota's most cherished resources—its green space and its cultural life. To maintain it, he engineered a partnership between the Minneapolis Park and Recreation Board, which cares for the grounds, and the Walker, which oversees the artworks. At this writing, forty-five objects from the collection are installed there, including classic figurative bronzes by Jacques Lipchitz, Henry Moore, and George Segal; a huge cinder-block *X* by Sol LeWitt and an abstraction of steel plates and poles by Richard Serra; Frank Gehry's leaping glass fish and Deborah

Butterfield's trompe l'oeil stallion; and a trio of cheeky, sausage-shaped benches in neon colors by Franz West. All these works contribute to the diverse experience the Garden provides, but its emotional and physical centerpiece is the monumental, photogenic *Spoonbridge and Cherry*, a collaboration between Claes Oldenburg and Coosje van Bruggen that has become one of the Twin Cities' most recognizable icons.

Among the Garden's many charms is its relative stability, especially within the context of a society that seems more volatile every day. One can return often to visit favorite sculptures that seem more reassuringly settled as the seasons pass and the plantings mature around them. Yet the Garden is far from a static environment—its landscape is recurrently activated and enlivened by myriad Walker programs, including dance and music events, films, workshops, talks, exhibitions, and projects by artists-in-residence. The illustrated timeline that follows summarizes the history and highlights of this remarkable urban space, from its beginnings as the swampy site of an armory to the temporary installation of an artist-designed miniature golf course in the summer of 2004. The last entry is the addition, in the Garden's southern extension, of a commissioned environment by James Turrell entitled *Sky Pesher* (2005). In this underground room, which is open to the changing skies, one can meditate on nature's simultaneous calm and fluidity, attributes mirrored by the Garden itself.

J.R.

View of the Minneapolis Sculpture Garden from the Walker Art Center terraces, 2004

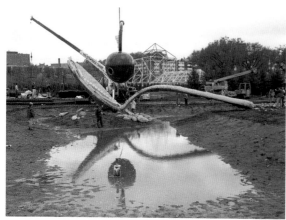

Installation of Claes Oldenburg and Coosje van Bruggen's *Spoonbridge and Cherry*, 1988

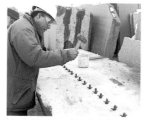

Martin Puryear at the Cold Spring Granite Company, 1987

1985

Claes Oldenburg and Coosje van Bruggen are commissioned to create a fountain-sculpture centerpiece for the Garden, which later debuts as *Spoonbridge and Cherry* (1985–1988)

1987

Mark di Suvero's monumental *Arikidea* (1977–1982) is the first artwork installed in the Garden

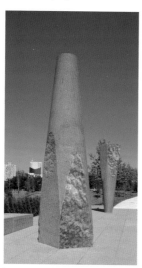

Installation view of Martin Puryear's *Ampersand*, 1988

1988

The glass and steel Cowles Conservatory, designed by Alistair Bevington of the Barnes architectural office, opens at the Garden's westernmost edge

Siah Armajani's Irene Hixon Whitney Bridge (1988), commissioned to link the Garden to Loring Park, is completed

Martin Puryear's Walker-commissioned *Ampersand* (1987–1988), made of granite quarried in Minnesota, is installed at the Garden's entrance

Frank Gehry's *Standing Glass Fish* (1986), commissioned for his Walker retrospective, is installed in the central Palm House of the Cowles Conservatory

The exhibition *Sculpture Inside Outside* opens at the Walker, featuring indoor works by Garden artists

The Minneapolis Sculpture Garden opens September 10 and draws more than 500,000 visitors in its first year

Ann Carlson in *Dead*, 1989

1989

Choreographer and artist-in-residence Ann Carlson performs on a white horse in *Dead*, the world premiere of the final segment of her *Animals* series

Walker Director Martin Friedman (left) and Minneapolis Park and Recreation Board Superintendent David Fisher at the dedication of the Minneapolis Sculpture Garden, 1988

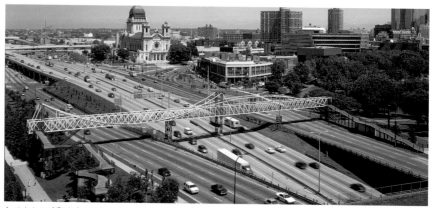

Aerial view of Siah Armajani's Irene Hixon Whitney Bridge, 1988

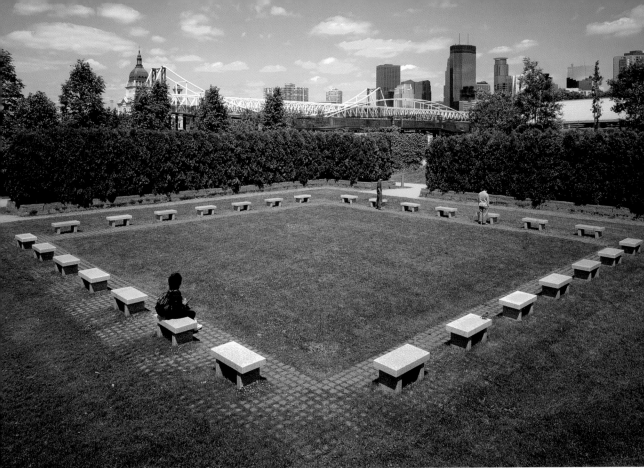

Jenny Holzer Selections from *The Living Series* 1989 granite; edition 3/3 17 1/4 x 36 x 18 in. (43.8 x 91.4 x 45.7 cm) each of 28 Anonymous gift from a local resident with appreciation for the Minneapolis Sculpture Garden and contemporary art, 1993 1993.97–1993.124

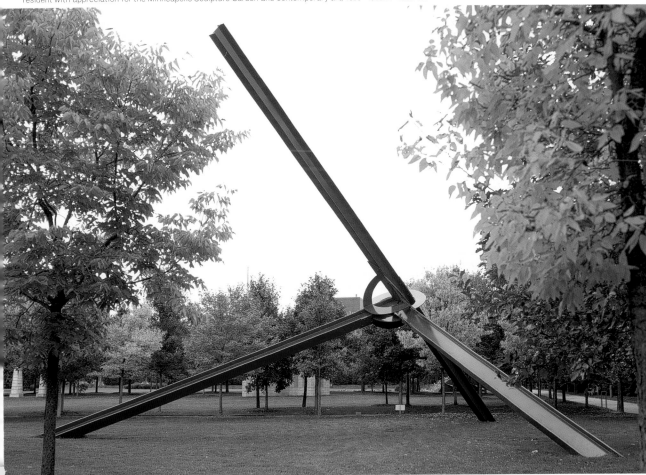

Mark di Suvero *Molecule* 1977–1983 steel, paint 456 x 662 x 532 in. (1158.2 x 1681.5 x 1351.3 cm) Gift of Honeywell Inc. in honor of Harriet and Edson W. Spencer, 1991 1991.2

A Garden Chronicle

The Kenwood Armory and adjacent gardens, circa 1915

Siah Armajani's *Covered Foot Bridge*, 1970

1893
The City of Minneapolis acquires a 10-acre tract of land for what would become known by 1900 as the Parade

1904
Construction of the Kenwood Armory begins on the Parade grounds

1907
Kenwood Armory dedication is held

1913
Armory Gardens opens

1927
Thomas Barlow Walker opens the Walker Art Galleries opposite the Armory Gardens

1933
The Kenwood Armory is razed after a survey by military agencies proclaims it in danger of immediate collapse due to unstable soil conditions

1935
The Minneapolis Park Board assumes ownership of the Armory grounds

1963
The Guthrie Theater opens opposite the Armory Gardens

1966
To make way for the construction of Interstate 94, the Armory Gardens is partially destroyed and the site is later abandoned

1970
Siah Armajani's *Covered Foot Bridge* (1970), a temporary commission for the exhibition *9 Artists/9 Spaces*, is displayed on the former Armory grounds

1971
The Walker Art Center opens its new building, designed by architect Edward Larrabee Barnes

As part of the Walker's inaugural celebration, Mark di Suvero's 40-foot-high steel sculpture *Are Years What? (For Marianne Moore)* (1967) is installed on the land opposite the building

1984
Edward Larrabee Barnes designs the Minneapolis Sculpture Garden on the former Armory grounds site in collaboration with landscape architect Peter Rothschild

Landscape architects Barbara Stauffacher Solomon and Michael Van Valkenburgh Associates, Inc. are commissioned to design the Regis Gardens for the Cowles Conservatory

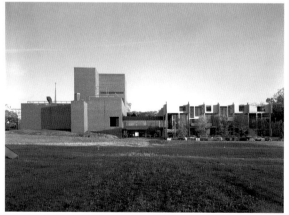

The Walker Art Center–Guthrie Theater complex from the future site of the Minneapolis Sculpture Garden, circa 1971

Model of Edward Larrabee Barnes' design for the Minneapolis Sculpture Garden, circa 1987

1998
Fax from Barry McGee for the installation of the exhibition *Regards, Barry McGee*

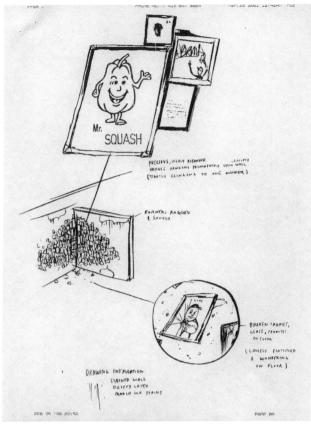

Installation of artist's books by Matta, Walker Art Center Library, 2003

Press Collection

Public Relations and Marketing Department

Types of Records:
Press releases, press clippings, scrapbooks, press books of Walker Art Center activities.

Audio/Visual Collections:

Architectural Drawings and Models

300 drawings, 20 models by architects who have worked on buildings and grounds of the Walker Art Center and Minneapolis Sculpture Garden.

Types of Records:
Architectural drawings, blueprints, schematics, models, and drawings

Photographs

Contracted and staff photographers 100,000 images

Types of Records:
Walker family photographs, Walker Art Galleries and Walker Art Center photographs of exhibitions, installations, buildings, and events. Formats include stereocards, cabinet photographs, glass-plate negatives, lantern slides, gelatin silver prints, negatives, transparencies, and slides.

Audio

4,000 carriers

A collection of taped performances, interviews, lectures, workshops, and conversations with artists presented by the Walker Art Center, including visual arts, performing arts, film/video, and education. Audio exists on analog open-reel tape, cassettes, CD, and DAT.

Video/Film

2,500 titles

A collection of performances and workshops as well as commissioned works, residencies, and documentaries presented by the Walker Art Center.

Special Collections

40 linear feet

äda'web, Center Arts Council, Center Opera Company, Bruce Conner, Rolphe Dauphin, Elizabeth Murray, Clara Nelson, North American Life Insurance Company Building (subsequently Allianz), Susan Okie, Catherine Opie, John Rogers Shuman, Ron Vawter, Hudson Walker.

Types of Records:
Correspondence, contracts, scripts, memos, minutes, press clippings, photographs, oral history tapes, transcripts, and stage elements.

Edmond R. Ruben Film and Video Study Collection

770 titles

Ruben Film and Video Study Collection includes independent, avant-garde, and feature presentation videos and films.

Various film formats, including 16mm, 35mm, and 8mm. Various video formats, including VHS, 3/4 in. UMatic, and Betacam SP.

Slide Library

Approximately 200,000 slides

Contains images of Walker exhibitions, programming events, and works in the permanent collection as well as a general art study collection that includes architecture and design material.

1985

Drawing of the John Cowles Conservatory by Alistair Bevington, Edward Larrabee Barnes Associates

THE GRAND UNION
c/o Yvonne Rainer
137 Greene Street
New York, N.Y. 10012
(212) 533-4292

Sue –
254-4193
David Gordon
Ch. 3-2908

23 kids
North High
1-3
Steve Kummel
333-1883

May 13, 1971

Dear Sue Weil:

We all got together last night and came up with some decisions and in-
formation that I shall pass on to you:

We need: 150 people - dancers and non-dancers, both sexes - as many
 as possible available Monday morning, May 24.

 10 dark-colored 1940ish men's cloth overcoats (in good condition).
 1 raft for pond.
 2 motorcycles with owner-drivers.
 50 red rubber balls (tennis ball size).
 20 la rge kites.
 6 jumpropes.
 6 large black umbrellas.
 1 bicycle.

 1 three-man jazz group or rock group.

 1 bolt of purple silk or synthetic that is as light as silk.
 10 1940ish men's felt hats.

 indoor sound system including tape recorder and turn-table.
 outdoor speakers and sound system.
 1 portable tape recorder (Ewer, if possible).

a sound)7 microphones
engineer to)7 head sets (earphones)
set it all)Control panel controlling each microphone and head set individ-
us.)ually (for lecture-demonstration on Wednesday evening).

Our tentative schedule is to rehearse Monday, xxx Tuesday, and Wednesday;
lecture-demonstration Wednesday night; all-day schedule of events Thursday
- from dawn to around 11 PM; Grand Union performance Friday night.

Accomodations should be arranged from Sunday night for Lloyd, Dunn, Dong
(Lincoln Scott), Rainer, Gordon, and Green; from Wednesday night for Becky
Arnold; from Thursday night for Trisha Brown. Yes, we are still known
as the Grand Union, and this time there will be eight of us: Trisha
Brown, Nancy Green, David Gordon, Yvonne Rainer, Douglas Dunn, Dong,
Becky Arnold, Barbara Lloyd. Since it is imperative to all of us to save
money, it would be a great help if you could arrange for us to stay in
people's houses. Barbara and Dong are prepared to camp out.

2

About the teaching schedule Barbara and I would like to set up for the
week of May 31:

 5 technique cla sses at $3 per class, $15 for five.
 3 workshop sessions Monday, Wednesday, and Friday at $12 (no singles)
 $25 for the whole course

 maximum of 30 people in the technique sessions, 20 in the workshop.

I am enclosing our biographies in case you need them.

Thank you loa ds for whatever you can accomplish in these matters. I
am sure it will all work out.

Very best regards,

Yvonne

Letter from Yvonne Rainer to Performing Arts Coordinator Suzanne Weil, 1971

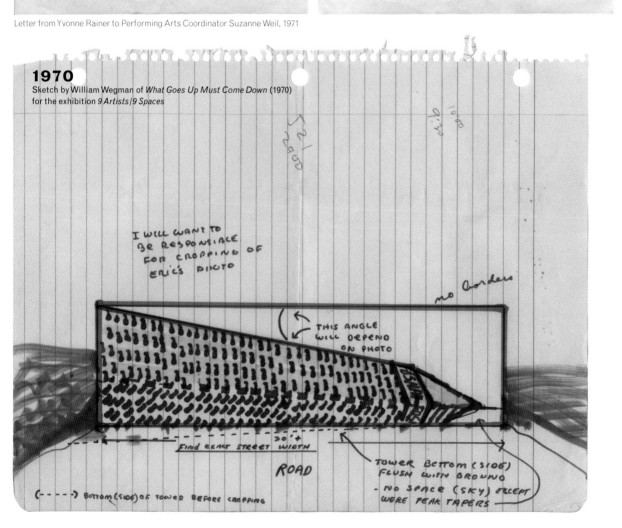

1970
Sketch by William Wegman of *What Goes Up Must Come Down* (1970)
for the exhibition *9 Artists / 9 Spaces*

Archives
1864–Present

T. B. Walker Collection

In 1879, Thomas Barlow Walker founded the Walker Art Gallery in his home in downtown Minneapolis. The Gallery eventually moved to its present site, and consisted of Walker's private collection of modern European paintings, Chinese jades, miniatures, porcelain, armor, and Indian portraits. The family operated the Gallery until 1938 when the Minnesota Arts Council (MAC) was founded. MAC and the Work Projects Administration (WPA) created an art center from the gallery; the institution was renamed the Walker Art Center.

Types of Records: Correspondence with artists, museums, art galleries, the City of Minneapolis, and patrons; acquisitions, permanent collection loans, appointment books, diaries, photographs, land survey notebooks, other philanthropies including Abbott Northwestern Hospital, Bethany Home, and Hennepin Methodist Church.

Walker Art Center Institutional Records 1939–Present

Begun in 1939 under the Work Projects Administration (WPA) and the Minnesota Arts Council (MAC), the Walker Art Center is an arts facility providing many cultural, educational, and social activities for the community. Major holdings include:

Director's Office

Daniel Defenbacher, 1940–1951; H.Harvard Arnason, 1951–1960; Martin Friedman, 1961–1990; Kathy Halbreich, 1991–present.

Types of Records: Correspondence with artists, Walker family members, galleries, museums, arts organizations, and community organizations; administrative records including acquisitions, loans, exhibitions, T. B. Walker Foundation, special events, MAC, and Art School records.

Exhibition Records

Visual Arts, Registration, Program Services departments

Types of Records: Correspondence with artists, galleries, museums; administrative records including loans, exhibit development and research, lectures, residencies, commissions, biographies, bibliographies, and transcripts of conversations with artists.

Performing Arts

Performing Arts Department, Performing Arts Council, Center Arts Council

Types of Records: Correspondence with artists, arts organizations, and Guthrie Theater; administrative records including programming, box office records, commissions, lectures, residencies, biographies, bibliographies, transcripts of conversations with artists.

Film/Video

Film/Video Department, Film in the Cities, media arts

Types of Records: Correspondence with filmmakers, television, radio and film, and arts organizations; administrative records including program plans, box office reports, acquisitions, commissions, residencies, lectures, biographies, bibliographies, and transcripts of conversations with artists.

Education

Education and Community Programs Department

Types of Records: Correspondence with grant facilities, arts organizations, artists, schools, teachers, and students; administrative items including scheduling, tours, programming for lectures, workshops, classes, commissions, and residencies.

Design

Design and Editorial Department

Types of Records: Walker Art Gallery and Walker Art Center exhibition catalogues, issues of *Everyday Art Quarterly* and *Design Quarterly*, programs, brochures, calendars, posters, and announcements.

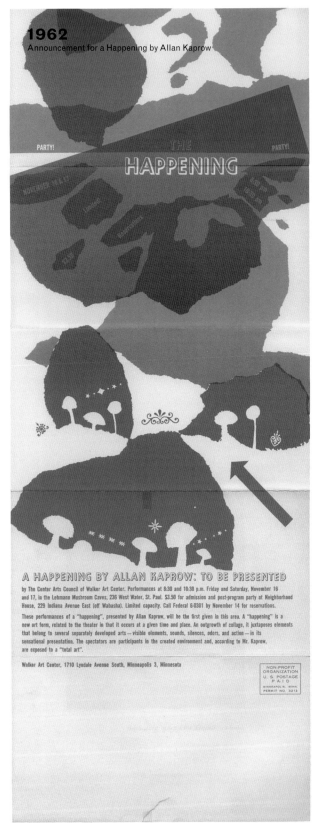

1962
Announcement for a Happening by Allan Kaprow

A HAPPENING BY ALLAN KAPROW: TO BE PRESENTED

by The Center Arts Council of Walker Art Center. Performances at 8:30 and 10:30 p.m. Friday and Saturday, November 16 and 17, in the Lehmann Mushroom Caves, 236 West Water, St. Paul. $3.50 for admission and post-program party at Neighborhood House, 229 Indiana Avenue East (off Wabasha). Limited capacity. Call Federal 6-0301 by November 14 for reservations.

These performances of a "happening", presented by Allan Kaprow, will be the first given in this area. A "happening" is a new art form, related to the theater in that it occurs at a given time and place. An outgrowth of collage, it juxtaposes elements that belong to several separately developed arts — visible elements, sounds, silences, odors, and action — in its sensational presentation. The spectators are participants in the created environment and, according to Mr. Kaprow, are exposed to a "total art".

Walker Art Center, 1710 Lyndale Avenue South, Minneapolis 3, Minnesota

NON-PROFIT ORGANIZATION
U. S. POSTAGE PAID
MINNEAPOLIS, MINN.
PERMIT NO. 3213

DSD

Director
Walker Art Center
Minneapolis, Minn.

Dear Sir:

During the week of February 7th to 12th, 1949,
John Cage and I plan to be in the vicinity of
Minneapolis.

It would be a pleasure to make an arrangement
with you to present a concert.

Please let me know if any of the enclosed
interests you. I shall be glad to forward fur-
ther information, publicity or sample programs.

? (

Very sincerely yours,

Merce Cunningham

nothing else
in letter

Merce Cunningham
12 East 17th St.
New York 3, N.Y.
October 12, 1948

TERMINAL IRON WORKS
DAVID SMITH BOLTON LANDING, N. Y.

5/20/52

Dear Harvey-

Here are my expenses. In the incidentals is $1
for a drink on the plane, strictly therapy
but that is the only extra.

Since the Hotel and expenses total over 200
probably why don't you divide the total in
half and pay me ½ expenses for a drawing
for Walker and the University, Then there will
be no expense, so called, and the 2
drawings can be called purchases. I'd rather
the record showed no travel expense but 2
drawing purchases. I want to give a drawing
to each Walker & the University but I don't
want particularly to make gifts - as the
record establishes a precedent, which I do
not want, for I don't give this with every
speech.

If this, due to your setup is impractical then
for 2 (already received) I give the choice of 2
drawings to Harvey Arnason who can then
do with them as he sees fit.

Set it up - so it doesn't show my gift.

Letter from David Smith to Walker Director H. Harvard Arnason, 1952

TERMINAL IRON WORKS
DAVID SMITH BOLTON LANDING, N. Y.

Harvey I liked and enjoyed my trip
to both your institutions. It was interesting
and I enjoyed all the social parties
you gave.

My shows here were well received but
sales were low. Both Life + Look are
writing articles but this stuff may never
come off, The writers & researchers like
my work but the editors consider it
not of public interest usually. They've
done it before - and never published it.

Working hard - little gardening too for exercise
new series of a unity on forms relating
to function of past machine (agriculture) form
into a Contemporary aesthetic. Probably have
8 pieces in this series.

Will you send me a photo of the Walker facade
I'd like to have it and think about it.

Shall I look for a job here.

Regards, and my thanks to
Mrs Arnason for her kindness
- David

COMMUNITY ART CENTER

The activities and staff will be controlled solely by The Minnesota Arts Council, a recently organized non-profit corporation. Anybody can become a member without charge. Minimum dues are $1 per year. Optional higher dues can be paid if desired. Membership involves no obligations.

The affairs of the Council are managed by a board of trustees. Various city officials are ex officio trustees. The Minneapolis Society of Fine Arts and the Walker Foundation can each appoint one trustee. However, a majority of the Board are selected by the members, so the control is truly democratic.

It is an experiment with infinite possibilities, for persons of all kinds and classes — rich and poor, conservative and liberal — not only to rub elbows in classrooms but also to serve together on the same board of management.

Those who have consented to be elective trustees until the first election by members in May, 1939, are:

John T. Baxter, Jr.
Mrs. John S. Bouman
Rev. Raymond B. Bragg
Arthur Brin
Mrs. Henry W. Cook
Dr. Donald J. Cowling
Elizabeth Dorsey
Lella Wichie Harding
Mrs. F. Peavey Heffelfinger
F. E. Heinemann
H. Lindley Hosford

Roy Jones
John M. Kuypers
Mrs. Ruth Lawrence
Addison Lewis
Benjamin E. Lippincott
Dr. Dwight E. Minnich
Elizabeth Quinlan
Carroll F. Reed
Mrs. H. Longstreet Taylor
Rolf Ueland
Frank W. Verrall
Elmer E. Young

WALKER FOUNDATION — Building and Maintenance / Permanent Art Collection

FEDERAL ART PROJECT — $55,000 or more per year

COMMUNITY — (Dues and Contributions to Minn. Arts Council) $5,500 required first year

ACTIVITIES PLAN

MINNESOTA ARTS COUNCIL MEMBERS

BOARD OF TRUSTEES

COMMITTEES

DIRECTOR AND STAFF

EXHIBITS — Permanent — Walker Collection / Monthly — Minnesota Artists / Travelling and Special Exhibits

FREE CLASSES, LECTURES, ETC. (Day and Evening)

COMMUNITY ACTIVITIES — Beautification of City / Social Work — Housing, Playgrounds, Etc. / Group and Club Meetings and Performances

EXTENSION WORK — Branch Galleries and Centers to be opened throughout State. / Lecturers and Exhibits to be lent to schools, etc.

FINE ARTS — Drawing and Prints / Painting / Sculpture

CRAFTS — Pottery / Weaving and Textiles / Wood and Metal Work / General Hobbies Direction

DESIGN — Interior Decorating / Costumes, Etc.

MISCELLANEOUS — Music / Drama / Dance / Photography / Creative Writing

ACTIVITIES

Free daytime and evening lectures, classes, workshops and performances, with emphasis on ACTUAL PARTICIPATION in arts and crafts BY EVERYBODY.

Dramatization of a world-famous art collection by grouping and presenting various parts from time to time so as to make them understandable, exciting.

Regular exhibits of work by our own living Minnesota artists and frequent travelling exhibits of work by artists known throughout the world.

ACTIVITIES

Meetings and programs of other organizations with related interests, whether such interests be art, literature, civic improvement or anything else for the enrichment of our lives.

Statewide extension activities through maintaining branch centers or galleries and lending exhibits and lecturers to schools and other institutions

This Minneapolis Journal photo illustrates another interesting activity possible at the Community Center,— photographic development and printing for amateurs.

This photograph is a scene from "Hans Brinker and the Silver Skates." Dramatic expression and the actual mounting and acting of plays by students, is one of the important activities planned for the Center. Photo from The Minneapolis Journal Library.

Minnesota Arts Council prospectus for the acquisition of the Walker Art Galleries and its redevelopment as a civic art center, 1939

City Gets Famous Blue Horses Hitler Rejected

Masterpiece by Franz Marc Purchased by Walker Gallery

Hey, Adolf—Minneapolis has those Blue Horses you didn't like.

Remember? "Blue Horses" by Franz Marc, which art critics now consider one of the masterpieces of Twentieth century painting.

You, Adolf, got that picture heaved out of Germany because you thought that little paper-hanging job you had in Vienna made you an art critic. But the real critics have got you pegged as an artist just like the Russians have got you pegged as a soldier.

Either way it spells BUM.

You didn't like "Blue Horses," the big massive oil, showing three champing horses in blue against a landscape of bright red hills. It was a little too modernistic for you (particularly because the horses are blue rather than white, brown or black) so you just labeled it "degenerate" and kicked it out of the Reich.

But now the critics are call-

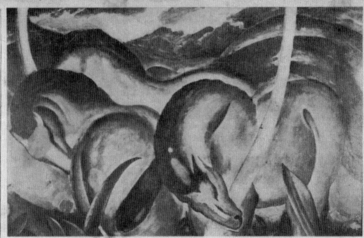

IT'S A MASTERPIECE, BUT HITLER WOUDN'T KNOW IT.

ing Franz Marc the Matisse of Germany and Alfred Barr, director of the Museum of Modern Art, says Marc was the most brilliant of twentieth century German painters.

Marc's famous painting hangs today in Walker Art Center, the latest acquisition of the Minneapolis gallery purchased through the Gilbert M. Walker Memorial fund. The picture is the first example of modern art to be presented in the gallery's collections. Officers say it marks another step toward carrying out the policy of developing a comprehensive collection for educational purposes, while at the same time maintaining a high artistic standard.

So Hitler's boner becomes Minneapolis' gain.

Times — Thurs, March 26 — 1942

Article from the *Minneapolis Times* on the Walker's purchase of Franz Marc's *Die grossen blauen Pferde* (*The Large Blue Horses*) (1911), March 26, 1942

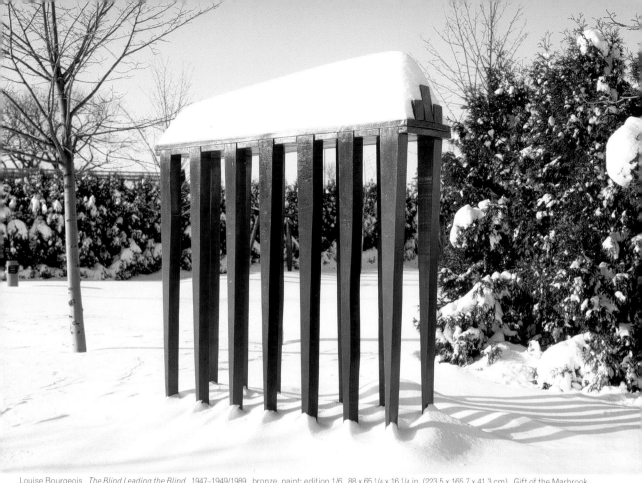

Louise Bourgeois *The Blind Leading the Blind* 1947–1949/1989 bronze, paint; edition 1/6 88 x 65 1/4 x 16 1/4 in. (223.5 x 165.7 x 41.3 cm) Gift of the Marbrook Foundation, Marney and Conley Brooks, Virginia and Edward Brooks, Jr., Markell Brooks, and Carol and Conley Brooks, Jr., 1989 1989.69

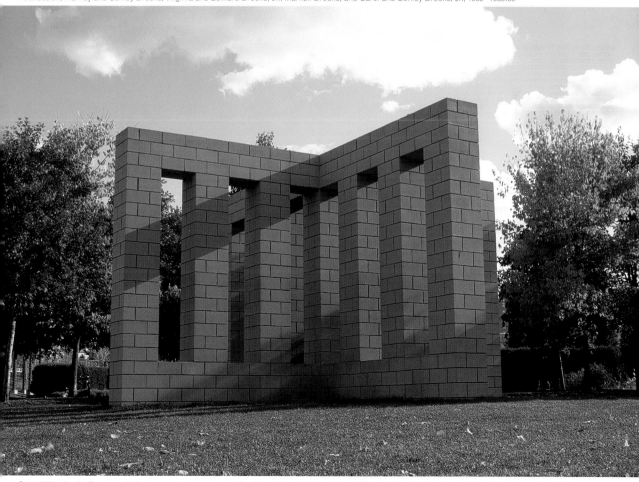

Sol LeWitt *X with Columns* 1996 cinder block, concrete 168 x 312 x 312 in. (426.7 x 792.5 x 792.5 cm) Partial gift of the artist with funds provided by the Judy and Kenneth Dayton Garden Fund; materials provided by Anchor Block Company, 1996 1996.135

Liz Lerman Dance Exchange performs in Nari Ward's installation *Rites-of-Way*, 2000

Fifteenth-anniversary celebration of the Minneapolis Sculpture Garden, 2003

Walker in the Rough mini golf, 2004

2000
Artist-in-residence Nari Ward's commissioned *Rites-of-Way* (2000) is installed on the sculpture plaza

2001
Artist-in-residence Liz Lerman Dance Exchange performs the commissioned work *Hallelujah/Minneapolis: In Praise of Beauty and Disorder*

2002
Grow or Die (2002), a commissioned work by artist-in-residence Sarah Sze, is installed beneath the floor of the Cowles Conservatory

Sam Durant's *Direction through Indirection (Bronze Version)* is unveiled in the Garden, 2003

2003
Rock the Garden, featuring Wilco, draws some 7,000 people; 8,000 more celebrate the Garden's fifteenth anniversary the following day

Sam Durant's *Direction through Indirection (Bronze Version)* (2003), completed as part of his artist residency, is installed

2004
Walker without Walls, a yearlong series of citywide events held during the Walker's closure for expansion construction, premieres in the Garden

The Garden's artist-designed mini-golf course draws more than 27,000 players during its three-month run

Led by artists-in-residence Ragamala Music and Dance Theater, some fifty-five performers from the Twin Cities and around the world perform the commissioned work *Sethu* (*Bridge*) (2004)

2005
Sky Pesher (2005), a commissioned *Skyspace* by James Turrell, is installed in the Garden's extension adjacent to the new building

Sarah Sze installs *Grow or Die* in the Cowles Conservatory near Frank Gehry's *Standing Glass Fish* (1986), 2002

Ragamala Music and Dance Theater in *Sethu* (*Bridge*), 2004

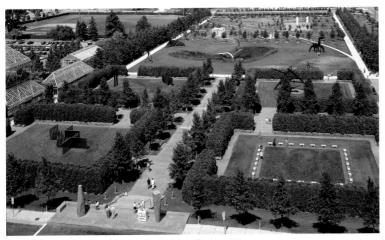

Aerial view of the expanded Minneapolis Sculpture Garden, 1996

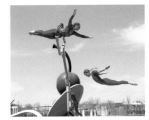

Elizabeth Streb/Ringside in *Fly*, 1997

1992
A 3.5-acre expansion designed by Michael Van Valkenburgh Associates, Inc., which includes the Alene Grossman Memorial Arbor and Flower Garden, opens

At 11.2 acres, the Garden is now one of the largest urban sculpture parks in the United States

The 53-by-110-foot granite sculpture plaza is unveiled with an exhibition of works by Magdalena Abakanowicz

The Alene Grossman Memorial Arbor and Flower Garden, 1992

1994
The exhibition *The Garden in the Galleries* opens, highlighting indoor pieces in the Walker's collection by Garden artists

Choreographer and artist-in-residence Chuck Davis' large-scale commissioned dance work *Babu's Magic* is performed in the Garden

Mark Luyten curates a series of films screened as part of his two-year artist-in-residence project

1995
The exhibition *Joel Shapiro: Outdoors* opens on the sculpture plaza

1996
Two-way Mirror Punched Steel Hedge Labyrinth (1994–1996), a commissioned sculpture by Dan Graham, is installed

1997
Mario Merz's *Untitled* (1996–1997), a commissioned neon sculpture forming the Italian words *città irreale* (unreal city), is installed on the roof of the Cowles Conservatory

The Garden has hosted more than 3 million visitors since its opening

Artist-in-residence Elizabeth Streb/Ringside performs *Bounce*, *Surface*, and the commissioned works *Across* and *Fly*

1998
More than 10,000 visitors celebrate the tenth anniversary of the Minneapolis Sculpture Garden

Atelier van Lieshout's *The Good, the Bad, and the Ugly* (1997), a commissioned two-part sculpture consisting of a mobile art lab and a wooden house, is unveiled

The Walker launches a 360-degree virtual Garden tour designed by Marek Walczak for its online Gallery 9

The Jayhawks and the Hot Head Swing Band perform for an audience of more than 4,000 people at the Walker's first annual Rock the Garden outdoor concert

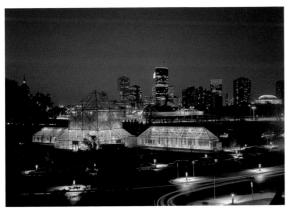

The Cowles Conservatory at night, circa 1990

Installation view of Atelier van Lieshout's *The Good, the Bad, and the Ugly*, 1998

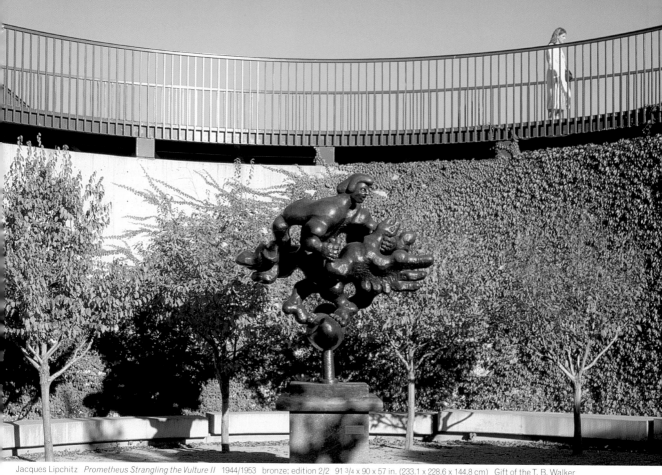

Jacques Lipchitz *Prometheus Strangling the Vulture II* 1944/1953 bronze; edition 2/2 91 3/4 x 90 x 57 in. (233.1 x 228.6 x 144.8 cm) Gift of the T. B. Walker Foundation, 1956 1956.17

Kinji Akagawa *Garden Seating, Reading, Thinking* 1987 granite, basalt, cedar 45 x 144 1/2 x 40 in. (114.3 x 367 x 102 cm) In memory of Elizabeth Decker Velie, 1988 1988.370

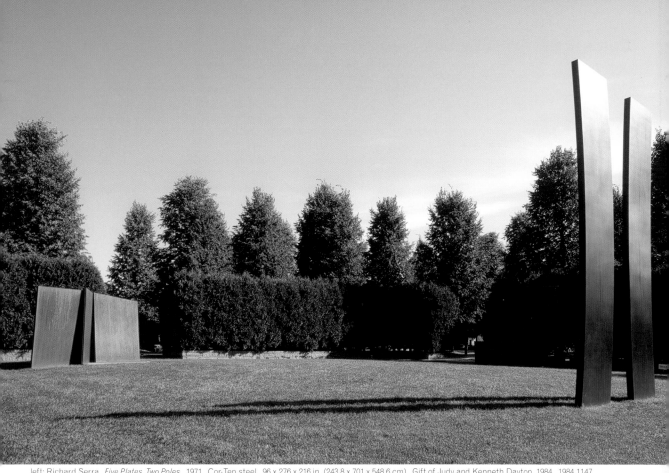

left: Richard Serra *Five Plates, Two Poles* 1971 Cor-Ten steel 96 x 276 x 216 in. (243.8 x 701 x 548.6 cm) Gift of Judy and Kenneth Dayton, 1984 1984.1147
right: Ellsworth Kelly *Double Curve* 1988 bronze 216 x 40 x 4 1/2 in. (548.6 x 102 x 11.4 cm) each Gift of Judy and Kenneth Dayton, 1988 1988.380 © Ellsworth Kelly

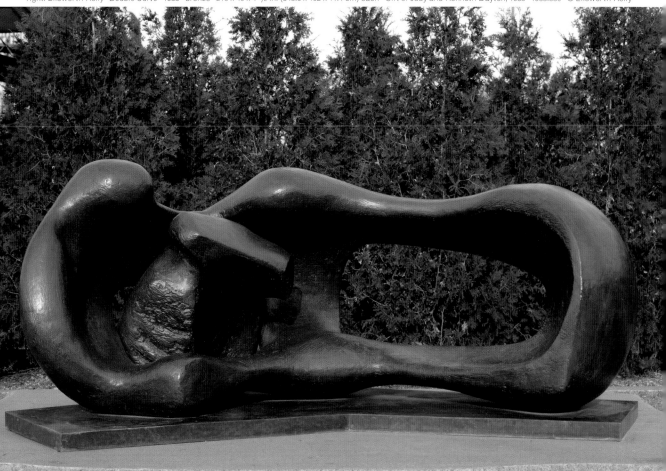

Henry Moore *Reclining Mother and Child* 1960–1961 bronze; edition 3/7 90 x 35 1/2 x 52 in. (228.6 x 90.2 x 132.1 cm) Gift of the T. B. Walker Foundation, 1963 1963.11

Notes to the Artist Entries

The following entries provide information on some of the artists whose work has been collected or commissioned by the Walker Art Center. This selection is only a sampling, and the present volume should be considered a companion to *Walker Art Center: Painting and Sculpture from the Collection*, Martin Friedman, ed. (Minneapolis: Walker Art Center; New York: Rizzoli International Publications, 1990), which contains information on additional artists and objects. Supplementary materials, images, and updated holdings are online at http://collections. walkerart.org.

Entries are arranged in alphabetical order by the artist's surname, ensemble name, or project title. Each includes data on that artist or group's involvement at the Walker: commissions, performances, screenings, exhibitions, residencies, and collection holdings. This information is current through January 2005.

Commissions These are most often formal requests for an artist to produce a new work to be exhibited or presented by the Walker. All commissions are listed by title (if applicable) and date of completion or debut performance. Net art commissions include a URL, if still active.

Performances and Screenings These categories document selected presentations of an artist's, filmmaker's, or group's work by the Walker and include programs held at the institution as well as those initiated by the Walker and presented at off-site venues. The date given reflects the year an event was presented by the Walker.

Exhibitions This section lists selected exhibitions presented at the Walker in which work by the artist was included. It is limited to major group and solo shows organized or co-organized by the Walker between 1940 and 2005, as well as solo exhibitions organized by other institutions that traveled to the Walker. It does not include exhibitions drawn primarily from the permanent collection, unless they traveled. Dates given reflect the year an exhibition opened at the Walker. If the show had a related publication or tour, this is noted. The Online Exhibitions category includes Walker-organized shows programmed for and accessible via the Internet.

Residencies This is a broad category that includes artists or groups who have spent an extended period of time at the Walker creating or developing new works as well as those who have participated in a more formal residency involving community workshops or projects. Residencies usually have a related commission, performance, screening, or exhibition. Dates given reflect the period during which the project occurred, but do not indicate an artist's continued presence at the Walker during that period.

Holdings The total number of works in the Walker's collections by each featured artist is listed by category. Included are objects in the Visual Arts Permanent Collection, the Library Collection of artists' books, the Study Collection, the Edmond R. Ruben Film and Video Study Collection, and the Digital Arts Study Collection. Works listed as "video" may be videotapes of various formats, videodiscs, or DVDs. Those listed as "multimedia" have components in more than one medium. "Unique works on paper" refers primarily to collages or paintings on paper. "Preparatory materials" includes working drawings, models, and source materials related to objects in the collection. Specific information about the holdings can be obtained by contacting the Walker's Registration Department.

Authors Entries and essays by guest authors (including Walker alumni) are identified with full names. Entries by Walker staff members are designated by initials only. A short biography of each author, along with a key to the initials, appears on pages 594–597.

Illustrations Unless otherwise noted, all illustrated objects are part of the Walker's collections, and images from films, videos, DVDs, laser discs, Web sites, net artworks, and works with moving-image components are frame enlargements or stills.

Illustration captions are drawn from data in the Walker's records. For dimensions, height precedes width precedes depth in inches and centimeters, rounded to the nearest tenth. Unless otherwise noted, measurements describe unframed objects. Some works include multiple components; this is not always reflected in the caption.

0100101110101101.org

Formed 1998

-- **Commissions**
life_sharing (http://gallery9.walkerart.org/lifesharing) (2001)
-- **Holdings**
1 net artwork

0100101110101101.org is the name of a "band of media artists"[1] that coalesces around particular projects. Since much of its work is aimed at questioning, if not dismantling, conventional notions of public and private, it actively avoids identifying its members by name. The designation 0100101110101101.org itself has no specific meaning except for the general connotations of digital data (zeros and ones) and networks (.org), and its most important attribute seems to be that it is impossible to remember although instantly recognizable.

In 1998, 0100101110101101.org began to invent the life and works of Darko Maver, an imaginary Serbian artist, which culminated in the presentation of a documentary about his work in 1999 at the 48th Venice Biennale.[2] The group also made a copy of the Vatican's official Web site—with small but significant alterations—at vaticano.org. In 1999, it cloned the password-protected net-art site Hell.com and made it available free of charge on its own site. It also made clones of Olia Lialina's net-art gallery Art.Teleportacia and the site of the net-artists' group Jodi. Each of these actions was designed to complicate the commonplace rhetoric about the role of networks in democratizing information and the ways that net art undermines art-world conventions of ownership and authenticity.

In 2001, the Walker Art Center commissioned *life_sharing* for its online Gallery 9 from two members of the group. "Life sharing" is an anagram of "file sharing," a protocol that allows remote computers to share files across a network. For *life_sharing*, the artists made the entire contents of their computer—from the operating system to the software to all of their personal files, including e-mail—accessible in real time to anyone on the Internet. For them, this was akin to sharing their lives: "Whoever works with a computer on a daily basis, at least for a few years, will soon realize that his own computer resembles more and more its owner. You share everything with your computer: your time (often even for thirteen hours a day), your space (desktop), your culture (bookmarks), your personal relationships (e-mails), your memories (photo archives), your ideas, your projects. A computer, with the passing of time, ends up looking like its owner's brain. . . . If you accept the assumption of a computer being the thing that gets closer to your brain, you will also assume that sharing your own computer entails more than sharing a desktop or a book, something we might call life_sharing."[3]

In essence, with *life_sharing*, 0100101110101101.org made clear its commitment to the ideas underpinning its earlier plagiarism work by making the "lives" of its members open source, so to speak—freely available for anyone else not only to view, but to copy and manipulate at will. However, *life_sharing* is not about the contents per se of 0100101110101101.org's hard drive

or simply a way to facilitate the public voyeurism of the private. It is about transparency as a principle, akin to "form follows function." The work becomes a performance of the everyday.

Steve Dietz

Notes
1. Quoted in the introduction to the artist's Web site, http://www.0100101110101101.org.
2. See http://www.0100101110101101.org/home/darko_maver/index.html.
3. Quoted in "File Sharing" proposal for *life_sharing*, http://gallery9.walkerart.org/lifesharing/.

0100101110101101.org Selections from *life_sharing* 2001 digital media
Digital Arts Study Collection

Berenice Abbott
American, 1898–1991

‑ ‑ **Holdings**
178 photographs

As an expatriate New Yorker living in Paris in the 1920s, Berenice Abbott came to prominence as a portrait photographer after having been the studio and dark-room assistant of Surrealist artist Man Ray for almost three years. Her reputation for producing psychologically probing images preceded her, and artists, writers, socialites, and other members of her bohemian social circle, such as Sylvia Beach, André Gide, James Joyce, and Peggy Guggenheim, came to her unsolicited.

After a brief return visit to New York City in early 1929, Abbott was struck by its energy as well as the broad technological and societal changes that had occurred there during the eight years she had been away. She could not deny the hold this place had on her, and decided to return to her homeland to embark on the monumental project of documenting the streets, bridges, brownstones, storefronts, and sky-scrapers of New York and several of its boroughs in order to capture the city as it was radically transform-ing into a modern metropolis. Abbott had worked steadily on the series for six years when the Federal Art Project of the Works Progress Administration offered her funding in 1935. Published in book form in 1939, the portfolio *Changing New York* is one of the most celebrated documentations of the urban experi-ence in the history of American photography.

A little-known chapter in Abbott's biography has become part of Walker Art Center history. In 1943, prominent New York gallerist and arts patron Hudson D. Walker approached the artist about the possibility of documenting the operations of his family's lumber business. Thomas Barlow Walker, his grandfather and founder of the Walker, was a lumber baron whose Red River Lumber Company (RRLC) operated mills in Crookston, Minnesota; Grand Forks in the Dakota Territory; and Westwood, California.[1] Hudson had fol-lowed Abbott's career closely since including her in his first photography show in 1938. Fully aware of her doc-umentary prowess, he wrote the following to an execu-tive of the mill in Westwood in order to persuade the company to consider a commission: "I consider her one of the dozen top-flight photographers in the country, and believe that she would be able to dig up a lot of unusual material which would be of real advertising value to us."[2]

Abbott accepted Walker's subsequent offer to spend two weeks at the lumber camp for a fee of $1,000 plus supplies and traveling expenses.[3] Accustomed to studio photography or shooting outdoors in relatively static urban environments, she was forced to acclimate quickly to working more spontaneously with a hand-held Rolleiflex camera in wind-swept, heavily forested areas and in factory settings where people and machinery were in constant motion. However, the style and content of these photographs are signature Abbott—towering Ponderosa pines take the place of the skyscrapers that had awed her more than a decade earlier. As with *Changing New York*, Abbott docu-mented for perpetuity a fleeting moment of history with her images of America's workforce at the height of World War II, when women and the elderly took over jobs once held by legions of young men who had been drafted into the armed services.

Back in her New York studio, Abbott selected fifty-four of the strongest photographs from her three hundred negatives. Although these pictures were intended to and did serve the purposes of the RRLC, Walker was quick to realize the appeal they might have to a larger art audience, and subsequently organized a touring exhibition entitled *Logging and Lumbering in the Pine Forests of California*. Abbott printed several exhibition copies of her photographs for the 1944 tour that traveled to two San Francisco–area museums.[4] After the show closed, the artist filed away her set of prints and negatives in her darkroom, and Walker inex-plicably stored his under a couch in his home.[5] Upon his death in 1976, the discovery of the forgotten prints revived interest in this body of work, resulting in a 1979 exhibition at the Hudson D. Walker Gallery of the Fine Arts Work Center in Provincetown, Massachusetts.

E.C.

Notes

1. "T. B. Walker and Family: An Inventory of Their Papers at the Minnesota Historical Society, Biographies of the Walker Family, and Histories of Walker Businesses," manuscript, Minnesota Historical Society, St. Paul, Finding Aid/Manuscript Collections. Thomas Barlow Walker began exploring the California forests in 1889 and acquiring properties in the northeastern California timberlands in 1894. Concurrent with the construction of Westwood, its company town, he retired, leaving the mills in the hands of his sons, including Archie D. Walker, Hudson's father. Archie was the Minneapolis-based secretary of RRLC from 1908 to 1933, when he replaced his brother Willis as company president, serving in this capacity until at least 1956, when RRLC was sold and its assets were liquidated.
2. Hudson D. Walker, correspondence with Lee Opsahl, June 1, 1943 (Hudson D. Walker papers, Archives of American Art).
3. Hudson D. Walker, correspondence with Lee Opsahl, June 25, 1943 (Hudson D. Walker papers, Archives of American Art). Due to the ra-tioning of flashbulbs and film during World War II, Walker had to pull strings through the Eastman Company to provide Abbott with the sup-plies she needed.
4. The tour originated at the M. H. de Young Memorial Museum, San Francisco (February 22–March 20, 1944), and traveled to Mills College Art Gallery, Sausalito, California (March 21–April 20, 1944).
5. Hank O'Neal, *Berenice Abbott: The Red River Photographs*, exh. cat. (Provincetown, Massachusetts: Fine Arts Work Center, 1979), 12.

Berenice Abbott *Plywood Grader* from *The Red River Photographs* 1943 gelatin silver print mounted on board 14 x 19 3/8 in. (35.56 x 49.21 cm)
Gift of Louise McCannel, 1994 1994.41

Berenice Abbott *Fallers—Starting the Undercut* from *The Red River Photographs* 1943 gelatin silver print mounted on board 18 x 15 1/2 in. (45.7 x 39.4 cm) Gift of Louise McCannel, 1994 1994.18

Berenice Abbott *Jammer Swamper* from *The Red River Photographs* 1943 gelatin silver print mounted on board 18 x 15 1/4 in. (45.7 x 38.7 cm) Gift of Louise McCannel, 1994 1994.26

Vito Acconci

American, b. 1940

-- **Exhibitions**

Artist and Printer: Six American Print Studios (1980; catalogue, tour), *First Impressions: Early Prints by Forty-six Contemporary Artists* (1989; catalogue, tour), *The Last Picture Show: Artists Using Photography, 1960–1982* (2003; catalogue, tour), *The Squared Circle: Boxing in Contemporary Art* (2003; publication)

-- **Holdings**

14 videos, 1 edition print/proof, 2 print portfolios, 3 books

Vito Acconci *Theme Song* 1973 videotape (black and white, sound); unlimited edition 33:15 minutes T. B. Walker Acquisition Fund, 1999 1999.62

äda'web

Vivian Selbo, American, b. 1958; Benjamin Weil,
French, b. 1962

– – **Holdings**
1 net artwork

Notes
1. Vivian Selbo, "'ah, 'da process' . . . questions? some answers . . .,"
September 1998, http://gallery9.walkerart.org/bookmark.html?id=148
&type=text&bookmark=1.
2. Benjamin Weil, "Untitled (ÄDA'WEB): A Brief History of äda'web,"
1998, http://gallery9.walkerart.org/bookmark.html?id=140&type=text&
bookmark=1.

In the source code of äda'web (1994–1998), the pioneer-
ing Web site of online art curated by Benjamin Weil and
designed by Vivian Selbo, the following apt self-descrip-
tion is embedded: "A research and development plat-
form, a digital foundry, and a journey. Here artists are
invited to experiment with and reflect upon the web as
a medium."[1]

Through the happenstance of early Internet mania,
äda'web was founded in 1994 as part of a commercial
enterprise, but by 1998 its corporate parents were
unwilling to support its cutting-edge approach, and the
mothballed site was donated to the Walker Art Center
for preservation and ongoing access. Nevertheless,
during that period, the staff of äda'web collaborated on
more than twenty groundbreaking Web-specific proj-
ects, including commissioned work by Doug Aitken
(*Loaded 5x*, 1997), Jenny Holzer (*Please Change Beliefs*,
1995), Matthew Ritchie (*The Hard Way*, 1996), Julia
Scher (*Securityland*, 1995), and Lawrence Weiner
(*Homeport*, 1996), all of whom have other work in the
Walker's collections.

äda'web was a harbinger of a new kind of online
art "space," launching just as the first commercial
World Wide Web browser was released and sparking
a decade of unparalleled experimentation on and with
the Internet. It was unique at the time in its approach
to curating and commissioning work, in a brand new
medium, from established artists. As Weil writes: "Not
unlike printmaking studios or foundries, where artists
confront their projects with the technical expertise
of a producer or group of producers, äda'web was set
to offer artists the possibility of addressing the new
medium without necessarily having any specific notion
of computing."[2]

The projects äda'web accomplished in collabora-
tion with various artists are significant and stand
alone, but the site was also an international community
platform for the critical contextualization of a burgeon-
ing digital culture. Among its contributions in this
arena was a series of forums on art and technology
in the 1990s, which it cosponsored with the Museum
of Modern Art, New York.

Its most significant accomplishment, however, is the
dynamic and playful interface that knits together the
various components of the site in a profoundly experi-
ential navigation that has seldom been achieved since.
It is perhaps best compared to the daring architecture
of Richard Rogers and Renzo Piano's Centre Pompidou
in Paris, which makes the visit itself as worthwhile as
the art displayed within and energizes the surrounding
urban fabric, just as äda'web catalyzed the online art
world with its sophisticated understanding of both art
and the Internet.

Steve Dietz

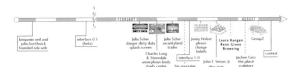

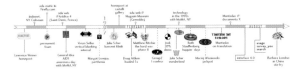

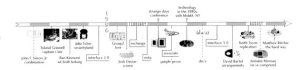

Selection from äda'web (http://gallery9.walkerart.org/adaweb/)
1994–1998 digital media Digital Arts Study Collection

Doug Aitken
American, b. 1968

- - **Exhibitions**
Unfinished History (1998; catalogue, tour), *Let's Entertain* (2000; catalogue, tour), *American Tableaux* (2001; publication, tour)
- - **Holdings**
2 photographs, 1 video, 1 book

One could say that Doug Aitken is a child of the age of entropy. Born in 1968, he is part of a generation that has come of age in a world defined by the viral sprawl of suburban housing developments across the landscape and a parallel intensification of the information overload offered through the media. Working primarily in film and video, Aitken has taken a cartographic trajectory with his projects over the last few years, negotiating a path between the topography of the landscape and the electronic flows of the media. What becomes apparent when viewing the entirety of his filmic output is that the glacial power of entropy—the slow leakage of energy—lies at the heart of much of his work.

This can be seen most clearly in *Diamond Sea* (1997), which premiered simultaneously as a single-channel video in the 1997 Biennial Exhibition at the Whitney Museum of American Art in New York and as a multi-channel video installation at New York's 303 Gallery. The work is the result of the artist's obsession with an area on the map of Namibia the size of California that bore the designation "Diamond Areas 1 and 2." These highly profitable desert mining regions have been closed to the outside world since 1908, creating a hermetically sealed time capsule of sorts, unexposed to the gaze of ninety years of media culture. Fascinated by the kind of light he might find there, Aitken spent a year sorting through bureaucratic red tape before obtaining access to this part of Namibia. The result of about a month traveling around the area, his film documents a bizarrely alien territory populated by a wide array of exotic and highly sophisticated mining technology, shifting sand, and wild Portuguese horses—descendants of the equine survivors of a shipwreck.

As the artist himself has suggested, this was his *Fitzcarraldo* (Werner Herzog's maniacally heroic 1982 film about hauling a riverboat over a small mountain). Like Herzog, Aitken was driven to this place by a blind faith. Once he arrived, he found an enormous negative space that had nothing tangible around which he could form a narrative. His camera nonetheless found its way to a series of highly automated, computer-controlled mining machines, abandoned corporate dormitories, surveillance helicopters, and the desert itself. These he brought together with both live sound recorded on location as well as the music of electronica and noise producers such as Aphex Twin, Gastr del Sol, and Oval. Providing a visual equivalent to the tradition of ambient music, Aitken takes a region completely cut off from the outside world and gives it the status of a subject. Quoting Vladimir Nabokov, artist Robert Smithson once suggested that "the future is but the obsolete in reverse."[1] *Diamond Sea* shows us this mechanism at work by poetically documenting the dissipation of architectonic structures into their surroundings, depicting the future as a landscape littered with the detritus of entropic catastrophes.

D.F.

Notes
1. Robert Smithson, "Entropy and the New Monuments," in Jack Flam, ed., *Robert Smithson: The Collected Writings* (Berkeley: University of California Press, 1996). Originally published in *Artforum* 5, no. 10 (June 1966): 26–31.

Doug Aitken *Diamond Sea* 1997 videotape (color, sound) 20 minutes
Justin Smith Purchase Fund, 1997 1997.75

Chantal Akerman

Belgian, b. 1950

- - **Commissions**
Bordering on Fiction: Chantal Akerman's "D'Est" (1993/1995)
- - **Exhibitions**
Bordering on Fiction: Chantal Akerman's "D'Est" (1995;
catalogue, tour)
- - **Holdings**
1 multimedia work

Through minimal, hyperrealist films that examine the movement, structure, and pace of everyday activities, Chantal Akerman has secured a place as one of the most acclaimed directors working today. Her films encompass both the long passages of stasis and repetition and the moments of explosive movement that make up daily life. Her early masterpiece, *Jeanne Dielman, 23 quai du Commerce, 1080 Bruxelles* (1975), is a look at three days in the life of an obsessive-compulsive Belgian housewife. Akerman called it "a film about space and time . . . and about how you organize your life in order to have no free time at all so that you don't let anxiety and the feeling of death come in to submerge you."[1] The 210-minute film includes segments of real-time representation, such as the cooking and eating of every meal during the three-day period— a device that gives viewers a visceral understanding of the routinized nature of domestic tasks.

In *Jeanne Dielman*, repetition feels hyperobsessive and manic; in the quasi-documentary *D'Est* (*From the East*), completed in 1993, Akerman explores its other face—stasis and inertia. She shot the film in Germany, Poland, and Russia, countries in the throes of massive social change during the early 1990s after the fall of communist regimes. Akerman has written, "While there's still time, I would like to make a grand journey across Eastern Europe . . . [I'd like to film] countries that shared a common history since the war and are still deeply marked by this history, even in the very contours of the earth. Countries now embarking on different paths."[2] The explosive upheaval of political change translates, in her film, to immobility—empty shops, canceled trains, and endless lines. The citizens of Akerman's eastern Europe make resigned, slow progress toward what they know to be unattainable. Trouble is impending, but perhaps it never comes. Still, they wait, because it's all they can do.

Bordering on Fiction, Akerman's first multimedia installation, is a deconstruction of *D'Est* into three components in three spaces.[3] One enters a cinemalike room in which the entire film is being screened continuously; next, one encounters a large gallery containing eight triptychs of video monitors on pedestals, each showing a four-minute looped excerpt. The final space is an intimate chamber with one monitor that presents a single image from the film. As the picture gradually fades to black, Akerman recites two texts—a passage in Hebrew from Exodus and a selection from her own writing on *D'Est*. The viewer's journey is a reverse tour of the artist's working process—from the completed work to its individual shots or segments and ending with

language itself, which is where Akerman always begins a film. The installation repeats and clarifies the structures that underlie the film, and yet is more than an analysis. Walking through it, one takes a version of the grand journey through Europe that Akerman made in the course of her filming.

J.R.

Notes
1. Quoted in Kathy Halbreich and Bruce Jenkins, *Bordering on Fiction: Chantal Akerman's "D'Est,"* exh. cat. (Minneapolis: Walker Art Center, 1995), 69.
2. Ibid., 15–45.
3. *D'Est* has its origins in the invitation Akerman received in 1990 to make an installation about the coming together of the European community. The project initiators were Walker Director Kathy Halbreich, then curator at Boston's Museum of Fine Arts; independent curator Michael Tarantino; and Susan Dowling of WGBH Television. Akerman made *D'Est*, then used it as the basis of the installation *Bordering on Fiction*.

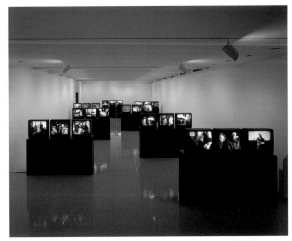

Chantal Akerman *Bordering on Fiction: Chantal Akerman's "D'Est"* 1993/1995 25-channel video installation, 16mm film (color, sound) installed dimensions variable Justin Smith Purchase Fund, 1995 1995.112
©Chantal Akerman and Lierac Productions

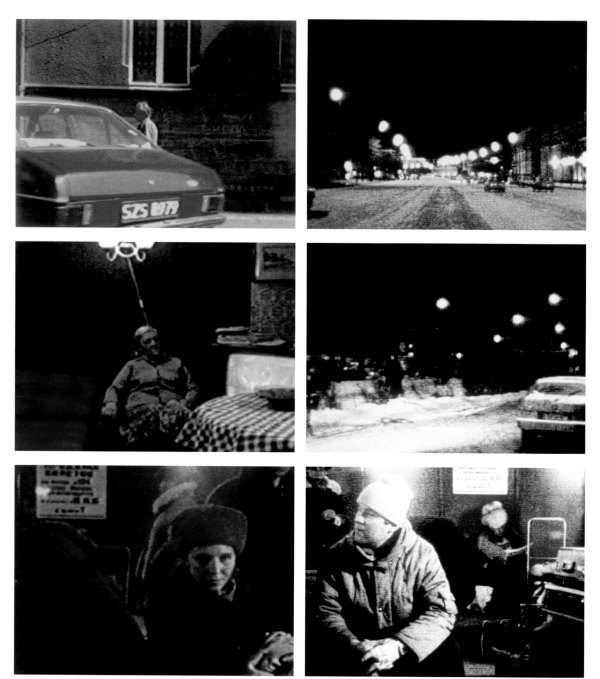

Chantal Akerman *Bordering on Fiction: Chantal Akerman's "D'Est"* 1993/1995 25-channel video installation, 16mm film (color, sound)
installed dimensions variable Justin Smith Purchase Fund, 1995 1995.112 ©Chantal Akerman and Lieurac Productions

Josef Albers
American, b. Germany, 1888–1976

-- Exhibitions
The Classic Tradition in Contemporary Art (1953; catalogue), *First
Annual Collectors Club Exhibition* (1957; catalogue), *Eighty Works
from the Richard Brown Baker Collection* (1961; catalogue), *Josef
Albers: Homage to the Square* (1966; organized by the Museum of
Modern Art, New York; catalogue)

-- Holdings
1 painting, 3 unique works on paper, 125 edition prints/proofs,
7 portfolios of prints, 1 book

Josef Albers *Homage to the Square: "Gentle Hour"* 1962 oil, acrylic
on board 48 1/8 x 48 1/8 in. (122.2 x 122.2 cm) Gift of the T. B. Walker
Foundation, 1967 1967.28

Francis Alÿs

Belgian, b. 1959

-- **Exhibitions**
Painting at the Edge of the World (2002; catalogue)
-- **Holdings**
1 drawing, 1 multimedia work, 1 video

In a deliberate contradiction of the conventional hypothesis that dominant centers determine the nature of artistic and cultural production in the so-called peripheries, Francis Alÿs relocated from Belgium to Mexico in the late 1980s. Trained as an architect, he has been elaborating on a body of work informed by two major influences: his personal encounters with religious and secular rituals that he confronts/provokes/performs on an everyday basis; and cultural sources such as political history, children's books, fairy tales, street culture, and urban legends. Embracing a variety of media, including painting, drawing, installation, film, and performance, his work is framed either by the urban context that surrounds him or by the mythical space of the artist's studio.

Alÿs' practice is conceived as a metaphysical reflection on the unbalanced politics of the world and the capacity of art and the artist to affect the narrative of history as a logical relation of "means" to "ends." He stages a subtle, perhaps absurd refusal of the cultural time and space that have defined a Western idea of modernity based on linear progress. He frees art from its cultural insularity. His work is animated by a manipulation of narrative structure in which there is never closure; it remains open-ended, liberated from climax, denouement, beginning, and end. Often allegorical, it is populated by characters who seem to have emerged from the self-centered isolation and elusive simplicity of a Samuel Beckett play, and in many cases are identified by the artist as his alter egos: the Liar, the Prophet, the Thief, the Collector, the Sleeper.

The Modernists (1998) is emblematic of Alÿs' paintings and drawings. Realized on vellum, it presents an isolated character enigmatically struggling with a "right angle," the icon of modernist architecture and Cartesian thinking. This meditation on modern times paradoxically borrows from a timeless aesthetic, somewhere between Giotto's Renaissance and René Magritte's Surrealism.

No less allegorical is *Cuando la fe mueve montañas (When Faith Moves Mountains)* (2002–2003), which grew out of Alÿs' participation in the 2002 Lima Biennale in Peru. A documentary in the form of an installation, the work is composed of a series of drawings, press clippings, photographs, and videos. It was initiated by Alÿs and his collaborators, art critic Cuauhtémoc Medina and filmmaker Rafael Ortega, who invited 500 volunteers equipped with shovels to form a "human comb" at the bottom of a sand dune on the outskirts of Lima in order to move the dune a few inches from its original location during the course of a single day.

While the title of the piece is a clear biblical reference ("Faith can move mountains," Mark 11:23), the event and its documentation call into question a specific social situation: the tension Alÿs experienced when visiting Peru for the first time in 2000, during the last months of Alberto Fujimori's dictatorial presidency. For decades, Lima has been gnawing at its surrounding landscape in order to accommodate waves of Indian and peasant migrants and manage the conversion to a megalopolis. By taking the mountain for a walk, Alÿs addresses the issues of immigration and urban development in Peru.

Flirting with the absurdity of a maximum effort leading to a minimum result, *Cuando la fe mueve montañas* relates to an idea, dear to Alÿs, that "from time to time, doing something leads to nothing; from time to time, doing nothing leads to something."[1] It nevertheless suggests the power of a community-based action, the participation of each individual along the lines of the slogan "one person, one vote." Moving a mountain is therefore an allegory for a democratic dream. On another level, the work displays the legacy of movements such as Land Art, for which nature provided an ideal field for an expanded idea of sculpture. In Alÿs' case, the field at stake would be the social one, echoing the notion of social sculpture elaborated in the 1970s by Joseph Beuys and providing a context for an event that hopefully will remain in collective memory as a local myth, a fable transmitted from generation to generation.

P.V.

Notes

1. Francis Alÿs in conversation with the author, Mexico City, March 2003.

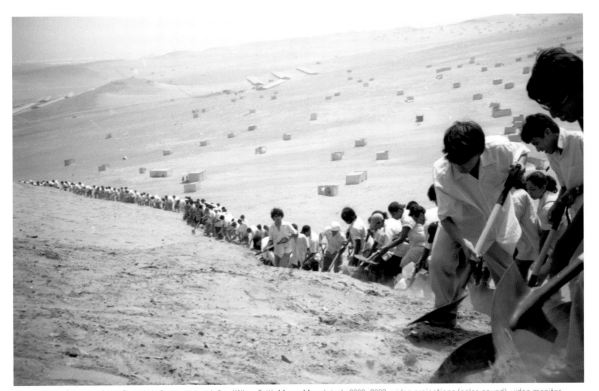

Francis Alÿs Selection from *Cuando la fe mueve montañas* (*When Faith Moves Mountains*) 2002–2003 video projections (color, sound), video monitor, acrylic, graphite, masking tape on vellum, black-and-white photographs, color photographs, offset lithograph on paper, photocopies on paper, shirt installed dimensions variable T. B. Walker Acquisition Fund, 2004 2004.48

Francis Alÿs *The Modernists* 1998 graphite, masking tape on vellum 30 x 30 in. (76.2 x 76.2 cm) Miriam and Erwin Kelen Acquisition Fund for Drawings, 2004 2004.2

Carl Andre

American, b. 1935

‑ ‑ **Exhibitions**
Artists' Books (1981)
‑ ‑ **Holdings**
2 sculptures, 5 drawings, 2 edition prints/proofs, 6 books,
1 periodical

In a conversation with artist Hollis Frampton in 1962, Carl Andre suggested that his need in terms of sculpture could be fulfilled by "three one-inch bright steel ball bearings," while his need in terms of literature could be satisfied by reading the New York telephone directory.[1] Such a statement sums up concisely the program of an artist who for more than forty years has conducted simultaneous sculptural and poetic careers. Even if poetry preceded sculpture, both practices share the same methodology. In both, Andre's attempt is to separate matter/materials from representation in order to reach the essentials or the smallest necessary denominator of art.

Ideographic and calligraphic, Andre's poems share a lineage that includes Stéphane Mallarmé's *A Throw of the Dice*, Guillaume Apollinaire's *It Rains*, Ezra Pound's *Cantos*, and the 1950s Brazilian movement of Concrete poetry by the group Noigrandes,[2] which extended its ramifications into music, architecture, and the aesthetically revolutionary international art movement of Neo-Concretism. In his poems, the structure is the content and vice versa. Generally typed on 8 1/2-by-11-inch sheets of paper, the poems combine particles of texts that exhaust the physical space of the page. Deliberately confounding what is to be seen and what is to be read, Andre explores the formal, plastic potential of the typewriter, drawing from the abstract aesthetic of the Russian Constructivists of the 1920s, for whom the form of art fundamentally derived from the medium (colors, sounds, words) and its construction. Andre's Concrete poems often are emblematic of such graphic experimentation in which impersonal materials and an industrial, if not bureaucratic or engineering, sensibility allow the principle of composition to be replaced by one of construction.

L A M E N T O N T H E I N D I A N W A R S 1 9 6 5 (1965) is organized differently as a column at the center of the page. It is literally a stacking of words, such as "white, land, red, heads, bone, blood," in which the plural s is often obliterated by red ink. The rough and rhythmic alternation of words and the weight of the red editorial marks provide, beyond any narrative structure, a visual and resonant equivalent of the brutality of the Indian wars in the American colonies. Written in 1965, the piece seems to echo an early series of poems that Andre wrote combining his fascination with the Indian war of King Philip (1675–1676) and the book *Indian History, Biography, and Genealogy* by E. W. Peirce.[3] The structure of these poems was built by the isolation of each word from the original Peirce text. About them, Andre declared, "History has given me a subject, history has not given me a method."[4] His method—consisting of combining words and

eliminating the voice of the poet, narrative, or anecdote to the benefit of the material—is also one he applies to sculpture by combining masses and eliminating the "hand" of the artist.

Since the late 1950s, Andre has contained his sculptural practice within three specific techniques: stacking, dispersing, and aligning. The range of materials he chooses is diverse: wood, stone, and metal. He dismisses alloys and refuses mixtures. The materials are systematically arranged as units measuring the available space and seen as its two-dimensional extension. Over the years, Andre's sculptural interest has shifted from a focus on the shapes and objects to the structure of space.

Aisle (1981), a geometric alignment of thirty-eight 1-by-1-by-3-foot wood timbers, is characteristic of Andre's use of interchangeable units of raw, uncut materials to both divide the space and provide its phenomenological measurement.[5] *Slope 2004* (1968) is an alignment of six thin, 36-square-inch, hot-rolled steel plates on the floor, running as a diagonal from the wall. It belongs to a body of Andre's sculpture that, under diverse geometrical arrangements, invites the audience to step, walk, and stand on the work. More than moving the experience of art from the visible to the tactile, such a work subverts the traditional understanding of what sculpture and its experience are. It echoes and anticipates radical practices that unfold a sociopolitical critique of institutional art by requiring the direct engagement of the audience; in this relationship, the work functions as a place, a public sphere rather than an object.

Carl Andre Selection from *L A M E N T O N T H E I N D I A N W A R S 1 9 6 5*
1965 carbon print, ink, colored pencil on paper 10 7/8 x 8 3/8 in. (27.6 x
21.3 cm) each of 9 Clinton and Della Walker Acquisition Fund, 2002 2002.1

An essential protagonist of Minimalism, Andre has succeeded in overcoming the literal reduction of a visual syntax to elementary geometrical forms by building—through his use of materials—a critical monument to the United States, its history, its literature, its nature, and its industry.

P.V.

Notes

1. "On Sculpture and Consecutive Matters, October 14, 1962," in *Carl Andre/Hollis Frampton: 12 Dialogues 1962–1963*, Benjamin H. D. Buchloh, ed., (Halifax: Press of the Nova Scotia College of Art and Design; New York: New York University Press, 1980), 13.

2. The group Noigrandes was founded in 1952 by three poets from São Paulo, Brazil: Haroldo de Campos, Augusto de Campos, and Decio Pignatari. Noigrandes and Concrete poetry were seminal to the birth of the Neo-Concretism movement that included such artists as Hélio Oiticica and Lygia Clark and led to an aesthetic revolution across the disciplines.

3. Ebenezer Weaver Peirce, a Federalist soldier, devoted his attention after the war to local (Massachusetts) biographical and historical writing under the title *Indian History, Biography, and Genealogy*, published in 1878.

4. "On Certain Poems and Consecutive Matters, March 3, 1963" in *Carl Andre/Hollis Frampton*, 77.

5. The interchangeable and serial nature of the work suggests Constantin Brancusi's *Endless Column* (1938), except that Andre brings the traditional phallic verticality of that sculpture down to the endless horizontality of railroad tracks.

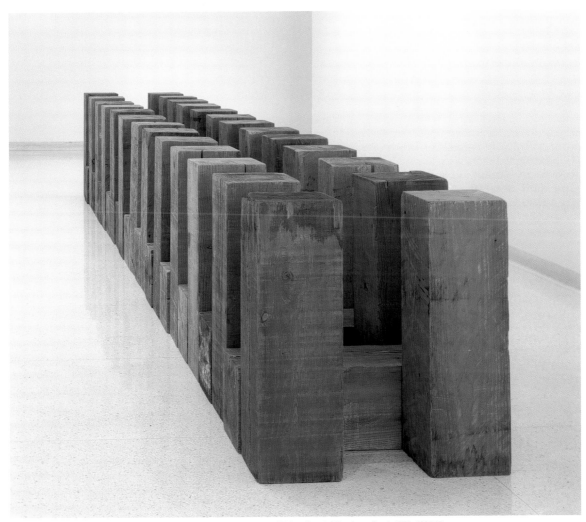

Carl Andre *Aisle* 1981 redwood 36 x 300 x 36 in. (91.4 x 762 x 91.4 cm) Walker Special Purchase Fund, 1987 1987.17

Giovanni Anselmo

Italian, b. 1934

- - **Exhibitions**
Artists' Books (1981), *Zero to Infinity: Arte Povera 1962–1972* (2001;
catalogue, tour), *The Last Picture Show: Artists Using Photography,
1960–1982* (2003; catalogue, tour)
- - **Holdings**
1 sculpture, 3 books

Giovanni Anselmo *Direzione* (*Direction*) 1967–1970 schist, magnetic
compass, glass 6 1/4 x 70 1/4 x 27 1/2 in. (15.9 x 178.4 x 69.9 cm) The
Frederick R. Weisman Collection of Art and the T. B. Walker Acquisition
Fund, 1996 1996.130

Over the past forty years, Giovanni Anselmo has
produced a body of sculptural work that has bridged
the gap between poetics and physics. Emerging in
the 1960s with a group of Italian artists gathered by
curator Germano Celant under the heading Arte
Povera, Anselmo became fascinated with the sculp-
tural possibilities of invisible energies, such as magne-
tism and gravity, that pervade our natural environment.
Like many other artists associated with Arte Povera,
including Mario Merz and Alighiero Boetti, Anselmo
embarked on a search for a new vocabulary of three-
dimensional form. His investigations led him toward
a wide range of nontraditional sculptural materials,
such as granite, iron, cotton, vegetable matter, and
light, which gave him the freedom to explore the all-
pervasive character of the unseen forces of nature,
because ". . . energy exists beneath the most varied of
appearances and situations."[1]

Much of his work can be described in the sense of
what American art historian Rosalind Krauss has
termed "sculpture in the expanded field." In Anselmo's
case, this expanded sculptural field extends beyond
the actual materials of the artwork itself into the world
around us. This can be seen clearly in his 1967–1970
sculpture *Direzione* (*Direction*), which makes manifest
his preoccupation with the universal laws of physics.
The work consists of a slab of schist (a metamorphic
rock formed by high temperatures and intense pres-
sure) that has been cut into a triangle resembling the
shape of an arrowhead. In its surface the artist has
embedded a compass so that the sculpture can be
oriented with its apex pointing toward true north.
By channeling the natural physical forces of the cos-
mos, *Direzione* offers a path beyond the traditional con-
straints of sculpture and the space of the gallery, and
in so doing directs the viewer to move into the infinite
expanse of the universe that surrounds us. As Anselmo
says, "The work continues beyond the bounds of space,
because the [*sic*] magnetism is the cause of orientation
in the macrophysical world."[2] In his hands then, sculp-
ture constitutes a nodal point in a matrix of infinite
physical forces that permeate the world we inhabit.

D.F.

Notes
1. Giovanni Anselmo, "I, the World, Things, Life," in Germano Celant,
Arte Povera (New York: Praeger, 1969), 109. Reprinted in Richard Flood
and Frances Morris, *Zero to Infinity: Arte Povera 1962–1972*, exh. cat.
(Minneapolis: Walker Art Center, 2001), 178.
2. Artist's statement, June 30, 1997 (Walker Art Center Archives).

Alexander Archipenko

American, b. Ukraine, 1887–1964

- - **Exhibitions**

The Classic Tradition in Contemporary Art (1953; catalogue),
The John and Dorothy Rood Collection (1960; catalogue),
Alexander Archipenko (1967; organized by UCLA Art Galleries,
Los Angeles; catalogue)

- - **Holdings**

1 sculpture

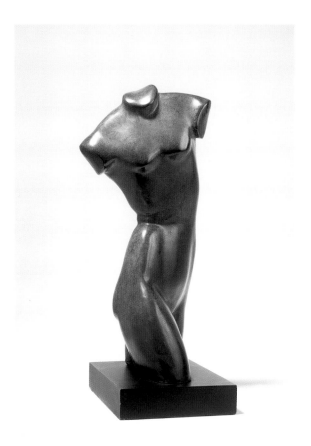

Alexander Archipenko *Turning Torso* 1921/1959 bronze; edition 5/6
18 5/8 x 9 3/4 x 8 3/4 in. (47.3 x 24.8 x 22.2 cm) Gift of the T. B. Walker
Foundation, 1960 1960.25

Kaoru Arima

Japanese, b. 1969

-- **Exhibitions**
How Latitudes Become Forms: Art in a Global Age
(2003; catalogue, tour)
-- **Holdings**
28 unique works on paper

Since 1997, Kaoru Arima has produced works on a daily basis, filling notebooks, plain paper, and pages torn from newspapers in various languages with his eccentric figurative drawings. His imagery alludes to a wide range of sources, unfolding a complex and intricate iconography: the Roman god Priapus emerging from the back of a child centaur; a hydrocephalous salary-man wearing nothing but a tie; a mermaid flirting with a hairy devil; a man growing puppets from his own arms. Twisted mythologies merging with underground icons, primal anxiety juxtaposed with absolute serenity, and sharp sarcasm next to naïve poetry—all these contradictions animate Arima's odd drawings.

Arima draws with a delicate, almost nervous line and lets his figures occupy the center of the page, isolating them on a patch of white paint when he uses a newspaper support. A very short text is embedded in each, providing a parallel or equivalent to the visual information. These texts are as absurd as the drawings, revealing a delight in word play, puns, and the comedy of life. With the images, they reveal a philosophical worldview that seems consistent with the fears, fascinations, beliefs, and taboos in contemporary Japanese society. An integral part of his practice as an artist is the Art Drug Center, an exhibition space in the remote location of Inuyama City that has become a necessary local link between communities and cultural projects.

Arima merges cultural references with philosophy and "zero-emotion" humor. In an oblique way, he follows the poetic tradition of the haiku—his drawings are like very short poems that appear to be cute aphorisms yet are informed by direct personal experience. His practice is fed by the dual traditions of Zen Buddhism and Conceptual Art, which aim to systematically analyze and exhaust the temporal, spatial, and cultural parameters that constitute art and culture. The subversive dimension of Arima's work stems from the fact that each of these traditions critiques the other, but neither dominates. The artist proposes a related reading of his work that is both profound and disarmingly simple: "If I look deeper into my work, I'm probably searching for the reason for my existence. . . . I'm describing weaknesses and strengths existing together as one, which may sound depressing to you, but I'm enjoying my life every day."[1]

P.V.

Notes
1. Artist's statement, March 4, 2002 (Walker Art Center Archives).

Kaoru Arima *untitled* 2001 acrylic, graphite, colored pencil, ink on newspaper 18 1/2 x 12 3/8 in. (47 x 31.4 cm) Miriam and Erwin Kelen Acquisition Fund for Drawings, 2002 2002.35

Kaoru Arima *untitled* 2000 acrylic, graphite, colored pencil, ink on newspaper 21 1/2 x 16 1/16 in. (54.6 x 40.8 cm) Miriam and Erwin Kelen Acquisition Fund for Drawings, 2002 2002.47

Siah Armajani

American, b. Iran, 1939

-- Commissions

Covered Foot Bridge (1970), *Fifth Element* (1971), Irene Hixon Whitney
Bridge (1988), *Bridge Book* (1991)

-- Exhibitions

1962 Biennial of Painting and Sculpture (1962; catalogue), *Drawing
in Minnesota* (1965; catalogue), *1966 Biennial of Painting and
Sculpture* (1966; catalogue), *Invitation 1967* (1967), *9 Artists/9 Spaces*
(1970; catalogue), *Drawings: 10 Minnesota Artists* (1971; catalogue),
Works for New Spaces (1971; catalogue), *Scale and Environment:
10 Sculptors* (1977; catalogue), *The Garden in the Galleries* (1994),
The Cities Collect (2000)

-- Holdings

1 painting, 4 sculptures, 4 drawings, 1 unique work on paper,
1 edition print/proof, 2 books, 6 models

Siah Armajani was born into a highly educated and
cultured Christian family in Tehran. He was educated
at a Presbyterian missionary school, where he thrived
in his studies of Western philosophers such as Socrates,
Hegel, Nietzsche, and Heidegger.[1] It was there that he
received his first lessons in American history as well.
He recalls, "When I was in high school in Iran, one of
my teachers was very familiar with American philoso-
phers, especially Emerson, who had translated Hafez,
the great Persian Sufi poet, from German into English,
which earned him a special place in Persian literature.
That teacher knew a lot about Jefferson and Adams,
and instilled in me a passion for democracy."[2] Yahya
Armajani, the artist's paternal uncle, who was already
in the United States teaching history at Macalester
College in St. Paul, Minnesota, recognized Siah's intel-
lectual curiosity and encouraged his nephew to join
him. The younger Armajani immigrated to the United
States in 1960 and took classes in mathematics while
majoring in philosophy. This course of study reac-
quainted him with the work of Emerson, who, accord-
ing to the artist, "underlined the excitement, the
unpredictable madness of America in terms of daily
life. Unpredictable because the past is forgotten inten-
tionally; Emerson wanted to break away from Europe
intellectually and to develop a truly American context.
This led to pragmatism rather than metaphysics, to
anthropology rather than philosophy—to John Dewey's
insistence that all ideas be tested according to their
applicability to life."[3]

Emerson's words continued to inspire Armajani as
he searched for a way to bring his political and social
consciousness in line with his lifelong dream of being
an artist. He set up a studio in downtown Minneapolis
and continued producing paintings in the same vein
that he had in college. *Prayer* (1962), which Armajani
completed prior to graduation, was included in the
Walker Art Center's *1962 Biennial of Painting and
Sculpture* and entered the collection that same year.[4]
Despite his inclination toward all things American in
his studies at the time, Armajani retains in this work
a vestige of his Iranian heritage and native language,
Persian Farsi, which he continues to speak and write
fluently.[5] He selected poems from the thirteenth and

fourteenth centuries, including the works of Sufi writers
Rumi and Hafez, and transcribed them by hand in
black ink onto the canvas. By including only excerpts
and sentence fragments from these poems, he severely
restricted the narrative flow, rendering it virtually
unreadable, and in so doing, accentuated the all-over,
cumulous pattern. Created in the abstract idiom of the
time but with text instead of expressive gestures, the
work connects the past to the present and the literary
to the visual, thereby bridging the gap between cul-
tures and time periods. The artist's use of text as image
also reflects the widespread practice in Islamic art
and architecture of including Koranic quotations as
integral decorative and thematic elements rather than
incorporating figural embellishments, which are
considered profane.

In conjunction with his ongoing, autodidactic
studies of American history and populist ideologies,
Armajani had also begun educating himself in the
eighteenth- and nineteenth-century American building
techniques of anonymous structures, such as log cab-
ins, barns, covered bridges, shingle-style schoolhouses,
Quaker reading rooms, and other vernacular forms.
This background, coupled with his interest in the
socially relevant and utopian art of the early twentieth-
century Russian Constructivist and Suprematist move-
ments, helped him clarify his focus toward public art
and his commitment to democratic ideals. Over the
course of his career, Armajani would go on to build
pragmatic structures out of wood and metal, including

Siah Armajani *Prayer* 1962 oil, ink on canvas 70 3/4 x 50 3/4 in.
(179.7 x 128.9 cm) Art Center Acquisition Fund, 1962 1962.53

bridges, houses, reading rooms, and various other indoor and outdoor dwellings (both ephemeral and permanent) as well as freestanding sculpture. Not interested in building monuments to his ego or anyone else's, he unequivocally states, "I am interested in the nobility of usefulness. My intention is to build open, available, useful, common, public gathering places. Gathering places that are neighborly. They are not conceived in terms of wood and steel, but in terms of their nature as places at hand, ready to be used."[6]

His first forays into sculpture came with the creation of bridges, some intended to exist only as models, others as temporary constructions or large-scale, permanent installations. *Bridge for Robert Venturi* (1970), in the Walker's collection, is one of many nonutilitarian bridge models that he fabricated out of balsa wood between 1968 and 1975.[7] Typical of his early *Limit Bridges* series, none of which were produced full scale, the primary function as a thoroughfare is rendered defunct by structural blockages and bisections. By placing the bridge entrances at the midsection rather than at either end and creating steep inclines in both directions, Armajani frustrates viewers' expectations of normative passage and challenges preconceived notions about the role of architecture in the built environment.

This and other architectural projects ultimately led to one of Armajani's most important commissions, the Irene Hixon Whitney Bridge, which opened to pedestrian foot traffic in September 1988.[8] This 375-foot steel-truss construction—a combination of suspension, arched, and closed steel trestle bridge types—spans fifteen lanes of traffic to connect the Minneapolis Sculpture Garden with the urban oasis of Loring Park. The bridge has become an icon for the city as well as a metaphor for the peaceful coexistence of the diverse backgrounds and interests of the population. Armajani collaborated with then-director Martin Friedman, the Minnesota Department of Transportation, the Minneapolis Park Board, and countless engineers and steelworkers to bring the project to fruition. The bicolor treatment of the bridge's armature was the artist's antidote to the harsh midwestern weather and a nod to one of Armajani's architect-heroes of old, Thomas Jefferson: "The yellow is from Monticello. Jefferson called it the color of wheat, of the harvest, but it is also the color of happiness. The blue is just—well, the sky. Minneapolis has these long, gray winters, so I felt that colors should be light."[9] Armajani has long integrated poetry into his sculptural compositions, and this project was no exception. He commissioned New York School poet John Ashbery to compose an original work that could be read by pedestrians traversing the bridge. Upon its completion, Friedman aptly described Armajani's masterpiece as "a symbol of serenity as well as transition."[10]

Since 2000, Armajani has expanded his repertoire of materials to include glass and plexiglass, and in so doing has been able to capitalize on the metaphoric possibilities of transparency, fragility, metamorphosis, and transcendence.[11] Enigmatic, yet literally and conceptually accessible, *Glass Room* (2000) is a contemplative space set on wagon wheels that incorporates many of the artist's familiar sculptural forms borrowed from domestic architecture—an aluminum-frame

Dutch door opens onto an ethereal chamber containing a bronze folding cot and an oversized chair of slatted wood. In addition, a model of a nineteenth-century American clapboard house rests on a platform projecting out from one of the exterior walls. The notion of flexible and mobile architecture is contained in the glass metaphor, where forms are not fixed and measurable. With this piece, Armajani has succeeded in his mission to provide an environment that is at once "open, available, and useful," encouraging us to enter, sit, and contemplate.

E.C.

Notes

1. For more information on the artist's biography, see Calvin Tomkins, "Profiles: Open, Available, Useful—Siah Armajani," *New Yorker*, March 19, 1990, 48–72.
2. Quoted in Martin Filler, "Designed to Bridge Two Cultures, Two Arts," *New York Times*, November 17, 2002, 36.
3. Tomkins, "Profiles," 53.
4. This acquisition ushered in what would become a major institutional commitment on the Walker's part to the collection and exhibition of Armajani's work early in his career, and for more than four decades. Important early group shows included *9 Artists / 9 Spaces* (1970), in which the artist was commissioned to create *Covered Foot Bridge* (1970), often referred to as "Bridge Over a Nice Triangle Tree," in the empty lot of what would become the Minneapolis Sculpture Garden; *Works for New Spaces* (1971); and *Scale and Environment: 10 Sculptors* (1977), which included numerous bridge and house pieces.
5. In a conversation with the author on December 4, 2001, Armajani explained that Persian calligraphy uses the same alphabet as Arabic but has its own peculiar sensibility that might be missed by Western readers.
6. Quoted in Tomkins, "Profiles," 49.
7. This work was dedicated to American architect Robert Venturi, whose book *Complexity and Contradiction in Architecture* (New York: Museum of Modern Art, 1966) was an important influence on Armajani's burgeoning artistic practice. A champion of vernacular architecture, Venturi rejected the monolithic and austere forms found in modernist architecture in favor of structures that retain a historical sensibility.
8. The bridge was a gift of the family of Irene Hixon Whitney to the citizens of Minneapolis, and it is owned and maintained by the Minnesota Department of Transportation. Although not part of the Walker's collection, it is a major component of the Minneapolis Sculpture Garden.
9. Quoted in Tomkins, "Profiles," 48.
10. Martin Friedman, "Growing the Garden," *Design Quarterly* 141 (1988): 15.
11. Armajani has acknowledged that his glass works have been influenced by architect Bruno Taut's *Glass House* (1914/1915) and an article written by architectural historian Rosemarie Haag Bletter entitled "The Interpretation of the Glass Dream—Expressionist Architecture and the History of the Crystal Metaphor," *Journal of the Society of Architectural Historians* 40, no. 1 (March 1981): 20–43.

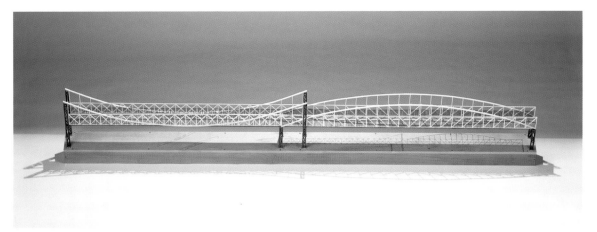

Siah Armajani Model for the Irene Hixon Whitney Bridge 1985 wood, paint 12 x 74 x 4 in. (30.5 x 188 x 10.2 cm) Acquired in connection with the construction of the Minneapolis Sculpture Garden, 1986 1986.60

Siah Armajani Model for *Red School House for Thomas Paine* 1976–1977 wood, cardboard, paint 10 1/4 x 23 x 31 in. (26 x 58.4 x 78.7 cm) Gift of the artist in honor of Martin Friedman, 1990 1990.171

Siah Armajani *Bridge for Robert Venturi* 1970 wood, stain 14 x 76 5/8 x 12 1/4 in. (35.6 x 194.6 x 31.1 cm) Purchased with the aid of funds from Mr. Brooks Walker, Jr., 1977 1977.67

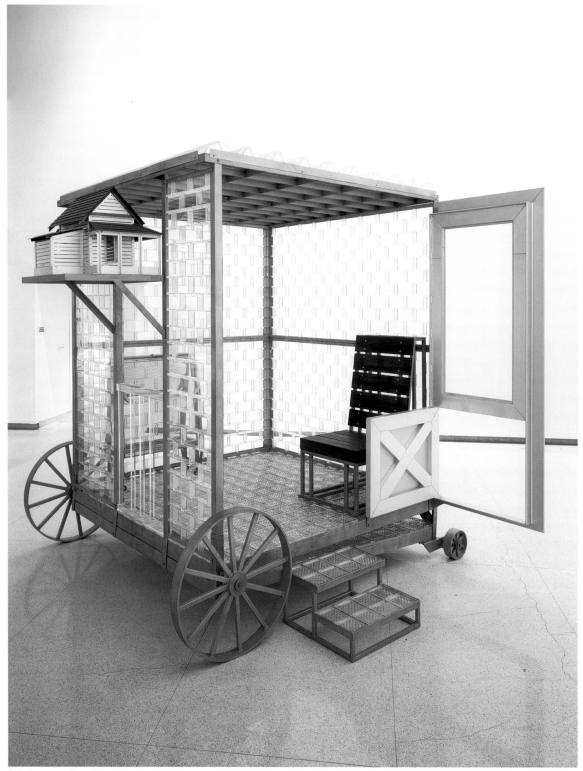

Siah Armajani *Glass Room* 2000 stainless steel, wood, bronze, aluminum, glass, plexiglass 114 x 106 x 127 in. (289.6 x 269.2 x 322.6 cm) Gift of Martha and Bruce Atwater, Judy and Kenneth Dayton, Penny and Mike Winton, Margaret and Angus Wurtele, and the T. B. Walker Acquisition Fund, 2001 2001.23

Jean (Hans) Arp

French, b. Germany, 1886–1966

- - Exhibitions

Second Annual Regional Sculpture Exhibition (1945; catalogue),
The Classic Tradition in Contemporary Art (1953; catalogue), *Jean Arp*
(1954; catalogue), *Reality and Fantasy, 1900–1954* (1954; catalogue),
Editions MAT 1964 and 1965 (1966), *Banners and Tapestries* (1967),
De Stijl: 1917–1931, Visions of Utopia (1982; catalogue, tour), *The 20th-
Century Poster: Design of the Avant-Garde* (1984; catalogue, tour)

- - Holdings

1 sculpture, 1 edition print/proof, 1 book

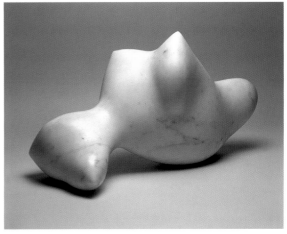

Jean (Hans) Arp *Aquatique (Aquatic)* 1953 marble 13 1/2 x 25 5/16 x
9 3/16 in. (34.3 x 64.3 x 23.3 cm) Gift of the T. B. Walker Foundation,
1955 1955.4

Richard Artschwager

American, b. 1923

- - Exhibitions

First Impressions: Early Prints by Forty-six Contemporary Artists
(1989; catalogue, tour), *Duchamp's Leg* (1994; catalogue, tour)

- - Holdings

1 painting, 1 sculpture, 1 edition print/proof, 12 multiples

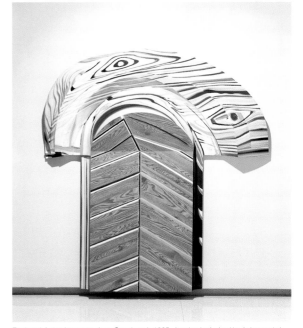

Richard Artschwager *Low Overhead* 1985 laminated plastic, latex paint
on plywood 96 x 93 x 93 in. (243.8 x 236.2 x 236.2 cm) T. B. Walker
Acquisition Fund, 1985 1985.714

Frank Auerbach

British, b. Germany, 1931

- - **Holdings**

1 painting, 1 drawing, 4 edition prints/proofs

Frank Auerbach *E.O.W. Looking into the Fire I* 1962 oil on paperboard
12 1/4 x 10 3/4 in. (31.1 x 27.3 cm) Gift of Sam and May Gruber in honor of
Kathy Halbreich, 1996 1996.174

George C. Ault

American, 1891–1948

- - **Exhibitions**

The Precisionist View in American Art (1960; catalogue, tour),
American Tableaux (2001; publication, tour)

- - **Holdings**

1 painting, 1 gouache/watercolor

George C. Ault *Sullivan Street, Abstraction* 1924 oil on canvas 24 1/4 x
20 in. (61.6 x 50.8 cm) Art Center Acquisition Fund, 1961 1961.2

Milton Avery

American, 1893–1965

-- **Exhibitions**

110 American Painters of Today (1944; catalogue, tour), *136 American Painters* (1946; catalogue), *Contemporary American Painting and Sculpture: Collection of Mr. and Mrs. Roy R. Neuberger* (1952; catalogue), *Lowenthal Collection of American Art* (1952; catalogue), *First Annual Collectors Club Exhibition* (1957; catalogue), *Art Fair* (1959; catalogue), *Milton Avery* (1983; organized by the Whitney Museum of American Art, New York; catalogue), *The Cities Collect* (2000)

-- **Holdings**

1 painting, 1 drawing

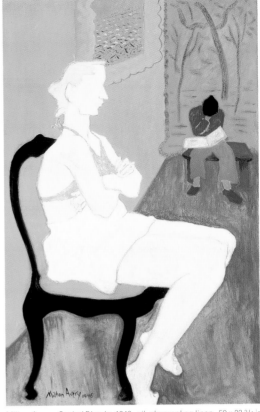

Milton Avery *Seated Blonde* 1946 oil, charcoal on linen 52 x 33 3/4 in. (132.1 x 85.7 cm) Gift of Mr. and Mrs. Roy R. Neuberger, New York City, 1952 1952.6

Lutz Bacher

American, b. 1952

-- **Exhibitions**

Artists' Books (1981), *American Tableaux* (2001; publication, tour)

-- **Holdings**

1 painting, 1 sculpture

Lutz Bacher *Playboy #1, Peace* 1991 acrylic on canvas 44 5/16 x 36 1/16 in. (112.6 x 91.6 cm) Anonymous gift, 2001 2001.158

Francis Bacon

Irish, 1909–1992

- - **Exhibitions**

Reality and Fantasy, 1900–1954 (1954; catalogue), *Expressionism 1900–1955* (1956; catalogue, tour), *Kraushaar Galleries Exhibition* (1958), *Paintings from the Des Moines Art Center* (1984), *The Cities Collect* (2000)

- - **Holdings**

1 painting

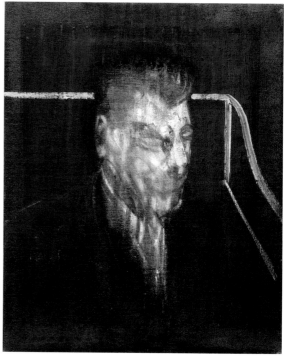

Francis Bacon *Head in Grey* 1955 oil on canvas 24 1/8 x 20 1/8 in. (61.3 x 51.1 cm) Donated by Mr. and Mrs. Edmond R. Ruben, 1995 1995.71

John Baldessari

American, b. 1931

- - **Exhibitions**

John Baldessari (1991; organized by the Museum of Contemporary Art, Los Angeles; catalogue), *The Last Picture Show: Artists Using Photography, 1960–1982* (2003; catalogue, tour)

- - **Holdings**

1 photograph, 2 edition prints/proofs, 1 print portfolio, 8 books, 1 periodical

John Baldessari *Embed Series: Oiled Arm (Sinking Boat and Palms)* 1974 2 black-and-white photographs mounted on paperboard 16 3/4 x 23 1/2 in. (42.5 x 59.7 cm) each T. B. Walker Acquisition Fund, 1996 1996.50

Fiona Banner

British, b. 1966

- - **Exhibitions**

American Tableaux (2001; publication, tour)

- - **Holdings**

1 multimedia work, 1 edition print/proof, 1 print portfolio, 1 book

Fiona Banner *The Nam* 1997 offset lithograph on paper 2 5/8 x 11 1/4 x 8 1/2 in. (6.67 x 25.58 x 21.59 cm) Walker Art Center Library Collection, 2002 2002.36

Fiona Banner *Trance* 1997 graphite on paper, audiocassette recording drawing: 8 1/2 x 16 in. (21.59 x 40.64 cm) Butler Family Fund, 2001 2001.120

Edward Larrabee Barnes
American, 1915–2004

- - **Commissions**
Walker Art Center building (1966–1971; addition 1984)
Minneapolis Sculpture Garden (1986–1988)

The Walker Art Center project was the first of many museum commissions that New York–based architect Edward Larrabee Barnes would receive during his long and distinguished career. In May 1971, the new building opened to great critical acclaim and quickly became a national model for museum design. Art critic Hilton Kramer declared, "In meeting its obligation to provide contemporary works of art with exhibition space sympathetically attuned to *their* qualities, rather than to the architect's own overbearing vision of what all art should be, Mr. Barnes' design succeeds where the grandiose ideas of his more famous contemporaries have often failed."[1] This sentiment was echoed in reactions from others in the art world, including gallery owner Leo Castelli, who remarked, "It is probably the best museum space that we have in the United States."[2]

Such praise was, in part, due to Barnes' ability to capture the emergent qualities of the so-called white cube aesthetic that would become the dominant presentation technique for contemporary artworks in galleries and museums. The pristine interiors of the galleries underscored this approach, with expansive white walls, ceilings, and floors. Openness was achieved through the use of precast concrete T-sections that produced column-free spaces with uninterrupted vistas. Design choices were consciously recessive, but not characterless. Variations in ceiling height and gallery proportions as well as the introduction of natural light through a few strategically placed windows and skylights created subtle changes in the environment.

The design's unique spiral configuration defined the architectural experience of the building. From the outset, Barnes focused on processional movement: "We want the visitor to remember paintings in space, sculpture against sky, and a sense of continuous flow. It is flow more than form that has concerned us. The sequence of spaces must be seductive. There must be a subtle sense of going somewhere, like a river."[3] The site's small footprint and extensive requirements (seven galleries, auditorium, restaurant, offices) necessitated a vertical arrangement of spaces. The problem of upward circulation was solved through a helical plan that features a central staircase and elevator with galleries spiraling out in a pinwheel-like fashion. Programmatically, the largest exhibition spaces unfold as a sequence of three galleries forming a U and connected by a short run of wide "waterfall" stairs, which make movement from one space to another fluid and nearly effortless.

Because the compact site did not allow for an outdoor courtyard, Barnes added a series of rooftop terraces that, like the interior, spiral up the structure on three levels. Designed with large-scale sculptures in mind, these platforms provide dramatic backdrops and views of the downtown skyline. Barnes' design is deceptively simple and subtly complex. From the exterior, the building is clearly defined by a series of cubic volumes that recall the Minimalist sculpture of the era. Its dark, plum-colored brick cladding contrasts with the light, bright interiors. In effect, Barnes created a structure that is both sculpture and pedestal.

His design captured the zeitgeist of the period, providing a sense of place for the Walker's ambitious programs. Upon completion of the building, he noted, "A museum is not a temple to the donors, or a monument to the architect, or a security vault—in short, it is not a thing in itself. It is part of the fabric of daily life, sharing urban benefits and problems with its neighbors."[4]

A.B.

Notes
1. Hilton Kramer, "Grace, Flexibility, Esthetic Tact," *New York Times*, May 30, 1971, sec. 19D.
2. Quoted in Peter Blake, "Brick-on-Brick and White-on-White," *Architecture Plus*, July/August 1974, 40.
3. Edward Larrabee Barnes, *Design Quarterly* 81 (1971): unpaginated.
4. Ibid.

Walker Art Center building and entry, 1971

Walker Art Center exhibition galleries, 1971

Matthew Barney

American, b. 1967

- - **Screenings**

A Film Program and Regis Dialogue: Matthew Barney: The
Cremaster Cycle (2003)
- - **Exhibitions**

Duchamp's Leg (1994; catalogue, tour), *Matthew Barney Cremaster 2:
The Drones' Exposition* (1999; catalogue), *The Cities Collect* (2000)
- - **Holdings**

1 drawing, 8 multimedia works, 1 video, 2 edition prints/proofs,
1 portfolio of prints, 1 multiple

Matthew Barney's career began, paradoxically, with a very profound absence. The night before his New York debut in 1991, he locked himself inside the gallery and began to climb. Using customized mountaineering equipment such as titanium ice screws and a climbing harness, he made his assault on the architecture. He ascended walls, moved across the ceiling, and finally descended into a basement gallery containing a sculptural tableau that included a weight-lifting bench cast from petroleum jelly housed in an industrial refrigeration unit. The next day, visitors saw only a video of the artist's climb and the sculptural and performative residue of his presence. Barney might have left the building, but he opened a door onto a new aesthetic gambit: a powerful hybridization of sculpture, performance, and the moving image that has grown more complex since that first exhibition. Today, his universe is composed of a wildly complex pantheon of figures and forces, each of which overflows with narrative connotations and sculptural possibilities. Driving these intricate narratives is a systematic investigation into the generative nature of physical resistance in the creation of form. In Barney's world, objects cannot take physical shape and narratives cannot develop without the struggle of a protagonist against an opposing force.[1]

One of the artist's most astonishing contributions is his ability to expand the possibilities for sculpture—not only through his choice of such unorthodox materials as petroleum jelly and self-lubricating plastic, but through his insistence on the sculptural possibilities of both performance and film. Both aspects have their roots in a wide range of cultural references and artistic sources: for example, Barney has acknowledged a debt to Bruce Nauman, who used his own body to explore the limitations of his studio space in such videos as *Bouncing in a Corner No. 1* or *Slow Angle Walk (Beckett Walk)* (both 1968). Vito Acconci's notorious *Seed Bed* (1972), with its hidden onanistic performance, also comes to mind, and it is impossible not to think of Richard Serra's thrown-lead pieces, whose dynamic forms were shaped by the surfaces they encountered.[2] These art-historical progenitors are fused with references to the artist's childhood heroes, including the Oakland Raiders' legendary offensive lineman Jim Otto or escape artist Harry Houdini, both of whom tested the extreme physical thresholds of the body. When the visual and narrative influence of films such as Sam Raimi's *Evil Dead II* (1987) or Stanley Kubrick's *The Shining* (1980) are thrown into the mix, it becomes

clear that we are not simply dealing with cultural bricolage but with a fundamentally hybrid conception of sculptural practice.[3]

The motor force of physical resistance that animates Barney's work is apparent in his three-channel video installation *DRAWING RESTRAINT 7* (1993). Here the mythological world of ancient Greece is thrown into perverse proximity with Barney's own cosmology of physical restraint and unrealized desire. On three separate monitors, a group of satyrs (done up in elaborate prostheses of the artist's devising) play out a ritualized struggle for dominance in the back of a stretch limousine. A satyr with underdeveloped horns (played by Barney) spins around and around in an endless cycle of expenditure without return; his two brethren engage in a Greco-Roman wrestling match as they both attempt to create a mark with their horns in the condensation on the moon roof. As one forces the other into submission, a drawing is created. All the while, the limousine drives over and through all six major bridges and tunnels entering New York City. In this work, drawing has been taken into an expanded quasi-biological register, where the lines of force generated by its protagonists' exertions become a kind of protean form of mark-making. In the end, neither protagonist wins, as they align their Achilles tendons and flay one another in a reenactment of Apollo's revenge on Marsyas for his hubris in thinking that he himself could become a god.

With its emphases on the formative power of resistance, expenditure without result, and mythological hubristic failure, *DRAWING RESTRAINT 7* can in many ways be viewed as an epigraph or even a prequel to Barney's monumental *Cremaster* cycle, which was begun in 1994 and completed in 2002. An operatic series of five epic films, the *Cremasters* constitute a biological, mythological, and topological recasting of classical mythopoetic narratives in the form of a series of phantasmic quests. As Nancy Spector suggests, "Born out of a performative practice in which the human body—with its psychic drives and physical thresholds—symbolizes the potential of sheer creative force, the cycle explodes this body into the particles of a contemporary creation myth."[4] It is the anatomy of the body itself that provides this creation myth with its title, as it refers to the cremaster muscle, which controls the raising and lowering of the testicles in response to such external stimuli as fear and changes in temperature. The entire cycle alludes to the moment in prenatal development just prior to the assignment of gender—an undifferentiated physical state that embodies the tension between stasis and dynamic movement. That moment provides the metaphorical superstructure for the endless sequence of expenditure and renewal of energy that permeates the narrative of the *Cremaster* cycle.

While linked by a certain repetition of themes, the five *Cremaster* films do not form a continuous narrative with repeating characters. Shot out of sequence, each of the installments centers around a series of ritualized athletic endeavors and magical transformations in which landscape and architecture are characters in the plot. Each film also has at its core a quest that, as in classical mythology, forces the central character to overcome a series of escalating challenges before reaching

his goal. The protagonists (often played by Barney) are forced to engage in a range of physical tribulations, including Houdiniesque escapes, trials by tap-dancing, and heroic climbs across the proscenium of Budapest's Magyar Állami Operaház (State Opera House) and up the rotunda of New York's Guggenheim Museum. These challenges are played out in a narrative of subtle ascents and descents that mimics the movement of the cremaster muscle itself, and are set in a sequence of topographies that moves from West to East: from Idaho (*Cremaster 1*, 1995), Utah and Alberta, Canada (*Cremaster 2*, 1999), and New York (*Cremaster 3*, 2001) across the Atlantic to the Isle of Man (*Cremaster 4*, 1994) and Hungary (*Cremaster 5*, 1997). In addition to a video or film component, each *Cremaster* is also realized in the form of a multiple that includes sculptural objects housed in a vitrine of the artist's design; additional related sculptures, drawings, and photographs often have been shown at the debut of each film. As with his earliest works, these installations typically encompass a transformation of the architecture of the gallery into a complete, immersive design environment for viewing these films in which carpet, wall coverings, and even seating find themselves subject to Barney's sculptural vision.[5]

Like the satyr that chases its own tail in *DRAWING RESTRAINT 7*, the *Cremaster* project feeds on itself in a kind of systemic autophagy that is generative rather than destructive. The cycle builds a complex, closed system of references in which the epic play of forces can never come to a conclusion, but is instead held in a moment of undetermined suspension just prior to resolution. In the end, it is the body itself that is at the center of this opus. Ovid's *Metamorphoses* opens with the words "Of bodies changed to various forms I sing." These are the unspoken lyrics to the imaginary sound track playing in the background of Barney's work.

D.F.

Notes

1. Nancy Spector's catalogue essay for the Guggenheim retrospective of Barney's *Cremaster* cycle is the most comprehensive resource to date on these intricate works. See Nancy Spector, "Only the Perverse Can Still Save Us," in Nancy Spector, ed., *Matthew Barney: The Cremaster Cycle*, exh. cat. (New York: Solomon R. Guggenheim Museum, 2002), 2–91.

2. Richard Serra himself would play a central role in *Cremaster 3*. In one sequence, Serra throws liquid petroleum jelly into a wall along the rotunda of the Guggenheim Museum in a concatenation of Barney's materials with Serra's early aesthetic endeavors.

3. On Barney's relationship to film, see Richard Flood, "Notes on Digestion and Film," in Matthew Barney and Gracia Lebbink, eds., *Pace Car for the Hubris Pill*, exh. cat. (Rotterdam, Netherlands: Museum Boijmans van Beuningen, 1996), 21–35.

4. Spector, "Only the Perverse," 5.

5. *Cremaster 2* premiered at the Walker Art Center in 1999 in an installation that included a large group of sculptural objects (many of which were used in the film), a suite of photographs, flags, drawings, and stadium seating designed and fabricated by the artist. The entire installation was acquired jointly by the Walker and the San Francisco Museum of Modern Art. The Walker also owns the special-edition film vitrines related to the other four *Cremaster* films.

Matthew Barney *DRAWING RESTRAINT 7* 1993 intermedia room installation, including 3 video monitors, 3 laser discs (color, silent), 6 high-abuse fluorescent lighting fixtures, enamel on steel, internally lubricated plastic; edition 3/3 room: 108 x 264 x 120 in. (274.3 x 670.6 x 304.8 cm) 13 minutes T. B. Walker Acquisition Fund, 1993 1993.130

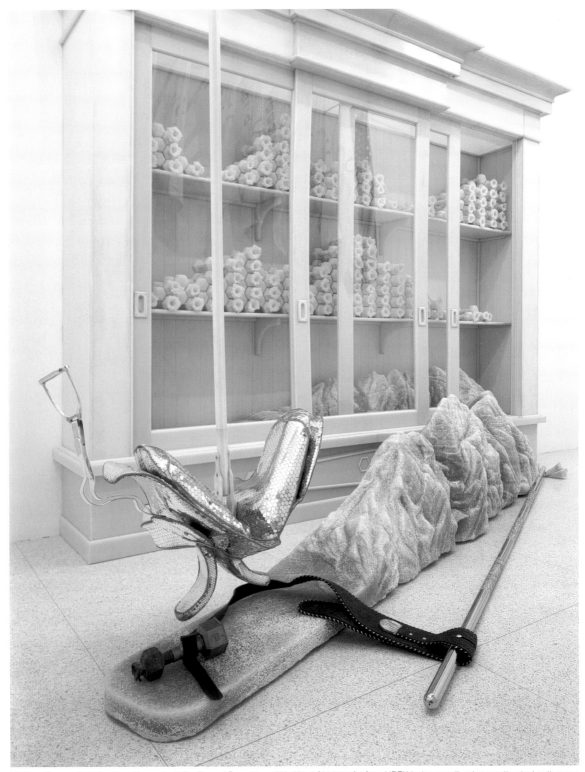

Matthew Barney Selection from *Cremaster 2: The Drones' Exposition* 1999 35mm film transfer from HDTV (color, sound), nylon, acrylic, steel, salt, epoxy, chrome-plated engraved brass, leather, sterling silver, brass, lead, Hungarian sidesaddle, silk, carpet, carpet inlay, graphite and petroleum jelly on paper, laminated chromogenic prints 74 ft. 1 3/4 in. x 33 ft. 6 3/4 in. (22.6 m x 10.23 m) installed 79:17 minutes Collection Walker Art Center and San Francisco Museum of Modern Art, T. B. Walker Acquisition Fund, 2000 2000.18

Matthew Barney *Cremaster 1* 1995–1996 screenprinted laser disc (color, sound), cast polyester, self-lubricating plastic, prosthetic plastic, patent vinyl, fabric, plexiglass; edition 6/10 vitrine: 49 7/8 x 47 3/4 x 35 3/4 in. (126.7 x 121.3 x 90.8 cm) 40:30 minutes T. B. Walker Acquisition Fund, 1996 1996.187

Matthew Barney *Cremaster 3* 2002 35mm film (color, sound), screenprinted DVDs, stainless steel, internally lubricated plastic, marble, sterling silver, acrylic; edition 6/10 vitrine: 44 x 48 x 40 1/8 in. (111.8 x 121.9 x 101.9 cm) 182 minutes T. B. Walker Acquisition Fund, 2002 2002.159

Matthew Barney *Cremaster 4* 1994/1995 prosthetic plastic, bridal satin banner, Manx tartan fabric cushion, screenprinted laser disc (color, sound) in screenprinted onionskin sleeve, self-lubricating plastic, plexiglass; edition 9/10 vitrine: 41 1/2 x 47 3/4 x 35 3/4 in. (105.4 x 121.3 x 90.8 cm) 42 minutes T. B. Walker Acquisition Fund, 1995 1995.94

Matthew Barney *Cremaster 5* 1997 35mm film (color, sound), screenprinted laser disc, acrylic, polyester, nylon, velvet, silver; edition 8/10 vitrine: 37 7/8 x 35 3/4 x 47 1/2 in. (96.2 x 90.8 x 120.7 cm) 56 minutes T. B. Walker Acquisition Fund, 1998 1998.79

On an untitled drawing by Matthew Barney

When Chaos Theory was in the air, there was a saying that a butterfly fluttering its wings over Brazil might unleash a tornado in Texas. Matthew Barney's *Cremaster* cycle feels a bit like this metaphor. Everything is connected to everything else in a hugely ambitious roll call of places and personae, systems and symbols, mythologies and folkways willed by the artist into a genealogy of intense intricacy.

Drawing—as a kind of conceptual storyboarding—lies at the heart of Barney's complex imaginings. On small sheets of paper, he makes nervous, delicate pencil marks, which delineate the grandest of visions. His drawings describe an intense interconnectedness and suggest the ecstasy of form-making, which marks out the *Cremaster* cycle.

In one of the early scenes of *Cremaster 2*, just before the formalized coupling that results in the pollinated insemination of Gary Gilmore, Bessie Smith (his Mormon mother) utters the words:

"Now we have it out into verse
The secret of the Universe
Inter-invigoration and inter-control
And interdependency within the whole
Of forms, of Truth and Love and Light,
All to Masterpoint then held tight."[1]

One drawing—part of the ensemble entitled *The Drones' Exposition*—charts a compact map of interdependency within the whole. A honeycomb of hexagons and a fertile pool of royal jelly establishes coordinates that reach from Frank (father of Gary) Gilmore's testes (ruled by the cremaster muscle) to Harry Houdini's (Barney's inspiration) handcuffs and from the epic spine of the Rocky Mountains to the Salt Flats of Utah. It is a diagram of desire, drawing links between the forces of geology and genealogy, confronting the slowness of glacial movement with the momentary spasms of conception and execution.

Barney's pencil marks are overlaid in parts with a viscous, transparent gel—Queen's jelly or honey or seminal fluid. The substance trips associations with the universe of fluids that defines *Cremaster 2*—the receding glacier and the melting ice, the ectoplasm and the Vaseline—and amongst all these pale liquids, the violence of the dark congealing blood on a garage floor in Utah.

James Lingwood

Notes
1. The words are those of New Zealand–based writer Edgar Roy Brewster (1905–1978), who designed his life around the bee, constructed buildings based on beehives, and developed a "Norian" philosophy, which like the hexagonal structures of the natural world, had no right angles.

Matthew Barney Selection from *Cremaster 2: The Drones' Exposition* 1999
graphite, petroleum jelly on paper, nylon 9 1/4 x 11 3/4 x 1 3/16 in. (23.5 x 29.8 x 3 cm)
framed Collection the Walker Art Center and San Francisco Museum of Modern
Art, T. B. Walker Acquisition Fund, 2000 2000.18

Jennifer Bartlett

American, b. 1941

-- Exhibitions

Painting: New Options (1972; catalogue), *Jennifer Bartlett* (1985;
catalogue, tour), *First Impressions: Early Prints by Forty-six
Contemporary Artists* (1989; catalogue, tour)

-- Holdings

4 paintings, 1 drawing, 1 multimedia work, 1 portfolio of prints

Jennifer Bartlett *Fire/Nasturtiums* 1988–1989 oil on canvas, enamel on
wood painting: 84 x 60 1/4 x 2 1/8 in. (213.4 x 153 x 5.4 cm) sculpture:
35 1/4 x 32 1/2 x 30 3/4 (89.5 x 82.6 x 78.1 cm) T. B. Walker Acquisition Fund,
1989 1989.66

William Baziotes

American, 1912–1963

-- Exhibitions

Paintings to Know and Buy (1948), *Contemporary American Painting:
Fifth Biennial Purchase Exhibition* (1950; catalogue, tour),
*Contemporary American Painting and Sculpture: Collection of Mr.
and Mrs. Roy R. Neuberger* (1952; catalogue), *Reality and Fantasy,
1900–1954* (1954; catalogue), *60 American Painters: Abstract
Expressionist Painting of the Fifties* (1960; catalogue), *Eighty Works
from the Richard Brown Baker Collection* (1961; catalogue)

-- Holdings

1 painting

William Baziotes *Opalescent* 1962 oil on canvas 42 3/8 x 50 1/4 in. (107.6 x
127.6 cm) Gift of the T. B. Walker Foundation, 1963 1963.5

Bernd and Hilla Becher

German, b. 1931; German, b. 1934

- - **Exhibitions**

Photography in Contemporary German Art: 1960 to the Present (1992;
catalogue, tour), *The Last Picture Show: Artists Using Photography,
1960–1982* (2003; catalogue, tour)

- - **Holdings**

1 photographic suite

Bernd and Hilla Becher *Wassertürme (Water Towers)* 1972 gelatin silver
prints mounted on paperboard 55 1/4 x 39 1/2 in. (140.3 x 100.3 cm) Justin
Smith Purchase Fund, 1996 1996.190

Robert Bechtle

American, b. 1932

- - **Holdings**

3 drawings

Robert Bechtle *Covered Car–High Street* 2001 charcoal on paper 19 3/4 x
27 1/2 in. (50.2 x 69.9 cm) T. B. Walker Acquisition Fund, 2002 2002.64

Larry Bell

American, b. 1939

-- **Commissions**
Garst's Mind No. 2 (1971)

-- **Exhibitions**
6 artists 6 exhibitions (1968; catalogue), *14 Sculptors: The Industrial Edge* (1969; catalogue), *Works for New Spaces* (1971; catalogue)

-- **Holdings**
2 sculptures, 1 drawing, 1 book

Larry Bell untitled 1967–1968 glass, metal 60 1/2 x 28 1/4 x 28 1/4 in. (153.7 x 71.8 x 71.8 cm) Gift of Mike and Penny Winton, 1989 1989.511

Rudolf Belling

German, 1886–1972

-- **Holdings**
1 sculpture

Rudolf Belling *Kopf in Messing* (*Head in Brass*) 1925 brass 15 1/4 x 8 13/16 x 8 11/16 in. (38.7 x 22.4 x 22.1 cm) Gift of the T. B. Walker Foundation, 1957 1957.2

Lynda Benglis

American, b. 1941

-- **Commissions**
Adhesive Products (1971)
-- **Exhibitions**
Works for New Spaces (1971; catalogue), *Painting: New Options*
(1972; catalogue), *First Impressions: Early Prints by Forty-six*
Contemporary Artists (1989; catalogue, tour)
-- **Holdings**
2 sculptures

Lynda Benglis *Excess* 1971 purified beeswax, damar resin, pigments
on Masonite and wood 36 x 5 x 4 in. (91.4 x 12.7 x 10.2 cm) Art Center
Acquisition Fund, 1972 1972.11

Wallace Berman

American, 1926–1976

-- **Exhibitions**
Duchamp's Leg (1994; catalogue, tour)
-- **Holdings**
1 unique work on paper, 1 multiple

Wallace Berman *Untitled* 1967 Verifax collage, negative image 48 x
45 1/2 in. (121.9 x 115.6 cm) T. B. Walker Acquisition Fund, 1990 1990.160

Joseph Beuys
German, 1921–1986

- - **Exhibitions**
Photography in Contemporary German Art: 1960 to the Present
(1992; catalogue, tour), *In the Spirit of Fluxus* (1993; catalogue, tour),
Duchamp's Leg (1994; catalogue, tour), *Joseph Beuys Multiples* (1997;
catalogue, tour), *The Last Picture Show: Artists Using Photography,
1960–1982* (2003; catalogue, tour)
- - **Holdings**
492 multiples, 4 books, 2 posters

Joseph Beuys conceived one of the most compelling—
and still provocative—aesthetic programs of the post-
war period, one that continues to cause reverberations.
His sculpture, performances, lectures, and political
activism were all part of a grand, enormous goal: the
transformation of Western culture into a more peaceful,
democratic, and creative system. His famous slogan
"Everyone is an artist" proposed that this could be
achieved, if only human beings would apply their
innate creative energies toward positive change; he
christened this kind of activity "social sculpture." These
were highly utopian aspirations, no doubt, but Beuys
dedicated all his energy to them, hoping to stimulate
the change he believed was necessary to reinvigorate
society. Along the way he developed a range of wildly
inventive art forms and served as a model for a whole
generation of young artists.

Born in 1921 in Krefeld, in northwestern Germany,
Beuys was the only child in a middle-class, strongly
Catholic family. As a youth he pursued dual interests
in art and the natural sciences, eventually choosing a
career in medicine. But in 1940 he joined the Luftwaffe
for a five-year tour during which he was wounded sev-
eral times and held in a British prisoner-of-war camp;
he returned home physically, emotionally, and spiritu-
ally depleted. Upon his recovery he redirected his
energy toward art, spending the better part of a decade
studying, reading, and drawing, and in 1961 he was
appointed to a professorship at the Kunstakademie
Düsseldorf, then an active center for contemporary art.
During the early 1960s he became acquainted with
the experimental work of the group known as Fluxus,
who invented hybrid art forms that erased boundaries
between literature, music, visual art, performance,
and everyday life. Fluxus was a critical catalyst that
enabled Beuys to develop his own practice into an
innovative fusion of organic and natural materials,
ritualized movement, and complex, symbolic iconogra-
phy. His "expanded concept of art" eventually came
to include teaching, lectures, discussion, and political
activities as well as traditional artistic media—a radical
concept, even today.

An important part of Beuys' plan for the broad distri-
bution of his ideas was the production of multiples—
two- or three-dimensional objects made in multiple
copies. He spoke of them as vehicles, traveling objects
meant to move his ideas through space, through which
he "stayed in touch with people."[1] He envisioned them
wandering in many directions, serving as proxies for
his charismatic presence and sparking debate, just as

his lectures and actions often did. If one had seen Beuys
himself speak or perform, his multiples could serve as
memory aids or even relics. (The whiff of sanctity, ico-
nicity, and magic that drifts along with this word is not
unsuited to Beuys' ideas about the artist's role in soci-
ety.) By the time of his death in 1986, he had made hun-
dreds of multiples in many formats, including sculpture,
prints, found objects, recordings, videos, photographs,
broadsides, postcards, and books; he employed all of
his signature materials—from fat, felt, copper, iron, and
wax to text, sound, and moving imagery. Each multiple
is a condensed notation of a moment in Beuys' work
or life: an idea, a material, a performance, a drawing,
a lecture, an exhibition, a journey, a collaboration. As
a group, they provide as complete a picture of his richly
diverse output as possible, allowing viewers who may
be far removed from him in distance or time an extraor-
dinary proximity to the vitality of his ideas.

When the Walker Art Center's staff was considering,
in 1991, how best to represent Beuys in the collection,
the wide-ranging inclusiveness of a large body of

Joseph Beuys *La rivoluzione siamo Noi* 1972 phototype on polyester, ink,
ink stamp; edition 7/180 75 1/2 x 39 3/8 in. (191.8 x 100 cm) Published by
Modern Art Agency, Naples, and Edition Tangente, Heidelberg Alfred and
Marie Greisinger Collection, Walker Art Center, T. B. Walker Acquisition
Fund, 1992 1992.490

Joseph Beuys *Iphigenie/Titus Andronicus* (*Iphigenia/Titus Andronicus*)
1985 glass, iron, black-and-white photographic film negative, black-and-white film positive, stamped oil paint; Artist's Proof 4/5 from an edition of
45 28 3/8 x 21 3/4 x 1 3/4 in. (72.1 x 55.3 x 4.5 cm) framed Published by Edition
Schellmann, Munich and New York T. B. Walker Acquisition Fund, 1997
1997.74

Joseph Beuys *Amerikanischer Hasenzucker* (*American Hare Sugar*) 1974
offset lithograph on paper, packet of sugar, cotton wool, cardboard box,
ink stamps; edition 7/40 box: 2 1/2 x 3 1/2 x 4 3/8 in. (6.4 x 8.9 x 11.1 cm) closed
Published by Edition Staeck, Heidelberg, Germany Alfred and Marie
Greisinger Collection, Walker Art Center, T. B. Walker Acquisition Fund,
1992 1992.206

multiples seemed potentially more useful than the relatively limited thematic associations possible in a single sculptural work. A comprehensive (but not complete) collection of multiples was located and eventually acquired from Alfred and Marie Greisinger, collectors of contemporary art and proprietors of a pastry café in Baden-Baden, Germany. Since then, the Walker has continued to fill gaps in the collection and, at this writing, holds 492 of the 625 multiples Beuys made over a twenty-year period.

Among the best known of them is *Filzanzug* (*Felt Suit*), which Beuys made and wore in 1970 during a performance with American artist Terry Fox at the Kunstakademie Düsseldorf. Felt was a constant in Beuys' sculptural vocabulary, and signified for him not only physical warmth and insulating properties but what he called "spiritual warmth or the beginning of an evolution."[2] His phrase suggests physical transformations that are brought about through heat (as in incubation), as well as conversions of the strictly metaphysical type; wearing the *Felt Suit*, therefore, could be doubly transformative. Its form is basic and its tailoring purposely crude, without buttons or buttonholes, in keeping with the primal quality of the fabric. As Beuys put it, "Felt doesn't strive to be smart, so to speak. One has to conserve the character, omit mere trifles. . . . " This garment thus alludes to some of the fundamentals of human well-being: warmth and continual growth.

Schlitten (*Sled*) of 1969 also deals with the necessities of survival, but this object is associated with the very personal (if semi-mythical) tale of Beuys' own near-demise after a plane crash during World War II. As he later told it, the fighter jet in which he was flying was shot down during a blizzard in the Crimea, a region in Eastern Europe. Members of a nomadic tribe discovered him in the snow and tended his wounds by covering them with fat and wrapping him in felt to generate warmth. The story, which seems to have been embellished by the artist, his translators, or both, and was quickly discredited by (American) critics, has nonetheless endured, in part because it is a powerful metaphor for the near-death and rebirth of both an individual and a nation after the devastation wrought by National Socialism.[3]

In 1974 Beuys expanded on the notion of discussion-as-art by structuring his first visit to the United States as a lecture tour, with stops in New York, Chicago, and Minneapolis. The tour was an extended performance of sorts, a social sculpture that he later dubbed "Energy Plan for the Western Man." For those unable to hear him speak, he produced sixteen multiples to commemorate the trip, including postcards, prints, a videotape, and several altered found objects. One of them, *Amerikanischer Hasenzucker* (*American Hare Sugar*), came out of a chance discovery during dinner at Nye's Polonaise Room in Minneapolis on his last night in the United States. On the table he noticed a sugar packet bearing the image of a hare—with the stag, one of his totem animals—and collected as many as he could find, later using them as one element in a multiple.[4] The packet bears an odd rendering of the animal gazing at its reflection in a pool of water—an image that might suggest Beuys' self-conscious attention to his own

Joseph Beuys *Schlitten* (*Sled*) 1969 wooden sled, felt, fabric straps, flashlight, fat, oil paint, string; edition 48/50 13 3/4 x 35 7/16 x 13 3/4 in. (34.9 x 90 x 34.9 cm) Published by Galerie René Block, Berlin Alfred and Marie Greisinger Collection, Walker Art Center, T. B. Walker Acquisition Fund, 1992 1992.218

Joseph Beuys *Filzanzug* (*Felt Suit*) 1970 sewn felt, ink stamp; edition 27/100 69 x 49 1/2 x 7 in. (175.3 x 125.7 x 17.8 cm) overall installed Published by Galerie René Block, Berlin Walker Special Purchase Fund, 1987 1987.121

persona, which he often characterized as that of sha-
man or prophet pointing the way to a better future.

Beuys' work in all its rich forms is highly allusive
and draws on much of the accumulated knowledge
of Western civilization. While the success of his ambi-
tious program has been the subject of much debate,
his enormous influence on the development of postwar
art is undeniable. His exploration of sculptural form
and materials, his mesmerizing performances, and his
ideas about the powerful potential of consciously
applied creativity are still catalytic forces in the art
world. Coming to terms with his involvement in the war
was a lifelong process that informs, at least obliquely,
much of his art; at its best, his work is a rare merger of
groundbreaking formal exploration and heartbreaking
human truth.

J.R.

Notes
1. Quoted in "Questions to Joseph Beuys," an interview by Jörg
Schellmann and Bernd Klüser, reprinted in Jörg Schellmann, ed.,
Joseph Beuys: The Multiples (Cambridge, Massachusetts: Busch-
Reisinger Museum, Harvard University Art Museums; Minneapolis:
Walker Art Center; Munich and New York: Edition Schellmann, 1997), 9.
2. Quotes in this paragraph from ibid., 16.
3. For a comprehensive discussion of the crash story and its
implications, see Peter Nisbet's essay "Crash Course," in Gene Ray,
ed., *Joseph Beuys: Mapping the Legacy* (New York: D.A.P.; Sarasota,
Florida: John and Mable Ringling Museum of Art, 2001), 5–18.
4. More information about this first U.S. visit can be found in Joan
Rothfuss, "Joseph Beuys: Echoes in America," in *Mapping the Legacy*,
37–54; and in Klaus Staeck and Gerhard Steidl, *Beuys in Amerika*
(Heidelberg, Germany: Edition Staeck, 1987).

Joseph Beuys *ohne Titel* aus *Spur 1* (*Untitled* from *Trace 1*) 1974
lithograph on paper; Artist's Proof 3/17 from an edition of 98 20 1/2 x
28 1/4 in. (52.1 x 71.8 cm) Published by Propyläen Verlag, Berlin Alfred and
Marie Greisinger Collection, Walker Art Center, T. B. Walker Acquisition
Fund, 1992 1992.489

7000 Oaks, Minnesota

Perhaps the most grandly scaled of Joseph Beuys' projects
was *7000 Oaks*, a five-year effort to plant seven thousand
trees in Kassel, Germany. Begun in 1982 and completed post-
humously in 1987 (the final tree was planted by the artist's
son Wenzel), the project was carried out by Beuys and hun-
dreds of volunteers who planted trees in locations deter-
mined by community councils and citizens' initiatives. Near
each tree a basalt stele was sunk into the earth; the combina-
tion of rigid, static stone with the continuously self-trans-
forming tree was meant to evoke the harmonious coexistence
in nature of opposing states of being. Each pair was a sculp-
tural group on its own, as well as part of an enormous social
sculpture that sparked conversations about a host of social
and environmental issues.

Beuys imagined that his project would inspire similar
efforts throughout the world, professing, "We shall never stop
planting." In spring and summer 1997, the Walker Art Center
sponsored *7000 Oaks, Minnesota*, a three-part undertaking led
by independent curator Todd Bockley. During the first phase,
one thousand trees were planted in Cass Lake, a town of 860
people on Leech Lake Reservation in northern Minnesota.
Red maple, crab apple, white cedar, and plum trees were
offered to the town's residents and business owners, who
were asked to display a green ribbon on their front doors to
indicate their interest. The *Cass Lake Times* noted that the
community had come together to realize the planting and that
the trees "would provide shade for generations to come."[1]

7000 Oaks, Minnesota continued in fall 1997, when Bockley
and a group of students from St. Paul Central High School
planted trees on the school grounds and in surrounding
neighborhoods. The project's symbolic center is a single
native cottonwood tree and basalt stele, planted on October
4, 1997, in the Minneapolis Sculpture Garden adjacent to the
Walker. *7000 Oaks, Minnesota* was approved by Beuys' widow,
Eva, who keeps a register of tree-planting efforts carried out
in the spirit of her husband's work. She later responded with
a letter of appreciation: "I am so glad to hear what you do! . . .
An extraordinary idea and very fitting. Naturally I think it is
very difficult to realize this [type of project]. I at least know
how difficult the realization for Beuys in Kassel was. So I am
very grateful that there are so many in America prepared to
honor this project."[2]

J.R.

Notes
1. "1000 Trees Available for Planting," *Cass Lake Times*, May 8, 1997.
2. Eva Beuys, correspondence with Todd Bockley, January 23, 1998
(Walker Art Center Archives).

Residents of Cass Lake,
Minnesota, taking part
in *7000 Oaks, Minnesota*,
spring 1997

Dawoud Bey

American, b. 1953

- - **Commissions**
Patrick (1995)
- - **Exhibitions**
Dawoud Bey: Portraits 1975–1995 (1995; catalogue, tour),
The Cities Collect (2000)
- - **Residencies**
1995
- - **Holdings**
7 photographs

As a photographer, Dawoud Bey has been fascinated by Harlem, the New York neighborhood where his parents lived before he was born. After their move to Queens and Bey's birth, they made frequent trips back to see friends and relatives, and Bey developed a spiritual connection to the area that brought him back long after the family visits had ceased. The 1969 Metropolitan Museum exhibition *Harlem on My Mind* drew a young and politically active Bey to visit—not because it was a photography show, though he had received his first camera two years earlier, but because of the controversy that was created by the catalogue and the media.[1] He stayed and was enthralled by the photographs: "It gave me a sense of photography's documentary power, its potential to be a repository of collective memory, a doorway into another experience."[2]

Bey began photographing in Harlem in 1975, and was given a solo exhibition of his early work at Harlem's Studio Museum in 1979. These photographs, and his subsequent work made in black urban neighborhoods throughout the Northeast, drew strongly from a classic 35mm documentary style rooted in the earlier street photographs of artists such as James Van Der Zee, Walker Evans, and Roy DeCarava.

By the mid-1980s, Bey sought more from his images and began to explore the relationship between the sitter and the photographer. He switched from a handheld 35mm to the larger 4-by-5-inch view camera. He hauled this cumbersome box, complete with its dark cloth and tripod, throughout neighborhoods he had photographed a decade earlier. His long-term presence in the community and his patience with the large-format camera helped to establish a trust between the artist and his subjects. The 1989 photograph *A Young Woman Between Carrolburg Place and Half Street*, Washington, D.C., exemplifies this period of Bey's portraiture. Using Polaroid Positive/Negative Type 55 film, he was able to share the image with his subject immediately—giving the sitter a print while he retains the negative.

These startling images are hybrids. While not the voyeuristic street photographs that comfortably place the viewer in the role of passerby, they retain the grit of the street. Neither are they formal portraits like those found atop the television, piano, or sideboard in most family homes. Rather, they are arresting portraits of people who are fixtures in their neighborhoods, unfamiliar to much of the art-viewing public. Bey doesn't flinch from the bleak backgrounds and hard stares of his subjects. He allows the sitter an equal role in the making of the image, and in that instant when the shutter opens, we can sense this connection being made. Bey explains, "I wanted the subjects in those photographs to be possessed of the power to look, to assert oneself, to meet the gaze of the viewer. Having had so much taken from them, I want my subjects to reclaim their right to look, to see, and to be seen."[3]

Though Bey was seasoned as a portrait photographer on the street, his move into studio photography in 1991—complete with lights, colored-paper backdrops, and the Polaroid 20-by-24-inch view camera—was a shift that allowed the artist to explore the connecting power of the gaze even further. Gone was the context of the street that linked these earlier images to the documentary tradition. Now Bey was faced with the studio and the technology to create luscious large-format images, which he often assembled using multiple panels to invoke an underlying relationship between sitters. *Brian and Paul* depicts a pair of students from Columbia College in Chicago, where Bey was in residence for eight weeks in 1993. While their physical relationship is suggested by the hand that crosses from one image to the next, their attention is shared not with each other but with the world at large. The slightly larger-than-life scale of the images, the starkness of the setting, and the richness of the palette serve to create a formal portrait of youth culture that is at once individual and culturally familiar. Bey embraces color the same way he embraced the structure of the street's architecture—as a means to provide a context for the sitter. However, he has also said that his work of this period is rooted in the formal portraiture of Old Master painters Raphael and Franz Hals,[4] and here he revels in the rich textures and colors of each subject's clothing, jewelry, hair, and skin because the sitters themselves use these elements to establish their identity.

Elizabeth Wright Millard

Notes

1. The exhibition was controversial on many fronts—from the curator's use of audiovisual multimedia to accusations that it was too radical in one sense and too patronizing in another. Bey recalls, "The issue of anti-Semitism was raised in response to an essay by a young black

Dawoud Bey *Brian and Paul* 1993 Polaroid 29 1/2 x 43 1/2 in. (74.9 x 110.5 cm) Justin Smith Purchase Fund, 1994 1994.74

woman which appeared in the catalogue, and this controversy found its way into the media. Reading and hearing about it made me want to go see what the fuss was all about." Dawoud Bey quoted in Jock Reynolds, "An Interview with Dawoud Bey," in Kellie Jones, ed., *Dawoud Bey: Portraits 1975–1995*, exh. cat. (Minneapolis: Walker Art Center, 1995), 102.
2. Ibid., 107.
3. Artist's statement, April 25, 1994 (Walker Art Center Archives).
4. Ibid.

Dawoud Bey *A Young Woman Between Carrolburg Place and Half Street*, Washington, D.C. 1989 silver print (Polaroid Positive/Negative Type 55 film); edition 3/10 24 x 20 in. (61 x 50.8 cm) Gift of the artist in memory of Gerald E. Gladney, 1995 1995.121

Artist-in-Residence, 1995

Many of Dawoud Bey's photographic portraits are of teenagers. The steady, open gazes of these black and Hispanic urban youths evidence a self-confidence and self-awareness that contradict media-propagated stereotypes. Bey's interest in teenage subjects stems from his recognition of both their demonization in the media and their power as "arbiters of style in the community."[1] His portraits humanize these young men and women, demonstrating their unique ability to serve as emblems of their times.

Bey's Walker Art Center artist residency in the summer of 1995 brought him together with a group of sixteen Minneapolis teens for two weeks of photography workshops. Using first standard and later large-format Polaroid cameras, the participants created their own photographs and served as subjects for Bey's portraits. For the artist, the interaction was about more than just finding new subjects for his own work: "It was important to me that they have a voice as well, to describe some of their own experiences. . . . In the end, it's not just about me. There are whole communities out there that have no voice. I want my work and my projects to begin to address that."[2] Bey's photographs from his residency were displayed that fall in the Walker exhibition *Dawoud Bey: Portraits 1975–1995*. The piece titled *Patrick* (1995), of workshop participant Patrick Blanchard, was later acquired for the collection.

By drawing young people into his practice—as both participants and subjects—Bey wanted to engage them more concretely in the world of art. He recognized that teenagers are an often-overlooked audience and wanted to give them a new reason to engage with the Walker. His residency provided an excellent model for the Walker's Teen Arts Council, which was founded the following year.

L.D.

Notes
1. Jock Reynolds, "An Interview with Dawoud Bey," in Kellie Jones, ed., *Dawoud Bey: Portraits 1975–1995*, exh. cat. (Minneapolis: Walker Art Center, 1995), 106.
2. Quoted in Mary Abbe, "The Eyes of Dawoud Bey," *Star Tribune* (Minneapolis), September 15, 1995, sec. E.

Dawoud Bey (center) with workshop participants, 1995

Charles Biederman

American, 1906–2004

-- **Exhibitions**
1964 Biennial of Painting and Sculpture (1964; catalogue), *Charles Biederman: Retrospective 1934–1964* (1965; catalogue), *1966 Biennial of Painting and Sculpture* (1966; catalogue)

-- **Holdings**
3 sculptures

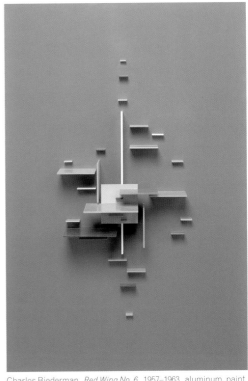

Charles Biederman *Red Wing No. 6* 1957–1963 aluminum, paint 38 7/16 x 26 1/4 x 8 5/8 in. (97.6 x 66.7 x 21.9 cm) Gift of the artist through the Ford Foundation Purchase Program, 1964 1964.31

Frank Big Bear

American, b. 1953

-- **Exhibitions**
The Cities Collect (2000)

-- **Holdings**
2 drawings, 1 edition print/proof, 1 book

Frank Big Bear *Chemical Man in a Toxic World* 1989–1990 colored pencil on paper 90 x 44 in. (228.6 x 111.8 cm) T. B. Walker Acquisition Fund, 1991 1991.10

Dara Birnbaum

American, b. 1946

-- **Exhibitions**
Let's Entertain (2000; catalogue, tour)
-- **Holdings**
2 videos, 1 book

Dara Birnbaum *Technology/Transformation: Wonder Woman* 1978
videotape (color, sound); unlimited edition 5:50 minutes T. B. Walker
Acquisition Fund, 1999 1999.73

Bernhard Blume

German, b. 1937

-- **Exhibitions**
Vanishing Presence (1989; catalogue, tour), *Photography in
Contemporary German Art: 1960 to the Present* (1992; catalogue, tour)
-- **Holdings**
1 photograph, 1 photographic suite, 1 multiple

Bernhard Blume Selection from *Kant zuliebe* (*For the Sake of Kant*)
1981 gelatin silver prints, screenprint on paper 30 x 20 in. (76.2 x 50.8 cm)
each of 5 John and Beverly Rollwagen, Cray Research Photography Fund,
1989 1989.35

John Bock

German, b. 1965

- - **Holdings**
1 multimedia work

John Bock is a shaman. No, he's a showman. A mad economist? A slapstick performer? Or perhaps he's an idiot savant? If so, then it is Bock who has put the savant back in the idiot. It is increasingly difficult to categorize the work of this artist as it ranges across a wide variety of media and practices, including installation, performance, sculpture, theater, and film. What binds his works together is that they all exude an intensely manic, anarchically humorous energy and an improvisational, ad hoc quality in their construction and enactment. The performative quality of the work is at the heart of his artistic agenda. Drawing on the absurdist legacy of Dada, the Dionysian performances of the Vienna Actionists, Joseph Beuys' shamanistic pedagogy, the agit-prop qualities of revolutionary street theater, and even the gothic heavy metal excess of Alice Cooper, Bock has developed his very own theater of the absurd that elevates multiple personalities to the level of an aesthetic strategy.

Much of the confusion surrounding Bock's work (and even within it) can be explained by the fact that he studied both economics and art, simultaneously, while attending the university in Hamburg, Germany. His earliest works fully embraced this academic schizophrenia, taking the form of what he called "lectures" in which he would use a chalkboard or an overhead projector to diagrammatically map the dynamic connections between the art world and economic systems. As these lectures evolved and their level of narrative complexity increased, the artist added more and more props that eventually took the form of full-blown stage sets. The playful subversiveness of these performances was matched by his aberrant choice of materials of a provisional and idiosyncratic nature at best, including secondhand furniture and clothing, cotton balls, toothpaste, shaving cream, and copious effluvia of other household liquids.

Like many of his works, *FoetusGott_in_MeMMe* (*FetusGod_in_Sissy*) (2002) is a sculpture that takes the form of lowbrow religious reliquary or an archaeological fragment. Its origins come from its use as a theater set for an outdoor performance staged by Bock near the Museum Fridericianum in Kassel, Germany, during the run of the exhibition Documenta 11. Four characters— The Actor, The Dead Man, The Farmer's Wife, and I Theorist (played by Bock himself)—cavort on the stage as the "memme" (the sofa at the center of the installation) prepares to give birth to a divine child. As The Actor argues with I Theorist over his accommodations, food, wages, and travel arrangements, all hell breaks loose. Performers go crashing through walls as corn flakes, iceberg lettuce, dirt, and Nivea skin cream flow freely across the stage. It is as if we had walked in on a children's summer theater production of Samuel Beckett's *Waiting for Godot*, directed by Pee-wee Herman. Taking method-acting to a riotous extreme,

Bock's performances embrace as their anthem William Butler Yeats' contention that "things fall apart; the center cannot hold," creating wildly joyful if enigmatic works that speak to the absurdity of the human condition.

D.F.

John Bock *FoetusGott_in_MeMMe* (*FetusGod_in_Sissy*) 2002 mixed media, videotape (color, sound) installed dimensions variable 11 minutes T. B. Walker Acquisition Fund, 2003 2003.52

Performance of John Bock's *FoetusGott_in_MeMMe* (*FetusGod_in_Sissy*), Documenta 11, Kassel, Germany, 2002 pictured: Thomas Loibl

Alighiero Boetti
Italian, 1940–1994

- - **Exhibitions**
Unfinished History (1998; catalogue, tour), *The Cities Collect* (2000),
Zero to Infinity: Arte Povera 1962–1972 (2001; catalogue, tour)
- - **Holdings**
1 painting, 1 multiple, 5 books, 1 periodical

In 1968, the twenty-eight-year-old Alighiero Boetti
changed his name to liberate his artistic practice. The
name change was commemorated by a photographic
postcard, titled *Gemelli (Twins)*, showing the artist stroll-
ing down a leafy allée holding hands with himself.
It's a strangely touching image in which the handclasp
signals both dominance and recessiveness. The new
name addressed the now-twinned personality of
"Alighiero e Boetti" (Alighiero and Boetti). Explaining
his newly proclaimed duality, Boetti stated: "Alighiero
is the more childlike, which is directed toward the out-
side, to a trusting environment. Alighiero is the name
used by people who know me. Boetti is more abstract
because family names categorize and classify. This is
true for everyone. The first name gives a feeling of trust
and intimate friendship. As a family name, Boetti is an
abstraction, an expression."[1]

In the previous year, Boetti had his premiere exhibi-
tions. The first was in his hometown of Turin, Italy; the
second was in Rome, which later became his primary
residence. The exhibition in Turin, at Galleria Christian
Stein, offered a startling introduction to an artist of daz-
zling variety, whose liberating use of industrial materi-
als would signal a new understanding of sculptural
possibility. It is also important to note that the exhibition
introduced Boetti to critic Germano Celant and the art-
ists Celant would that same year identify as the avatars
of a new artistic disposition, Arte Povera.

While Boetti's work remains associated with Arte
Povera to this day, he withdrew himself from its roster
only a year after he had been drawn into it. "It was a
very exciting time, especially for materials—that was
a discovery. . . . You see, the enthusiasm about seeing
all those materials was fantastic, but then it got to be
too much. Unfortunately, there were phases where
Arte Povera was like going to the drugstore, where
there is simply too much stuff available. Then in 1968
there were the exaggerations in which I participated
until I couldn't stand it anymore, and that was the end,
finito."[2] What followed was one of the most singular
and prolific arcs in twentieth-century art production.

In 1971, Boetti visited Afghanistan, which would for
the better part of the decade become his alternate
home. It was there that the artist began his series of
embroidered world maps, a campaign that lasted until
the Russian incursion in 1979, and then was revived
briefly by Afghani refugees in Pakistan between 1982
and 1985. Boetti or his assistants made drawings for the
maps, then chatted with the embroiderers, who were
given total freedom in realizing the finished artworks.
Like much of Boetti's output, the maps provide a haunt-
ing record of passing time as the seamstresses' needle-
work tightened or relaxed boundaries, as if the globe

itself were inhaling and exhaling. Such is the wonder-
ing, dualistic elegance of Alighiero e Boetti.

R.F.

Notes
1. Quoted in Rolf Lauter, *Alighiero e Boetti* (Milan: Edizioni Charta,
2004), 8.
2. Ibid., 14.

Alighiero Boetti Announcement card for his opening at Galleria Christian
Stein in Turin, Italy, 1967 Walker Art Center Library Collection

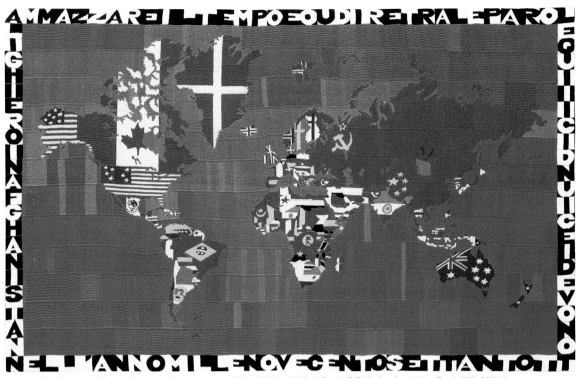

Alighiero Boetti *Mappa* (*Map*) 1978 embroidery on canvas 35 1/4 x 57 7/8 in. (89.5 x 147 cm) T. B. Walker Acquisition Fund, 2003 2003.41

Alighiero Boetti *Classifying the Thousand Longest Rivers in the World* 1997 Walker Art Center Library Collection

Agostino Bonalumi

Italian, b. 1935

Holdings

1 painting

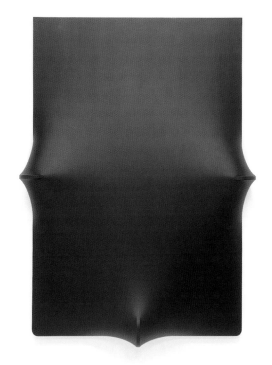

Agostino Bonalumi *Dark Grey* 1966 acrylic on canvas relief 75 x 51 x 10 1/2 in. (190.5 x 129.5 x 26.7 cm) Gift of the Contemporary Arts Group, 1967 1967.15

Lee Bontecou

American, b. 1931

Holdings

1 sculpture, 5 edition prints/proofs

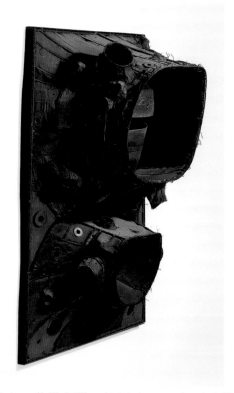

Lee Bontecou *Untitled* 1961 welded steel, canvas, wire, velvet 56 x 39 1/2 x 21 1/8 in. (142.2 x 100.3 x 53.7 cm) Gift of the T. B. Walker Foundation, 1966 1966.10

Stan Brakhage

American, 1933–2003

- - **Screenings**

Stan Brakhage: Visiting Filmmaker (1976), Filmmakers Filming (1979; catalogue), Stan Brakhage: Visiting Critic (1979), Regis Dialogue and Retrospective: Stan Brakhage: The Art of Seeing (1999; brochure)

- - **Holdings**

27 films

The Walker Art Center Film Study Collection became a reality with the establishment of the Edmond R. Ruben Film and Video Study Collection in 1973. It brings together an international selection of works, from classical cinema to the avant-garde. Its educational and critical functions are twofold: one, to analyze film in terms of its structure, the particular strategies and devices employed by the artist(s); and, two, to place the individual film within its social/cultural context to further discern the elements that contributed to its final form. Stan Brakhage's *Anticipation of the Night* (1958), acquired from the artist, was one of the founding works in the collection. To a new generation of film and media artists, it has become a crucial source for understanding the history of the abstract and representational image-recording strategies of the avant-garde.

A giant in the history of cinema, Brakhage began his creative life as a poet, and modern poetry remained an enduring influence on his prolific and seminal career as a filmmaker. His first works, made in the early 1950s, are dreamlike narratives. He made *Anticipation of the Night* by utilizing the handheld camera as an extension of his physical and spiritual being, radically releasing film from representational space. With this crucial step, Brakhage freed himself from the norms of narrative filmmaking and embarked on a combined path of abstraction and mythmaking. He made the filmic poetic.

Suggesting parallels to Abstract Expressionism, he flattened cinematic space in order to orchestrate light, color, and movement. And he signed his films, scratching "by Brakhage" into the final frames. This repeated gesture, which filled the screen with his authorial mark, is emblematic of his unique contribution to twentieth-century American art. His filmic language developed within the world of American avant-garde that included Maya Deren, Marie Menken, Joseph Cornell, Kenneth Anger, Gregory Markopoulus, and Harry Smith. His writings, first collected in "Metaphors on Vision" (1963), are key to the development of late twentieth-century film theory.[1]

Brakhage grounded film theory in the primacy of vision. In "Metaphors on Vision" he writes, "Imagine an eye unrolled by man-made laws of perspective, an eye unprejudiced by compositional logic, an eye which does not respond to the name of everything but which must know each object encountered in life through an adventure in perception."[2] His dedication to visual experience guided his approach to such mythic themes as sexuality, birth, family, and death. *Window Water Baby Moving* (1959) intimately portrays the birth of Stan and Jane Brakhage's first child. The rhythmic use of montage builds dramatic tension until the breaking of cinematic illusion becomes a metaphor for the arrival of new life.

With a prelude and four parts, the epic *Dog Star Man* (1959–1964) is a tour de force that displays the full range of Brakhage's innovative cinematic techniques, including superimposition, photographic distortion, the varying of film exposures, and marking and painting directly on the celluloid. Through such means, he envisioned the solitary pilgrimage of the artist in nature as symbolic of a worldview at once terrifying and wondrous.

John G. Hanhardt

Notes

1. Stan Brakhage, "Metaphors on Vision," *Film Culture* 30 (Fall 1963), unpaginated.
2. Ibid.

Stan Brakhage *Anticipation of the Night* 1958 16mm film (color, silent) 42 minutes Edmond R. Ruben Film and Video Study Collection Courtesy the Estate of Stan Brakhage and www.fredcamper.com

Lee Breuer/Mabou Mines

Lee Breuer, American, b. 1937; Mabou Mines, formed 1970

Commissions

Lee Breuer/Robert Telson: *The Gospel at Colonus* (1983), *Red Beads* (work-in-progress) (1999)

Performances

The Red Horse Animation; *Play*; *Come and Go* (1971), *B-Beaver*; *Arc Welding* (with Gene Highstein); *Music for Voices* (with Philip Glass); *The Saint and the Football Player* (1973), *The B-Beaver Animation*; *The Lost Ones* (1975), *The Lost Ones* (by Lee Breuer/David Warrilow); *Dressed Like an Egg* (by JoAnne Akalaitis) (1978), *A Piece of Monologue*; *Ohio Impromptu* (by David Warrilow) (1980), *A Prelude to Death in Venice* (1981), *Dead End Kids: A History of Nuclear Power* (by JoAnne Akalaitis); *Sister Suzie Cinema* (by Lee Breuer); *The Lost Ones* (by David Warrilow) (1982), *The Gospel at Colonus* (by Lee Breuer/Robert Telson) (1983; world premiere), *Hajj* (1986), *Red Beads* (1999)

Exhibitions

Artists' Books (1981)

Residencies

Mabou Mines (1972, 1975, 1976, 1977, 1999), JoAnne Akalaitis (1979), Lee Breuer (1980), Lee Breuer/Robert Telson (1981)

Mabou Mines and its cofounder Lee Breuer have been part of the bedrock of New York City's experimental theater/performance art underground for more than three decades. The collaborative formed in 1970, with an artistic mission rooted in the exploration and creation of new performance methods. In that era of countercultural unpredictability, Mabou Mines found corresponding ideals being realized by artists at La MaMa Theatre, in the Performance Group, and with fellow theater radicals Richard Foreman and Robert Wilson. However, the group remained singular in its unconventional approach to dismantling traditional power structures. Through cooperative and shared creative processes, Mabou Mines uses existing (often classical) and original texts, with members each taking a turn at the helm as directors, performers, and writers of the works they present. Over the years, the company has included JoAnne Akalaitis, Philip Glass, David Warrilow, Ruth Maleczech, and Fred Neumann.

As individuals, each brings a subjective consciousness to the selected material, which is then collectively interpreted. The subject matter has differed wildly according to its progenitor, from the company's highly stylized *The Saint and the Football Player*, examining sport as the romantic apex of American culture, to Akalaitis' heavily politicized *Dead End Kids* to Breuer's *A Prelude to Death in Venice*, starring a Bunraku puppet. Adaptations of Shakespearean classics (*Lear*; *The Tempest*) and a compendium of Samuel Beckett works (*Play*; *Come and Go*; *The Lost Ones*) are funneled through the collective's razor-sharp examination of language and influenced by their belief in the interrelatedness of each piece, regardless of frame, context, or origin.

Breuer's landmark *The Gospel at Colonus*,[1] was coproduced and co-commissioned by the Walker Art Center and the Brooklyn Academy of Music, New York, and copresented at the Guthrie Theater in the fall of 1983. Rooted in Sophocles' *Oedipus at Colonus*, this modern reimagining paradoxically explores the Greek tropes of fate and tragedy with the transcendent passion and catharsis of a black American Baptist tradition. The work was originally conceived as a companion piece to Mabou Mines' *Sister Suzie Cinema* (1980), which examined the contemporary lyrical impact of doo-wop and rhythm and blues and its importance as an iconic force in the American consciousness. But it became increasingly clear that *The Gospel at Colonus* required its own, separate production. Composed by Robert Telson, the music featured the J. D. Steele Singers, Morgan Freeman, and the Five Blind Boys of Alabama, with the group's Clarence Fountain playing Oedipus. By using classical Greek narrative with cadence and oratory based in black American gospel and storytelling history, Breuer laid a path toward a new American classicism. Astoundingly, his experimental sensibilities were not diluted in the revisitation of established tomes; instead, his controversial adaptations upended easily digestible stories, rendering them almost unrecognizable. His own distinct reality was forged in the understanding that new performance values must be continuously applied to text and language to remain vital. Like culture, like aesthetic, Mabou Mines' artistic process and its (neverending) result are in constant flux.

D.B.

Notes

1. Developed by Breuer separately from Mabou Mines.

Lee Breuer/Mabou Mines *The Gospel at Colonus* Guthrie Theater, Minneapolis, 1983

Marcel Broodthaers
Belgian, 1924–1976

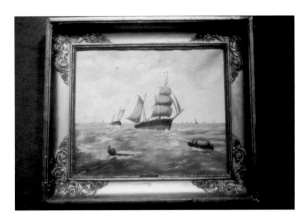

-- **Exhibitions**
Marcel Broodthaers (1989; catalogue, tour), *Duchamp's Leg* (1994; catalogue, tour), *Painting at the Edge of the World* (2001; catalogue), *The Last Picture Show: Artists Using Photography, 1960–1982* (2003; catalogue, tour)
-- **Holdings**
4 paintings, 23 films, 1 multiple, 12 books, 1 periodical

Marcel Broodthaers was a poet-turned-visual artist who made his first work in 1964, at age forty, by embedding in plaster all remaining copies of his book of poems, *Pense-Bête*.[1] With this droll gesture he embarked on a brief but prolific career during which he made paintings, sculpture, films, books, and prints as well as exhibitions/installations of his own work, which he referred to as "décors"—all suffused with his graceful wit and love of language. He was entranced by the interplay among objects and the images, words, and ideas we use to evoke them, a focus that links his works closely to those of Belgian artist René Magritte and French poet Stéphane Mallarmé, both of whom he acknowledged as influences. But Broodthaers' practice was a postmodern one, and as such it also addressed issues surrounding the production and consumption of art as well as the cultural conditions through which we experience it.

He managed to broach these conceptual themes in a disarmingly simple way. Many of his sculptural works were made from found objects—mussel shells, spades, wine bottles, buckets, magazine clippings—that he juxtaposed in surprising ways, as in the glass-fronted white cupboard filled completely with eggshells or the tower of glass jars containing identical photos of a woman's glamorously made-up eyes. These are elegant objects, but also sly memoranda on the relationship between the original and the reproduction.

Broodthaers' slide-projection piece *Bateau Tableau* (*Boat Picture*) (1973) is one of about two dozen works he made in this format.[2] Its eighty images are all photographs of one object: a late nineteenth-century amateur painting of boats at sea, which he had purchased in a Paris curio shop.[3] He photographed the entire canvas along with dozens of details—billowing sails, flapping flags, crew members perched on the gunwales, cloudy skies—then arranged them in a sequence that begins with shots of the painting framed, then unframed, as if it had been released from stasis and sent on its way. Thereafter, the shots vary between close-ups and long views, a rather filmic method that suggests a narrative about a journey on the high seas.

Tucked into this story are photographs of the frayed canvas tacked to the painting's edge, and images in which the painting slips out of the film frame, as if the slide has become stuck in the projector. These pictures gently remind us that this is not a boat, but an image of one; not a painting but photographs of a painting. As Magritte demonstrated, we often confuse these categories; in this work's rhyming title, Broodthaers gives us a linguistic demonstration of how easily we can make

Marcel Broodthaers Selections from *Bateau Tableau* (*Boat Picture*) 1973
80 35mm slides; installed dimensions variable T. B. Walker Acquisition Fund, 1997 1997.102

this mistake. He remarked, "If you repeat 'tableau' and 'bateau' ten consecutive times, you will inevitably end up by saying bateau instead of tableau and tableau instead of bateau, and by the sound of things you could hold forth on the last bateau as easily as on the last tableau."[4] Broodthaers' literate work is similarly limber, in both mind and eye.

J.R.

Notes

1. *Pense-bête* is a French term for a mnemonic device, like putting a knot in a handkerchief, but also suggests the phrases "think animal" and "think stupid." See Michael Compton, "In Praise of the Subject," in Marge Goldwater, ed., *Marcel Broodthaers*, exh. cat. (Minneapolis: Walker Art Center, 1989), 24.

2. For a discussion of Broodthaers' many slide projections, see Anna Hakkens' essay in Frank Lubbers, Anna Hakkens, and Maria Gilissen, eds., *Marcel Broodthaers, projections*, exh. cat. (Eindhoven, the Netherlands: Stedelijk Van Abbemuseum, 1994), 10–33.

3. Manuel J. Borja-Villel, Michael Compton, and Maria Gilissen, eds., *Marcel Broodthaers: Cinéma*, exh. cat. (Santiago de Compostela, Spain: Centro Galego de Arte Contemporánea, 1997), 226. The painting was also the subject of four related works: the films *Analyse d'une Peinture* (*Analysis of a Painting*) (1973) and *Deux Films* (*Two Films*) (1973), and a film and book of 1973–1974, both titled *A Voyage on the North Sea*.

4. Quoted in Hakkens, *Marcel Broodthaers, projections*, 25.

Broodthaers Films

Marcel Broodthaers made more than forty films in a period of less than twenty years. Yet his films are rare: they were not widely distributed and even today are infrequently screened.[1] Their importance, however, is unquestionable. They are essentially a bridge between the earlier modernist tradition of an artist making a film or two (as embodied by Fernand Léger and Marcel Duchamp) and the contemporary practice of an artist employing it as a coequal medium.

Broodthaers often referenced silent trick cinema and slapstick comedies. Early motion pictures captured boldfaced dichotomies: they appealed to the uneducated and to intellectuals alike; they entertained and offered trenchant social critique. For an artist obsessed with the complexity of definitions (both verbal and visual), film history provided the means to explore the medium and, above all, a way to question its relation to reality. Broodthaers' films thus form an urtext for postmodern visual art.

Context is now a touchstone in contemporary art, but this concept is one that Broodthaers examined early on in his films: How does an object, event, or idea change when it is physically, temporally, culturally relocated? In his last film, *La Bataille de Waterloo* (*The Battle of Waterloo*) (1975), Broodthaers reflected on this question by intercutting images of his London exhibition with footage of the British Trooping of the Colour and that of an actress undoing an Italian toy puzzle called "La Battaglia di Waterloo." Repositioned in our time, the historical battle becomes subsumed and repackaged by popular culture and the commercial world. For Broodthaers, this result was emblematic, inevitable, and vital.

D.S.

Notes

1. The Walker holds twenty-three films by Broodthaers, which were donated by his widow, Maria Gilissen, on the occasion of the artist's 1989 Walker-organized retrospective.

Marcel Broodthaers *La Bataille de Waterloo* (*The Battle of Waterloo*) 1975 16mm film (color, sound) 11 minutes Edmond R. Ruben Film and Video Study Collection

Glenn Brown

British, b. 1966

- - **Exhibitions**
"Brilliant!" New Art from London (1995; catalogue, tour)
- - **Holdings**
1 painting

Since the early 1990s, Glenn Brown has been engaged in a kind of Romantic necrophilia, resuscitating the expired painterly bodies of Surrealist Salvador Dalí, sci-fi illustrator Chris Foss, and British postwar Expressionist painter Frank Auerbach, among others. In each case, Brown has appropriated images of their works, either in part or in whole, from reproductions of the original paintings that he has found in books. He then meticulously and obsessively copies the images onto canvas, being sure to erase all traces of his own gestural brushstrokes. His version of an Auerbach, for example, appears from afar to be as tumultuous and thickly impastoed as the original; on closer inspection, however, it becomes clear that Brown is a master of trompe l'oeil. The textured surfaces of his source paintings are rendered in hyperreal near-flatness, the result of a painstaking and time-consuming technical process he developed for the purpose. He also sometimes crops his source images, changes their colors, or skews their perspectives. This gap between his "night of the living dead" (the title of one of his early works) and their original daylight counterparts instills his work with an underlying sense of Romantic longing.

Brown's quotation and subsequent transformation of these source paintings is not, however, simply another instance of postmodern irony. Unlike the strategies of photographic appropriation practiced by a previous generation of artists, including Richard Prince and Sherrie Levine, Brown's works—each of which often takes up to five months to complete—have an intensely laborious, almost lovingly handcrafted quality. In fact, in a certain sense, his paintings give a new meaning to Robert Smithson's invocation of Vladimir Nabokov's assertion that "the future is but the obsolete in reverse," as Brown works backward through many mediated layers of the reproduction of these paintings in order to put them back onto the canvas by hand. As he explains, "In all of [my sources], there was originally a model sitting in a chair in the studio who gets characterized by that artist. He finishes it and it gets photographed. Then the photograph gets turned into a print, which gets put into a book. I get that book and do my painting from it. Through those stages, the original person gets further and further back. Further and further lost, further removed. The whole notion that there was a character underneath the image kept me wanting to do them. It was that sense of loss, as if they were ghosts."[1]

Brown's *You Never Touch My Skin in the Way You Did and You've Even Changed the Way You Kiss Me* (1994) is based on an Auerbach painting of 1983, *Head of Julia*, which Brown found reproduced in a gallery catalogue.[2] His doppelgänger Auerbach focuses only on a central portion of the head featured in the original, greatly enlarging it while changing and intensifying

its colors. Like all of Brown's work, it is as much a meditation on our relationship to memory as it is on the act of painting itself. He once likened his painterly program to the planet in Andrei Tarkovsky's science-fiction film *Solaris* (1972), which resurrected replicant versions of dead people from the memories of the living. As the artist has suggested, "I'm bringing things which aren't real back into a state of physically being there. The sadness is that these things know they're not real."[3]

D.F.

Notes
1. Douglas Fogle, "Interview with Glenn Brown," in Richard Flood, ed., *"Brilliant!" New Art from London*, exh. cat. (Minneapolis: Walker Art Center, 1995), 16.
2. Brown borrowed the title—itself a poignant metaphor for his project—from a 1989 song by pop singer Lisa Stansfield.
3. Fogle, "Interview with Glenn Brown," 17.

Glenn Brown *You Never Touch My Skin in the Way You Did and You've Even Changed the Way You Kiss Me* 1994 oil on canvas 60 x 48 1/4 in. (152.4 x 122.6 cm) Butler Family Fund, 1994 1994.166

Trisha Brown
American, b. 1936

Trisha Brown arose from an era in which American dance found itself in a kind of stasis. With a few notable exceptions, the idioms of modern dance had, for many, reached their creative and constructive limits. The emergence of a new vocabulary in the 1960s was predicated by a social climate of upheaval and the interrogation of established dance theory. Along with her contemporaries, Brown helped forge a new, decentralized form of communication that launched a postmodern dance aesthetic. With the formation of the Trisha Brown Dance Company in 1970, her work has evolved organically in expansive directions (including opera, dance cycles, and large-scale pieces for proscenium stage), with each new phase a distillation of the singular movement style she has created.

In 1961, Brown began attending choreographer Robert Dunn's composition classes in Merce Cunningham's New York studio. In this laboratory climate of new ideas—participants included Robert Rauschenberg, Simone Forti, and Yvonne Rainer—a wide range of creative and social concerns converged into what became known as the Judson Dance Theater (1962–1967), of which Brown was a founding member.[1] The experimental performance group was loosely configured, but its participants rallied around a then-revolutionary concept that aimed to erase the distinctions between art and life. Informed by the cross-pollination of artistic disciplines and guided by an egalitarian ethos of nonevaluative critique, all subjects and devices—nondancers, games, improvisation, pedestrian action—were considered legitimate material.

Although the first planned Judson/Walker Art Center residency in 1967 was reconsidered,[2] many of the company's associates reconvened as the Grand Union (1970–1976). In 1971 they opened the Walker's new building with a residency and performances, the group's first significant paid engagement.[3] With Brown in its ranks, they transformed the concourse/lobby into an explosion of cardboard boxes and miscellany, while climbing over and around a precarious cagelike structure—an early test of spatial and stage boundaries.

Rejecting the tyranny of a rigid vocabulary, the new dance examined beauty, style, history, and context. It was anti-academy, strove for personal authenticity, and transmuted ephemeral ideas into being through movement. The latter is personified in *Homemade* (1965), a deconstruction of perception versus reality. With a projector strapped to her back, Brown moved simultaneously with a film (by Robert Whitman) of herself performing identical movements. With *Floor of the Forest*[4] (1970), she conjured a symbolic woodland indoors with a grid made of pipes and clothing suspended from the ceiling; in *Man Walking Down the Side of the Building* (1970), she challenged the dancer's traditional nemesis—gravity—using pulleys and ropes instead of leaps and spins.

The first *Accumulation* pieces (made in 1971) were based on mathematical growth patterns and entailed the enactment of a basic exercise (a rotating fist with extended thumb) in repetition. New motions were added at intervals, creating a string of systematically repeated actions that could be staged almost anywhere. More than an exercise in simple locomotor movement, *Accumulation* marked a significant moment—it was both a dance and not a dance. Either way, it emphasized Brown's capacity to subtly demonstrate her thinking process while leaving the imagined possibilities wide open. She complicated the task in the Walker debut of *Group Primary Accumulation* (1973), which was performed on rafts floating on Minneapolis' Loring Pond.[5] Displacement (dancers floated into new positions while enacting the dictum) resulted in a changed physical proximity to the ground/water and to each other, further causing an unconscious shift in variation.

With each new dance, Brown posed a set of problems, sometimes to be solved through actions, other times spawning only new questions. The Walker-commissioned landmark *Glacial Decoy*[6] (1979) deliberately shunned the buildup of movement, instead relying on sudden and unexpected shifts in phrase that fractured traditional patterns of climax. An indicator of the large-scale, theatrically complex work to come, *Glacial Decoy* crystallized the personal choreographic language Brown has developed and continues to hone. In *Son of Gone Fishin'* (1981), music and choreography were used as parallel developments; *Lateral Pass*[7] (1985) demanded attention to the purely mechanical actions of falling and standing via time-based construction. Brown's commanding use of controlled impulse is elemental in later works such as *El Trilogy* (2000), an homage to the spirit and structures of jazz.

In Brown's view, "the image, the memory, must occur in performance at precisely the same moment as the action derived from it. Without thinking, there are just physical feats."[8] The postmoderns lifted the veil on dance creation, acknowledging its inner workings and moving out of its hermetically sealed world into a wider domain of ideas, debate, and criticism. This new platform opened the door for reflexive dialogue between traditions and vocabulary, making room for a subversion of history, even as a new one was created.

D.K.

Notes

1. Attendees in Dunn's class included David Gordon, Yvonne Rainer, Paul Berenson, Deborah Hay, Steve Paxton, and others.

2. From unpublished correspondence between Steve Paxton and then-Performing Arts coordinator John Ludwig. Jill Johnston and Yvonne Rainer fell ill; Ludwig expressed reservations about Judson's proposed work being the right approach for the Walker at that time (Walker Art Center Archives).

3. For details on the circumstances surrounding the residency and its larger philosophical implications for the group, see Sally Banes, *Terpsichore in Sneakers: Post-Modern Dance* (New York: Houghton Mifflin Company, 1977), 227.

4. For its Walker-sponsored performance in 1979, the work incorporated piles of clothing, books, and other debris, and was therefore titled *Rummage Sale and Floor of the Forest*.

5. The work was titled *Raft Piece* for the 1974 Walker performance.

6. Set by Robert Rauschenberg.

7. Set by Nancy Graves.

8. Quoted in Lise Brunel, *Trisha Brown* (Paris: Éditions Bougé, 1987), 46.

Trisha Brown Dance Company *Lateral Pass* Hamline University Theater, St. Paul, 1985

Trisha Brown Dance Company *Group Primary Accumulation (Raft Piece)* Loring Pond, Minneapolis, 1974

Scott Burton
American, 1939–1989

-- **Exhibitions**
Scott Burton Chairs (1983; organized by the Fort Worth Art Museum, Fort Worth, Texas, and the Contemporary Arts Center, Cincinnati, Ohio; catalogue), *The Garden in the Galleries* (1994)
-- **Holdings**
4 sculptures

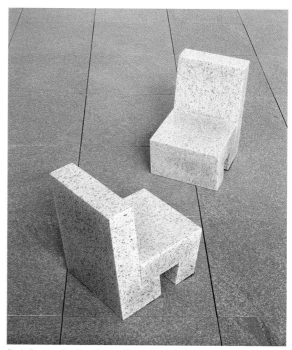

Scott Burton *Two-Part Chairs, Obtuse Angle (A Pair)* 1983–1984 granite; edition 1/2 33 x 24 x 33 in. (83.8 x 61 x 83.8 cm) each Gift of the Butler Family Fund, 1984 1984.3

Scott Burton was an artist of stunning clarity who retained an ambiguous relationship with the term "artist" until his death in 1989. His career encompassed (in the following order) brilliantly cogent criticism, sparingly minimalist performance, occasional curatorial excursions, and a body of sculpture that was also liberatingly usable furniture. The form to which he devoted his greatest concentration was the chair. At first he simply made arrangements of furniture found abandoned on the street, setting up tableaux and experimenting with serenely uninflected activities that would ultimately lead to performances (which he called "Behavior Tableaux") in which the human body and the furniture shared a choreographic codependency ("preverbal kinesic and proxemic systems of human interaction"[1]). The final stage of Burton's development was the creation and utilization of his furniture in the public realm, where it was intended to be both amenity and totem. He was very much concerned with the totality of the gesture whereby his sculpture was conceived in relationship to the architecture of the landscape. It was important to Burton that he was recognized as a public artist.

Today, Burton's career feels particularly modern in its embrace of the ambivalent and its unwillingness to just resolve itself into a single practice. His intricate relationship with function and aesthetics began quite early. In an interview with critic Peter Schjeldahl, Burton talked about the towering importance of design to his work: "[In] Washington, D.C., in the '50s, where my family had moved from Alabama, modern furniture just spelled modernism to me, and modernism spelled liberation. It was still avant-garde then. Furniture companies like Herman Miller, Knoll, and Dunbar meant as much to me as Picasso and de Kooning, in much the same way. I was just obsessed."[2] In the end, Burton was annoyed at being constantly asked to differentiate his work between design and art; for him there was no difference. The synthesis he achieved between the two was due solely to the intense, questioning creativity he brought to both.

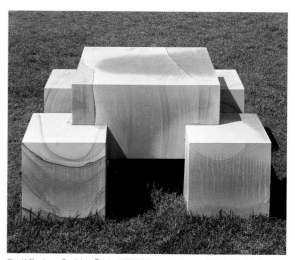

Scott Burton *Seat-Leg Table* 1986/1991 sandstone; edition 2/5 28 1/2 x 56 x 56 in. (72.4 x 142.2 x 142.2 cm) Gift of Honeywell Inc. in honor of Harriet and Edson W. Spencer, 1992 1992.159

R.F.

Notes
1. Scott Burton, correspondence with Martin Friedman, March 14, 1972 (Walker Art Center Archives): "It uses several performers whose movements and groupings illustrate preverbal kinesic and proxemic systems of human interaction ('body language' and 'personal space' arrangements)."
2. Quoted in Peter Schjeldahl, "Scott Burton Chairs the Discussion," *Village Voice*, June 1, 1982, 86.

James Lee Byars

American, 1932–1997

- - **Holdings**
1 sculpture, 5 multiples, 5 books

Though raised in suburban Detroit, James Lee Byars spent the formative years of his itinerant artistic career in Japan, where from 1958 he based himself in Kyoto for a decade. Byars immersed himself in the art and philosophy of the country, teaching English to support himself while studying traditional ceramics and papermaking with master craftsmen. His early works—large, concertina-folded paper constructions revealed in long ceremonial performances—were inspired by the elegance and economy of traditional Noh theater. Though he had made frequent trips back to the United States during his Japanese sojourn, Byars returned home in 1967 for a more extended stay. Here his work encompassed a series of staged group actions in which people interacted with huge garment constructions. In *Film Strip* (1967), for example, dozens of volunteers donned a vast clear plastic poncho and paraded at midnight in front of New York's Metropolitan Museum of Art.

The white suit and gold mandarin outfit, the masked face, the top hat, and the lashings of purple silk—Byars' persona and sartorial proclivities from here on would maintain an undoubtedly earnest sympathy for Zen philosophy on the one hand, yet on the other an increasing fondness for irony-free operatic glitz that could teeter into wonderfully "wrong" grandiose allusions. His attention would increasingly turn toward Europe. Whether standing on the pediment of the Museum Fridericianum at Documenta 5 in Kassel, Germany, in 1972, unfurling a giant cloth figure of the Holy Ghost in the Piazza San Marco for the Venice Biennale in 1975, presenting near-annual exhibitions at the celebrated Wide White Space Gallery in Antwerp, or staging his first major solo show at the Kunsthalle Bern in 1978, the artist and his sagelike appearances became a staple of the continental art circuit.

Throughout the 1980s, while based in Venice—a fittingly unique, decadent, and East-West intersecting city—Byars began to make more sculpture. Huge pillars, discs, urns, halos, and particularly spheres in white marble, gilded marble, or basalt stood in contrast to his fragile paper works or fleeting performance actions. There is something disconcerting about Byars' elemental, impenetrable forms of this period and their cosmic, celestial, or even occult baggage. Like the iridescent slabs of artist John McCracken, or the pillar in Stanley Kubrick's film *2001: A Space Odyssey*, they harness an otherworldly reverence that makes them seem as if they could hover or break apart to unleash untold powers at any moment.

A series of works from around 1986 consists of cryptic objects—marble lozenges, star- and donut-shaped "books"—presented in antique-looking tall wooden reliquaries. *The Philosophical Nail* (1986) alludes to the paraphernalia of sainthood and the crucifixion of Christ, hijacking the Catholic cult of the veneration of holy relics. Said to be able to spontaneously duplicate

themselves and transmute their purported powers through mere proximity, pieces of the cross, holy lances, holy nails, and the like represent a paragon of Duchampian transubstantiation as they vanquish their humble origins to attain disproportionate significance. Also recalling phrases such as "hitting the nail on the head," this bent tack literalizes linguistic shorthand for succinctness or perfection, terms around which Byars' oeuvre circles in fickle orbit.

M.A.

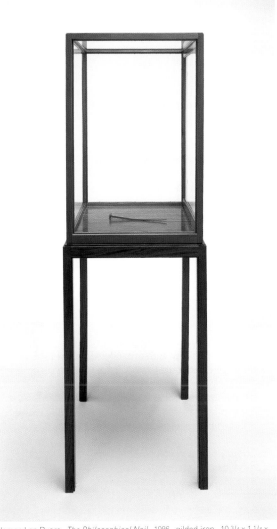

James Lee Byars *The Philosophical Nail* 1986 gilded iron 10 3/4 x 1 1/4 x 1 1/4 in. (27.3 x 3.2 x 3.2 cm) Gift of the Judith Rothschild Foundation, 1999 1999.59

André Cadere

French, b. Poland, 1934–1978

-- **Exhibitions**
Artists' Books (1981)
-- **Holdings**
1 sculpture

In 1970, André Cadere embarked on his signature body of work—the *Barres de bois rond* (*Round Bars of Wood*), which were a part of a larger conceptual project that he would sustain until his untimely death in 1978. For each of the approximately one hundred eighty bars he created during his short career, the artist followed a consistent process: he cut dowels of various sizes into segments for which diameter equals length,[1] drilled a hole in the center, and painted each unit before "stringing" them like beads onto a smaller dowel and gluing them into place. Cadere imposed limitations in terms of color and size: his palette was restricted to red, orange, yellow, green, blue, violet, black, and white, and the overall length was kept to only those dimensions that would allow him to carry a bar comfortably.[2]

The organizing principle behind the *Barres de bois rond* was Cadere's application of seven mathematical systems that he called "permutations," into which he introduced an intentional error. Each bar followed one of the systems to dictate the order of the colored segments.[3] By employing this complex process, he sought to create what he called "established disorder,"[4] an oxymoron he found useful to his exploration of duality.

Although each bar is an independent work of art, they also became subsidiary components in an ongoing, peripatetic performance. His primary concern was to eschew dependence on cultural institutions by showing his works in unorthodox ways. On numerous occasions he entered (uninvited) what he called "artistic sanctuaries" and surreptitiously placed one of his bars among the works in the exhibition; an anarchic, intrusive act that caused great consternation among his fellow artists and curators. The ensuing disruption was of principal importance to his critique of the art establishment. He also carried his pieces in the streets, parks, and cafés of Europe's art capitals, thereby creating his own exhibition spaces. According to Cadere, "[It] is obvious that a round bar of wood can be exhibited anywhere, without patron or client, a special location, or an express authorization. . . . However, the very same work can be hung on a wall—including a gallery wall—and fixed or set up in any number of ways in the place traditionally assigned to 'classical' works. For it is important that this 'classical' power should not marginalize my pieces, isolating them in something like an 'avant-garde' zone."[5] It is clear that Cadere was no naïf; he was aware that in order for his work to be seriously considered by the art intelligentsia, he would have to acquiesce occasionally to traditional installation modes. This element of flexibility enabled him to show his work "toward and against everyone and everything."[6]

E.C.

Notes

1. Since each of the bars is handmade, the actual diameter and length of each segment is variable.

2. The number of colors in a single bar ranges from three to seven, and the number of segments from as few as twelve up to fifty-two. The Walker's piece has four colors: white (W), black (B), orange (O), and red (R); and fifty-two segments, an example of one of the longest bars he made.

3. For instance, the bar in the Walker's collection adheres to the following permutation: 1234-2134-2314-2341-3241-3421-3412-4312-4132-4123-1423-1243-1234. Starting with the white end, with W = 1, B = 2, O = 3, R = 4 (error below in bold): WBOR-BWOR-BOWR-BORW-OBRW-ORBW-ORWB-**OR**WB-RWOB-RWBO-WRBO-WBRO-WBOR. Starting with the red end, with R = 1, O = 2, B = 3, W = 4 (error below in bold): ROBW-ORBW-OBRW-OBWR-BOWR-BW**RO**-BWRO-WBRO-WRBO-WROB-RWOB-ROWB-ROBW. All seven of Cadere's numerical permutations can be found in Bernard Marcelis, "André Cadere: The Strategy of Displacement," in Carole Kismaric, Chris Dercon, and Bernard Marcelis, eds., *André Cadere: All Walks of Life*, exh. cat. (Long Island City, New York: P.S. 1 Contemporary Art Center, 1992), 77–82.

4. Quoted in Marcelis, "Strategy of Displacement," 74.

5. Quoted in David Bourdon, "André Cadere, 1934–1978," *Arts Magazine* 53, no. 3 (November 1978): 103.

6. Cadere, excerpt from correspondence to his dealer Yvon Lambert, June 5, 1978, in *All Walks of Life*, 22.

André Cadere *Barre de bois rond (Round Bar of Wood)* 1977 wood, paint 71 1/2 x 1 1/4 x 1 1/4 in. (181.6 x 3.2 x 3.2 cm) Justin Smith Purchase Fund, 2001 2001.209

John Cage

American, 1912–1992

The enduring legacy of John Cage is one of visionary scope and joyous exploration. His wide-ranging artistic interests encompassed music, poetry, painting, dance, and other creative realms. His private and intellectual pursuits were many; he was also a philosopher, amateur mycologist, student of mathematics, and lover of botany. Throughout his remarkable life, he sought integration of the myriad worlds he touched, both public and personal.

Cage created his own instrumentation to fit the precise needs of his compositions, including what he called the "prepared piano,"[1] for which he would write numerous works. He viewed all sounds as legitimate musical territory, an attitude that, when put into practice, elicited both negative and ecstatic reactions from an audience. In his quest to locate a music that held no fixed meaning but would elucidate the oneness of everyday life and art, he embraced the use of silence as sound in formal composition (as in his classic *4' 33"*).[2] Free of cultural or philosophical associations, the work demanded active listening on the part of the audience and suggested a sculptural quality that allowed ambient noise to become almost a visualization of the building blocks of sound.

Another groundbreaking development was Cage's compositional theory of indeterminate notation. Based on his interest in chance, the method brought together two disparate factions: notation as a controlled variable and live performance, in which notes could be repeated yet never exactly replicated. By the time of his first headline visit to the Walker Art Center in 1964,[3] Cage was employing these and other innovations in relation to dance,[4] primarily with choreographer Merce Cunningham. Both believed the two disciplines, though independent formations, could work collaboratively. They would return to the Walker many times over the next twenty-five years, in a variety of incarnations, including a memorable split evening in 1974 during which Cage recited *Empty Words* (1974), a nonsyntactical mix of phrases, words, syllables, and letters written by subjecting Henry David Thoreau's journal to *I Ching* (*Book of Changes*) chance operations.

Cage also performed at the Walker numerous times as a solo artist. In 1970, he orchestrated *Musicircus* (1967), a wild, Happening-like event with a colorful array of performers at Macalester College in St. Paul.[5] In the following decade, he wrote *Music for Five*[6] (1985) for Zeitgeist, the Twin Cities–based new music ensemble that performed its U.S. premiere.

Cage lived as he composed his musical works, with an eye toward questions rather than answers. His appreciation for the complexities and paradoxes contained in modern life allowed him to imagine limitless possibilities in music and other endeavors. The impact of his contributions continues to reverberate today, not only in the tradition of the avant-garde, but as part of the mainstream culture, a testament to the veracity of his work and the beauty of his life.

D.K.

Notes

1. Cage would hang a variety of nuts, bolts, screws, and industrial materials on the interior strings of a standard piano, resulting in the desired timbre and sound range of a percussion orchestra.
2. For a discussion of this piece, see David Revill, *The Roaring Silence: John Cage: A Life* (New York: Arcade Publishing, 1992), 165–166. The piece *4' 33"* was first performed on August 29, 1952, by Cage's longtime pianist, David Tudor. One audience member stood and declaimed, "Good people of Woodstock, let's drive these people out of town."
3. He appeared with Merce Cunningham Dance Company (including Steve Paxton and Viola Farber), Robert Rauschenberg, and David Tudor. Cage served as the dance company's musical advisor from 1953 to 1992.
4. Revill, *Roaring Silence*, 75. Cage wrote music for choreography as early as 1940, including pieces for Gertrude Lippincott, a Walker benefactor and organizer of the institution's first dance concert.
5. Performers included gymnasts, Swedish folk dancers, a "soul" choir, ballroom dancers, bagpipe players, rock bands, harpsichordists, kazooists, barking dogs, flautists, and many others.
6. Formally annotated as *Music for*, the title changes according to the number of players.

John Cage (left) and Merce Cunningham *A Dialogue* Walker Art Center Auditorium, 1974

Alexander Calder

American, 1898–1976

Exhibitions

Second Annual Regional Sculpture Exhibition (1945; catalogue), *Contemporary American Painting and Sculpture: Collection of Mr. and Mrs. Roy R. Neuberger* (1952; catalogue), *Lowenthal Collection of American Art* (1952; catalogue), *Alexander Calder* (1953), *Reality and Fantasy, 1900–1954* (1954; catalogue), *Eighty Works from the Richard Brown Baker Collection* (1961; catalogue), *Calder's Universe* (1977; organized by the Whitney Museum of American Art, New York), *The Garden in the Galleries* (1994)

Holdings

4 sculptures, 1 unique work on paper, 1 edition print/proof, 3 books, 1 model

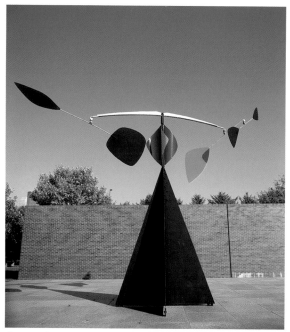

Alexander Calder *The Spinner* 1966 aluminum, steel, paint 235 x 351 x 351 in. (596.9 x 891.5 x 891.5 cm) Gift of Dayton Hudson Corporation, Minneapolis, 1971 1971.16

Ann Carlson

American, b. 1954

Commissions

Dead (1989), *Rodemeover* (1996)

Performances

Middle Child (1988), *Dead* (1989; world premiere), *Animals* (1990), *Rodemeover* (1996; world premiere)

Residencies

1989, 1996

Ann Carlson *Dead* Walker Art Center Auditorium, 1989

Anthony Caro

British, b. 1924

- - **Exhibitions**

Anthony Caro (1975; organized by the Museum of Modern Art, New York, and the Museum of Fine Arts, Boston; catalogue)

- - **Holdings**

3 sculptures, 3 unique works on paper, 1 multiple

The story of Anthony Caro's emergence as one of the most celebrated postwar sculptors has all the elements of a great myth of accession. In the early 1950s, Caro was the foundry assistant to the most radical British sculptor of the day, Henry Moore, and his own work echoed his mentor's distorted bronzes of the human figure. Yet following a trip to America in 1959—where he met artists David Smith, Kenneth Noland, and Robert Motherwell as well as critic Clement Greenberg—Caro underwent a Damascene conversion and famously abandoned figuration, did away with pedestals, gave up "making objects" and "that whole illustrative thing."[1] By 1962, his sculptural language featured large, sprawling constructions made from bolted and welded scrap metal, which were painted in single bright colors. With the fervent support of American critics, particularly Greenberg and Michael Fried, Caro introduced a fresh set of concerns to sculpture that became both a touchstone and a justification for the "rightness," "essence," and "necessity" of modernist formalism. His canonization by American institutions was sealed by the New York Museum of Modern Art retrospective of his work, which the Walker Art Center hosted in the fall of 1975.

Caro's new sculptures were composed and assembled—rather than carved or cast—with elements dispersed and scattered in a resolutely nonmonumental, ground-skimming fashion. *Sculpture Three, 1962* (1962) is exemplary of this first flush of what might be described as sculpture-drawing. Here it's as if his capacity to make massive metal sculpture appear whimsical mocks all the clichés of the sculptor and his combative assault on unhewn slabs. Like the mobiles of Alexander Calder, though without the politeness to organize themselves around a pivot, Caro's works of this period trade in lightness and eccentric balletic poise.

Fried and Greenberg couched such works in militantly formalist ways; for them, "all the relationships that count are to be found in the sculptures themselves and nowhere else."[2] Yet looking at *Sculpture Three, 1962* more than forty years later, it seems as bright as children's playground apparatus or a line of chic agricultural equipment—less pedantically self-obsessed, less bombastically "compelled by a vision" than these arch-modernists would have had us believe.[3]

M.A.

Notes

1. Roy M. Close, "Remodeled self led to constructed art," *Minneapolis Star*, September 12, 1975, sec. 2B.

2. Michael Fried in the introduction to Caro's 1969 retrospective catalogue at the Hayward Gallery, London, quoted in Peter Fuller, "Anthony Caro," *Studio International* 193, no. 985 (January–February 1997): 70.

3. Clement Greenberg, "Anthony Caro," *Arts Yearbook 8: Contemporary Sculpture* (New York), 1965, 106–109. Reprinted in *Studio International* 174, no. 892 (September 1967): 116–117.

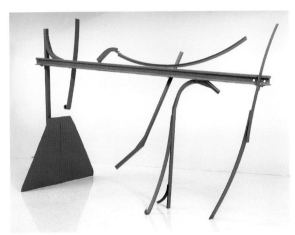

Anthony Caro *Sculpture Three, 1962* 1962 steel, aluminum, paint
78 1/2 x 62 7/8 x 148 5/8 in. (199.4 x 159.7 x 377.5 cm) Gift of the T. B. Walker Foundation, 1967 1967.27

Matthew Carter
British, b. 1937

- - **Commissions**
Walker typeface (1994–1995)
- - **Exhibitions**
Graphic Design in America: A Visual Language History
(1989; catalogue, tour), *Walker Design Now* (1996)

Since its inception, the Walker Art Center has embraced design not only as a programming activity but also as an important element in forming its public image. The Walker practically invented the modernist institutional identity for museums, which favored sans-serif typefaces, generous white space, and a grid system to arrange words and images. This style had dominated its graphic identity for more than thirty years.

In the early 1990s, the Walker sought to more openly reflect its multidisciplinary programs and culturally diverse audiences. In this spirit of self-examination and shifting demographics, Matthew Carter was commissioned to design a new typeface to mirror the changing institution. His forty-five years of experience in creating typefaces in all major technologies—from metal to photographic to digital—would be invaluable in the realization of the commission.

Then–Design Director Laurie Haycock Makela formulated a concept that would guide the development of the typeface: "We began with the idea that a typeface could be an identity—a font rather than a logo—that would run through the system like blood."[1] The prospective design would also be diverse and flexible enough to reflect the variety of the institution's activities. Taken together, these two ideas would serve to dismantle the Walker's monolithic, modernist identity and would focus attention on the potential of language for graphic expression.

The resulting design, entitled Walker, is a variable typeface whose ultimate look and feel is determined by the designer. Walker is intended for headline purposes and thus exists as an all caps alphabet. In its base form it is a bold sans serif, a style that provides an important link to the institution's previous typographic palettes. Describing its basic structure, Carter states, "I think of [it] rather like store window mannequins with good bone structure on which to hang many different kinds of clothing."[2] What distinguishes Walker from any other font are its "snap-on" serifs. By using various computer keystroke commands, the designer can choose among five different types of serifs to attach to any character. In addition, horizontal rules can be placed above and below letters to underline and/or "overline" text—a feature, like a clothesline, from which letters can be hung.[3] To realize the technical innovation of the snap-on serifs, Carter employed a strategy similar to one he developed for Devanagari, a typeface used for Hindi text that allows dependent vowels to be typeset in the correct location of a letterform with simple keystrokes.[4]

The Walker typeface provides a distinctive look that affords great variability in its composition. Conceptually, it represents a revision of modernist typography insofar as it focuses attention on the space between letters,

words, and lines of text. The result, however, is not so much about voids as it is about spanning them, as designer Moira Cullen notes: "In Walker the serifs are the ultimate connectors, the antithesis in type of a modernist apartheid. Each character holds its own frame, but an inspired or decisive stroke can will the letterform to nuzzle its neighbour or extend an arm or leg across the white divide."[5]

A.B.

Notes
1. Quoted in Moira Cullen, "The Space Between the Letters," *Eye* 5, no. 19 (Winter 1995): 73.
2. Quoted in ibid., 74.
3. Margaret Re, *Typographically Speaking: The Art of Matthew Carter* (New York: Princeton Architectural Press, 2003), 26.
4. Ibid., 26–27.
5. Cullen, "The Space Between the Letters," 75.

ABCDEFGHIJKLMNO
PQRSTUVWXYZ&
1234567890

H H H H H

E⫶ EH EH EH

WALKER
WALKER-ITALIC

WALKER-UNDER
WALKER-BOTH
WALKER-OVER

Specimen sheet for the Walker typeface showing various serif and font options

Examples of the Walker typeface used in the monthly event calendars, 1995–1996

Enrico Castellani

Italian, b. 1930

Holdings

1 painting

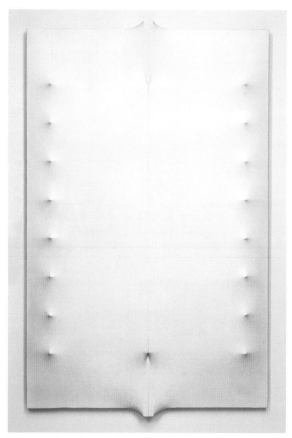

Enrico Castellani *Superficie Bianca* (*White Surface*) 1963 painted canvas relief 61 x 39 x 2 1/8 in. (154.9 x 99.1 x 5.4 cm) Art Center Acquisition Fund, 1964 1964.44

Vija Celmins

American, b. Latvia, 1938

-- **Exhibitions**

Vija Celmins (1993; organized by the Institute of Contemporary
Art, University of Pennsylvania, Philadelphia; catalogue)

-- **Holdings**

1 painting, 1 edition print/proof, 1 portfolio of prints, 2 books

Since the 1960s, Vija Celmins has created meticulously
detailed paintings, drawings, and prints of such envi-
ronments as the night sky, desert floor, or ocean surface
that question the nature of illusion and reality. Her
artworks are modest in scale, yet contemplate what
she calls "impossible images . . . nonspecific, too big,
spaces unbound."[1] Celmins uses photographs, both
found and her own, as a point of departure. She labori-
ously creates her pieces through rigorous transcription
from source image to final form—in the process, the
work transcends the photograph to assume a physical
life of its own.

Born in Riga, Latvia, in 1938, Celmins and her fam-
ily relocated to Germany during World War II, and
in 1948 immigrated to the United States, settling in
Indianapolis, Indiana. Unable at first to read or speak
English, she spent much time as a child drawing. In
1955 she entered art school, and in 1961, received a
scholarship to attend Yale Summer School, where she
met fellow painters Chuck Close, Brice Marden, and
others who encouraged her work. In 1962, she enrolled
at the University of California, Los Angeles, to con-
tinue graduate study in painting.[2] There she became
enamored of the ocean, desert, and sky of the
California landscape.

Like many painters in the early 1960s, Celmins
sought to break from the legacy of Abstract
Expressionism. Her first paintings, produced in 1964,
were still lifes of everyday items found in her studio.
Painted in lush grays, the objects—a hot plate, a space
heater, a lamp—all seemed tinged with a threat of
impending danger, a spirit unlike the bright Pop
images appearing on the opposite American coast.[3]
These were followed by grisaille paintings, based on
photographs, of more unsettling subjects: bomber
planes, a revolver, an automobile accident. Other early
paintings were more prosaic, inspired by endless
stretches of Los Angeles freeway observed from her car.

From the late 1960s to the early 1980s, Celmins
abandoned painting for drawing, which she felt was
a more direct form of working. With pencil, she began
to create images of horizonless environments, such as
ocean surfaces, moonscapes, and starry skies, executed
as "all-over" compositions that moved into an arena
more abstract than pictorial. In 1981, she moved to New
York, and soon resumed painting her favorite subjects.
Night Sky #6 (1993) is from her series of "galaxy" paint-
ings. Unlike her other subjects, mainly originated from
her own photographs, the night sky pictures are typi-
cally culled from publications on astronomy. *Night Sky*
#6 was constructed in multiple layers of oil paint, each
sanded to a pristine finish. It is small but borderless,
evoking a sense of vast, ethereal depth, though on close

inspection, the surface is resolutely flat—an interweav-
ing of crisp and hazy white dots on velvet black.

Celmins observes that her work is about the experi-
ence of looking.[4] Though her method is rigid, it reveals
her deep interest in the physical properties of her mate-
rials. And, while her surfaces are inherently structural,
her attention to detail, atmosphere, and light lend the
works an air of the sublime. Like Close or Gerhard
Richter, both artists who work from photographs and
to whom her work is often compared, Celmins has cre-
ated options by eliminating them. "I'm always aware
of the limits of painting," she remarked to Close in 1992,
"and have come to think that the limits are what give
it more meaning."[5]

S.E.

Notes

1. Quoted in "Vija Celmins in Conversation with Jeanne Silverthorne,"
Parkett 44 (1995): 40.
2. Prior to entering graduate school, Celmins traveled to Europe,
where she first encountered the work of Diego Velázquez. She recalls
"the somberness of the paintings, the beautiful grays, blacks, and
pinks." The artist in a self-narrated "Chronology," in William S. Bart-
man, ed., *Vija Celmins* (New York: A.R.T. Press, 1992), 61.
3. Celmins acknowledges her awareness at the time of the paintings
of Jasper Johns, Andy Warhol, Robert Rauschenberg, and Malcolm
Morley as well as the still lifes of Giorgio Morandi.
4. Of her images, Celmins remarked in 1993, "I feel it is essential to
[have] a sense of why they were done and how. Because that is the
ART part, and the real connection to the work." Celmins letter
to Peter Boswell, May 24, 1993 (Walker Art Center Archives).
5. Celmins interviewed by Chuck Close in Bartman, *Vija Celmins*, 12.

Vija Celmins *Night Sky #6* 1993 oil on linen mounted on wood 19 1/8 x
22 3/8 in. (48.6 x 56.8 cm) Purchased with the aid of funds from Harriet and
Edson W. Spencer and the T. B. Walker Acquisition Fund, 1995 1995.12

John Chamberlain
American, b. 1927

-- **Exhibitions**
Eighty Works from the Richard Brown Baker Collection (1961;
catalogue)
-- **Holdings**
2 sculptures, 1 edition print/proof, 1 book, 2 periodicals

John Chamberlain *Clyde* 1961 metal 14 x 15 x 15 in. (35.6 x 38.1 x 38.1 cm)
Gift of Fred Mueller, New York, 1970 1970.19

Dinos and Jake Chapman

British, b. 1962; British, b. 1966

-- **Exhibitions**
"Brilliant!" New Art from London (1995; catalogue, tour)
-- **Holdings**
1 sculpture

Dinos and Jake Chapman achieved infamy in the early 1990s as the international art world turned its attention to London and the loose affiliation of artists who would become known as the "Young British Artists" or YBAs. Educated at the Royal College of Art, from which they graduated in 1990, the Chapman brothers worked for a short time independently, but soon joined forces and have since acted as a single (albeit schizophrenic) entity.

This fraternal duo has been both celebrated and disparaged for their irreverent attitude as well as for the iconoclasm and shock value of their artistic output. What Dinos has called "completely trouble-some objects,"[1] their infamous sculptural series of "Fuckfaces"—conjoined, androgynous child manne-quins often with male and/or female genitalia on their faces—have led to widespread critical accusations of obscenity and tastelessness. Nonetheless, the artists are unapologetic for not offering a redemptive, cultural experience. "It's gallows humor," explains Dinos. "Flippancy is one method of approaching subject mat-ter that is too appalling to deal with."[2] In their own defense, they have openly acknowledged that their work is created "in service to a certain critical dis-course"[3]—their interest in psychoanalytic theory and the abject has led them to the writings of Sigmund Freud and Georges Bataille, which, among others, provide the underpinnings for their artistic practice.

One of their earliest collaborative works was an appropriation of *Los Desastres de la Guerra* (*The Disasters of War*), a series of eighty-three etchings by Spanish artist Francisco de Goya (1746–1828).[4] The Chapmans' 1993 reinterpretation brought each of the Spanish master's images to life in a tabletop installation of myriad miniature toy-soldier figurines perpetrating barbarous acts, each on its own grassy knoll—an archi-pelago of war crimes.

The following year they returned to Goya's prints, this time creating a life-size fiberglass sculpture of one of the most unspeakably grotesque images in the series, *Great Deeds Against the Dead*, in which three soldiers are stripped bare and bound to a dead tree, their bodies mutilated and castrated. Despite the graphic depiction and deadly serious content of its source, the over-the-top artificiality of the Chapmans' piece introduces a black humor that keeps the viewer's anxiety in check—these are not sentient beings, but mannequins with expressionless faces, flawless plasti-cine skin, and bad hair. For *Year Zero* (1996), the Chapmans have playfully mimicked their own version of Goya's horrific scene, placing it in a vaguely dysto-pian time and place outside history. In this third itera-tion, the tree is in its prime, lush with verdant foliage, while hermaphroditic, childlike figures frolic in Edenic innocence clothed only in their sneakers, vaguely

echoing the poses of the mutilated soldiers. Whether violence will erupt again is unknown, and perhaps irrelevant, as the artists intend their objects to be: "We fantasize about producing things with zero cultural value, to produce aesthetic inertia . . . works of art to be consumed and then forgotten."[5]

E.C.

Notes
1. Douglas Fogle, interview with Dinos and Jake Chapman, "Our Own Work Is Crap," in Richard Flood, ed., *"Brilliant!" New Art from London*, exh. cat. (Minneapolis: Walker Art Center, 1995), 22.
2. Quoted in Sarah Kent, "The Chapman Brothers," *Time Out London*, October 1, 2003, 22.
3. Quoted in Robert Rosenblum, "Revelations: A Conversation Between Robert Rosenblum and Dinos and Jake Chapman," in Jake Chapman and Mollie Dent-Brocklehurst, eds., *Unholy Libel: Six Feet Under*, exh. cat. (New York: Gagosian Gallery, 1997), 153.
4. Executed from 1810 to 1820, and published posthumously in 1863, this work depicted the atrocities committed by Napoleonic troops against the Spanish peasants who rose up in violent opposition to the French occupation and installation of Napoleon's brother, Joseph Bonaparte, on the Spanish throne.
5. Rosenblum, "Revelations," 149.

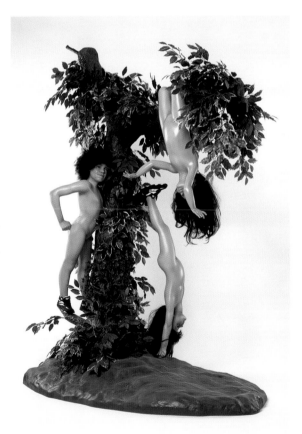

Dinos and Jake Chapman *Year Zero* 1996 fiberglass, paint, synthetic wigs and eyelashes, synthetic shoes, fabric, plastic 96 x 114 x 43 in. (243.8 x 289.6 x 109.2 cm) Gift of Peggy and Ralph Burnet, 1996 1996.176

Sarah Charlesworth

American, b. 1947

- - **Exhibitions**
The Last Picture Show: Artists Using Photography, 1960–1982
(2003; catalogue, tour)
- - **Holdings**
1 photograph, 1 photographic suite

How precisely do we see history? More to the point, how does our culture use photographs to visually construct that history? These are some of the questions that Sarah Charlesworth began to investigate in her earliest works. Emerging in the 1970s as part of a generation of American artists who came of age in a world increasingly dominated by the ubiquity of the media, she turned to photography as a critical tool in order to explore the circulatory power of this realm of images. In her first foray into this new media landscape, Charlesworth created a series of photographic works between 1977 and 1979 grouped together under the title *Modern History*, which examined the circulation of pictures in the international print media. As she herself suggested in 1979, "In these works, I am concerned not so much with that which lies behind as that which asserts itself through images . . . the history, the force, which exerts itself through their particular and systematic usage, in the immediate yet expanded world we see as our context."[1]

In *April 21, 1978*, her second installment in the *Modern History* series, Charlesworth focused her critical lens on the life of a single photographic image as it migrated around the world on the front pages of forty-five different newspapers over the course of two days. The image was the infamous photograph of the kidnapped Italian Prime Minister Aldo Moro taken by his captors in the Red Brigades terrorist group. It depicts the soon-to-be-murdered captive holding up a copy of the newspaper *La Repubblica* emblazoned with the banner headline *"Moro assassinato?"* Charlesworth's approach to this image was an analytical one that sought to investigate the structural syntax of the photograph's placement within the newspapers in which it was reproduced. What did its size, location, and editorial cropping in each particular publication say about the importance and cultural power attached to that image and event in different parts of the world? The artist's aesthetic strategy was deceptively simple in that she rephotographed each front page of the newspaper on which this photo appeared, and then removed everything except the masthead and pictures, leaving them to float on a field of empty white space. The resulting work tracks the respiration of this image across the world from its complete domination of the front page of the Roman daily *Il Messaggero* to its diminutive placement alongside a prominent photograph of Queen Elizabeth II in the *Globe and Mail* of Toronto. Like the Abraham Zapruder film that captured the assassination of John F. Kennedy, this photograph became much more than simply a documentary marker of a tumultuous historical moment; it actually came to stand in for that moment itself. Charlesworth's version of modern

history is one that foregrounds the power of such images to shape our collective experience, an effect completely relevant to a contemporary world in which the words "Abu Ghraib prison" immediately summon a series of photographic images that have themselves become an infamous part of history.

D.F.

Notes
1. Sarah Charlesworth, "Unwriting: Notes on Modern History," in *Modern History*, exh. cat. (Edinburgh, Scotland: New 57 Gallery, 1979), 1.

Sarah Charlesworth Selection from *April 21, 1978* from *Modern History*
1978 45 black-and-white direct positive prints; Artist's Proof 1/2 from an edition of 3 dimensions variable Justin Smith Purchase Fund, 2003
2003.44

Mel Chin
American, b. 1951

Can art stimulate social change? Mel Chin is among the many artists who would say yes, a response that aligns him with practices ranging from the utopian dream of Russian Constructivism to the avant-garde mysticism of Joseph Beuys to every creator of any sort of propaganda art. But he is wary of success in this enterprise, because his aim is not to support a specific ideology, but to enhance opportunities for discourse and change. "I aspire to make art that would be indistinguishable from direct political action some day," he says, "then to supersede that as fast as possible."[1]

Chin's works of the late 1980s and early 1990s address specific geopolitical, social, and environmental issues and have been called "sculptural witnesses to ecological and political tragedies."[2] Each is weighted with complex iconography that connects contemporary social issues to ideas from alchemy, philosophy, myth, religion, and history; the materials Chin uses come as

directly as possible from the cultures he references. Exhaustive research is central to his practice, and learning and remembering are key activities for him.

The Opera of Silence (1988) is typical of these works. Exhibited at the Walker Art Center in 1990 and acquired later that year, it is an oversized replica of a Beijing Opera drum made of hog hides stretched over a wooden armature. Chin and an assistant cut and sewed the hides into a pattern resembling the eagle's-head emblem of the U.S. Central Intelligence Agency (CIA); the backside of the drum is covered with white theatrical makeup, used in the Beijing Opera to signify treachery. The whole massive structure is propped up by a slender device made of bone and wood.

Chin's references to the CIA and China allude to the ongoing occupation of Tibet by the Chinese, in which the CIA is said to have meddled with disastrous effect, although the agency continues to deny any involvement.[3] On the drum, the two superpowers are made inseparable, the patterns of one woven into the structure of the other. The device supporting the weighty instrument is composed of two objects used in traditional Tibetan rituals: a death's-head staff and a trumpet made from a human bone. Chin's configuration may be a pun on the balance of power in the conflict, but the chief motif is silence: both Tibetan trumpet and Chinese drum have been made mute, symbolic of the suppression of the Tibetan people by China, and the official denials from both Beijing and Washington, D.C.

Although these references may not be obvious to the viewer, Chin isn't concerned that his message will

Mel Chin *The Opera of Silence* 1988 wood, hog hide, steel, theatrical makeup, paper, bone, ink, plastic filler 66 x 70 x 67 in. (167.6 x 177.8 x 170.2 cm)
T. B. Walker Acquisition Fund, 1990 1990.154

be lost. "My intention is to transcend the materials and propel the imagination; so that you look at the sculpture, and its presence sticks in your mind," he says. "Someday it will come back to you and the message will become clear, like a poem that you don't understand at the first reading."[4] Chin has continued this tactic in his recent work, which is more directly activist, collective, and ephemeral. For a 1996 project, *In the Name of the Place*, Chin and a group of collaborators inserted props into the sets of the prime-time television drama *Melrose Place*. The props functioned as subliminal messages, often with overtly political content—characters snuggled under sheets adorned with a pattern based on the shape of rolled condoms, or received Chinese take-out that came in containers bearing slogans from the Tiananmen Square protest. In such works, Chin's strategy is "not to subvert, but to assist with a creative process, thus infecting the host with the possibility of options not open for discourse within their existing, rigid, tripartite structures."[5] More than a maker of objects, he sees himself as a catalyst for change.

J.R.

Notes

1. Quoted in Benito Huerta, ed., *Inescapable Histories: Mel Chin*, exh. cat. (Kansas City, Missouri: Exhibits USA, 1996), 45.

2. Thomas McEvilley, ed., *Soil and Sky: Mel Chin*, exh. cat. (Philadelphia: Fabric Workshop, 1993), 4.

3. Beginning in 1958, the CIA reportedly provided Tibetan rebels with arms and training in guerrilla tactics, only to withdraw support after 1968 when President Richard Nixon decided to seek rapprochement with China.

4. Quoted in Peter Boswell, *Viewpoints: Mel Chin*, exh. bro. (Minneapolis: Walker Art Center, 1990).

5. Mel Chin, "My Relation to Joseph Beuys Is Overrated," in Gene Ray, ed., *Joseph Beuys: Mapping the Legacy* (New York: D.A.P.; Sarasota, Florida: John and Mable Ringling Museum of Art, 2001), 136.

Revival Field

Part sculpture, part scientific experiment, Mel Chin's *Revival Field* (1991–1994) was installed in conjunction with the artist's residency at the Walker Art Center in 1991. The work made use of living, growing vegetation to draw cadmium and other toxins from the soil at the Pig's Eye Landfill in St. Paul, Minnesota—a Superfund site. *Revival Field* was comprised of two sections of land enclosed by chain-link fencing: a circle subdivided by intersecting paths that contained leaching plants; and an outer square plot in which a nonleaching plant provided a control sample for the experiment. Seeded in a crosshairs pattern intended to identify the "targeted" area for cleanup, hyperaccumulators such as dwarf corn, romaine lettuce, alpine pennythrift, and bladder campion drew the cadmium into their root systems. The work remained in place for three years; the plants were annually harvested and tested to determine the amount of contaminants they had absorbed. The project echoed the environmentally conscious work of Joseph Beuys and Robert Smithson, and was considered part of a larger ecological-art movement in which artists in the late 1980s and early 1990s responded to the growing concern about pollution and environmental damage.[1]

Revival Field represented a fascinating blend of art and science, as demonstrated by the cosponsorship of the project by the Science Museum of Minnesota. Chin viewed the work with an artist's eye, seeing it as a sculpture in which he "chiseled" away the contaminants with the tools of biochemistry and agriculture to reveal the final product: ecologically healthy soil. A scientist, however, could regard it as a source of important long-term data on this low-cost approach to reclamation of polluted land. For environmentalists, the piece called attention to the problem of toxic sites and provided an example of the creative solutions being brought to bear on the issue.

L.D.

Notes

1. For a summary of the movement and its historical precedents, see Robin Cembalest, "The Ecological Explosion," *Artnews* 90, no. 6 (Summer 1991): 97–105. The difficulty in recognizing as art these interventions into nature is highlighted by Chin's experience seeking funding for *Revival Field* from the National Endowment for the Arts. His request for a $10,000 grant was denied by then-chairman John Frohnmayer, who overrode his own panel's recommendation and stated he had doubts about the project's artistic merits. After a storm of protest from museum directors and curators, Frohnmayer reversed his decision.

Mel Chin at *Revival Field*, Pig's Eye Landfill, St. Paul, 1991

Chuck Close

American, b. 1940

- - **Exhibitions**

Close Portraits (1980; catalogue, tour), *First Impressions: Early Prints by Forty-six Contemporary Artists* (1989; catalogue, tour), *The Cities Collect* (2000), *Chuck Close: Self-Portraits 1967–2005* (2005; co-organized with the San Francisco Museum of Modern Art; catalogue, tour)

- - **Holdings**

2 paintings, 1 photograph, 11 edition prints/proofs, 1 book

Celebrated as one of the most influential figurative painters of our time, Chuck Close has remained a vital presence by focusing exclusively on portraiture, a genre often underrecognized in contemporary art. Since the 1960s, Close has used his inimitable style of representational painting to portray friends, family, fellow artists, and himself. In all of the media in which he works, whether painting, drawing, photography, collage, or printmaking, he begins with the photograph as his subject. By choosing, as he often remarks, to consistently "alter the variables" in the way he transposes his photographic sources, he has created a remarkable pictorial language that continues to become richer and to expand through time.

By 1967, Close had completed graduate work at Yale University, moved to New York City, and abandoned the abstract work of his school years to begin painting from photographs. "I wanted something very specific to do where there were rights and wrongs," he has remarked, "and so I decided to just use whatever happened in the photograph . . . By limiting myself to black paint on white canvas, I would have to make decisions early and live with them."[1] At the same time, he sought to eliminate any brushes or tools with which he was comfortable working: "I was constructing a series of self-imposed limitations that would guarantee that I could no longer make what I had been making and push me somewhere else."[2]

His first attempt was an enormous painting of a reclining female nude, from which he honed some of the decisions about where to go next, such as using an airbrush, a tool with which he was unfamiliar. Making this work led Close to paint his first self-portrait.[3] "The day that I photographed myself I was actually photographing the nude, which I had just completed; I had film left over and I shot myself. There wasn't anyone to look through the viewfinder, so I focused on the wall and got the distance from the lens to the wall that was in focus. I cut a little cardboard strip, and then I moved the camera back out into the middle of the room and I would put the strip of cardboard between the lens and me so I knew that I would be in focus. I didn't realize I was tilting so much in all these photographs. And I didn't realize that I was going to get so much out of focus. Then I realized the minute I started to make the painting that it was far more interesting because there was a *range* of focus. The tip of the nose blurred and the ears and everything else went out of focus, so I began to engineer that. . . . I also didn't realize, until I made the painting, how crucial

it was to shoot from below so that the painting looms over you."[4]

Big Self-Portrait (1967–1968) was a watershed image for Close, in that it established his basic working method, which he has continued to use in various permutations to this day. Using a technique employed by both Renaissance painters and modern-day billboard artists, he overlaid a grid on his source photograph and, over the course of four months, transposed his subject square by square to the new 9-by-7-foot canvas.[5] The finished painting was arresting. The artist's rumpled, mug-shotlike visage indeed loomed from the canvas, cigarette dangling from his lips. Close recalls that the process of making this painting was extremely liberating, as his rigorous process of working only from information available in the photograph forced him to make marks and forms that were entirely new to him.[6] He went on to paint a related group of eight black-and-white "heads," as he refers to them, which included portraits of fellow artists Nancy Graves, Richard Serra, and Joe Zucker and composer Philip Glass. In the years that followed, he reintroduced color into his work, began to fully explore his formula in drawings and prints, and embraced Polaroid photography as another means of building an image.

Continuing the modus operandi that allowed him "to find things in the rectangle and slowly sneak up on what I want . . . to make it all happen in the rectangle instead of on the palette and in context,"[7] Close began to explore new means of creating his images—ranging from "dot" drawings to collages of pressed and dyed paper pulp to paintings and drawings made with his own fingerprints—that began to shake up the smooth surface sheen and photographic veracity of his earlier

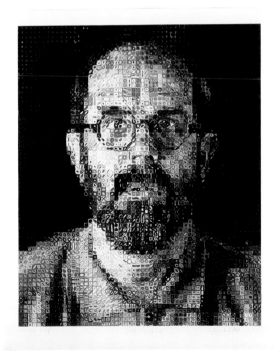

Chuck Close *Self-Portrait* 1995 screenprint on paper; Museum Proof from an edition of 50 64 1/2 x 54 in. (163.8 x 137.2 cm) Published by Pace Editions, New York Gift of the artist, 1999 1999.39

work. By the mid-1980s, he had embraced a brilliant color palette. His grids began to be more apparent, and he had introduced marks into his system that were self-contained, allowing each square to emerge as a miniature abstraction in itself.

Beginning in 1988, Close faced new personal and artistic challenges after suffering a collapsed spinal artery that initially left him paralyzed from the neck down. Through his remarkable courage and tenacity, his condition improved, and though dependent on a wheelchair, he was able to begin painting again with a customized brace. The paintings made following this event resumed the train of thought begun with his dot drawings, but became looser and more gestural than ever before. In canvases such as *Kiki* (1993), the candy-colored pinks and greens, delicate lavender, acid yellow, and other unexpected combinations reveal Close as a highly intuitive colorist. The blocks of color in the painting amass across the canvas as watery pixels—resolutely abstract at close range and joltingly real as the whole is absorbed and the artificial hues begin to reveal flesh, hair, and features.

Close's work continues to evolve in surprising ways. Incorporating new techniques, from nineteenth-century daguerreotypes to twenty-first-century computer-generated Iris prints, he has remained committed to rigorous experimentation within his rigidly defined practice. Through more than thirty-five years of "isms" and art movements, Close has operated on his own continuum, one that never fails to propel his work to new places.

S.E.

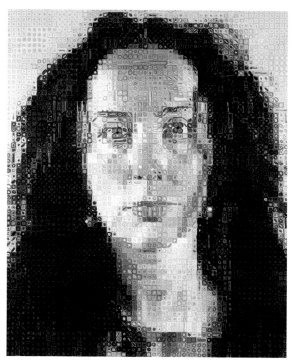

Chuck Close *Kiki* 1993 oil on canvas 100 x 84 1/8 in. (254 x 213.7 cm)
Gift of Judy and Kenneth Dayton, 1994 1994.7

Notes
1. Close, interview with the author and Madeleine Grynsztejn (Elise S. Haas Senior Curator of Painting and Sculpture, San Francisco Museum of Modern Art), artist's studio, New York City, September 30, 2003 (transcript of audiotape, Walker Art Center Archives).
2. Ibid.
3. The Walker purchased *Big Self-Portrait* out of Close's studio in 1969; the $1,300 sale was the artist's first to a museum. The Walker has continued to add to its holdings of Close's work by assembling a collection of self-portrait prints that span his career. Executed in techniques ranging from etching and linoleum block to woodcuts and handmade constructions of dyed paper pulp, the self-portrait prints form a fascinating microcosm of the artist's work overall.
4. Close, interview with the author and Grynsztejn, 2003.
5. The size of the canvas was determined by the proportions of the source photograph. For a detailed discussion of Close's working process in making the painting, see Lisa Lyons, "Changing Faces: A Close Chronology," in Martin Friedman and Lisa Lyons, *Close Portraits*, exh. cat. (Minneapolis: Walker Art Center, 1980), 30–33.
6. Lyons, "Changing Faces," 33.
7. Close, interview with the author and Grynsztejn, 2003.

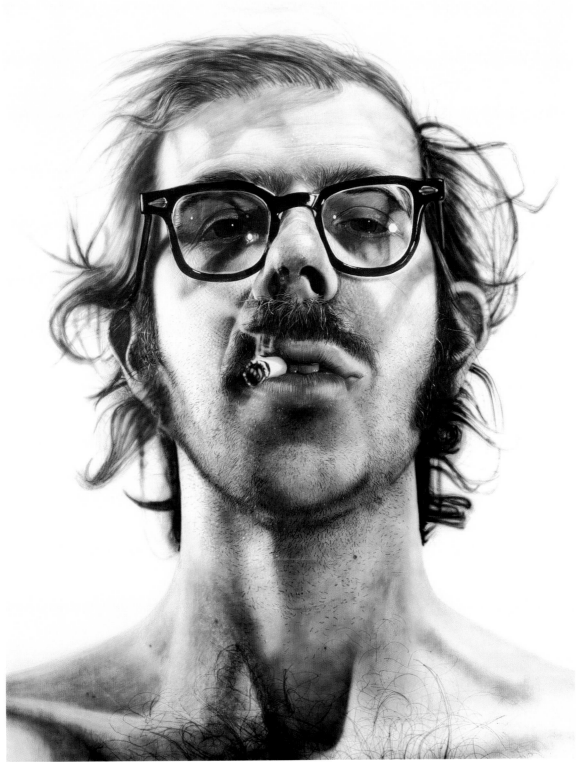

Chuck Close *Big Self-Portrait* 1967–1968 acrylic on canvas 107 1/2 x 83 1/2 in. (273.1 x 212.1 cm) Art Center Acquisition Fund, 1969 1969.16

James Coleman
Irish, b. 1941

-- **Exhibitions**
The Squared Circle: Boxing in Contemporary Art (2003; publication)
-- **Holdings**
1 film, 1 video

James Coleman creates projected-image works that blend tight formalism with a pervasive lyricism, operating between cinema and photography. His earliest pieces from the 1970s—such as *Playback of a Daydream* (1974)—confront the viewer with a sparse, self-conscious filmic experience. They recall the reflexive film installations of Dan Graham, while also drawing on another creative lineage, namely "structuralist" or "materialist" cinema. Spurning the comprehension of an impartial witness, Coleman's early experiments often inveigle the beholder in unfolding scenarios that compel interpretation, rather than mere observation.[1] It's by dint of his desire to anticipate narrative, doubt, and multiplicity that his practice departed from its rigorous conceptual-perceptual origins toward what would become his primary medium: sequences of projected slides with voice-overs.

The installation *Box (ahhareturnabout)* (1977) exemplifies a segue from harder-edged exercises into an increasing concern in the 1980s with romantic, operatic, and political themes. Black-and-white footage of the 1927 Jack Dempsey/Gene Tunney heavyweight championship rematch is shown in a continuous loop. Yet it sporadically goes black, pulsing on and off as if the film itself were deliberately trying to frustrate us, or somehow communicate. In the accompanying audio, a voice—the artist's own—recounts a fighter's (imagined) inner monologue: "Stand, keep the range, watch the hook . . ." The physical fight becomes echoed in a struggle of identities. Is the voice the master of the action, or is it controlled by it? And what does this mean for our own fight to understand what we are witnessing, particularly as the flashings-off seem to be like winces of empathy as punches land? Known as the "long count" fight, the match itself was marked by interpretative dispute. World champion Tunney eventually triumphed after coming back from a seventh-round knockdown for which the referee delivered an incredibly drawn-out ten-second count.

While elaborating on the heritage of the "flicker" film, *Box (ahhareturnabout)* is also prophetic, anticipating the numerous gallery-based works over the past decade that have taken preexisting footage as a point of departure.[2]

M.A.

Notes
1. *Playback of a Daydream* is a film that alternates drawn images of the familiar textbook "duck-rabbit" optical illusion. The perceptual experience of this work—here at the level of innate neurological function—compels the "interpretation" of ambiguous images as representations of animals with rabbit ears and/or duck beaks.

2. Though films made entirely from appropriated readymade footage have been around since Joseph Cornell's *Rose Hobart* (1936), if not earlier, a generation of artists who came to prominence in the 1990s—Douglas Gordon and Pierre Huyghe among them—struck a new engagement with this dynamic.

James Coleman *Box (ahhareturnabout)* 1977 16mm film (black-and-white, synchronized audio) continuous loop T. B. Walker Acquisition Fund, 1991 1991.96 ©James Coleman

Robert Colescott
American, b. 1925

- - **Exhibitions**
Robert Colescott: Recent Paintings (1998; organized by Miriam
Roberts, United States Commissioner, in association with SITE
Santa Fe and the University of Arizona Museum of Art; catalogue),
The Cities Collect (2000), *American Tableaux* (2001; publication, tour)
- - **Holdings**
1 painting, 1 edition print/proof

Few artists in the history of American art have shoul-
dered the mantle of cultural critique with as much
humor, deadly seriousness, and aplomb as Robert
Colescott. Throughout his long career, he has con-
fronted the divisive subjects of race and sex head-on
in his colorfully expressionist paintings that betray an
extensive knowledge of art history and the sociopoliti-
cal consequences of discrimination and its global part-
ner, colonialism. Since the mid-1970s, when Colescott
began appropriating the compositions of masterpieces
such as Eugène Delacroix's *Liberty Leading the People*
(1830), Emanuel Leutze's *Washington Crossing the
Delaware* (1851), and Vincent van Gogh's *The Potato
Eaters* (1885), he has engaged in "blackfacing" and
satire by replacing their subjects with Aunt Jemimas,
pickaninnies, minstrels, and other overtly racist charac-
ters.[1] Clearly objectionable, these gross exaggerations
and distortions are used by Colescott to undermine
cultural myths. The artist has acknowledged that he is
"pushing the standards of taste. I'm exploiting stereo-
types, questioning the heroic in art. I use humor as bait,
pulling you in to confront the social comment. The
visual joke alone is a sidetrack. There's another layer."[2]
His inflammatory and ironical tactics also subvert the
iconic status of these paintings by exposing the domi-
nant discourse that produced them.

In the decades of the 1980s and 1990s, Colescott
made the transition from revisionist history painting
into somewhat more hermetic and personal subject
matter. While based on the same set of issues that
had long concerned him, his repertoire of subjects
expanded to take on religion, castration, ethnicity,
and miscegenation, among many others. In the Walker
Art Center's painting *Exotique* (1994), Colescott mines
the problematic concepts of exoticism and "the other"
through three figural pairings.[3] Anchoring the composi-
tion is an enigmatic yellow-and-white silhouetted form
suggestive of the yin and yang symbol, which may
have been employed by the artist to suggest the inter-
dependence of the female principle with the male. To
the right, a ridiculous-looking Frenchman exchanges
words with a black woman who wears a colorful dress
made from what appear to be African textiles. His vora-
cious gaze and wandering hands attempt to take pos-
session of her. "You are so exotic, dear madame!!,"
he flatters, to which she retorts with the more politically
correct, "If you please, dear sir!! Afrocentric!!!" Up
above, an elongated purple figure positioned in the
classic pose of the odalisque responds to them both,
exclaiming, "*Yo tambien!*" (Me too!) (in Spanish, Pablo
Picasso's native tongue). The Picassoid mask and a

strange anthropomorphic black cat are thinly veiled
references to two paintings from art history that have
been identified by scholars as brothel scenes in which
race and gender provide fruitful avenues of interpre-
tation: Picasso's *Les Demoiselles d'Avignon* (1907) and
Edouard Manet's *Olympia* (1863), respectively. The
final pair at the lower left—a robed, praying figure
speaking Arabic to a large, fair-skinned nude woman—
reinforces the construct of the exotic "other" as the
source of both fear and fascination, an emblem of dif-
ference that is both demonized and romanticized.
Despite all attempts at communication, Colescott's fig-
ures seem hopelessly trapped in a centrifuge of cultural
misunderstanding. In a 1987 statement on his work, the
artist concluded that rather than providing a panacea,
"the paintings end up devouring themselves in the final
irony."[4] In Colescott's world, perhaps this is all we
should expect.

E.C.

Notes
1. Colescott's reinterpretations of these paintings were *Homage to
Delacroix: Liberty Leading the People* (1976), *George Washington Carver
Crossing the Delaware: Page from an American History Textbook* (1975),
and *Eat Dem Taters* (1975).
2. Quoted in Lucy R. Lippard, *Mixed Blessings: New Art in a
Multicultural America* (New York: Pantheon Books, 1990), 239.
3. *Exotique* was exhibited at the 47th Venice Biennale, June 15–
November 4, 1997. Colescott was the first black artist to represent
the United States with a solo show in the U.S. Pavilion.
4. Quoted in Lippard, *Mixed Blessings*, 241.

Robert Colescott *Exotique* 1994 acrylic, gel medium on canvas
84 x 72 in. (213.4 x 182.9 cm) T. B. Walker Acquisition Fund, 1995 1995.23

Bruce Conner

American, b. 1933

- - **Screenings**

Bruce Conner: Visiting Filmmaker (1978); Filmmakers Filming (1981; catalogue); An Anxious Cinema: Bruce Conner (1982); ABC: Anger, Breer, Conner (1988)

- - **Exhibitions**

First Impressions: Early Prints by Forty-six Contemporary Artists (1989; catalogue, tour), *Duchamp's Leg* (1994; catalogue, tour), 2000 BC: THE BRUCE CONNER STORY PART II (1999; catalogue, tour), *The Last Picture Show: Artists Using Photography, 1960–1982* (2003; catalogue, tour)

- - **Holdings**

5 sculptures, 1 drawing, 1 unique work on paper, 1 multimedia work, 2 photographs, 16 films, 1 video, 40 edition prints/proofs, 1 portfolio of prints, 2 multiples, 4 books, 2 posters

Over the course of his fifty-year career, Bruce Conner has been something of an artistic chameleon, working in sculpture, film, collage, painting, photography, printmaking, performance, and conceptual art. He has courted diversity and unpredictability to the point where he has seemingly made an art out of elusiveness, abandoning a given type or style of work whenever he felt he was becoming too closely identified with it. As a result he has gained a fractured following. Devotees of his experimental films of the 1960s and 1970s might be totally unaware of the nylon-shrouded assemblages that were the springboard for his success in the art world in the 1950s and early 1960s, and vice versa. Younger viewers might be familiar only with the intricate Rorschach-like drawings of the 1980s and 1990s.

The Walker Art Center's 1999 exhibition 2000 BC: THE BRUCE CONNER STORY PART II, which looked at Conner's lifetime achievement through the lens of its relation to his films, did much to increase awareness of the full breadth of his accomplishment, though its protean diversity still resists easy understanding. Both in the course of organizing that show and in its wake, the Walker has assembled the largest and most significant grouping of Conner's work outside of the artist's own studio.

For all its diversity, there are several consistent threads that run through much of Conner's work. The most important of these is the conception of the artwork as subject to renewal and redefinition each time it is viewed, almost as if it were a living being continually regenerating and metamorphosing. By and large, he achieves this through a kind of optical overload, a high-density presentation that results in a tug-of-war between the detail and the whole. No matter how many times one views a typical Conner work—be it an assemblage, drawing, movie, or collage—it typically resists full resolution. There is always something that changes—perhaps a detail never noticed before, perhaps a visual effect based on the optical phenomenon of "persistence of vision"—that keeps it uncertain and alive. In this sense, his individual artworks share something in common with his career as a whole.

Conner was born in McPherson, Kansas, in 1933, and grew up in Wichita. In 1957, shortly after graduating from the University of Nebraska, he moved to San Francisco at the urging of his high-school friend Michael McClure, who had moved there earlier in the decade and become a key figure in the celebrated San Francisco Poetry Renaissance. There Conner quickly fell in with a vibrant group of artists that included Wallace Berman, Joan Brown, Jay DeFeo, Wally Hedrick, George Herms, and Jess, many of whom worked or experimented in a mixed-media style that came to be called "assemblage."[1]

Although he had worked in collage prior to his move, it was in San Francisco that Conner began working in the assemblage style that first brought him to national and international attention. The key work in this regard is his monumental two-sided collage UNTITLED (1954–1961). The "front" side was begun and largely completed while Conner was still an undergraduate at the University of Nebraska. Its scuffed, brown-toned surface is made from distressed cardboard and scraps of wood. A pair of collaged cardboard circles punctuates the composition, along with two rectangles made from a flattened metal can and a piece of metal screening tacked to a wooden framework. The use of scrap materials and the carefully balanced, abstract composition recall the work of German Dadaist Kurt Schwitters. The "back" side of the collage developed over time. Conner noticed that works of art often accumulated labels as a result of changing ownership or inclusion in exhibitions, and that this history embodied a form of art-world validation: "So I started clipping out seals like *Good Housekeeping* and *Parents' Magazine* seals, Chick Sexing Association

Bruce Conner THE BRIDE 1960 wood, nylon, string, wax, paint, candles, costume jewelry, marbles, paper doily, etc. 36 1/2 x 17 x 23 in. (92.7 x 43.2 x 58.4 cm) Braunstein/Quay Gallery and T. B. Walker Acquisition Fund, 1987 1987.23 ©Bruce Conner

seals, all sorts of things, and started sticking them on the back."[2] Over time, this side of the work became a dense collage of papers that included labels reading "Warning: You are in Great Danger" and "Fragile," an "Ez for Prez" sticker (from when Conner ran his own "Ezra Pound for president" campaign in 1956), images from movie and science-fiction magazines, pictures of nudes from stag magazines, reproductions of artworks featuring women in varying degrees of undress (ranging from Boucher's *Bath of Venus* to Brancusi's abstract *Eve*), photographs of Marcel Duchamp and James Joyce, and much more. In time, Conner came to view the disparity between the harmonious, almost classical "front" side of UNTITLED and the visually cacophonous "back" side as emblematic of the contrast between a person's proper, composed "public" face and his private, subconscious being.

Conner's first true assemblage, RATBASTARD (1958), has a similarly hybrid history. It began as a thickly impastoed, vaguely flesh-toned painting, which, in a fit of frustration, the artist sliced and gouged. Intrigued by its injured condition, he then ran a thick steel wire through the various wounds, added collage elements—including a photo of people viewing a cadaver on a table and an illustration of a medieval torture scene—swathed the work in nylon (attractive because of its capacity to both reveal and conceal, nylon became a staple of many of his assemblages), and pierced it with nails. As a final touch, he added a cloth "handle," so that he could carry it as a portable emblem of psychic distress and alienation. It became the first of a series of "Rat" pieces—including RATBASTARD 2 (1958), also in the Walker's collection—that served as testaments to the alienation of the circle of artists and poets whose company he kept.

Other assemblages attest to Conner's lifelong love of movies. THE BRIDE (1960), one of his few freestanding sculptures, features a wooden armature swathed in white-painted nylon and topped with candles whose melted wax has dripped down over it. As Conner was making the piece, it reminded him of the figure of Miss Havisham, the aging spinster and jilted bride whose accidental self-immolation is the climax of David Lean's 1946 film version of Charles Dickens' *Great Expectations*. SON OF THE SHEIK (1963) presents a tongue-in-cheek homage to the androgynous appeal of silent-film heartthrob Rudolph Valentino.

Much of Conner's own reputation rests on the influence of his films of the late 1950s and 1960s, such as A MOVIE (1958), COSMIC RAY (1961), and REPORT (1963–1967), which were made from scraps of found footage edited together to create dense, ambiguous narratives. Echoes of each of these are to be found in artworks in the Walker's collection. The back of UNTITLED is like a two-dimensional equivalent to the contemporaneous, groundbreaking A MOVIE, a cinematically dense, twelve-minute compilation of brief film clips whose emotional impact moves from the comic to the tragic to the sublime. Included in it are segments from a stag film, the Hindenburg disaster, and an atomic bomb blast that all directly echo images in UNTITLED.

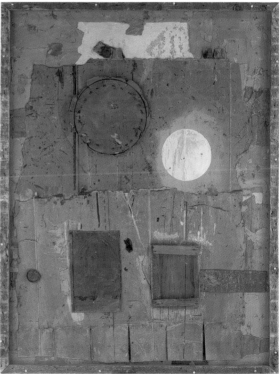

Bruce Conner UNTITLED 1954–1961 paper, wood, adhesive, nails, paint, staples, metal, tar, feathers, plastic, etc. on Masonite 63 7/8 x 49 5/8 x 4 1/8 in. (162.2 x 126.1 x 10.5 cm) T. B. Walker Acquisition Fund, 1992 1992.37 top to bottom, back and front views ©Bruce Conner

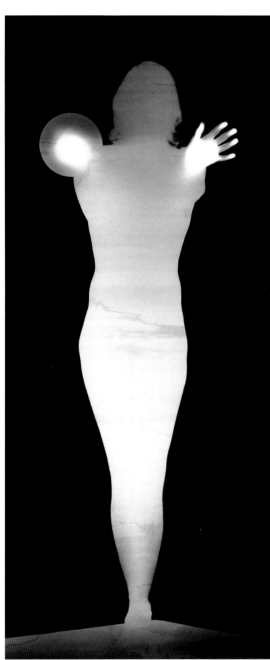

Bruce Conner ANGEL 1975 gelatin silver print photogram 85 x 39 in. (215.9 x 99.1 cm) Butler Family Fund, 1989 1989.67 ©Bruce Conner

The Walker's collection also includes a collage made from a series of filmstrips that make up the complete 1961 film COSMIC RAY, sandwiched between two sheets of plexiglass. This presentation, created for the Walker's 1999 exhibition of his work, allows viewers to experience in a different form the remarkable inter-play between dark and light that lies at the heart of the film. It also enables them to experience it in material form, much as Conner did when he made it, splicing the strips together in his home editing room.

Lastly, Conner's TELEVISION ASSASSINATION (1963–1964/1975) is a three-dimensional sculpture/instal-lation that, like his film REPORT, takes as its subject the events surrounding the 1963 assassination of President John F. Kennedy. But while REPORT is made from spliced strips of film documenting media reports of the tragedy, TELEVISION ASSASSINATION deals with another shooting that was actually caught on live TV: Jack Ruby's murder of Lee Harvey Oswald. Conner first issued the footage, all of which was filmed directly off his television set in the days after the Kennedy-Oswald killings, as an 8mm film in 1964. In 1975, he created the installation piece by projecting the film onto the screen of a nonfunctioning sixties-era television, thereby returning the images to their original source.

Conner's involvement with film, which he produced mostly in black and white, influenced much of his non-filmic work from the mid-1960s to the present. Many of these later works—principally collages, drawings, and photographs—explore visual effects of black and white in terms of darkness and light. The Walker holds a num-ber of pieces from this period, including a full set of off-set lithographs (1970–1971) and all three volumes of his photoetched collages THE DENNIS HOPPER ONE MAN SHOW (1970–1973).

Also in the Walker's collection are two examples—ANGEL and NIGHT ANGEL—from the series of ANGEL photograms Conner created in 1974 and 1975. In a dark room, the artist affixed long sheets of light-sensitive photographic paper to the wall. He then stood before the wall while an assistant, Edmund Shea, turned on a slide projector. When the paper was developed, it turned black wherever the light had struck it; the areas where the light had been blocked by Conner's body remained white. By exposing the paper to light for dif-ferent amounts of time, he could get effects that ranged from pure white silhouettes to grayed silhouettes with white highlights to constellations of white points in a black field that can hardly be identified as representing the human figure. In these works, the artist's body is dematerialized into pure light, hence the series title.

Throughout his career, Conner has made liberal use of unorthodox materials—everything from shredded nylon to filmstrips to felt-tip pens. In 1974 he pushed the envelope even further, using the legal requirements of California's education system as the subject and medium for one of his artworks. Hired to teach an art course at San Jose State University, he was required by state law to submit his fingerprints to university authori-ties. At first, Conner balked. By this time, issues of iden-tity and authorship had become an integral part of a number of works. At various times in his career, he had either not signed his works or had inscribed his name

in such a crude fashion that the identity of the creator was thrown into question. In 1965, when invited to make prints at the Tamarind Lithography Workshop, he initially refused to sign the finished works. When Tamarind's management complained that unsigned prints would have no value beyond the paper and materials used to make them, Conner compromised by "signing" them with his fingerprint, a sly poke at the printmaking taboo against getting dirty fingerprints on a plate or print. When San Jose State demanded a set of his fingerprints, he cited the Tamarind incident as evidence that his fingerprint had commercial value. In the end, the artist turned an unwelcome demand into a creative opportunity: he had a set of "limited edition" fingerprints made at the Palo Alto Police Department, on official police forms, one of which went to the university. The remainders were incorporated into a multiple called PRINTS (1974), in which the forms, along with an assortment of photographs and photocopied documents relating to the San Jose State incident, were enclosed within a steel lockbox.

Peter Boswell

Notes
1. William Seitz, curator at the Museum of Modern Art in New York, gave currency to the term "assemblage," which had been coined in the early 1950s by French artist Jean Dubuffet, when he titled a major 1961 exhibition examining the recent proliferation of mixed-media work *The Art of Assemblage*. Conner himself has never been comfortable with the term, preferring to refer to his found-object works as "collages," "reliefs," and "sculptures."
2. Bruce Conner, unpublished interview with the author, July 20, 1983, quoted in Peter Boswell, "Theater of Light and Shadow," in 2000 BC: THE BRUCE CONNER STORY PART II, exh. cat. (Minneapolis: Walker Art Center, 1999), 28.

Bruce Conner TELEVISION ASSASSINATION 1963–1964/1975 8mm film (black and white, silent), Zenith television set with painted screen, Bolex film projector, film reel, electric cord, television: 15 1/8 x 21 x 11 in. (38.4 x 53.3 x 27.9 cm) projector: 9 x 8 1/2 x 5 1/2 in. (22.9 x 21.6 x 14 cm) Gift of Robert Shapazian, 1992 1992.29 ©Bruce Conner

Conner Films

Bruce Conner's films have had a great impact on a broader realm of film and video. The lineage of his deft editing techniques and his early exploration of music tied to images lead far away from the galleries and classrooms that exhibit experimental film. In the commercial world, his work influenced movies such as Dennis Hopper's *Easy Rider* (1969), and his impact on music videos remains pervasive. To some, Conner is even the embodiment of the purest independent cinema: one man acting as director, cameraman, and editor, with no contravening support.

The artist has been making films since the late 1950s. Usually short and often set to music, Conner's films are informed by his work in assemblage and collage and draw on Joseph Cornell's idea of filmmaking as the arrangement of found footage. His first, A MOVIE (1958), was made entirely from commercial stock (taken mostly from newsreels) and his second, COSMIC RAY (1961), from cartoons and soft porn films. But Conner's approach sometimes took a more somber note when he selected images of pop and political culture to address the anxiety of the times (Cold War dread, assassinations, conformity versus rebellion). He further expanded found-footage methods in CROSSROADS (1976) by joining multiple films of the first underwater atomic bomb test into a thirty-six-minute meditation on one image.[1]

Conner's experience producing light shows at San Francisco rock concerts imbued some of his film work with psychedelic sensibilities—and a belief that music in cinema can be more than just a sound track. For BREAKAWAY (1966), he dispensed with static camera work and filmed singer and choreographer Toni Basil dancing and posing. One year later, he cut this footage to a recording of one of her pop songs, perfectly matching her image, the camera movement, and the music. Conner's subsequent work injected these techniques into music videos for Devo, David Byrne, and Brian Eno—and into popular culture at large.

D.S.

Notes
1. Conner actively sought this 1946 footage—the product of more than five hundred government cameras—going so far as to explore the National Archives in Washington, D.C. The Walker holds an uncommon 35mm print of CROSSROADS.

Bruce Conner BREAKAWAY 1966 16mm film (black and white, sound) 5 minutes Edmond R. Ruben Film and Video Study Collection ©Bruce Conner

Joseph Cornell
American, 1903–1972

- - **Screenings**
Homage to Joseph Cornell (1979)
- - **Exhibitions**
Joseph Cornell (1953), *Reality and Fantasy, 1900–1954* (1954;
catalogue), *Duchamp's Leg* (1994; catalogue, tour)
- - **Holdings**
6 sculptures, 6 unique works on paper, 4 films, 1 book

Joseph Cornell's poetic, intimately scaled boxes conjure a magical world filled with fantasy, esoterica, and mystery, yet Cornell was self-taught as an artist and never traveled abroad, living most of his adult life in a modest frame house in Queens, New York, with his mother and invalid brother. His yearnings—for places not visited, inaccessible young women, eras long past—are as crucial to his work as his frequent walks in the city (he was for a time a traveling textile salesman) and his love of theater, cinema, music, ballet, and the circus. He was a lifelong stargazer and an inveterate scavenger, browsing antique shops, bookstalls, secondhand stores, planetariums, and penny arcades for raw materials. In 1932, he had his first solo exhibition at Julien Levy Gallery in New York, which had introduced Surrealism to the American public. Cornell was influenced by their ideas, but he never considered himself a Surrealist—he disliked the group's reading of his works as sophisticated toys for adults, and did not share their theories about dreams and the subconscious.[1] For him, those realms were the stuff of everyday life.

Cornell's work falls into informal series that he clustered around specific topics or motifs. A particular favorite was the nineteenth-century ballerina Fanny Cerrito, who was famed for her role in *Ondine, ou La Naïade* (1843), the tale of an ethereal sea siren whose passion for a young fisherman threatens her immortality. Cornell made dozens of works on the theme of Ondine/Cerrito, often in the form of small keepsake boxes. The Walker Art Center's collection includes an untitled piece made around 1942 that is similar to others dedicated to Cerrito: a few small shells, a scrap of chiffon, and a sprinkling of glitter in a box lined with pink velveteen. A handful of rose petals, both real and artificial, allude to Ondine's declaration that she would rather fade like a rose than give up her love. They also symbolize the irreconcilable clash between the mortal and the immortal—a common theme in the romantic ballet and one Cornell addressed throughout his career in various ways.[2]

Other series, developed in greater depth during the 1950s and 1960s, include the Aviaries, Soap Bubble Sets, Celestial Navigation Variants, and Sand Fountains. Many allude in some way to the heavens, as Cornell subscribed to several journals on astronomy and was fascinated both by the rich mythology of the skies and the scientific data being gathered through postwar space exploration.[3] *Andromeda (Sand Fountain)* (1953–1956) addresses a favorite constellation (and one of the many inaccessible female "stars" of whom Cornell dreamed).[4] A later work, *Eclipsing Binary, Algol, with Magnitude Changes* (circa 1965), refers to an observed phenomenon: Algol, the most famous of the eclipsing binary stars. It is a two-star system in which a visible, bluish star is orbited by a larger, dimmer orange star. Every 2.87 days, the two cross paths and a partial eclipse occurs, causing the bluish star's magnitude to plummet. In this work, Cornell has combined a diagram of Algol with a bright orange rubber ball that rolls along two metal rods and a broken white clay pipe from Holland—the kind he had used to blow bubbles as a child—that for him signified his Dutch ancestry.[5] Since both Cornell's mother and brother had died within the year before he made this work, it is tempting to read it

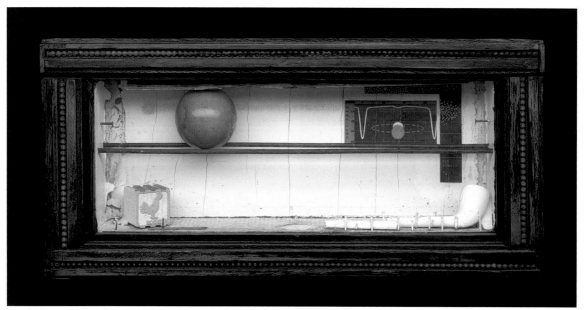

Joseph Cornell *Eclipsing Binary, Algol, with Magnitude Changes* circa 1965 wood, glass, clay, rubber, steel, paper, paint 7 15/16 x 17 1/8 x 3 7/8 in.
(20.2 x 43.5 x 9.8 cm) Gift of The Joseph and Robert Cornell Memorial Foundation, 1993 1993.222

as a reflection on the complex nature of family systems and an acknowledgment that the world had become, for him, a temporarily darker place.

J.R.

Notes

1. See Lynda Roscoe Hartigan, "Joseph Cornell, A Biography," in Kynaston McShine, ed., *Joseph Cornell*, exh. cat. (New York: Museum of Modern Art, 1980), 103.
2. For an exhaustive discussion of Cornell's fascination with romantic ballet, see Sandra Leonard Starr, *Joseph Cornell and the Ballet*, exh. cat. (New York: Castelli, Feigen, Corcoran, 1983), especially pages 19–35 on the works dedicated to Fanny Cerrito.
3. See Mary Ann Caws, ed., *Joseph Cornell's Theater of the Mind: Selected Diaries, Letters, and Files* (New York and London: Thames & Hudson, 1993), 221.
4. Although the Walker Art Center organized Cornell's first solo museum exhibition in 1953, his work was not acquired for the collection until 1971, when *Andromeda (Sand Fountain)* was purchased. See Deborah Solomon, *Utopia Parkway: The Life and Work of Joseph Cornell* (New York: Farrar, Strauss, & Giroux, 1997), 220–221, and the Walker Art Center Archives.
5. He also lined the bottom of the box with pages from a Dutch-language book.

Joseph Cornell untitled (pink ballet case) circa 1942 wood, glass, dried rose, leaf, shells, cloth, plastic, mica, cardboard 1 7/8 x 4 1/2 x 3 7/16 in. (4.8 x 11.4 x 8.7 cm) Gift of The Joseph and Robert Cornell Memorial Foundation, 1993 1993.224

Cornell Films

Joseph Cornell's reputation as a visual artist is founded on his collages and box constructions, yet it is possible that his greatest influence on art was as a filmmaker. Despite the fact that Cornell was not prolific and screenings of his films were relatively rare, they reached an audience that included America's burgeoning film avant-garde. His use of found footage and collage, as well as his emphasis on lyric-dream imagery over scripted narrative, inspired a generation of filmmakers, including Stan Brakhage, Rudy Burkhardt, Ken Jacobs, Larry Jordan, Jonas Mekas, and Jack Smith.

It may be argued that Cornell originated the "found-foot-age" film. In 1936, influenced by Surrealist contemporaries (and possibly the ethos of Duchamp's "readymades"), Cornell cut and rearranged an existing Hollywood movie. Conceptually and practically, he produced a new film without picking up a camera. The repercussions of this leap were not fully explored until Bruce Conner and Stan VanDerBeek led the late 1950s boom in found-footage films. Ironically, by that time, Cornell was hiring young avant-garde filmmakers (including Brakhage) to go out and film images for him.

Cornell's most influential work remains *Rose Hobart* (1936). As a lifelong cinephile, the artist found silent films to be the most expressive. He emphasized precisely this potential by taking a silent, jungle melodrama (*East of Borneo*, 1931; directed by George Melford), editing out the obvious plot, inserting some extraneous footage, slowing the speed, adding music, and projecting this rearrangement through a blue glass filter.[1] The resulting work is a languid dream world of exotic mystery and Freudian intrigue. It is simply without precedent in cinema and lives in the many subsequent films that speak with its rich vocabulary.

D.S.

Notes

1. The color of *Rose Hobart* is not a settled matter. It is certain that Cornell's original projections produced a blue film. In 1968, however, the first prints of the film were produced on color stock. The color apparently selected by the artist at that time was a shade of rose, perhaps serving as both a pun on the title and a nod to eclipse phenomenology (an eclipse being a pivotal image in the film). It has also been suggested that this color was a mistake that Cornell—possibly relishing the surreal serendipity—chose not to correct. The Walker holds one of the rose-tinted prints.

Joseph Cornell *Rose Hobart* 16mm film (tinted, sound); footage appropriated from Universal Picture's *East of Borneo* (1931) 19 minutes Edmond R. Ruben Film and Video Study Collection

A Visit with Andromeda

This box could have been the work of Edgar Allan Poe or Emily Dickinson. They both had a liking for metaphysical mysteries. They are poets of dark corners, objects with enigmatic properties, and night sky. Cornell said that when he studied astronomy in school, he was frightened by the concept of infinity. Imaginary travels were his preoccupation, though he made sure that he slept in his own bed every night. Except for the four years he spent as a student at the Phillips Academy in Massachusetts, he never set foot outside the New York City area. A true loner, Cornell records in his journals seeing faces of extraordinary beauty in poorly lit subway stations. I did too. Just last night as the express train sped past a station, I caught sight of an extraordinarily beautiful small boy.

This badly battered, nearly empty box with glass over it makes one think of a dusty window—but where? Perhaps in a hotel in some old city along the Mediterranean? There's an airshaft with a brick wall and a faded Roman fresco of a woman with banded wrists to which floating chains have been attached. She must be Andromeda, the one who in a Greek myth was rescued by Perseus from a rock on the seashore, where she was chained by her parents as an offering to the sea monster that terrorized the land. Her name was afterwards given to a galaxy whose diffuse light coming from billions of stars is so distant that it takes two million years for it to reach us.

A broken cordial glass with remnants of some liquid rests on the windowsill, left by a previous visitor. Someone, I am imagining, who having arrived at the hotel dead tired after a long journey, had fallen asleep and wakened at dusk not knowing the day or the hour in a room he doesn't recognize. He stands at the window, looking at Andromeda. Two of her fingers on the right hand have stars on their tips. She is reaching toward someone who is no longer part of the view, someone who has vanished through the triangular hopper and the opening beyond. He remembers that Perseus was amazed by the beauty of a woman whom he had taken for a marble statue, had not the wind stirred her hair and he noticed tears streaming from her eyes.

Cornell invites us to become small and play a game. This box can be moved, turned upside down, and shaken, making the blue sand sink as in an hourglass. I prefer it to be stationary. I'm back at that hotel recalling how, in the old myth, the sea roared and the girl in chains remained silent when asked her name by the hero. Nostalgia for happier times and for purer lost loves was Cornell's constant subject. His boxes make me think of beautiful, hermetic poems in which we find ourselves dazzled by the images, moved to speculate on several possible meanings without in the end being able to settle upon one. In the meantime, as with all great works of art, we have become captives. The more we peek at the box, the more we come to occupy its imaginary space until we are all there, alone with our thoughts, in a blue light of a desert night.

Charles Simic

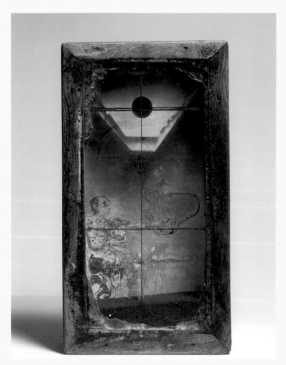

Joseph Cornell *Andromeda (Sand Fountain)* 1953–1956 wood, glass, wine glass, paper collage, sand, paint 14 x 7 3/4 x 3 3/4 in. (35.6 x 19.7 x 9.5 cm)
Gift of Mr. and Mrs. Russell Cowles (Elizabeth Bates Cowles Foundation) and Judy and Kenneth Dayton, 1971 1971.1

Tony Cragg

British, b. 1949

-- **Commissions**
Ordovician Pore (1989)
-- **Exhibitions**
Artists' Books (1981), *The Garden in the Galleries* (1994)
-- **Holdings**
2 sculptures

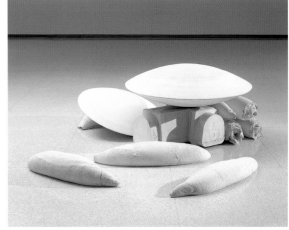

Tony Cragg *Generations* 1988 plaster 27 9/16 x 78 3/4 x 98 7/16 in. (70 x 200 x 250 cm) T. B. Walker Acquisition Fund, 1990 1990.73

Ralston Crawford

American, b. Canada, 1906–1978

-- **Exhibitions**
136 American Painters (1946; catalogue), *Contemporary American Painting: Fifth Biennial Purchase Exhibition* (1950; catalogue, tour), *Contemporary American Painting and Sculpture: Collection of Mr. and Mrs. Roy R. Neuberger* (1952; catalogue), *The Classic Tradition in Contemporary Art* (1953; catalogue), *Reality and Fantasy, 1900–1954* (1954; catalogue), *American Prints Today* (1959), *Art Fair* (1959; catalogue), *The Precisionist View in American Art* (1960; catalogue, tour), *Ralston Crawford Photographs: New Orleans Jazz* (1963), *The Cities Collect* (2000)
-- **Holdings**
1 painting, 1 edition print/proof

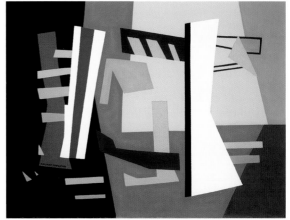

Ralston Crawford *Third Avenue El* 1949 oil on canvas 30 3/8 x 40 5/16 in. (77.2 x 102.4 cm) Gift of the T. B. Walker Foundation, Gilbert M. Walker Fund, 1951 1951.15

Merce Cunningham
American, b. 1919

"When I dance, it means: this is what I'm doing."[1] This
telling quote encapsulates the discursive and visionary
qualities of an iconoclast whose body of work encom-
passes and has influenced the disciplines of dance,
music, film, visual arts, and more. Neither modern nor
postmodern, Merce Cunningham remains a choreogra-
pher unclassifiable by the standard dance lexicon. And
yet, somehow, "contemporary" seems a woefully inad-
equate descriptor. Though he has consistently rejected
the impulse to have his work "read" in any conventional
sense, there is no doubt that a highly rigorous formal
vocabulary has taken root. Cunningham places the
gesture—movement—above all else, while advancing
the still radical notion that each art form is independent,
yet intertwined through enactment. Indeed, it is this
very subjectivity that lies at the heart of his dance.

Cunningham's obvious creative leanings were
encouraged by his family during his childhood in
Centralia, Washington. Early dance instruction (tap,
ballroom, and an array of traditional and ethnic forms)
indicated a flair for the dramatic, and his continued
interest in the theatrical led him to the Cornish School
in Seattle, Washington (now Cornish College of the
Arts), where he pursued drama, later switching to
dance. He became closely acquainted with the school's
headmistress, Nellie C. Cornish, a prominent early
influence. The school employed as instructors a num-
ber of former Martha Graham dancers, and he went on
to dance with her company from 1939 to 1945. It was
also at Cornish that he formed the most significant col-
laborative relationship of his life and career with com-
poser John Cage. Merce Cunningham and Company
officially performed its first season in December 1953, at
what is now the Lucille Lortel Theatre in New York City.[2]

The company's first Walker Art Center–sponsored
performance took place in 1963 on the minuscule stage
of the Woman's Club Theater in Minneapolis. Dancing
were Cunningham, Carolyn Brown, Steve Paxton, Viola
Farber, Judith Dunn, and Marilyn Wood.[3] Cage served
as musical director and Robert Rauschenberg as set
and costume designer. The Walker's first full-scale resi-
dency with the company in 1969 was among the earli-
est of its kind, not only in Minnesota but also in the
United States, and it continues to serve as an effective
outreach model for new audiences. Later residencies
included talks, lecture/demonstrations, and perfor-
mances at venues ranging from the Minneapolis
Regional Native American Center Gymnasium and
the Benedicta Arts Center in St. Joseph, Minnesota, to
events with long-standing partners such as Northrop
Auditorium and the Hennepin Center for the Arts. As
part of the 1969 residency, the company performed
Canfield, a work often cited as an example of choreog-
raphy that is based entirely on time structures rather
than on narrative, representative gestures with fixed
meaning or dependence on exact rhythmic notation.
The process not only enables the autonomous devel-
opment of musical components, but also allows
Cunningham to choreograph in sections that may be
reordered, excised, or combined anew with other
works, while establishing the independence of move-
ment for its own sake.

A later example using a variation on the above
principle is *Doubletoss* (1993), a work created by the
merging of two separately choreographed dances.[4]
Both compositionally and thematically, the piece
focuses on binaries, which are emphasized by costum-
ing (two sets, different according to which dance is
being performed at a given time), set design (a black
scrim upstage, creating the effect of double worlds),
and duets intertwined with ensemble movement.
Various rhythms and postures come together in a deli-
cate anarchy of phrases that somehow translate as
both disjointed and unified. Takehisa Kosugi's[5] score
Transfigurations, composed with processed radio fre-
quencies, was curiously similar to the high-pitched
squeals of whale song, a perhaps unintended invoca-
tion of the natural in opposition to the sound source.

The significance of this methodology can be traced
to the revelatory freedom gained by the use of chance,
particularly in relation to the composition of phrasing.
Although indebted chronologically and perhaps in
spirit to the early procedures used by Dadaists such
as Marcel Duchamp and Hans Arp, Cunningham's
method is honed specifically to meet the needs
required by the medium of dance. Those dictates could
range from space considerations to the physical limita-
tions of the body; however, it is fair to say that conceptu-
ally, chance operations remained an open-ended idea,
and only one dimension of his choreographic practice.
Chance has enabled Cunningham to identify connec-
tive transitions from one phrase to the next, but also
constructs the rejection of wholeness, which is anath-
ema to his approach. To suggest that such a thing could
exist is contrary to the logic that drives the work—an
eradication of the veneer of unity.

The discrete coexistence of music and dance as
both Cunningham and Cage imagined it is critical to

understanding their practice. As a central tenet, it was an obvious necessity to address both the linkages and the sovereignty of the two in context. In 1981, the Saint Paul Chamber Orchestra (then directed by Dennis Russell Davies) dedicated an entire year to the work of Cage and copresented a number of Cunningham residencies and performances, including the groundbreaking Perspectives series,[6] which high-lighted musical elements of the repertoire, complete with lectures, classes, and films. Along with Cage, experimental composers such as Pauline Oliveros, Maryanne Amacher, and Gordon Mumma were frequent contributors to the company's musical legacy. A number would form meaningful individual relationships with the Walker and were invited back over the years to perform independently. Of particular note is collaborator and accompanist David Tudor's 1976 residency project, an aural environment in which electronic sounds, derived from the resonant qualities of sculptures and found objects, played in the galleries and drifted into the lobby like a sonic blizzard. Titled *Rainforest*, the piece was first heard in Minneapolis as part of the company's 1972 residency.

As reflected in the company's fiftieth-anniversary performance of *Split Sides* at the Brooklyn Academy of Music in 2003, Cunningham's eclectic taste for unexpected musical partnerships remains—this time in the form of a collaboration with Icelandic band Sigur Rós and Britain's Radiohead. A roll of the dice on the day of the premiere determined the order in which segments of the overall dance were to be performed, a nod to Cunningham's first chance piece *Sixteen Dances for Soloist and Company of Three* (1951) (dictated by the tossing of a coin). Further, additional production elements such as set, lighting, and costumes are also formed autonomously, often coming together with choreography for the first time at dress rehearsals and even on the day of first-run performances. Mutual trust and a congruous understanding of Cunningham's aims (or lack thereof) have allowed extraordinary creative liberty for the company's collaborators, who have included Jasper Johns, Andy Warhol, Roy Lichtenstein, Rei Kawakubo, Morris Graves, Isamu Noguchi, and recently, Terry Winters. This rich history, and a thorough examination of Cunningham's place in the annals of multidisciplinary collaboration, were presented in the Walker-organized 1998 exhibition *Art Performs Life: Merce Cunningham/Meredith Monk/Bill T. Jones*.[7]

It is important to note that while Cage and Cunningham shared a belief in the validity of indeterminacy as a practice, each at times applied the method differently in his own work, as it proved useful. According to Cunningham, "My use of chance methods . . . is not a position which I wish to establish and die defending. It is a present mode of freeing my imagination from its own clichés and it is a marvelous adventure."[8] While the use of chance could be considered a logical precursor to the achievement of "naturalness," the definition of this ideal was distinct for both artists. Each strove for "the imitation of nature in the manner of her operation"[9] through their practice, but they were divergent epistemologically. Cage's rejection of the highly individualized self through the erasure of conceptual and formal distinctions can be interpreted in

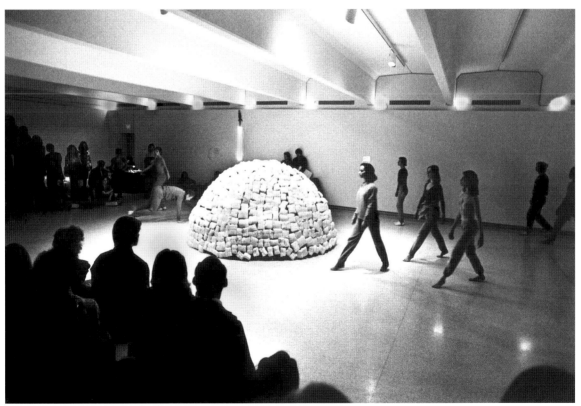

Merce Cunningham Dance Company *Canfield* *Mario Merz* exhibition galleries, Walker Art Center, 1972

alignment with the Zen philosophies he ascribed to, whereas Cunningham takes a Wildean approach, one that maintains a conscious separateness from the world in order to make some sense of it. One absorbs the notion in seeing his dance—in essence, a map for how to live a life, how to make a choice, and how to reconcile the intellectual fragmentations that occur in one's being.

"The audience is where you are," says Cunningham. This elegant statement, akin to a mantra, embodies freedom and boldly underscores the enormity of his task: an impartation that there are no fixed points in space and time, no boundaries to be transcended. Rather, each place one resides is independent and vibrant, and interrelatedness is favored over inspiration.

D.K.

Notes

1. Artist's statement, Merce Cunningham Dance Company Web site, http://www.merce.org (accessed October 22, 2004).

2. The first unofficial performances by the group were given at Black Mountain College in August 1953, billed as Merce Cunningham and Company. It is now known as Merce Cunningham Dance Company.

3. The company was invited by the Center Arts Council, the Walker's performing arts arm before the formal establishment of its Performing Arts Department in 1970.

4. With the Walker, Northrop Auditorium and the Cunningham Dance Foundation co-commissioned a three-year, three-commission series of works: *Fabrications* (1987); *Field and Figures* (1989); and *Doubletoss* (1993).

5. Takehisa Kosugi became the company's musical director after the tenures of John Cage and David Tudor (who served as advisor).

6. Cunningham collaborators Marty Kalve and Kosugi were participants.

7. For an excellent contextualization of dance's relationship to the modern museum, see Sally Banes, "Dancing in the Museum: The Impure Art," in Philippe Vergne, Siri Engberg, and Kellie Jones, eds., *Art Performs Life: Merce Cunningham/Meredith Monk/Bill T. Jones*, exh. cat. (Minneapolis: Walker Art Center, 1998), 10–15.

8. Quoted in Stephanie Jordan, "Freedom from the Music: Cunningham, Cage & Collaborations," in Germano Celant, ed., *Merce Cunningham* (Milan: Edizioni Charta, 1999), 62.

9. John Cage quoted in David Vaughn, *Merce Cunningham: Fifty Years*, Melissa Harris, ed. (New York: Aperture, 1997), 7.

Merce Cunningham at the Firehouse Theater, Minneapolis, 1977

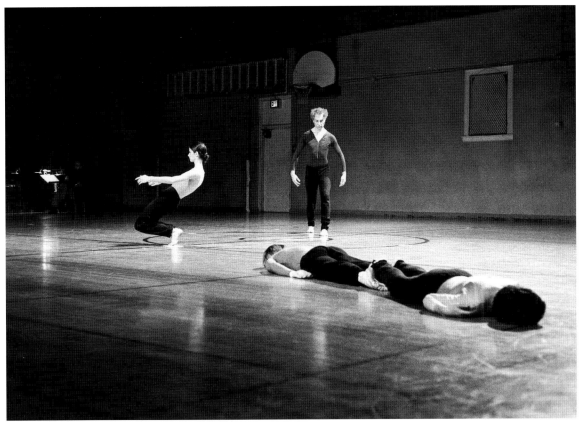

Merce Cunningham Dance Company untitled informal performance University of Minnesota Armory, Minneapolis, 1978

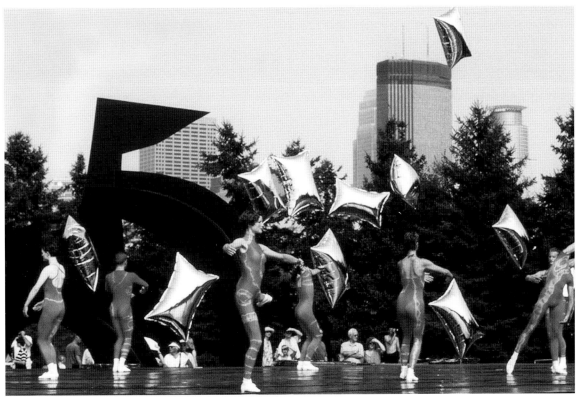

Merce Cunningham Dance Company *Event for the Garden* Tenth-anniversary celebration of the Minneapolis Sculpture Garden, 1998

John Currin

American, b. 1962

– – **Exhibitions**
Painting at the Edge of the World (2001; catalogue)
– – **Holdings**
1 painting, 1 drawing

Few could have guessed that the return of painting in the early 1990s would take such a Baroque dimension as it did in John Currin's work. Or should we say Mannerist? Emerging as one of the young-generation painters whose main concern lies in the human form, Currin could very well be the most sophisticated of the group—which also includes Elizabeth Peyton and Lisa Yuskavage—in his realistic rendition of the human anatomy. Realism is not what is at stake here, however. Female bodies are rendered both veristically corporeal and unsettlingly uncanny: nubile, rosy-cheeked girls endowed with impossibly large breasts; older urbane women with zero body fat and brutally short haircuts; and nude women, classically alluring and impenetrable as the biblical or mythological icons in Northern Renaissance paintings. In reaction to the growing lexicon of strange feminine typology in Currin's paintings, charges of misogyny have frequently surfaced. At the same time, the artist's brushwork has grown more sensitive and visceral. Critics who initially read his works as intentionally "bad" or "kitschy," moved progressively to describing them as masterful.

In *Park City Grill* (2000), the central figure is a young woman who seems to be having a jolly good time with a male companion. Long-stemmed glasses nestle in their hands. Her wavy, shoulder-length platinum-blonde hair is elegantly feathered to reveal a broad forehead and a long neck—not a graceful, swanlike neck but an oddly robust one, grafted on a body too slight to prop it up. Her shoulder jutting out of the arm-hole of her sleeveless dress is bony, and the arm extending from it appears emaciated and is elongated out of proportion. The uneven, ashen skin tone of the man's face contrasts with the disconcerting pallor of her flesh.

For many, Currin's figures evoke immediate references to names in art-history textbooks. The woman in this painting is reminiscent of Parmigianino's Mannerist masterpiece *Madonna with a Long Neck* (1534). There is also a certain allegorical tone that gives his works an air of classicism and suggests that they are morality tales whose codes are not entirely clear. On another level, leapfrogging back to presecular, classical times for artistic references signifies, for Currin, a political gesture. He has expressed an antipathy toward the ideological cast of his education, in which he felt subjected to the modernist privileging of abstraction and the postmodernist declaration of "the death of the author." Pronouncing that modernism and abstraction do not have authority over him was "like not feeling guilty about not going to church anymore."[1] While this striking simile suggests a sense of creative liberation, his stance on image-making is anything but simple, as revealed in another statement: "There is still this feeling of shame in the late twentieth century about painting pictures, visual pleasure; these are still off limits."[2] Currin's paintings may have audaciously stepped back into the realm of pleasure. Nevertheless, they also let beholders know that the guilt and shame associated with image-making and viewership are deeply entrenched proscriptions in our visual culture. The complexity of our responses to his paintings, then, may run far deeper than the surfaces of his canvases.

D.C.

Notes
1. Quoted in Alison M. Gingeras, "John Currin," in Alison M. Gingeras, ed., *"Dear Painter, paint me . . .": Painting the Figure since Late Picabia*, exh. cat. (Paris: Éditions du Centre Pompidou, 2002), 75.
2. Ibid., 77.

John Currin Park City Grill 2000 gouache on paper 7 1/2 x 6 in. (19.1 x 15.2 cm) Miriam and Erwin Kelen Acquisition Fund for Drawings, 2001 2001.59

John Currin *Park City Grill* 2000 oil on canvas 38 1/16 x 30 in. (96.7 x 76.2 cm) Justin Smith Purchase Fund, 2000 2000.107

Dorit Cypis
American, b. Israel, 1951

-- **Commissions**
Backstage at the Walker (1995); *Out of Time* (1998)
-- **Exhibitions**
Sculpture on Site (1998; publication), *American Tableaux*
(2001; publication, tour)
-- **Holdings**
2 sculptures, 1 photograph, 1 photographic suite

Dorit Cypis attended the California Institute of the Arts (CalArts) in the mid-1970s, where the then-new theories of semiotics and deconstruction saw professors and students alike grappling with the effects of these ideas on art practice. For the artist, deconstruction created a gap between subject and object, a disconnect that allowed her to focus on practices more keyed to the personal, to the spaces of subjectivity. Asking the question "How does one make work about the body within a theoretical framework?", she used analytical modes to address the realm of the body. Her early work, heavily influenced by film and cinematic experience, utilized performance as well as slide and overhead projections (in the days before video projection) in an attempt to reinsert the figure in the picture, to place the viewer's physical form in the space of the photographed, and projected, body.

Three of the works in the Walker Art Center's collection were created during a short period, a moment for Cypis in which she was entrenched in a work called *X-Rayed (altered)*. The piece, commissioned by the Whitney Museum of American Art, New York, in 1988, was a large-scale, slide-dissolve installation that projected image after image of a nude woman. Distraught after seeing the installed piece, the individual depicted in the work demanded that Cypis destroy it. Wanting to explore the psychological implications of such an extreme reaction, the artist decided to re-create the work using her own body, a pivotal move that in turn compelled her to continue and deepen explorations of the human form.

My Father's Nudes (1989) is a sculpture composed of an Oriental rug, a wooden salon table, and framed snapshots of famous nudes. The work, at its psychological center, represents Cypis' tense relationship with her father, a bond strained by her evocative use of her own naked body in her artwork. As the artist explains, her father returned from a trip to France with a handful of pictures of nudes from eighteenth- and nineteenth-century Northern European paintings and sculptures in the Louvre. When she asked him why he would give her such photos, he replied, "So, you think you have a monopoly [on] being naked?" For Cypis, her father's gift collapsed Freudian theories with ideas of home. In the sculpture, she reframes her father's snapshots in order to reframe his view of the nude. This action is as much reclamation as empathy. The Old World European style of too many Oriental carpets and heavy wood furniture used in the work, influenced by her immigrant parents, evokes the salons in which such nudes were viewed and the particular class of people who had the power to own such images.

Yield (the Body) (1989) was, for the artist, a somewhat didactic attempt to engage fellow female photographers in a dialogue about representation. She invited four women (Linda Brooks, Nan Goldin, Lynn Hambrick, and Ann Marsden) to shoot nudes of her, thereby transforming herself, a photographer, from subject to object, while at the same time forcing a discourse among her peers. As late as 1988, audiences were unused to looking at photos of women *by* women, especially naked, voluptuous figures. This work became something of a manifesto, a methodological tool to explore the ramifications of such a situation; Cypis received much criticism for it. Some called it revisionist, a reinforcement of sexism, but for Cypis the investigation begs the question of how a work can be sexist when it documents the artist's own, willing body.

The photos in *Yield (the Body)*, presented as unframed snapshots, are propped on small brass easels, with each photographer's work assigned to one of four shelves. This strategy presents the pictures as if they were merely books on a shelf, each offering a different theory of representation. Each row is labeled with an attributive artist's card, reminding the viewer of the specific authorship on display. One large, convex, box-framed photo crowns the shelves. This life-size image (sixty inches across) is a self-portrait of the artist, an abstracted form made so by the techniques employed to make the picture. It is the photographer's view of herself as well as an anonymous body. An empty easel sits before it, subtly inviting a photo for display, and rhetorically inviting the viewer to engage in the game of representation.

Jenelle Porter

Dorit Cypis *My Father's Nudes* 1989 framed chromogenic prints, nineteenth-century wood table, Oriental-style carpet 36 x 78 x 114 in. (91.4 x 198.1 x 289.6 cm) T. B. Walker Acquisition Fund, 1993 1993.2

Hanne Darboven

German, b. 1941

- - **Exhibitions**

Artists' Books (1981), *Photography in Contemporary German Art: 1960 to the Present* (1992; catalogue, tour)

- - **Holdings**

2 drawings, 8 books, 1 periodical

Hanne Darboven *Construction Drawing* 1966 graphite, ink on paper
21 7/8 x 16 7/8 in. (55.6 x 42.9 cm) Clinton and Della Walker Acquisition Fund,
1999 1999.24

Henry Darger

American, circa 1892–1973

- - **Holdings**

1 unique work on paper

Henry Darger *Untitled (Side A: During slack up in storm escape for fair.
Side B: After MC calls run.)* circa 1940 watercolor, pencil, ink, paper
collage on paper 19 x 70 in. (48.3 x 177.8 cm) double-sided Gift of Nathan
and Kiyoko Lerner, 1996 1996.54

Gene Davis

American, 1920–1985

-- **Exhibitions**
Gene Davis: Recent Paintings (1978; tour)
-- **Holdings**
3 paintings

Gene Davis *Untitled* 1960 acrylic on canvas 92 1/8 x 92 1/8 in.
(234 x 234 cm) Gift of the artist, 1980 1980.21

Stuart Davis

American, 1894–1964

-- **Exhibitions**
92 Artists (1943; catalogue), *110 American Painters of Today*
(1944; catalogue, tour), *136 American Painters* (1946; catalogue),
Watercolor—U.S.A. (1946; catalogue, tour), *Seeing Pictures* (1950),
*Contemporary American Painting and Sculpture: Collection of
Mr. and Mrs. Roy R. Neuberger* (1952; catalogue), *Lowenthal
Collection of American Art* (1952; catalogue), *The Classic Tradition
in Contemporary Art* (1953; catalogue), *Paintings by Stuart Davis*
(1957; catalogue, tour), *Art Fair* (1959; catalogue), *The Precisionist
View in American Art* (1960; catalogue, tour), *20th Century Master
Prints* (1975; tour)
-- **Holdings**
1 painting, 4 edition prints/proofs

Stuart Davis *Colonial Cubism* 1954 oil on canvas 45 1/8 x 60 1/4 in.
(114.6 x 153 cm) Gift of the T. B. Walker Foundation, 1955 1955.7

Willem de Kooning
American, b. the Netherlands, 1904–1997

- - **Exhibitions**

Modern Art in Advertising: Designs for Container Corporation of America (1948; catalogue), *Expressionism 1900–1955* (1956; catalogue, tour), *60 American Painters: Abstract Expressionist Painting of the Fifties* (1960; catalogue), *Willem de Kooning: Drawings/Sculptures* (1974; catalogue, tour), *Selections from the Martha Jackson Collection* (1975; catalogue), *20th Century Master Prints* (1975; tour), *Willem de Kooning: The Late Paintings, the 1980s* (1996; catalogue, tour), *The Cities Collect* (2000)

- - **Holdings**

1 painting, 2 drawings, 4 edition prints/proofs, 1 multiple, 1 periodical

The opening passage of "Burnt Norton," the first part of T. S. Eliot's poem "Four Quartets," begins: *Time present and time past/Are both perhaps present in time future,/And time future contained in time past./If all time is eternally present/All time is unredeemable./What might have been is an abstraction/Remaining a perpetual possibility/Only in a world of speculation./What might have been and what has been/Point to one end, which is always present.*[1] Willem de Kooning's artistic career followed a temporally circuitous path that in hindsight resonates with Eliot's profound verse. One of the undisputed leaders of the Abstract Expressionist movement, or New York School, de Kooning blazed a distinctive trail through the history of mid-twentieth-century art in which his innovations were inevitably followed by his retraced steps and subsequent new discoveries. For the artist, his past was always vividly present.

By the late 1940s, de Kooning had established his singular gestural style of abstraction—alongside another practitioner of action painting, Jackson Pollock—whose biomorphic forms and rhythmic lines reminiscent of Asian calligraphy coexisted within his often turbulent compositions. With his *Women* series of paintings and drawings, de Kooning would become the cause célèbre of the art world for supposedly turning his back on nonobjective, pure painting by returning the figure to prominence in his work.[2] The artist defended himself by pointing out that the figure had never actually left his formal repertoire. He also was (and still is) widely (and arguably unjustly) criticized for his misogynistic depiction of women as menacing and predatory; critics read the bestial disfigurement and feverish intensity of the slashing strokes of his pencil or paintbrush as virtually enacting violence against womankind.

In a 1953 *Artnews* article by de Kooning's friend and champion, Thomas Hess, he described the artist's two-year ordeal to execute one of his most celebrated paintings from this genre, *Woman I* (1950–1952).[3] Hess revealed de Kooning's working method, stemming from his practice in the 1940s of making charcoal tracings on transparent paper of large sections of previous works in order to jump-start his creative process or productively throw it off balance. Once the paintings were underway, the artist made change an inherent component of his artistic process. He would frequently scrape away large areas of the canvas, leaving behind faint pentimenti and underpainting, while also concealing unresolved passages with a thick coat of paint.[4] He also went to great lengths to keep his canvases moist, so that he could return to them day after day.[5] Hess wrote elsewhere that de Kooning had "gone back continuously to older shapes, re-creating new ones from them, as if he were impelled to bring a whole life's work into each section of each new picture."[6]

The paintings that de Kooning embarked upon in the 1980s continued this tendency toward rigorous, constant revision and self-quotation. He kept paintings from his distant past as well as works in progress constantly on view in the studio, so that he could freely refer to forms and colors; in addition, he used homemade flash cards and projected images of previous works as formal crib sheets. He also sanded over used canvases and incorporated the remaining skeletal marks into his compositions, and continued the use of transparent vellum to trace and superimpose images ad infinitum. Another technique that he used to keep things fresh and unstable was to rotate the canvas on the easel so that there was no definitive top or bottom, right or left side, until he declared it finished. With all these tricks of his trade, de Kooning was able to maintain disequilibrium and indeterminacy, conditions that had long been of interest to him.[7]

The artist stopped painting almost entirely between 1978 and 1980 as he—with the aid of his estranged wife, Elaine de Kooning, and several dedicated studio assistants—was slowly and painfully loosening the grip of several decades of alcohol abuse. It was also at this time that those closest to him began to remark on his forgetfulness and general distraction. (The diagnosis in 1989 was Alzheimer's disease.)[8] Nonetheless, from 1980 to 1981, he immersed himself in his work, and the result was a remarkable corpus characterized by flatly luminous ribbons of sensual color interrupted by poetic expanses of white, a clear shift from his heavily impastoed, landscape-inspired canvases of the previous decade. Not surprisingly, these paintings still evoked the figure—although what remained were powerful vestiges of lyrical curves and ambiguous protuberances. In 1980, he produced only a handful of canvases. By 1983, according to his studio assistant, "he just breathed them out."[9] In 1987, de Kooning's pace had slowed and the work, "despite extraordinary passages, lost its overall structural coherence."[10] Three years later, de Kooning laid down his paintbrush for the last time.

E.C.

Notes

1. T. S. Eliot, "Burnt Norton," in "Four Quartets," *T. S. Eliot: The Complete Poems and Plays, 1909–1950* (New York: Harcourt, Brace & World, Inc., 1930), 117.

2. De Kooning exhibited his *Women* series for the first time at Sidney Janis Gallery in the spring of 1953. The Museum of Modern Art acquired *Woman I* (1950–1952) that same year.

3. Thomas Hess, "De Kooning Paints a Picture," *Artnews* 52, no. 1 (March 1953): 30–33, 64–67. This article was illustrated with the work of another of de Kooning's close friends, photographer Rudy Burckhardt.

4. Hess also demonstrated that it was at this same time that de Kooning began photographing his paintings in progress, so that

he could study the evolution of his forms or return to compositions that were obliterated in the process of working. The artist would continue this practice in the 1980s. Progressive states of the 1980s paintings are illustrated in *Willem de Kooning: The Late Paintings, the 1980s*, Gary Garrels, ed., exh. cat. (San Francisco: San Francisco Museum of Modern Art; Minneapolis: Walker Art Center, 1995), 38–79.

5. Richard Shiff discusses various techniques used by de Kooning to extend the drying time, including covering the canvases with wet newspapers and creating his own special formula of paint mixed with an emulsion of safflower oil, water, and one or more solvents. See Richard Shiff, "Water and Lipstick: De Kooning in Transition," in *Willem de Kooning Paintings*, Marla Prather, ed., exh. cat. (Washington, D.C.: National Gallery of Art, 1994), 35. De Kooning once remarked, "I like a nice, juicy, greasy surface." See Hess, "De Kooning Paints a Picture," 65.

6. Thomas Hess quoted in Shiff, "Water and Lipstick," 34.

7. Shiff makes this point in his essay, ibid., 33.

8. For an insightful and balanced account of de Kooning's battles with alcoholism and Alzheimer's disease, and the impact his physical and mental health had on his artistic production, see Robert Storr, "At Last Light," in *The Late Paintings, the 1980s*, 38–79.

9. Tom Ferrara quoted in ibid., 53.

10. Ibid., 48.

Willem de Kooning *Woman* circa 1952 pastel, graphite on paper 13 1/2 x 10 5/16 in. (34.3 x 26.2 cm) Donated by Mr. and Mrs. Edmond R. Ruben, 1995 1995.67

Willem de Kooning *Untitled XII* 1983 oil on canvas 80 x 70 in. (203.2 x 177.8 cm) Gift of Peggy and Ralph Burnet, 2001 2001.131

Thomas Demand

German, b. 1964

-- **Exhibitions**
Stills: Emerging Photography in the 1990s (1997; catalogue)
-- **Holdings**
1 photograph

Thomas Demand is in the paradoxical position of being a sculptor whose completed work takes a photographic form. Perhaps more accurately, he is an artist who negotiates the territory between the three-dimensionality of the world of objects and the flatness of pictorial reproduction. Emerging on the contemporary international art scene in the mid-1990s, Demand has developed a uniquely hybrid artistic method in which he painstakingly reconstructs images culled from our culture's vast photographic archive, replicating them in his studio as life-size sculptural tableaux that he constructs out of paper and cardboard. These exceptionally precarious and meticulously lit structures act "as stage sets, existing in the artist's studio only long enough to be captured on film by his camera, after which they are destroyed, living on only in the two-dimensional mnemonic half-life of his large-scale color photographic prints.

At first glance, these works appear to be hyperreal depictions of the banal architectural spaces that we inhabit in our day-to-day lives. We are confronted with a vacant staircase in an institutional setting, a generic hallway in an anonymous apartment building, or a ransacked office. Upon closer inspection, however, these images become visually unstable as the seams holding together their carefully constructed worlds begin to show. This instability is initially the product of the deliberately handmade look of Demand's re-creations. Yet there is also an underlying psychological unease in these photographs, an uncanniness that emanates as much from the ambiguous content of the work, which rests just beyond the threshold of apprehension, as it does from its not quite trompe l'oeil means of production. As it turns out, these scenarios are based on found photographs of culturally significant, if unnotable, sites: the storage shelves of Leni Riefenstahl's film archive in *Archive* (1995); the hallway outside serial killer Jeffrey Dahmer's apartment in *Corridor* (1996); or the room where L. Ron Hubbard wrote his manifesto of Scientology in *Room* (1996). Each of these subjects is psychologically loaded, yet completely devoid of any visual clues as to their significance and of any traces of human presence. Demand himself offers very little in the way of an interpretative foothold for the viewer—his deadpan, generic titles are as mute as the blank paper surfaces of his sculptural constructs.

This inscrutability is similarly at work in *Barn* (1997), in which Demand presents us with a haunting reconstruction of a darkened, rustic architectural interior. Deriving its only sources of light from two windows and the gaps between the boards making up its walls, this barn takes on a somewhat menacing aspect that is only amplified by the claustrophobic perspective of the image. Was this the scene of some horrible crime?

The site of some literal (dis)embodiment of an American gothic? It is hard not to project our own obsessions into the blankness of Demand's spaces as they reach out to us on both a psychological and a physical level. As it turns out, however, this image is modeled on a photograph of Jackson Pollock's last painting studio on Long Island, which in itself triggers another chain of associations, along the path of photography's relationship to painting, modernism, Hans Namuth's famous photographs of Pollock, and so on. In the end, all of Demand's images have been resurrected from a state of obscurity in the flow of history and the media's news cycles, and respirate between a state of denotative solidity and decay, frozen in time by his lens, yet precariously captured just before their collapse into a chain of multiple associations.

D.F.

Thomas Demand *Barn* 1997 chromogenic print 72 1/4 x 99 3/4 in.
(183.5 x 253.4 cm) Butler Family Fund, 1998 1998.80

Maya Deren

American, b. Ukraine, 1917–1961

– – Screenings

New Art (1948), The Film as an Art Form (1954, 1955), Legend of Maya Deren (1977), Myth and Ritual in the American Avant-Garde (1980), Ruben Cinematheque: American Avant-Garde (1991), From the Ruben Collection: American Experimental Films (2000)

– – Holdings

6 films

Escaping from increasing anti-Semitism in the Ukraine, Maya Deren (born Eleanora Derenkowsky) and her family immigrated to Syracuse, New York, in 1922. Her father was a psychiatrist and her mother oversaw her education in the United States and Switzerland. Deren's interest in words, language, and movement was profound and lasted throughout her life. After working as a writer, editor, and social activist in New York, she moved to Los Angeles in 1941 with Katherine Dunham's dance company. There she met her second husband, Alexander Hammid, an avant-garde filmmaker from Czechoslovakia who, like other European experimental filmmakers (including Hans Richter and Oskar Fischinger), had migrated to Los Angeles during World War II. Deren brought her love of language and poetry to filmmaking when she made, under Hammid's mentorship, her first film, *Meshes of the Afternoon* (1943).

This film marks the beginning of an American avant-garde filmmaking movement. Evoking the traditions of European trance films such as Robert Wiene's *Das Kabinett des Doktor Caligari (The Cabinet of Dr. Caligari)* (1919) and Jean Cocteau's *Le sang d'un poète (The Blood of a Poet)* (1930), *Meshes of the Afternoon* presents the action as a dream and the main character (played by Deren) as a somnambulist caught between dreaming and waking states. It became a challenge to other American filmmakers, not only to use film creatively rather than commercially, but also to explore its potential as self-expression.[1]

Meshes of the Afternoon engaged Deren's interest in ritual (introducing the now-famous sequence of four footsteps from sand to grass to pavement to carpet) as well as psychological symbolism (for example: key, knife, mirror, mask), which was popularized by Freud's dream interpretations and the advent of psychotherapy. After moving back to New York in 1943, she made four more films: *At Land* (1944); *A Study in Choreography for Camera* (1945); *Ritual in Transfigured Time* (1945–1946); and *Meditation on Violence* (1948).[2] Her knowledge of dance and movement continued to influence how she constructed these works, while advancing her ideas beyond *Meshes of the Afternoon*. Cutting to the images within the frame mimics the way a dancer moves and exemplifies Deren's style of using a single physical gesture as a complete film form. She created new ways to defy space and time with her montage style of building sequences based on concept rather than content.

While much of her work was concerned with ritual, from 1947 to 1955 she elaborated on this interest when she filmed ritualistic dances and voodoo ceremonies in Haiti. The footage was edited in 1985 by Teiji and Cherel Ito, twenty-four years after the filmmaker's death, to become *Divine Horsemen: The Living Gods of Haiti*. Though we will, of course, never know how this film would have looked if Deren had completed it herself, it retains her distinct style of filming, her portrayal of the body, her use of movement as ritualistic expression, and her interest in dream states evident in all her work. This lifelong investigation, distilled in her films and writings, became her legacy and influenced generations of experimental filmmakers.

S.M.

Notes

1. The Walker Art Center's involvement with Deren—and with film-making as an art form—dates to 1948, when she presented her films in a program entitled New Art. Deren, who preferred to show her work in galleries, museums, and schools rather than in traditional movie theaters, returned to the Walker in 1955 to do a lecture/demonstration and a screening of her latest film, *The Very Eye of Night* (1955).
2. These films, plus *Meshes of the Afternoon* and *The Very Eye of Night*, are in the Walker's Edmond R. Ruben Film and Video Study Collection.

Maya Deren *Meshes of the Afternoon* 1943 16mm film (black and white, sound) 18 minutes Edmond R. Ruben Film and Video Study Collection

Mark di Suvero

American, b. China, 1933

- - **Exhibitions**
Works for New Spaces (1971; catalogue), *Homage to Picasso* (1980), *The Garden in the Galleries* (1994)
- - **Holdings**
4 sculptures, 19 edition prints/proofs, 1 multiple, 1 model

In 1960, critic Sidney Geist entered Richard Bellamy's legendary Green Gallery in New York and was inspired to write one of the most ecstatic reviews of his career, in which he made the hyperbolic proclamation, "From now on nothing will be the same."[1] The recipient of his praise was a twenty-seven-year-old sculptor who had relocated from San Francisco to New York in 1957, and after a period of adjustment to the ways and means of Manhattan, had begun producing what Geist described as "a body of work at once so ambitious and intelligent, so raw and clean, so noble and accessible, that it must permanently alter our standards of artistic effort."[2] The sculptor was Mark di Suvero, who would soon emerge as one of the most important American artists of his generation.

At the time of his debut, di Suvero was living in a ramshackle studio that one writer described as "a crumbling, nineteenth-century Fulton Fish Market edifice, in which one climbs up creaking wooden staircases, mounts unsteady ladders, shrinks along sagging catwalks, and finally reaches a mammoth attic that resembles, with its canted eaves of timbers, the overturned hull of a wind-jammer."[3] This was the evocative milieu from which the artist found material wealth for his sculptures in the form of refuse he scavenged from the streets, gutted buildings, and demolition sites in his neighborhood.

The works created from 1959 to 1966 were sprawling constructions of cast-off timbers with found objects, such as ladders and tires, which were tied together with heavy chains, ropes, and cables and positioned with bolts and nails on a scale rivaling that of the monumental canvases of the Abstract Expressionists. In fact, this was an observation that many contemporaries and critics made when confronted with these sculptures. Even the irascible and polemical artist Donald Judd wrote in his 1965 landmark essay "Specific Objects": "Di Suvero uses beams as if they were brush strokes, imitating movement, as [Franz] Kline did. The material never has its own movement. A beam thrusts; a piece of iron follows a gesture; together they form a naturalistic and anthropomorphic image."[4] Intended as a criticism, but accepted by the artist as an apt description of his intensions and a nod to the heroic vision of his forefathers, di Suvero created the last work of his assemblage style that same year. *Stuyvesantseye* (1965),[5] which the artist has ambiguously described as "a New York history dream-autobiography,"[6] is a tree of disparate objects, such as a chair, barrel, and fireplace log, that sprout from branches of curvilinear metal pipes—a truly Freudian and Surrealist-inspired juxtaposition. The whole complex pivots on a platform with wheels, allowing it to be transported and enabling the dangling chair to be set in motion.

Since 1962, di Suvero has been interested in the kinetic and participatory possibilities of sculpture and the natural precursor to that concept: direct public interaction. By introducing movable elements, he invited viewers to push, pull, sit, or climb on his works. He has attributed this democratic strategy to the influence of artist Alexander Calder, with whom he felt a great affinity. According to di Suvero, "Anybody who does motion in sculpture has to relate to him. . . . Calder's joy is real. He was able to take steel and make it balance. This is a man who knew about invisible centers of gravity, but he backed away from doing motion on a large scale. . . . Calder chose a dancing motion that had to do with a special kind of pleasure that human eyes need, which is the pleasure of leaves in the wind, of branches, a kind of gentle relationship to the human hand."[7] Di Suvero's *Arikidea* (1977–1982), with its wooden platform swing suspended by steel cables from a triangular armature, provides a gentle rocking motion and a respite from the ambulatory demands of negotiating the Minneapolis Sculpture Garden, where it has been on view since 1987.[8]

This work as well as its partner in the Garden, *Molecule* (1977–1983), are prime examples of the artist's large, outdoor steel works that he had transitioned to in the mid-1960s. What allowed this shift to monumental scale was his first use of a hydraulic crane in 1967, and his identification of steel girders and I-beams as ideal materials for his purposes. In contrast to the Minimalist artists' preferences for industrial fabrication, di Suvero has always preferred to do the building, welding, cutting, bolting, and crane operations himself, with the aid of a few assistants. With their architectonic forms jutting out into space and their dramatic, ruler-straight profiles silhouetted against the sky, di Suvero's works successfully contain a protean energy and dynamism that are unequaled in twentieth-century sculpture.

E.C.

Notes

1. Sidney Geist, "A New Sculptor: Mark di Suvero," *Arts Magazine* 35 (December 1960): 40.

2. Ibid.

3. Max Kozloff, "Mark di Suvero: Leviathan," *Artforum* 5, no. 10 (June 1967): 41.

4. Donald Judd, "Specific Objects," *Arts Yearbook* 8 (1965), reprinted in *Donald Judd: Complete Writings 1959–1975* (Halifax, Nova Scotia: Press of the Nova Scotia College of Art and Design; New York: New York University Press, 1975), 183.

5. The work's title is a reference to Peter Stuyvesant (1592–1672), the last Dutch governor of New Netherlands before the settlement surrendered to the English in 1664 and received its current appellation of New York. The artist's choice may have been motivated by his difficult life circumstances and physical condition at the time. In March 1960, just months before the opening of his Green Gallery show, he was working as a lumber delivery man, which occasionally required riding on top of passenger elevator compartments when his loads were too large. When an elevator failed to stop on its ascent, he was trapped and broke his back. Di Suvero was subsequently confined to a wheelchair, but went on to beat the odds by walking again. The artist has stated that Stuyvesant, who was an amputee, had been "driven crazy

by his bum leg." See Nancy Roth, "Mark di Suvero: *Stuyvesantseye*," in Martin Friedman, ed., *Walker Art Center: Painting and Sculpture from the Collection* (Minneapolis: Walker Art Center; New York: Rizzoli International Publications, 1990), 177.

6. Di Suvero, correspondence with Walker Administrative Director Don Borrman, March 27, 1972 (Walker Art Center Archives).

7. Deborah Solomon, "On the Waterfront with Mark di Suvero," *Journal of Art* 3 (October 1990): View section, 9.

8. *Arikidea* was the first piece to be installed in the new Minneapolis Sculpture Garden in 1987. As the work was in the process of being acquired by the Walker, gallerist Richard Bellamy wrote a letter of thanks to the donors, aptly describing *Arikidea* as "a grand baroque work with strong image quality that is revealed not instantly and is delicately poised with all its massive complexity." Bellamy, correspondence with Kenneth and Judy Dayton, October 18, 1985 (Walker Art Center Archives).

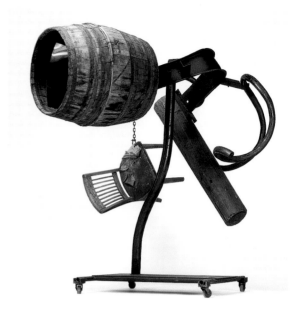

Mark di Suvero *Stuyvesantseye* 1965 wood, steel 86 x 89 1/4 x 95 7/8 in. (218.4 x 226.7 x 243.5 cm) Gift of the T. B. Walker Foundation, 1972 1972.8

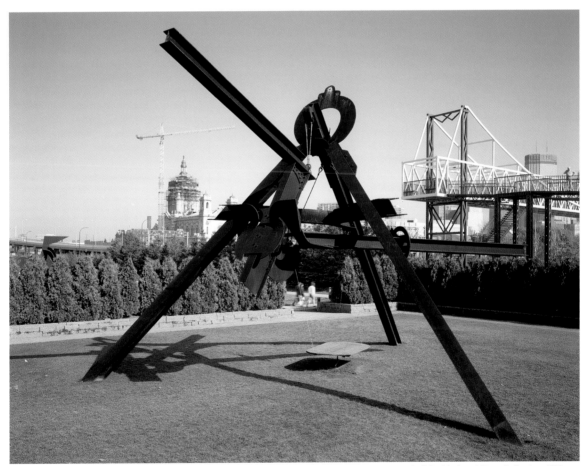

Mark di Suvero *Arikidea* 1977–1982 Cor-Ten steel, steel, wood 316 1/2 x 510 x 450 in. (803.9 x 1295.4 x 1143 cm) Gift of Judy and Kenneth Dayton, 1985 1985.43

Jan Dibbets

Dutch, b. 1941

- - **Exhibitions**
Artists' Books (1981), *Jan Dibbets* (1988; catalogue, tour),
The Last Picture Show: Artists Using Photography, 1960–1982
(2003; catalogue, tour)
- - **Holdings**
2 unique works on paper, 1 photograph, 2 photographic suites,
2 books, 1 periodical

Although his formal education was in painting, Jan Dibbets created photographic works early in his career that evidence a fresh approach to other media and an abandonment of rigid styles. Specifically, he used photography as an analytical tool to develop new ways of understanding visual phenomena. These early works, titled *Perspective Corrections* (1967–1969), initiated his lifelong exploration of the essential nature of both perception and representation by combining two illusions: the assumed transparency of photography, the way an object photographed seems to occupy a real space beyond the photograph's surface; and an illusion created by the artist himself, such as a trapezoid drawn on his studio wall and shot from an angle that makes it read as a square on the flat plane of the physical photograph.

A pioneer of what would soon be called Conceptual Art, Dibbets was included in a number of important international exhibitions, such as *When Attitudes Become Form* at the Kunsthalle, Bern, in 1969, and *Information* at the Museum of Modern Art, New York, in 1970. These exhibitions sparked communication among artists working in different countries and on different continents, establishing a sense of community among a generation sharing many of the same ideas and attitudes. His work after 1970 shows the influence of these important encounters with other artists, especially the seriality of American Minimalism. (Indeed, he and artist Sol LeWitt have had an enduring friendship.)

In *Daylight, Flashlight, Outside Light, Inside Light* (1971), Dibbets repeats the act of photographing his subject—two potted plants on a windowsill—twelve times under slightly altered conditions. This lyrical piece reads like a filmstrip, but in fact is an empirical study of the effects of varying light conditions. It is as if he is discovering the medium's possibilities all over again, step by step, and seeing the world for the first time through the photographs. As in much of his work, he focuses on the building blocks of visual perception— such as light—using photography as merely one tool. Throughout his career, Dibbets has continued to employ the interaction of light and windows as a double metaphor for the camera's lens and the human eye.

The artist soon turned this analytical eye and collaged-panorama technique to the subject of landscape. Playing with the famously low Dutch horizon line and flat topography, he gradually rotated the camera to create fictitious mountains when the photographs are assembled in a row. Here he is again relying on our trust in the medium. We have learned to believe in a photo's ability to show us things as they are, yet the artist undermines this effect by using images of real land to create a fictional landscape. Abstraction, and the role of the artist in creating such illusions, are classic problems in painting that Dibbets' approach suggests is also an underlying issue in photography. His works lay the foundation for the projects of contemporary artists like Andreas Gursky and Thomas Demand. For Dibbets, however, the artist's role in these illusions is always revealed. As in *Daylight, Flashlight*, his works bear the instructions for their own creation in pencil sketches and annotations beneath the image.

In each of the ten photographs that comprise *Horizon 1°–10° Land* (1973), a single image of the flat Dutch landscape is rotated to create a diagonal horizon line. From left to right in the progression, the reoriented views have been framed in such a way that they drop incrementally by one degree, gradually shifting the sky back toward its natural orientation. The elements also get increasingly wide, allowing more of the skewed field of vision to be revealed. The methodical logic of this multipart piece is indicated by a sequence of degree measurements at the bottom of each photograph.

The serially additive process Dibbets uses in *Horizon 1°–10° Land* parallels the approaches of some American Minimalists. Several such works in the Walker Art Center's collection include Donald Judd's untitled red progression of 1965 and Sol LeWitt's *Cubic Modular Piece #2 (L-Shaped Modular Piece)* (1966), or Arte Povera artist Mario Merz's explorations of the medieval Fibonacci counting system as referenced in *Igloo* (1971). Seriality allows for controlled experiments, ordering the visual environment by repeating the same form, sometimes with slight variations according to a predetermined system. The interest in and imposition of such ordering principles was widespread in the late 1960s and early 1970s, though none yielded such poetic results as Dibbets' photographs, which seek to understand and communicate the nature of perception by revealing our own capacity for abstraction. Today, Dibbets continues to turn his camera's eye toward new subjects in his personal investigation of the visual world, surprising us with dizzying views of cathedrals and fantastic windows on the world.

Elizabeth Mangini

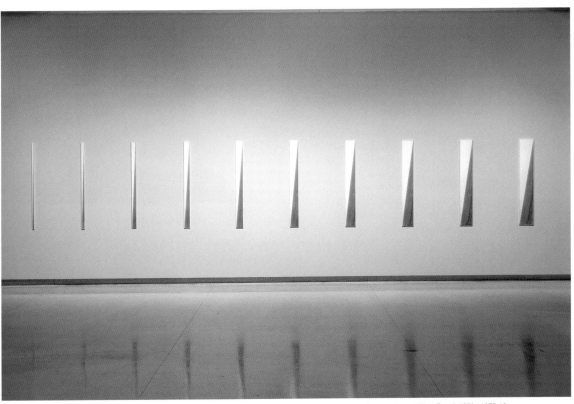

Jan Dibbets *Horizon 1°–10° Land* 1973 color photographs 48 in. (121.9 cm) x variable widths Art Center Acquisition Fund, 1978 1978.19

Jan Dibbets *Autumn Melody* 1974 color photographs, graphite on paper 11 x 57 in. (27.9 x 144.8 cm) Gift of Judy and Kenneth Dayton, 1999 1999.55

Rineke Dijkstra

Dutch, b. 1959

- - **Exhibitions**
Let's Entertain (2000; catalogue, tour)
- - **Holdings**
1 video

Over the past ten years, Rineke Dijkstra has based her practice on the scrutiny and portraiture of teenagers on beaches in Eastern Europe and North America, young mothers with their newborn babies, Portuguese matadors, French foreign legionnaires, adolescent Bosnian refugees, and Israeli soldiers, among others. Formally, all her portraits share a frontality reminiscent of August Sander's systematic typology of the social strata of the Weimar Republic. What distinguishes Dijkstra's work is a human touch—her models, her objects, always remain subjects who agree to be part of a conversation with both the photographer and the camera. Her images never fail to picture a tension that reveals self-confident, unsettled, dazed, unsteady identities. She focuses on specific qualities—the curve of a neck, the twist of an ankle, a drop of blood, a bead of sweat, the concealment of a shoulder. This emphasis, along with her ability to capture the historical moment in the details of the portrait, places her closer to traditions of classical painting than of straight photography.

The *Buzz Club, Liverpool, England/Mysteryworld, Zaandam, Netherlands* (1996–1997), Dijkstra's first video work, was shot at two European dance clubs. She recorded clubgoers in a makeshift studio adjacent to the main dance floor. Complaisance is absent; empathy is there instead. Isolated from the group and edited from the signifiers of their world, her subjects confront or avoid the camera's gaze, sway to the beat, blow smoke rings, stare, or suddenly let loose with frenetic dancing. Everything—the clothing, the hairdos, the body language, the jewelry, the attitudes, the music—participates in carving out a mesmerizing gap of time and space in the world of teenagers struggling to define their identity. They are pulled in the uncanny tension between childhood and adulthood, individuality and uniformity, strength and vulnerability.

Such a disjunctive feeling is reinforced, almost literally, by the device of the large-scale double projection in which music and images are not always in sync, allowing and channeling the viewer's perception of the space between the protagonists. Whether working in photography or video, Dijkstra carves moving, yet never sappy images of contemporary social history. She programmatically captures in her subjects the gazes, poses, and twitches that elevate the images to melancholic, humanistic meditations on the transitional nature of being.

P.V.

Rineke Dijkstra *The Buzz Club, Liverpool, England/Mysteryworld, Zaandam, Netherlands* 1996–1997 double projection, digital video transferred to DVD (color, sound); Artist's Proof 1/2 from an edition of 8 26:40 minutes
T. B. Walker Acquisition Fund, 2001 2001.20

Burgoyne Diller

American, 1906–1965

-- **Exhibitions**

The Classic Tradition in Contemporary Art (1953; catalogue),
Burgoyne Diller: Paintings, Sculpture, Drawings (1971; catalogue, tour)

-- **Holdings**

1 painting

Burgoyne Diller *First Theme* 1963–1964 oil on canvas 72 1/8 x 72 in.
(183.2 x 182.9 cm) Gift of grandchildren of Archie D. and Bertha H. Walker,
1972 1972.23

Jim Dine

American, b. 1935

- - **Exhibitions**

Eighty Works from the Richard Brown Baker Collection (1961; catalogue), *Banners and Tapestries* (1967), *Artist and Printer: Six American Print Studios* (1980; catalogue, tour), *Jim Dine: Five Themes* (1984; catalogue, tour), *First Impressions: Early Prints by Forty-six Contemporary Artists* (1989; catalogue, tour), *Duchamp's Leg* (1994; catalogue, tour), *The Cities Collect* (2000)

- - **Holdings**

1 painting, 1 sculpture, 1 gouache/watercolor, 2 unique works on paper, 1 multimedia work, 31 edition prints/proofs, 5 portfolios of prints, 8 books

For more than four decades, Jim Dine has created a profound vocabulary of iconic images with which to communicate a pantheon of emotions stemming from his exploration of the depths of human experience, both in the mind and in the world. A native of Cincinnati, in 1958 he moved from Ohio to New York, where he was befriended by young and up-and-coming artists such as Red Grooms, Claes Oldenburg, and Tom Wesselmann. There he became an integral part of the burgeoning avant-garde scene that was at once laying Abstract Expressionism to rest and offering an alternative to the prevailing aesthetic of action painting. By the mid-1960s, Dine's work had become synonymous with Pop Art, a movement with which he has never felt a strong affinity. He has long disassociated himself by arguing that his sources are personal, not popular, and that his works pertain more to his lifelong search for the self and for insights into what it means to be human. In 1977, he insisted, "I'm not a Pop artist. I'm not part of the movement because I'm too subjective. Pop is concerned with exteriors. I'm concerned with interiors."[1]

In the spring of 1966, Dine spent two months in London, where he was commissioned by Paul Cornwall-Jones at Editions Alecto to produce a print portfolio.[2] He later returned to England with his wife and three children in June 1967, and decided to abandon painting,[3] a moratorium that opened him to other creative endeavors, including printmaking and poetry. By 1969, he had taken up painting again, having sufficiently banished his demons and come to terms with his early success and his self-imposed outsider status.

This personal renaissance led to a series called *Painting Pleasures*, which includes the Walker Art Center's *July London Sun* (1969), a work that addresses the subjects of the act of painting itself and Dine's identity as an artist. Following the French Impressionists' tradition of plein air painting, he strove to record the effects of air and light, while also capturing the very particular atmospheric conditions that he had experienced in London and nowhere else.[4] Dine has frequently turned to art-trade motifs, such as palettes or color charts, for their abstract qualities but also "to venerate painting for the sake of painting."[5] Similarly, in this work he has placed a portable easel with requisite canvas attached in front of his larger, four-panel work.[6] The easel, the identical gestural brushstrokes that appear on the lower right canvas and its miniature

counterpart, and the ghostly word "pleasures" that the artist stenciled on the bottom edge of the lower left canvas all self-reflexively point to the elation and release brought about by his return to his favored medium after a long hiatus.

Dine's prodigious career has encompassed a wide range of media, including sculpture. In the winter of 1982–1983, he traveled to Los Angeles to work on a large series of bas-reliefs commissioned for the newly renovated Biltmore Hotel, and during his stay, he was invited to teach a bronze-casting course at the Otis Art Institute of Parsons School of Design.[7] With the assistance of the art department staff and a select group of students, he began work on *The Crommelynck Gate with Tools* (1983). Dine had executed a series of paintings two years earlier in which the gate image made its first appearance, and he attributes his use of this motif to a dream he had of the nineteenth-century iron gate that stands in front of the Parisian studio and residence of master printer Aldo Crommelynck. "For eight years I could see the gate from the table where I made etchings, and it became a symbol for me of France and my friendship with Aldo and his wife, Pep," Dine recalls. "I saw in its arabesque shapes a way to make a painting that would be the closest I would ever come to abstraction. Of course, it didn't end up that way. It never does."[8] Approximately twice as large as the actual gate, his sculpture includes direct wax castings of his own tools, such as hammers, axes, pickaxes, cutters, and wrenches as well as wooden sticks, which were heated and twisted to alter their appearance, then cast in bronze and welded to the armature of the gate. Tools have been a part of Dine's consciousness since he was a very young boy working in his grandfather's hardware store, and continue to assert a pervasive presence in his oeuvre. He has even gone so far as to refer to them as his "passports to feeling."[9] For an artist who has relentlessly exposed his inner life through his art in a fearless search for meaning, this gate with all its talismanic accretions is the ultimate revelatory motif.

E.C.

Jim Dine *The Crommelynck Gate with Tools* 1983 bronze; edition 1/6 108 x 132 x 36 in. (274.3 x 335.3 x 91.4 cm) Gift of Mr. and Mrs. Edson W. Spencer, the R. C. Lilly Foundation, Clarence Frame, Ann Hatch, and John A. Rollwagen and Beverly Baranowski, 1984 1984.5

Notes

1. Quoted in John Gruen, "Jim Dine and the Life of Objects," *Artnews* 76 (September 1977): 38.

2. Dine created a portfolio of ten screenprints with collage entitled *Tool Box* (1966).

3. Dine had been feeling increasingly alienated from the New York art world and was also having a disagreement over money with his dealer in New York, Sidney Janis. He spoke freely about this rift in his interview with Germano Celant and Clare Bell in Germano Celant and Clare Bell, eds., *Jim Dine: Walking Memory, 1959–1969*, exh. cat. (New York: Solomon R. Guggenheim Museum, 1999), 204.

4. The artist has stated that the Walker's painting relates directly to an earlier work, *Long Island Landscape* (1963), currently in the collection of the Whitney Museum of American Art, New York. Dine, unpublished interview by Martin Friedman, November 18, 1981 (Walker Art Center Archives).

5. Quoted in Marco Livingstone, *Jim Dine: The Alchemy of Images* (New York: Monacelli Press, 1998), 92.

6. His decision to use four canvases in a grid formation was a practical one; his art supply store did not carry anything larger, and he had wanted to work on a very large scale. However, the qualities of formal division had also long appealed to him and he had successfully used this format in the past. See Friedman interview, 1981 (Walker Art Center Archives).

7. In November 1981, Dine's longtime Los Angeles patron Gene Summers commissioned the artist to create the work for the Biltmore's restaurant. Dine worked with the Otis Art Institute of Parsons School of Design to produce the piece. See Maurice Tuchman, *Jim Dine in Los Angeles*, exh. bro. (Los Angeles: Los Angeles County Museum of Art, 1983).

8. Quoted in Graham W. J. Beal, *Jim Dine: Five Themes*, exh. cat. (Minneapolis: Walker Art Center, 1984), 136.

9. Quoted in Martin Friedman, "Brushstrokes, Passports and Bones," in Martin Friedman, *Jim Dine: New Tool Paintings*, exh. cat. (New York: Pace Wildenstein, 2002), 4.

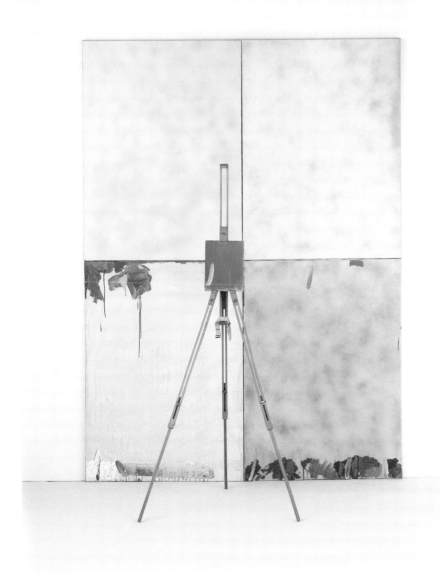

Jim Dine *July London Sun* 1969 acrylic on canvas, wooden easel 98 x 72 x 47 1/2 in. (248.9 x 182.9 x 120.7 cm) overall Gift of Mr. and Mrs. Miles Q. Fiterman, 1991 1991.164

Eugenio Dittborn

Chilean, b. 1943

-- **Holdings**

1 painting

Eugenio Dittborn *10th History of the Human Face (to Commission and to Collect) (Numbers 84a and 84b)* 1991 painting, stitching, photoscreenprint on nonwoven fabric, envelopes 82 3/4 x 110 1/4 in. (210.2 x 280 cm) Gift of the Peter Norton Family Foundation, 1993 1993.95

Stan Douglas

Canadian, b. 1960

-- **Screenings**

Magnetic North (2000; catalogue, tour)

-- **Exhibitions**

Let's Entertain (2000; catalogue, tour)

-- **Holdings**

2 photographs, 2 videos, 4 books, 2 periodicals

Stan Douglas *Monodramas* 1991 laser disc (color, sound); Artist's Proof from an edition of 5 18:35 minutes T. B. Walker Acquisition Fund, 1996 1996.186

Carl Theodor Dreyer

Danish, 1889–1968

-- **Screenings**
Cinema of Carl Theodor Dreyer (1974)
-- **Holdings**
1 film

Carl Theodor Dreyer *The Passion of Joan of Arc* 1928 16mm film (black and white, silent) 123 minutes Edmond R. Ruben Film and Video Study Collection

Jean Dubuffet

French, 1901–1985

-- **Exhibitions**
Reality and Fantasy, 1900–1954 (1954; catalogue), *Expressionism 1900–1955* (1956; catalogue, tour), *Second Annual Collectors Club Exhibition* (1958; catalogue), *Art Fair* (1959; catalogue), *Paintings from the Stedelijk Museum, Amsterdam* (1959; catalogue, tour), *Eighty Works from the Richard Brown Baker Collection* (1961; catalogue), *Faces and Figures* (1961), *Jean Dubuffet: Retrospective* (1966; organized by the Dallas Museum of Fine Art, Dallas, Texas; catalogue), *Jean Dubuffet: Monuments/Simulacres/Practicables* (1973; catalogue), *20th Century Master Prints* (1975; tour), *Paintings from the Des Moines Art Center* (1984)
-- **Holdings**
3 paintings, 1 sculpture, 2 edition prints/proofs, 4 books

Jean Dubuffet *Les Péréquations* (*The Levelings*) 1971 vinyl, acrylic on polyester resin panel, polyester, fiberglass 128 1/2 x 193 1/2 x 6 in. (326.4 x 491.5 x 15.2 cm) Gift of the T. B. Walker Foundation, 1974 1974.8

Marcel Duchamp
American, b. France, 1887–1968

‑‑ **Exhibitions**
The Classic Tradition in Contemporary Art (1953; catalogue), *Reality and Fantasy, 1900–1954* (1954; catalogue), *Not Seen and/or Less Seen of/by Marcel Duchamp/Rrose Sélavy 1904–64* (1965; organized by Cordier and Ekstrom Gallery, Inc., New York; catalogue), *20th Century Master Prints* (1975; tour), *The 20th-Century Poster: Design of the Avant-Garde* (1984; catalogue, tour), *Duchamp's Leg* (1994; catalogue, tour), *The Cities Collect* (2000)
‑‑ **Holdings**
1 film, 1 multiple, 11 books, 1 periodical

Among the most radical aspects of Marcel Duchamp's practice—which is a fountainhead in the history of twentieth-century art—was his insistence that the most interesting art springs from a nimble mind rather than a skilled hand. Operating out of a spirit of serious play, he used chance techniques and quasi-mechanical processes to create his works, sidestepping the personal and the handmade. He made so many variations, versions, and replicas of his objects that conventional distinctions between definitions of "original" and "reproduction" collapse like a house of cards. This activity was taken to its logical limits in his notorious "readymades"—functional objects without aesthetic pretension (such as a urinal), which he simply purchased and designated as his artwork (and which, today, exist only as copies, since all the "original" readymades have been lost). Duchamp's work developed alongside and against the formal explorations of Cubism, clearing an alternate conceptual path that has been followed by artists from Jasper Johns to members of Fluxus to Robert Gober.

In 1935 Duchamp wrote to a patron that he was thinking of making "an album of approximately all the things I produced."[1] The next year he embarked on the project, which lasted more than thirty years, and produced nearly 300 albums containing dozens of two- and three-dimensional reproductions of his works—an artist's version of a salesman's sample kit.[2] The albums, which he titled *de ou par Marcel Duchamp ou Rrose Sélavy* (*From or by Marcel Duchamp or Rrose Sélavy*), are like miniature retrospectives of his career in personal, portable museums.[3] When opened, the box becomes architectural, with three vertical "walls" and a "floor," and its unbound contents can be examined in any order the viewer wishes. The reproductions were supervised by Duchamp but made by others, using techniques (such as collotype, a labor-intensive process used to reproduce photographs) that reside somewhere between the mechanical and the handmade. Authorship is confused by the work's ambiguous attribution (to either Duchamp or his alter ego, Rrose Sélavy), and we are even given two ways to think about its creation: the passive "from" and the active "by." This work is often cited as the catalyst for artists' burgeoning interest in multiples during the 1960s, and it certainly inspired Fluxus artist George Maciunas to create unorthodox anthologies like the *Fluxkit*, which was packaged in a briefcase. Although made in multiple copies, such works were not seen as secondary documents. As Duchamp noted drily in 1952, "Everything important that I have done can be put into a little suitcase."[4]

J.R.

Notes
1. Quoted in Ecke Bonk, *Marcel Duchamp: The Box in a Valise*, trans. David Britt (New York: Rizzoli, 1989), 147.
2. The boxes contained between sixty-eight and eighty objects each, depending on the year of issue. The Walker Art Center's copy, from Series F, was produced in 1966 in Milan by Duchamp scholar Arturo Schwarz and signed by Duchamp. It contains eighty items documenting works from 1910 to 1954. See Bonk, *Box in a Valise*, 301.
3. This work is often referred to as *Boîte-en-valise* (*Box in a Valise*), but that is the correct subtitle only for the first twenty-four copies (Series A), which are contained in a leather carrying case. The rest are subtitled simply *Boîte*. See Bonk, *Box in a Valise*, 257.
4. Quoted in ibid., 257. A 1943 copy of the *Boîte-en-valise* was shown at the Walker in 1965 as part of the traveling exhibition *Not Seen and/or Less Seen of/by Marcel Duchamp/Rrose Sélavy 1904–64*.

Marcel Duchamp *de ou par Marcel Duchamp ou Rrose Sélavy (Boîte)* (*From or By Marcel Duchamp or Rrose Sélavy [Box]*) 1941/1966 glass, vinyl, lithographs on paper, ceramic, wood, cloth-covered board; Series F, edition of 75 box: 16 3/8 x 15 1/4 x 3 7/8 in. (41.6 x 38.7 x 9.8 cm) closed Gift of Ann and Barrie Birks, 1994 1994.5

Raymond Duchamp-Villon

French, 1876–1918

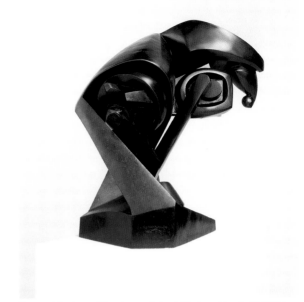

Raymond Duchamp-Villon *Le grand cheval* (*The Large Horse*) 1914/1957
bronze; edition 4/6 39 5/8 x 39 3/8 x 20 3/4 in. (100.7 x 100 x 52.7 cm) Gift of the
T. B. Walker Foundation, 1957 1957.6

Sam Durant
American, b. 1961

– – **Commissions**
Walker Art Center Garden Project with Audio Narrative, Ojibwe, Lakota, and Dakota Truths and Myths from the Invisible Present, Past, and Future-plus Retrocession Monument: Direction through Indirection (Bronze Version) (2003)
– – **Residencies**
2002–2003
– – **Holdings**
1 sculpture, 1 photograph, 1 photographic suite

Conceptually rigorous and aesthetically adventuresome, Sam Durant's work is hard to classify. Raised in Boston and now based in Los Angeles, Durant mixes the political and historical weight of the former with the seemingly fluffy yet deadly serious popular culture meanderings of the latter. His photographs, sculpture, drawings, and sound installations feverishly splice and juxtapose the disparate, finding, for instance, intriguing connections between art historian Rosalind Krauss and the tragic figure of Kurt Cobain. In a similar vein, he explores the darkly American themes of class, race, death, and the conflicts of progress in relation to such disparate figures as Huey Newton, Abraham Lincoln, Robert Smithson, Neil Young, and Miss America pageant protesters. Nevertheless, Durant's method of free association is never without a solid aesthetic and intellectual spine holding it all together.

In his early series *Chairs #1–#6* (1995), Durant poses classic mid-century Eames chairs with their undersides facing up. Propped roughly against scruffy floorboards, they suggest evidence at the scene of an unspeakable crime. For some, simply being denied their accustomed reverent viewing of high modernist furniture is the crime itself, but Durant also uses this dethronement to hint at the issues of class, privilege, and unquestioned assumptions that cloud contemporary life. He continues this discussion in the outdoor bronze sculpture *Direction through Indirection (Bronze Version)* (2003), which features an upside-down tree trunk with gnarled and exposed roots, a recurring motif that he has investigated in a number of drawings and sculptural installations. These stumps reference a 1969 installation by Robert Smithson, a leader of the Land Art movement, at Captiva Island, Florida. However, where Smithson was concerned with theories of entropy and regeneration, Durant pulls this loaded emblem into the bloody present of continuing civil-rights struggles for African Americans and Native Americans.

As a universal symbol, the tree has manifold meanings: tree of life, tree of knowledge, family tree. In many American Indian myths, a tree marks the meeting of sky and underworld or the cosmic center of a community or household. Yet with *Direction through Indirection*, the stump has been uprooted, violated, and then rendered infinite by its placement on a reflective stainless-steel plate, revealing a glimmer of hope and a hint at second chances. This sculpture was developed in the context of a residency, during which Durant worked with Native American teens, and the site itself only

undergirds the content. The land on which the Minneapolis Sculpture Garden sits once served as a seasonal camp for the Dakota. The uprooted tree also suggests the history of European lumber barons—including, as the artist points out, Walker Art Center founder Thomas Barlow Walker, who acquired logging rights on native lands in the 1800s, which contributed to the dislocation of Minnesota's Native American tribes. It is in this historical context that Durant comments, "I saw turning things upside down as a kind of politicizing, a kind of acknowledgment of a world that for Native Americans is turned upside down."[1] As always, this artist powerfully captures the specific within the universally metaphoric, the political within the symbolically charged.

O.I.

Notes
1. Sam Durant, interview with the author, August 2003 (Walker Art Center Archives).

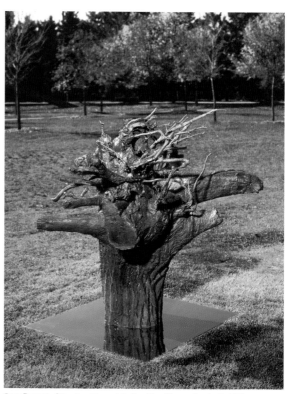

Sam Durant *Direction through Indirection (Bronze Version)* 2003
bronze, stainless steel; edition 1/3 65 x 64 x 80 in. (165.1 x 162.6 x 203.2 cm)
T. B. Walker Acquisition Fund, 2004 2004.25

Sam Durant *Chair #4* from *Chairs #1–#6* 1995 chromogenic print;
edition 2/3 16 x 20 in. (40.6 x 50.8 cm) McKnight Acquisition Fund, 1998
1998.70

Artist-in-Residence, 2002–2003

Sam Durant has been interested in Native American history
and politics since he was a young boy growing up in Boston,
so it was no surprise when he decided to focus his residency
project on that specific Twin Cities community. The American
Indian Movement (AIM), a civil-rights group, was founded in
Minneapolis, and helped spark the creation of public charter
schools dedicated to teaching Native American history and
culture. One of those, the Heart of the Earth Survival Charter
School in Minneapolis, was the first school approached by
Durant, who wanted to record the voices, thoughts, and
rhythms of Native American youths. The artist also worked
closely with media students at the Four Directions Charter
School in North Minneapolis.

Rather than simply taking a reverential stance toward
the past, Durant used a simple microphone to capture and
amplify the powerful contemporary voices of an often-
invisible population. The students shared their rapping skills,
poetry, and traditional folktales as well as their thoughts
about contemporary issues such as the joys of basketball
and the negative impact of drug addiction, alcoholism, and
prison time. Behind this raw sound, Durant added pulsing
beats like those heard on many of the radio stations popular
with teens. He also captured the spirit of the past as it
lives in the present during powerful drumming sessions
at the Heart of the Earth and the Little Earth Community
Powwow. These segments serve as regular punctuation on
the project's resulting thirty-minute soundscape, which
sonically enveloped Durant's sculpture *Direction through
Indirection (Bronze Version)* in the Minneapolis Sculpture
Garden. Together, the sculpture and the sound track form
one composite work titled *Walker Art Center Garden Project
with Audio Narrative, Ojibwe, Lakota, and Dakota Truths
and Myths from the Invisible Present, Past, and Future-plus
Retrocession Monument: Direction through Indirection
(Bronze Version)* (2003).

O.I.

Sam Durant (right) with student at the Four Directions Charter School,
Minneapolis, 2003

Sam Durant *Chair #3* from *Chairs #1–#6* 1995 chromogenic print;
edition 2/3 16 x 20 in. (40.6 x 50.8 cm) McKnight Acquisition Fund, 1998
1998.70

Eiko & Koma

Eiko, Japanese, b. 1952; Koma, Japanese, b. 1948

-- Commissions
Canal (1989), *Wind* (1993), *River* (1995), *Offering* (2002; indoor version, world premiere)

-- Performances
White Dance (1981), *Grain* (1984), *Canal* (1989), *Land*; *Wind* (1993), *River* (1996), *Offering* (2002; indoor version, world premiere), *Snow* (2003)

-- Residencies
1989, 1993, 1996, 2003

Simultaneously ancient and modern, shamanistic and deeply organic, the performance world Eiko & Koma inhabit is primordial in its expression; time acts almost as a silent third member of the duo. Their brand of movement theater executes choreography at a glacial pace that carries within it the potential to change the experience and perception of time itself.

Born and raised in Japan, the artists create works informed by the politics and global cultural movements of the 1960s as well as the democratic and community aspects of life in America (the couple's adopted home since 1976). Their early but major influences were the teachings of Tatsumi Hijikata and Kazuo Ohno, two founders and masters of butoh, the radical postwar Japanese dance-theater form. Also evident in their work are elements of Neue Tanz, the German modern dance movement of the 1970s, and other forms of German Expressionism that heavily shaped butoh's conception.

Drawing their power from Zen Buddhism[1] and its interrelated properties of nature, silence, repose, and the human body, Eiko & Koma populate their own works, using the tools of duration and process as guideposts. Each intricately crafted moment is heavy with the weight of meditation, yet conveys buoyancy in the delicacy of its execution. Simplicity, openness, the integrity of organic materials, and a sense of existential confrontation are their long-standing hallmarks.

At a time of expanding global influences in the national dance landscape, *White Dance* (1976; their first work) was performed as part of the Walker Art Center's New Dance USA festival in 1981.[2] In separate Walker engagements during the following fifteen years, Eiko & Koma presented the *Environmental Trilogy*: *Land*, *Wind*, and *River*. Cited as the launch point of their dedication to site-specific work, *River* took place not onstage, but in the waters of Medicine Lake in Plymouth, Minnesota. The piece provided a direct connection to nature as well as to a broader-based audience within the regional park and recreation area whom the artists hoped would happen upon the performance. They performed the work at dusk with a resolute sense of humility and inclusiveness that gathered the community together to explore the incontrovertible bonds between art and the environment.[3]

In part as a response to September 11, 2001, the ritualistic work *Offering* (2002) was created for performances on a plaza overlooking the Hudson River in New York City, near the World Trade Center site.[4] A work of beauty, pain, and healing, *Offering* attempts to sanctify a desecrated space. With this "transportable dance or living site-installation," the artists "hope to offer audiences the solace that they personally receive from nature's eternal rhythms—in which movement and stillness, life and death are but a breath apart. They aspire to bring a glimpse of the breathing universe into our wounded urban landscape."[5] The indoor version[6] of *Offering* opened with the performers emerging from within the theater's crumbling proscenium arch toward an icon not unlike a funeral pyre. The exquisite grace they created from the abstraction of their bodies seemed to channel the collective sadness of tragedies past. A lament, yes, but more a reminder of the revelatory power of hope and unity.

P.B.

Notes

1. For a detailed explanation of the importance of Zen philosophy to Eiko & Koma's work, see Suzanne Carbonneau, "The Weight of History, the Lightness of the Universe," Festival Program (Lewiston, Maine: Bates Dance Festival, 2002).

2. Although non-Western dance forms had long been assimilated, process methods and specific cultural philosophies were becoming more visible in American choreography.

3. Eiko on *River*: "We were guests of the river, and grateful for the beauty and pleasure we were allowed to share. Nor were these and we the only guests. Bats, insects, wind, moon, mist, children, geese, and fisherman were there before and after. . . . Even things that would normally be distractions in the theater became part of the scenery, for which we can take neither blame nor credit. . . . Rowboats drifted by and voices whispering in wonderment did not interrupt these dreams. Such inclusiveness is a joy." Excerpt from Eiko's essay on the artists' Web site, http://www.eikoandkoma.org/ekriverenv.html.

4. Beginning with *River*, the two have often produced separate but parallel indoor versions of each outdoor work.

5. Eiko & Koma, excerpt from the artists' Web site, http://www.eikoandkoma.org/ekoffering.html.

6. The Walker commissioned and held the world premiere of the indoor version of *Offering* as part of its 2003 Out There Festival, copresented with the Southern Theater, Minneapolis.

Eiko & Koma *River* Medicine Lake at French Regional Park in Plymouth, Minnesota, 1996

Sergei Eisenstein
and the Soviet Avant-Garde of the 1920s

Sergei Eisenstein, Russian, 1898–1948; Yakov Protazanov,
Russian, 1881–1945; Vsevolod Pudovkin, Russian, 1893–1953;
Abram Room, Russian, b. Poland, 1894–1976; Dziga Vertov,
Russian, b. Poland, 1896–1954

- - **Screenings**

Film and Lecture (1952); New Art (1952); Public Film Series (1955,
1956, 1961); Films by Six Great Directors (1960); Members' Film
Series (1969); Sergei Eisenstein's *Battleship Potemkin*: Premiere of
the Restored Version (1972); Russian Films (1973); Special Program
(1974); Early Cinema from the Soviet State Film Archives (1975);
Walker Art Center Film Study Collection (1976, 1977); Film Forms
(1977); Rediscovery (1979); Arthur Kleiner 1903–1980 (1980); Sounds
for Silents (1984); Sergei Eisenstein's *Battleship Potemkin* (with
the Minnesota Orchestra) (1985); Sounds for Silents (1986); Ruben
Cinematheque: Classic Soviet Cinema (1990); Ruben Cinematheque:
Unknown Soviet Cinema (1990); Yakov Protazanov's *Aelita* (with
new score by Dennis James) (1990); Ruben Cinematheque: Back
by Popular Demand (1992); Dziga Vertov's *Man with a Movie
Camera* (with Walker-commissioned score by Tom Cora) (1996);
Ruben Cinematheque: Two Tributes: Sergei Eisenstein and Shirley
Clarke (1998)

- - **Holdings**

11 films

Sergei Eisenstein ranks among the greatest filmmakers
in history. Along with other Soviet directors who made
their mark in the silent era, he set out to produce films
that were revolutionary in form as well as in subject. In
addition to their artistic significance, these works would
also influence international film theory and subsequent
experimental filmmakers, including the American
avant-garde.

In the wake of the 1917 Bolshevik Revolution, many
Russian Constructivist artists brought distinctly modern-
ist styles to the public arenas of architecture, industrial
design, graphics, and theater. An atmosphere of
creative ferment would last roughly a decade and be
stifled with the start of Joseph Stalin's first Five Year
Plan in 1928. Even a popular entertainment like the
science-fiction epic *Aelita* (1924), directed by Yakov
Protazanov, could showcase remarkable Constructivist
sets and costumes designed by Alexandra Exter and
Isaac Rabinovich.[1]

But the filmmakers who managed to transform cin-
ema as an art medium primarily came of age during
the Revolution. Eisenstein originally studied to be an
engineer, and then abandoned school in 1917 to serve
the cause through art: first in graphic design, then in
theater. His mentor was stage director Vsevolod
Meyerhold, who advocated a theater and performance
style that combined scientific principles of movement as
well as acrobatics, pantomime, and abstract set design.
Meyerhold's Constructivist approach was a major influ-
ence on Eisenstein, who formulated his concept of the
"montage of attractions" in which various visual, aural,
and performative elements combined to induce an
emotional response in the audience. He compared his
concept to the circus, where the total effect of simultane-
ous variety acts can transcend any single performer.

While Eisenstein was developing these ideas in the
theater, young filmmaker Lev Kuleshov was devising
complementary theories in workshops he conducted
at the new State Film School. Motivated in part by the
scarcity of raw film stock, Kuleshov focused on mon-
tage, or editing, as the factor that distinguished cinema
as an art. He discovered that each film image acquired
much of its meaning from its context (the shots that pre-
ceded or followed it on the screen) and that altering the
context could change an image's meaning.

An amusing example of this principle occurs in
Shakhmatnaya Gorychka (*Chess Fever*) (1925), a short
comedy codirected by Vsevolod Pudovkin, an actor
and pupil of Kuleshov's who would soon emerge as a
major filmmaker in his own right. In this brisk satire
of the Russian mania for chess, the neglected fiancée
of an obsessed fan seeks consolation from world cham-
pion José Capablanca, who "performs" in the comedy
without knowing it. Apparently the filmmakers
approached him on the pretext of filming a newsreel
and later edited him into the story, where he appears
to be flirting with the young woman.

Purloined celebrity also inspired another group of
filmmakers to construct a whole feature comedy around
the 1926 Moscow visit of Hollywood's "First Couple,"
Douglas Fairbanks and Mary Pickford, and to build
their story's climactic episode around the gracious kiss
that Mary innocently bestows on one of the actors.
While Pickford and Fairbanks were certainly unaware
of their appearance in that film, they did return to the
United States bearing a copy of one movie they had
found particularly impressive: Eisenstein's second film,
Bronenosets Potyomkin (*Battleship Potemkin*) (1926).

Both Eisenstein and Pudovkin elaborated on
Kuleshov's concept of the unedited shot as cinema's
raw material and of montage as its compositional tool.
Pudovkin would specialize in using images as "build-
ing blocks" to create dynamic and dramatic stories
about sympathetic protagonists who become involved
in the class struggle, from his first feature *Mat* (*Mother*)
(1926) through *Konyets Sankt-Peterburga* (*The End of
St. Petersburg*) (1927) and *Potomok Chingis-Khana*

Sergei Eisenstein *Ivan Groznyy II: Boyarsky zagovor (Ivan the Terrible, Part II)*
1958 16mm film (black and white/color, sound) 88 minutes Edmond R.
Ruben Film and Video Study Collection

(*The Heir to Genghis Khan*) (1928). As spectacular as his editing flourishes would be, they always served the emotions of the story and its characters. In adapting his montage of attractions from stage to screen, Eisenstein believed he had found a way to convey intellectual ideas in addition to emotional effects.

Based on the prerevolutionary episode of a 1905 naval mutiny, *Battleship Potemkin* features one of Eisenstein's signature sequences at the Odessa Steps, where citizens have gathered in support of the fugitive sailors. Czarist forces descend the stairs like a face-less machine, firing on innocent civilians. In a violent barrage of fragmented details, time is alternately com-pressed and elongated. The horror of the moment is embodied in central images of a woman and a baby carriage; she is killed, and the runaway pram descends the stairs into chaos. In Eisenstein's view, cinematic time could be "truer" than real time. The power of mon-tage could literally make a stone lion stand up in out-rage and roar.

In subsequent films, including *Oktyabr* (*October: Ten Days That Shook the World*) (1928), Eisenstein devel-oped his editing theories in progressively conceptual directions. As the Soviet Union adopted the orthodoxy of Socialist Realism, he would face censorship and accusations of formalism.

Dziga Vertov, another key filmmaker and theorist, went so far as to dispense with narrative altogether. Working exclusively with documentary and newsreel material, as in his masterful "city symphony" *Chelovek s Kinoapparatom* (*Man with a Movie Camera*) (1929), he combined actualité footage with radical editing techniques as a self-described "Kino Eye" revealing "life as it really is." Narrative filmmaker Abram Room approached contemporary city life with a more psycho-logical perspective in *Tretya Meshchanskaya* (*Bed and Sofa*) (1927), a landmark drama about women's rights and modern marriage.

An extraordinary era in Soviet film had essentially come to a close by the early 1930s. Copies of some of these classics were subsequently brought to the United States, particularly through efforts by the Museum of Modern Art, New York, and its nascent film department, and these found their way into universities and film society screenings. In the late 1940s, a significant avant-garde filmmaking movement started to emerge in America. It is reasonable to surmise that the 1920s experiments of Eisenstein, Vertov, Pudovkin, and their comrades were inspirational for the innovations of Maya Deren, Stan Brakhage, Kenneth Anger, and their contemporaries.

Richard Peterson

Notes

1. Protazanov's *Aelita* is represented in the Edmond R. Ruben Film and Video Study Collection by an extremely rare 35mm print, struck from the original negative and donated by the Soviet Union following its loan for the Walker Art Center's 1990 exhibition *Art Into Life: Russian Constructivism, 1914–1932*.

Sergei Eisenstein *Bronenosets Potyomkin* (*Battleship Potemkin*) 1926 16mm film (black and white, sound) 67 minutes Edmond R. Ruben Film and Video Study Collection

Dziga Vertov *Chelovek s Kinoapparatom* (*Man with a Movie Camera*) 1929 16mm film (black and white, silent) 67 minutes Edmond R. Ruben Film and Video Study Collection

Sergei Eisenstein *Oktyabr* (*October: Ten Days That Shook the World*) 1928 16mm film (black and white, silent) 103 minutes Edmond R. Ruben Film and Video Study Collection

Yakov Protazanov *Aelita* 1924 35mm film (black and white, silent) 99 minutes Edmond R. Ruben Film and Video Study Collection

Mary Esch

American, b. 1965

- - **Exhibitions**
Dialogues: Mary Esch/Daniel Oates (1997; publication)
- - **Holdings**
1 suite of drawings, 1 portfolio of prints

Mary Esch has spent the better part of her career investigating the act of storytelling in drawings, paintings, and prints that often take a revisionist look at history, myths, and fables. In a body of work completed for her 1997 *Dialogues* exhibition at the Walker Art Center, for example, the artist transported the viewer into the wondrous and violent realms of the fairy tale through the dreamlike tableaux of a series of paintings and drawings. While these works display a fascination with the moral lessons of fables such as those of the Brothers Grimm, her stories take a decidedly sharp turn away from the self-assured conclusions of their historical progenitors. If the tale of Hansel and Gretel is clear cut in the resolution of its narrative conflict, such is not the case in Esch's work, which weaves a circuitous and at times bizarre path through her fantastic worlds, twisting them to her own ends and leaving them far more open to speculative interpretation.

Esch's paintings portray garish vignettes where figures driven from the pages of unknown stories frolic, do battle, and act out strange scenes of joy and barbarism. Their cartoonish quality calls to mind the work of so-called outsider artist Henry Darger, whose obsessive drawings and writings portray a violent struggle in a mythical world of his own making. Esch shares Darger's almost perverse delight in upending lessons taught by the likes of Aesop. In Esch's mind, the history of the fable is one in which particular moral positions are circumscribed in their conclusions. The storylines of her paintings work against this trend, as their narrative trajectories are not so completely clear. A duck absurdly proclaims its divinity in one work, while in another two soldiers do battle with pistols amidst a raucous crowd of rambunctious girls. Part of Esch's strategy is to leave the meaning of these seductively naive and childlike images open to interpretation. But in each case, she captures something of the dark underside of the works of the Brothers Grimm, adding at times a gothic tension to complement the lightheartedness of these scenarios. In her *Red Riding Hood Studies* (1997), she chose to twist its elements to fit her needs. Composed of a cycle of twelve drawings, the series depicts a sequence of events in which the heroine stumbles upon a hyena that consumes her. She is not, however, saved from the creature's ravenous appetite by the heroics of a timely woodsman, but manages to extricate herself from the belly of the beast in a kind of quasi-feminist act of assertiveness. But the story never ends—for as we work our way through these drawings, it begins again in a kind of eternal recurrence that defuses the standard interpretation of the original. Like Hansel and Gretel nibbling on the sweet cake that made up the house of the wicked witch, Esch's work uses and then slowly gnaws away the

sanitized veneer of the fairy tale, revealing beneath its surface both the pathos and the infinite possibility of the act of storytelling.

D.F.

Mary Esch Selection from *Red Riding Hood Studies* 1997 colored pencil on paper 12 1/2 x 9 3/8 in. (31.8 x 23.8 cm) each of 12 Miriam and Erwin Kelen Acquisition Fund for Drawings, 1997 1997.76

Luciano Fabro

Italian, b. 1936

- - **Exhibitions**
Artists' Books (1981), *Zero to Infinity: Arte Povera 1962–1972*
(2001; catalogue, tour)
- - **Holdings**
1 sculpture, 1 multiple, 2 books

Among those artists affiliated with the concept of "Arte Povera," Luciano Fabro is the only one attracted to that movement's forbidden material, the one most associated with high Renaissance sculpture—marble. While his early work of environmental measuring devices in steel and copper tubing and a more discursive body of work known collectively as *Tautologies* possessed a Euclidian spareness and logic, his growing vocabulary of sculpture gradually expanded to include materials like mirrors, silk, blown glass, and porphyry. His most glamorous body of work, *Piede* (*Foot*) (1968–1971) is a campaign of gigantic, gorgeously grotesque individual avian feet replete with knotted talons made from glass, copper, bronze, aluminum, brass, and marble. Each foot climbs to the ceiling in a sleeve of fabulously constructed silk. Clearly in violation of the somewhat puritanical sumptuary laws of Arte Povera, Fabro sought to ward off criticism by crafting a declaration (published in the periodical *Flash Art*) to coincide with the first exhibition of the *Piede* at the Venice Biennale of 1972. In it, he clarified that the work is an homage to Italian craftspeople whose myriad skills were called upon to produce his Mannerist bestiary.

Between 1968 and 1973, Fabro worked on what has arguably become his best-known, least-seen work, *Lo Spirato* (*The Dead*). First modeled in clay and later carved from an exquisite, richly veined slab of gray marble, *Lo Spirato* portrays a male body lying on a thin mattress covered by a sheet. The linen clings in folds to the feet, calves, thighs, crotch, arms. Just as it crests at the rib cage, it is as if the entire sculpture exhales and the sheet caves into the mattress where the head has already disappeared. It is the negative of Andrea Mantegna's extraordinary *The Lamentation over the Dead Christ* (circa 1490), his foreshortened painting in the Brera Museum, Milan. While *The Lamentation* is an affirmation of a fallen hero, *Lo Spirato* is the presentation of an existential dilemma. The inscriptions on the sculpture's base address Fabro's authorial dilemma: "From the Full to the Empty without any solution of continuity" and "I represent the obstruction of the object in the vanity of ideology." Ironically, because of a hairline fracture, *Lo Spirato* remains confined in Fabro's studio rather than risk its destruction through a move to another location.

It is hard to summarize the riot of ideas that animate Fabro's work, in which politics, philosophy, geometry, and mythology all claim preeminence. His armada of sculptures in the shape of Italy analyzes his homeland with wit, bravado, and always a grudging empathy. Other sculptures stretch the properties and hierarchies of the materials he selects to work with. *Sisyphus* (1994), a later, more playful work in the Walker Art Center's collection, combines the skills of etching, stone-carving, gold inlay, and pizza-making. A rolling pin of marble (embedded with a constellation of gold stars) is incised with his nude self-portrait and rolled over a bed of flour to create the image of the artist pushing the object forward and away, forever trapped in an activity that is ceaseless and thanklessly metaphoric. The myth of Sisyphus is one that adapts without alteration to a modern context, and Fabro reiterates its potency with wit and multidisciplinary mastery.

R.F.

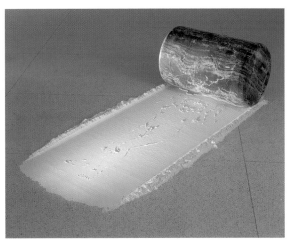

Luciano Fabro *Sisyphus* 1994 marble, gold leaf, flour 23 x 37 3/4 x 23 in.
(58.4 x 95.9 x 58.4 cm) Gift of the Norwest Foundation on behalf of Norwest
Bank Minnesota, 1995 1995.13

Patrick Faigenbaum

French, b. 1954

Holdings

1 photograph

Patrick Faigenbaum *Paris, 1993* 1993 gelatin silver print; edition 3/3
36 3/4 x 35 5/8 in. (93.4 x 90.5 cm) Gift of Barbara Gladstone, 1997 1997.128

Angus Fairhurst

British, b. 1966

- - **Exhibitions**

"Brilliant!" New Art from London (1995; catalogue, tour)

- - **Holdings**

1 sculpture, 3 videos, 1 suite of posters

In 1988, Surrey Quays—one of several former dockyard complexes along the River Thames in an area of East London known as Docklands—became the site of *Freeze*, a renegade art exhibition curated by then–Goldsmiths College art student and enfant terrible Damien Hirst. For this exhibition, Hirst brought sixteen current classmates and recent graduates together to breathe new life into a dilapidated warehouse with the goal of finding an alternative to exhibiting their works within the highly political academic and gallery systems. What couldn't have been predicted was that this show would also resuscitate a stagnant London art scene and attract international attention to a select group of emerging artists who would eternally be imprinted with the epithet "Young British Artists" or YBAs.[1] Although the show would not garner much critical press when it opened, it all but insured the infamy of its participants, including artist-of-all-trades Angus Fairhurst.

Fairhurst works in a multidisciplinary fashion, turning variously to painting, drawing, photography, video, animation, and sound-based and live performance pieces. A common thread running through his artworks is his interest in constructing stunted narratives that frustrate expectations by never reaching a climax or point of resolution. The product of cyclical and repetitive actions, his time-based works address the constructs of "before and after" and the tendency for the mind to jump ahead to form foregone conclusions.

In 1995, the Walker Art Center organized the exhibition *"Brilliant!" New Art from London*, to which Fairhurst contributed two hand-drawn, animated videos, edited in ten-second loops and displayed on monitors. In *Strange Loops (Catching and Dropping)* (1995), no sooner does a naked man fall from above into the arms of a gorilla than he is dropped again. Similarly, in *Strange Loops (Stripping)* (1995) the beast peels the expressionless man's skin from head to toe, like a banana. This editing style reveals the artist's view of the cyclical nature of time and history: "You can't avoid loops. That's the way things actually operate."[2] Also on view was *A Cheap and Ill-fitting Gorilla Suit* (1995), an installation that included the eponymous costume hanging flaccidly from a hanger and a video in which the naked artist is seated at a table sewing pieces of furry material together into a gorilla suit. He then puts it on, stuffs it with newspaper, and violently jumps up and down until the whole thing comes apart at the seams and falls off, rendering him naked again.[3]

For years, Fairhurst had been creating sketchbook drawings of the misadventures of an anthropomorphic ape (the artist's alter ego), which he kept in his private collection until he felt he was ready to "get the peccadilloes out in public."[4] In all of these works, the projection of human qualities onto an animal and vice versa has served as a practical means through which the artist has been able to mine the human condition as well as represent the baseness and brutality of mankind and so-called civilized society. However, there is also a decidedly comic aspect that resounds with the existential dark humor of Samuel Beckett, an influence that Fairhurst readily acknowledges.[5]

E.C.

Notes

1. The notoriety of many of the YBAs must be attributed in part to the intense media coverage surrounding the controversial 1997 exhibition *Sensation*, which was organized by London's Royal Academy of Arts and toured to New York's Brooklyn Museum in 1999, highlighting the collection of art patron and advertising magnate Charles Saatchi.
2. Fairhurst, interview by Walker research fellow Marcelo Spinelli, in Richard Flood, ed., *"Brilliant!" New Art from London*, exh. cat. (Minneapolis: Walker Art Center, 1995), 35.
3. The installation also included a set of computer-generated bubble-jet prints of stills from the video *A Cheap and Ill-fitting Gorilla Suit*.
4. Fairhurst, audiotaped interview with Marcelo Spinelli, March 11, 1995, London (Walker Art Center Archives).
5. See Clarrie Wallis, "In the Realm of the Senseless," in Gregor Muir and Clarrie Wallis, eds., *In-A-Gadda-Da-Vida: Angus Fairhurst, Damien Hirst, Sarah Lucas*, exh. cat. (London: Tate Publishing, 2004), 101.

Angus Fairhurst *A Cheap and Ill-fitting Gorilla Suit* 1995 videotape (color, sound); edition 1/5 4 minutes T. B. Walker Acquisition Fund, 1996 1996.96

Chris Faust

American, b. 1955

-- **Exhibitions**
American Tableaux (2001; publication, tour)
-- **Holdings**
3 photographs

Chris Faust *Bankrupt Developer Homes, Apple Valley, MN* 1991 black-and-white photograph 15 1/2 x 41 7/8 in. (39.4 x 106.4 cm) Justin Smith Purchase Fund, 1999 1999.35

Lyonel Feininger

American, 1871–1956

-- **Exhibitions**
92 Artists (1943; catalogue), *Watercolor—U.S.A.* (1946; catalogue, tour), *Paintings to Know and Buy* (1948), *Contemporary American Painting: Fifth Biennial Purchase Exhibition* (1950; catalogue, tour), *Pictures for the Home* (1950), *Contemporary American Painting and Sculpture: Collection of Mr. and Mrs. Roy R. Neuberger* (1952; catalogue), *Lowenthal Collection of American Art* (1952; catalogue), *The Classic Tradition in Contemporary Art* (1953; catalogue), *Expressionism 1900–1955* (1956; catalogue, tour), *Second Annual Collectors Club Exhibition* (1958; catalogue), *Art Fair* (1959; catalogue), *Franz Marc and the Blue Rider* (2001)
-- **Holdings**
1 painting, 1 edition print/proof

Lyonel Feininger *Barfüsserkirche II* (*Church of the Minorites II*) 1926 oil on canvas 42 3/4 x 36 5/8 in. (108.6 x 93 cm) Gift of the T. B. Walker Foundation, Gilbert M. Walker Fund, 1943 1943.20

Peter Fischli and David Weiss

Peter Fischli, Swiss, b. 1952; David Weiss, Swiss, b. 1946

- - **Commissions**
Empty Room (1996)
- - **Exhibitions**
Duchamp's Leg (1994; catalogue, tour), *Peter Fischli and David Weiss: In a Restless World* (1996; catalogue, tour), *The Cities Collect* (2000), *The Last Picture Show: Artists Using Photography, 1960–1982* (2003; catalogue, tour)
- - **Holdings**
1 sculpture, 10 photographs, 3 videos, 1 multiple, 2 books

As French theorist Gilles Deleuze mused in 1977, "Many people have worked in pairs: the Goncourt brothers, Erkmann-Chatrian, Laurel and Hardy. But there are no rules, there is no general formula."[1] Deleuze spoke from experience, as he himself was already operating as part of a celebrated philosophical tag team with Félix Guattari. His seemingly innocuous remark on the nature of collaboration conjures a fitting epithet for the careers of the most thoroughgoing artist pair of our time. Swiss duo Peter Fischli and David Weiss delight in the marvel of everyday life, exploring seemingly trivial subjects with the innocence of daydreaming children. Caught snugly somewhere between the often-inscrutable Deleuze and Guattari, and the bungling of Stan and Ollie, their practice mixes the profound and the inept in equal doses.

Despite their diversity in both the media they employ—16mm film, photography, carved and cast sculpture, video installation—and the range of subjects they have tackled, their works nonetheless are infused with consistent themes. Or rather, in a natural affinity for the "no rules" and "no general formula" that Deleuze describes, motifs echo with casual wonder and for no particular reason. Cats reappear several times throughout their oeuvre—recently in the 2001 video *Büsi* (*Kitty*), which petitions us to relish, as the artists must have done, the simple pleasure of watching a domestic feline lapping up a saucer of milk.[2] Caves, tunnels, and sewers are another particular obsession—a testament to Switzerland's alpine wilderness, the country's engineering prowess, and the modern mythology of Swiss cleanliness and efficiency. Indeed, Fischli and Weiss' work also embraces an earnest yet gently mocking celebration of the Swiss nation, its historic political neutrality as much as its picture-postcard scenery and cuckoo-clock clichés. The artists' tunnel fixation is most evident in *Kanalvideo* (*Canal Video*) (1992), in which the artists appropriated footage shot by remote control to check for cracks in a drained underground sewer. More than an hour in length, the videotape unfurls like a low-budget attempt at a time-travel special effect. We appear to be sucked into the screen as we trundle down this "black hole," replete with weird sci-fi color changes, exaggerated from the video camera's struggles with the gloom.

Fischli and Weiss began collaborating in 1979, and spent periods of the next three years in Los Angeles before both settling in their native Zürich, where they continue to live and work. *Wurstserie* (*Sausage Series*) (1979) was the first series of works the artists produced together, and the Walker Art Center acquired a set in 1993. They are technically unpretentious photographs—indeed, their competence as studio-based still lifes seems completely inconsequential—that document the result of an activity deemed somewhat inappropriate for all grown-ups with supposedly good manners: playing with your food. Cold cuts and frankfurters, wieners and other processed meats—alongside cigarette butts pressed into service as surrogate people—become the props and protagonists in dramatic dioramas. The comical use of the "wrong" materials for art-making and the technically cavalier execution of the photographs seem to conflict with the often disastrous events they wish to portray. Fittingly, *Der Brand von Uster* (*The Fire of Uster*) from this series commemorates an event from 1832, where a desire for technological efficiency was similarly spurned. In protest against the mechanical cotton-spinning machines that were threatening their craft, textile workers in a Swiss town burnt their factory to the ground with Luddite petulance.

Made two years later, *Plötzlich diese Übersicht* (*Suddenly This Overview*) is a series of more than two hundred clumsy sculptures rendered in unfired clay, a familiar medium of classroom art. With a willful mediocrity characteristic of their work, Fischli and Weiss depict unremarkable objects and scenes (*Peanuts, Bread,* or *Woman in the Supermarket*) as well as imagined "Eureka!" moments from history (such as *Marco Polo shows the Italian spaghetti, brought back from China, for the first time*). Such attempts at encyclopedic production—a twist on the relentless seriality of the Minimalist "specific object," perhaps—has the compelling charm of a child trying to imagine everything in their world, all at once, or recounting their day in a tumble of "and then . . . and then . . . and then. . . ." In a similar way, *Le rayon vert* (*The Green Light*) (1993) exploits the ability of the humblest of materials to imagine the grandest of events. In a darkened space, a flashlight points toward a "cut-glass" plastic cup that spins on a record turntable to make a kaleidoscopic pattern on a nearby wall. Referring to an elusive, almost mythical meteorological phenomenon, where the setting sun

Peter Fischli and David Weiss *Der Brand von Uster* from *Wurstserie* (*The Fire of Uster* from *Sausage Series*) 1979 chromogenic print; edition 17/24 9 1/2 x 13 3/4 in. (24.1 x 34.9 cm) Clinton and Della Walker Acquisition Fund, 1993 1993.188.10

dips below the horizon to produce a green glow, Fischli and Weiss allude to spectacular nature through bathos, doing "the best they could do."[3]

The premiere survey exhibition of their work, *Peter Fischli and David Weiss: In a Restless World*, opened at the Walker in the spring of 1996, which also marked the first time the artists' work had been seen in-depth in the United States. From their early cast-rubber sculptures to their most famous film, *Der Lauf der Dinge* (*The Way Things Go*) (1987), the exhibition was largely designed around a series of illuminated "moments" of artworks, encountered in dimly lit, windowless galleries as if caught in shafts of light in a magical cavern. The show included an adapted version of their untitled project for the Venice Biennale the year before. Several days worth of videotape presented on multiple monitors—a visit to a cheese factory, a diversion to a favorite grotto, or Fischli's idle half-hour spent filming Weiss' trip to the dentist—commemorate wanderlust and sheer ordinariness.

Empty Room (1995–1996) was commissioned especially for the exhibition and later acquired for the Walker's collection. Part of the artists' ongoing series of trompe l'oeil studio paraphernalia, the work comprises some one hundred fifty hand-carved polyurethane sculptures that together mimic a room still in preparation. Pieces of board and two-by-fours, paint buckets, boxes of tools, coffee cups, and brushes were modeled on objects used by the Walker's exhibition crew and those from the artists' studio. The crafting of these items, lovingly shaped and rendered to exactly resemble these most lowly things—a way in which the artists "misuse" their time—entails an uncanny transubstantiation. *Empty Room* was later reconfigured to create the illusion of workshop storage under the stairs and was on display in the Walker's galleries until 2004.

M.A.

Notes

1. Gilles Deleuze, *Dialogues* (Paris: Flammarion, circa 1977; reprinted in New York: Continuum, 2002), 16.
2. *Büsi* (*Kitty*) was first shown on the giant screen of New York's Times Square. The Walker owns one of the subsequent DVD editions.
3. Fischli and Weiss discuss this "the best they could do" attitude in their interview with artist Rirkrit Tiravanija, "Real Time Travel: Fischli and Weiss," *Artforum* 34, no. 10 (Summer 1996): 78–86, 122–126.

Peter Fischli and David Weiss Selections from *Empty Room* 1995–1996 polyurethane, paint installed dimensions variable T. B. Walker Acquisition Fund, 1996 1996.132

Peter Fischli and David Weiss *Kanalvideo* (*Canal Video*) 1992 videotape transferred to laser disc (color, silent); edition 6/12 62 minutes Gift of the artists, 1996 1996.136

Peter Fischli and David Weiss *Büsi* (*Kitty*) 2001 videotape transferred to DVD (color, silent); edition 11/150 6:30 minutes Clinton and Della Walker Acquisition Fund, 2001 2001.128

Dan Flavin
American, 1933–1996

In the hands of Dan Flavin, the ordinary is rendered extraordinary. Restricting himself to the limited vocabulary of generic fluorescent light—an emblem of standardized uniformity nearly invisible in its ubiquity—the artist embarked on a careerlong project to "combine traditions of painting and sculpture in architecture with acts of electric light defining space."[1] His use of industrially produced materials and the multidimensional space of the gallery reflected a growing interest among artists of his generation who would come to prominence under the collective moniker of Minimalism.

Flavin's earliest experiments with light began in 1961, with incandescent and fluorescent bulbs affixed to the margins of Masonite boxes, which he hung on the wall and called "icons." For someone steeped in the traditions of the Roman Catholic Church, the conjunction of the sacred with the profane was not without irony: "My icons differ from a Byzantine Christ held in majesty; they are dumb—anonymous and inglorious … constructed constructions celebrating barren rooms. They bring a limited light."[2] Although he would soon jettison the constructions to focus on the unadorned light fixture, irony maintained an ongoing presence in his investigations.

While territorializing the larger area of the gallery, Flavin was frequently drawn to marginal locations such as corners, baseboards, stairwells, and other spaces considered atypical for aesthetic presentation. Such is the case with a 1966 work made up of six eight-foot lights in a square configuration. It addresses the corner not only in its position spanning the junction of two planes, but also in the way in which the vertical fixtures are oriented inward, exposing their utilitarian backside to the viewer. Elevated some fifteen inches above the floor, the piece has the air of a painting hanging on the wall, and in this it highlights the artist's challenge to the conventions of art history. Since the Renaissance, painting has been understood as a "window on the world" opening onto a perspectival space; yet in Flavin's treatment, the sense of actual rather than illusionistic space is thwarted by the dematerialization of the corner, creating a palpable tension between flatness and depth. The suffuse glow illuminates the corner and, in so doing, paradoxically obscures it.

Flavin's rejection of artistic convention extended to the labels "sculpture" and "environment," which he abandoned for his work in favor of "proposals" or "situations." His choice of language underscores the contingency, rather than the autonomy, of his propositions— particularly in the case of the installations the artist favored over studio production. Indeed, as was his infrequent habit, Flavin would from time to time

reconfigure and rededicate existing works as he did with the Walker Art Center's *untitled (to dear, durable Sol from Stephen, Sonja and Dan) two*. Originally exhibited in 1966 as *untitled*—his first square across a corner—and composed of just four cool-white fixtures, its configuration, color, and ultimately dedication, were modified by the artist to its present state upon its initial installation in 1969 at the Walker.[3] The potential to reconceptualize sculpture in relation to space was explicit: "I knew that the actual space of a room could be disrupted and played with by careful, thorough composition of the illuminating equipment."[4] This was heightened further by his development of a vocabulary of "corner," "barrier," and "corridor" pieces that physically delimit the architectural envelope and occupy the viewer's space. At the same time, his works escape the restraints imposed by frames, pedestals, and other means of display, and their illimitable glow bleeds beyond their physical confines just as it exceeds the limits of art-historical language.

The corner piece dedicated to Sol LeWitt, as well as another work in the Walker's collection, *"monument" for V. Tatlin* (1969), reflect Flavin's practice of dedicating works to family, friends, and meaningful figures. The latter is part of the artist's best-known and most-sustained series; the title makes reference to Russian Constructivist Vladimir Tatlin's unrealized *Monument to the Third International*, but here, too, Flavin's sardonic wit emerges: "I always use 'monuments' in quotes to emphasize the ironic humor of temporary monuments.

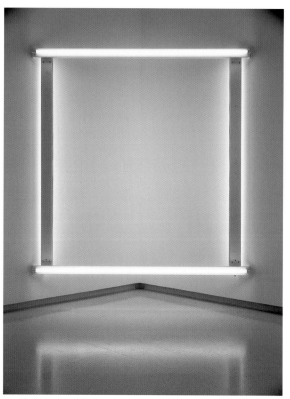

Dan Flavin *untitled (to dear, durable Sol from Stephen, Sonja and Dan) two*
1966/1969 cool white, daylight fluorescent tubes, fixtures 96 x 96 x 8 in.
(243.8 x 243.8 x 20.3 cm) Gift of the Northern States Power Company, 1969
1969.11

These 'monuments' survive only as long as the light system is useful (2,100 hours)."[5] The irony of raising an art object constructed from generic materials to the status of a monument is thus multiplied by its impermanent status and editioned existence. This strategy resonates as well with a shift in the cultural consciousness born of the tumult of the late 1960s. Belying this, however, are the dedications that form an autobiographical map of Flavin's personal and professional life, insisting on a sentiment and warmth absent from prevailing accounts of Minimalism.

J. Fiona Ragheb

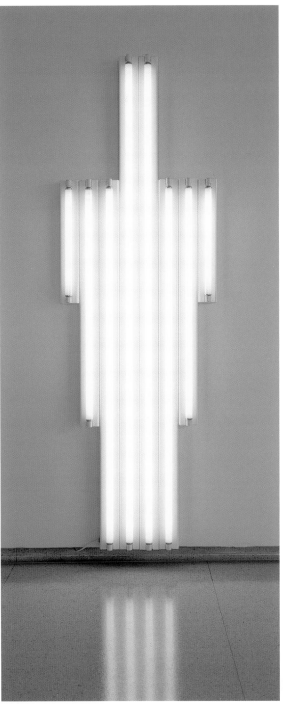

Notes

1. Flavin, "'. . . in daylight or cool white,' an autobiographical sketch," *Artforum* 4, no. 4 (December 1965): 24.

2. Quoted in Brydon Smith, ed., *fluorescent light, etc. from Dan Flavin*, exh. cat. (Ottawa: National Gallery of Canada; Vancouver: Vancouver Art Gallery, 1969), 20.

3. This practice began almost from the start with Flavin's breakthrough piece *the diagonal of personal ecstasy (the diagonal of May 25, 1963)*—the first work made solely of fluorescent lights. Flavin subsequently rechristened it as *the diagonal of May 25, 1963 (to Constantin Brancusi)*, and even later rededicated it to Robert Rosenblum and produced it in cool white rather than the yellow of the earlier iterations. Similarly, the Walker piece was originally made up of four cool white lamps—the two verticals attached to the side walls, the top horizontal facing upward, and the bottom one facing the viewer. For further information on the history of the Walker's corner piece, see Michael Govan et al., *Dan Flavin: The Complete Lights, 1961–1996* (New Haven: Yale University Press, 2004).

4. Flavin, ". . . in daylight or cool white," 19–20.

5. Quoted in Suzanne Muchnic, "Flavin Exhibit: His Artistry Comes to Light," *Los Angeles Times*, April 23, 1984. Although the *Tatlin* series references that artist's work, Flavin titled other works "monuments," including two from 1966 with direct references to mortality, *"monument" on the survival of Mrs. Reppin* and *monument 4 for those who have been killed in ambush (to P. K. who reminded me about death)*.

Dan Flavin *"monument" for V. Tatlin* 1969 cool white fluorescent tubes, fixtures; edition 3/5 96 1/16 x 32 1/16 x 4 3/4 in. (244 x 81.4 x 12.1 cm) Gift of Leo Castelli Gallery, 1981 1981.25

Saul Fletcher

British, b. 1967

Saul Fletcher Selection from *Untitled #142* 2001 black-and-white
Polaroids; edition 5/5 4 1/8 x 5 1/8 in. (10.5 x 13 cm) each of 7 T. B. Walker
Acquisition Fund, 2003 2003.33

Fluxus

It has been nearly fifty years since Fluxus began taking shape in lofts, performance halls, and makeshift gallery spaces across the United States and Europe, yet a precise definition of the group is still a subject of spirited debate. Broadly, it can be described as a clutch of international artists, writers, performers, and composers who came together in the late 1950s out of a shared desire to erode the boundaries separating artistic disciplines and encourage attentive appreciation of the events of everyday life. Inspired by the ideas of composer John Cage and (through Cage) maverick artist Marcel Duchamp, Fluxus rejected the values and conventions of high art in favor of new forms that were accessible, interactive, hybrid, and playful. The name Fluxus, from the Latin *flux*, connotes change, movement, renewal, and fluidity—values that informed every aspect of the group's activities. For many, Fluxus is a concept expansive enough to include the minimal compositions of La Monte Young, the mystically tinged performances of Joseph Beuys, the wry photographic sculpture of Robert Watts, the Concrete poetry of Emmett Williams, the manifestos and historiographic charts of George Maciunas, and the conceptual objects and films of Yoko Ono—all artists who stood under the Fluxus banner at some point during their careers. Others prefer to define the group more narrowly,[1] yet there is general agreement that Fluxus has had a profoundly liberating and leavening effect on the contemporary art world.

Fluxus has its roots in performance, and its most important early manifestations were the many festivals, often billed as concerts of "new music," which were staged throughout Europe and the United States in the 1960s. Wearing classical concert dress, the artists performed iconoclastic "event scores"—short texts instructing them, for example, to dismantle a piano, polish a violin, urinate into a bucket, or simply count the audience out loud. Some scores were private, almost Zen-like: George Brecht's *Word Event* (1961) reads simply "exit," designating as art something that most of us do dozens of times during the course of a normal day: walk out, quit, or retreat. Other scores were energetic and even violent, such as Nam June Paik's *One for Violin Solo* (1962), in which the performer grasped a violin by its neck, slowly raised it over his head, then smashed it down on a table, shattering it into bits (which sometimes were saved, boxed, and kept as a relic of the event). The concerts were like live anthologies of the unexpected: music might be the product of a telephone call, a flushing toilet, or a haircut; poetry was visual;

paintings were danced. Audiences of the time were both perplexed and delighted.

Fluxus scores share an important characteristic with classical compositions: anyone can perform them, anywhere, according to their own interpretation. There is no single correct way to "exit" or smash the violin; artworks are not seen as the property of the artist, but as ideas to be shared, passed around, and eventually absorbed (with transformative effect) into daily life. Scores could also be realized as objects. Maciunas—the chief editor, curator, and impresario of Fluxus—imagined rugs, pennants, and flags printed with the word "exit," his interpretation of Brecht's *Word Event*.[2] Many artists sent their ideas to Maciunas, who freely adapted them as editions, booklets, and graphics or collected them in anthology publications like *Fluxus 1* or *Fluxkit* (which were directly inspired by Duchamp's mini-museum *Boîte-en-valise* [*Box in a Valise*]). He marketed these works through Fluxus newsletters for low prices, twenty-five cents and up, thus entirely bypassing the gallery system; Maciunas, who was Lithuanian, subscribed to the European utopian creed that well-designed, inexpensive artworks should be available to everyone.[3]

By its very nature, Fluxus defies categorization and, thus, institutionalization. At the Walker Art Center, as at many museums, Fluxus slipped in through the "back door"—the library collection. There, its oddly bound anthologies, its manifestoes, posters, mail art, and broadsides, and its small boxed games and puzzles found a home in which they needn't be labeled as one thing or another. In 1989, the Walker acquired for its collection a large body of material that had been assembled by Jeff Berner, a Bay Area artist active with Fluxus during the late 1960s. This has since been augmented with additional purchases and gifts; highlights of the holdings include copies of the *Fluxus 1* and *Flux Year Box 2* (1967) anthologies;[4] a number of boxed editions by artists such as Brecht, Robert Filliou, Shigeko Kubota,

Flux Year Box 2 1967 Anthology of works by Eric Andersen, George Brecht, John Cale, John Cavanaugh, Willem de Ridder, Albert Fine, Ken Friedman, Fred Lieberman, George Maciunas, Yoko Ono, Ben Patterson, James Riddle, Paul Sharits, Bob Sheff, Stan VanDerBeek, Ben Vautier, Robert Watts mixed media box: 3 3/8 x 8 x 8 3/8 in. (8.6 x 20.3 x 21.3 cm) closed McKnight Acquisition Fund, 1999 1999.50

Maciunas, Larry Miller, Watts, Ben Vautier, and many others; and a nearly complete run of publications from Something Else Press, founded in 1964 by Dick Higgins. Dozens of pieces of ephemera—posters, programs, announcements, postcards, and the like—document the activities of Fluxus and like-minded artist groups such as Zaj and Aktual Art. The latter, an activist coalition founded by Czechoslovakian artist Milan Knížák, is represented in the collection by an unusually large number of rare manifestoes, book works, and relics of its guerrilla street performances. All of these combine to give a sense of the raucous, freewheeling nature of Fluxus, which has transformed our understanding of art and its role in daily experience.

J.R.

Notes

1. One of the most prominent historians to do so is Jon Hendricks, curator of the Gilbert and Lila Silverman Fluxus Collection, the largest private collection of Fluxus in the world. Hendricks defines as Fluxus a work that was created, produced, conceived, marketed, or otherwise "touched" by George Maciunas, the group's leading theoretician, curator, editor, and self-appointed mastermind. This definition has been used to shape the Silverman Collection. See Jon Hendricks, ed., *O Que é Fluxus? O Que Não é! O Porque./What's Fluxus? What's Not! Why.*, exh. cat. (Rio de Janeiro: Centro Cultural Banco de Brasil; Detroit: The Gilbert and Lila Silverman Fluxus Collection Foundation, 2002).

2. He apparently never produced them. See Jon Hendricks, *Fluxus Codex* (Detroit: The Gilbert and Lila Silverman Fluxus Collection, in association with Harry N. Abrams, New York, 1988), 193–194.

3. See his "Price List for Fluxshop & Mail-Order Warehouse," reproduced in Elizabeth Armstrong and Joan Rothfuss, eds., *In the Spirit of Fluxus*, exh. cat. (Minneapolis: Walker Art Center, 1993), 32.

4. Because Maciunas assembled these anthologies as needed, sometimes over periods of years, each copy is different. *Flux Year Box 2* always includes several Super 8 film loops, but the Walker's copy contains more than most, perhaps because it was originally in the collection of filmmaker and Fluxus friend Jonas Mekas.

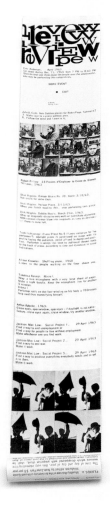

George Maciunas *Fluxus Preview Review* 1963 offset lithograph on paper 65 1/4 x 3 15/16 in. (165.7 x 10 cm) Walker Special Purchase Fund, 1989 1989.144

Shigeko Kubota *FluxNapkins* 1967 plastic, paper box: 1/2 x 4 3/4 x 4 in. (12 x 10.2 x 1.3 cm) closed Walker Special Purchase Fund, 1989 1989.263

George Brecht *Valoche/a Flux Travel Aid* 1975 wood, paper, objects box: 6 1/8 x 10 1/16 x 8 1/2 (15.6 x 25.6 x 21.6 cm) closed Walker Special Purchase Fund, 1989 1989.111

Lucio Fontana

Italian, b. Argentina, 1899–1968

- - **Exhibitions**

Lucio Fontana: The Spatial Concept of Art (1966; catalogue, tour), *Selections from the Martha Jackson Collection* (1975; catalogue), *The Cities Collect* (2000)

- - **Holdings**

2 paintings, 1 sculpture, 1 drawing, 2 books

Lucio Fontana was born of Italian parents in Rosario de Santa Fe, Argentina. His father, a successful stone-cutter and monument maker, took his son back to Milan when he was six years old so he would receive a proper education. That included, besides technical training and an art apprenticeship, a stint in the Italian armed forces. In 1922, he returned to Rosario to run his father's business and to set up a studio in which he produced sculptures reminiscent of Aristide Maillol. After five years, the draw of a Europe in full artistic ferment became too much and Fontana returned to Milan, where he enrolled in Adolfo Wildt's sculpture class at the Brera Academy.

With Fausto Melotti, Atanasio Soldati, and Luigi Veronesi, Fontana founded a Milanese chapter of Abstraction-Création in 1934. An interest in ceramics led him to Albisola, the country's mecca for potters, and from there to Paris, where he found employment at the Manufactures de Sèvres. Fellow artists called him the "Futurist ceramist" as he explored the French capital and sought out Joan Miró, Tristan Tzara, and Constantin Brancusi. Having returned to Milan, Fontana accepted, just prior to the declaration of war, an invitation from the Argentinean government to compete for an official commission. Marooned in his native country by the outbreak of hostilities, he settled down to win every sculpture prize in sight until there were no more challenges left in the figurative arena.

By 1946, lionized but restless, Fontana established the freewheeling Academia d'Altamira, where he was surrounded by young artists. Here he drafted, and his students signed, the *Manifesto Blanco* (*White Manifesto*), a rallying cry for activities that anticipated Happenings, Fluxus, and political street theater by almost twenty years. It also contained a blueprint for Fontana's 1947 *Manifesto Spaziale* (*Spatialist Manifesto*), published soon after his return to Milan. Bounced between countries, the artist remained Argentinean at heart. "A child of the pampas, I know as much about space as your hero Jackson Pollock, who grew up in Wyoming," he told this author in later years. The Spatialist movement proper was born in 1949 with his first spatial environment, *Ambiente Spaziale a Luce Nera* (*Spatial Environment with Black Light*), at the Galleria del Naviglio in Milan.

The Walker Art Center was first among American museums to acknowledge Fontana's art world bonafides. Its 1966 exhibition *Lucio Fontana: The Spatial Concept of Art* featured eighty works, including an *ambiente spaziale*, and prompted spinoffs such as a Fontana-inspired dance piece and couture show. Twelve years passed before the Guggenheim Museum in New York organized a retrospective, wrongly credited in the press with "introducing Lucio Fontana to America."

The artist did not attend the preview of his Minneapolis exhibition. Still reeling from having been savaged by reviewers of the *Ten Paintings of Venice* at the Martha Jackson Gallery in 1961, he avoided another trip by claiming that the forthcoming Venice Biennale required all his attention. Favored to win the grand prize in Venice that year, he had to content himself with the national prize for his spectacular all-white installation even as top honors went to his Argentinean epigone Julio Le Parc.

With its perforations, incisions, and lacerations (Fontana's three "spatialist" gestures) programmatically presented, the Walker's exhibition intentionally confined itself to the Spatialist period. Of course, it included the artist's lush and imaginative variations on those three themes, from some of the gold and silver *Venice* series, the bronze and ceramic *Natura* (*Nature*), and the sheet-metal tributes to New York, to the candy-colored *Fine di Dio* (*The End of God*) ovals and the otherworldly *Teatrini* (*Small Theater*) in their lacquered frames. A less conceptual and more historic approach would have allowed for Fontana's participation in the vanguard of prewar sculpture as well as for his prodigious output of mostly figurative, often religiously inspired, and always baroquely fashioned ceramics.

A medium-sized 1961 bronze, *Concetto Spaziale "Natura"* (*Spatial Concept "Nature"*), was acquired by the Walker from Martha Jackson in the wake of the exhibition. Begun just two years earlier, the *"zòlle-nature"* or earth clods were modeled in clay before being cast in bronze. They resembled the excrescences of telluric upheavals and the Siberian meteorites, photographs of which I noticed on Fontana's studio bulletin board. The work's single most distinguishing feature is a wound-like cleft, indicative of penetration and birth. Reviewing the Minneapolis exhibition in the *New York Times* of January 7, 1966, Hilton Kramer praised the *Concetto*

Lucio Fontana *Concetto Spaziale "Natura"* (*Spatial Concept "Nature"*) 1961 bronze 33 x 38 1/2 x 34 in. (83.8 x 97.8 x 86.4 cm) Gift of the T. B. Walker Foundation, 1966 1966.4

Spaziale "Natura" for their "uncommon power" but added, in the same sentence, that they "represented nothing in the way of sculptural innovation."

Thirty years hence, the museum added a 1958 *Concetto Spaziale* on paper to its collection. One can count about a hundred holes in seven horizontally aligned rows, perforated from the back and surrounded by a pencil-drawn oval. The *buchi* (holes), as Fontana referred to them, entered his idiom in 1949, constituting the first of his Spatialist interventions. Transgressive but liberating all the same, these perforations demonstrate the artist's frustration with illusionism and with the picture plane as an inviolable barrier. Passing beyond it, he allowed the drama of relief and the play of light and shadow subtly to become a part of his composition. A logical outgrowth of these drawings was illuminated ceilings, using drilled holes and indirect light, which Fontana created in collaboration with architects and which were featured with great effect in the Milan Triennales of the 1950s.

The freehand oval, for Fontana, was a cosmic shape that he adopted as a signature device around 1951 to 1952. It relates to, and may in fact have had its origin in, the splotches and spirals of Enrico Baj's contemporaneous "nuclear" paintings. The Spatialist and the Nuclear movements were two rival, but somewhat interrelated, formal options in the postwar Milanese art world. The chameleonic Fontana was known for taking cues, on occasion, from younger artists whose work he admired, encouraged, and acquired for his own collection.

In 1998, two representative paintings rounded out the Walker's holdings of Fontana's works. They were a purchase and a gift, respectively, from the Fondazione Lucio Fontana in Milan. *Concetto Spaziale—Attesa (Spatial Concept—Expectation)* (1964–1965) is a fine example of that single vertical slash (*taglio*) so dramatically recorded by Ugo Mulas in a series of photographs of Fontana working in his Corso Monforte studio. *Attesa*, to the artist, meant "wait . . . and see"; it promised another reality behind the visual one; the teasing removal of the veil has been replaced by the impetuous wielding of the knife. Its physicality notwithstanding, the gesture is metaphysical without the usual religious or mystical connotations. The canvas is chastely covered with a water-based white pigment, and the slash is closed with black gauze on the reverse so it retains a crisp shape.

The second painting takes on extra meaning for being one of the very last canvases the artist finished before succumbing to a heart attack in the summer of 1968. It features a central laceration, graphically accentuated by a double outline and an encapsuling oval, both scratched into the oil-paint surface with the end of a small brush. Another white monochrome, this painting typifies that quest for purity (or was it neutrality?) that seemed to obsess painters and sculptors in the late 1950s and early 1960s, from Fontana, Piero Manzoni, and the Zero Group on one side of the Atlantic to Ellsworth Kelly, Robert Ryman, and Sol LeWitt on the other.

Jan van der Marck

Lucio Fontana *Concetto Spaziale (Spatial Concept)* 1958 perforations, graphite on paper 13 x 9 1/2 in. (33 x 24.1 cm) Miriam and Erwin Kelen Acquisition Fund for Drawings, 1995 1995.84

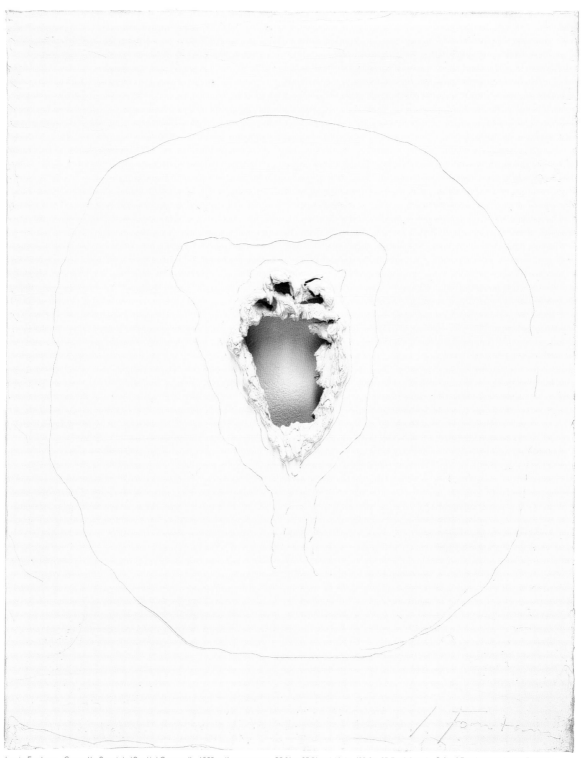

Lucio Fontana *Concetto Spaziale* (*Spatial Concept*) 1968 oil on canvas 32 3/8 x 25 7/8 x 1 1/8 in. (82.2 x 65.7 x 2.9 cm) Gift of Fondazione Lucio Fontana, 1998 1998.114

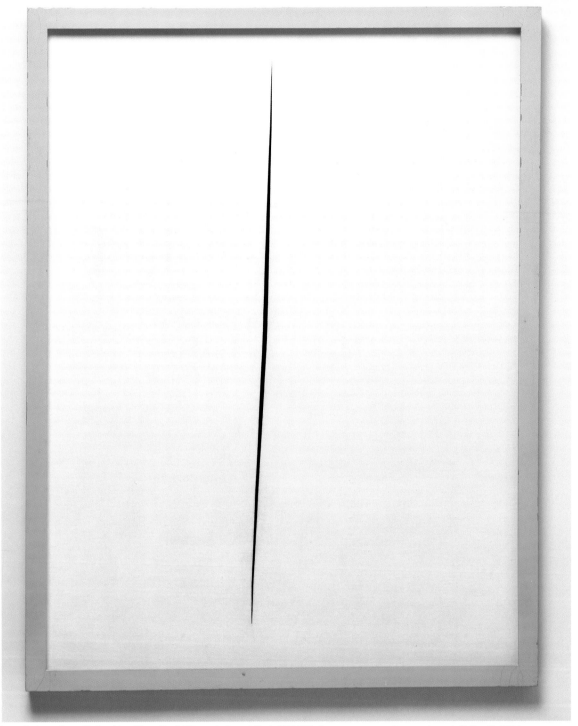

Lucio Fontana *Concetto Spaziale—Attesa* (*Spatial Concept—Expectation*) 1964–1965 tempera on canvas, lacquered wood 58 3/4 x 46 x 2 3/8 in. (149.2 x 116.8 x 6 cm) framed T. B. Walker Acquisition Fund, 1998 1998.113

Hollis Frampton
American, 1936–1984

Notes
1. Annette Michelson, "Time out of Mind: A Foreword," in Hollis Frampton, *Circles of Confusion: Film, Photography, Video Texts 1968–1980* (Rochester, New York: Visual Studies Workshop Press, 1983), 18.
2. Hollis Frampton, transcript of untitled lecture, December 1977, Carpenter Center for the Visual Arts, Cambridge, Massachusetts, excerpted in Bruce Jenkins and Susan Krane, *Hollis Frampton: Recollections/Recreations* (Cambridge, Massachusetts: MIT Press, 1984), 116.

- - **Screenings**
Hollis Frampton: Visiting Filmmaker (1972), Filmmakers Filming (1981), Memoriam: Hollis Frampton (1984), Ruben Cinematheque (1993, 1994)
- - **Exhibitions**
Duchamp's Leg (1994; catalogue, tour)
- - **Holdings**
8 unique works on paper, 134 photographs, 2 photographic suites, 5 films, 34 edition prints/proofs, 24 preparatory materials for works

Hollis Frampton and Marion Faller *Apple advancing (var. "Northern Spy")* from *Sixteen Studies from Vegetable Locomotion* 1975 black-and-white photograph 11 x 14 in. (27.9 x 35.6 cm) Clinton and Della Walker Acquisition Fund, 1993 1993.212

In approaching the work of Hollis Frampton, it is useful to borrow from the parlance of the late 1990s and to speak of the artist and filmmaker as an "early adopter." A prodigy of sorts who was educated as a scholarship student at Phillips Academy in Andover, Massachusetts (along with classmates Frank Stella and Carl Andre), Frampton became conversant with multiple forms of artistic practice: he began with poetry and across his career conducted a knight's tour of the visual arts, working in still photography and film, painting and printmaking, xerography, and early digital art. His entry into photography came in the late 1950s, when the medium was still adjusting to the shift from view-camera aestheticism to the urban mode of straight shooting. Frampton's still work was presciently conceptual and marked by an intervention that bore an uncanny, but characteristic, admixture of high culture and hijinks.

Active as a teacher and theorist but best known for his experimental films, Frampton was accorded his very first film retrospective in the fall of 1972 at the Walker Art Center. His transition from still to moving pictures had been allegorized a year earlier in his 1971 film *nostalgia*, in which a series of his photographs was systematically destroyed on a hotplate. This action, captured on film, served both to enact a form of closure for the artist and to creatively suggest the allure of the motion picture as a medium for art—its formal possibilities, its vocation for recalibrating the past, and what the critic Annette Michelson read as its "conjunction of poetry and science."[1]

Over the intervening years, until his untimely death in 1984, he labored on what he termed "three grand cooperations" with Marion Faller (his longtime companion and colleague) as well as an ambitious film cycle, *Magellan*. The former included his widely exhibited photographic series *Sixteen Studies from Vegetable Locomotion* (1975), a bald-faced historical fiction that posited the existence of images that complement Eadweard Muybridge's celebrated studies of animal and human locomotion. *Magellan*, incomplete at the time of his death, constituted an unprecedented aspiration to render cinematically the entirety of human experience in a series of films designed to be screened sequentially over a period of one year and four days—what the artist described as "a work of sculpture in time rather than space."[2]

Bruce Jenkins

Hollis Frampton *nostalgia* Part 1 of *Hapax Legomena* 1971 16mm film (black and white, sound) 36 minutes Edmond R. Ruben Film and Video Study Collection

Helen Frankenthaler

American, b. 1928

Helen Frankenthaler *Alloy* 1967 acrylic on canvas 118 1/8 x 64 1/8 in.
(300 x 162.9 cm) Gift of grandchildren of Archie D. and Bertha H. Walker,
1971 1971.11

Peter Friedl

Austrian, b. 1960

- - **Exhibitions**

Let's Entertain (2000; catalogue, tour), *The Squared Circle: Boxing in Contemporary Art* (2003; publication)

- - **Holdings**

1 video

Peter Friedl *King Kong* 2001 DVD (black and white, sound); edition 3/3
3:57 minutes Clinton and Della Walker Acquisition Fund, 2003 2003.72

Lee Friedlander

American, b. 1934

- - **Exhibitions**

Press Photography: Minnesota Since 1930 (1977; catalogue, tour), *Lee Friedlander: Letters from the People* (1993; catalogue), *American Tableaux* (2001; publication, tour)

- - **Holdings**

10 photographs

Lee Friedlander *Galax, Virginia* 1962 black-and-white photograph 11 x
14 in. (27.9 x 35.6 cm) Gift of Mr. and Mrs. Edmond R. Ruben, 1979 1979.55

Bill Frisell

American, b. 1951

In 1998, guitarist and composer Bill Frisell sought to create a large-scale musical statement that would encompass his increasingly diverse range of interests and styles: the sweeping pastoralism of lost Americana; a cinematic sense of orchestration; Nashville country and bluegrass; the raw qualities of distortion, tape loops, and electronics; skillful yet unconventional writing for horns; and, of course, the melodic and improvisational jazz guitar mastery for which he first gained attention. The Walker Art Center offered the commissioning funds, rehearsal time, and a presenting platform that would allow him to realize this ambition. The resulting suite of eighteen compositions for septet premiered at the Walker in November 1999 (subsequently titled *Blues Dream* and released by Nonesuch in 2001), and constituted both a summation of his work to that point and the culmination of his long-standing relationship with this institution.

Frisell's appearances from 1986 to 2002 reflect many of the contours of this irrepressibly curious musician's evolution. Noted for his signature atmospheric guitar sound, Frisell has an inclusive musical sensibility that renders the labels jazz, rock, bluegrass, experimental, and blues music meaningless.[1] At the time of his first Walker performance in 1986, he was deeply immersed in the art of jazz guitar and heavily influenced by the sophisticated harmonic approach of master jazz guitarist Jim Hall. Their rare duo concert was the realization of a dream for both Frisell and local audiences. In the following years, he collaborated with composer and saxophonist John Zorn for shows that included Zorn's piece *Godard/Spillane*[2] and a performance by the avant-rock group Naked City.[3] These projects reflected Zorn's quick-cut collage aesthetic as well as the general eclecticism of New York's 1980s downtown scene in which an increasingly confident, yet ever-modest Frisell was becoming an iconic force.

His regard for cinema and melancholic Americana (as well as his understated sense of humor) never rested too far below the surface. It emerged full blown in his live scores for film, including his settings for a trio of Buster Keaton movies, *Go West*, *One Week*, and *The High Sign*.[4] In the mid-1990s, Frisell became enraptured with the complexity, virtuosity, and easy freedom of bluegrass and Nashville music, resulting in an invitation to bassist Victor Krauss and dobro master Jerry Douglas to join him in the recording of *Nashville*, which the trio performed at the Walker in 1997.

Frisell's interest in global rhythms and the diverse traditions of many non-Western musical idioms was reflected in a group he dubbed the Intercontinentals, which performed one of its earliest live concerts as part of the Walker's 2002 cross-cultural music series Longitude/Amplitude. With collaborations and influences that range from comic artist Jim Woodring to musicians Marianne Faithfull and Elvis Costello to film director Gus Van Sant, Frisell has created an impressive canon of musical metaphors that continues to grow in its reach and significance.

P.B.

Notes
1. John L. Walters, *The Guardian* (London), April 13, 2001. In a review of *Blues Dream*, he says of Frisell: "His appeal goes deeper and wider than mere jazz brilliance. His tone infiltrates the environment and catches your ear . . . complex, rich, full of layers . . . the touch and timbre adds a dimension of experience and authority that few musicians deliver with such consistency."
2. The performance of the Walker-commissioned *Godard/Spillane* featured Zorn, Frisell, Jim Staley, Christian Marclay, Wayne Horvitz, David Weinstein, Carol Emmanuel, Bobby Previte, and Arto Lindsay.
3. With Zorn, Fred Frith, Wayne Horvitz, and Joey Baron.
4. Copresented with Northrop Auditorium.

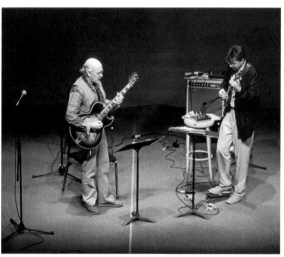

Bill Frisell (right) and Jim Hall, Walker Art Center, 1986

Katharina Fritsch
German, b. 1956

-- **Exhibitions**
Duchamp's Leg (1994; catalogue, tour)
-- **Holdings**
28 multiples

Katharina Fritsch thinks in pictures.[1] For more than two decades, she has produced both handmade and industrially fabricated objects that begin as immaterial visions in her imagination. Fritsch mines the fertile ground of her thoughts, experiences, and dreams as well as the history, myths, and fairy tales of her native Germany in search of archetypal or clichéd images from consumer culture that transcend autobiography. At once familiar and uncanny, her often darkly subversive subjects reside in a strange and melancholy world, the nature of which is subliminal and difficult to articulate. "At the moment viewers come into the space, the important thing is that they are drawn into something that perhaps does not seem so 'clean' at first," Fritsch explained in 1996, prior to mounting a major retrospective at the San Francisco Museum of Modern Art. "The fact that you perceive something, that you are astonished about something before you can identify its name or concept—these experiences are outside language."[2]

Formal clarity, strict order, purposeful repetition, and multiplication of forms have also been guiding impulses that at times have led to a protracted and labor-intensive artistic process. For Fritsch, scale, dimension, proportion, and color must coalesce perfectly or the sculpture is rejected, and the process of conceptualizing begins again. Gary Garrels, curator of the 1996 retrospective, aptly explains that for this extremely exacting artist, "locating a point of tension in form and proportion that corresponds to a personal and intuitive sense of rightness is critical. She has described this search as finding a standard, a specificity of scale and material, so that an object is transformed and removed from its ordinary function or association, existing apart from its normal circumstances."[3]

In 1979, Fritsch moved from her parents' house in Münster to Düsseldorf in order to study with Fritz Schwegler at the highly competitive Kunstakademie Düsseldorf, made famous by such artists as Joseph Beuys, Sigmar Polke, and Gerhard Richter. Although she was admitted to the program as a painter, Fritsch soon began exploring model-making. Some of these early handmade pieces include miniature architectural structures reminiscent of those found in the cities of Essen and Langenberg, where she spent her early years—a tapered, cylindrical brick chimney; a tunnel constructed out of wax; and a gray plastic mill building complete with gabled roof and water wheel. The heterogeneity of these forms is due to their varied sources in the artist's childhood memories.[4]

In 1980, Fritsch brought these works and several others together for her first public exhibition at the Kunstakademie.[5] Having learned and processed the lessons of the Minimalist artists who eschewed the use of pedestals (which she negatively associates with

monuments) in favor of placing sculpture directly on the floor, Fritsch distinguished herself with a somewhat radical next step. Instead of opting to present a single, floor-bound sculpture, she brought several together and placed them on top of a simple, utilitarian table. The self-conscious placement of seemingly unrelated and emotionally inflected objects in space would become integral to Fritsch's mature artistic practice, which has taken many forms, including ephemeral performative and sound pieces, landscape architectural drawings, and large-scale installations. She has also elevated the multiple (three-dimensional editioned objects) to a position of central importance in her oeuvre.

Throughout her career, Fritsch has reused motifs by altering their size and presenting them singly or in groups. For instance, in 1982 she created *Madonnenfigur* (*Madonna Figure*), an unlimited-edition multiple and replica of a devotional figurine commemorating the 1858 miraculous apparition of the Virgin Mary in Lourdes, France. Cast by hand in plaster and painted a matte finish of garish, fluorescent yellow, this former idol, intended to bolster religious fervor once the pilgrim is back home, becomes a different kind of icon. In Fritsch's hands it is transformed into a toy and rendered banal, even ridiculous. Color itself becomes a leveler and an irritant, signaling the viewer to stop and reconsider the subject in its altered state. By also multiplying the number of possible figures infinitely, Fritsch concurrently extinguishes the aura of the source image, while maintaining what she has referred to as "a spiritual structure."[6]

Two years later, this multiple became a component in a multipart piece entitled *Warengestell* (*Display Stand*) (1979–1984). Composed of five glass shelves installed with eleven other multiples by the artist—including *Anturien* (*Anthurium*) (1980), *Grünes Seidentuch* (*Green Silk Scarf*) (1982/1989), *Schafe und Weisser Pappkarton* (*Sheep and White Cardboard Box*)

Katharina Fritsch *Pudel* (*Poodle*) 1995 plaster, paint; edition 22/64
16 x 17 x 6 1/2 in. (40.6 x 43.2 x 16.5 cm) T. B. Walker Acquisition Fund, 1996
1996.59

(1982/1990), and *Fischring und Stern* (*Fish Ring and Star*) (1983/1994), each also in the Walker Art Center's collection—this work foregrounded her interest in the thin line between high art and kitsch, and served as a not-so-subtle critique of the commodification of art. In 1987, Fritsch turned again to the *Madonnenfigur*, this time for her notorious public installation of the life-size Virgin in a pedestrian area in Münster, located between a Karstadt department store and a Dominican church. Still another reinterpretation of the multiple appeared the same year as *Warengestell mit Madonnen* (*Display Stand with Madonnas*), in which two hundred eighty-eight of the objects were installed on nine round, aluminum shelves. This fluidity of purpose and context suggests the potency of her chosen subject and her achievement at finding the essence and rightness of things.

E.C.

Notes

1. See Susanne Bieber, interview with Katharina Fritsch, "Thinking in Pictures," in Iwona Blazwick, ed., *Katharina Fritsch*, exh. cat. (London: Tate Publishing, 2002), 98.
2. "Matthias Winzen in conversation with Katharina Fritsch," in Gary Garrels and Theodora Vischer, eds., *Katharina Fritsch*, exh. cat. (Basel: Museum für Gegenwartskunst; San Francisco: San Francisco Museum of Modern Art, 1996), 72, 78.
3. Gary Garrels, "Katharina Fritsch: An Introduction," in *Katharina Fritsch* (Basel, San Francisco), 18.
4. Ibid., 16.
5. The other objects exhibited were all created in 1979: *Besen* (*Broom*); *Sträusse in Vasen* (*Bouquets in Vases*); *Schwarz-weisses Auto* (*Black and White Car*); *Grünes Futteral* (*Green Case*); and *Topfdeckel* (*Pan Lids*).
6. Winzen interview, 80. It is also worth noting that while many of her multiples are industrially mass-produced, the *Madonnenfigur* was handmade in the artist's studio.

Katharina Fritsch *Hexenhaus und Pilz* (*Witches House and Mushroom*) 1999 wood, polyester, paint; edition 4/8 31 1/2 x 25 3/4 x 15 3/4 in. (80 x 65.4 x 40 cm) T. B. Walker Acquisition Fund, 2000 2000.10

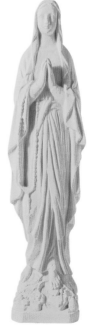

Katharina Fritsch *Maus* (*Mouse*) 1991/1998 polyester resin, paint; edition 87/240 7 1/2 x 2 1/4 x 9 1/2 in. (19.1 x 5.7 x 24.1 cm) T. B. Walker Acquisition Fund, 1999 1999.11

Katharina Fritsch *Madonnenfigur* (*Madonna Figure*) 1982 plaster, paint; unlimited edition 12 x 3 1/4 x 2 1/4 in. (30.5 x 8.3 x 5.7 cm) Butler Family Fund, 1991 1991.44

Frank Gaard

American, b. 1944

-- **Commissions**

Billboard Spectacle (In Memory of Guy Debord) (2004)

-- **Exhibitions**

Viewpoints—Frank Gaard: Paintings (1980; publication)

-- **Holdings**

1 painting, 4 unique works on paper, 2 edition prints/proofs, 4 books

Frank Gaard *Untitled* 1977 oil on canvas 60 x 108 in. (152.4 x 274.3 cm)
Gift of the Associates of the Minneapolis College Art and Design, 1993
1993.1

Anna Gaskell

American, b. 1969

- - **Exhibitions**
Stills: Emerging Photography in the 1990s (1997; publication)
- - **Holdings**
3 photographs, 1 multiple

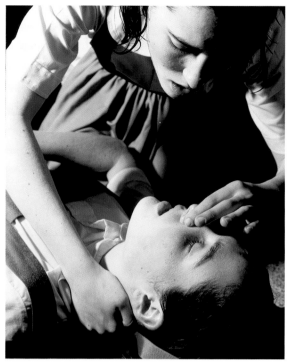

Anna Gaskell *Untitled #2 (Wonder)* 1996 chromogenic print; Artist's Proof 1 from an edition of 5 46 1/4 x 38 1/4 in. (117.5 x 97.2 cm) Clinton and Della Walker Acquisition Fund, 1998 1998.73

The dark storybook world of Lewis Carroll's *Alice in Wonderland* is reinterpreted in Anna Gaskell's uncanny *Wonder* series (1996–1997), her first set of photographs created after completing her MFA at Yale University School of Art. In *Wonder*, the artist takes liberties with Carroll's Victorian tale, casting a pair of dark-haired twin girls in the role of Alice. Dressed in angelic blue pinafores, white tights, and black Mary Jane shoes, Gaskell's Alices appear in mysterious and disquieting scenes that echo the disorienting adventures of their fictional counterpart. Revealing the influences of cinema and the theatrical images of photographers such as Cindy Sherman and Gregory Crewdson, Gaskell's staged pictures straddle the line between fiction and reality. Artificial lighting, unexpected camera angles, and extreme cropping contribute to the filmic quality and introduce a dreamlike atmosphere to her narrative. By thrusting us from one vantage point to another and by varying the dimensions of her works with images as small as 8-by-10 inches and as large as 50-by-60 inches, the artist recalls Alice's disorienting make-believe world and the dramatic, unsettling shifts she experiences in her size and identity.

In Gaskell's carefully choreographed scenes, Alice appears frolicking in a meadow and exploring the woods, adopting enigmatic poses that establish a realm in which girlhood is both sweet and sinister. In *Untitled #2 (Wonder)* (1996), for example, Alice and her doppelgänger appear in a tightly cropped image with one girl crouching over the other, holding her head and nose as if about to administer mouth-to-mouth resuscitation. Both girls appear again in *Untitled #15 (Wonder)*, where it is unclear if they are fighting or playing, or if they are struggling together or against each other. With neither girl clearly defined, the focus of this picture is on one girl's face covered in the dark, wild tresses of the other—her teeth clenched tightly on a lock of hair. The frenzy of such images turns to eerie stillness in *Untitled #11 (Wonder)*, where now only one girl appears, lying face down on a stone garden walkway, strangely reminiscent of a forensic crime-scene photo. While the ultimate fate of Gaskell's Alice is ambiguous in this magical and dangerous world, we are left with a wonderfully unsettling view into an alternate reality in which logic collapses and nothing is as it seems.

Irene E. Hofmann

General Idea

Formed 1968

AA Bronson, Canadian, b. 1946; Felix Partz, Canadian, 1945–1994; Jorge Zontal, Italian, 1944–1994

- - **Exhibitions**

Artists' Books (1981), *Duchamp's Leg* (1994; catalogue, tour), *Let's Entertain* (2000; catalogue, tour)

- - **Holdings**

6 multiples, 4 books, 27 periodicals

General Idea was a partnership formed in 1968 by artists AA Bronson, Felix Partz, and Jorge Zontal. This collective, which effectively disbanded in the 1990s after the deaths of Partz and Zontal, challenged the cultural and social assumptions of consumerist society, using a wide range of media that included performance, installation, video, photography, and sculpture. Their collaborative working method critiqued the value placed on authorship and originality, and their work helped establish queer identity and the AIDS epidemic as important topics for artistic investigation.

A key part of General Idea's practice was the production of multiples and editions, and the Walker Art Center Library holds a number of them in various formats. Although not necessarily mass-produced, the multiple undermines the idea of the original, unique work of art, and often is designed to reach a public beyond the art world. Like artist Edward Ruscha, whose books of the 1960s were among the first artworks sold outside traditional fine-art venues, General Idea distributed its low-cost, reproducible works through alternative methods, in part as a subversion of the commercial art market. This populist practice, however, meant that the group's work was sometimes overlooked by collectors. According to the artists, "By the late 1970s we had a substantial production of editions behind us, and yet, because these works were thought of as ephemeral or were simply too cheap to be sold in a gallery, they were not known or not taken seriously."[1] Still, instead of changing their practice to accommodate the market, the artists opened a shop, Art Metropole, to publish, distribute, and sell their multiples.[2]

Among the multiples in the Library's collection is *Test Pattern TV Dinner Plate* (1988), a rectangular porcelain sushi plate with a design based on the vertical bands of a color-television test pattern. It was made as part of a 1988 project for Spiral Gallery in Tokyo, and was inspired by the ubiquitous presence of video monitors in all aspects of Japanese culture. Spiral Gallery also had a restaurant and shop, which were as prominent as their gallery spaces, and *Test Pattern TV Dinner Plate* served all three. The shop sold a signed edition of the multiple; the galleries held three arrangements of one hundred forty-four plates meant to be read as paintings; and the restaurant served sushi daily on them. A laminated place mat of the same design was also issued. The blurring of commerce and art was complete.

One of their most successful editions was *FILE Megazine*, published from 1972 to 1989, of which the Walker owns the complete run of twenty-seven issues. *FILE*'s red-and-white logo mimicked that of *Life* magazine, a familiar sight on newsstands of the day. However, *FILE* was a kind of worm invading the media's distribution system; its strange and obscure content made it unlike anything else at the newsstand, but then that was the general idea.

One of the members of General Idea once called art a curious and elitist drink, one with heady cultural properties that, to his way of thinking, had never really been exploited. Works such as the multiple *Nazi Milk Glass* (1984) (meant to hold a cocktail) and *The Getting into the Spirits Cocktail Book* (1980) literalize his metaphor. They were developed for the Boutique of *The 1984 Miss General Idea Pavilion*—a tongue-in-cheek framework the artists developed to parody spectacularized aspects of popular culture such as beauty pageants and trade shows. "As the 'Pavilion' stood for the museum, and as every museum must have its gallery shop, we designed 'the Boutique' . . ."[3] Here the group found its niche—they combined the humor and double entendres of Dada with the branding and marketing techniques of Madison Avenue.

R. Furtak

Notes

1. *General Idea, Multiples: Catalogue Raisonné: Multiples and Prints 1967–1993* (Toronto: S. L. Simpson Gallery, 1993), unpaginated introduction.
2. Located in Toronto, the shop opened in 1974 and has since broadened its activities to include book works, multiples, and other materials by a range of artists working in experimental formats.
3. General Idea, interview with Sandra Simpson, in *Multiples Catalogue Raisonné*, unpaginated.

General Idea Selection of multiples, 1980–1991 Walker Art Center Library Collection

Alberto Giacometti
Swiss, 1901–1966

- - **Exhibitions**
Reality and Fantasy, 1900–1954 (1954; catalogue), *Expressionism 1900–
1955* (1956; catalogue, tour), *Alberto Giacometti: A Retrospective
Exhibition* (1974; organized by the Solomon R. Guggenheim Museum,
New York; catalogue), *20th Century Master Prints* (1975; tour)
- - **Holdings**
1 sculpture, 2 edition prints/proofs, 1 print portfolio, 2 books

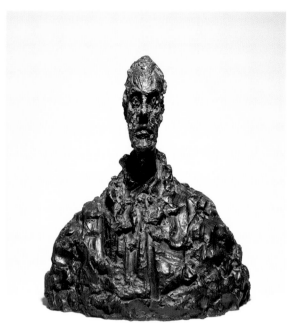

Alberto Giacometti *Buste de Diego (Bust of Diego)* circa 1954 bronze;
edition 1/6 15 1/16 x 13 1/8 x 7 5/16 in. (38.3 x 33.3 x 18.6 cm) Gift of the T. B.
Walker Foundation, 1957 1957.1

Sam Gilliam
American, b. 1933

- - **Commissions**
Carousel Merge (1971)
- - **Exhibitions**
Works for New Spaces (1971; catalogue), *Artist and Printer:
Six American Print Studios* (1980; catalogue, tour)
- - **Holdings**
1 painting, 1 unique work on paper, 5 edition prints/proofs,
1 portfolio of prints

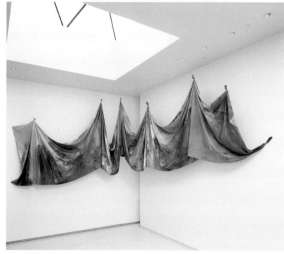

Sam Gilliam *Carousel Merge* 1971 acrylic on canvas 120 x 900 in. (304.8 x
2286 cm) installed dimensions variable Gift of Archie D. and Bertha H.
Walker Foundation, 1971 1971.14

Philip Glass
American, b. 1937

In May 1970, having nearly completed a total renovation of its building, the Walker Art Center opened (some of) its doors to present a concert series titled *7 Evenings of New Music*.[1] Featuring composers Robert Ashley, David Berman, Alvin Lucier, Gordon Mumma (billed as Sonic Arts Group), Steve Reich, and Philip Glass in his premiere Walker-presented performance, the concerts were among the first given outside New York and offered the broader public an introduction to this most puzzling, radical, and ultimately liberating new musical frontier.[2] Already an accomplished composer, Glass had rejected much of his early training as a classical musician, turning away from the Western twelve-tone system of serialism and concentrating instead on developing his own compositional style and aesthetic.

A job transcribing music for Ravi Shankar had led Glass on his first visit to India in 1966, where he was exposed to non-Western music and Indian compositional technique. Taking these lessons with him, he returned to New York in 1967 and immersed himself in the burgeoning downtown scene. Here Glass would develop a number of long-term associations with compatriots such as choreographer Lucinda Childs, the theater company Mabou Mines (of which he was a founding member), and visual artists Sol LeWitt and Richard Serra. During the next few years, Glass produced an array of works that delved deeply into the rigors of Minimalism. These were met initially with resistance from fellow composers and audiences, before gaining a cult following from steady underground concertizing by his new group, the Philip Glass Ensemble.

Glass had already begun serious work based on repetition before completing *Music in Twelve Parts* (1971–1974), a four-hour epic that still stands as an object lesson in theoretical experimentation. Absent the crescendos and musical denouements typical of classical composition, the piece asks the listener instead to locate various metamorphoses of sound and rhythm in unexpected chord progressions, deeply recessed one-note drones, hidden melodies, and twisted tonality. Its completion marked the end of Glass' long journey through the formalities of Minimalism and the challenges of an alternate notation system, demonstrated by his next landmark work, the modern baroque opera *Einstein on the Beach* (1975–1976), created with Robert Wilson. It is arguably the piece that launched Glass into the public consciousness as well as the musical establishment. Though nonnarrative and without a clear plot, *Einstein on the Beach* attracted both traditional and neophyte audiences with its highly theatrical visual elements, loopy text, and unusual staging.[3] It would mark the turning point of an astonishing career—ranging from film scores to theater to dance to recorded and symphonic works—that rests firmly in popular acceptance, yet still challenges audiences to make use of transition and change, those interstitial passages that often contain more to ponder than what is actually seen or played.

D.K.

Notes

1. In the May 1970 Walker Art Center calendar, a notation under the concert listing reads: "Wear old clothes; the parts of the building which will be used are safe but unfinished." The building officially opened in May 1971.

2. Tim Page, "Music in 12 Parts," in Richard Kostelanetz, ed., *Writings on Glass* (New York: Schirmer Books, 1997), 99. Glass notes, "To organize our first tour, I sent out something like one hundred twenty letters and got six responses. We played in Tacoma, St. Louis, Minneapolis, and a few other places."

3. The five-hour opera *Einstein on the Beach* has four interconnected acts with no intermission; attendees were encouraged to come and go during the performance.

Philip Glass Walker Art Center Auditorium, 1972

Robert Gober
American, b. 1954

In 1984, Robert Gober had his first solo exhibition. For five days only, an invited audience could see the artist's *Slides of a Changing Painting* (1982–1983). The work was a documentation of a constantly morphing painting on board that Gober photographed in his studio. "I had this little board on a table, about 11-by-14 inches, on which I painted on and off for a year. I had my camera and lights mounted over it. I would paint, take a slide, scrape the paint off, add more paint, take a slide. I took thousands of slides over the course of a year and then edited them down and showed them with a dissolve—basically a memoir of a painting."[1] As one slide merges into the next, a haunting narrative of loss and regeneration glides by, with the clicking of the slide projector playing the role of a relentless metronome. The images themselves linger most attentively on a human torso that evolves from male to female to hermaphrodite. The torso becomes a room, is penetrated by a conduit, disappears into a thicket of vines, splits to reveal a waterfall. Seasons pass from one to the next and everywhere there is water—gushing, pouring, pooling. As remarkable as the images themselves is the fact that *Slides of a Changing Painting* has remained over the succeeding years the abundant source for much of Gober's ensuing sculpture. Back in 1984, only a handful of people saw *Slides of a Changing Painting*, and there were no reviews. To this day, it has been seen only rarely; but for those who have experienced the piece, it becomes clear that it is the Rosetta stone for Gober's sculpture. Talking about the work, the artist comments: "I knew in the beginning what the end form would be, that they [the paintings] would be slides. I always thought of myself as a painter, but I could never make paintings. I was never interested in the physical objectness of a painting, but the process and imagery really interested me. It was the heyday of neo-expressionism, and I had a kind of allergic reaction to it. So, in a way, my intuitive response to that gluttonous situation was to make a surfeit of paintings that didn't really exist."[2]

The following year, Gober opened an exhibition devoted exclusively to his sculpture and everything changed. The dominant sculptural form in the show was a sink—kitchen sink, laundry sink, bathroom sink. Each was instantly recognizable, yet completely alien. The sculptures' materiality was built up from a wooden armature covered in wire lath, then plastered and painted. The semigloss enamel paint covering the sinks did not pretend to mimic porcelain any more than the plasterwork imitated a flawless, machined surface.

Each work reveled in its handmade homeliness. The exhibition offered a whole new hypothesis for sculpture, one that affirmed the seriality of Minimalism while celebrating the virtues of the handcrafted. That the sinks had no provision for plumbing also signaled a Surrealist edginess that would remain a signature of the work. Then too, the exhibition came at the height of the AIDS epidemic, and it was remarked early on that the unplumbed sinks functioned something like surrogates for the dead, deprived as they were of that which defined their nature. This resolve to deal with the politics of disease would continue in Gober's work throughout the 1980s. Yet, in the sinks (and succeeding works such as male legs protruding from walls, some embedded with drains or candles), Gober is continually drawn to a vocabulary of functional forms (beds, chairs, playpens, drains, urinals, doors, conduits) that, in his hands, take on grave emotional beauty. Each of his sculptures, in its own way, is a portrait of an emotion or a human condition, whether it be the isolation of childhood or the seductive power of the reimagined fact.

In 1992, at the Dia Art Foundation in New York, Gober staged the most intricate of an ongoing series of psychologically plotted installations that, in their physical scope and metaphoric sweep, truly fall under the rubric of *Gesamtkunstwerk*. These installations exhibit a totality of vision as well as a growing thematic bravado that snakes its way into many corners of the human experience. It is the water (first seen in *Slides of a Changing Painting*) that turns Gober's environments into a drowned world where redemption is always a whispered promise, but often heard in a cautionary voice. In the Dia installation, the sinks—this time fully plumbed and gushing with water—gave voice to the promise. Talking of the exhibition, Gober said: "I wanted the feeling of the show to be positive and mature. And I think I felt that making the sink functional wasn't only an internal imperative of expressing who I am, but maybe it was also a response to so much of the interpretation that had to do with the nonfunctioning sink and the epidemic and myself as a gay man. I think I felt a need to turn that around and to not have a gay artist represented as a nonfunctioning utilitarian object, but one functioning beautifully, almost in excess."[3]

After the Dia exhibition, Gober continued to make individual objects as he had before, but the anxiety of their presence did not diminish. Sculptures of a lounge chair and enormous tissue and lard boxes gutted by bronze conduit pipes, a Brobdingnagian stick of butter occupying an equivalently extravagant piece of wax paper that measures out gigantic tablespoons all generated strange adventures in scale and psychological perception. Male/female torsos, which earlier in the decade were hermaphroditic wax torsos tossed into right-angled corners, began turning up in laundry baskets and milk crates—not as horrific back-alley discoveries, but as strangely commodified inevitables. A standard child's nursery-school chair placed over a drain accommodates a larger-than-life box of tissues to create a portrait of the psychologically freighted all-American child sitting on a world of repressed anxiety.

As the last century drew to a close, Gober created another work of shattering power (now on permanent

display at the Schaulager in Basel, Switzerland). The installation was created for Los Angeles' Museum of Contemporary Art and resolves itself around a larger-than-life-size concrete statue of the Virgin Mary standing atop a sewer drain. Below the drain lies a limpid pool of water filled with sea plants and outsize coins all inscribed with Gober's birth year. The Madonna's womb is penetrated by a large bronze conduit. Behind her, in the distance (visible through the conduit), is a domestically scaled wooden staircase down which torrents of water rush, producing a sound that, if experienced in one's home, would spell disaster. At the bottom of the steps, the water gathers and then gushes into the blackness of a storm drain. Off to the right and left of the Madonna are two silk-lined suitcases lying open on the floor. Their interiors are also drains in which one can glimpse sparkling tidal pools and the legs of a man holding a diapered infant over the water. The work is apocalyptic in its complex merger of rapture and serenity. In that complexity lies the profound seductiveness of Gober's art, which looks unblinkingly at life as a grand, occasionally grinding reality that is, by turns, harrowingly ordinary and breathtakingly transcendent.

R.F.

Notes

1. Quoted in Richard Flood, *Robert Gober: Sculpture + Drawing*, exh. cat. (Minneapolis: Walker Art Center, 1999), 127.
2. Ibid.
3. Ibid., 21.

Robert Gober Selections from *Slides of a Changing Painting* 1982–1983
89 color transparencies for projection 26 x 39 in. (66 x 99.1 cm) projected
T. B. Walker Acquisition Fund, 1992 1992.152 ©Robert Gober

Robert Gober *The Subconscious Sink* 1985 plaster, wood, steel, wire, lath, paint 90 x 83 5/8 x 25 1/2 in. (228.6 x 212.4 x 64.8 cm) Clinton and Della Walker Acquisition Fund and Jerome Foundation Purchase Fund for Emerging Artists, 1985 1985.396 ©Robert Gober

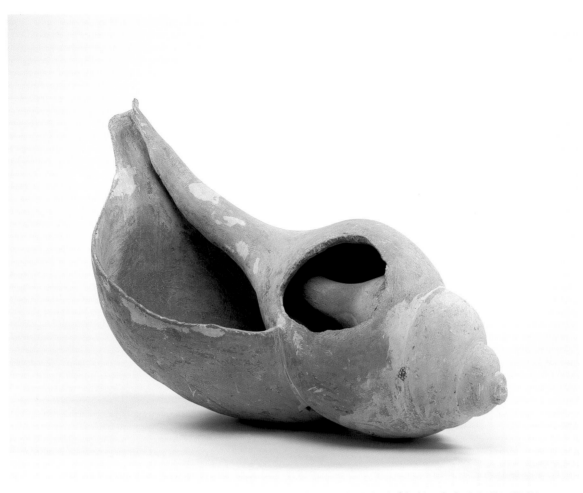

Robert Gober *Untitled* 1982 plaster over matrix wire lath 65 1/2 x 34 3/4 x 40 in. (166.4 x 88.3 x 101.6 cm) Gift of Jennifer Bartlett, 1994 1994.224
©Robert Gober

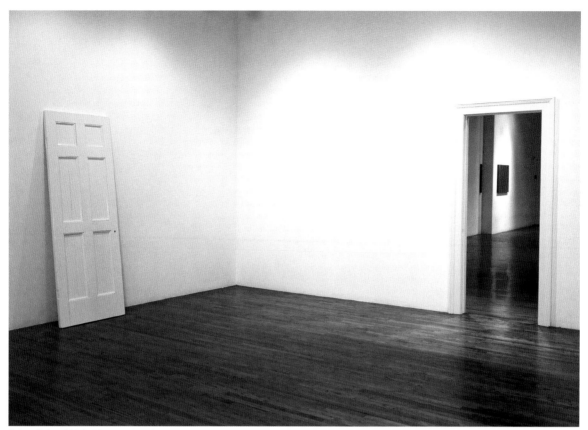

Robert Gober *Untitled Door and Door Frame* 1987–1988 wood, enamel paint, door door: 84 x 31 3/4 x 1 1/2 in. (213.4 x 80.7 x 3.8 cm); door frame: 90 x 43 1/4 x 8 in. (228.6 x 109.9 x 20.3 cm) Gift of the John and Mary Pappajohn Art Foundation, 2004 2004.68 ©Robert Gober

On an untitled sculpture by Robert Gober

Robert Gober is a poet of the uncanny, the fragmented, and the inexplicable. The objects he creates are at once down-to-earth and fantastic, appealing to our knowledge of the everyday—ordinary bodies, utensils, housewares—at the same time as they reach down to perturb the deepest levels of the unconscious.

Untitled (1999), a work of modest dimensions made of cast plastic, beeswax, hair, pigment, and cedar, is a perfect example of Gober's achievement. A torso lies in an ordinary milk crate—a torso that is a bit wrinkled and rumpled, rather like the clothes one would expect to find in a laundry basket. Already the viewer is unsettled, distressed. What is a realistic human torso doing in a milk crate? Memories of Jeffrey Dahmer flash through our heads, shades of perversity and violence. Yet the piece as a whole exudes tranquility, a benign peacefulness. The torso lies there like a baby in its bed, protected and enclosed by its latticework cradle.

But then, what a torso! For the body in question is half female and half male, the halves joined fluently, without borders or separation, in the middle. Manly hair covers the chest and belly of one side; a soft, hairless breast and an obtrusive pink nipple mark the other. On one level, one might say that this torso is a paradigm of Platonic perfection, the human body at its origins as Aristophanes described it in Plato's *Symposium*, before the two halves of humanity were cut apart and thereby rendered imperfect. "The original human nature was . . . man, woman, and the union of the two having a name corresponding to this double nature, which once had a real existence, but is now lost, and the word 'androgynous' is only preserved as a term of reproach." Our lives are spent in search of that lost totality, and it is this desire and pursuit of the whole that is called love. From this point of view, Gober's *Untitled* may be understood as the paradigmatic image of a lost felicity.

On the other hand, this torso as a visible object suggests a perverse joining of irreconcilable opposites, a freak of nature. The hermaphrodite strikes us as an appalling anomaly, a never-to-be-resolved contradiction. Having it all, in gender terms, can only be disturbing, and the absence of head, arms, and legs in the context of convincing realism—body hair, nipple, delicately nuanced flesh—can only have sinister implications.

Gober's torso, though, must mean something different to male and female spectators. Although it literalizes androgyny, it is yet not quite a hermaphrodite, which needs both male and female sex organs. To the male spectator, this torso must be unsettling: his manly, hairy chest has sprouted a perky breast! For the female, it has overtones of loss, associated with the omnipresent specter of breast cancer, mastectomy, masculinization. For men and women alike, of course, it presents a disconcerting ambiguity; yet for me, a distinct seductiveness as well. Both at once! The baglike integument, softening and derealizing the body form, suggests perhaps a kind of gift, a present of erotic takeout, as it were. Sometimes I think I am a little in love with Gober's torso. It's not the first time someone fell in love with a statue, after all; think of Pygmalion and Galatea, brought to life by Venus. I don't want to bring Gober's torso to life, however, because it seems to me that, in its irreconcilable doubleness, it is already pregnant with a poignant vivacity. Alive, it would merely be a monster.

Linda Nochlin

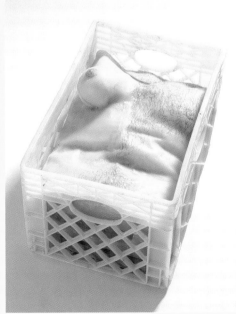

Robert Gober *Untitled* 1999 cast plastic, beeswax, hair, pigment, cedar 12 1/2 x 18 3/4 x 13 in. (31.8 x 47.6 x 33 cm)
T. B. Walker Acquisition Fund, 1999 1999.38 ©Robert Gober

David Goldes

American, b. 1947

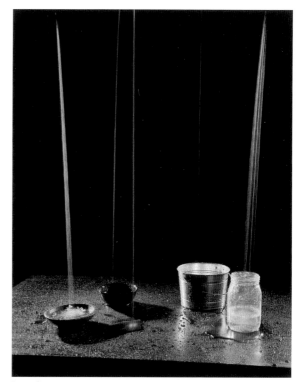

David Goldes *Pouring* 1994 gelatin silver print; edition 3/25 34 3/4 x 27 in.
(88.3 x 68.6 cm) Clinton and Della Walker Acquisition Fund, 1996 1996.193

Felix Gonzalez-Torres

American, b. Cuba, 1957–1996

- - **Exhibitions**
Let's Entertain (2000; catalogue, tour)
- - **Holdings**
17 photographs, 32 edition prints/proofs, 3 multiples

Felix Gonzalez-Torres was born in Cuba and immigrated, via Puerto Rico, to the United States in 1979. He studied poetry and photography, which he employed in his art with utmost economy and subtlety to speak equally to the personal and the political with remarkable elegance and eloquence. Widely read in contemporary theoretical literature, the artist was also fiercely committed to political causes of the time—the heady years of the late 1980s and early 1990s when the so-called culture wars raged on. At the same time he worked as a member of the activist artist collective Group Material, he continued his utterly singular practice, which was anything but doctrinaire. Instead, during a lamentably short career, he turned art into a vanishing act.

In two of his best-known series, Gonzalez-Torres exhibited stacks of paper sheets to be taken home and piles of candies to be melted on tongues, both replenished magically and "endlessly." While making clear references to the industrial, obdurate objects of Minimalism,[1] his stack pieces are printed with monochromatic colors, textual snippets, reproduced newspaper clippings, or photographs of natural landscapes, often of the sky. Each sheet in the untitled stack in the Walker Art Center's collection is printed with an image of the calm surface of water. He also placed individually wrapped candies, intended to be consumed by viewers, in piles in the corners of rooms or spread them evenly on the floor. Distributing information or oblique poetics, the series were, and are, an implicit critique of the art market, questioning the very notions of commodification and ownership. The candy piles, with their oral associations, effectively conflated fears of contagion (AIDS) and the transubstantiation of the Eucharist. On a more personal level, the works were also often about Ross Laycock, the artist's longtime partner, who died of AIDS in 1991.

In 1992, Gonzalez-Torres started making light strands—simple extension cords on which low-wattage lightbulbs are evenly spaced—that may be installed variably according to given spaces and as the owners see fit.[2] He made most of them in the next two years. Although they do not involve gifts in the way the stack pieces and candy piles do, their fluidity, openness, and formal simplicity are hallmarks of his practice. Toward the end of his life, the artist repeatedly stated that his public was, first and foremost, his lost lover. It is tempting, then, to see the sudden, almost explosive output of the light strands as an act of remembering, as if the artist were lighting candles for departed souls.

In the opening sequence of Alain Resnais' 1959 film *Hiroshima, mon amour*, the female protagonist utters these words: "You are good for me because you destroy me."[3] Gonzalez-Torres, living at the end of the twentieth century and facing a cruel epidemic and institutionalized hate, saw art-making as a necessary rejoinder to love, that terrible double-edged blessing and curse. And as we take part in the artist's generous acts of giving or behold the gentle iridescent lights, we are reminded of how socially committed he was, how his art redefined beauty itself, and more than anything else, how his art speaks volumes about love.

D.C.

Notes
1. The most obvious Minimalist precedents for Gonzalez-Torres' works are Donald Judd's stacks or cubes and Carl Andre's floor pieces. The corner pieces are art-historically reminiscent of Robert Morris' benchmark installation at his one-person show at the Green Gallery, New York, in 1964, in which Morris installed a group of gray polyhedrons, including a corner piece.
2. In 1991, Gonzalez-Torres made *Untitled (March 5th) #2*, which consists of two lightbulbs attached separately at the ends of two extension cords, but did not start using multiple bulbs until 1992. Most of the light strands have twenty-four or forty-two lightbulbs per string. The Walker's light strand has twenty-four. See Dietmar Elger, ed., *Felix Gonzalez-Torres Catalogue Raisonné, Volume II* (Ostfildern-Ruit, Germany: Cantz Verlag, 1997).
3. Gonzalez-Torres discusses the film, directed by Alain Resnais and based on a script by Marguerite Duras, in an interview with Tim Rollins. See William S. Bartman, ed., *Felix Gonzalez-Torres* (New York: A.R.T. Press, 1993), 14.

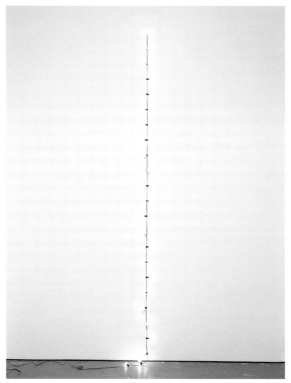

Felix Gonzalez-Torres "Untitled" (Last Light) 1993 lightbulbs, plastic light sockets, extension cord, dimmer switch; edition 14/24 installed dimensions variable Gift of Gilbert and Lila Silverman, Detroit, Michigan, 2003 2003.53
©The Felix Gonzalez-Torres Foundation

Arshile Gorky

American, b. Armenia, 1905–1948

Exhibitions

Modern Art in Advertising: Designs for Container Corporation of America (1948; catalogue), *Arshile Gorky* (1951; organized by the Whitney Museum of American Art, New York; catalogue), *Reality and Fantasy, 1900–1954* (1954; catalogue), *Expressionism 1900–1955* (1956; catalogue, tour), *60 American Painters: Abstract Expressionist Painting of the Fifties* (1960; catalogue), *Selections from the Martha Jackson Collection* (1975; catalogue)

Holdings

1 drawing, 1 book

Arshile Gorky *Sochi* 1943 graphite, colored crayon on paper 14 1/16 x 16 13/16 in. (35.7 x 42.7 cm) Donated by Mr. and Mrs. Edmond R. Ruben, 1995 1995.68

Adolph Gottlieb

American, 1903–1974

Exhibitions

110 American Painters of Today (1944; catalogue, tour), *136 American Painters* (1946; catalogue), *Paintings to Know and Buy* (1946), *Contemporary American Painting: Fifth Biennial Purchase Exhibition* (1950; catalogue, tour), *Contemporary American Painting and Sculpture: Collection of Mr. and Mrs. Roy R. Neuberger* (1952; catalogue), *Four Abstract Expressionists* (1953; organized by Kootz Gallery, New York), *1958 Biennial of Paintings, Prints and Sculpture* (1958; catalogue, tour), *60 American Painters: Abstract Expressionist Painting of the Fifties* (1960; catalogue), *Adolph Gottlieb: Recent Paintings* (1963; catalogue), *The Cities Collect* (2000)

Holdings

2 paintings

Adolph Gottlieb *Trio* 1960 oil on canvas 60 1/4 x 90 in. (153 x 228.6 cm) Gift of Mrs. Esther D. Gottlieb, 1963 1963.36

Sheela Gowda
Indian, b. 1957

-- **Exhibitions**
How Latitudes Become Forms: Art in a Global Age
(2003; catalogue, tour)
-- **Holdings**
1 sculpture

Sheela Gowda began her career as a figurative painter, but as with many artists, an epiphanic crisis in her life and work brought about an entirely new mode of production. After receiving a master's degree in painting from the Royal College of Art in London, Gowda returned to her hometown of Bangalore, India, where she was living when the 1989 Bombay and 1990 Hyderabad riots broke out. What she saw as a threat to the social fabric caused by burgeoning Hindu fundamentalism led her to question the form and content of her work: "I felt a sense of inadequacy as an artist. I felt very deeply about the things that were happening around me, but the question was how to bring it into my own artistic language without being illustrative or superficial. On the other hand, it was also an extension of the concerns in my earlier paintings that were dealing with violence and its relation to sensuality."[1] As a result, Gowda's work evolved into a type of figurative abstraction that, while in dialogue with Western modernism, was able to carry the specific political and bodily fragmentation she was seeking to articulate.

This formal solution also led her to explore elemental materials associated with the daily domestic labor of Indian women, such as cow dung, which is used in religious rituals and as a fuel. According to the artist, "It had potential, being sacred on the one hand and on the other being shit. . . . I wanted to subvert its traditional meanings."[2] Gowda also used kumkum, a vermilion pigment customarily used by married Hindu women to adorn their foreheads between the brows with a dot or *bindi*. Gowda was able to capitalize on the feminine connotations of this material, with its ceremonial and cosmetic uses and blood-red hue, in her most monumental and labor-intensive installation to date, *And Tell Him of My Pain* (1998/2001), in the Walker Art Center's collection.[3]

The piece is composed of two discrete, sinuous cords that Gowda created by threading the entire length (750 feet) of a ball of red thread onto a needle, which was then placed at the halfway point just as one would do in preparation for hand-sewing. After repeating this process one hundred eight times, with that number of needles and lengths of thread, she gathered the strands together and "anointed" them with a mixture of wood glue and kumkum, except for the bunch of needles at one end (which the artist calls the head) and the last five to ten inches on the other (the tail). Gowda has described this performative process as a strange kind of Happening, "the process of making a body, but also being the body."[4] While she has also compared the work to an umbilical cord or creeping vine, the artist is hesitant to overload it with metaphors. She is equally comfortable with the view that the piece is purely

linear: "Over the past twenty years, line has been the most persistent element in my work, so much so that [*And Tell Him of My Pain*] is basically a sculpture as drawing. This has come about because of my particular interest in and study of Indian paintings, which are predominantly linear. . . . I am also dealing with the site. . . . On the wall, it reads as a line; on the floor, it reads as a linear, sculptural form."[5]

E.C.

Notes
1. Sheela Gowda, interview by Victoria Lynn, "Sensuality and Violence in the Art of Sheela Gowda," *ART AsiaPacific* 3, no. 4 (1996): 80.
2. Ibid.
3. The source of the title is taken from an early Tamil poem devoted to Vishnu by ninth-century saint and poet Nammalvar, included in an anthology translated by A. K. Ramanujan, *Hymns for the Drowning* (New Delhi: Penguin Books India, 1992, 1993). Gowda, correspondence with the author, April 6, 2004 (Walker Art Center Archives).
4. "Sheela Gowda in Conversation with Christoph Storz and Suman Gopinath," in Sarah Campbell and Grant Watson, eds., *Drawing Space: Contemporary Indian Drawing, Sheela Gowda, N.S. Harsha, Nasreen Mohamedi*, exh. cat. (London: Institute of International Visual Arts, 2000), 53.
5. Ibid., 52.

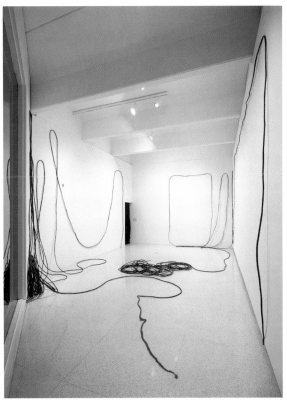

Sheela Gowda *And Tell Him of My Pain* 1998/2001 thread, pigment, glue, needles installed dimensions variable Julie and Babe Davis Acquisition Fund, 2002 2002.29

Dan Graham

American, b. 1942

- - **Commissions**

Two-way Mirror Punched Steel Hedge Labyrinth (1994–1996)

- - **Exhibitions**

Artists' Books (1981), *Let's Entertain* (2000; catalogue, tour); *American Tableaux* (2001; publication, tour); *The Last Picture Show: Artists Using Photography, 1960–1982* (2003; catalogue, tour)

- - **Holdings**

3 sculptures, 3 photographs, 2 videos, 2 edition prints/proofs, 1 book, 2 periodicals, 1 model

It is difficult to imagine the state of art, music, architecture, or criticism in the United States without the influence of Dan Graham. As an art dealer, a filmmaker, a performer, a photographer, an art critic, a music producer, a writer, a poet, and the author of a rock opera, Graham is a different kind of artist—one whose ultimate goal is to explore and expose the relationships between the different disciplines that constitute the mechanism of perception in a cultural system. Deeply influenced by the writings of anthropologist Margaret Mead and by psychoanalysis and ideological criticism inherited from the Frankfurt School via Herbert Marcuse, he has over the years produced a body of work that can be seen as an essay on the condition of human life in a postmodern, postindustrial era. Whether his artistic interventions take place in a gallery, between the pages of a magazine, on a stage, in a movie theater, on television, or on the streets, Graham continues to deconstruct, clarify, and expose the nature and condition of an individual's status and behavior within a public sphere dominated by the logic and integrated spectacle of corporate capital and politics.

In 1964, Graham opened the John Daniels Gallery in Manhattan with friends.[1] He organized exhibitions of work by artists with whom he shared intellectual and aesthetic affinities, such as Sol LeWitt, Dan Flavin, Donald Judd, and Robert Smithson. Financial challenges overshadowed the artistic program, and the gallery closed in 1965. Graham escaped his creditors by moving to New Jersey. There he began a photographic series that is still developing as a matrix of his concerns and his oeuvre. Using a cheap Kodak camera, he photographed the housing environment of New Jersey. His goal was to create images that anyone could produce. First shown as a slide projection, the work, titled *Homes for America*, is a series of images outlining a typology of all possible variations on decorative motifs or materials.[2] Through the photographs, Graham draws a critical parallel between the housing industry and the seriality inherited from the aesthetic of Minimal Art. In December 1966, *Homes for America* was published in *Arts Magazine*, accompanied by an article written by the artist.[3] The original design by Graham included a text about the nature of suburban housing developments, illustrated by photographs stressing their mass-produced and serial quality. In the pages of the magazine, *Homes for America* was not a mere reproduction of an artwork; it was an artwork informed and distributed by the means of information itself, by the medium of the magazine as a public space. It was not art *about* the media (like Pop Art) but art *as* media, art as information. Graham used information as an aesthetic and the media as a vernacular form appropriate to the nature of his discourse. The quotidian and serial nature of the magazine was the perfect conduit for a critique of the seriality of Minimal Art through an analysis of vernacular suburban architecture.

Embedded in Graham's work is the use of mirrors and glass as critical tools as well as an ongoing fascination with the suburbs as a homogenizing location of social climbing. This is at the heart of *Alteration to a Suburban House* (1978/1992). The work seems to be a direct extension of Graham's 1977 action *Performance/ Audience Mirror* in which the artist stood between a large mirror and the audience. He first described himself facing the group, then turned and described himself in front of the mirror, facing the image of a public observing a performer in the unfathomable depth of its own reflected image. *Alteration* is an architectural model of a suburban street in which one house faces two others. The dwelling's normally solid facade has been replaced by a glass wall; in the back, parallel to the wall, a mirror divides the public living areas from the private. The glass wall opens the living area to the public gaze, like a shop window or a living billboard advertising a very specific lifestyle and decor. The mirror reflects not only the inside of the house, but its immediate surroundings: the neighboring houses, passersby, and cars are projected into the private environment of the living area, where voyeurism and surveillance merge. *Alteration* does not comment only on vernacular architectural codes. Just as *Homes for America* implies a critical take on Minimalism and Pop Art strategies, this series of models presents the glass wall as the icon of "noble" modernist architecture as developed by Mies van der Rohe, among others. To the Arcadian reconciliation of nature and culture made possible by the glass, Graham adds here a third party: the contextual complexity of the urban space, as outlined in architect Robert Venturi's 1966 essay *Complexity and Contradiction in Architecture*. Venturi challenged the orthodoxy of modernism by championing an architecture that promoted richness and ambiguity over unity and clarity, contradiction and redundancy over harmony and simplicity, answering van der Rohe's "less is more" with his equally famous "less is bore." Not allying himself with either of these theoretical models, Graham combines both in order to understand where and why each of them might have failed their users.

Drawing on French psychoanalyst Jacques Lacan's theory of the "mirror stage" giving rise during childhood to the mental representation of the subject, Graham started in the 1980s to build architectural pavilions informed by his former investigations into modernist, vernacular, and corporate architecture as well as his experimentation with audience behavior. The sculptures *Two-way Mirror Punched Steel Hedge Labyrinth* (1994–1996) and *New Space for Showing Videos* (1995) belong to this generation of works. These two pieces, conceived on comparable premises, address the institutional context of a sculpture garden and an art center.

Two-way Mirror Punched Steel Hedge Labyrinth, installed outdoors in the Minneapolis Sculpture Garden and informed by Graham's interest in Renaissance, Mannerist, and Baroque gardens, embodies the modernist marriage of architecture and nature in a maze where the glass walls not only reflect nature, but are nature themselves (arborvitae). The maze is less architectural than perceptual, in which artifice and nature are confounded. *New Space for Showing Videos* is an indoor environment, made of alternating standard and two-way mirrors, that carve out spatially the concept of seeing and being seen, a strategy familiar to corporate surveillance architecture. In this maze of bays are video monitors and casual seating that create a convivial social atmosphere in which watching and being watched are confused. The space reinforces the idea of a social contract on which was born the very notion of the public museum.

Media and popular culture have been other systems of signs and ritual ripe for scrutiny within Graham's own "comparative anthropology." The video documentary *Rock My Religion* (1982–1984) applies to rock music what curator Jean-François Chevrier has called a "montage of dissimilar historical moments" to define Graham's practices.[4] In *Rock My Religion*, the artist drafts a history that begins with the Shakers and their practices of self-denial and ecstatic communal trances and ends with the emergence of rock music as the religion of the teenage consumer in the isolated suburban context of the 1950s. He identifies rock's sexual and ideological context in postwar America as a form of cathartic and secular religion.

Pedagogical, spectacular, and playful all at once, Graham's work has always attempted to expose the mechanism of alienation by analyzing the impact of social codes—propagated by the media or architecture—on the individuation process. Less a dogmatic criticism than an incitement to remain alert, his practice is, as critic Thierry de Duve wrote, a "stocking of utopia."[5]

P.V.

Notes
1. The gallery's other partners were John Van Esen and Robert Tera.
2. As a slide show, *Homes for America* was shown in 1966 in the exhibition *Projected Art* at the Finch College Museum of Art, New York.
3. Unfortunately, the article was inadvertently illustrated with an image of a wooden house in Boston taken by photographer Walker Evans. Graham's intended illustrations appear in a lithographed edition of the original design for *Homes for America* realized between February 19 and May 20, 1971, at the Nova Scotia College of Art and Design in Halifax. The lithograph is in the Walker's collection.
4. Jean-François Chevrier, "Dual Reading," in Jean-François Chevrier, ed., *Walker Evans and Dan Graham*, exh. cat. (New York: Whitney Museum of American Art, 1994), 16.
5. Thierry de Duve, "*Dan Graham et la critique de l'autonomie artistique (Dan Graham and the Critique of Artistic Autonomy)*," in Christine van Assche and Gloria Moure, eds., *Dan Graham*, exh. cat. (Paris: Musée d'art moderne de la ville de Paris, 2001), 49–67.

Dan Graham *Rock My Religion* 1982–1984 videotape (black and white/color, sound); unlimited edition 55:27 minutes T. B. Walker Acquisition Fund, 1999 1999.74

Dan Graham *New Space for Showing Videos* 1995 two-way tempered-mirror glass, clear tempered glass, mahogany 84 x 160 x 213 in. (213.4 x 406.4 x 541 cm) T. B. Walker Acquisition Fund, 2002 2002.216

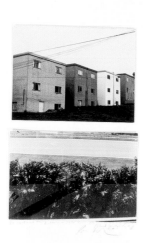

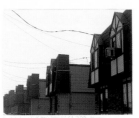

Dan Graham *World War II Housing, Vancouver, B.C. | View from Window of Highway Restaurant, Jersey City, NJ* 1974/1967 chromogenic prints mounted to board 34 5/8 x 24 15/16 in. (88 x 63.4 cm) Justin Smith Purchase Fund, 2002 2002.27

Dan Graham *Living Room in Model Home | Tudor Style Housing Project* 1978 chromogenic prints mounted to board 34 1/2 x 24 15/16 in. (87.6 x 63.3 cm) Justin Smith Purchase Fund, 2002 2002.28

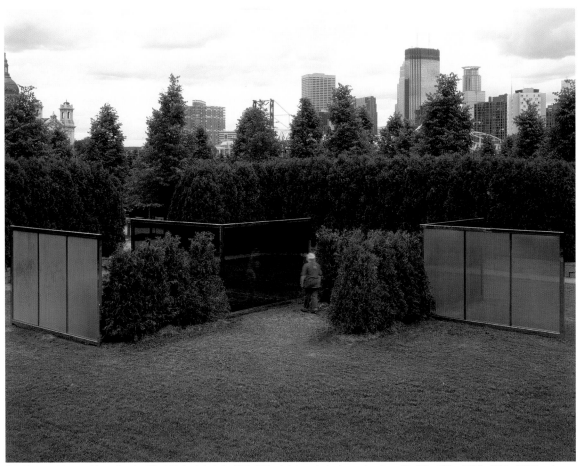

Dan Graham *Two-way Mirror Punched Steel Hedge Labyrinth* 1994–1996 stainless steel, glass, arborvitae 90 x 206 x 508 in. (228.6 x 523.2 x 1290.3 cm)
Gift of Judy and Kenneth Dayton, 1996 1996.133

Dan Graham *Alteration to a Suburban House* 1978/1992 wood, felt, plexiglass 11 x 43 x 48 in. (27.9 x 109.2 x 121.9 cm)
overall installed Justin Smith Purchase Fund, 1993 1993.52

Robert Grosvenor
American, b. 1937

- - **Exhibitions**
14 Sculptors: The Industrial Edge (1969; catalogue)
- - **Holdings**
1 sculpture, 2 drawings, 1 preparatory drawing for work

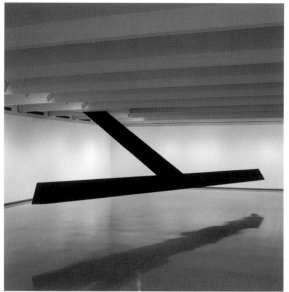

Robert Grosvenor *Untitled* 1967 wood, paint, steel 105 1/2 x 469 1/2 x 207 in. (268 x 1192.5 x 525.8 cm) Gift of M. A. Lipschultz, 1976 1976.14

Andreas Gursky

German, b. 1955

- - **Exhibitions**

Let's Entertain (2000; catalogue, tour), *The Cities Collect* (2000), *Painting at the Edge of the World* (2001; catalogue), *The Squared Circle: Boxing in Contemporary Art* (2003; publication)

- - **Holdings**

1 photograph

Andreas Gursky had trained in commercial photography at the Folkwangschule in Essen, Germany, before being accepted to study under the tutelage of photographers Bernd and Hilla Becher at Düsseldorf's famed Kunstakademie in 1981. The couple preached a "typological" method, exemplified by their own dispassionate photographs of industrial architecture. They shunned photography as a means for snapping fleeting emotions—epitomized by the work of Henri Cartier-Bresson—and instead impressed upon their students a doctrine that operated with a patient anthropological consistency, where deliberate inhibition of the camera's use dictated what was a permissible subject and how to shoot it. Gursky's classmate Thomas Ruff, for example, made a series of identically framed portraits (1984–1989), while recent graduate Thomas Struth had produced straight-down-the-middle-of-the-streetscapes in the late 1970s. And though Gursky also produced such governed series—*Pförtnerbilder* (1981–1985) concentrated on guards in corporate lobbies—the so-called Becher School photographers each wandered away from the strict formula of their masters, albeit indelibly inspired by their teaching. For Gursky, it was the lyrical work of American photographers, particularly Stephen Shore and Joel Sternfeld, and the large backlit transparencies of Canadian Jeff Wall that proved to be the greatest influences.[1] Gursky's mature practice assimilates the powerful presence of Wall's art and the Americans' love of vernacular culture with the Bechers' gaze of blank wonder.

Though their subjects are surprisingly varied—cattle ranch, discount store, glacier, trade fair, golf driving range, electronics factory, port, museum, or humble gray carpet, for example—Gursky's photographs all share a deliciously panoramic point of view that can induce the vertiginous clarity of an IMAX movie experience. Populated with adoring stadium-rock fans, frantic stock-market traders, or après-ski diners, his encyclopedic crowd scenes depict homo sapiens at work and at play in compositions in which Canaletto's paintings meet the *Where's Waldo?* children's books.

The success of Gursky and his Kunstakademie colleagues heralded technical as well as aesthetic innovations, not least in the digital "stitching" of negatives and the sheer size of the photographic prints that this allowed. The artist's career took off in 1989, the year the Berlin wall fell. Buoyed by the effervescent economy of the Cologne art market and the patronage of, at first, chiefly American collectors, he was able to sustain the production of unprecedentedly expensive photographs.[2] With international acclaim came global travel, and as the 1990s unfolded, the locations and events that he recorded often literally reached Olympian proportions (with the Winter Games in *Albertville*, 1992).

The title of *Klitschko*, in the Walker Art Center's collection, acknowledges Wladimir Klitschko, a Ukrainian boxer whose triumphant bout against Axel Schulz in Cologne, which earned him the European Heavyweight crown in 1999, is at the core of the photograph. Though the crowd is concentrated on the ring, the composition also apprehends the vast lighting rigs, scoreboards, and speakers that are suspended above this sporting stage. With the audience illuminated, and the postfight interview relayed onto a giant screen alongside a media broadcast—Gursky grafted in these screenshots digitally—the artist has directed this spectacle as if it were a piece of avant-garde, self-reflexive "theater in the round."

M.A.

Notes

1. Gursky admitted in 1992: "I am in such a tough spot with Jeff Wall. I have made pictures that you would readily take for a Jeff Wall. But these I won't show. I know that I admire him; he is a great model for me. I am trying to get along with that in the most honest way possible and to let the influence run its course." Quoted in Peter Galassi, ed., *Andreas Gursky*, exh. cat. (New York: Museum of Modern Art, 2001), 43.
2. The prints eventually reached the physical limits of the paper roll, at approximately six feet in the smallest dimension.

Andreas Gursky *Klitschko* 1999 chromogenic print; edition 3/6 81 5/16 x 103 x 2 1/4 in. (206.5 x 261.6 x 5.7 cm) framed Partial gift of Charles J. Betlach II, 2000 2000.25

The indistinction between the Brothers Klitschko (it's Wladimir, by the way. Vitali didn't fight in Cologne that year—are we to be boxing scholars now?) is the kernel of the idea, how the individual dissolves in the multitude, how the portrait becomes the landscape; a code key to the brutally ecstatic formalism of the masses zenithing with "May Day IV" (1998) and failing at 2001's "Madonna I," where the icon stands apart from the mass as it on a different reality track; is this a dialectical image designed to tear open history?

Klitschko

"Hanging tableaux" illustrated in the manner of the panoramas. They show landscapes (Bosporus, Italy), mythologies, genre scenes (savages of the South Seas).

Dufour

The interest of the panorama is in seeing the true city—the city indoors. What stands within the windowless house is the true. . . . The windows that look down on it are like loges from which one gazes into its interior, but one cannot see out these windows into anything outside. (What is true has no windows; nowhere does the true look out to the universe.)

Benjamin

Perhaps it's a return to the panorama or the panopticon ("not only does one see everything, but one sees it in all ways."); it recalls this just as it negates the pure use of the photograph for attaching bodies to names, as in Nadar's portrait of Baudelaire, but more decisively, Week to identify unclaimed corpses. But nothing happens in the room of the camera. Isn't it the individual in the photos of sweatshops and trading floors? The ratios, or "Rhine 2" (near shore, water, far shore, sky) echo "View of Delft"—but Art History makes nothing happen, as they say. Such landscapes are now inseparable from those of candy and shoes, apartment supercomplexes and hotel dining rooms: the formalism of global capital, Commune portraits circulated after the Bloody Week that dissolves the bloody heat of money, flat, fat, sterile. Or have I misunderstood?

Gursky

For all the numerous large-scale pictures from the Sistine Chapel to the latest billboard, Veronese's "Wedding at Cana" in the Louvre (1562) is the first time I understood some pictures invent the crowd; to be apprehended as a whole (the at-once in which the camera will specialize); it requires not multiple viewings but many viewers—reduplication of the individual, not in the picture, but in public space. (Worth mentioning? Veronese sometimes painted with his brother Vitali, or Benedetto.)

Viewer

I would rather return to the dioramas, whose brutal and enormous magic has the power to impose on me a useful illusion....These things, because they are false, are infinitely closer to the truth.—Salon of 1859

Baudelaire

Joshua Clover

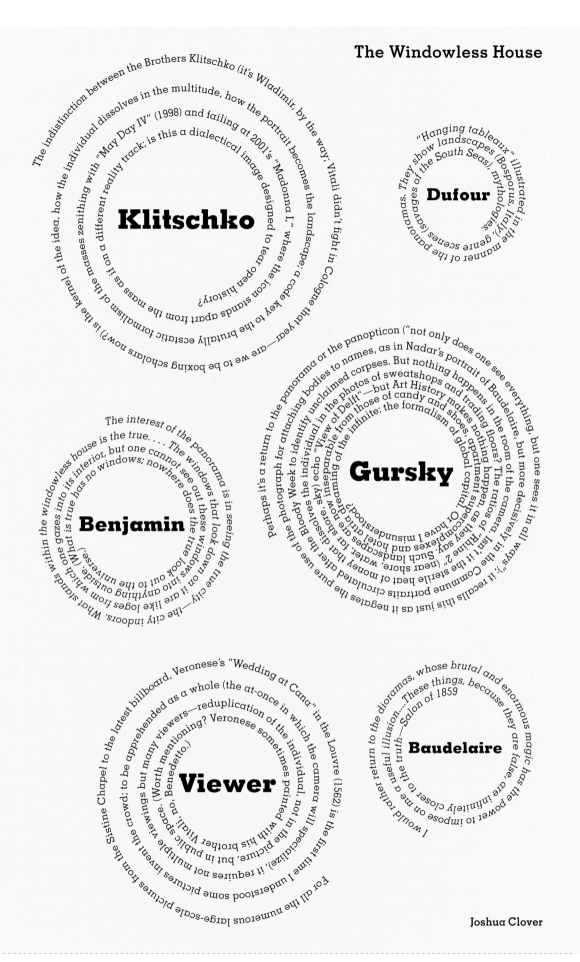

Philip Guston
American, 1913–1980

The distinctive episodes that mark Philip Guston's painting career make it tempting to treat his creative life as the progressive evolution of a style. This hereditary approach, however, ultimately fails to do justice to an artist as complex as Guston. From high-school hijinks with friend Jackson Pollock (both were expelled from Manual Arts High School in Los Angeles for distributing satirical leaflets) to his beginning as a federally sponsored muralist with the Works Progress Administration in the 1930s, the artist who emerged might be better understood as suffering from a chronic, nagging painting itch that required constant scratching.

Large-scale public works with David Alfaro Siqueiros in Mexico, metaphysical compositions influenced by Piero della Francesca and Rembrandt, exquisite tonal tours de force as well as bleakly humorous, incompetent-looking "comic-book" paintings—Guston's fifty-year case history testifies to a diagnosis of vital conflict between abstraction and figuration: what to paint, and how to paint it, compounded with a catatonic, "My God, did I do *that*?"[1] Like a cycle of substance abuse that alternates between cold-turkey abstinence and falling-off-the-wagon binges, his addiction to the application of paint to canvas was marked by years of complete temperance, spectacular introversion, and persistent aesthetic restlessness. Painting was both a symptom and a self-medication.[2]

The Walker Art Center's two major Guston works fall on either side of 1970, the year in which the artist first exhibited a group of canvases that demonstrated how he had found a completely novel way to manage his painting affliction. If for the past twenty years he had been pursuing a highly acclaimed abstract program with an almost homeopathic subtlety, his new narrative paintings were dramatically risky and invasive procedures. With all the unorthodox faith and some of the logic of cranial trephination, his insistence that he "wanted to tell stories" resulted in the release of a torrent of wonderfully undignified and seemingly flat-footed, cartoonlike canvases.[3] He admitted that "when the 1960s came along, I was feeling split, schizophrenic. The [Vietnam] war, what was happening in America, the brutality of the world. What kind of man am I, sitting at home, reading magazines . . . and then going into my studio *to adjust a red to a blue*? I thought there must be some way I could do something about it. . . . I wanted to be whole between what I thought and what I felt."[4]

Guston's polluted, congested, suggestively figurative, and teasingly titled "dark paintings" of the early 1960s—of which *Winter* is exemplary—were replaced with a freshly biographical and topical lexicon. Feeling that the artist had dishonored his mastery of abstraction in favor of a bastardized Pop Art, however, most supporters (including his own dealer at the time) were appalled at the new work, with one disingenuously grumbling that Guston was "a mandarin pretending to be a stumblebum."[5] The suicide by hanging of the artist's father during his childhood; the mendacity of the Nixon administration; the racial friction, violence, cynicism, and stale malevolence lurking in everyday American society all spewed into these compositions. At first, the canvases were peopled by "hoods"— Guston-surrogates with clownishly anachronistic Ku Klux Klan–like outfits. The hoods drove around town in cars with their conspirators, pointed accusatory fingers at each other, painted lame paintings, and puffed on cigarettes.

Bombay (1976) is like a cantankerous Color Field painting, as if the artist were doodling on the works of his onetime Abstract Expressionist peers. Mark Rothko's quasi-spiritual blurs become what we might imagine as a dirt "field" and a cloudy "sky," and the gray band along the lower edge lazily casts the "zips" of Barnett Newman as a wall or a road. What look like hobnailed boots, nail-studded shoe soles, or horseshoes often appear in Guston's work of this period, in conjunction with spindly, hairy leg stumps. Here these motifs occupy the middle ground, bunched together like a cluster of tombstones. The twinned forms at the bottom of the composition are either gazing upward, if we read them as disembodied, roving evil eyeballs; or standing side-by-side, if we see them as headless torsos staidly posed, tourist-photo style, in front of a panoramic landscape.

Cobbling together a shamed, antiheroic prospect for painting from the detritus of the post-Watergate, post-Vietnam social order, Guston's figurative "bad painting" interlude—like Francis Picabia's "pinup" paintings of the 1940s—is a crucial maneuver in the legacy of twentieth-century painting. The sensibilities of dysfunction, bitter irony, and apparent recklessness that Guston birthed would be regurgitated in fresh forms by a new strain of New York art that emerged in the 1980s.

M.A.

Notes
1. "Philip Guston Talking," transcript of a lecture given at the University of Minnesota, Minneapolis, March 1978, in Renée McKee, ed., *Philip Guston Paintings 1969–1980*, exh. cat. (London: Whitechapel Art Gallery, 1982), 55.
2. *Bad Habits* is the title of a Guston painting from 1970.
3. "I got sick and tired of all that Purity! [I] wanted to tell stories." Quoted in Bill Berkson, "The New Gustons," *Artnews* 69, no. 6 (October 1970): 44.
4. Quoted in Musa Mayer, *Night Studio: A Memoir of Philip Guston* (London: Thames & Hudson, 1991), 171.
5. Hilton Kramer, "A Mandarin Pretending to Be a Stumblebum," *New York Times*, October 25, 1970, sec. B, 27.

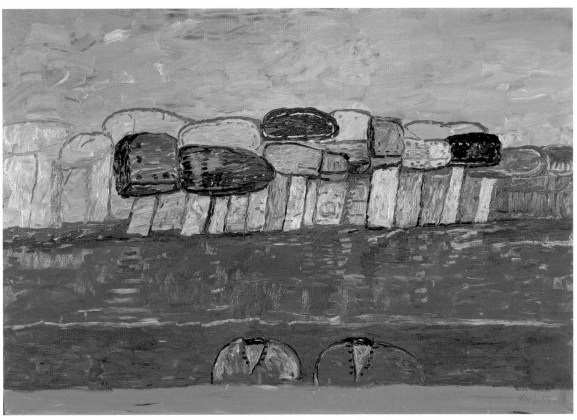

Philip Guston *Bombay* 1976 oil on canvas 78 x 114 1/2 in. (198.1 x 290.8 cm) Bequest of Musa Guston, 1992 1992.172

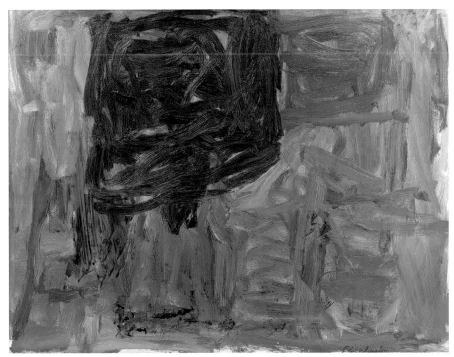

Philip Guston *Winter* 1961 oil on paper 30 1/8 x 40 1/16 in. (76.5 x 101.8 cm) Gift of the T. B. Walker Foundation, Longview Foundation, 1964 1964.11

Joanna Haigood

American, b. 1957

- - **Commissions**
CHOMU (butterfly dreams) (1993), Picture Powderhorn (2000)
- - **Performances**
CHOMU (butterfly dreams) (1993; world premiere), Picture
Powderhorn (2000; world premiere)
- - **Residencies**
Joanna Haigood (1993), Joanna Haigood/Zaccho Dance Theatre
(1998–2000)

A passion for flight—physical in form and metaphysical in notion—forged with a deeply inquisitive interest in the "memory of spaces" has propelled choreographer Joanna Haigood to astonishing artistic heights. As founder and artistic director of Zaccho Dance Theatre, she and the San Francisco–based company locate natural, architectural, and culturally rich environments in which to weave narrative exploration and movement. Haigood's works bring to light the history and character of their sites, integrating feats of courage and artistic conviction through aerial flight and suspension. Compelling new approaches to movement in aerial work as in *Clock Tower* (1996) and historically resonant immersion pieces such as *Invisible Wings* (1995) have garnered Haigood national recognition as a prime mover in site-specific work.

The Walker Art Center's relationship with Haigood began with the commission of *CHOMU (butterfly dreams)*, presented in the Minneapolis Sculpture Garden in July 1993. Haigood and visual artist Reiko Goto created a seven-station walk-through performance installation that brought into relief metaphors of urban life and nature as imagined through the seemingly invisible life cycles of butterflies.

The Walker commissioned *Picture Powderhorn* in 1998. The artist's goals were lofty: to realize a complicated technical production that had the potential to achieve cultural transformation through deep community involvement, while poetically reenvisioning the daily realities of inner-city life. The iconic catalyst and central metaphor was the massive yet often-overlooked architecture of grain elevators. For two years, Haigood and Walker staff members researched sites in the area. "I define place not only as it refers to location and physical structures, but as an expression of accumulated experiences and social responses," says Haigood. "I am interested in how we affix meaning to place."[1] In August 2000, she transformed the massive ConAgra grain silos in Southeast Minneapolis into an enormous performance stage. Suspended by specially designed rigging and harnesses, Zaccho's aerialists performed at dusk, swinging and soaring off the surface of 120-foot-high concrete silos and interacting within the immense projections of video artist Mary Ellen Strom.

Picture Powderhorn was the culmination of Haigood's two-year residency, during which she worked with a group of teens over the course of three months to explore and document the Powderhorn Park neighborhood in Minneapolis. The young people captured stories, sights, and sounds of the area, providing choreographic inspiration for Haigood and audiovisual reference points for Strom and composer Lauren Weinger. With grand images of flowing wheat fields and inner-city streets juxtaposed with the sounds of trains and laughing children, these dramatically symbolic performances stood as a potent metaphor for the confluence of art and sustenance tethered in urban dreams and rural goals. In the end, *Picture Powderhorn* was a death-defying and life-affirming celebration of a vital Minneapolis community.

D.B.

Notes
1. Quoted in "The Art of Observation: Teens Picture Powderhorn with Artist-in-Residence Joanna Haigood," Walker Art Center calendar (July/August 2000), 9.

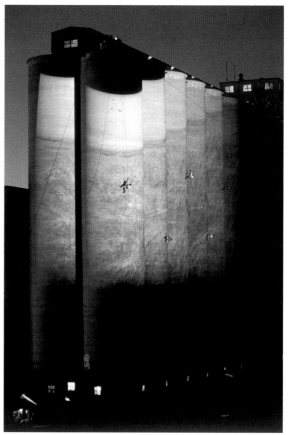

Joanna Haigood/Zaccho Dance Theatre *Picture Powderhorn* ConAgra Marquette Grain Terminals, Minneapolis, 2000

Ann Hamilton

American, b. 1956

-- **Commissions**
Untitled installation with David Ireland (1992)
-- **Performances**
Ann Hamilton/Meg Stuart/Damaged Goods, *Appetite* (1998),
Ann Hamilton/Meredith Monk, *mercy* (2002)
-- **Exhibitions**
Ann Hamilton/David Ireland (1992; publication), *The Cities Collect* (2000)
-- **Residencies**
Ann Hamilton/David Ireland (1992), Ann Hamilton/Meredith Monk (2002)
-- **Holdings**
1 multimedia work, 8 photographs, 2 edition prints/proofs, 1 book

Ann Hamilton *Untitled (mouth/stones)* 1993 laser disc (color-toned image, sound), LCD screen; edition 2/9 30 minutes T. B. Walker Acquisition Fund, 1995 1995.25

David Hammons
American, b. 1943

- - **Exhibitions**
Viewpoints—Malcolm X: Man, Ideal, Icon (1992; catalogue, tour)
- - **Holdings**
1 sculpture, 1 video, 1 book

"Catch me if you can" seems to be what is on David Hammons' mind as he walks the streets of Manhattan. Who—or what—is he trying to elude? As an artist who feeds his work with a philosophy inherited from the political activism of black nationalism, Hammons has worked to resist and challenge the dominant culture and its vision of centrality. He attempts to escape the constraining cast of art history as it has been written by a Eurocentric and white tradition, a tradition that carries the weight of a history based on exclusion and domination. The white cubes of galleries and institutions are the sites in which this history is played out. There, according to Hammons, the light is on but no one is home.

He seeks an alternative that would counter and subvert the mainstream culture's notion of an avant-garde where "art is dangerous only one-tenth of a second."[1] In terms of aesthetic strategies, he has often been compared to Marcel Duchamp and the Arte Povera movement. If true at first glance, these associations nevertheless seem contradictory to Hammons' artistic aim of identifying alternative critical and theoretical tools. He leans against the wall of art history, but he also has his back against it, as if about to be shot. *The Holy Bible: Old Testament* (2002) demonstrates such a critical relationship with a dogma he considers overrated and decrepit. A sculpture in the form of a publication, the work is an appropriation of Arturo Schwartz's book *The Complete Works of Marcel Duchamp*, rebound in leather with gilt edges and embossed with gold to mimic and debunk both Duchamp and the Old Testament with their respective cultural and ideological baggage.

From a specific point of view—that of African American culture—Hammons absorbs and critically recycles notions of racism, primitivism, postcolonialism, and exoticism, using them to undermine stereotypical representations. His aesthetic is fed by the rubbish, the castoffs, of the urban wasteland in which he strives to reassess the subversive potential of art. The sculpture *Flight Fantasy* (1978) encompasses many elements central to Hammons' oeuvre. The mobile is part of a series of sculptures completed between 1978 and 1980 that are dominated by allusions to flying, being high, the bird kingdom, even jazz artist Charlie "Bird" Parker. *Flight Fantasy* is made from bamboo dowels, feathers, African American hair, and shards of 45rpm records. Half bird, half African sculpture or fetish icon, it pinpoints a stereotype often at play in the artist's work: the jazz musician as the epitome of the black artist, just as sport (mainly boxing and basketball) is a derogative cliché of black social promotion. Hammons' use of human hair is recurrent, serving to critique the status of the black body in American culture as well as the fetishism

of its representation. Cut and collected hair, from Samson to voodoo magic, can convey a sense of empowerment or enfeeblement, and its appearance in Hammons' works urges the viewer to decipher the presence, or the absence, of "the souls of black folks."[2]

The video *Phat Free* (1995/1999) plays ambiguously on the jazz stereotype by opening on a black frame with a drumming sound track similar to a free jazz improvisation. As the image appears on the screen, it becomes clear that the sound is actually a bucket being kicked through the nighttime streets of Manhattan by the artist. The title, typical of Hammons' play with words, refers both to hip-hop slang and to the American obsession with weight. The mundane action is representative of Hammons' other street "performances." Often inconsequential and decidedly un-phat, his street activities—whether urinating on a Richard Serra sculpture and throwing sneakers at it or selling snowballs on the sidewalk[3]—remain facetious and ludicrous, calling attention to the artist's status both as an outcast and as a jester for whom "play" is a critical and emancipating way to be part of the world.[4] The piece also stresses the philosophical economy of his work: doing something with nothing. A mesmerizing film, *Phat Free* kicks us around while Hammons reminds us, with a laugh, what "kicking the bucket" really means.

Over the years, Hammons has developed a critical discourse and aesthetic based on observation and appropriation of street culture. Through street-smart strategies, he reimagines the relationship between the arts and audiences and reinvents a way to give visibility to peripheral cultural practices. As the Brazilian artist Hélio Oiticica once said, "The museum is the world: daily experience."[5]

P.V.

Notes

1. Hammons, conversation with the author, New York, winter 2004 (Walker Art Center Archives).
2. *The Souls of Black Folks* is the title of W. E. B. Du Bois' 1903 book, which has come to be an important milestone in the history of black nationalism.
3. In 1981, Hammons urinated on Richard Serra's *TWU* (1980), a monumental steel sculpture that was located on a street corner in downtown Manhattan, and threw twenty-five pairs of tied-together sneakers on top of it. His infamous performative work *Bliz-aard Ball Sale* took place in 1983.
4. In this, Hammons seems to embody Eugen Fink's philosophy of play as a symbol of the world. See Eugen Fink, *Spiel als Weltsymbol* (Stuttgart: Kohlhammer, 1960).
5. Hélio Oiticica, "Position and Program," in Guy Brett, ed., *Hélio Oiticica*, exh. cat. (Rotterdam: Witte de With Center for Contemporary Art; Minneapolis: Walker Art Center, 1992), 104.

David Hammons *Flight Fantasy* 1978 phonograph record fragments, hair, clay, plaster, feathers, bamboo, colored string 38 x 56 in. (96.5 x 142.2 cm)
T. B. Walker Acquisition Fund, 1995 1995.24

David Hammons *Phat Free* 1995/1999 videotape transferred to DVD (color, sound), paper, paperboard box; edition 6/25 6:25 minutes Digital video
production by Alex Harsley T. B. Walker Acquisition Fund, 2001 2001.25

Go Figure: The Art of David Hammons

David Hammons is a trickster. He's fashioned and manufactured that image since arriving in the Big Apple. His emergence happened when abstract art was moving into the background and Pop Art was in its ascendancy. Installation, video, and conceptual art had yet to make themselves manifest. Mr. Hammons' strategy was to claim a niche for himself and his art. Like musician Miles Davis and poet Amiri Baraka before him, he figured the easiest way to make himself known through his art was, and still is, to maintain a low profile and be as inconspicuous and invisible as possible. He hardly ever appears at his own openings.

Mr. Hammons is a walker—a walker in the city. His studios are located in Harlem, but he himself resides in Brooklyn—with a view of the isle of Manhattan where he can imagine its tunnels. Oh sure, he can be spotted from time to time, from the late afternoon to the wee small hours of the morning, perambulating casually through the city—uptown to downtown, peeping into store windows, browsing in and around art galleries and bookstores, and spending a lot of time probing flea markets. With a paper bag full of peanuts, tossing shells on the ground, Mr. Hammons is in constant search of "stuff" that is different. He might be what you would call one who celebrates "odd lots." How well I remember the day he walked into my gallery, A Gathering of the Tribes, with a two-foot statue of Louis Armstrong, with a two-foot smirk on his own face and on the statue as well, smiling from ear to ear. Why, he had discovered it in the corner of a flea market, hidden under several layers of newsprint.

He also believes in making himself scarce. Of his many adventures into the art world, the two that captured my imagination the most are as follows. He invited a group of art curators, many from Africa, to visit his museum-gallery in Spanish Harlem. He left the curators in a state of shock, at a loss for words—the space was drenched in darkness without a sliver of light to be found anywhere. He labeled their visit a performance piece. Of course, the next time he was offered a block-long gallery warehouse at the Ace Gallery. To the utter surprise of the New York art world, again he left the place in total darkness and named the exhibition *Concerto in Black and Blue* (2002).

When Mr. Hammons was invited in 2000 by the Museo Reina Maria Sofia to put together a show at the Crystal Palace in Madrid, he had no idea what he was going to do. But once he missed his plane in Poland, or was it Hungary, the idea hit him like a flash of lightning. He had to send a wire to Madrid to let them know that he would be arriving late. That in itself became his work of art, his performance piece. I received a call the following day from David. He instructed me to gather as many artists and poets as I could find and have them meet at Tribes on a certain day, and to make sure that they brought their art and poetry with them.

It was havoc that day at Tribes. Artists and poets were lined up from the tiny office, through the gallery, into the living room, out the back room, down the stairs onto the stoop, and up and down the block—awaiting the time to send their images and poems by fax to the Crystal Palace in Madrid, where three fax machines had been hoisted up to the ceiling of the building so that the faxed pages could descend from around the world like messages from the heavens. The conductor-composer Lawrence D. "Butch" Morris had been hired to perform on opening night. The music, which had been looped, was as eerie as the faxes descending from the sky. Outside the Crystal Palace, thunder and lightning showered a downpour upon the surrounding space. It created a beauty that has yet to be surpassed.

Where was Mr. Hammons? Why, he was on several telephones and computers, calling, e-mailing, and generally directing his friends from around the world to continue with their faxing. This went on for a matter of months. At the show's end, more than ten thousand faxes lay on the Crystal Palace floor. It took more than a week to edit them down to three hundred. These were boxed and packaged with a CD of the event, and shipped off to museums and collections around the world.

And there goes David Hammons—the trickster, the shaman, putting one over on the art world again. Go figure.

Steve Cannon

Marsden Hartley

American, 1877–1943

Although he radically modified his idiosyncratic style many times—often in response to the latest trends in European modernism—Marsden Hartley's oeuvre is distinctively his own: a blend of homegrown American transcendentalism, formal inventiveness, and deeply felt emotional response to the visible world. According to his biographers,[1] his life was defined by conflicting needs for both solitude and human companionship, which kept him in constant, restless motion (as an adult he never remained in any one lodging for longer than ten months) and complicated his personal relationships. But it also made for an astonishing range of experiences: he lived in more than two dozen cities on two continents; he was associated with the Munich-based Blaue Reiter (Blue Rider), New York Dada's Societé Anonyme, Gertrude Stein's Paris salon, and Alfred Stieglitz's galleries 291 and An American Place. His stylistic influences included, to varying degrees, Paul Cézanne, Henri Matisse, Wassily Kandinsky, Pablo Picasso, Albert Pinkham Ryder, and Charles Demuth. Yet somehow (perhaps in spite of himself) there is an unmistakable Hartleyesque flavor to all his work, whether landscape, still life, or portraiture.

An obvious talent at a young age, Hartley attended art schools in Cleveland and New York on a series of scholarships and grants. His youthful enthusiasms were mystical and spiritual in nature: he was entranced by the writings of Ralph Waldo Emerson; briefly considered becoming a priest; and spent the summer of 1907 at Green Acre, a utopian community in Maine where he was introduced to Eastern religions. During these years he concentrated on rendering the fleeting moods of nature, especially mountains (to him, they were "entities of a grandiose character" with "profound loneliness") and skies ("it is in reality the sky that makes a scene vivid"[2]). One of the earliest known Hartley works, *Storm Clouds, Maine* (1906–1907), is a dramatic duet between the two and also a portrait of Speckled Mountain in the town of Lovell, Maine.[3]

In 1909, Hartley had his first solo exhibition at 291, New York's most progressive gallery. It was run by Alfred Stieglitz, who became an important mentor and financial supporter during Hartley's life of almost continuous poverty. With Stieglitz's help, the artist made his first trip to Europe in 1912. He felt instantly at home there and for the next two decades shuttled between continents as world events and his finances allowed. During those turbulent years, his aesthetic approach vacillated between the formal and the expressionistic, though all of his works—from semi-abstractions to quotidian still lifes—sound a slightly mad, subterranean note of excitement that keeps rigor at arm's length. Among his most powerful paintings are the mystical studies of military parades, insignia, and uniforms made in Berlin during World War I, where Hartley was living "rather gayly in the Berlin fashion—with all that implies . . ."[4] Some of his most radical forays into nonobjectivity were the *Movements*, based on forms of sailboats, that he painted in 1916 while summering in Provincetown, Massachusetts, with radical journalist John Reed. More sober were the still life and landscape studies made in southern France during the 1920s, while he was firmly under the spell of Cézanne.

Hartley returned permanently to the United States in 1934. He was fifty-seven years old, destitute, and still without the critical success he felt he deserved. The defining experience for the last decade of his life was his friendship with the Mason family, with whom he boarded during 1935 and 1936 in a remote Nova Scotia fishing community. The Masons welcomed him warmly as one of their own, and he basked in their close family life and their "enviable balance between the material and the spiritual worlds."[5] After the two Mason boys, Donny and Alty, were drowned in a storm in 1936, Hartley was heartbroken, especially at the loss of twenty-eight-year-old Alty, to whom he was especially close. His many tributes to the family include powerful, idealized portraits such as *Cleophas, Master of the "Gilda Grey"* (1938–1939), Hartley's representation of Francis Mason, the family patriarch, whom he described as "so dark and rugged he is & the boys also. All of them look like cinnamon bears, & are terrifying powerful, & so quiet & childlike."[6] In his brutish paw Cleophas gently holds a rose, a flower Hartley associated with all the Mason men but especially Alty, who often wore one behind his ear. Hartley's last memorial to the family was on his easel when he died in 1943—the tender, sensual, transcendent bouquet entitled *Roses*.

The Walker Art Center has an extraordinary collection of Hartley's works because of the artist's connection to Hudson D. Walker, grandson of the institution's founder, T. B. Walker. Hudson ran an art gallery in New York from 1937 to 1941, and became Hartley's dealer after Stieglitz had finally grown tired of the artist's demanding personality. Hudson vigorously promoted the work, even organizing a traveling exhibition that was presented at the Walker in 1940.[7] Most of the ten Hartley paintings in the collection were gifts from Hudson or his immediate family.

J.R.

Notes

1. A standard work is Barbara Haskell's *Marsden Hartley*, exh. cat. (New York: Whitney Museum of American Art, 1980).

2. Quoted in ibid., 17.

3. Elizabeth Mankin Kornhauser, *Marsden Hartley*, exh. cat. (New Haven and London: Yale University Press, 2003), 288.

4. Hartley in a letter to Alfred Stieglitz, March 15, 1915, quoted in Haskell, *Marsden Hartley*, 31.

5. Hartley in a letter to Adelaide Kuntz, September 9, 1936, printed in Gerald Ferguson, ed., *Marsden Hartley and Nova Scotia*, exh. cat. (Halifax, Nova Scotia: Mount Saint Vincent University Art Gallery, 1987), 45.

6. Hartley, letter to Adelaide Kuntz, November 4, 1935, printed in ibid., 41. Francis was the model for the protagonist of Hartley's story "Cleophas and His Own: A North Atlantic Tragedy." The artist finished this tale of Canadian fisherfolk in late 1936, after the drowning of Donny and Alty, and used the fictitious names for his series of memorial portraits. "Gilda Grey" was the name of the Mason family boat. Hartley's story is published in full in Ferguson, *Marsden Hartley and Nova Scotia*.

7. The exhibition *Marsden Hartley* opened in Boston in late 1939 and traveled to Baton Rouge, Louisiana; San Antonio, Texas; Portland, Maine; San Francisco, California; Lincoln, Nebraska; and the Walker, before ending its tour in early 1940 at the St. Paul Art Gallery.

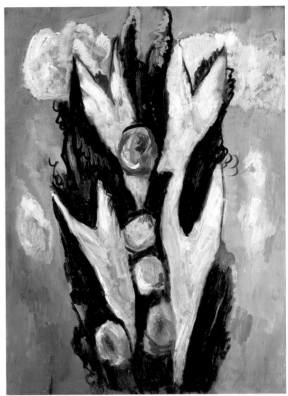

Marsden Hartley *Roses* 1943 oil on canvas 40 1/8 x 30 1/8 in. (101.9 x 76.5 cm) Gift of Ione and Hudson D. Walker, 1971 1971.47

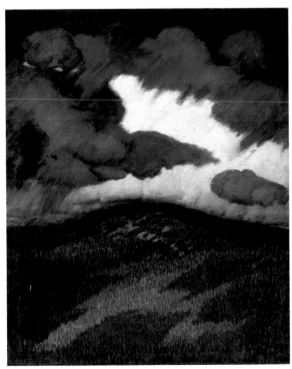

Marsden Hartley *Storm Clouds, Maine* 1906–1907 oil on canvas 30 x 25 in. (76.2 x 63.5 cm) Gift of the T. B. Walker Foundation, Hudson Walker Collection, 1954 1954.8

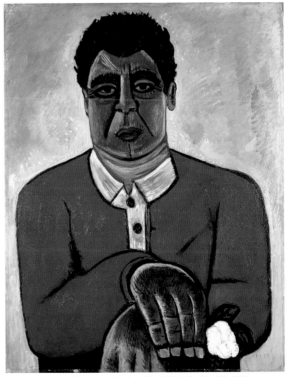

Marsden Hartley *Cleophas, Master of the "Gilda Grey"* 1938–1939 oil on board 27 3/4 x 21 3/4 in. (70.5 x 55.3 cm) Gift of Bertha H. Walker, 1971 1971.44

Kay Hassan

South African, b. 1956

- - **Exhibitions**
no place (like home) (1997; catalogue, tour)
- - **Holdings**
1 unique work on paper

Kay Hassan uses his work to explore the charged quo-
tidian aspects of black life in South Africa. Miners,
clubgoers, workers, and market women populate his
photographs, installations, and paper-based works.
His art is marked by an exuberant energy and high
color, haunted by images of dislocation and disposses-
sion. But there is hope and perseverance, too. This
potent mix of themes and methods is inspired by
Hassan's childhood in the townships of Alexandra and
Soweto. As a child, he witnessed the seemingly con-
stant flight of black South Africans as apartheid poli-
cies forcibly took their land.

In early installations such as *Flight 1* (1995), Hassan
creates an environment evocative of forced migrations,
with bundles of wrapped clothes, dangling cooking
pots, and bicycles loaded down with water jugs and
sleeping mats. This installation also includes what the
artist calls a "construction"—a mural-size work made
from ripped-up billboard posters—depicting towns-
people on the run. He was inspired to adopt this collage
technique of deconstructing and reconstructing ever-
ubiquitous consumer advertisements when he lived
in Paris and watched people tear posters off subway
walls as souvenirs. He is interested in the wonder that
viewers of his work feel once they realize they are not
looking at a painting, but at a work made entirely of
discarded paper. Their sense of surprise can pull them
deeper into the work and into the worlds Hassan cre-
ates there.

Urban Cocktail (1997), from the Walker Art Center's
collection, portrays the animated patrons of a township
shebeen, an unlicensed gathering spot for music, danc-
ing, socializing, and drinking bootleg beer. Hassan's
mother ran such an establishment, so he is familiar
with its community role: "It's very educational, the she-
been. It's eye-opening in that you listen to all kinds of
conversations going on there—political conversations,
day-to-day incidents, what's happening in town, prob-
lems with the white man. You even found stolen goods
in the shebeens."[1] The dynamic scene in *Urban
Cocktail*, which is almost 8-by-33 feet wide, moves from
tan and bright ochre to dense browns and blacks, per-
haps suggesting a shift from interior to exterior or day
to night. As in other Hassan works, many of the figures
wear highly patterned garments—with bits of text
and logos reminding us of their source material—
reminiscent of traditional African fabrics. The subjects'
fractured and jutting faces are intriguingly masklike,
recalling the confluence of Cubist faceting and African
art forms. Yet even such a specific scene still reads
clearly across geographic and demographic lines.
Hassan links our humanity to theirs, their joys and trib-
ulations to ours. Common ground. Common cause.
Common being.

O.I.

Notes

1. "Kay Hassan Interviewed by Susan Robeson," in Richard Flood,
ed., *no place (like home)*, exh. cat. (Minneapolis: Walker Art Center,
1997), 58.

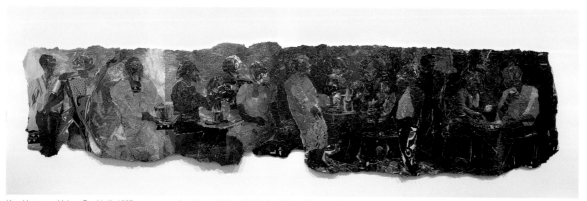

Kay Hassan *Urban Cocktail* 1997 paper construction 94 1/2 x 394 1/2 in. (240 x 1002 cm) Gift of JoAnn and Gary Fink, 2002 2002.313

Hock E AyeVi Edgar Heap of Birds

American, b. 1954

-- **Commissions**
Building Minnesota (1990)
-- **Exhibitions**
Claim Your Color: Hachivi Edgar Heap of Birds (1990; organized
by Exit Art, New York; publication)
-- **Residencies**
1990
-- **Holdings**
3 sculptures, 1 edition print/proof

Hock E Aye Vi (formerly spelled Hachivi) Edgar Heap
of Birds has built a wide-ranging, multidisciplinary
career that supports his commitment to full artistic
engagement in both public and private spheres. His
output is seamlessly linked to his life experiences: an
ongoing series of abstract acrylic paintings, for exam-
ple, is based on the natural canyon forms in his native
Oklahoma, and his diaristic drawings use language
to record memories, emotions, and encounters. His
declarative public sculptures explore the history and
culture of Native Americans, including that of the
Cheyenne and Arapaho nations on whose tribal lands
he has lived. Finally, the artist's extensive travels and
many residencies have resulted in collaborative,
community-based curatorial and educational projects
that look at the human condition through the lens of
regional politics, history, and geography.

In 1990, the Walker Art Center commissioned Heap
of Birds to make a public piece in conjunction with its
presentation of *Claim Your Color*, a traveling survey of
his work. The artist's research led him to a signal event
in state history: the U.S.–Dakota Conflict, fought over a
six-week period along the banks of the Minnesota River
in the late summer of 1862. The chronicle of the conflict
is an all-too-familiar one in American history: begin-
ning with white settlements that encroached on native
lands, it also features forced relocation, broken treaties,
treachery, brutality, racism, and greed. It concluded
with the largest mass execution in U.S. history: thirty-
eight Dakota men were hanged in late 1862, and two
others in 1865.[1] The cultural and intertribal wounds
from these events remain raw.

Heap of Birds' *Building Minnesota* (1990), installed
along a grassy stretch of parkland on the banks of the
Mississippi River, was essentially a memorial to those
executed after the conflict. It consisted of a sweeping
arc of forty signs bearing the names of the executed
men—given in both the original Dakota and an English
translation—along with his date and place of death
and a command to the viewer to "HONOR."[2] The signs
themselves are screenprinted aluminum panels bolted
on green metal posts, a format that purposely mimics
that of generic road signage and suggests that their
messages are informational, cautionary, or both.

Building Minnesota was placed near the site of one
of the earliest white settlements in the state, where the
rush of St. Anthony Falls was long ago redirected by
a lock and dam and the riverbank bristles with power
lines, grain elevators, and high-rises. The river itself
is still a busy thoroughfare for barge traffic and an
important source of power and water for the surround-
ing area. Heap of Birds' work thus links the events of
1862 with the commercial interests and economics that
likely fueled them, as well as with a reverence for the
land and its resources that is traditional in native cul-
tures. As he has written, "The forty signs are offered
along the water called the Mississippi, which remains
a highway for American business . . . we seek to honor
the life-giving force of the waters that have truly pre-
served all of us from the beginning, and to offer respect
to the tortured spirits of 1862 and 1865 that may have
sought refuge and renewal through the original purity
that is water."[3]

J.R.

Notes
1. The fighting, which claimed the lives of more than five hundred
people on both sides, only ended when the Dakota were overpowered
by an army of one thousand men led by Colonel Henry H. Sibley. A
military tribunal condemned 3,030 Dakota men to death by hanging.
All but forty had their sentences commuted by President Abraham
Lincoln; of those, thirty-eight were executed on December 26, 1862,
in Mankato, and two others (who were captured later) were hanged at
Fort Snelling in November 1865.
2. *Building Minnesota* was installed on West River Parkway in
Minneapolis from March 10, 1990, through late summer 1991.
3. Hachivi Edgar Heap of Birds, *Building Minnesota*, exh. pub.
(Minneapolis: Walker Art Center, 1990), unpaginated.

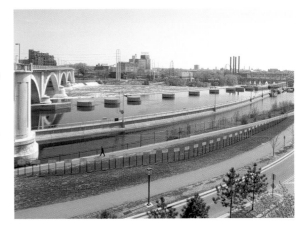

HONOR
Shakopee
Little Six

DEATH
BY
HANGING

NOV. 11, 1865, FORT SNELLING, MN. - EXECUTION ORDER ISSUED BY
PRESIDENT OF THE UNITED STATES — **ANDREW JOHNSON**

Hock E Aye Vi Edgar Heap of Birds *Shakopee (Little Six)* 1990 enamel on
aluminum 18 x 36 1/4 x 1/16 in. (45.7 x 92.1 x 0.2 cm) Acquired in conjunction
with the exhibition *Claim Your Color: Hachivi Edgar Heap of Birds* (1990), 1993
1993.132 ©1990 Hock E Aye Vi Edgar Heap of Birds top: Installation view of
Building Minnesota, Minneapolis, 1990

Barbara Hepworth
British, 1903–1975

- - **Exhibitions**
Barbara Hepworth: Carvings and Drawings 1937–1954 (1955; organized by the Martha Jackson Gallery, New York; catalogue), *First Annual Collectors Club Exhibition* (1957; catalogue), *The John and Dorothy Rood Collection* (1960; catalogue), *John Rogers Shuman Collection* (1960)
- - **Holdings**
2 sculptures

In 1931, a young Barbara Hepworth bored a hole in the center of a small, smoothly rounded, craggy mass of alabaster. Titled *Pierced Form* and now lost, the sculpture marked an important breakthrough for the artist, ushering her focus away from her earlier body of largely figurative works toward one concerned with an exploration of pure forms. It also presaged the classic Hepworth style—masterfully carved abstract sculptures whose potent perforations, occasionally accentuated with coloring or threading, create a dynamic impression of stasis and movement in balance.

Hepworth was born in Yorkshire in northern England and studied at the Leeds School of Art and the Royal College of Art in London. She traveled to Italy in the late 1920s, and through the 1930s found herself in close contact with influential artists of the period.[1] While the web of her acquaintances was wide, her closest relationships were with Ben Nicholson and Henry Moore, two of the most renowned British modernists of the time. Hepworth and Moore, who was a few years her senior, a fellow northerner, and a schoolmate, advocated direct carving, believing it to be the most effective way to bring out truth in a material. In their conjoined artistic conviction and practice, the two were natural inheritors of the tradition of British modern sculpture, the foundation of which was laid in the early twentieth century by such artists as Henri Gaudier-Breszka and especially Jacob Epstein. With Nicholson, Hepworth shared a marriage, three children, and artistic maturation and dialogue. They moved to St. Ives, Cornwall, in southern England in 1939, and Hepworth lived and worked there until her death in 1975.[2]

The two works by Hepworth in the Walker Art Center's collection were both produced in this later period. *Figure: Churinga* (1952) and *Curved form with inner form (Anima)* (1959) seem at first glance as distinct from each other as they can be—a vertically elongated, sinuous carving in Spanish mahogany versus a squat, rotund bronze cast. However, both similarly suggest a certain structural rigidity within organic fluidity, the negative space of punctuation in each alluding to, say, bones of a body or a womb pregnant with a fetal form. The last allusion is made even more likely by the subtitles Hepworth gave to the works. Sigmund Freud writes in *Totem and Taboo* about the Aruntas, an Australian aboriginal tribe, who believe that a birth takes place after the spirit of a dead ancestor, waiting in the physical location of a particular totem, impregnates a woman when she passes the spot.[3] *Churinga* is the name of the stone amulet found in such a totem. And

"anima," one of Carl Jung's famous archetypes, connotes the feminine nature harbored inside the male psyche. These particular notions of maternity and the unconscious capture Hepworth's understanding of exterior and interior as both transparent and opaque, and complexly interrelated one with the other. "There is an inside and an outside to every form," said Hepworth.[4] That statement, which sounds so simple and direct, turns out to be far from obvious, just like her sculpture.

D.C.

Notes
1. Hepworth met Pablo Picasso, Georges Braque, and Constantin Brancusi on her trips to Paris in the 1930s. Naum Gabo and Piet Mondrian, whom she also met in Paris, relocated to London by the end of the decade and joined the group that included Hepworth, Ben Nicholson, architect Walter Gropius, and critics Herbert Read and Adrian Stokes.
2. In her book *Barbara Hepworth: A Pictorial Autobiography* (New York: Praeger Publishers, 1970), the sculptor calls this period "Years with Ben Nicholson."
3. Sigmund Freud, *Totem and Taboo: Resemblances between the Psychic Lives of Savages and Neurotics* (1913), trans. A. Brill (London: George Routledge and Sons, 1919), 190.
4. Herbert Read, *Barbara Hepworth: Carvings and Drawings*, exh. cat. (Minneapolis: Walker Art Center, 1955), unpaginated.

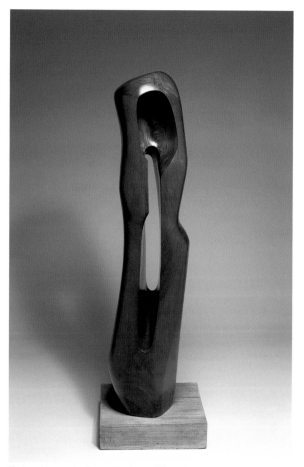

Barbara Hepworth *Figure: Churinga* 1952 mahogany 52 1/2 x 16 x 15 1/2 in. (133.4 x 40.6 x 39.4 cm) Gift of the T. B. Walker Foundation, 1955 1955.14

George Herms

American, b. 1935

- - **Holdings**
2 sculptures

George Herms is a sculptor whose artistic sensibility was formed during the late 1950s, a time when artists on both coasts responded to the excesses of American consumer culture by subsuming its products in their work. Many of them scavenged for mundane materials that reeked of real life, real stories, and real bodies. Using them was a way for artists to bring a measure of the visceral into the sublime ethereality that informed Abstract Expressionism, the dominant style of the day. In New York, Robert Rauschenberg's "combines" married gorgeous painterly surfaces with three-dimensional objects, allowing his work to exist in what he called "the gap between art and life." San Francisco–based Bruce Conner made powerful, often brutal sculptures that began as urban flotsam, which he nailed, wrapped, glued, stapled, melted, and tied. Such works were later called assemblages, a name that describes the additive process used to make them. Herms' assemblages might be better described as accumulations, since he never removes an object once he has placed it on a sculpture.

 The Berman Peace (1986) is one in a series of homages Herms has made to artists who have profoundly affected his thinking. Wallace Berman (1927–1977), a charismatic figure who was as celebrated for his serene, ur-hippie lifestyle as for his art, was one of Herms' most important mentors. "Ten years after the tragic loss of Wallace Berman," he has written, "I came to grips with that loss by making this celebratory homage.... The work commenced when I found the desk being thrown out of the building where my studio was in 1986. By turning the desk on its ear, I began to salute my friend."[1] The desk's drawers and compartments offer a carefully composed aggregation of overt and covert allusions to the subject, some of them in theatrical semidarkness. There is a photograph of Berman's wife, Shirley, and a red plate that hung in his window in Topanga, California; a playing card, because he was celebrated for his skill at card games; and a cascade of dusty blue fabric meant to suggest a waterfall. Objects that arrived in Herms' studio while he was working on the tribute were added to it—a letter from a mutual friend, a tongue cleaner contributed by Herms' daughter.[2] The title is a wryly affectionate tribute to Berman's pacifism and a corrective of the designation "post–World War II" for our modern era. If Herms had his way, we would call it, instead, "the Berman peace."

J.R.

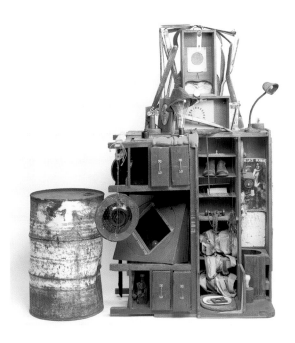

George Herms *The Berman Peace* 1986 mixed media 86 1/2 x 81 x 39 in. (219.7 x 205.7 x 99.1 cm) T. B. Walker Acquisition Fund, 1995 1995.102

Notes

1. Artist's statement, April 12, 1996 (Walker Art Center Archives).
2. Identification of individual elements on the sculpture was provided by Herms during a telephone conversation with Walker curator Peter Boswell, October 9, 1995 (Walker Art Center Archives).

Lynn Hershman

American, b. 1941

-- **Exhibitions**
Artists' Books (1981), *Duchamp's Leg* (1994; catalogue, tour)
-- **Holdings**
73 multiples, 1 photograph, 1 video

The feminist movement was a potent element in the unstable social and political climate that defined American culture during the 1960s and 1970s. Under the slogan "the personal is political," women challenged the many assumptions about gender roles and sexuality that had limited their options at nearly every turn. Control over their lives was at stake, and the female body became the battleground for the struggle. For artists like Lynn Hershman, the body also was fertile territory for new artistic practices that explored voyeurism, role-playing, identity, and social interaction. Her performances, films, videos, and installations address these issues through an exploration of narrative structure and the politics of viewing. Together her works offer one woman's view of what it means to be female in contemporary American society.

Since the early 1970s, Hershman has been based in San Francisco, where her first fully realized projects took place. In *The Dante Hotel* (1972–1973), she rented a room—Number 47—in a cheap, run-down North Beach establishment. There she installed a vignette around life-size wax sculptures of two women locked in an embrace—an imagined re-creation of what might have happened in the room, which had been home to a lesbian couple.[1] Hershman emphasized the overlap of art and life (and made viewers into voyeurs) by requiring her audience to visit the hotel, sign in at the desk, and obtain a room key in order to see the work.

The artist has said that the connection between *The Dante Hotel* and her next major work, *Roberta Breitmore* (1974–1978), was an organic one. "It seemed important to liberate the essence of the person who might have lived in room 47 . . . to flesh out experience through real life."[2] So she created Roberta, a fictional character whose life she lived/performed intermittently over a period of several years. Roberta had an apartment, a checking account, and a driver's license; she attended Weight Watchers, saw a psychiatrist, had sexual adventures (and misadventures), and kept a diary. Roberta was both real and artificial; she was and was not Hershman. In her utter ordinariness, she also represented Everywoman, who "witnessed, reflected, and documented the resonant nuances of her culture's alienation."[3]

In 1994, Hershman issued a work containing an assortment of sixty-four objects and documents related to *Roberta Breitmore*. She organized the material in thematic sections that elucidate the project's evolution and structure. For example, *Roberta's External Transformations* includes seven items (her purse, coat, driver's license, dental X-ray, etc.) with the following explanatory note: "Roberta faced the world with a defined image which was distinguished by her makeup and dress." Other sections are titled *Adventures, The*

Double Is One, Anonymous Social Identities, and so on. In Hershman's words, the work "reflects the simulation of a persona in a way the original does not."[4] It also, of course, allows the project to have a life beyond its original real-time context.

J.R.

Notes
1. For details on this and other projects, see *Lynn Hershman* (Herimoncourt, France: Centre International de Création Vidéo, 1992) and Rod Slemmons, ed., *Paranoid Mirror: Lynn Hershman*, exh. cat. (Seattle: Seattle Art Museum, 1995).
2. Lynn Hershman, "Reflections and Preliminary Notes," in *Paranoid Mirror*, 13.
3. Ibid.
4. Lynn Hershman, correspondence with Walker curator Elizabeth Armstrong, 1994 (Walker Art Center Archives).

Lynn Hershman *Roberta Construction Chart* 1973/1994 chromogenic print 40 x 30 in. (101.6 x 76.2 cm) Gift of Dr. and Mrs. Arthur Lester, 1994 1994.222

Herzog & de Meuron

Established 1978
Jacques Herzog, Swiss, b. 1950; Pierre de Meuron, Swiss,
b. 1950; Harry Gugger, Swiss, b. 1956; Christine Binswanger,
Swiss, b. 1964; Robert Hösl, German, b. 1965; Ascan
Mergenthaler, German, b. 1969

-- **Commissions**
Walker Art Center master plan and building expansion (1999–2005)
-- **Exhibitions**
Herzog & de Meuron: In Process (2000)

In 1999, the Walker Art Center engaged the architectural firm Herzog & de Meuron to develop a master plan and design for an expanded facility. Central to the Walker's vision was the creation of not only additional galleries to display its growing collections, but also new spaces, such as a theater, to house and present multidisciplinary programs. The concept also included a number of gathering places where visitors could converge, opening the possibility of serendipitous encounters with new people, ideas, and art forms. The site plan places the expansion along Hennepin Avenue—a gesture that reorients the Walker toward the city center again (its front door was once on this street), while creating a new park that faces the surrounding residential neighborhood. The entire expanded campus serves as an important urban landmark connecting downtown Minneapolis to the nearby Uptown neighborhood. The new building also links directly to the Edward Larrabee Barnes–designed complex, which opened in 1971.

Herzog & de Meuron's expansion consists of two parts: a cubic tower and a long, horizontal link. The cube contains a theater, a special events space, and a restaurant, and is a deliberate reference to the vertical massing of the Barnes building. Connecting to the original structure is a double-story volume that includes galleries and social spaces with offices above, as well as a new rooftop terrace. The overall scheme intelligently weaves together existing and expansion spaces, opens the closed circulation of Barnes' spiral layout, and creates multiple new pathways to explore the Walker.

New social spaces, in-between zones that fall outside the conventional programmatic realm of galleries and theater, create an archipelago of variously sized and shaped lounges scattered throughout the ground-floor level that links the two buildings. Distinct from, but adjacent to, the galleries, these lounges express a distinctly human-scale architecture. One large space overlooks a new garden; the room's openness and dramatic 26-foot-high floor-to-ceiling glass provide a relaxed setting for the contemplation of art and nature. Another follows the slope of Hennepin Avenue, one of the city's busiest thoroughfares, its double-glass curtain wall placing visitors in movement parallel to the urban flow. Other lounges that contain interactive installations for visitors are situated in the interstitial spaces formed between the canted outside walls and the plumb inside walls of the new galleries.

Herzog & de Meuron is best known for experiments with a wide range of materials and processes, such as the stone gabions used in its Dominus Winery in Napa Valley, California; the application of photographic images into concrete and glass; or highly seductive surfaces and structures like its gemlike Prada store in Tokyo or the translucent polycarbonate façade for the Laban Dance Centre in London. Despite the frequent reduction of the firm's work to the scenographic and its attendant fixation on external appearances, it is its tactical response to the Barnes design that provides the most engaging moments, many of which occur within.

There is a strong dialogical relationship between the original Barnes building and the expansion. The opacity and darkness of Barnes' brick cubes are countered with the white angular masses of Herzog & de Meuron's design, while greater transparency is achieved through large expanses of glass that reveal the animation of spaces within. Although the new tower mimics the massing of the Barnes building, it sustains a much more expressive posture and positions itself in tension with its immediate environment. The weightiness of the Barnes is juxtaposed with the lightness of the new tower's silver metal cladding, which changes its appearance throughout the day, depending on the light—from grisaille to diaphanous. The Barnes' brick cladding is repeated in the floor of the expansion—a displacement from exterior to interior, wall to floor. The new galleries preserve the flexible design and white cube aesthetic of the Barnes building and repeat its use of terrazzo floors. The expansion engages in a creative spatial dialogue with its predecessor, providing people with glimpses of light and dark, new and old, city and garden.

The new cube's surface is wrapped in raised, expanded aluminum-mesh panels that have been folded and stamped with a pattern of creases. The effect is like a crumpled piece of paper, or a creased fabric, suggesting fragility in spite of its great mass. Lightness is further enhanced by the perforations in the façade, including several irregularly shaped and variously sized windows. The visual weight of the cube is undermined by its seemingly free-floating quality—cantilevered over the plaza below and jutting out toward the street. Although referred to as a cube, this volume is in fact a multifaceted structure with unique sides. This non-orthogonal geometry is carried to other parts of the building, most notably the exterior walls of the new galleries, which fold and cant upward and downward in dynamic trajectories. Openings into these walls echo the asymmetry and angularity of the windows. Similarly shaped public seating elements become three-dimensional embodiments of these openings, scattered and clustered along pathways.

The design of the Walker follows a more recent path within the architects' work to explore new possibilities that are beyond the purity of modernist and minimalist forms associated with their early work. Herzog & de Meuron has created a design for the new Walker that will be, perhaps, best remembered for its spatial experience and its creative juxtaposition and ingenious reconciliation of seemingly opposing qualities: new yet familiar, intimate yet grand, fragile yet strong, simple yet complex, dynamic yet composed.

A.B.

Herzog & de Meuron Installation of aluminum mesh panels, Walker Art Center, 2004

Herzog & de Meuron View of main staircase, Walker Art Center,
January 2005

Herzog & de Meuron View of public spaces facing Hennepin Avenue,
Walker Art Center, January 2005

Thomas Hirschhorn

Swiss, b. 1957

-- **Exhibitions**
Unfinished History (1998; catalogue, tour)
-- **Holdings**
1 painting, 10 unique works on paper, 1 multiple

For more than a decade, Thomas Hirschhorn has rigorously, with incredible determination, carved out an aesthetic of discontent: "Not about hope, or about creating points of stabilization, it is about showing my disgust with the dominant discourse and showing my contempt for the fascination with power."[1] If the work and the artist clearly admit a debt to some "father figures" such as Piet Mondrian, Joseph Beuys, Allan Kaprow, or David Hammons, Hirschhorn's methodology owes equally to thinkers who illustrate a tradition of resistance, including Gilles Deleuze and Félix Guattari, Georges Bataille, Antonio Gramsci, or Toni Negri. The power of images and language, the structure of semiotic knowledge, and the possibility of an alternative discourse (or at least a critical one) are what animate Hirschhorn's aesthetic program. Trained as a graphic designer, he is concerned with the economics and politics of public discourse. Disenchanted with the constraints attached to design practices as well as to practical politics, he found in art a utopian field where an analysis of the fabric of collective meaning could happen on his own terms.

Hirschhorn's work assumes a wide diversity of forms: room-size sculptures, drawings, videos, writings, assemblage/paintings, altars, pavilions, displays. In each instance, the medium tends to be contextualized to its location: paintings, sculptures, or drawings in museum and galleries; altars, pavilions, or displays in public areas. Using the word "display" instead of the art-specific word "installation," he makes clear that his forms do not come from an art-historical background, but from a deliberate desire to confront a street-based, commercial language. Similarly, his "altars" follow the visual language of spontaneous urban commemoration or worship, often involving what he calls positive, planned vandalism or a direct engagement of the audience (passersby) with the work.

His visual vocabulary includes cheap plywood, sawhorses, plastic sheeting, adhesive tape, fluorescent lights, plastic flowers, cheesy candles, low-quality artwork reproductions, aluminum foil, and pictures found in newspapers and magazines collaged on cardboard and saturated with his ballpoint pen writings. He uses these materials to construct rudimentary commercial logos (Mercedes, Rolex, CNN), which he then juxtaposes with historical, sociopolitical images: Chanel with dictatorships, BMW with Kosovo, Nike with neo-Nazis. He epistemologically weaves a network of contradictory images in order to better question them, to better understand what they stand for.

Abstract Relief: Archaeology (2000) follows this premise. It belongs to a series of paintinglike reliefs in which Hirschhorn analyzes the condition of globalization and human welfare in a postcolonial world. Built on a rough wooden structure approximately 4-by-4 feet, the relief of adhesive tape, aluminum foil, plastic wrap, and plywood depicts a map of the world that seems to be invaded by a spreading red virus. In the lower right corner of the work is an accumulation of magazine photographs; images of archaeological excavations confront images of disasters and concentration camps. Hirschhorn raises—frontally, brutally, simply, and with a disarming naiveté—the question of our global condition, its history, and its unconfessed archaeology. Deliberately edgy, this memory of our present borrows its technique from the handmade collages, reliefs, and paintings the artist saw in East German homes, miles away from any art-educated demographics.[2] Without sarcasm or postmodern irony, Hirschhorn recycles this homespun aesthetic and turns it against the certitudes that constitute art history—or more bluntly, the history of acceptable taste. He does not, however, raise the notion of good taste, bad taste, or kitsch, but attempts to learn from vernacular taste. By producing an object that carries all the parameters of an aesthetic anomaly, he literally questions the anomalies in the gaps of knowledge systems.

The series of drawings/assemblages titled *Blue Serie* (2001) was conceived as a reflection of endless

Thomas Hirschhorn *Blue Serie (♀)* 2001 paper, plastic, tape, magazine prints, ink 12 5/8 x 17 5/16 in. (32.1 x 44 cm) Miriam and Erwin Kelen Acquisition Fund for Drawings, 2002 2002.14

Thomas Hirschhorn *Blue Serie (Acéphale)* (*Blue Series [Headless]*) 2001 paper, plastic, tape, magazine prints, ink 12 3/8 x 17 1/2 in. (31.4 x 44.5 cm) Miriam and Erwin Kelen Acquisition Fund for Drawings, 2002 2002.12

discontent. Images that the artist does not or refuses to understand—of public hangings, mass graves, refugee camps, weapons of mass destruction, battlefields, and beheadings—are juxtaposed with glamour shots of models; on top of everything, Hirschhorn has scrawled words and drawn teardrops. The series embodies the Bataillian tension between desire and death, Eros and Thanatos. The artist may be asking: "Is this the price we pay?" or "Who is paying the price, and why?" Displayed in an American context, these pictures raise another issue, one of the circulation and censorship of images. Most of the photographs involved in the series come from non-American publications and have never been seen by a U.S. audience. The next logical question is why; Hirschhorn's *Necklace CNN* (2002) might not be able to answer.

His program reassesses the possibility of artists' involvement with the history of their own time. He embraces the challenge of emancipating himself from anecdotal facts in order to access an undisclosed

version of what constitutes our awareness. There is a utopian aesthetic in Hirschhorn's work, an urge toward engagement through art akin to that which philosopher Jacques Rancière shares when he writes about "the idea of a politics that would no longer be the politics that had once been in accordance with the dream of an art that would no longer be art."[3]

P.V.

Notes
1. Quoted in Benjamin H. D. Buchloh, "Cargo and Cult: The Displays of Thomas Hirschhorn," *Artforum* 40, no. 3 (November 2001): 108–114, 172–173.
2. Hirschhorn, conversation with the author, Minneapolis, fall 2003.
3. Jacques Rancière, "The Political Agenda of the Crab," in Laurence Bossé, Hans-Ulrich Obrist, and Julia Garimorth, eds., *Anri Sala: Entre chien et loup* (*When the Night Calls It a Day*), exh. cat. (Paris: Musée d'art moderne de la ville de Paris; Hamburg: Verlag der Buchhandlung Walther König, 2004), 75–82 .

Thomas Hirschhorn *Abstract Relief: Archaeology* 2000 wood, aluminum, plastic, cardboard, tape, magazine collage 85 x 120 1/2 x 12 1/2 in. (215.9 x 306.1 x 31.8 cm) T. B. Walker Acquisition Fund, 2001 2001.22

David Hockney
British, b. 1937

- - **Exhibitions**
London: The New Scene (1965; catalogue, tour), *Homage to Picasso* (1980), *Artist and Printer: Six American Print Studios* (1981; catalogue, tour); *Hockney Paints the Stage* (1983; catalogue, tour), *David Hockney: Fax Prints* (1990), *The Cities Collect* (2000)
- - **Holdings**
2 paintings, 4 drawings, 2 unique works on paper, 189 edition prints/proofs, 1 portfolio of prints, 2 books, 1 periodical, 8 models, 1 printing plate

The subjects of David Hockney's exuberant work serve as a compendium of his visual world: portraits of friends and family, still lifes and studies of gardens and interiors, landscapes familiar and foreign, and—famously—bright turquoise California swimming pools, with palm trees and bathers. His loving attention to the world around him, along with his unabashed affection for color and his virtuosic skill as a draughtsman, links him with another great domestic sensualist, Henri Matisse, who likewise was "unable to distinguish between the feeling I have about life and my way of translating it." Matisse dreamed of an art that was as mentally soothing as "a good armchair that provides relaxation from fatigue";[1] Hockney, for his part, has said, "I have always believed that art should be a deep pleasure."[2] However, his acknowledged mentor is not Matisse, but Picasso—from the youthful melancholia of the Blue period to the astonishing inventiveness of Cubism to the machismo of his late, lusty Minotaurs.[3] Like his mentor, Hockney is extraordinarily prolific and has an appetite for experimentation. He has worked in painting, drawing, photography, and printmaking (with such unorthodox tools as the fax machine and the photocopier) and he has made vibrant set designs for the opera and ballet. But too much should not be made of his affinity with Picasso, for Hockney has absorbed the legacy of the past, as every artist must, and reworked it into something very much his own.

The artist was born in Bradford, an industrial city in northern England, and attended the Bradford School of Art for two years before moving to London in 1959 to continue his studies at the Royal College of Art. During those pre-Pop years, American abstraction was the avant-garde model, but Hockney never gravitated in that direction. He always preferred to work figuratively, at first in a linear, expressionistic style that featured text and literary motifs drawn from fairy tales and poetry, and later in a pared-down style with brighter colors and more contemporary imagery. These later pictures aligned him, during the mid-1960s, with the cheeky, anarchic work of the British Pop artists, who included Peter Blake, Allen Jones, and Joe Tilson. All were presented at the Walker Art Center in a 1965 exhibition entitled *London: The New Scene*; Hockney was by then painting "larger-than-life people in idealized landscapes and interiors which are fantasies of plasticized splendor."[4] In those early years, the artist felt that "style is something you can use, and you can be like a magpie, just taking what you want. The idea of the rigid style then seemed to me something you needn't concern yourself with, it would trap you."[5]

During the 1970s Hockney traveled extensively and moved households several times before eventually settling in Los Angeles, where he has lived ever since. His work began to reflect the bright light and lush landscape of his immediate environment, and he returned in earnest to the motif of the swimming pool, which he had already explored in the 1960s. His crisp compositions of sparkling azure water, tanned boys, diving boards, splashes, ripples, and the blank backsides of California bungalows are among his most distinctive works. *Paper Pools*, a series of works begun in 1978, is an experimental fusion of painting and papermaking in which colored paper pulp was poured into cookie-cutterlike molds, run through a press to consolidate the layers, and finished with additional dyes and pulps applied by hand—a perfect marriage of gorgeous, watery images and liquid technique.

Hollywood Hills House (1981–1982) is a portrait of the first house Hockney bought in Los Angeles, painted from memory while he was in London for the Christmas holidays. "I just painted it to cheer myself up in gray London; I happened to have three canvases, and the picture was a kind of triptych. I shipped it unfinished back to California and finished it there."[6] The flattened volumes of the furniture and shallow interior spaces in

David Hockney *Green Pool with Diving Board and Shadow (Paper Pool 3)* 1978 colored, pressed paper pulp; variant edition of 15 50 1/2 x 31 7/8 in. (128.3 x 81 cm) Walker Art Center, Tyler Graphics Archive, 1983 1983.80 ©David Hockney

the left panel are reminiscent of Cubism; in the central and right panels, bright, Fauvist colors deftly define sun, shade, palm, and pool.

The most prominent objects in Hockney's painted living room are two small models for stage sets, on which he was working at the time he made this picture.[7] He had been doing costumes and decor for the opera since 1975, when his designs for Igor Stravinsky's *The Rake's Progress* debuted at the Glyndebourne Opera Festival in Lewes, East Sussex. Hockney used William Hogarth's bawdy eighteenth-century engravings as a starting point, adapting their precise crosshatching and muted palette to underscore the stringency of Stravinsky's music. He continued designing for the opera and ballet, enjoying the chance to challenge his working habits with new assignments. In 1983, he reinterpreted eight of his projects for the Walker's exhibition *Hockney Paints the Stage*, organized by then-director Martin Friedman. Over the course of six weeks in Minneapolis, Hockney turned the galleries into a magical series of tableaux featuring scaled-down facsimiles of his designs, some of which he edited and changed for the occasion. The result, according to one review, was a show that "seemed alive, like a theater production in and of itself, rather than a record of events past."[8]

In recent years, Hockney has continued to experiment, using the fax machine as a printer and mass-distribution tool for playful multipart drawings. He makes photographs and composite Polaroid portraits, and of course he still paints and draws. The richness of the world around him is, as it has always been, his chief delight and his main subject, and it is one of the things that he believes makes his work so appealing to others. "The art that relates to human beings, to their passions, is what pleases people. It's the passion that people recognize."[9]

J.R.

Notes

1. Henri Matisse, "Notes of a Painter," 1908, reprinted in Jack Flam, *Matisse on Art* (Berkeley: University of California Press, 1995), 37–43.
2. David Hockney, *That's the Way I See It* (San Francisco: Chronicle Books, 1993), 133.
3. While attending London's Royal College of Art, Hockney encountered Picasso's work for the first time in a large exhibition at the Tate Gallery, which he visited eight times. He has since collected the complete thirty-three-volume Zervos catalogue raisonné of Picasso's works. See Gert Schiff, "A Moving Focus: Hockney's Dialogue with Picasso," in Maurice Tuchman and Stephanie Barron, eds., *David Hockney: A Retrospective*, exh. cat. (Los Angeles: Los Angeles County Museum of Art, 1988), 41.
4. Press release for the 1965 exhibition *London: The New Scene* (Walker Art Center Archives).
5. Quoted in Schiff, "A Moving Focus," 41.
6. Hockney, *That's the Way I See It*, 84.
7. The models are designs for Maurice Ravel's *L'enfant et les sortileges* (on the left) and Francis Poulenc's *Les mamelles de Tirésias* (right). Both were produced at the Metropolitan Opera in 1981, on a triple bill that also included Erik Satie's *Parade*. Hockney designed sets and costumes for all three. The artist has said the exterior of his house in Hollywood Hills was painted in bright colors based on his designs for the Ravel opera, and that the interior palette was inspired "partly by

seeing the *De Stijl* exhibition at the Walker." See Martin Friedman, *Hockney Paints the Stage*, exh. cat. (Minneapolis: Walker Art Center, 1983), 56.
8. Kenneth E. Silver, "Hockney, Center Stage," *Art in America* 73, no. 11 (November 1985): 158.
9. Quoted in Anthony Bailey, "Profiles: Special Effects," *New Yorker*, July 30, 1979, 67.

David Hockney at work on *The Rake's Progress* in the Walker Art Center galleries, 1983

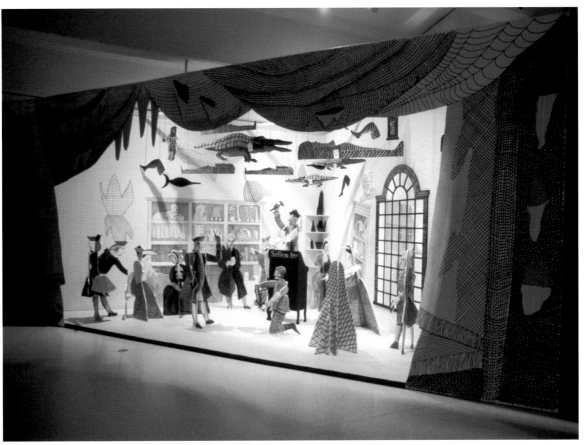

Installation view of *The Rake's Progress* in the exhibition *Hockney Paints the Stage*, 1983

David Hockney *Hollywood Hills House* 1981–1982 oil, charcoal, collage on canvas 59 7/8 x 120 1/2 in. (152.1 x 306.1 cm) Gift of Penny and Mike Winton, 1983 1983.5 ©David Hockney

Howard Hodgkin

British, b. 1932

- - **Exhibitions**
London: The New Scene (1965; catalogue, tour)
- - **Holdings**
2 paintings, 1 multiple, 1 book

When it opened in Minneapolis in 1965, the Walker Art Center's *London: The New Scene* was the most significant exhibition of young British art to have been staged in America since the end of World War II. The favored metaphor was one of fog lifting over London to reveal a newly "swinging" art scene. The show was a hit, heralded by local headlines such as "Museum Can Be Rollicking Place to Enjoy," while over the pond the London press tagged its artists the "Minneapolis 13."[1]

Howard Hodgkin, thirty-two years old at the time, was selected to exhibit alongside other rising stars—including a twenty-seven-year-old David Hockney, a thirty-three-year-old Bridget Riley, and a thirty-two-year-old Peter Blake—in a show of remarkably prescient leaps of curatorial faith.[2] The exhibition received a great deal of press coverage, though Hodgkin's paintings were given scant attention. They could not be easily lumped with the suburban Pop sensibility that many of the artists exemplified (though some commentators tried), or with the geometric abstractions of other painters. Such a lack of press suited the artist just fine; in fact, he professed a hatred of being treated as "news."[3] Despite this critical reticence, his stature steadily grew. By the 1980s he was widely celebrated, representing his country at the 1984 Venice Biennale and receiving the second Turner Prize the following year.

Hodgkin's paintings are concerned with direct interpersonal communication and a self-consciously old-fashioned necessity to conjure emotional states in paint. They are typified by often riotously saturated, almost fauvist colors with paint distributed from impasto blobs to wide fluid veils. Gestures often spill out onto the frames as if their exuberance couldn't be contained. Though less explicit in the 1964 Walker-owned work *Large Portrait* (featured in *London: The New Scene*), the titles of his works frequently allude to the people or exotic places that triggered them. *Going for a Walk with Andrew* (1995–1998) is more typical of this trait, as the painting attempts to take on the condition of memory. As the artist describes, "The subjects of most of my work are the relationships between various nameable individual human beings in their surroundings. . . . I have got to find a two-dimensional equivalent to my three-dimensional experience."[4] The Andrew of the title is most likely British art historian Andrew Graham-Dixon, the presenter of the BBC television series *Renaissance*, whose monograph on Hodgkin was published in 1994.[5]

M.A.

Notes
1. See, for example, Martin Friedman, "Young London: The Fog Lifts on a New Scene," *New York Times*, December 20, 1964. Also, "Museum Can Be Rollicking Place to Enjoy," *Minneapolis Star*, February 12, 1965, and "Newsight," *Daily Mail* (London), February 26, 1965.
2. The exhibition, curated by Martin Friedman, included Peter Blake, Bernard Cohen, Harold Cohen, Robyn Denny, Hockney, Howard Hodgkin, Allen Jones, Phillip King, Jeremy Moon, Bridget Riley, Richard Smith, Joe Tilson, and William Tucker. *London: The New Scene* opened at the Walker before touring to Washington, D.C., Boston, Seattle, Vancouver, and Toronto. Thirty years later, the 1995 Walker-organized show *"Brilliant!" New Art from London*, curated by Richard Flood, pulled off a similar feat by introducing another generation of young British artists to American audiences.
3. Hodgkin, interview by art historian Edward Lucie-Smith, undated transcript (Walker Art Center Archives).
4. Ibid.
5. Andrew Graham-Dixon, *Howard Hodgkin* (New York: Harry N. Abrams, 1994).

Howard Hodgkin *Going for a Walk with Andrew* 1995–1998 oil on wood, frame 48 x 56 5/16 x 3 3/4 in (121.9 x 143 x 9.5 cm) Gift of Judy and Kenneth Dayton, 2002 2002.26

Hans Hofmann
American, b. Germany, 1880–1966

- - **Exhibitions**

Paintings to Know and Buy (1948), *Contemporary American Painting: Fifth Biennial Purchase Exhibition* (1950; catalogue, tour), *Contemporary American Painting and Sculpture: Collection of Mr. and Mrs. Roy R. Neuberger* (1952; catalogue), *The Classic Tradition in Contemporary Art* (1953; catalogue), *Four Abstract Expressionists* (1953; organized by the Kootz Gallery, New York), *Reality and Fantasy, 1900–1954* (1954; catalogue), *Expressionism 1900–1955* (1955; catalogue, tour), *Paintings by Hans Hofmann* (1958; organized by the Whitney Museum of American Art in association with the Art Galleries of the University of California, Los Angeles; catalogue), *Animals in Art* (1960), *60 American Painters: Abstract Expressionist Painting of the Fifties* (1960; catalogue), *Eighty Works from the Richard Brown Baker Collection* (1961; catalogue), *The Cities Collect* (2000)

- - **Holdings**

4 paintings

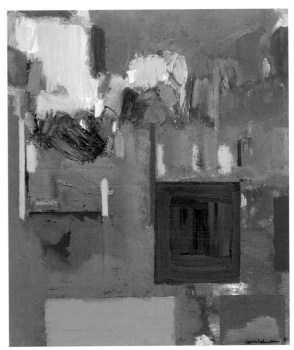

Hans Hofmann *Image of Cape Cod: The Pond Country, Wellfleet* 1961 oil on canvas 62 x 53 7/8 in. (157.5 x 136.8 cm) Gift of Judy and Kenneth Dayton, 1999 1999.52

Edward Hopper
American, 1882–1967

Quiet, luminous, spare, and evocative, the paintings of
Edward Hopper are both affectionate observations
of American life and formally sophisticated modernist
compositions that evince his love of past masters such
as Rembrandt, Degas, and Manet. Hopper's subject
was the world around him: urban interiors, including
diners, hotel lobbies, offices, and theaters, most in
Manhattan, where he and his wife, Jo, lived for more
than forty years. He also painted the country houses,
churches, and Main Streets of rural New England,
where the couple summered. Above all, Hopper
painted light: sun streaming through curtained win-
dows; clapboard farmsteads in the warm glow and
long shadows of late afternoon; starkly lit interiors
framed by darkness. This dramatic illumination makes
his pictures strongly cinematic, although they never
offer a complete narrative. Rather, they hint at the art-
ist's deep love for the natural world and his intense
curiosity about his fellow human beings.

One of his best-known works, *Office at Night* (1940),
is also one of his most mysterious. Is this a scene from
a detective novel? Are the man and woman about to
fall into each other's arms, or are they hatching a plot?
Perhaps bad news has just arrived, or bankruptcy is
impending. Hopper wrote a short explanation of the
painting in which he notes that it "was probably first
suggested by many rides on 'L' trains in New York City
after dark and glimpses of office interiors that were so
fleeting as to leave fresh and vivid impressions on my
mind. My aim was to try to give the sense of an isolated
and lonely office interior rather high in the air, with the
office furniture which has a very definite meaning for
me." What that meaning was, he doesn't say; instead
he goes on to discuss the painting's three light sources
and the relationship of the woman's figure to the stark
lines of the file cabinet. The text concludes, "Any more
than this, the picture will have to tell, but I hope it will
not tell any obvious anecdote, for none is intended."[1]

Office at Night was acquired by the Walker Art
Center in 1948, eight years after the establishment of
its new mission as a progressive institution dedicated
to contemporary art and design. Then-director Daniel
Defenbacher had already implemented several pro-
grams intended to educate the public about the salu-
tary effects of living with good design and modern art.[2]
In a move that now seems both shrewd and innovative,
Defenbacher hatched a collaboration with a depart-
ment store in downtown Minneapolis, Young-Quinlan,
in which they jointly presented one hundred twenty-
seven paintings by as many artists in an exhibition

entitled *Paintings to Know and Buy*. It brought art
directly to the shopping public; as a contemporary jour-
nalist noted, "If people won't voluntarily go where mod-
ern art is, modern art must go where people are."[3]
Outside the authoritative space of the museum, visitors
were encouraged to trust their own taste, choosing a
painting like they might choose a new dress (the invita-
tion card promised, "You'll like some of the pictures
immensely; others you'll tolerate; and of a few you'll
say 'Not for me!'").[4] Although archival records are
sketchy, they show that at least three paintings were
sold to private collections, and that the young Walker
Art Center made its most ambitious acquisition up to
that point: ten works, for a total of $13,405, including
Yasuo Kuniyoshi's *Lay Figure* (1938), Theodoros Stamos'
Archaic Release (1946), and Hopper's *Office at Night*.

J.R.

Notes
1. Edward Hopper, letter to Walker curator Norman A. Geske, August
25, 1948 (Walker Art Center Archives). For extensive discussions of this
painting and its development, see Gail Levin, "Edward Hopper's 'Office
at Night,'" *Arts* 52, no. 5 (January 1978): 134–137, and Levin's book
Edward Hopper: An Intimate Biography (New York: Knopf, 1995).
2. Defenbacher's initiatives included the Idea House and the Everyday
Art Gallery, whose histories are detailed in Andrew Blauvelt, ed., *Ideas
for Modern Living*, exh. bro. (Minneapolis: Walker Art Center, 2000). See
also Defenbacher's outline of his vision for the new Art Center in
Walker Art Center of the Minnesota Arts Council (Minneapolis, 1940;
Walker Art Center Archives).
3. John K. Sherman, "Mahomet Defenbacher Takes Art to Mountain,"
Minneapolis Star, May 31, 1948 (Walker Art Center Archives).
4. Exhibition invitation card, 1948 (Walker Art Center Archives).

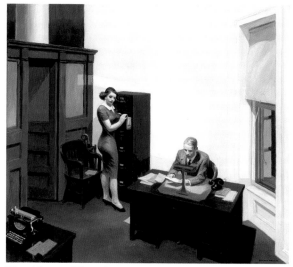

Edward Hopper *Office at Night* 1940 oil on canvas 22 3/16 x 25 1/8 in.
(56.4 x 63.8 cm) Gift of the T. B. Walker Foundation, Gilbert M. Walker
Fund, 1948 1948.21

Craigie Horsfield

British, b. 1949

-- **Exhibitions**
Craigie Horsfield (1993; tour)
-- **Holdings**
1 photograph

When Craigie Horsfield speaks about the images he makes, he often uses the phrase "slow history." By this he means a history of daily events, interactions, and sensations that accrues and circles back on itself in "small" narratives about real lives lived. Horsfield adapted the concept from the work of French historian Fernand Braudel, who wrote of a "history of man in relation to his surroundings . . . that unfolds slowly and is slow to alter, often repeating itself and working itself out in cycles which are endlessly renewed."[1] This is not the history of wars, political events, or other "short, sharp, nervous vibrations," as Braudel described them. Slow history is built from nothing more or less than daily encounters with people, objects, and places in one's physical environment. These quiet events are the subjects of Horsfield's photographs, which are offered as a corrective to what he sees as the alienating effects of the speed, forward motion, fragmentation, and flux of contemporary life.

Horsfield studied at St. Martins School of Art in London, where he began in 1968 as a painter but soon switched to photography because he was intrigued by its problematic relationship to the real world and "the immanence of its history."[2] Over the course of the next two decades, he filled boxes with negatives of various sizes, but never published or exhibited them until 1988. By then he had arrived at a technical means and format that owed as much to painting as to photography. He makes only one (usually large-scale) print from each negative, and prefers a square format, inspired by the Suprematist canvases of Kasimir Malevich. His prints have a matte surface that he thinks of as penetrable and vulnerable, like skin; the images are grainy, dark, and soft, with a painterly feel that cannot be fully experienced in reproduction.

Horsfield has made most of his pictures in London and various cities in Poland, where he has lived his life; as a group they form a kind of fragmented diary of his quotidian encounters. The Walker Art Center's photograph was made in Krakow, where the artist resided from 1972 to 1979. There, at the center of Europe, he found a place where "desires, confused and distant memory, the subterranean movements of culture, of people and the land, break through to the surface."[3] Life there was, he felt, negotiated exactly as it might have been in past centuries. *Klub Pod Jaszczurami, Rynek Glowny, Krakow. February, 1976.*—made at a dance club, where Horsfield worked as a disc jockey—recalls Brueghel's satirical paintings of sixteenth-century revelries in which dancers grip one another awkwardly, their faces distorted with lust or gluttony. The negative was made in 1976, but the artist didn't print it until fifteen years later; he always allows some time to pass between the photographic act and the making of the print. During this lapsed time, the event recedes into memory and allows the print to exist as a discrete object rather than a recording. Separated, the two are nevertheless connected; Horsfield believes this may suggest that "all time may be conceived of as simultaneous."[4]

In recent years, he has made large-scale installations (such as *The El Hierro Conversation* of 2003, a collaborative project describing the lives of people in the Canary Islands) as well as intimately scaled still lifes that he calls "irresponsible drawings." These seemingly disparate practices bracket an oscillation between communal concern and individual sensual pleasure—the poles of human experience that Horsfield so values. "I see [my] pictures as positive; there is even a hopeful aspect at their center, an affirmation about life that has to be sustained. It is hemmed in by difficulty, always under threat, but it endures."[5]

J.R.

Notes
1. Fernand Braudel, *On History*, trans. Sarah Matthews (Chicago: University of Chicago Press, 1982), 4.
2. Horsfield, interview with Jean-François Chevrier and James Lingwood, in Jean-François Chevrier and James Lingwood, eds., *Craigie Horsfield*, exh. cat. (London: Institute of Contemporary Arts, 1991), 8.
3. Ibid.,16.
4. Craigie Horsfield, "A Project for *Artforum*," *Artforum* 32, no. 9 (May 1994): 119.
5. *Craigie Horsfield*, 24.

Craigie Horsfield *Klub Pod Jaszczurami, Rynek Glowny, Krakow. February, 1976.* 1991 black-and-white photograph mounted on aluminum 104 x 107 in. (264.2 x 271.8 cm) Rollwagen/Cray Research Photography Fund, 1991 1991.91

Huang Yong Ping
French, b. China, 1954

- - **Exhibitions**
Huang Yong Ping: A Retrospective (2005; catalogue, tour)
- - **Holdings**
1 sculpture

During the 1980s, Huang Yong Ping was a founding member of Xiamen Dada, a group of Chinese artists who were disgruntled with the artistic traditions fostered during the Cultural Revolution. Xiamen Dada viewed "official" Chinese painting as an impediment to modernity in the arts, and they attempted to link Chinese traditions of Zen and Taoism to the ideas of such Western modernists as Marcel Duchamp, John Cage, Joseph Beuys, Ludwig Wittgenstein, and Michel Foucault. The group distinguished itself with often violent actions against Socialist Realism, or anti-art provocations such as burning their own paintings. At its root, Xiamen Dada acknowledged that art and ideology were intricately interwoven in China's sociopolitical arena. Because of this background Huang places cultural hybridity at the center of his practice, alongside an aesthetic of skepticism regarding established cultural, religious, social, and political orders. Through his efforts to reinvent the language of art, he attempts to provoke real social change.

Since moving to Paris in 1989, Huang has been concerned with confronting the definitions of history and truth offered by both Eastern and Western hegemonic ideologies. While living in Asia, he referred to the Western avant-garde tradition in order to counter official Chinese ideology; in Europe, he introduces Eastern ideas and practices to undermine ingrained Eurocentric habits of thinking and cultural stereotypes. For example, he uses chance and the practice of *I Ching* (*Book of Changes*) to deconstruct the politicized "Hegelian rationalism," contradicting the idea that the world can be understood according to the formula in which the real is rational, and the rational is real. Huang's artistic universe contains diverse materials and approaches, including insect and reptile environments, and room-size installations in which ready-made objects and traditional symbols give shape to his critical understanding of art, history, and politics. Working within the tradition of installation art, Huang uses space and architecture to explore the phenomenological experience of a work, beyond its mere objecthood.

The History of Chinese Painting and the History of Modern Western Art Washed in the Washing Machine for Two Minutes (1987–1993) is emblematic of Huang's philosophy. Conceived in 1987, then accidentally destroyed, the work was reconstituted in 1993. Atop an old tea crate inscribed with the date and the history of the piece, Huang has left a pile of paper pulp obtained by "washing" two textbooks—on the history of Chinese art and the history of Western modern art respectively—in a washing machine. In doing so, he is attempting to reconcile two traditions often seen as antagonistic. The act of cleaning the books may seem as iconoclastic as an auto-da-fé, but the subversive quality of the act has little to do with wiping out dissent. Instead, Huang seeks to activate a philosophy (and then an aesthetic) of correlation, which has its roots in traditional Chinese philosophy, and the idea that no situation is monolithic but rather always composed of two entities that both oppose and complement each other. One could characterize such a phenomenon, and therefore Huang's practice, as enlightenment through difference. Referring in his work to different cultural traditions, he does not seek exoticism or to provoke cultural antagonism, but proceeds by rebounds and detours to relocate our understanding of modernity. His attempt includes his awareness that any questioning of knowledge and language also questions the established social and political orders.

P.V.

Huang Yong Ping *The History of Chinese Painting and the History of Modern Western Art Washed in the Washing Machine for Two Minutes* 1987–1993 Chinese tea box, paper pulp, glass 30 1/4 x 19 x 27 1/2 in. (76.8 x 48.3 x 69.9 cm) T. B. Walker Acquisition Fund, 2001 2001.125

Wing Young Huie

American, b. 1955

- - **Exhibitions**
Unfinished History (1998; catalogue, tour), *Dialogues: Paul Beatty/ Wing Young Huie* (1999; publication)
- - **Holdings**
6 photographs

Wing Young Huie *Hmong Teenager Getting a Haircut—Frogtown* 1996
silver print; edition 1/75 20 x 15 11/16 in. (50.8 x 39.9 cm) T. B. Walker
Acquisition Fund, 1996 1996.89

Michael Hurson
American, b. 1941

- - **Holdings**
1 sculpture, 1 suite of drawings

Notes
1. Robert Pincus-Witten, "Michael Hurson: A Fabric of Affinities," *Arts Magazine* 50, no. 10 (June 1976): 76–80.
2. Directed by JoAnne Akalaitis, *Red and Blue* played at the New York Public Theater in the summer of 1982.
3. Artist's statement, September 4, 2002 (Walker Art Center Archives).

While still a student at the Art Institute of Chicago, Ohio-born Michael Hurson caught the attention of taste-maker Henry Geldzhaler (newly appointed curator at the Metropolitan Museum of Art) and, more important, of Robert Pincus-Witten, a young instructor at the Art Institute. Geldzhaler bought a drawing, but Pincus-Witten went on to become one of Hurson's most impassioned champions. Writing in *Artforum* and *Arts Magazine*, he took great care to position Hurson as an artist of note without attempting to locate his art: "Hurson is, above all else, a painter and like so much painting today, his is realized in activities still assimilable to sculpture, or photography, or theater, or even commercial art."[1] From the start of his career, Hurson has resolutely avoided the epic, the grand, the operatic. Instead, his work is a series of modest acts of grace that are at once simple and eerie—paintings of deliriously dancing eyeglasses, miniature balsa models of commonplace architectural incidents, prints and drawings of Beckettian characters and landscapes. Indeed, Hurson's play *Red and Blue*,[2] an extended dialogue between two colored lightbulbs, owes a debt to Beckett.

The two pieces by Hurson in the Walker Art Center collection represent two very different bodies of work. *Corner of a Studio/View of an Exhibition* (1973) is one of a series of balsa architectural vignettes that toured from the Museum of Contemporary Art in Chicago to the Museum of Modern Art in New York in 1973. It is a starkly spare meditation capturing the loneliness of an artist's calling. The other, *Palm Springs Cartoon* (1971), is one of many "cartoons" the artist has drawn over the years that deals specifically with the Palm Springs residence of his mentor and employer, Burr Tillstrom. From 1969 to 1971, Hurson worked as Tillstrom's assistant at the height of his fame as the originator of the pioneering television show *Kukla, Fran and Ollie*. The two had met years before and would remain friends until Tillstrom's death in 1985. Composed of seven drawings, the work records afternoon into evening at a pool shared by Hurson, Tillstrom, and his dog Emily. When asked to write about the work, the artist created a powerful reminiscence that goes far beyond its specifics. The conclusion perfectly captures all that makes Hurson's work so exquisitely human and essential: "This and all of a cartoon is but a story about family and acquaintances and dogs (or pets) and hand puppets and two friends what knew we'd been in great periods as then it was as I called that precious day; he was afar, and now very far away at present—Where? Save for in the heart still, he'd been most fortunate to been he, there was none better than he and what he did. . . As it was then for me, to have known him, and then as it is now for me, just as lucky, still, to have known this and write of this, too."[3]

R.F.

Michael Hurson *Corner of a Studio/View of an Exhibition* 1973 (detail) balsa wood 9 1/8 x 28 x 8 7/8 in. (23.2 x 71.1 x 22.5 cm) T. B. Walker Acquisition Fund, 2003 2003.1

Michael Hurson Selection from *Palm Springs Cartoon* 1971 charcoal pencil on paper 11 x 8 1/2 in. (27.9 x 21.6 cm) each of 7 Justin Smith Purchase Fund, 2002 2002.223

Pierre Huyghe

French, b. 1962

- - **Exhibitions**
Let's Entertain (2000; catalogue, tour)
- - **Holdings**
1 multimedia work, 1 video

In 1994, Pierre Huyghe hired actors to re-create every-day street scenes for his camera—workers on a build-ing site, for example. The photographs were later pasted on billboards adjacent to the place where this unremarkable behavior had taken place, substituting disruptingly ordinary images for banally ostentatious advertisements.

Huyghe's practice is haunted by such reorientations of reality. Throughout the late 1990s, he created a clutch of multimedia works that exploited film dubbing, trans-lation, and subtitling to track the duplicitous nature of the cinematic event. In *Remake* (1994–1995), he reshot an entire Alfred Hitchcock film with amateur perform-ers; for other projects he has asked the original actors to revisit their old roles. Like his European contemporaries and collaborators, including Dominique Gonzalez-Foerster, Philippe Parreno, Liam Gillick, and Angela Bullock, Huyghe often trades in unfinished stories and intertwined propositions.

Huyghe and Parreno purchased the rights to a nascent animated *manga* (Japanese graphic novel) character in 1999, naming her Annlee and conceiving an enterprise-cum-exhibition entitled *No Ghost Just a Shell, un film d'imaginaire* (1999–2002). Annlee would serve as an infinitely adaptable vessel around which invited artists could develop new artworks that are, in essence, remakes without any original.[1]

Huyghe's *Two Minutes Out of Time* (2000) and Parreno's *Anywhere Out of the World* (2000), also in the Walker Art Center's collection, are both computer-generated animations of Annlee avatars that recount alternative prologues to the *No Ghost Just a Shell* proj-ect. Accompanying Huyghe's film is a poster of a forlorn Bambi-eyed girl, the earliest image of Annlee. Yet in her following "episodes," it's clear that she is more than just a bit sad. As an object of (psycho)analysis, Annlee is ridden with powerful symptoms of dissociative disor-ders: mood swings, sleepwalking, flashbacks, amnesia, and time loss. *Two Minutes Out of Time* is a psychotic, cerebral overture told in hallucinations. At first Annlee describes herself in the third person, recounting her inauspicious origins as "a fictional character with a copyright designed by a company and proposed for sale." In moments of clarity, Annlee understands herself as a "deviant sign" that is "haunted by your imagina-tion," before being abruptly possessed by a persona with the voice of a young American girl.

M.A.

Notes
1. The project, whose title refers to Mamoru Oshii's classic *anime* film *Ghost in the Shell* (1995), eventually involved fifteen artists, including Gonzalez-Foerster, Gillick, and Bullock as well as Rirkrit Tiravanija,

Joe Scanlan, and Richard Phillips. It was brought to an end in December 2002, with a fireworks performance by Huyghe and Parreno. The artists transferred Annlee's copyright to a legal entity with the specific purpose of enforcing a ban on any further use of her image. See Pierre Huyghe and Philippe Parreno, eds., *No Ghost Just a Shell* (Zürich: Kunsthalle Zürich; Eindhoven, the Netherlands: Van Abbemuseum; Cambridge, England: Institute of Visual Culture; Köln, Germany: Verlag der Buchhandlung Walther König, 2003), and Philip Nobel, "Annlee: Sign of the Times," *Artforum* 41, no. 5 (January 2003): 105–109.

Pierre Huyghe *Two Minutes Out of Time* 2000 DVD (3-D animation, sound), screenprint on paper; edition 3/4 4 minutes screenprint: 67 3/8 x 46 1/16 in. (171.1 x 117 cm) Butler Family Fund, 2001 2001.136

Improbable Theatre

Formed 1996
Julian Crouch, British, b. 1962; Phelim McDermott,
British, b. 1963; Lee Simpson, British, b. 1963

- - **Commissions**
The Hanging Man (2003)
- - **Performances**
70 Hill Lane (1999), *Shockheaded Peter* (with the Tiger Lillies, 2000),
Spirit (2001), *The Hanging Man* (2003)
- - **Residencies**
2002, 2003

Improbable Theatre creates ensemble-based theatrical
experiments that thrive on improvisation, personal
risk, humor, and a unique brand of stage magic. Repre-
senting the combined writing, directing, performance,
and design talents of London-based Julian Crouch,
Phelim McDermott, and Lee Simpson, the company
devises innovative ways to tell stories while creating
a balance between the formally experimental and
refreshingly accessible.

The Walker Art Center has been involved with
Improbable Theatre almost from the company's start,
helping to anchor its inaugural U.S. tour with *70 Hill
Lane*. The production opened the Walker's 1999 Out
There series and was perhaps also the high point of
its Inanimate Objects: Adventures in New Puppetry
series of that season. The piece already bore elements
now considered Improbable trademarks: source mate-
rial drawn from the lives of company members; dark
humor; everyday objects brought to life; a fascination
with death and childhood; an intentional casualness;
and the regular breaking of theater's "fourth wall."

Crouch and McDermott's over-the-top outlandish-
ness was in fullest view in *Shockheaded Peter*, their col-
laboration with subversive cabaret trio the Tiger Lillies,
which was presented at Minneapolis' Theatre de la
Jeune Lune in 2000. This large-scale, black-comic "junk
opera" puppet show was inspired by *Der Struwwelpeter*
(*Slovenly Peter*), the cautionary and grisly nineteenth-
century collection of children's tales by Heinrich
Hoffmann. The following year, they returned with *Spirit*,
a piece in which interpersonal risk, surreal stagecraft,
and autobiography reached new levels. Improvising
and reenacting their real-life interactions interwoven
with poignant storytelling, the actors took the kind of
high-wire chances that left audiences wondering just
how much further this company could go.

It was this history that led to the commission and
coproduction of Improbable Theatre's largest-scale
work to date, *The Hanging Man*.[1] While most of the
company's past work was developed and produced
in London, its relationships with U.S. institutions such
as the Walker and the Wexner Center for the Arts in
Columbus, Ohio, were becoming increasingly central
to the support of new productions.[2] The three founders,
along with American sound designer Daron West
(SITI Company), were invited to the Walker for a devel-
opmental residency to conceptualize the piece's
early stages.

Like all of Improbable Theatre's work, *The Hanging
Man* did not start with a script but in a rehearsal room
with the threads of several ideas—in this instance, the
concept of a man so rigid he cannot die when he tries to
hang himself—and visual inspiration from seventeenth-
century paintings of Punchinellos in masks. Theater and
improv exercises, paintings, puppetry, company mem-
bers' own existential musings on modern times, music,
and comedy all fed into their layering process. The
result, which toured the United States and Europe, was
an alluring and unpredictable "medieval mystery
play," one that has clear implications for the future
direction of twenty-first-century performance theater.

P.B.

Notes
1. Coproduced with the West Yorkshire Playhouse, the Wexner Center
for the Arts, the Lyric Hammersmith, and Wiener Festwochen.
2. For a thorough examination of the processes and outcomes related
to the Walker Art Center, Wexner Center for the Arts, and Improbable
Theatre's presentation/collaboration model, see Suzanne Callahan,
Singing Our Praises: Case Studies in the Art of Evaluation (New York:
Association of Performing Arts Presenters, 2005).

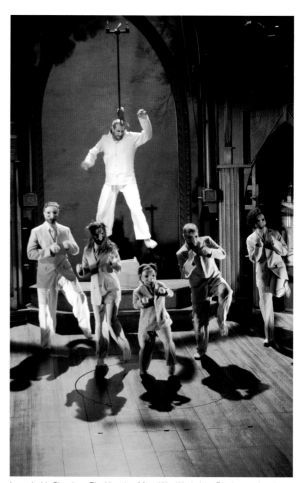

Improbable Theatre *The Hanging Man* West Yorkshire Playhouse, Leeds,
England, 2003

Robert Indiana

American, b. 1928

-- **Commissions**

Set design for Virgil Thomson's *The Mother of Us All* for the Center Opera Company, Minneapolis (1967)

-- **Exhibitions**

Stankiewicz and Indiana (1963; catalogue), *The Cities Collect* (2000), *American Tableaux* (2001; publication, tour)

-- **Holdings**

1 painting, 3 edition prints/proofs, 1 book

Robert Indiana *The Green Diamond Eat The Red Diamond Die* 1962 oil on canvas 60 1/4 x 60 1/4 in. (153 x 153 cm) each of 2 Gift of the T. B. Walker Foundation, 1963 1963.45

Robert Irwin

American, b. 1928

- - **Commissions**
untitled (1971)
- - **Exhibitions**
6 artists 6 exhibitions (1968; catalogue), *Works for New Spaces*
(1971; catalogue), *Robert Irwin: Artist-in-Residence* (1976)
- - **Residencies**
1976
- - **Holdings**
2 paintings, 1 sculpture, 2 unique works on paper

Some thirty years after its installation at the Walker Art Center as part of the museum's inaugural exhibition *Works for New Spaces*, Robert Irwin's untitled perceptual work is, more than ever, a seminal statement that has helped to redefine the role of the artist and the contemporary canon itself. Commissioned by the Walker in 1971 for a major space in its then-new building designed by Edward Larrabee Barnes, Irwin's work was, from the beginning, fully intended to be a site-determined environment addressing the scale and structural parameters of the space. In response to this commission, Irwin constructed a mock-up of the Walker's gallery in 1970 in his Los Angeles studio, and then proceeded to evolve the conceptual framework of the piece and its materials, which included synthetic scrim, wooden frames, concealed double-stripped fluorescent lights, and floodlights. Out of these seemingly straightforward materials emerged an elusive and enduring work that both creates and challenges the limits of perception. An oblique plane of scrim slanting away from the viewer creates two spatial volumes that are only perceived as indistinctly separate due to the immateriality of the scrim, but form a unity that is capable of being experienced visually while being both fugitive and real: in short, a work that leaves, in the artist's words, "as few traces of myself as possible"[1]—yet establishes an immensely powerful presence.

The more one experiences this and other works by Irwin over his remarkable evolution, the more one truly comprehends that the separation between art and thought, which is a convention of Western philosophy, is in fact artificial. Instead, adopting Irwin's stance, art is the most profound inquiry into the nature of thought and experience itself—in his words, "an inquiry that takes me to places I never thought I'd be." More significantly perhaps, in art-historical terms, a work of art for Irwin "has its own set of rules" not dictated by any other human enterprise. This is because art is essentially not about objects, but about perception, which—again in Irwin's astute judgment—is "one of the great beauties of our lives." Hence the art "object" or experience is in fact a dialogue between the artist who created it, and the viewer. "The issue," according to Irwin, "is about context, not objects: how we perceive objects in context."

The viewer unfamiliar with Irwin's artistic journey may well wonder how he reached this point of hugely individual self-determination. Starting in the late 1940s and early 1950s as an Abstract Expressionist, Irwin was encouraged by the work of Willem de Kooning, which

he felt reflected the observation that "perception is deeply tactile." At this early stage in his development, however, Irwin chose not to be limited by what he saw as another set of conventions, and he began to question exactly what a painting was, and to see such works in an entirely different and much-expanded perceptual sense—simply as objects. This new "agenda" for his work led, between 1963 and 1969, to the enormously influential series of dot and disc paintings that further expanded the artist's understanding of perceptual experience. From 1970 onward, Irwin found himself existing outside the art world's self-contained, limited, but very functional systems for creation, presentation, and consumption. He deliberately set aside all assumptions of what art was and is, evolving with extraordinary focus and concentration a seminal body of work that was primarily installation- or environment-based. Often temporal in nature, this work is grounded in the frame of reference of the viewer, defined by perceptual phenomena, and determined by the unique circumstances of each situation. The untitled work presented here, so critical to the historical accuracy of the Walker's permanent collection, epitomizes Irwin's quest to redefine the nature of contemporary art and thought.

Richard Koshalek

Notes
1. All quotes in this essay by Robert Irwin are from the documentary film *Robert Irwin: The Beauty of Questions*, directed by Leonard Feinstein (University of California Extension Center for Media and Independent Learning, Berkeley, 1997).

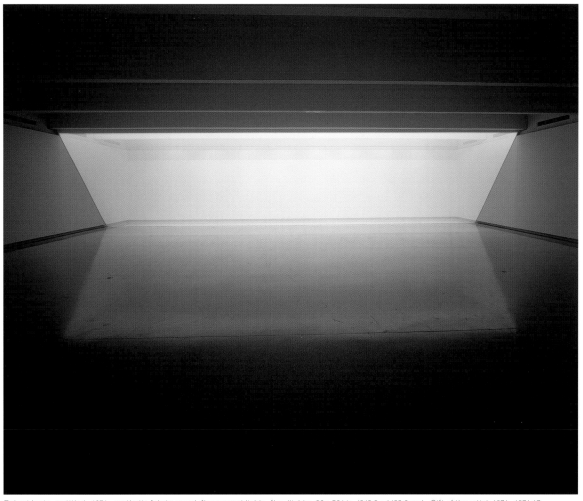

Robert Irwin untitled 1971 synthetic fabric, wood, fluorescent lights, floodlights 96 x 564 in. (243.8 x 1432.6 cm) Gift of the artist, 1971 1971.17

Zon Ito

Japanese, b. 1971

-- **Commissions**
Vacant Lot (2003)
-- **Exhibitions**
How Latitudes Become Forms: Art in a Global Age
(2003; catalogue, tour)
-- **Holdings**
1 sculpture, 1 book

When Zon Ito was growing up in Osaka in the 1970s, vacant lots were his playgrounds. He used to snatch praying mantises and grasshoppers with tweezers or scoop little fish from neighborhood ponds. So much for his early artistic education, later formalized by a degree from the University of Fine Arts in Kyoto, where he currently lives and works. Ito's fascination for things natural is at the core of his artistic vocabulary, described in a variety of lowbrow media, including drawing, embroidery, book-making, and animation.

A series of five handmade books, *Scrap Works of Scum* (1999) is exemplary of Ito's playful and surreal take on the relationships between man and nature. When the covers of each volume are aligned side-by-side, they reveal a sunlit mountain landscape, deserted but for a few eerie human and animal beings. In each book—titled respectively *View of the River*; *Luminous Book*; *Animal Picture Book*; *Super Rainbow*; and *Scrap Works of Scum*—aerial shots of a fisherman at the bend of a river, fluorescent insects, psychedelic landscapes, and hallucinatory vistas form a disjointed collection of playlets that grapple as much with the frailty of life as with the tenuous nature of memory and the subversive power of the unconscious.

Vacant Lot, a series of five embroideries on fabric commissioned by the Walker Art Center for its 2003 exhibition *How Latitudes Become Forms: Art in a Global Age*, similarly tackles the oneiric and the uncanny to bring about visions of the world seen from under rather than above, scrutinizing the forgotten, the leftover, and the overlooked. Suspended on a string in the traditional manner of displaying kimonos, the five panels are cut in the shape of actual vacant lots. While one side of each panel is overcrowded with embroidered details depicting the underground life of insects in vivid colors, the other side is spare, bearing only the half-formed letters of the title on a dense dark blue background framed by images of a dog and wild grass.

For this accomplished guitarist who once performed in the now-defunct rock and roll band Anti-Gravity Johnny while swinging in the air as the other musicians played upside down, the key word may very well be "underground." The seemingly anomalous world Ito depicts is a globalized vision born as much out of Osaka's local life and Japanese *anime* as of American psychedelic and hippie youth culture and the artist's own brand of quiet subversiveness.

Claire Tancons

Zon Ito *Vacant Lot* 2003 embroidery on fabric 67 1/2 x 227 1/2 x 3/4 in. (171.5 x 577.9 x 1.9 cm) installed Butler Family Fund, 2003 2003.57 top to bottom, front and back views

Cameron Jamie

American, b. 1969

- - **Exhibitions**
How Latitudes Become Forms: Art in a Global Age
(2003; catalogue, tour)
- - **Holdings**
1 multimedia work

Cameron Jamie's work—a blend of video, performance, sculpture, and drawing—turns a sharp critical gaze on various underground and fringe aspects of American suburban culture, particularly in California's San Fernando Valley, the middle- and working-class suburb where the artist grew up. Using a methodology informed by scientific and forensic anthropology, he explores vernacular rituals such as backyard wrestling and Halloween spook houses, making films and photographs that hint at the significance of these subcultures and their influence on individuals' fictional worlds and fictional selves.

BB (2000) was filmed after a long investigation of the backyard-wrestling phenomenon in southern California, in which teenage boys imitate the moves of their favorite wrestling stars with equal measures of youthful athleticism, sexuality, violence, and aimlessness. For two years Jamie followed groups of young people in the San Fernando Valley, shooting videos, going to their wrestling shows, and integrating himself into their community.[1] Eventually, he abandoned the video footage he'd made and shot *BB* in one afternoon in black-and-white Super 8 film with no sound and edited it in-camera.[2] He added a sound track—the timeless, demented, slow, forceful music of the Melvins— that creates a dreamlike state, reinforcing the nightmarish spectacle of the backyard ritual.[3] "It was very important to show the middle-class utopian suburbs in America as a third-world hell," Jamie says. "*BB* was also a very biographical work that said so much about my own upbringing."[4] The autobiography includes Jamie's long fascination with the spectacle of the World Wrestling Federation, as well as his own earlier performances of one-on-one "apartment wrestling" documented in his videos *The New Life* (1996) and *La Baguette* (1997). In *BB* Jamie takes the documentary format to another level, to what he has referred to as a purgatory state—a middle ground that, in his view, is perfectly embodied in the very notion of the suburb.

BB is one of a trilogy of films that explores quasi-macabre rituals. *Spook House* (2003), shot in Detroit around Halloween, documents residences that have been converted by their inhabitants into haunted houses, dungeons, and torture chambers. The artist relates this phenomenon to the nineteenth-century French Grand Guignol theater, which specialized in productions designed to terrify and sicken viewers through the display of violence and horror. *Kranky Klaus* (2003) looks at a Christmas ritual in rural Austria involving a shaggy creature known as the Krampus, which visits villages to punish those who have misbehaved. Ominous and intense, these three films are "outlets for people to express fantasies and ideas about themselves" and also comment on "ritualized social theatrics in America that people rarely or never acknowledged."[5]

P.V.

Notes
1. Jamie says his many road trips began to feel like the exploration of events on another planet or in a distant universe. "So the title [*BB*] was metaphorical in referencing the scale of something small and mysterious, like a tiny planet, and its double meaning as an ammunition bullet for youth became more meaningful by the time the project had materialized as a Super 8 film." From correspondence with the author, July 28, 2004 (Walker Art Center Archives).
2. The Walker's collection includes a DVD installation version of the Super 8 film.
3. In 2003, the Walker screened *BB* in the Auditorium with a live performance by the Melvins.
4. Quoted in Jens Hoffmann, "Cameron Jamie: Comparative Anatomy," *Flash Art* 36, no. 229 (March/April 2003): 69.
5. Ibid., 68–69.

Cameron Jamie *BB* 2000 Super 8 film transferred to 35mm film and DVD (black and white, sound), sound track by the Melvins; Artist's Proof 1/2 18:20 minutes T. B. Walker Acquisition Fund, 2003 2003.19

Derek Jarman
British, 1942–1994

- - **Screenings**
Of Angels and Apocalypse: The Cinema of Derek Jarman (1986;
publication), Derek Jarman Revisited (1992), Into the Nineties /
World AIDS Day: *Blue* (1993)
- - **Holdings**
7 films, 2 videos

Notes
1. William Horrigan, "Derek Jarman," in William Horrigan, ed.,
Of Angels and Apocalypse: The Cinema of Derek Jarman (Minneapolis:
Walker Art Center, 1986), unpaginated.

Derek Jarman made his first visit to the Walker Art
Center in 1986 for his retrospective Of Angels and
Apocalypse: The Cinema of Derek Jarman. Coming
from a fine arts background and already established
as a painter (he was short-listed for the 1986 Turner
Prize), Jarman invented himself as a filmmaker in 1970
and went on to produce dozens of shorts and features
until his death from AIDS-related complications in
1994. The Walker series was Jarman's first U.S. touring
show, coinciding with the release of *Caravaggio* (1986),
his dazzling meditation on the Renaissance genius.

Nothing if not personal, Jarman's films are driven by
the traditions into which he had been born or entered
and that he would replenish or subvert: the cultural
patrimony inherited as a British citizen; his disposition
as a gay man in the pre- and post-AIDS twentieth cen-
tury; and his self-awareness as a visual artist. Those
preoccupations animate *The Angelic Conversation*
(1985), structured around actress Judi Dench's voice-
over of the fourteen Shakespeare sonnets addressed
to a young man and set to a visual field of lyrical homo-
eroticism unparalleled then in cinema history. As I
wrote at the time of Jarman's visit, the film "feels like
the missing link (stumbled across thirty years late)
between Eisenstein and Anger . . . it's an *urtext* of a
certain homosexual film avant-garde."[1]

Blue (1993) is Jarman's summary—a radical gesture
of producing a feature-length film consisting solely of a
deep blue light, with music, rumination, and conversa-
tion on the sound track. Since art school, Jarman had
admired the artist Yves Klein, and *Blue* uses video tech-
nology (transferred to 35mm film) to approximate the
retinal values of International Klein Blue, the aquama-
rine color indelibly associated with the French painter.
Beyond exemplifying one visionary paying homage to
a forebearer, Jarman's *Blue* is also about an artist star-
ing down his own impending death—it was Klein's blue
that Jarman professed to see while being administered
eyedrops to fend off the blindness descending upon
him from the ravages of AIDS.

Blue would come to exist as a book and as a radio
program, as an element in a live performance and as
a gallery installation; its first appearance at the Walker
was as a 35mm film screened on December 1, 1993,
for World AIDS Day. In 1986, as we walked across
Loring Park from his hotel toward Hennepin Avenue
in Minneapolis, Jarman told me he was HIV positive.
His days on earth between then and his death in 1994
are what *Blue* so serenely resolves.

Bill Horrigan

Derek Jarman *The Angelic Conversation* 1985 35mm film (color/black
and white, sound) 78 minutes The Edmond R. Ruben Film and Video Study
Collection

Alexej Jawlensky

Russian, 1864–1941

- - **Exhibitions**

Expressionism 1900–1955 (1956; catalogue, tour), *Paintings from the Stedelijk Museum, Amsterdam* (1959; catalogue, tour), *Franz Marc and the Blue Rider* (2001)

- - **Holdings**

1 painting

Alexej Jawlensky *Akt* (*Nude*) 1912 oil on board 20 7/8 x 19 1/2 in. (53 x 49.5 cm) Donated by Mr. and Mrs. Edmond R. Ruben, 1995 1995.72

Neil Jenney

American, b. 1945

- - **Holdings**

1 painting

Neil Jenney *Man and Task* 1969 acrylic on canvas 61 x 68 x 3 1/2 in. (154.9 x 172.7 x 8.9 cm) framed T. B. Walker Acquisition Fund, 1992, by exchange, 1993 1993.96

Lisa Jevbratt

Swedish, b. 1967

- - **Commissions**
A Stillman Project for the Walker Art Center (http://gallery9.walkerart.org/jevbratt/) (1998), *16 Sessions* (with C5) (http://www.walkerart.org/gallery9/c5/) (1999)
- - **Online Exhibitions**
The Shock of the View: Artists, Audiences, and Museums in the Digital Age (1999), *Art Entertainment Network* (2000)
- - **Holdings**
1 net artwork

Lisa Jevbratt is a cartographer of cyberspace. *A Stillman Project for the Walker Art Center* (1998), *16 Sessions* (with C5, 1999), and *1:1* (1999)[1] all take innovative approaches to visualizing the vast quantity of data that is available through the Internet and tackle the philosophical issues involved in mapping essentially unbounded, dynamically changing virtual space.

Trained at traditional art academies in Sweden, Jevbratt went on to study philosophy at Lund University, where she became immersed in issues of representation. As she puts it, "It seemed like the only way to do interesting art would be by working more directly with the computer as a language machine, creating systems that would embody, rather than represent, the implications of computer technologies on culture."[2]

In 1998, the Walker Art Center commissioned Jevbratt's *Stillman Project*. It is named after a character in Paul Auster's novel *City of Glass*, in which the detective Quinn is hired to follow Peter Stillman around New York City. For thirteen days, despite dogged pursuit, he cannot decipher what Stillman is up to. But when he traces his peregrinations on a map of the city, he sees that Stillman is "writing" a letter each day, which over time is composing a message. As Jevbratt says, "Only when Quinn maps his information differently does it become meaningful."[3]

"Stillmanizing" the Walker's site meant installing parasitic software that piggybacked on the Web server and had two components. When a visitor or, as Jevbratt prefers, a "mingler" first opened a page on the site, he or she was asked to respond to this question:

Which of the following best represents the nature of the Internet?

1. Information: The network is a linkage for consumption. [red]
2. Discourse: The network is a linkage for discussion. [green]
3. Action: The network is a linkage for engagement. [blue]

Based on the mingler's answer, he or she was assigned a color, which then additively modified the color of any hyperlink on the site the mingler had clicked on. Subsequently, new minglers could follow links that were the color of the answer they most identified with, following a collaboratively produced trail of virtual bread crumbs—and modifying it themselves as they navigated. Or they could open an abstract

representation of the site that mapped all pages according to their predominant color.

Instead of the map being a tool to decode the message, as in Auster's text, the message—minglers' online wanderings—becomes a way to dynamically generate the map, which in turn is used to understand the virtual territory, which is then modified by its use, and so on, recursively.

Steve Dietz

Notes
1. For more information about *1:1*, see http://aen.walkerart.org.
2. Jevbratt, interview with the author, February 1999 (http://gallery9.walkerart.org/jevbratt/).
3. Lisa Jevbratt, "The Stillman Projects/Concept," http://spike.sjsu.edu/~jevbratt/stillman/YSH/concept.html.

Lisa Jevbratt Selection from *A Stillman Project for the Walker Art Center* 1998 digital media Digital Arts Study Collection

Jasper Johns

American, b. 1930

In 1958, at his first solo exhibition in New York City, Jasper Johns dazzled the art world with startlingly beautiful paintings and drawings of unexpectedly mundane images: targets, numerals, and the American flag. His work emerged at a time when Abstract Expressionism still held sway as the dominant style, and Johns' canvases, with their gorgeously tactile surfaces built up of encaustic and collage, retained the painterly qualities of that style. His imagery, though, was obstinately commonplace, without a hint of the transcendental emotion that the previous generation had hoped to convey through abstraction. Critics of the time wrote about his work as a continuation of Dada (the irreverent "anti-art" movement of the early twentieth century), and in fact Johns has been deeply engaged by the thinking of Marcel Duchamp, whose "readymades" seem to be conceptual precursors for Johns' paintings and sculptures of such banalities as alphabets, beer cans, and flashlights.[1] But rather than looking backward to Dada, Johns was in fact at the forefront of a new sensibility that, within a few years, would produce Pop Art.

Johns himself went on to other things. His work turned darkly melancholy in the mid-1960s, in expansive monochromatic canvases that included cryptic texts, found objects, and fragmented imagery. These pensive works spoke evocatively but never explicitly about the pain of loss and the difficulty of human relationships. During the 1970s, he pursued a rigorous exploration of the formal aspects of picture-making through an abstract hatch-mark motif he had noticed on a passing car. Personal content returned in the 1980s in dense, scrapbooklike compositions made from a miscellany of images including his own works; quotations from Picasso, Holbein, and other artists; favorite objects; his studio and living spaces; and childhood memories. The reintroduction of personal iconography—now in a more open way—was a result of a conscious decision on Johns' part. In 1984 he admitted, "In my early work I tried to hide my personality, my psychological state, my emotions . . . but eventually it seemed like a losing battle. Finally, one must simply drop the

reserve."[2] Flags and targets continue to crop up in these late works, but they sit side-by-side with depictions of family photographs and childhood mementos.

Johns' working method has consistently been based on theme and variation—once he adopts a motif, he reworks it in as many ways as he can conceive, changing scale, medium, or color; dissecting its parts; mirroring or shifting its position within the composition, and so on. These motifs recede and then reappear in a new form, sometimes over decades: the flag, for example, which he first used in 1954, has been a constant presence, appearing as recently as 2000 in a trio of linoleum-cut prints. Johns is enormously curious about how changing one aspect of a thing can alter how we see and experience it: "I'm concerned with a thing's not being what it was, with its becoming something other than what it is, with any moment when one identifies a thing precisely and with the slipping away of that moment."[3] This fascination with change, and his strong preference for images he does not have to invent, have led him to use a number of forms traced from other images, including one whose source he has not revealed: the so-called Green Angel, the principal motif in the Walker Art Center's 1990 painting of the same name. Hovering somewhere between abstraction and representation, it is aggravatingly opaque, yet it makes the entirely reasonable demand that we start by seeing it for what it is—a picture—instead of wondering what it is a picture of. Johns' work rewards this kind of patient, careful looking.

Given his preoccupation with change, perception, and memory, printmaking—a medium that lends itself to extensive reworking and variation—had a natural appeal for Johns. He made his first print in 1960, a scribbly lithographic rendering of a target, and has since made more than 350 editions using dozens of techniques. The trajectory of his graphic oeuvre mirrors that of his paintings; thus his early prints concentrate on images of "things the mind already knows."[4] In addition to that first target, he has depicted flags, alphabets, the numerals one through nine, and common household objects like lightbulbs and coat hangers. During

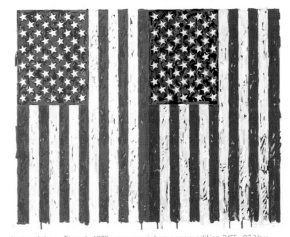

Jasper Johns *Flags I* 1973 screenprint on paper; edition 3/65 27 3/8 x 35 1/2 in. (69.5 x 90.2 cm) Published by Jasper Johns and Simca Print Artists, Tokyo Gift of Judy and Kenneth Dayton, 1988 1988.251

the late 1960s and 1970s, he experimented with new techniques such as the softly graduated hues of the "rainbow-roll"; he was also among the first to use offset printing processes to make fine-art prints. Since then he has become known as a virtuoso graphic artist, with an output that ranges from enormously complex screenprints with dozens of colors to large-scale Carborundum prints to simple, one-color linoleum cuts. The Walker's holdings include a complete archive of his prints—the only one in a public collection— which was the basis for two traveling exhibitions: *Jasper Johns: Printed Symbols* (1990) and *Past Things and Present: Jasper Johns since 1983* (2003).[5]

The burgeoning interest in printmaking during the 1960s was among the many shifts in a postwar art world in which the tenets of modernism—purity of media, truth to materials, and sanctity of authorship— were called into question. Many artists found it natural and productive to work across disciplines and in collaborative situations. Johns drew particular inspiration from two key innovators in the performing arts: composer John Cage, whose music mined the properties of ambient sound, noise, and silence; and choreographer Merce Cunningham, whose dance took a similar stance against artifice, concerning itself instead with the natural, uninflected movements of the human body. Johns met both Cage and Cunningham through Robert Rauschenberg, and the four became close friends who traded ideas and occasionally worked collaboratively.

During the 1960s, both Rauschenberg and Johns served as set designers for Cunningham's dance company.[6] One of Johns' first projects was *Walkaround Time* (1968), for which he created costumes and a set comprising seven transparent plastic boxes bearing screenprinted designs based on the imagery of Duchamp's *The Bride Stripped Bare by Her Bachelors, Even (The Large Glass)* (1915–1923). The transparency of the set elements is a reference to the glass of Duchamp's original sculpture, which slides into focus at the end of the piece when the dancers move the lightweight boxes into a configuration matching the composition of *The Large Glass*. The mechanized eroticism of Duchamp's work is echoed in Cunningham's choreography, which includes passages of turning, rolling, and interlocking movement for two or three dancers, and a striptease performed while running in place.[7] The Walker acquired Johns' original set pieces from the Cunningham Dance Foundation in 2000,[8] finding it emblematic of an era of adventuresome, interdisciplinary experimentation, but also of the institution's long relationship with three artists—Johns, Cunningham, and Duchamp—who have radically changed the course of twentieth-century cultural history.

J.R.

Notes

1. Johns has said he was unfamiliar with Duchamp's work until after his 1958 solo exhibition. Kirk Varnedoe, *Jasper Johns: A Retrospective*, exh. cat. (New York: Museum of Modern Art, 1996), 386, n. 114.

2. Johns, interview with April Bernard and Mimi Thompson, "Johns on . . . ," *Vanity Fair*, February 1984, 65.

3. Johns, quoted in G. R. Swenson, "What Is Pop Art? Part II," *Artnews* 62, no. 10 (February 1964): 43.

4. Johns, quoted in "His Heart Belongs to Dada," *Time*, May 4, 1959, 58.

5. The bulk of the prints came through two gifts: master printer Kenneth Tyler donated 92 works in 1985, and another 227 were added in 1988 through a gift by Judy and Kenneth Dayton. Since that time, Johns has donated one example of each print he makes.

6. Rauschenberg was resident designer from 1954 to 1964, and Johns was appointed artistic advisor in 1967.

7. See Ned Carroll and Sally Banes, "Cunningham and Duchamp," in Germano Celant, ed., *Merce Cunningham* (Milan: Edition Charta, 1999), 179–185; and Susan Sontag et al., *Dancers on a Plane: Cage, Cunningham, Johns*, exh. cat. (New York: Knopf, with Anthony d'Offay Gallery, London, 1990).

8. The company retains a working version of the set, which they use when performing the dance. The original pieces were meant to be inflated, but due to deterioration of the plastic material they can no longer be filled with air. When exhibited they are stretched over armatures of lightweight steel tubes inserted in the original rod pockets.

Jasper Johns *Light Bulb* 1969 embossed lead; Gemini II from an edition of 60 38 1/2 x 16 3/4 in. (97.8 x 42.6 cm) Published by Gemini G.E.L., Los Angeles Gift of Kenneth E. Tyler, 1985 1985.684

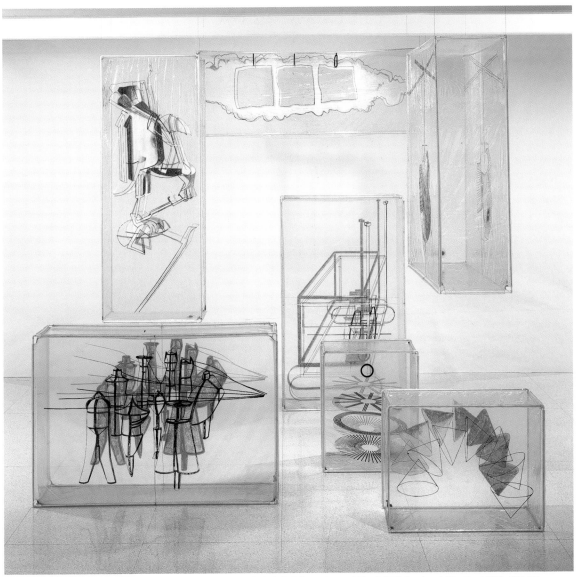

Jasper Johns Set elements for *Walkaround Time* 1968 plastic, paint installed dimensions variable T. B. Walker Acquisition Fund, 2000 2000.404

Jasper Johns *Flashlight* 1960 bronze, glass; edition 3/3 4 5/8 x 7 3/4 x 4 1/4 in. (11.8 x 19.7 x 10.8 cm) Gift of Judy and Kenneth Dayton, 1998 1998.111

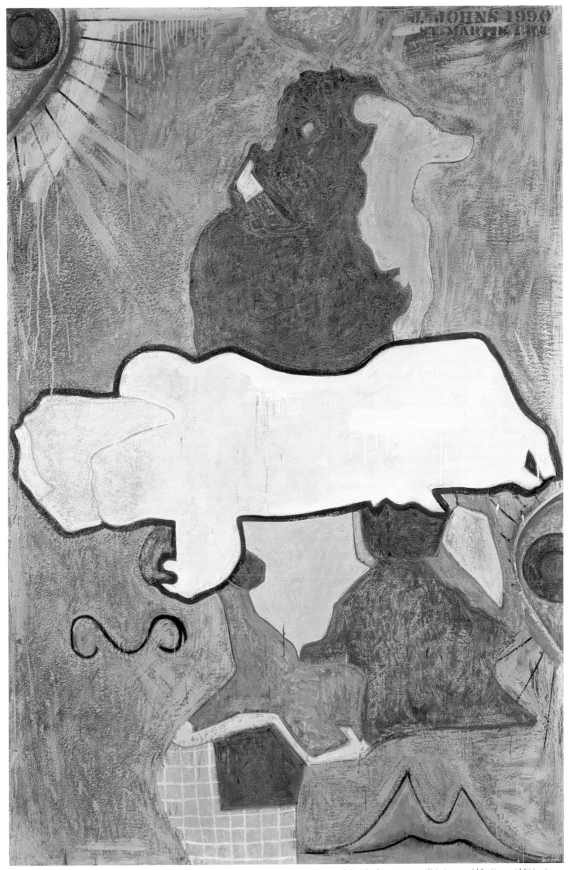

Jasper Johns *Green Angel* 1990 encaustic, sand on canvas 75 1/8 x 50 3/16 in. (190.8 x 127.5 cm) Anonymous gift in honor of Martin and Mildred Friedman, 1990 1990.205

Subject: A Song

"Out of the crooked timber of humanity, no straight thing was ever made." —Immanuel Kant

Out of the pills and the pencils, out of toothbrushes and night guards, out of CDs and Altoids, out of feathers and staplers, out of time clocks and syllabi, out of tissues and scissors, nothing straight has ever been made.

Out of computers and mouse pads, out of CDs and CD-ROMs, out of pens and sedentary mentalisms, out of philosophers and lampshades, out of pennies and a penis, out of calculators and prescription pills, out of envelopes and white envelopes, out of industrial shelving and the moonlight, nothing straight has ever been made.

Out of Venetian blinds and dream-catchers, out of dreams of Lichtenberg and the desire of art history, out of wars and branches, out of shadows of my fingers and your hand, out of your riveting nipples and her weightless eyes, out of rockets and buttons, out of the number 5 and out of a red rhino, out of moustaches and Mona Lisas, out of black numbers, nothing straight has ever been made.

Out of colored sand and autumnal trophies, out of chaos and beds, out of a crooked woman and the straight edge of a crystal, out of jade and dust, out of mankind's poor penis and the archaic song of sacrifice, out of Pluto, Medea, and Goofy, out of black boots and van Gogh's shoes, out of a battered self-portraiture, nothing straight has ever been made.

Out of baseballs and dresser drawers, out of blue jays and imitation, out of snow inside worlds and the universe in a walnut, out of no place and the best place, out of an image of hope and the abjection of jargon, out of sheaths and blossoming antennae, on the day without adjectives, out of the absolutely necessary meeting of the girl and the swan, bestial for the swan, nothing entirely straight has ever been made.

Out of words, out of dictionaries and guesses, out of the contingent letter and the space between letters, out of the tongue and the T, nothing straight has ever been "built."

Out of the slightly ruined forest, out of the desire that covers me and the strangled globe, out of the forced marriage of the feather, the pen and the eraser fluid, out of the shadows of light, out of the almost invisible sheath and the dream of tactility, out of the swan and the sign, out of the dream and the game and the impossible, on the day of the permanent flaw, with the heat of it, nothing entirely straight has ever been made.

David Shapiro

Jasper Johns *Untitled* 1997 intaglio on paper; Artist's Proof 3/15 from an edition of 49 20 x 25 3/4 in. (50.8 x 65.4 cm)
Published by Universal Limited Art Editions, Bay Shore, New York Gift of the artist, 1998 1998.102

Larry Johnson

American, b. 1959

- - **Exhibitions**

American Tableaux (2001; publication, tour)

- - **Holdings**

1 photograph, 1 photographic suite

Larry Johnson started out as a painter, but by the early 1980s—and having graduated from California Institute of the Arts—he was making photographs, despite the fact that he "always liked pictures, but never liked 'photography.'"[1] Johnson's photography is grudgingly photographic, borrowing the medium's capacity to duplicate glossy prints, but dispensing with the messy business of lenses, f-stops, and deciding what to shoot.

The Walker Art Center owns *Untitled (Movie Stars on Clouds)* (1983), a key early work. Six prints spell out the names of cinematic icons from the mid-1950s and early 1960s in italicized serif type over indistinct backgrounds, like the end credits of some lost classic: Montgomery Clift, Sal Mineo, Clark Gable, Natalie Wood, James Dean, Marilyn Monroe—stars of either *Rebel Without a Cause* (1955) or *The Misfits* (1961). The work contains many of the traits common to Johnson's practice ever since, not least the most-celebrated invention of his native southern California: celebrity itself. The mingling narratives of actor and acted-out—those life-imitating-art clichés—surface as we realize that all of the stars featured met with tragic demises, whether murdered, drowned, or drug-induced. The inclusion of Mineo, who was ostracized by Hollywood for his homosexuality, and Clift, who remained a wreck of denial, anticipates the more overtly gay context of Johnson's later work. Yet, as David Robbins has suggested, there is further significance in that all these stars were somehow at a break-even point of stardom, whereas today,

"after nearly a century of existence, stars have come to take up more cultural space than they can support. There is a star-deficit. Star mannerism has set in."[2]

Johnson made such mannerism his specialty. His candy-colored word-works of the 1980s—at first purloined texts from supermarket tabloids and then self-concocted—would delight in a poetry of celebrity preening, bitchy testimonials, wild-child-alcoholic confessions, and self-justifying therapy froth, all in an anonymous first-person voice. *Untitled (I Had Never Seen Anything Like It)* (1988) deliberately flirts with the possibility that it's a Johnson "exclusive," while its porno-narrative mocks both the appetite for "outings" of movie stars and, with its nonsensical letter coloring, the suspicion that it might host some secret-coded "gay language."

M.A.

Notes

1. Johnson, quoted in David Rimanelli, "Larry Johnson: Highlights of Concentrated Camp," *Flash Art* 23, no. 155 (November/December 1990): 121.
2. David Robbins, "Larry Johnson: Stars," *Aperture* 110 (Spring 1988): 46.

ON ONE OCCASION WHEN I WAS WALKING SUNSET BOULEVARD, AN ABSOLUTELY BEAUTIFUL MUTED GREEN CAR PULLED UP BESIDE ME. I HAD NEVER SEEN ANYTHING LIKE IT BEFORE, BUT I LEARNED IT WAS A JAGUAR XKE, AND I RECOGNIZED THE YOUNG MAN WHO WAS DRIVING IT. FOR PURPOSES OF OUR STORY, WE WILL CALL HIM QUINT VANTAGE, SINCE HE IS A WELL-KNOWN AND HIGHLY SUCCESSFUL ACTOR WHOSE SUCCESS IS LARGELY DEPENDENT UPON HIS AIR OF MACHISMO. "HOW FAR YOU GOING?" HE CALLED OUT. I TOOK ONE LOOK AT HIM AND ANSWERED, "ALL THE WAY."

Larry Johnson *Untitled (I Had Never Seen Anything Like It)* 1988 color coupler print; Artist's Proof 1 from an edition of 3 45 3/4 x 90 3/4 x 2 in. (116.2 x 230.5 x 5.1 cm) framed T. B. Walker Acquisition Fund, 1996 1996.175

Lester Johnson

American, b. 1919

-- **Exhibitions**

Selections from the Martha Jackson Collection (1975; catalogue)

-- **Holdings**

1 painting, 1 drawing

Lester Johnson *Figures with Columns* 1965 oil on canvas 78 x 92 in.
(198.1 x 233.7 cm) Gift of Mr. and Mrs. David Anderson, New York, 1978
1978.2

Bill T. Jones
American, b. 1952

- - **Commissions**

The Promised Land (1990), *Still/Here* (1994), *Loud Boy* (2000), *The Table Project* (2001), *Lord Buckley* (2005)

- - **Performances**

Break (with Maria Cheng) (1981; world premiere), *Valley Cottage* (1981), *Secret Pastures* (1985), *D-Man in the Waters* (1990), *The Gift/No God Logic* (1990), *Perfect Courage* (with Rhodessa Jones/Idris Ackamoor) (1990), *The Promised Land* (1990; world premiere), *Perfect Courage* (1991), *Still/Here* (1994), *We Set Out Early . . . Visibility Was Poor* (1998), *The Breathing Show* (1999), *You Walk?* (2001), *The Table Project* (2001; world premiere), *Another Evening* (with Cassandra Wilson) (2003), *As I Was Saying . . . An Evening of Text and Music with Bill T. Jones and Friends* (2005; world premiere)

- - **Exhibitions**

Art Performs Life: Merce Cunningham/Meredith Monk/Bill T. Jones (1998; catalogue)

- - **Residencies**

Bill T. Jones (1981, 2000, 2001, 2005), Bill T. Jones/Arnie Zane Dance Company (1990, 1998, 1999)

Following the New York premiere of *Still/Here* in 1994, critic Arlene Croce accused Bill T. Jones of producing "victim art," a work she said was impossible to critique because it was drawn from the painful struggles of real people facing life-threatening illnesses.[1] The review set off a firestorm: accusations and countercharges on the "appropriate" content of art raged for months, moving beyond art circles into the broader public. The debate was both exhilarating—that art could matter so much in modern times that people would rush to the battle lines—and infuriating, that a critical establishment would try so hard to keep art within rarefied, proscribed boundaries. Ironically, the misunderstood work (which Croce never saw) was one of austerity and grace, humanity and power. Jones, as he would at other times in his career, tapped the zeitgeist, creating a defining moment for the culture of our times.

A courageous, at times conflicted choreographer, Jones has—across a career comprising some seventy-five dance works—deftly balanced social/political concerns with abstract works of formal beauty and complexity. Together with partner Arnie Zane, he helped introduce elements now commonplace in contemporary dance: partnering between men; the casting of dancers of all shapes, sizes, and colors; involvement of entire communities (professional performers and amateurs alike) in the creation of key works; the use of spoken word and movement simultaneously; the exploration of autobiographical truths (presaging much of the identity politics of the 1980s and 1990s); and the use of a full amalgam of movement styles and collaborative strategies.

The struggles between the literal and the abstract, the political and the formal, the angry and the cool have always fed Jones' work.[2] The son of migrant Southern Baptist farmworkers, Jones began unorthodox explorations of contact improvisation and personal revelation soon after meeting photographer and dancer Zane when they were college students in 1971.

Many commented on their contrasting appearances—Jones, a tall, muscular black man, partnering in art and life with Zane, a small, wiry white man. They cut an indelible image in downtown New York dance circles in the late 1970s. Rejecting the austere prescriptions of the Judson Dance innovators by embracing narrative, pop music, fashion, sets, costumes, and full theatricality, Jones and Zane began joining forces with a remarkable range of collaborators to make new work.[3]

The relationship the Walker has enjoyed with Jones is a rich one, spanning decades. He was first invited for a summer residency in 1981, at which time he premiered *Break*, an outdoor duo work (performed with local dancer Maria Cheng) on a stony beach on Nicollet Island. That fall, he came back with Zane to perform in the New Dance USA Festival. He has returned, usually with his full company, twelve more times between 1983 and 2005, developing community-based productions, researching and mounting new solo and large-scale company works, hosting public discussions, curating exhibitions, performing in schools, and teaching master classes. His September 1998 residency coincided with the exhibition *Art Performs Life: Merce Cunningham/Meredith Monk/Bill T. Jones*, which showcased sets, costumes, videos, installations, artwork, and sound from his career to that point. The engagement marked the start of an intensified eight-year annual commitment between the Walker and the Bill T. Jones/Arnie Zane Dance Company to make Minneapolis a "home away from home."

Soon after Zane's death due to AIDS in 1988, Jones responded by making an unforgettable, uncompromising work that would take on most, if not all, the issues that fed his rage: slavery, racism, homophobia, American history, AIDS, religion. The Walker offered the space and the resources to develop and present the work's most provocative segment, the final act called *The Promised Land*,[4] which would grow into a massive community-based initiative. After an angry, jarring opening and an overload of sights, sounds, and movement,[5] the work ended with what Jones called "my vision of heaven, a vision of peace and acceptance"[6]—sixty community members of all ages and races joined the company onstage, standing together nude without shame or fear, facing the audience and singing.[7] Sprawling, messy, enthralling, and audacious, the three-and-one-half-hour *Last Supper at Uncle Tom's Cabin/The Promised Land* helped to transform a generation of contemporary performing artists in America, their producers and presenters, and the communities to which the piece toured, raising the bar on what is possible to attempt onstage.

Sometimes it is not the monumentally scaled, but the modest and intimate that can produce compelling results. In March 2001, Jones returned to make *The Table Project*, an eight-minute dance for six people, set to a live performance of Franz Schubert's Trio in E-flat Major, op. 148 *Notturno*.[8] Exploring the conventions and expectations built around age and gender, this playful work consisted of the same movements performed four times consecutively by community members, first by a group of men aged fifty to sixty-five, then by girls aged eight to eleven, then boys, and

finally older women. Hand-in-hand, they stepped up and over the surface of a sculptural table designed by Bjorn Amelan. "The audience was an overflow, midday audience alive with families and children," Jones writes about the premiere, which was held in the building's outer lobby. "There was poignancy and great fun in watching such diverse groups of individuals watching this ritualized demonstration of cooperation."[9] The touching performance became a new vehicle by which Jones and his company could involve communities with their work while on tour. Audiences from New York City to Berkeley were uniformly fascinated and moved by its simple statement, which confounded stereotypes and offered a celebration of shared humanity.

Jones has spent a lifetime confronting the issues that, as he has often said, "unite us outside of the aesthetic"—the cultural and historical conflicts that continue to define the country and its people. In recent decades, he and the Walker have grown up together. His often painful struggles to balance what he believes are the responsibilities of an engaged citizen with a pure commitment to his art have served only to make his work richer, more emotionally engaged, and increasingly profound.

P.B.

Bill T. Jones *The Table Project* Walker Art Center, 2001

Notes

1. Arlene Croce, "Discussing the Undiscussable," *New Yorker*, December 26, 1994, 54–60.
2. Bill T. Jones, interview with Fletcher Jones, "The Sincerest Form of Flannery," *New York Times*, February 1, 2004, sec. 2. "I am caught in an ambiguous and ambivalent place. I am simply an artist making meaning out of the language of the era that has formed me. . . . Taking issue with power—I think that is what all art tries to do. No, I am not a polemicist. If anything, I am a poet. And I am trying to, without hitting you over the head with anything, ask you to look carefully at what your attitudes are."
3. Jones' collaborators have included musicians Max Roach, John Oswald, Jessie Norman, Cassandra Wilson, Daniel Johnson, Fred Hersch, Vernon Reid; visual artists Gretchen Bender, Jenny Holzer, Keith Haring, Huck Snyder, Robert Longo, Cletus Johnson; fashion designers Willi Smith, Liz Prince, Isaac Mizrahi; media artists Paul Kaiser and Shelly EshKar; novelist Toni Morrison, and many others.
4. Created in residence in the Twin Cities with co-commissioners and copresenters Northrop Auditorium and the University of Minnesota Dance Department.
5. The work featured huge, Day-Glo Africa-meets-vaudeville sets. Onstage, Jones' elderly and devout mother prayed for her son, who danced beside her. Also included was the real-life interrogation of a local minister by Jones about the existence of God.
6. Jones, interview with Burt Supree, "Four Points of the Compass," *BAM Next Wave Journal* (1990).
7. Ibid. "But these were the nineties, not the sixties. Two men naked on stage together implies sex, the sharing of bodily fluids, which is a no-no. Children and adults on stage naked? What about fat people? Are they allowed to show themselves naked? What about old people?"
8. Performed by Minneapolis' Bakken Trio.
9. Quoted in "The Table Project," 2002, excerpted from the Bill T. Jones/ Arnie Zane Dance Company Web site, http://www.billtjones.org/ people/index.html.

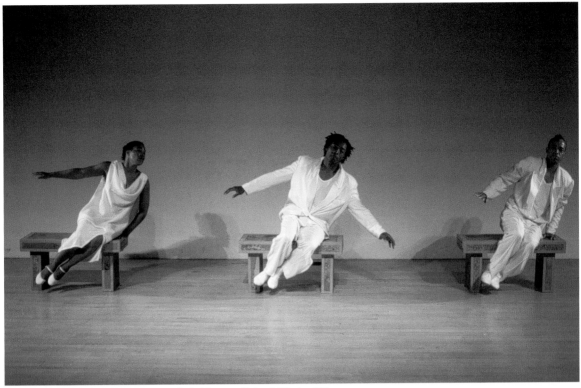

Bill T. Jones/Rhodessa Jones/Idris Ackamoor *Perfect Courage* Walker Art Center, 1990

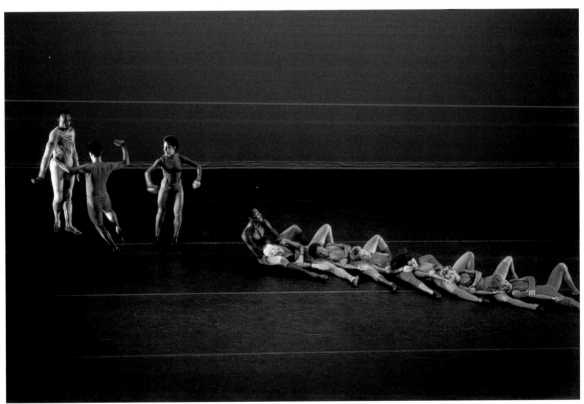

Bill T. Jones/Arnie Zane Dance Company *Secret Pastures* Ordway Studio Theatre, St. Paul, 1985

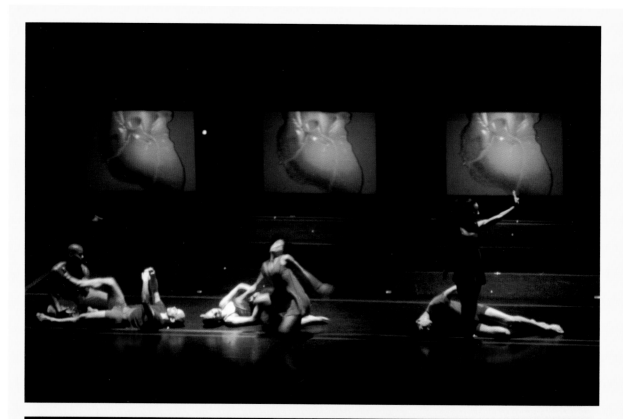

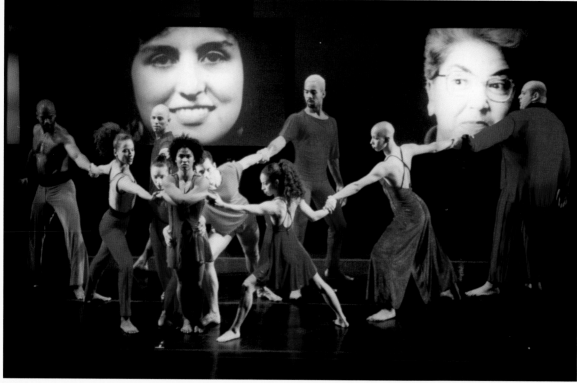

Bill T. Jones/Arnie Zane Dance Company *Still/Here* University of Michigan, Ann Arbor, 1995

"Still/Here," Still.

Gwendolyn Brooks' poem "Infirm"[1] is a prayer that precisely names Bill T. Jones' overall project:

> *Everybody here*
> *is infirm.*
> *Everybody here is infirm.*
> *Oh. Mend me. Mend me. Lord.*

Though the AIDS crisis provides impetus and subject matter for much of Jones' work, he forms essential and enduring questions that have wide-reaching relevance. Just as Brooks reminds us that "we are all infirm," in Jones' work mortality twinned with fierce living is the common denominator of the polis. Regarding his dance *Still/Here*, Jones writes: "The resources necessary to cope with life-threatening illnesses are the same as those necessary for truly owning one's life."[2] The work explores ways that we are simultaneously mortal and fully alive.

I don't think I fully understood that dichotomy in the 1980s, when the epidemic was the urgency everywhere and it seemed we were always waiting for the other shoe to drop. "HIV-positive" means something different now than it did in the eighties or in 1994, when Jones made *Still/Here*. Remembering the mid-1980s for me is remembering being part of a dancing community in Washington, D.C. So many of those men are now dead of AIDS-related illnesses, lustrous young black men like Eddie and David, big brothers, tutors in fabulosity who spun, glittered, and never grew old. Jones' still/here dancing body testifies to something else: endurance, work, self-care, scientific progress, perhaps genetics, sheer good fortune, so much I do not know. His creative process works toward the truest questions and then builds a movement vocabulary from the kinetic explorations of those questions. Rather than ask, "Do you believe in God?" he asks, "What does your god look like?" Now there is a question. He understands physical gesture profoundly, turning quotidian gestures into things danced, repeatable, and iconic.

Jones continually returns to community, its struggles and best hopes. *Still/Here* shows so many moments where communities form and fray. A woman who has just received an HIV-positive diagnosis surrenders to the arms of friends, then wrenches away. A man whose mother has just died of cancer argues bitterly with an aunt, flat hands turned palm-side out to deflect her words, protecting the vulnerable throat. Knots of bodies fall together, then fling apart. But Jones continues to arrange dancers in circles and move bodies in relationship to one another. The movements of his soloists are beautiful and rich, but most interesting, and persistent, is when and how he brings those individuals imperfectly, infirmly together.

Jones is a gorgeous dancer, but he is not a supersonic dancer. The whisper of stiffness in his body's movement articulates the aspect of dance and living that is strive, sweat, aspiration, and hope. Danced beauty need not be solely supersonic. I imagine what it feels like to be in his body, warming it in the morning, bringing it to suppleness and up to the expressive challenges of the day. I feel similar emotion in watching Mikhail Baryshnikov dance now, the famously supersonic body now compromised by injury, but finding in contemporary modern dance a movement vocabulary that in part allows us to witness the creep of mortality that does not eclipse the need to dance. As my own body remembers all that it can no longer execute, I remember my dancing friends, that community ever-reconvened in Jones' work, his circles of human beings. Who among us is not in some way infirm, patched back together, and still/here?

Elizabeth Alexander

Notes
1. Gwendolyn Brooks, *Blacks* (Chicago: Third World Press, 1987), 512.
2. Bill T. Jones with Peggy Gillespie, *Last Night on Earth* (New York: Pantheon Books, 1995), 252.

Donald Judd
American, 1928–1994

- - **Commissions**
untitled (1971)
- - **Exhibitions**
Eight Sculptors: The Ambiguous Image (1966; catalogue),
14 Sculptors: The Industrial Edge (1969; catalogue), *Works for New Spaces* (1971; catalogue), *Artists' Books* (1981)
- - **Holdings**
7 sculptures, 2 edition prints/proofs, 3 portfolios of prints,
1 multiple, 1 poster

Donald Judd's name is synonymous with Minimalism. Though he fiercely contested the identification throughout his career, Judd nevertheless became the standard against which the diversity of Minimalist practice was measured. In one recent study, the history of Minimalism is divided into "First Encounters" (1959–1963), "High Minimalism" (1964–1967), and "Canonization" (1967–1979)[1]—phases that may well describe the developmental trajectory of Judd's work. With each one-person exhibition in the 1960s—at the Green Gallery in 1963 and the Leo Castelli Gallery in 1966—Judd's work seemed to pole-vault to a higher level of rigor and refinement. Already in 1968, he was given a mid-career survey at the Whitney Museum of American Art in New York, a feat that signified a triumph not only for the artist but also, in a way, for Minimalist art as a whole. In the catalogue, exhibition curator William C. Agee characterized Judd's work as "one of the most original and stunning accomplishments of the 1960s" and declared that "the breadth of Judd's accomplishment lies . . . not as the center of a movement, nor as part of an ideological position, but as a series of unique works of high and individual quality."[2] What is striking about this assertion is the absence of the appellation "Minimal" or "Minimalism" in the essay, which by then had stuck, notwithstanding Judd's and other artists' distaste for it.

In the same year, Gregory Battcock, the energetic, quick-study editor at Dutton, Co., came out with *Minimal Art: A Critical Anthology*, which collected critical essays and articles on Minimalism. As much as it attempted to define the emergent movement and, by doing so, contributed to its canonization, Battcock's selection of writings and accompanying images, put together like a report by an embedded journalist, was a mixed-bag affair. In the introduction to the 1995 reprint of the anthology, Anne M. Wagner writes: "Battcock missed the mark as much as he hit it, if sniffing out the historically significant is taken to be the best description of his goal."[3] For Wagner, this odd mixture means that "minimal art was evidently, in 1968, a loose and capacious enough term."[4] The canonization of Minimalism was, then, far from a secure process. In fact, it was a paradoxical phenomenon—one in which its practitioners and cynics came to agree on its ascendancy, while there was no one opinion on its critical purchase. What mattered for Judd about that particularly equivocal art-historical turning point was that his being in the center of it mattered very little.

Battcock's anthology missed the mark by omitting Judd's "Specific Objects" (1965), the essay that remains a theoretical keystone of Minimalism. "Specific Objects" starts with a daring declaration: "Half or more of the best new work in the last few years has been neither painting nor sculpture."[5] The statement points to a path Judd was paving for himself, somewhere between the two mediums that were privileged in modernism and had become increasingly exhausted of innovative possibilities. Judd's main objection to painting, figurative or abstract, was its illusionism, the technique of suggesting another space on the flat surface and redemptive qualities beyond the pictorial. Figurative representation, together with metaphor and allegory in abstraction, was suspect: Judd asserted that "real space" was "more powerful and specific than paint on a flat surface." Although "real space" is "three dimensions," it does not mean that sculpture automatically resolves the problems of painting. In fact, most contemporary sculpture was composed of parts and turned aesthetic experience into one about the relationship of parts to the whole. For Judd, singleness or wholeness was a key quality he sought in his three-dimensional specific objects.

Between 1966 and 1971, concurrent with the period of "High Minimalism" segueing into "Canonization," Judd participated in three group shows at the Walker Art Center. His works in the Walker's collection, which range in date from 1965 to 1971, demonstrate the progressive condensation of his approach. By the time of the exhibition *Eight Sculptors: The Ambiguous Image* (1966), he had already started using synthetic, industrial materials—the list of which would eventually include aluminum, stainless steel, cold- and hot-rolled steel, galvanized iron, plexiglass, and brass—and was having his works professionally fabricated. Untitled (1965), a galvanized iron "progression" (the artist's term) sprayed in red, is a horizontal beam with four round-ended "bull nose" projections, whose widths grow in size, from left to right, in 1 1/2-inch increments, interspersed by three cubic recessions that correspondingly decrease in size. Three years later, the show *14 Sculptors: The Industrial Edge* included a number of artists working in the vein of Minimalism,[6] and one of the works Judd exhibited was untitled (1968), a rectangular box sitting directly on the floor. It is pierced longitudinally through the center, and the four sides are constructed of blue plexiglass. The two lateral open ends, shaped like an empty picture frame, are finished in stainless steel. On the one hand, the piece embodies the oft-cited quip made by Judd's contemporary, painter Frank Stella, "What you see is what you see." These words suggest how Minimalist work forecloses interpretive potential with a strictly self-referential materiality and, more specifically, may well describe the way in which form is content and form is structure in Judd's work. On the other hand, Judd liked colored plexiglass because it "has a hard, single surface and the color is embedded in the material. In some cases, it also gives access to the interior."[7]

Judd was invited again to show in *Works for New Spaces*, the first exhibition in the Walker's new Edward Larrabee Barnes–designed building that opened in

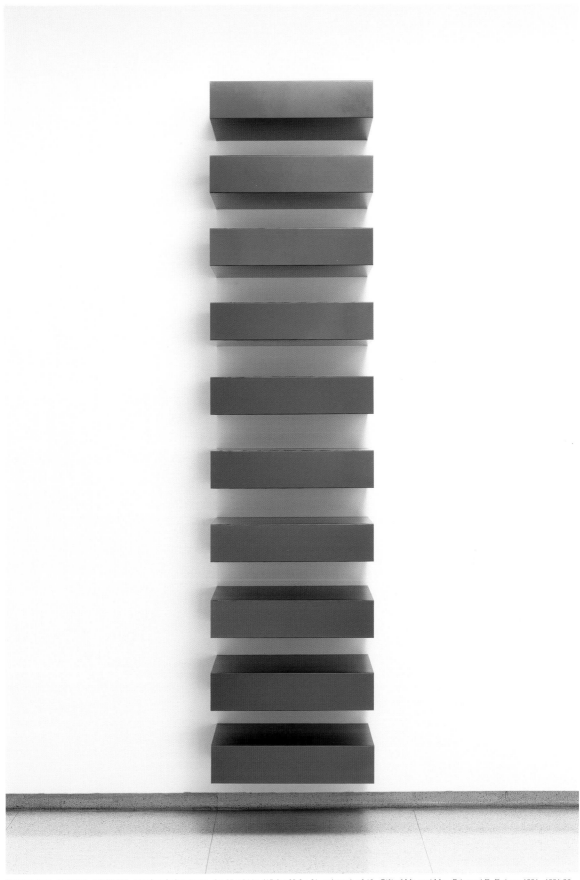

Donald Judd untitled 1969/1982 anodized aluminum 6 x 27 x 24 in. (15.2 x 68.6 x 61 cm) each of 10 Gift of Mr. and Mrs. Edmond R. Ruben, 1981 1981.26

1971. The intersecting cubes of Barnes' building mutually resonated with Judd's contribution to the exhibition, untitled (1971), which consists of six 48-inch-square units of blue anodized aluminum, spaced at one-foot intervals. The sides of each box are recessed by 3 1/2 inches, revealing the thickness of the material. The artist was more interested in the volume, not mass, of the form and the subtle, meticulous prestidigitation he effected in the form made it "less arbitrary, more rigorous."[8] The notion of seriality, which he had started exploring through repeated identical forms/volumes, is also evident in untitled (1969/1982). It is composed of ten boxes, each 6-by-27-by-24 inches, that are arrayed in a single vertical stack. The height of each box is the same as the space between it and the next one, and the first stack is placed at the same height from the floor. This regularity governing the arrangement of volumes and negative spaces turns the spaces into active components of the work. In a typically matter-of-fact manner, Judd described the stacks as follows: "I don't like any dramatic quality or incident or anything archaic. The boxes just hung on the wall in a practical manner."[9] And the order it creates is "not rationalistic and underlying but is simply order, like that of continuity, one thing after another."[10]

The Minimalists' "one-thing-after-another" seriality has been, at times, construed too reductively as mimicking the logic of industrial production. But Judd's apparently depersonalized method and his disinclination toward composition and representation, metaphor and allegory can be seen as an antidote to the decentering and alienating experience of modernity. In a similar vein, the bright colors and metallic surfaces of his objects point to "a profound and deeply felt relationship between his work and the spaces and surfaces of the modern city."[11] To "deeply felt" add "deeply thought," as Judd did not believe in the separation of feeling and thought. The aesthetic experience of Judd's art is, then, neither transcendental nor intellectualized, but one that envelops both, reflecting something more complete and cogent about our own times.

D.C.

Notes
1. See James Meyer, ed., *Minimalism* (London: Phaidon Press, 2000).
2. William C. Agee, *Don Judd*, exh. cat. (New York: Whitney Museum of American Art, 1968), 8.
3. Anne M. Wagner, "Reading Minimal Art," in Gregory Battcock, ed., *Minimal Art: A Critical Anthology* (Berkeley: University of California Press, 1995), 7.
4. Ibid., 8.
5. Judd, "Specific Objects," *Arts Yearbook* 8 (1965), reprinted in *Donald Judd: Complete Writings 1959–1975* (Halifax: Press of the Nova Scotia College of Art and Design; New York: New York University Press, 1975), 181.
6. Robert Morris, Ronald Bladen, and Robert Grosvenor, along with Judd, were in the benchmark exhibition *Primary Structures* at the Jewish Museum, New York, in spring 1966. Also in the Walker exhibition were Larry Bell, Craig Kauffman, and Ellsworth Kelly.
7. Judd, in John Coplans, "An Interview with Donald Judd," *Artforum* 9, no. 10 (June 1971): 45.
8. Ibid., 50.

9. Quoted in Marianne Stockebrand, "Catalogue," in Nicholas Serota, ed., *Donald Judd*, exh. cat. (London: Tate Publishing, 2004), 191.
10. The sentence is taken from a description of Stella's painting in Judd, "Specific Objects," 184.
11. David Batchelor, "Everything as Colour," in Serota, *Donald Judd*, 75.

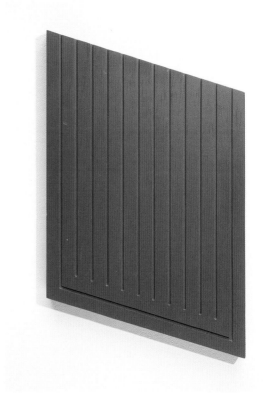

Donald Judd untitled 1968 oil on wood 24 1/2 x 16 3/4 x 2 in. (62.2 x 42.6 x 5.1 cm) Bequest of Thomas H. Ruben, 2004 2004.58

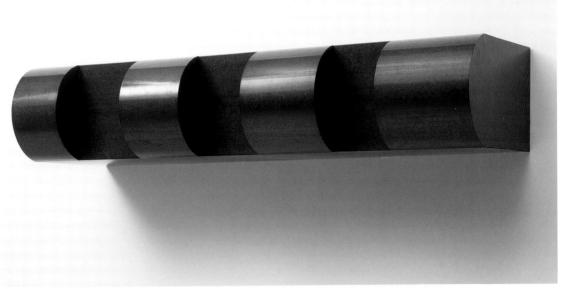

Donald Judd untitled 1965 lacquer, galvanized iron 14 $^{11}/_{16}$ x 76 $^{9}/_{16}$ x 25 $^{5}/_{8}$ in. (37.3 x 194.5 x 65.1 cm) Harold D. Field Memorial Acquisition, 1966
1966.44

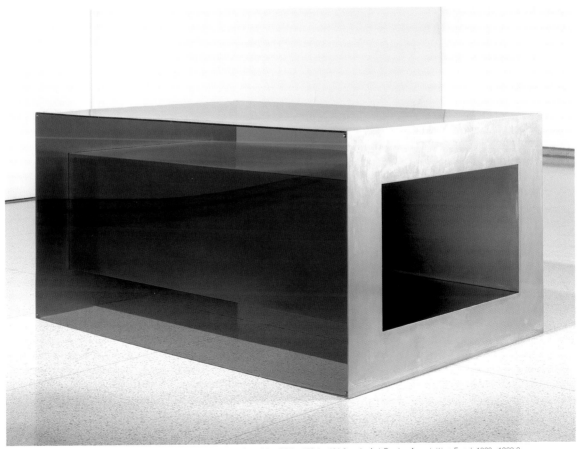

Donald Judd untitled 1968 stainless steel, plexiglass 33 x 67 $^{7}/_{8}$ x 48 in. (83.8 x 172.4 x 121.9 cm) Art Center Acquisition Fund, 1969 1969.9

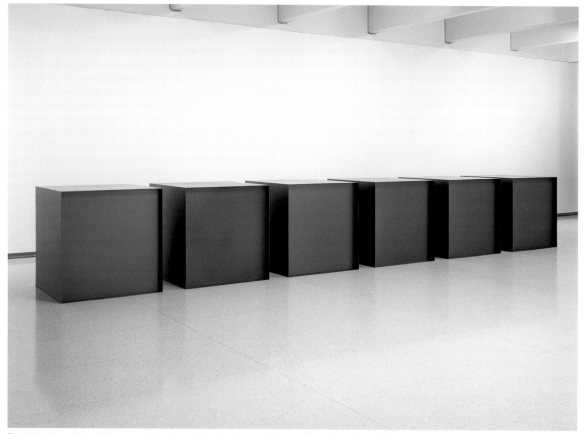

Donald Judd untitled 1971 anodized aluminum 48 x 48 x 48 in. (121.9 x 121.9 x 121.9 cm) each of 6 Gift of the T. B. Walker Foundation, 1971 1971.10

Stephen Kaltenbach

American, b. 1940

Stephen Kaltenbach *ART WORKS* 1968–2002 bronze; edition 9/100 4 7/8 x 8 x 1/2 in. (12.4 x 20.3 x 1.3 cm) T. B. Walker Acquisition Fund, 2002 2002.231

Anish Kapoor
British, b. India, 1954

-- **Holdings**
2 sculptures

Recalling alchemical processes, Anish Kapoor's sculptures combine material, form, color, and texture to produce a transformative whole that is more than the sum of its parts. Exploring such concepts as mystery, faith, the sublime, and beauty through visual language, Kapoor attempts to convey both the primordial and the enduring.

Mother as a Mountain is a work from the artist's signature "pigment" series. For him, color is a visual strategy to convey "the symbolic . . . the proto, the before words, the before thought . . . the visceral."[1] In this way, color functions in a non-narrative manner, as an index of abstract concepts. He says, "I work with red because it is the color of the physical, of the earthly, of the bodily."[2] These ideas are conveyed through form as well. The shape of the sculpture is reminiscent of the intimate space of the vagina, the robust shape of the female figure, or the monumental presence of nature as mountain. All intersect with the notion of procreativity, "mother" in its abstract sense, reflected in the multiplication of the central form, which in Hindu temple architecture, for example, is a visual strategy used to convey the sacred or divine. The referencing of various traditions is common in Kapoor's work, but he does this in a way that accesses themes that are larger than the specifics of culture or religion. The tension between the physical and the abstract is mirrored in the red powder that seems to dissolve the work's mass into the floor of the gallery.

The play with polarities is also present in *I*, a work from a series of sculptures seemingly hewn from a rocky outcropping and punctuated by a pigmented black circle. This void seems to penetrate the rock and even the gallery floor, again collapsing the boundaries between the work and the physical space that contains it. More than an optical illusion, the effect disorients the viewer's relationship to space and physical mass, if only for a moment. "The space contained in an object must be bigger than the object that contains it," Kapoor explains. "My aim is to separate the object from its object-hood."[3]

Deepali Dewan

Notes
1. Kapoor, interview with Joan Bakewell, BBC Radio 3, January 5, 2001. See transcript on the Doon School Web site, http://doononline.net/pages/info_features/features_spotlights/spotlights/akapoor/abbcr.htm.
2. Kapoor, interview with Heidi Reitmaier, "Descent into Limbo," *Tate Magazine*, no. 1 (September/October 2002): 92.
3. Ibid.

Anish Kapoor *Mother as a Mountain* 1985 gesso, powder pigment on wood 55 x 91 1/2 x 40 1/2 in. (139.7 x 232.4 x 102.9 cm) T. B. Walker Acquisition Fund, 1987 1987.117

Anish Kapoor *I* 1987 limestone, pigment 23 x 26 1/2 x 37 1/2 in. (58.4 x 67.3 x 95.3 cm) Gift of Penny and Mike Winton, 2001 2001.191

On Kawara

American, b. Japan, 1932

- - **Holdings**
5 paintings, 1 drawing, 1 book

For On Kawara, life, work, and the inevitable passage of time are inextricably bound. Kawara has described himself as a "tourist"[1] but might more accurately be considered an expatriated cosmopolitan who feels at home in the world, wherever he happens to be, without a preference for a particular culture or language. He left his native Japan in 1959, traveling to Mexico (where he lived for four years), then on to New York, Paris, and Toledo, Spain, with a side trip north to see the Altamira cave paintings, to which he had a profound response. Upon his return to New York via Paris in 1964, Kawara's exposure to the current art-world trends of Pop and Conceptualism led him to break with his previous figural style in favor of an increasingly idea-based practice.

On January 4, 1966, Kawara covered a small canvas with a deep blue acrylic and hand-painted the date in white across its midsection. This work inaugurated his *TODAY series* (also commonly referred to as "date paintings"), a cycle of works with a formally austere and strict conceptual regimen that has continued for almost forty years. Each is created on the date indicated and in the language of the country in which it was completed. They come in a variety of sizes and a limited palette of colors (black, gray, blue, red), and take eight to nine hours—a full day's work—to complete. On some days, he paints more than one; other days he doesn't paint at all. If he doesn't finish by the end of the day, the painting is destroyed. Upon completion, each is placed in a handmade cardboard box lined with a page from that day's newspaper.[2] After completing a work, Kawara records (in the language of the country he was in on the first day of the year) the pertinent details (date, size, color samples) in a loose-leaf journal that also includes a monthly calendar marking off the days on which he works.[3]

Kawara considers the disciplined and repetitive nature of his artistic activity as "brainwork" comparable to "meditation."[4] This mindfulness is captured in perpetuity in the date paintings: what is documented is a day in a life.[5] However, the calendar marks time for the artist and viewer alike—his paintings bring about an awareness of our own moments, both squandered and well spent. With the addition of the newspaper fragments, the consequences associated with the descent of sand through the hourglass of a single life are interwoven within the larger fabric of human endeavor, ultimately providing a social and political subtext for the work. By using language to focus attention on temporality and geography, Kawara successfully maps layovers along the itinerary of life, and in so doing, captures both time and space.

E.C.

Notes

1. Jonathan Watkins, "Survey: Where 'I Don't Know' Is the Right Answer," in *On Kawara* (London: Phaidon Press, 2002), 54.
2. The date paintings in the Walker's collection were created January 16 to 20, 1989, in Stuttgart, Germany. Each box has a newspaper clipping attached to the bottom. Those dated January 16 to 19 have pages from the *Stuttgarter Zeitung*, while January 20 has a page from the *Stuttgarter Nachrichten*. The headlines range in content from a train accident in Bangladesh (January 16) to a student demonstration (January 19) to the disarmament of nuclear weapons in the Soviet Union (January 20). Although an integral part of the work, the boxes are seldom exhibited alongside the paintings, per the artist's wishes.
3. The artist also included subtitles for each of his paintings in his journals. Occasionally they were composed of personal notes such as "I didn't sleep well last night," but more often they were determined by a headline selected from the enclosed newspaper clipping. He abandoned this practice on December 28, 1972, in Stockholm; his last one read, "I don't know." Thereafter, the subtitles were simply notations of the day of the week. See Watkins, "Where 'I Don't Know' Is the Right Answer," 42.
4. Kawara quoted in Lucy Lippard, "Just in Time: On Kawara," in On Kawara and Lucy R. Lippard, eds., *On Kawara Today 1967*, exh. cat. (Los Angeles: Otis Art Institute Gallery, 1977), unpaginated.
5. Not interested in the celebrity that sometimes accompanies art-world success, Kawara does not engage in interviews, nor does he allow his photograph to be published. This conspicuous absence makes his "presence" in the work even more poignant.

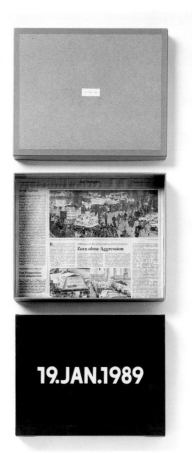

On Kawara Selection from *TODAY series* 1989 acrylic on canvas, paperboard box, newspaper 10 1/8 x 105 x 1 7/8 in. (25.7 x 266.7 x 4.8 cm) overall installed T. B. Walker Acquisition Fund, 1991 1991.90

Mike Kelley

American, b. 1954

- - **Exhibitions**
Duchamp's Leg (1994; catalogue, tour), *Let's Entertain* (2000; catalogue, tour), *Painting at the Edge of the World* (2001; catalogue)
- - **Holdings**
2 multimedia works, 1 video, 1 multiple

Since the late 1970s, Mike Kelley has produced a funny, nasty, transgressive, and sharp body of work that takes as its target notions of taste, morality, authority, and social responsibility and addresses the American social and psychological condition. Kelley grew up in a working-class community in the suburbs of Detroit, where he became involved with the counterculture scenes of rock and free jazz—from noise-rock pioneers Iggy and the Stooges to cosmic jazz musician Sun Ra—that became ideal critical tools for subverting ideological orders.

Kelley moved to Los Angeles in 1976, and it was there, as a student at CalArts, that he produced a series of performance works in which he collapsed his interest in popular culture with an acute awareness of art history, including such movements such as Dada, Futurism, Fluxus, and Viennese Actionism; artists like Vito Acconci, Guy de Cointet, La Monte Young, and Öyvind Fahlström; and events such as the Destruction in Art Symposium (London, 1966). Based on the urge to overcome the limitations projected on sculpture by a postminimal, postconceptual art discourse, his early performances (first realized at the Los Angeles Contemporary Exhibitions space in 1978) consisted of the artist manipulating handmade props that might also be seen as performative sculpture.

If the earliest performances were merely organized around nonsensical recitations and incantations about the objects Kelley built and their fluctuating meanings, over the years they became longer and more scripted, involving collaborators such as artist Tony Oursler and the band Sonic Youth. The performances also provided an early structure for what is still the core content of Kelley's work: an attempt to give shape to his unforgiving representation of the American psyche and its obsessions with religion, national history, education, adolescence, sexual identity, and the role of gender in the structure of social practices. These performances and their props have defined a unique visual language as well as a methodology relying on a distrust of conventional aesthetics, both of which are still at play in his work today.

In the sculpture *Four Part Butter-Scene N'Ganga* (1997), four washtubs full of brightly colored, mysteriously textured gooey stew and plastic fruits and vegetables are connected by a fixture of pipe and wire. At its base, each washtub is attached to a second, inverted tub that houses a speaker emitting excerpts from the sound track of the violently erotic "butter scene" in Bernardo Bertolucci's 1972 film *Last Tango in Paris*. The entire construction is suspended from the ceiling in an X shape. The tubs themselves are estimations of "n'ganga pots," cauldrons containing a fetid stew used in Santería rituals. According to Kelley, "The n'ganga

is considered the repository of enslaved tortured souls who are bound to carry out the evil spirits of the magician . . . the n'ganga stew is the limitless erotic made manifest . . . it is the pot which gives chaos its form and, in doing so, limits it."[2]

The sculpture reflects on the fear of the unknown, of the different. Starting with a 1989 news item about the abduction of a twenty-one-year-old white college student from Texas by a drug-smuggling gang who practiced black magic, Kelley takes this source to the next level by connecting it to Bertolucci's film, an "icon" of cultural and sexual aggression in which an aging American man (Marlon Brando) has his way with a young French woman (Maria Schneider). Sexuality and otherness constitute the American "ecology of fear" that Kelley is referring to in this X-rated and X-shaped installation.

The formal aspect, whether the X-shaped mobile or the binary structure of the inverted washtubs, appeared in Kelley's work as early as the "demonstrational" sculptures or performance-related diagrams of the late 1970s. Such a shape, answering neither to the abstract code nor to the figurative tradition, has been analyzed by art historian Howard Singerman as a testimony to Kelley's knowledge of structuralism and the writings of Claude Lévi-Strauss: "The binary operation is, for structuralism, the 'smallest common denominator of all thoughts'; appropriately, it is marked in structuralism's formal diagrams by an encircled *X*. The *X* lies at the center of the world and it builds the world in its image, through its repetition. But if it is the world's core—its content—it is also, as Kelley insists, empty. The center is not one but two, not presence but absence."[3] *Four Part Butter-Scene N'Ganga* seems to be an anomaly that mirrors acknowledged foundations of cultural dysfunction through a formal structure that resists any identifiable categorization.

The work *Repressed Spatial Relationships Rendered as Fluid, No. 4: Stevenson Junior High and Satellites* (2002) displays another angle of Kelley's deconstruction of American society, in this case by juxtaposing the authoritarian status of architecture as an expression of social order with his own personal history. The work, a mobilelike sculpture that hangs from the ceiling, is based on the architectural model of a school Kelley attended as a youth. Geometrical blocks represent the way he remembers the architecture, while a floor plan of the building maps out recovered memories of events that occurred in "repressed spaces." This sculpture continues an investigation that started in 1995 with the work *Educational Complex*, an architectural model of every school Kelley ever went to. These projects have grown out of the artist's interest in the phenomenon of Repressed Memory Syndrome. Memories of traumatic experiences such as childhood sexual abuse can be completely blocked from the conscious mind, leading to a variety of problems, including depression, anxiety, and eating disorders. In some psychological circles, it is believed that only by retrieving and confronting these repressed memories can a patient recover a healthy state.[4] With *Repressed Spatial Relationships Rendered as Fluid, No. 4: Stevenson Junior High and Satellites* Kelley—in a way that owes some debt to Michel Foucault's book *Discipline and Punish* as well as to

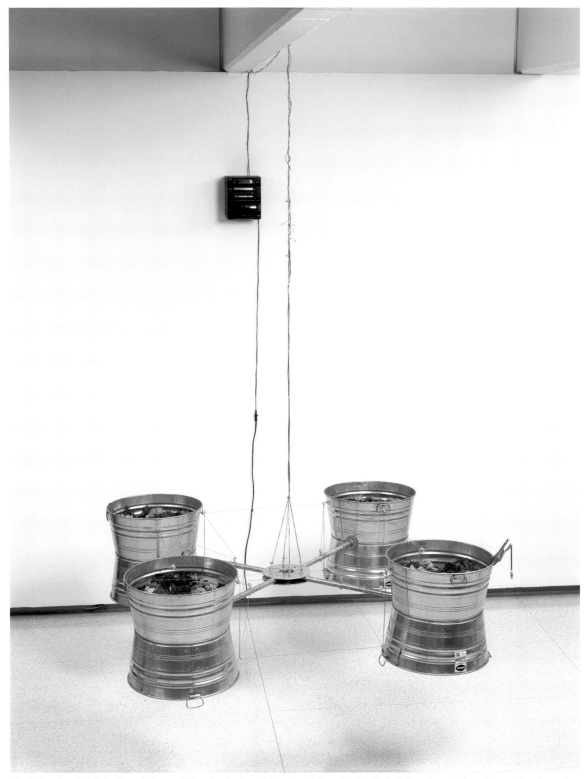

Mike Kelley *Four Part Butter-Scene N'Ganga* 1997 galvanized washtubs, pigmented vermiculite, plastic fruits and vegetables, cable, speaker wire, audio system, audio disc, adjustable wrench, locking pliers 25 x 111 x 111 in. (63.5 x 281.9 x 281.9 cm) T. B. Walker Acquisition Fund, 1997 1997.70

artist Dan Graham's photography series *Homes for America*—unfolds his obsession with what he perceives as the dysfunction of the American dream and its roots in the educational system.

Kelley's work provides a topography of the American subject as it develops through social, personal, political, and historical spaces. Informed by his knowledge of subversive countercultures, vernacular traditions, high art, and psychology, the work elaborates a methodology of watchful disrespect that leads the viewer to reconsider hidden, familiar things—what Sigmund Freud named the Uncanny—that have undergone repression only to reemerge again.[5]

P.V.

Notes

1. Mike Kelley, "Land-O-Lakes/Land-O-Snakes," in Kentaro Ichihara, *Mike Kelley: Anti-Aesthetic of Excess and Supremacy of Alienation* (Tokyo: Wako Works of Art, 1996), 17–23.

2. Ibid., 21.

3. Howard Singerman, "Charting Monkey Island with Lévi-Strauss and Freud," in Elisabeth Sussman, ed., *Mike Kelley: Catholic Tastes*, exh. cat. (New York: Whitney Museum of American Art, 1994).

4. On this topic, see Mike Kelley, "Missing Time—Works on Paper 1974–1976, Reconsidered," in José Lebrero Stals, ed., *Mike Kelley, 1985–1996*, exh. cat. (Barcelona: Museu d'Art Contemporani, 1997).

5. Kelley, "Playing with Dead Things: On the Uncanny," in *Foul Perfection—Essays and Criticism*, John C. Welchman, ed. (Cambridge, Massachusetts: MIT Press, 2002), 70–99.

Mike Kelley *Repressed Spatial Relationships Rendered as Fluid, No. 4: Stevenson Junior High and Satellites* 2002 aluminum, steel, wire, plexiglass, mixed media on paper drawing: 62 3/4 x 48 x 2 in. (159.4 x 121.9 x 5.1 cm) framed T. B. Walker Acquisition Fund, 2003 2003.10

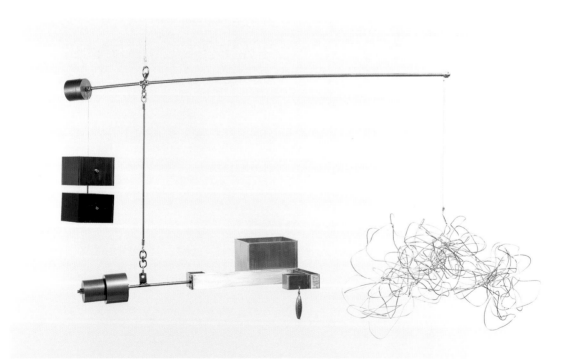

Mike Kelley *Repressed Spatial Relationships Rendered as Fluid, No. 4: Stevenson Junior High and Satellites* 2002 aluminum, steel, wire, plexiglass, mixed media on paper sculpture: 35 x 69 x 69 in. (88.9 x 175.3 x 175.3 cm) T. B. Walker Acquisition Fund, 2003 2003.10

Ellsworth Kelly

American, b. 1923

For more than fifty years, Ellsworth Kelly has worked to refine elements of the observed world into rigorous abstraction with a bold clarity and elegance. In doing so, he has demonstrated remarkable versatility as a painter, sculptor, draftsman, photographer, and printmaker. "My work has always been about vision, the process of seeing," he notes. "Each work of art is a fragment of a larger context. . . . I've always been interested in things that I see that don't make sense out of context, that lead you into something else."[1] His flat, immaculate compositions of pure line, simple forms, and saturated, unmodulated color are, in essence, found images, distillations of architectural details, shadows, plants, and other subtle forms that often might be overlooked. The contour of a leaf, the arch of a bridge and its reflection in water, and the soft curve of a hillside seen from the road have inspired paintings and sculptures alike.

Kelly's early art training was in the academic mode. He studied at the Pratt Institute in Brooklyn from 1941 to 1942, and, after serving in the armed forces in Europe from 1944 to 1945, he returned to the United States to study on the G.I. Bill at the School of the Museum of Fine Arts, Boston. In 1948, he returned to Paris, where he lived and worked until 1954, producing an important body of paintings, drawings, collages, and photographs. Since then, he has lived and worked in New York State. Though Kelly's work has been aligned with Pop Art, Color Field Painting, and Minimalism, it is more aptly placed along the fringes of these movements. Because he worked in Paris, his development in the 1950s occurred independently of such artists as Jasper Johns and Robert Rauschenberg, whose art was a direct reaction to the then-dominant style of Abstract Expressionism. Kelly's first mature works made in France predated by more than a decade the paintings of Frank Stella, Brice Marden, and other Americans associated with Minimalist Art in the 1960s.

From his early collages made in Paris to his large, freestanding sculptures, Kelly has continually searched for ways whereby his art might compose itself through chance—his forms, he has stressed, are shapes that "have always been there."[2] *Drawing Cut into Strips and Rearranged by Chance*, made in 1950, borrowed a technique used by Dadaist Jean Arp, whom Kelly had met in Paris that year.[3] It also was influenced by the artist's correspondence with composer John Cage, who, during their first meeting in Paris in 1949, showed Kelly some cut Japanese fabric stencils that he had been collecting from Paris shops.[4] The collaged composition recombines fragments from two of Kelly's rejected drawings. Though the order in which the strips are arranged is random, the artist nonetheless pasted them to the paper in a deliberate row to avoid overlap, and thus any reference to depth, since the illusion of flatness was now of paramount importance in his art.[5]

Kelly returned to New York in 1954, and soon after moved to Coenties Slip, a former landing place for wooden ships in lower Manhattan that housed a community of artists, including Robert Indiana, Agnes Martin, and Jack Youngerman, in deserted sail-making lofts. It was here that he made the painted aluminum sculpture *Gate* in 1959. He once described the work as taking shape by chance from an *X* he outlined on an envelope: "I folded it and cut it and it stood. I did it almost without thinking, almost as if I didn't decide."[6] The X-configuration used in the sculpture occurs frequently in Kelly's art of the late 1950s. Though it retains an element of flatness and frontality, *Gate* was a pioneering piece for the artist in that it marked the first time one of his forms moved fully off the wall, breaking ground for his sculptures in the round (which were initiated that same year) as well as for large-scale, freestanding indoor and outdoor pieces, which he has executed to this day in various metals and in wood.

Ellsworth Kelly *Black Curve* 1962 oil on canvas 42 1/8 x 34 5/8 in. (107 x 88 cm) Donated by Mr. and Mrs. Edmond R. Ruben, 1995 1995.73
©Ellsworth Kelly

It was also while living in Coenties Slip that Kelly painted *Black Curve* (1962). The painting is related to five canvases from the early 1960s that were composed of free-drawn curves executed in various colors. He has often worked in cycles, alternating between the curve, the rectangle, and other forms that interest him, moving freely between painting, sculpture, and works on paper. The curve in this painting was made during a period when the artist's shapes were often organic. After 1969, his curve paintings and wall reliefs were always "fragments of a circle," based on geometric figures rather than found contours.[7]

From his earliest paintings, Kelly has been interested in liberating color and form from content, asserting that the painting is an object, and the white wall, essential to the perception of the piece, is its ground. *Red Green Blue* (1964) is one of the few canvases executed in the 1960s in which he chose not to separate the colors into individual panels, a practice he had begun during his years in Paris. Kelly's interest in flat, unmodulated color is evident in the painting. Though not interested in texture and gesture, he nonetheless avoids a mechanized look, and strives for his hand to be apparent in the finished surface.[8]

Red Yellow Blue III (1966) is one of the first works he created as a large-scale, multiple-panel painting. By separating the vivid panels, Kelly forged a concrete relationship between the primary colors, seen as pure forms, and the white wall, read as a field or ground. The scale of the work creates ambiguous boundaries, as color continuously assumes part of one's peripheral vision. "I am less interested in marks on the panels than the 'presence' of the panels themselves," the artist remarked in 1969. "In *Red Yellow Blue*, the square panels present color."[9] One of the first of his generation to realize the possibilities of the shaped canvas, Kelly had been creating numerous works by the late 1960s in which his forms were the paintings themselves. In the double canvas *Yellow/Red* (1968), the positioning of the joined, shaped panels on the white wall is key, as the work becomes a study in perspective. Though perceived as pure, hard-edged shapes, both *Red Yellow Blue III* and *Yellow/Red* can be traced to Kelly's observant eye, as they recall the artist's photographs of shadows cast by open barn doors in the New York countryside.

Kelly considers his three-dimensional work to be a natural extension of his painting. Since 1959, he has explored the notion of a "folded" form in a variety of freestanding and wall-mounted works. *Green Rocker* (1968) is one of a group of floor pieces, many of which were painted in two colors, one on the top, one on the underside. *Green Rocker*, however, is a monochrome, since its planes are flattened to a greater degree, permitting an intimate relationship between the work and the gallery floor. While the title seems to allude to a rocking chair or a child's hobbyhorse, the sculpture is stationary, its movement merely implied. The curved, oval contours and color also relate to the delicate line drawings of plants and leaves—particularly water lilies—central to Kelly's work since the 1950s.[10]

Double Curve (1988), an outdoor sculpture in bronze commissioned for the Minneapolis Sculpture Garden, has its origins, like many of Kelly's three-dimensional

forms, in earlier paintings, drawings, and studies. The eighteen-foot-tall totems that compose this piece derive from, among other sources, his Brooklyn Bridge series of paintings from the 1960s and the 1959 painting *Rebound*. They also relate to a 1976 pressed-paper pulp work he made at the print workshop Tyler Graphics Ltd. in 1976. The standing forms of the sculpture have been likened to stele, upright stone slabs used as markers that appear throughout the history of art. They activate the garden space in which they are sited, forming a relationship with grass, trees, and particularly sky, all of which provide the background for the work.

Throughout his career, Kelly has used abstraction as a means for viewing the world with coherence and clarity. His works articulate his concerns about form, color, and their relationship to physical space, and present in themselves an opportunity to examine his process of seeing.

S.E.

Notes

1. Kelly in conversation with Mark Rosenthal, January 1991, New York. Cited in Mark Rosenthal, ed., *Artists at Gemini G.E.L.* (New York: Harry N. Abrams Inc., 1993), 83.
2. Kelly, interview with Henry Geldzahler, in *Paintings, Sculptures and Drawings by Ellsworth Kelly* (Washington, D.C.: Washington Gallery of Modern Art; Boston: Institute of Contemporary Art, 1963–1964), unpaginated.
3. Arp's work *Collage Arranged According to the Laws of Chance* (1916–1917) was made by dropping pieces of torn paper onto a larger sheet, and gluing them where they fell.
4. "I met John Cage in 1949 for two days. He was staying at the same hotel. He introduced himself to me, and I didn't know who he was then; but a friend of mine said, he's one of the new music people. I showed him one of my first abstract things, and he was the first to make me feel like maybe I could do something." Kelly interview with Peter von Ziegesar, "How Chance Operations Guide Work: An Interview with Ellsworth Kelly," *FORUM* 14, nos. 2–3 (June/July, 1989): 26.
5. Yve-Alain Bois, "Kelly's *Trouvailles*: Findings in France," in Yve-Alain Bois, *Ellsworth Kelly: The Early Drawings 1948–1955*, exh. cat. (Cambridge, Massachusetts: Harvard University Art Museums, 1999), 23.
6. Kelly, interview with Henry Geldzahler.
7. Artist's statement, March 21, 1996 (Walker Art Center Archives).
8. Kelly began this painting in New York in September 1964 and finished it in October at Joan Miró's graphic studio in the town of Levallois, France, prior to its first showing in Paris. Artist's statement, April 2, 1974 (Walker Art Center Archives).
9. Kelly, "Notes from 1969," in Barbara Rose and Ellsworth Kelly, *Ellsworth Kelly: Paintings and Sculptures 1963–1979*, exh. cat. (Amsterdam: Stedelijk Museum, 1979), 32.
10. In 1952, while living in France, Kelly visited Monet's studio in Giverny, where he saw the artist's late water lily-paintings and shortly afterward painted a green monochrome canvas.

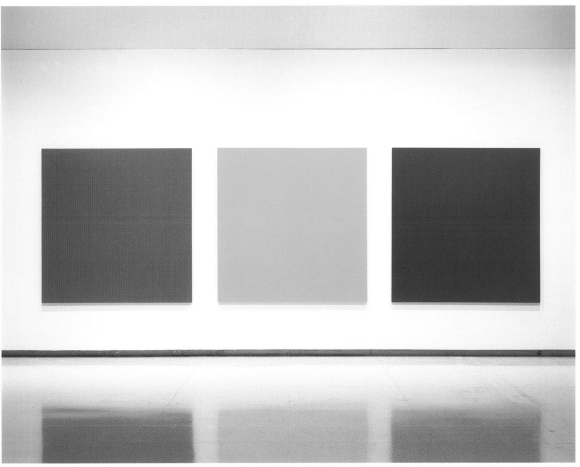

Ellsworth Kelly *Red Yellow Blue III* 1966 oil on canvas 70 1/2 x 70 1/8 in. (179.1 x 178.1 cm) each of 3 Gift of Judy and Kenneth Dayton, 1998 1998.13
©Ellsworth Kelly

Ellsworth Kelly *Gate* 1959 aluminum, paint 63 x 63 x 17 in. (160 x 160 x
43.2 cm) Gift of Kate Butler Peterson, 1997 1995.147 ©Ellsworth Kelly

Ellsworth Kelly *Red Green Blue* 1964 oil on canvas 90 x 66 in. (229 x
167.6 cm) Gift of the T. B. Walker Foundation, 1966 1966.9 ©Ellsworth Kelly

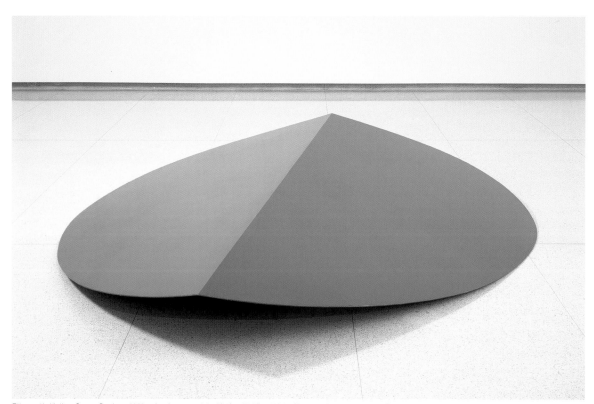

Ellsworth Kelly *Green Rocker* 1968 aluminum, paint 20 1/4 x 97 3/4 x 112 in. (51.4 x 248.3 x 284.5 cm) Purchased with matching grant from the Museum
Purchase Plan, the National Endowment for the Arts, and Art Center Acquisition Fund, 1969 1969.4 ©Ellsworth Kelly

Anselm Kiefer
German, b. 1945

- - Exhibitions
Photography in Contemporary German Art: 1960 to the Present
(1992; catalogue, tour), *The Cities Collect* (2000)
- - Holdings
2 paintings, 2 books

Born in Germany the year World War II ended, Anselm Kiefer probably could not help but be burdened by the weight of history. He studied art in Karlsruhe, then in Düsseldorf, where he met Joseph Beuys, whose abiding concern lay in exploring and teaching art's potential for healing and reparation. Kiefer chose painting as his primary mode of expression and expanded the medium by combining profound subject matter with eccentric materials such as straw, shellac, and lead, and unusual processes like open-air aging. Although his interest does not lie in reviving classical history painting, Kiefer's works approach that genre from the eighteenth and early nineteenth centuries in their grand physical scale, topicality, and astounding visual and material effects.[1] His paintings contain no landscapes peopled by perfectly proportioned anthropomorphic gods and godly humans. Instead, his settings are scorched earth or dimly lit sepulchers, with human beings all but evacuated. History is a dark cavern of the subconscious, inscribed with ruination and mourning, leading to even deeper labyrinths of archetypal mythologies.

From the very beginning of his artistic career, Kiefer has investigated what it means to be German and to be an artist in the tabula rasa left by National Socialism, which had confiscated visual imagery in toto. In *Occupation* (1969), an early photographic series done in a conceptualist vein, he took pictures of himself making the *Sieg Heil* gesture against the backdrop of historical monuments or expansive landscapes at different locations in Europe. In subsequent bodies of works in the 1970s and early 1980s, he persistently analyzed the question of what constitutes Germanness by exploring subjects such as the *Nibelungen* and other Wagnerian legends, "the tree and forest" mythology, Albert Speer's Nazi architectural monuments, and the figures of Margarete and Shulamite from Paul Celan's poem "Todesfuge" ("Death fugue").[2] In the early 1980s, the artist began to delve into a more eclectic mix—the Babylonian epic of Gilgamesh, the Norse myth of Edda, the Book of Exodus, and Egyptian mythology.

In the mid-1980s, biblical themes and medieval mysticism became especially prominent in Kiefer's vision, and both paintings in the Walker Art Center's collection are products of this change. *Die Ordnung der Engel* (*The Hierarchy of Angels*) (1985–1987) is based on the description of "celestial hierarchy" by Pseudo-Dionysius the Areopagite.[3] The title is inscribed above the horizon, drawn close to the upper edge of the painting in what appears to be sea foam or clouds. Across the horizontal expanse of the dark gray and earth-toned canvas, nine rocks of curdled lead are hung with wires at varying heights, each one identified, with a tag, as one of the nine orders of the celestial hierarchy.

An airplane propeller cuts across the top, as if sending the ranks of angels flying across the landscape. The propeller, a familiar motif in Kiefer's work, is meant as "an object moving through history and time in a spiral motion, finally arriving on the surface of his painting."[4] *Emanation* (1984–1986), by contrast, is a vertically elongated canvas. The horizon is placed in the lower section of the canvas, creating an ominous firmament stacked on top of a forbidding sea. The column of molten lead almost completely bisecting the painting refers to, among other sources, the description in the Bible of how God led the Israelites through the wilderness: "By day in a pillar of cloud . . . and by night in a pillar of fire" (Exod.13:21). Both the notion of emanation and the hierarchy of heavenly beings are features of medieval Jewish mysticism, inherited from the Neoplatonic philosophy of early Christian thinkers.[5]

German critic Andreas Huyssen, refusing to accept that Kiefer's paintings transcend history via myth, writes: "Kiefer's work can be read as a sustained reflection on how mythic images function in history, how myth can never escape history, and how history in turn has to rely on mythic images."[6] While Kiefer would certainly see his art as a resolute working-through of a disastrous history, not as an apology for or glorification of it, it is difficult to deny that his art generates an experience of transcendence, even if that means a descent into the bowels of the human spirit where nobility and charity, violence and rage, play equal parts.

D.C.

Notes

1. Occupying the highest position in the academic hierarchy of genres in the eighteenth and early nineteenth centuries, history painting—also known as the *grand genre*—found its subjects in mythological, historical, literary, or allegorical themes. It ranked above all other types of painting—portraiture and landscape, for instance—as it was intended to edify the mind rather than merely please the eye.

2. Andreas Huyssen succinctly inventories these different ingredients of German civilization explored in Kiefer's art in his essay "Anselm Kiefer: The Terror of History, the Temptation of Myth," *October* 48 (Spring 1989): 29. Paul Celan's poem was written in 1945 while he was in a concentration camp and published in 1952. It is reprinted in full in Mark Rosenthal, *Anselm Kiefer*, exh. cat. (Chicago: The Art Institute of Chicago; Philadelphia: Philadelphia Museum of Art, 1987), 95–96.

3. Dionysius the Areopagite is the first-century Athenian who was converted to Christianity by Saint Paul. The story is narrated in the Book of Acts (Acts 17:34). The author of *The Celestial Hierarchy*, however, was a fifth- or sixth-century philosopher who impersonated the original Dionysius and is thus called "Pseudo-Dionysius." See *The Columbia Encyclopedia* (Sixth Edition, 2001). In another painting of the same title—currently in the collection of the Art Institute of Chicago—Kiefer inscribes the philosopher's name, intentionally misspelling Areopagite as "Aeropagite." Rosenthal suggests that Kiefer draws a connection between the prefix "aero," which relates to air, aerial, and celestial, and angels and airplanes. See Rosenthal, *Anselm Kiefer*, 137.

4. Ibid., 137.

5. In his correspondence with Martin Friedman dated September 1989, Kiefer identifies the Bible, the Kabbalah, and the Babylonian Talmud as the painting's textual sources (Walker Art Center Archives).

6. Huyssen, "The Terror of History," 27.

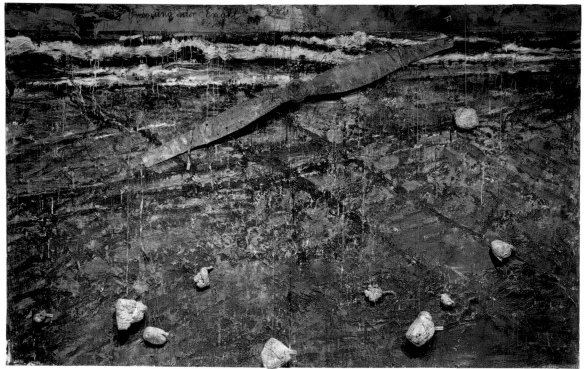

Anselm Kiefer *Die Ordnung der Engel* (*The Hierarchy of Angels*) 1985–1987 oil, emulsion, shellac, acrylic, chalk, lead propeller, curdled lead, steel cables, band-iron, cardboard on canvas 133 1/2 x 220 7/8 x 22 3/4 in. (339.1 x 561 x 57.8 cm) Gift of Penny and Mike Winton, 1987 1987.11

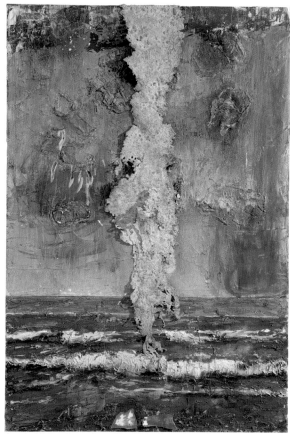

Anselm Kiefer *Emanation* 1984–1986 oil, acrylic, wallpaper paste, lead on canvas 161 1/2 x 110 3/4 x 9 1/4 in. (410.2 x 281.3 x 23.5 cm) Gift of Judy and Kenneth Dayton, 1990 1990.22

Edward Kienholz and Nancy Reddin Kienholz

Edward Kienholz, American, 1927–1994;
Nancy Reddin Kienholz, American, b. 1943

– – Exhibitions

Edward and Nancy Reddin Kienholz: Human Scale (1985; organized
by the San Francisco Museum of Modern Art; catalogue), *First
Impressions: Early Prints by Forty-six Contemporary Artists* (1989;
catalogue, tour), *Duchamp's Leg* (1994; catalogue, tour)

– – Holdings

1 sculpture, 1 edition print/proof, 3 multiples

Edward Kienholz and Nancy Reddin Kienholz *Portrait of a Mother with Past
Affixed Also* 1980–1981 mixed media 99 7/8 x 94 5/8 x 81 in. (253.7 x 240.4 x
205.7 cm) Walker Special Purchase Fund, 1985 1985.12

William Klein

American, b. 1928

- - **Screenings**

 Cinema Outsider: The Films of William Klein (1989; publication, tour)

- - **Exhibitions**

Vanishing Presence (1989; catalogue, tour), *Chris Marker and William Klein: Silent Movie/Moving Pictures* (1996; co-organized by the Wexner Center for the Arts, Ohio; publication), *American Tableaux* (2001; publication, tour)

- - **Holdings**

19 films, 2 videos, 4 books

William Klein, an expatriate American artist living in Paris, has excelled in photography and film, straddling both the commercial and the fine-art worlds just as he balances his experiences between both countries. According to film critic Claire Clouzot, "William Klein is truly committed. He is against all that is witch-hunting, reactionary, fundamentalist, bureaucratic, unjust, and bullshit. He is for rebellion, whether it be social, cultural, black, student, or Third World."[1] This leads to works that are raw, direct, and confrontational, just like the man himself. It was the politically charged and exuberant nature of his films that led the Walker Art Center to organize an international tour in 1989 with new prints struck for the Edmond R. Ruben Film and Video Study Collection.[2] The selection ranged from documentary portraits to biting political and social satires to imaginative sports films to experimental works. Working in film gives Klein the opportunity to present a deeper and at times more subjective view than he could express in photography.

Born in New York in 1928, he spent a good deal of time as a youth at the Museum of Modern Art, soaking up the exhibitions and screenings—especially the foreign films. He joined the army when he was eighteen and spent two years in occupied Germany and France before arriving in Paris in 1948 to study briefly at the Sorbonne with Fernand Léger. "When I first came to Paris after the war, my friends and I quickly turned to the Bauhaus," Klein reflects. "Their whole idea of multimedia, interdisciplinary work interested me."[3]

Alexander Liberman, director of American *Vogue*, was impressed with Klein's early experiments with photography and his graphic design for the architecture magazine *Domus*, and invited him to create a series of street photographs of New York City for *Vogue*. The magazine was scandalized by his interpretation of the city as filled with grime, slums, and vulgarity, but though his pictures were controversial, Klein remained on staff as a fashion photographer.[4] He assembled the gritty photos into the book *New York, Life Is Good & Good for You in New York: Trance Witness Revels* (1956). Chris Marker, then working as an editor at Edition du Seuil, heralded the merits of the book, which brought Klein wide acclaim upon its publication in France.[5] *Rome* (1960), *Moscow* (1964), and *Tokyo* (1964) followed,[6] and a great and collegial friendship developed between the two men. Klein and his wife, Jeanne, worked on Marker's film *La Jetée* (1962–1964),[7] portraying citizens of the future, and Marker organized *Loin du*

Vietnam (*Far from Vietnam*) (1967), a project in which Klein contributed the American section. The two were paired for the Walker's 1996 exhibition *Chris Marker and William Klein: Silent Movie/Moving Pictures*, in which Klein's painted contact sheets, rare books, and a video of his film *Contacts* (1983) were displayed alongside Marker's installation *Silent Movie*.

Living abroad afforded Klein the distance to address American social and political situations in his films with a fresh approach. Having spent his life as an outsider, first as a Jew in a predominantly Catholic neighborhood in New York and then as an American in Paris, he identifies with the outcast. This has played into both his selection of subjects for his documentaries and his rejection of objectivity in the form itself.[8] The uncompromising actions of outsiders play a key role in a trilogy of documentaries made between 1964 and 1980. Klein crafted *Muhammad Ali the Greatest* (1974) from footage of his first documentary, *Cassius le Grand* (released in the United States as *Float Like a Butterfly, Sting Like a Bee*) (1964–1965), and of Ali's match with George Foreman in Zaire. The viewer sees the price Ali paid for his refusal to serve in Vietnam,[9] and the Zaire section shows him, the underdog, taking the title when it was least expected. In 1969, Klein jumped at the chance to film Eldridge Cleaver when the Black Panther—who was in exile from the United States and on the FBI's most-wanted list—approached him. *Eldridge Cleaver, Black Panther* (1970) shows Cleaver making connections to liberation groups across Africa and discussing attempts that had been made on his life. More lighthearted is Klein's portrait of Little Richard, who had been fleeced financially and artistically. When Little Richard pulled out of the film, the director had impersonators play him and explain the musician's effect on them. In *The Little Richard Story* (1980), we see that Klein is interested in the ebullience of the cult of personality fueled by the media.

Klein drew upon his love of comics[10] to engage the student protesters hungry for political films in his over-the-top satire of international politics and American bumbling foreign policy, *Mr. Freedom* (1967–1968). Using outlandish puppets and cartoonlike costumes, the film introduces Mr. Freedom, a lumbering American imperialist superhero bent on avenging the assassination of his colleague. Arriving in France to start his investigation, he treats that nation like a Third World country and approaches everyone with the same lack of cultural sophistication Americans were accused of exhibiting in Vietnam at the time. The satire is so heavy-handed that the film was banned in France for several months during the 1968 protests.

Klein has lost none of his sting and dissonance. His most recent film, *Le Messie* (*Messiah*) (1999), is just as satirical, astute, and innovative as his earlier work. In it, George Frideric Handel's *Messiah* and its power to transform are interpreted by ensembles as disparate as the Lavender Light Gay and Lesbian Interracial Choir, a group of inmates, and uniformed police officers singing while their squad car lights blaze. Klein illustrates the lyrics of the oratorio with footage of Body Builders for Christ, bewitched gamblers, and angry protesters stomping on the American flag.

The title of the Walker's 1989 tour of Klein's films was dead-on: "Cinema Outsider." He has gained strength from working independently, and he has not had his art distilled by others. He has been responsible for all that is displayed, printed, or screened: covering the graphic design as well as the photography of his books; and painting the sets, designing the costumes and posters, writing the scripts, and directing his films. He can be judged by his singular vision, which embraces a moral consciousness and a passion for the cacophony of discord. When introducing Klein at the Walker in 1989, former Film/Video Director Bruce Jenkins summed it up best: "He's a one-man movement." His skills in photography, film, painting, and graphic design have made him one of the most influential, unrestrained, multidisciplinary artists of his time.

D.O.

Notes

1. Claire Clouzot, "William Klein or the Organization of Chaos," in Claire Clouzot, *William Klein Films* (New York: powerHouse Books, 1998–1999), 12.

2. Striking eleven new prints for the tour was a huge undertaking for the Walker Film/Video Department. Since 1989, the Walker has continued to strike additional prints and collect new films, including *In and Out of Fashion* (1993), *Le Messie*, and an English-language version of *Contacts* (1983). The films also continue to tour.

3. Quoted in James Startt, "William Klein: Hard-Edged Artist Warms to 'Messiah,'" *The Christian Science Monitor*, October 20, 1997.

4. Using his experience with *Vogue*, Klein spewed out one of the most searing critiques of the fashion world with his film *Qui êtes-vous, Polly Maggoo?* (*Who Are You, Polly Maggoo?*) (1965–1966). He was dismissed from *Vogue* after the film was released.

5. The book was not printed in the United States until decades later.

6. Three of these four rare books are in the Walker's holdings.

7. *La Jetée* is also in the Walker's Edmond R. Ruben Film and Video Study Collection.

8. This predates Werner Herzog's manifesto on truth in documentary film—a rejection of objective documentaries—which he presented at the Walker in 1998.

9. Ali was stripped of his title, his boxing license, and potential millions in earnings. His license was reinstated in 1970.

10. Klein had contributed some comics to *Stars and Stripes* while in the service.

William Klein *Qui êtes-vous, Polly Maggoo?* (*Who Are You, Polly Maggoo?*) 1965–1966 35mm film (black and white, sound) 105 minutes Edmond R. Ruben Film and Video Study Collection

William Klein *Le Messie* (*Messiah*) 1999 35mm film (color, sound) 111 minutes Edmond R. Ruben Film and Video Study Collection

William Klein *Broadway by Light* 1958 35mm film (color, sound) 12 minutes Edmond R. Ruben Film and Video Study Collection

William Klein *Muhammad Ali the Greatest* 1974 35mm film (color / black and white, sound) 120 minutes Edmond R. Ruben Film and Video Study Collection

William Klein *Mr. Freedom* 1967–1968 35mm film (color, sound) 100 minutes Edmond R. Ruben Film and Video Study Collection

Yves Klein
French, 1928–1962

- - **Exhibitions**
Duchamp's Leg (1994; catalogue, tour), *The Last Picture Show:
Artists Using Photography*, 1960–1982 (2003; catalogue, tour)
- - **Holdings**
1 painting, 1 sculpture, 1 multiple, 1 book

Half prophet, half charlatan, Yves Klein took the European art scene by storm in a brief career that lasted only from 1954 to 1962. Working in Paris during the apogee of geometric abstraction and Art Informel, in an intellectual scene dominated by existentialism, he carved out a theoretical ground based on his embrace of Rosicrucianism, his interest in Gaston Bachelard's philosophy of space, and the ethic coming from his career as a judo professional.

Klein was an experimenter who embraced painting, sculpture, performance, photography, music, architecture, and theoretical writing; he left posthumous plans for works in theater, dance, and cinema. Self-identified as "the painter of space," he inaugurated his defining series of monochromes in 1957, choosing an ultramarine blue of his own invention after trying various other hues.[1] According to Rosicrucian theory, such a blue would result from the fusion of all form and matter, but Klein's choice could also be understood as an extension of Bachelard's vision that "First there is nothing, then there is a deep nothing; then there is a blue depth."[2] Klein searched for immaterial spirituality through pure color, which led him to refute Art Informel and abstraction in general: "I am the painter of space. I am not an abstract painter but on the contrary a figurative and realistic one. Let's be reasonable, to paint space I owe it to myself to go there, into space itself."[3]

He touched on that space in his 1958 exhibition of pure, immaterial pictorial sensibility (he emptied the Iris Clert Gallery in Paris and painted it white), and in his collaborative experiment with architect Werner Ruhnau on "architecture" built of air, fire, and water. Klein actually leapt into space one morning in October 1960, appearing to throw himself out the window of a suburban building. The event was photographically documented, but Klein left the veracity of the image ambiguous, and with it the question of whether or not he had actually "levitated."[4]

On Sunday, November 27, 1960, Klein ran the photograph on the front page of the *Journal du dimanche*, a single-issue, self-published newspaper, thereby appropriating the day—and the entire Earth—as his theater of the void. The paper masqueraded as news and was available in newspaper kiosks, precipitating a shift in the status of photography, which conceptual artists and photographers would later embrace. In Roland Barthes' words, "The image no longer illustrates the words; it is now the words which, structurally, are parasitic on the image . . . the text loads the image, burdening it with a culture, a moral, an imagination."[5]

Klein's best-known works are the nearly two hundred *Anthropometries*, begun in 1958. Under his direction, nude female models were smeared with his ultramarine blue and used as "living brushes" to make body prints on prepared sheets of paper. The works were realized either in Klein's studio or during well-rehearsed public performances, and were initially understood as an extension of or a critical commentary on action painting. The artist aggressively dismissed that interpretation: "Many art critics claimed that via this method of painting I was in fact merely reenacting the technique of what has been called 'action painting.' I would like to make it clear that this endeavor is opposed to 'action painting' in that I am actually completely detached from the physical work during its creation. . . . I would not even think of dirtying my hands with paint. Detached and distant, the work of art must complete itself before my eyes and under my command. Thus, as soon as the work is realized, I can stand there, present at the ceremony, spotless, calm, relaxed, worthy of it, and ready to receive it as it is born into the tangible world."[6] More than an expression of the inner psyche of the artist, the *Anthropometries* seem to propose a way to give visual presence to a cosmic, spiritual body, or the immateriality of the aura, which neither photography nor cinema could capture.

One of the last *Anthropometries*, *Suaire de Mondo Cane* (*Mondo Cane Shroud*) (1961), was realized under very specific circumstances and could almost be seen as the shroud of Yves Klein. In 1961, after director Gualtiero Jacopetti proposed to include him in a film, Klein made an *Anthropometrie* on two layers of translucent gauze so that the camera could film through the fabric from behind and record the human brushes in action.[7] The result, *Mondo Cane Shroud*, has rarely been shown since, but it opens the door to a new understanding of Klein's interest in the possibilities offered by moving images and his ideas about making the immaterial visible by using a camera to produce a painting.

Jacopetti's film *Mondo Cane* (1962) was in the end so disrespectful of Klein and his work that the painter never recovered after its first humiliating screening at the Cannes Film Festival.[8] He died a few weeks later of a heart attack, leaving an unachieved oeuvre that is often seen as a precursor of Minimal, Conceptual, and Body Art but whose true aim was to reach "beyond the problematic of art"[9] and rethink the world in spiritual and aesthetic terms. For Klein, this meant a monochrome revolution.

P.V.

Notes
1. The color, which he called International Klein Blue, was created with the help of Parisian colorist Edouard Adam.
2. Klein quoting Bachelard in Yves Klein, *Yves Klein, Conférence de la Sorbonne, 3 Juin 1959* (Paris: Galerie Montaigne, 1992). Trans. Philippe Vergne.
3. Interview with André Arnaud, April 29, 1958, quoted in Nan Rosenthal, "La lévitation assistée," in Jean-Yves Mock, ed., *Yves Klein*, exh. cat. (Paris: Centre Georges Pompidou Musée national d'art moderne, 1983), 228.
4. Klein's leap was documented by photographers Harry Shunk and John Kender. Montaging the resulting photographs, Klein removed any suggestion of a safety net, leaving only the appearance of an empty street below him.

5. From Roland Barthes, "The Photographic Message," in *Image, Music, Text*, ed. and trans. Stephen Heath (New York: Hill, 1997), 15–31.

6. Yves Klein, "Manifeste de l'hôtel Chelsea," in *Yves Klein*, 196. Trans. Philippe Vergne.

7. Through comparison with the final film footage, *Mondo Cane Shroud* appears to have been made during rehearsal sessions.

8. *Mondo Cane* (*A Dog's World*) was a documentary-style film, a hybrid between a legitimate study of strange phenomena, and a voyeuristic, degrading exploitation of contemporary culture across the globe.

9. Yves Klein, *Le dépassement de la problématique de l'art* (Louvière, Belgium: Éditions de Montbliart, 1959) reprinted in Yves Klein, *Le dépassement de la problématique de l'art et autres écrits* (Paris: École nationale supérieure des beaux-arts, 2003), 80–117. Trans. Philippe Vergne.

Yves Klein *Suaire de Mondo Cane* (*Mondo Cane Shroud*) 1961 pigment, synthetic resin on gauze 92 1/8 x 116 15/16 in. (234 x 297 cm) Gift of Alexander Bing, T. B. Walker Foundation, Art Center Acquisition Fund, Professional Art Group I and II, Mrs. Helen Haseltine Plowden, Dr. Alfred Pasternak, Dr. Maclyn C. Wade, by exchange, with additional funds from the T. B. Walker Acquisition Fund, 2004 2004.64

Silvia Kolbowski

American, b. Argentina, 1953

-- **Exhibitions**
The Last Picture Show: Artists Using Photography, 1960–1982
(2003; catalogue, tour)
-- **Holdings**
1 photographic suite

While studying at New York's Hunter College in the late 1970s, Silvia Kolbowski abandoned painting in favor of a mode of photography that could articulate her increasing engagement with feminist and psychoanalytic theory. From the start of her exhibition history—with her inclusion in an exhibition at Artists Space in 1980, concurrent with Richard Prince and others—Kolbowski was linked with a group of artists and a set of concerns associated with the so-called Picture Theorists. Tipping its hat to a now-legendary show curated by Douglas Crimp that is perhaps more notable for whom it omitted, the term crystallized a quintessentially postmodern discussion around media representation, strategies of appropriation, and the disruption of cultural fictions.[1]

Kolbowski's first sustained series of work, *Model Pleasure* (1982–1984), alongside Sarah Charlesworth's *Objects of Desire* (1983–1984) and Cindy Sherman's first series of color photographs in 1980, were symptomatic of the increasing prominence of women artists in 1980s New York who were addressing the politics of gender. Kolbowski photographed pages from fashion magazines and other sources such as cookbooks and had the results generically printed and framed. Highlighting images of aspirational beauty served up by the advertising, cosmetics, and apparel industries, the artist pulled apart the values that these sanctioned representations of "woman" are made to ventriloquize by juxtaposing them with text and other imagery.

The ten fragments that comprise *Model Pleasure I* include variations on three images of enraptured models. From the looks of their fully rouged lips, blissfully closed eyes, and thrown-back heads, it would seem that the mere act of slipping on a couture jacket summons a state of sexual ecstasy. Purloined from an antiquated horticultural illustration, a single image shows an apple specimen annotated as "The Maiden's Blush"—what might be a euphemistically demure index of similarly orgasmic fruitfulness. Another of the photographs shows a burnished apple pie posed like pastry pornography, and two other shots show hands paring the skin of the fruit on a kitchen work surface. As the artist has written, the latter two images of domestic food preparation were unique in this body of work. "*Model Pleasure I* was an anomaly in the series in that it included, in addition to images drawn from existing sources, photographs of invented, theatrical settings,"[2] Kolbowski says. She draws on both the biblical symbolism of the apple in Eden as the fruit that tempted Eve into original sin and the apple pie's cultural role as a cipher of Norman Rockwellesque patriotic wholesomeness.

Influenced by linguistic and semiotic theory, *Model Pleasure* speaks in a language that playfully interrogates fashioned femininity. Like units of grammar, each image in each suite can be displayed in any order, and recombinations were made within the series. In 1984, for an exhibition at Nature Morte Gallery in New York, Kolbowski included a photograph of *Model Pleasure I* as installed at a previous show. Presaging the self-reflexive exhibition protocol and a reprisal of classically conceptual strategies that mark the artist's more recent work, Kolbowski brought the series to a close by implicating her own display ideology into the cycle of representation.

M.A.

Notes
1. *Pictures* was held at Artists Space, New York, in 1977. The artists included were Troy Brauntuch, Jack Goldstein, Sherrie Levine, Robert Longo, and Philip Smith.
2. Artist's statement, January 22, 2003 (Walker Art Center Archives).

Silvia Kolbowski Selections from *Model Pleasure I* 1982 chromogenic prints, gelatin silver prints; edition 1/3 8 1/2 x 10 1/2 x 3/4 in. (21.6 x 26.7 x 1.9 cm) framed, each of 10 T. B. Walker Acquisition Fund, 2002 2002.66

Jannis Kounellis

Italian, b. Greece, 1936

- - **Exhibitions**
Artist and Printer: Six American Print Studios (1980; catalogue, tour),
The Cities Collect (2000), *Zero to Infinity: Arte Povera 1962–1972*
(2001; catalogue, tour)
- - **Holdings**
2 sculptures, 1 book

Jannis Kounellis has, since the beginning of his professional career in the early 1960s, steadfastly aligned himself with the Italian movement of Arte Povera. Greek by birth, Kounellis has lived in Rome since he was twenty, and he entered the world of Italian art with a force of originality that secured him an early, loyal following. The art he makes represents in many ways the essence of Arte Povera in its use of wayward materials, ambivalent relationship with the past, and extreme aesthetic refinement. It is also work that brings together the most unlikely materials to create objects of synergistic balance. Three excerpts from a series of provocations by the artist provide crucial insight into his methodology and embrace of the ambiguous gesture: "I am against the condition of paralyzation to which the post-war has reduced us; by contrast, I search among fragments (emotional and formal) for the scatterings of history./I search dramatically for unity, although it is unattainable, although it is utopian, although it is impossible and, for all these reasons, dramatic./I am against the aesthetics of catastrophe; I am in favor of happiness; I search for the world of which our vigorous and arrogant 19th-century forbears left us examples of revolutionary form and content."[1]

There is a morbid grandeur haunting much of Kounellis' work. It elicits a response somewhat akin to stumbling upon the remains of a moss-carpeted stone wall in the middle of a forest; something of purpose remains but its essential rationale has long departed. He draws as close as possible to tableaux of such poetic insistence that the works appear almost played out until a spark (sometimes literally in the artist's use of torches, candles, and lamps) of conversation between sculptural elements sends the composition of the whole spinning into an indeterminate space where modernity and antiquity achieve a kind of unity. In this regard it is worth noting Kounellis' legendary gesture when, in 1969, he tethered twelve horses in Rome's L'Attico Gallery and completely reordered any preexisting notions concerning installation.

In the two works by Kounellis in the Walker Art Center's collection, plaster casts of neo-Roman statuary play a dominant role. An untitled work from 1974 brings together a marble-topped pastry table used for rolling flour, an antique oil lamp, and an assortment of plaster shards. The table is stolidly bourgeois, its turned legs and brass pulls waiting for the rolling dough, but instead there are broken shards providing the promise of another, more poetic kind of nurture. The untitled work from 1982 is a wall composed of travertine stones in which are embedded an assortment of plaster fragments; the wall is meant to close off a

doorway or window and is itself an ornamental version of a work the artist made for an exhibition in 1971 that marked an end to the early Arte Povera florescence.[2] The work from 1971 is purely stone and acted as an impediment to moving from one gallery to the next. It is interesting to note that what began as a literal blockage becomes, a decade later, a record of cultural sediment—not closure but rather containment. The latter work is notable insofar as it exemplifies perfectly Kounellis' 1970s vision wherein closure and fragmentation played major psychological and physical roles. It is also a model of how, in the 1980s, he began manipulating and recombining early ideas and forms. By assigning new meanings to his evolved vocabulary, Kounellis continues to manipulate his chosen fragments to expand his ideological universe.

R.F.

Notes
1. Quoted in Gloria Moure, *Kounellis*, exh. cat. (New York: Rizzoli, 1990), 223.
2. The exhibition *Arte Povera: 13 italienische Kunstler* was held at Kunstverein München, Munich, May 26–June 27, 1971.

Jannis Kounellis *Untitled* 1982 Feather River travertine, cast plaster, steel 99 x 59 x 12 in. (251.5 x 149.9 x 30.5 cm) installed Walker Special Purchase Fund, 1987 1987.28

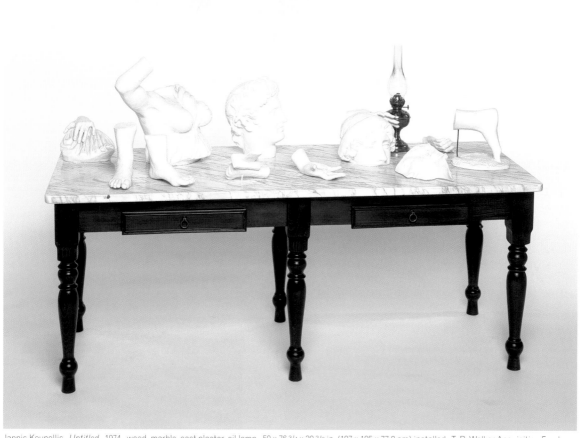

Jannis Kounellis *Untitled* 1974 wood, marble, cast plaster, oil lamp 50 x 76 3/4 x 30 3/8 in. (127 x 195 x 77.2 cm) installed T. B. Walker Acquisition Fund, 1997 1997.115

Udomsak Krisanamis

Thai, b. 1966

-- **Exhibitions**
The Cities Collect (2000), *Painting at the Edge of the World*
(2001; catalogue)
-- **Holdings**
1 painting

Udomsak Krisanamis is a Thai painter whose luxurious abstractions grew out of his confrontation with American culture and the English language, and yet they are deeply tied to the history of painting. After immigrating to New York in 1991, Krisanamis set about learning to read English by crossing out the words he knew in the newspaper. As his vocabulary grew, the newspaper pages became darker, with fewer gaps; these empty spaces mapped quite precisely the areas of opacity in his understanding of English. This mix of the known and the unknown—and its methodical translation into intricate webs of positive and negative space—became the basis for his paintings of the mid-1990s. Early canvases were covered with collages of short strips of newspaper, supermarket flyers, or other printed matter that stagger crookedly from top to bottom, or crisscross the composition in energetic, Pollockian skeins. Using a felt-tip pen, Krisanamis filled in everything except the spaces inside letter and number forms (for example, Q or 9). This systematic activity was carried out with a fluid painterly touch, and his canvases—made with increasingly vibrant materials, including printed fabrics, acrylic paint, colored papers, and tinted inks—are full of gesture, surface incident, irregularities, and pentimenti. They are also highly allusive: one might be looking into a starry night sky, or flying over a teeming city in the dark.

Krisanamis doesn't reveal much about his work or its intentions, but he has described his method as improvisation over a structure[1]—a musical analogy echoed in his practice of naming his paintings after song titles. For the Walker Art Center's work, *How Deep Is the Ocean?* (1998),[2] the artist stretched preprinted poly-cotton fabric so that its blue, purple, and white stripes run horizontally across the canvas. Cascading from top to bottom is a collage, made by covering most of the surface with irregular rows of short paper strips—neon-orange paper screenprinted with product names (Dannon, Lays) and prices in loopy blue and green type.[3] Using shiny midnight-blue ink, Krisanamis filled in around the ovals and circles formed by the type, occasionally letting the purple fabric show through. In more recent works, he has used glass noodles—a kind of Thai vermicelli made from mung bean threads—as an additional surface element. The transparent noodles add a specific reference to his Asian heritage, but only accidentally, as it were: Krisanamis is known for incorporating into his work whatever is at hand; he is Thai, and he cooks. (He has even occasionally substituted for his friend Rirkrit Tiravanija in the latter's cooking-performance installations.)[4]

Much of the history of postwar Western painting shows up in Krisanamis' paintings. The shimmering, all-over images make a nod to Jackson Pollock, of course, but also to the exquisitely filigreed Art Nouveau fantasies of Gustav Klimt. The underlying collage of printed papers recalls Jasper Johns' iconic flags and the early "hand-painted" Pop of Andy Warhol and Roy Lichtenstein. The viscous noodles stuck to his canvases even conjure up the decaying assemblages of chocolate and fat by Dieter Roth and Joseph Beuys. The allusions are rife; no wonder that, when asked to comment on the recurring debate about painting's demise, Krisanamis answered: "The death of painting? I would say, after me painting is born again."[5]

J.R.

Notes
1. " . . . most of [the paintings] are improvised . . . you have some structure and then after you lay out all the structure then comes the improvisation part." Krisanamis, interview with Kirsty Bell, in Christina Végh, ed., *Udomsak Krisanamis*, exh. cat. (Basel, Switzerland: Kunsthalle Basel, 2003), unpaginated.
2. "How Deep Is the Ocean?" is the title of a 1932 song by Irving Berlin.
3. The source material is only visible on the back of the canvas, where a few unpainted strips of this paper are adhered, seemingly randomly, around the bottom edges.
4. See Roberta Smith, "Udomsak Krisanamis," *New York Times*, May 17, 1996, sec. C.
5. Quoted in Bell interview.

Udomsak Krisanamis *How Deep Is the Ocean?* 1998 ink, printed paper collage on fabric 72 1/16 x 48 x 1 1/2 in. (183 x 121.9 x 3.8 cm) Clinton and Della Walker Acquisition Fund, 1998 1998.115

Yasuo Kuniyoshi

American, b. Japan, 1893–1953

-- **Exhibitions**
Art of the Print (1941), *92 Artists* (1943; catalogue), *John T. Baxter
Memorial Collection of American Drawings* (1949; catalogue),
Pictures for the Home (1950), *Lowenthal Collection of American Art*
(1952; catalogue), *Expressionism 1900–1955* (1956; catalogue, tour),
Art Fair (1959; catalogue), *John T. Baxter Memorial Exhibition* (1959),
American Tableaux (2001; publication, tour)
-- **Holdings**
2 paintings, 1 drawing

Yasuo Kuniyoshi *Lay Figure* 1937–1938 oil on canvas 38 3/16 x 58 3/16 in.
(97 x 147.8 cm) Gift of the T. B. Walker Foundation, Gilbert M. Walker Fund,
1948 1948.22

Gabriel Kuri

Mexican, b. 1970

-- **Holdings**
1 photograph

Gabriel Kuri *Arbol con Chicles* (*Tree with Chewing Gum*) 1999 laminated
chromogenic print; 2 Artist's Proofs from an edition of 3 51 1/2 x 34 1/4 in.
(130.8 x 87 cm) T. B. Walker Acquisition Fund, 2002 2002.182

Yayoi Kusama

Japanese, b. 1929

- - **Exhibitions**
Love Forever: Yayoi Kusama, 1958–1968 (1998; organized by the
Los Angeles County Museum of Art; catalogue)
- - **Holdings**
1 sculpture, 1 unique work on paper

Yayoi Kusama's art is vivid, courageous, relentless, and highly idiosyncratic. It is born equally of her compulsion to create and her immense ambition to succeed as an artist—a profession not considered suitable for Japanese women of her generation. In 1957, she immigrated to the United States to pursue her work, and two years later she had her first solo exhibition at the Brata Gallery, New York. She showed a group of vast abstract canvases that she called *Infinity Nets*, each with an all-over, interlocking pattern of lines and lacunae. "Massive, solid lace" was how Donald Judd described them in a review of the exhibition; Kusama herself has related the Nets to her lifelong hallucinations—overwhelming visions of dots, flowers, and nets that threaten to obliterate her and everything around her.[1] To escape annihilation, so to speak, she kept her repetitive visions at arm's length by confining them within her artworks.

Kusama continued to paint throughout the 1960s, and also made monochromatic collages of paper dots and stickers that recall the repetitive patterning of the *Infinity Nets*. Around 1961, she also began making obsessively decorated sculpture she sometimes called Compulsion Furniture. She and Judd, who had become a friend, scavenged the streets of Manhattan for cast-off objects, which she covered with dried noodles or protruding phallic shapes sewn of canvas and stuffed with cotton. Her first sculptural work, *Accumulation No. 1* (1961), is an old armchair frame that bristles with a multitude of white-painted phalluses. Subsequent objects—made from a couch, an ironing board, a baby carriage, high-heeled shoes, a kitchen stool—evoke a domestic environment nightmarishly (and hilariously) overrun by thousands of proliferating penises. Among this early group is the Walker Art Center's *Oven-Pan* (1963), a small piece that continues the theme of obsessive, dangerous consumption. A baking pan overflows with copper-colored phalluses, soft as yams; they have apparently mushroomed unexpectedly, for in the center of the pan sits an abandoned spoon holding a small serving of the dish. Presumably interrupted in midserve, the cook has fled. Kusama later said that works such as this embodied her ambivalence toward the erotic: "The sexual obsession and the fear of sex sit side by side in me."[2]

While adamantly her own, Kusama's spare paintings and cartoonish sculptures developed alongside Pop Art and have been perceived as cousins of Claes Oldenburg's soft sculptures and Andy Warhol's gridded paintings. Her sculptural installations and riotous public performances—which she called Naked Happenings, Anatomic Explosions, and Orgies—also flowed with the zeitgeist of the 1960s, featuring psychedelic light shows, group sex, and quasi-political protests. She appeared constantly in the tabloid media, but her notoriety eventually soured her art-world audience and she became unable to support herself through sales of her work. Under severe emotional and financial strain, she returned to Japan in 1972; a few years later, she voluntarily became a resident of a private psychiatric clinic in Tokyo. She has lived there since, maintaining a studio and continuing to make her work. Her career has been the subject of renewed interest since the late 1980s, when a retrospective of her work was organized in New York,[3] and in 1993 she was the sole artist to represent Japan in the Venice Biennale.

J.R.

Notes
1. Donald Judd, "Reviews and Previews: New Names This Month—Yayoi Kusama," *Artnews* 58, no. 6 (October 1959): 17. Kusama has often spoken of her mental illness and its relationship to her work. See Lynn Zelevansky's essay in *Love Forever: Yayoi Kusama, 1958–1968*, exh. cat. (Los Angeles: Los Angeles County Museum of Art, 1998), 10–41.
2. Quoted by Andrew Solomon in "Dot Dot Dot," *Artforum* 36, no. 6 (February 1997): 72.
3. The exhibition *Yayoi Kusama: A Retrospective* was curated by Alexandra Munroe and opened at the Center for International Contemporary Arts, New York, in 1989.

Yayoi Kusama *Oven-Pan* 1963 paint, canvas, cotton, steel, wood
9 3/4 x 18 1/2 x 24 in. (24.8 x 47 x 61 cm) T. B. Walker Acquisition Fund, 1996
1996.165

Jim Lambie

Scottish, b. 1964

- – **Commissions**
Zobop and *Psychedelic Soulstick* (2001)
- – **Exhibitions**
Painting at the Edge of the World (2001; catalogue)
- – **Holdings**
1 sculpture

Jim Lambie's work is subversive, but playfully so. The subversion is not in the blending of aesthetic categories; artists have been crossing those lines since the days of Marcel Duchamp. Instead, his work surprises in its blithe, affectionate mix of pop culture and formalist aesthetics. His life as a rock musician and deejay on the Glasgow club scene bleeds into his sculptural objects, which are made of cast-off record covers, turntables, or posters gussied up with glitter, beads, safety pins, junk jewelry, and other cheap trimmings. They fall into the established tradition of assemblage, but lack the angst of Beat-era works by the likes of Ed Kienholz or Bruce Conner. Likewise, Lambie's signature piece, *Zobop* (which has had many incarnations in various settings), is a striped floor painting reminiscent of Sol LeWitt's wall drawings, but instead of pencil or ink, Lambie uses brilliantly colored strips of electrical tape. He lets the architecture impose its own logic on the design, rather than the other way around, building his design by working inward from the perimeter of a room to the center, following the contents of the space fluidly. The act of covering an object or space is one of ownership; he says that it also "somehow evaporates the hard edge off the thing, and pulls you toward more of a dreamscape."[1]

In 2001, Lambie was invited to make a version of *Zobop* for the Walker Art Center's exhibition *Painting at the Edge of the World*. It covered a portion of one gallery, flowing around a stairway and onto the floor of a small elevator in the corner. The installation was completed by the addition of a *Psychedelic Soulstick*—one in an ongoing series of sculptures that Lambie makes by wrapping yards and yards of colored thread around a bamboo stick hung with small objects. The cocooned objects are things he handles during the course of his daily life: a guitar strap, a cigarette package, socks. He often installs the *Soulsticks* on *Zobop*; they animate one another, the stripe motif migrating from two to three dimensions and back again in a pulsating shift of scale. *Zobop* has often been compared to a dance floor, and the addition of one of the sticks reinforces this connection by naming two popular music genres, psychedelic and soul.

The form of the *Soulsticks* draws on a sculptural tradition that includes Richard Serra's lead "props" and the colored staffs made by French conceptual artist André Cadere. But perhaps the more telling allusion is to the shaman's stick: an object used by traditional healers in many cultures as an aid in the journey from profane space to the spirit world.[2] While he may be alluding to Joseph Beuys' notion of the artist-as-shaman, Lambie brings it up-to-date: for members of his generation, deejays and musicians carry the *Soulsticks*, and the dance floor is one of the few places left where ecstatic self-expression is still possible.

J.R.

Notes
1. Lambie, interview with Andrea Tarsia, published on the Web site of the Whitechapel Art Gallery, London, http://www.whitechapel.org/content474.html.
2. See Mircea Eliade, *Shamanism: Archaic Techniques of Ecstasy* (Princeton, New Jersey: Princeton University Press, 1972).

Jim Lambie *Psychedelic Soulstick (43)* 2003 bamboo, wire thread, guitar strap, cigarette package, sock, badges 48 x 4 x 2 3/4 in. (121.9 x 10.2 x 7 cm) Butler Family Fund, 2003 2003.58

John Latham

English, b. Mozambique, 1921

Holdings

1 sculpture

John Latham *Painting Is an Open Book* 1961 books, plaster, wire, wire mesh, wood, ceramic tile, glass, burlap mounted on board 63 x 36 x 7 1/2 in. (160 x 91.4 x 19.1 cm) T. B. Walker Acquisition Fund, 1987 1987.118

Lee Bul

Korean, b. 1964

- - **Exhibitions**
Let's Entertain (2000; catalogue, tour)
- - **Holdings**
1 sculpture, 1 edition print/proof

Lee Bul studied sculpture at Hong Ik University in Seoul, South Korea, graduating in 1987, the year that major pro-democracy, antiestablishment demonstrations rocked the country. Though not contiguously related to civil politics, Lee's practice has, from its origins in performance to the present, served to erode entrenched conservative ideologies of Korean culture—particularly Confucianism's invalidation of women—and mine the parallax view of Asian culture from the West. Confronting birth control and sexuality in early actions, she appeared naked save for a rock-climbing harness (*Abortion*, 1989) and donned soft-sculptural constructions with fleshlike appendages (*Sorry for suffering— You think I'm a puppy on a picnic?*, 1990). With recent sculptures and videos concerning karaoke and automotive design, she has consolidated her position as one of the most prominent Korean artists working today.

Executed between 1990 and 1997, the series of installations entitled *Majestic Splendor*, which brought Lee international recognition, featured real, dead snapper and other fish species displayed in clear polyethylene bags or hanging from hooks. Each fish was individually decorated with colorful beads and sequins that embellished their glossy scales and fins. Colliding natural and artificial strategies of display—and addressing the maintenance of beauty—the bejeweled fish gave off a rotting stench as they decayed during the course of their exhibition.[1] The artist's "Cyborg" sculptures—the first of which, *Cyborg Blue* and *Cyborg Red* (both 1997–1998), were included in the Walker Art Center's exhibition *Let's Entertain* (2000)—elaborate on this admixture of organic and man-made by recalling the limbs and torsos of the erotically charged armored women of *manga* comics and *anime* cartoons. In their evocation of both a technocratic lynching and damaged ancient marble statuary, Lee's later suspended white Cyborgs made from silicone, the material used in breast augmentations, address the female body in terms of a fetishized "future" and a classical past.

Plexus Blue (2000) inherits the decorative use of inexpensive jewelry employed in Lee's *Majestic Splendor* fish works and the allegorical woman of her Cyborgs. A split female torso form made of tan-colored leather is festooned with beads, necklaces, and broaches that appear to crawl over the skin surface and emerge from the interior like insects. They spill out from where the head should be, as if they were flames, plumes of blood, or the snakes of Medusa. As Lee explains, the use of this kitsch encrustation in her work recognizes a specifically female job: "It was an acknowledgment of the everyday elements of Korean social reality. In particular, the beads and sequins used to produce the decorative effect referred to the kind of cheap manual labor done by woman, and the dynamics of class and

consumption that were involved in Korea's economic development."[2] Housed in its own cabinet like a venerable relic, *Plexus Blue*'s flayed, scarified, beheaded, and dismembered female form invokes some kind of divine symbol of decadent butchery and sacrifice— a deity-heroine for millennial mythology.

M.A.

Notes
1. A version of *Majestic Splendor* shown as part of *Bul Lee/Chie Matsu: Projects 57* at the Museum of Modern Art, New York, in 1997.
2. Quoted in Franck Gautherot, "Lee Bul: Supernova in Karaoke Land," *Flash Art* 34, no. 217 (March–April 2001): 82.

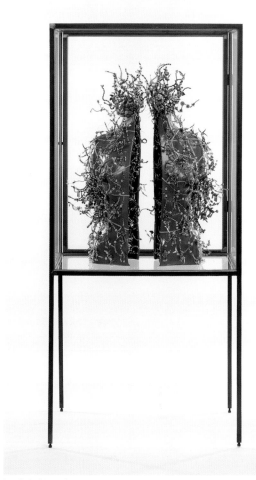

Lee Bul *Plexus Blue* 2000 leather, velvet, sequins, beads, glass, steel
67 1/2 x 31 1/2 x 23 5/8 in. (171.5 x 80 x 60 cm) T. B. Walker Acquisition Fund,
2000 2000.403

Jac Leirner

Brazilian, b. 1961

- - **Commissions**
To and From (Walker) (1991), *Blue Phase* (1992), *Little Pillow* (1992)
- - **Exhibitions**
Viewpoints—Jac Leirner (1991; publication)
- - **Holdings**
2 sculptures, 1 multiple

Jac Leirner's sculptures are elegant accumulations that suggest the frenetic circulation of ideas, objects, currency, and people within the art world. To make them, she collects ephemera that is worthless, or nearly so—devalued bank notes, used envelopes, empty cigarette packages, plastic shopping bags, business cards, promotional stickers. Much of this cultural flotsam is produced by museums, galleries, and other art world venues; Leirner slips it into her bag and later reinserts it into the marketplace in the form of handsome, formally precise artworks. She sorts these castoffs meticulously by type, color, or shape, and then systematically sews, stacks, glues, or strings them together in constructions equally informed by the minimal objects of Donald Judd and the "subversive geniality"[1] of Joseph Beuys.

An early group of works collectively titled *Pulmão (Lung)* (1987) was made from the parts of twelve hundred empty Marlboro boxes she had saved, leftovers from her two-pack-a-day smoking habit. The plastic outer wrappings, inner foil liners, tax stamps—everything was saved and made into objects: a sagging string of red-and-white boxes, a gossamer grid of stacked cellophane, a lung-shaped tangle of plastic pull-off strings. These works are poignantly autobiographical in their fragility. Leirner's presence is also felt in wall and floor installations made in 1992 from plastic tote bags emblazoned with museum gift-shop logos. Entitled *Names (Museums)*, they quietly acknowledge her role in the exchange of goods that has become part of our cultural experience. A recent series of freestanding sculptures was made from stickers produced by the art world infrastructure—airlines, publishers, shippers, galleries, art fairs—that Leirner affixed to detached glass windshields from buses and cars. As in her shopping-bag works, our culture's graphic insignia come together with its means of transport, a collision that alludes to art's movement, exchange, display, use, and consumption.

In 1991, the Walker Art Center presented Leirner's first solo exhibition in the United States, an ensemble of ten new works made from bank notes, labels, and envelopes. Thousands of worthless Brazilian cruzeiros formed snaking floor works (entitled *Blue Phase* for the color of the notes). These were intertwined with long strands of blank white paper rectangles cut to the same size as the notes—called *Ghost*, they also slithered down the gallery stairs into an installation of the Walker's collection, as if they were nosing around for content. Two works were made from envelopes that had carried Walker correspondence, sorted and stacked by size and dubbed *To and From (Walker)*.[2] Labels for

every exhibition that had been presented at the Walker between 1959 and 1991 were gridded on the wall, along with labels for every painting, sculpture, and drawing in the museum's collection.[3] Leirner turned these banal raw materials into signs for something that was no longer present: absences were transformed into objects that commented solipsistically on the system that had created and consumed them. The only work with intrinsic, specific value was a plexiglass box containing forty thousand U.S. dollar bills (connected to an alarm)—and this was, of course, not for sale.

Leirner has acknowledged that her work "may connote the inflationary economy in Brazil, relations between artworks and art market, [and] circulation of things." But she reminds us that "in reality, the work *is not about* these matters, it is a physical presence totally impregnated by them."[4]

J.R.

Notes
1. The phrase is Leirner's, quoted by Rob Silberman in "Jac Leirner at the Walker Art Center," *Art in America* 80, no. 2 (February 1992): 124.
2. Leirner requested that museum staff save envelopes from incoming correspondence during the nine months prior to her exhibition. Under her supervision, they were later punched and strung together on plastic cord or steel bars.
3. Of the two works in the Walker's collection, only one was part of this exhibition: *To and From (Walker)*. The other, *Blue Phase*, was made in 1992 for an exhibition at the Hirshhorn Museum, Washington, D.C., and later acquired by the Walker.
4. Artist's statement, August 24, 1993 (Walker Art Center Archives).

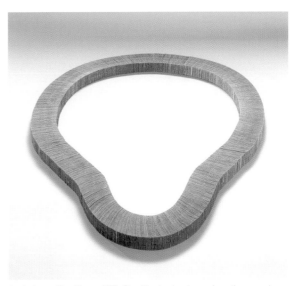

Jac Leirner *Blue Phase* 1992 Brazilian bank notes, polyurethane cord
63 in. (160 cm) diameter Butler Family Fund, 1993 1993.53

Ralph Lemon
American, b. 1952

- - **Commissions**
How can you stay in the house all day and not go anywhere?
(with Wayne Ashley/John Klima; http://geography.walkerart.org/
patton/) (2004); *Come home Charley Patton* (*The Geography Trilogy*:
Part 3) (2004)
- - **Performances**
Geography: Africa/Race (*The Geography Trilogy*: Part 1) (1997), *Tree*
(*The Geography Trilogy*: Part 2) (2000), Bruce Nauman's *Wall/Floor
Positions* (with Djédjé Djédjé Gervais) (2003), *Come home Charley
Patton* (*The Geography Trilogy*: Part 3) (2005)
- - **Exhibitions**
How Latitudes Become Forms: Art in a Global Age (2003)
- - **Residencies**
Ralph Lemon (1997, 2000, 2002, 2005), Ralph Lemon/Djédjé Djédjé
Gervais (2003)
- - **Holdings**
1 net artwork

Ralph Lemon is a seeker, a modern-day choreographic contemplative who culls kernels of artistic truth through movement, writing, and directing. Born and raised in Minneapolis, he graduated from the University of Minnesota in 1975, and was part of the Nancy Hauser Company before cofounding Mixed Blood Theater Company in 1976. He moved to New York in the late 1970s and, after a stint with Meredith Monk (whom he first saw perform at the Walker Art Center), formed his eponymous company in 1985. Lemon quickly gained attention for his collaborative acumen and singular facility for expression within the vacillating fiats of post-modern choreography in New York at that time.[1] The core of his celebrated style of the late 1980s and early 1990s seemed organically rooted in the body but could just as easily flow seamlessly into enigmatic austerity. Having embraced, in such works as *Boundary Water* (1984) and *Killing Tulips* (1993), both cerebral classicism and romantic rumination, Lemon's choreographic ambitions began to outgrow the constraints of formulaic formality: "When you start with the same dancers, you often end up making the same dance. Yes, there's a refinement. . . . But I began to question the relevance of a private language that no one outside my company understood."[2] At what seemed to be the height of his career, he decided to dissolve his company in 1995, after ten years of internationally acclaimed work, and to look beyond the familiarity of New York and the creative process as he knew it.

Since 1995, Lemon and a handpicked roster of international collaborators have been on a ten-year odyssey of diasporic discovery, a quest for the pieces of dance and the linkages to the past (and present) needed to complete a whole.[3] *The Geography Trilogy*—a profound examination of Lemon's own history—is a remarkable inquiry into the social gravities of race and identity at the turn of the twenty-first century. Lemon's ambitious vision for the movement vocabulary of the *Trilogy* has relied on the ebb and flow of many social tide pools— a language that swirls between notions of modern and traditional, East and West, light and dark, formal and free-form. His direction and choreography, equal parts art and anthropology, illuminate the clash and charm of cultural juxtapositions while striving to remain respectful of the considerable significance of dance traditions in distinct civic frameworks.

Presented by the Walker in November 1997, *Geography: Africa/Race* (*The Geography Trilogy*: Part 1) was performed by nine male dancers and musicians against artist Nari Ward's backdrop of shimmering walls of bottles and mattresses. The work is distinctly African yet unmistakably American, bringing to the surface rich metaphors of personal discovery formed out of ancestral exploration. As race was the root of Part 1, spirituality was the seed of Part 2, *Tree*. Following his sojourn and extensive research in Asia, Lemon again sought the spark of cultural collision in a piece that linked disparate customs and interlaced dances such as the Odissi of India with postmodern improvisation. *Tree* is an amalgam of movement, languages, folk songs, and incongruous images refracted through Lemon's vision: "Here was this quiet little man from a village in South China who in some part of his body, spirit, soul, or culture knew Robert Johnson[4] and knew the Mississippi Delta. . . . It summed up this work in a way I could never have devised."[5]

The Walker has assisted Lemon in realizing the conclusion of the *Trilogy* through commissioning support, two developmental residencies, and financially supporting *How can you stay in the house all day and not go anywhere?* (2004), the Web-based companion piece to the performance work. For Part 3, *Come home Charley Patton*, Lemon returned to rural America to reach further into the depth of a shared personal history. The work, which features the core *Trilogy* collaborators, includes his research into socially charged sites significant to the Civil Rights movement, lynchings (in both the South and the North), the roots of Mississippi Delta blues, and ideas drawn from the likes of Bruce Nauman and James Baldwin. Throughout his long involvement with the Walker, Lemon's craft, curiosity, and ebullient personality have touched many through myriad workshops, performances, residency activities, and collaborations.

D.B.

Notes
1. Attracted to the advantages of other forms of expression, Lemon has made work for and with some of the foremost creators of our time, including filmmaker and visual artist Isaac Julien, Batsheva Dance Company, Bebe Miller, the Lyon Opera Ballet, the Joffrey Ballet, John Cale, Rhys Chatham, and Frank Zappa, among many others.
2. Quoted in Christopher Reardon, "Pilgrim's Progress," *Dance Magazine*, September 2000, 65.
3. Collaborators on the *Trilogy* have included artist Nari Ward (set designer); dramaturge Katherine Profeta; dancers Djédjé Djédjé Gervais, David Thomson, Okwui Okpokwasili, and Miko Doi Smith; poet Tracie Morris; and composers and musicians James Lo, Francisco Lopez, and Paul D. Miller (aka DJ Spooky).
4. Renowned Delta blues guitarist (1911–1938).
5. Quoted in Reardon, "Pilgrim's Progress," 66.

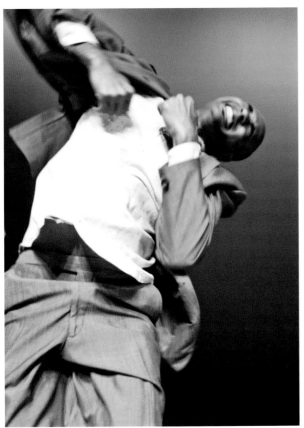

Ralph Lemon *Come home Charley Patton* (*The Geography Trilogy*: Part 3)
Krannert Center for the Performing Arts, Urbana-Champaign, Illinois, 2004

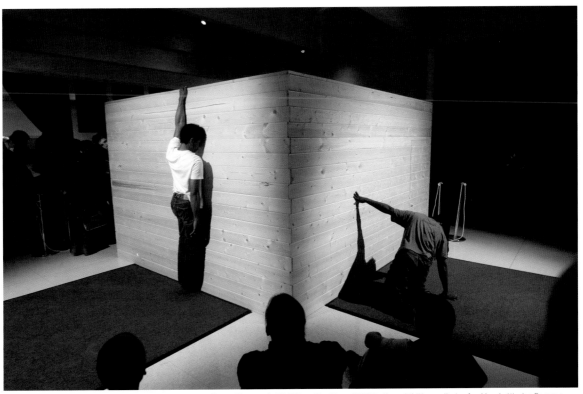

Ralph Lemon (left) and Djédjé Djédjé Gervais re-create Bruce Nauman's *Wall/Floor Positions* (1965) in the exhibition galleries for *How Latitudes Become Forms: Art in a Global Age*, Walker Art Center, 2003

Sherrie Levine

American, b. 1947

- - **Exhibitions**

Artists' Books (1981), *Duchamp's Leg* (1994; catalogue, tour),
American Tableaux (2001; publication, tour), *The Last Picture Show:
Artists Using Photography, 1960–1982* (2003; catalogue, tour)

- - **Holdings**

4 paintings, 1 sculpture, 1 drawing, 1 photograph, 1 photographic
suite, 3 multiples, 1 book

In 1982, Sherrie Levine was invited to join the roster
of artists exhibiting in Documenta 7 in Kassel,
Germany. The director was Rudi Fuchs, the Dutch
curatorial entrepreneur whose mission was clearly
to create his own *Gesamtkunstwerk.* Joseph Beuys
was central to the dynamic, but so too was Hans-
Jürgen Syberberg, the German filmmaker who cre-
ated the conflicted epic *Our Hitler* and was invited to
premiere his adaptation of Wagner's *Parsifal* at
Documenta. Additionally, Syberberg contributed an
enormous sculpture of Wagner's head that filled the
park in front of the museum. Under the eaves of the
Museum Fridericianum were paintings by Anselm
Kiefer and Hermann Nitsch, compositions of straw
and smoke and blood displayed only in natural light.
Circling the museum's dome was Lothar Baumgarten's
oddly proprietary litany of perished Amazonian tribes
emblazoned in mud red and gorgeous serif typeface.
The entirety of the exhibition was insistently muscular,
filled with Sturm und Drang, and ripe with nostalgia
for a kind of folkloric heroicism.

Into this updated version of Hrothgar's Mead Hall
arrived Levine with a suite of photographs entitled
After Egon Schiele. The photographs are 14-by-11-inch
chromogenic prints of Schiele's onanistic self-portraits
rephotographed from bookplates in catalogues. Now,
consider for a moment how utterly bizarre Levine's
contribution to the musky air of Documenta truly was.
Copy prints of bookplates of watercolors by a notorious
Austrian masturbator with no subject other than him-
self and his libido were not getting with the program,
and Fuchs was not amused. For a moment it looked like
the series might be dispatched from the Fridericianum
to a more distant venue, but the final decision had them
tucked into a neutral corner, where they glistened like
a feverish forehead.

In the early 1980s, appropriation was an American
strategy practiced primarily by a handful of young New
York Conceptualists. Appropriation practiced with the
unadorned, flat-footed assertiveness of Levine was
totally alien. Furthermore, it was absurd. What was the
point? It only made sense if you were an art insider who
appreciated the ironic innovation that gave the work its
spiky resonance. Or, if you weren't an insider, it was still
possible to simply be seduced or repelled by Levine's
tertiary photographs of the Schiele reproductions.
Either way, she struck a nerve that had everything to do
with authorship, originality, connoisseurship, testoster-
one, and the boundaries of artistic practice. At the time
it seemed like a cry in the dark; today, it echoes on like
a battle cry.

Throughout her career, Levine has managed to
keep the art world rattled. The naked appropriation
of others' work, the repurposing of iconic and inane
objects, the hermetic simplicity of an art-historical ges-
ture, and the ongoing—occasionally contradictory—
utilization of Conceptual strategy have all contributed
to her somewhat isolated position. Her career was born
in the late 1970s when she was identified as an interest-
ing Conceptualist whose work was purchase-proof and
who collaborated brilliantly with her peer Louise
Lawler. Both were part of a generation of influential
artists, all of whom would later be tagged as Picture
Theorists. In addition to Levine and Lawler, the most
prominent players in the cast of characters were Sarah
Charlesworth, Barbara Kruger, Richard Prince, and
Cindy Sherman.

Levine's most notorious appropriation was the sub-
ject of her 1981 exhibition at the newly opened Metro
Pictures in New York. *After Walker Evans* consisted of
twenty-two rephotographed pictures of Walker Evans'
legendary Dust Bowl series. Levine had sourced the
material from his government-sponsored collaboration
with James Agee, the genre-defining book *Let Us Now
Praise Famous Men.* The previous year, she'd rephoto-
graphed Edward Weston's portraits of his ephebic son
Neil but was forced to remove them from circulation by
the Weston estate. So when, a year later, she took pos-
session of the Evans material, there was no mistaking
her determination to append her career to masters of
the modern canon. When the exhibition opened, the
controversy exploded. Not surprisingly, critical theorists
(particularly those associated with *October* magazine)
were delighted to have something so deliciously multi-
tiered, while the arts journalists were delighted to have
something to tear apart. In the end, Levine proved the
winner insofar as there were far fewer people unaware
of her at the close of the exhibition. The Evans series
also brilliantly encapsulated the glamorously torqued
banality of her best work and cleared the way for fur-
ther, ever more intricate couplings with artists of some
sublimity, such as Man Ray and Marcel Duchamp, and
also the gentle humanist cartoonist George Herriman,
the creator of *Krazy Kat.*

For Levine, appropriation is a highly nuanced prac-
tice. It is not simply reproducing the reproduction;
it also involves imagining beyond the reproduction
to place the original in a new relationship with itself.
In, for example, a work such as *La Fortune (after Man
Ray: 3)* (1990), she imagines the celestial billiard table
portrayed in the Surrealist's painting *La Fortune* (1938)
right out of its picture frame and into the three-dimen-
sional world, where it sits resolutely on its four chunky
legs. Marcel Duchamp's *Fountain* (1917) is transformed
into a bronze urinal resembling, but distinct from,
Duchamp's "readymade" porcelain original. Levine's
Fountain (after Marcel Duchamp: A.P.) (1991) is any-
thing but readymade and, while retaining a literal ele-
ment of ironic reflection, it is also an homage to the
master of the surrogate self. In 1994, Levine turned to
Constantin Brancusi's *Newborn* (1915) for a tour de force
installation at the Philadelphia Museum of Art in which
six white glass sculptures of her *Newborns* were placed
on six grand pianos. She had finally, in her own

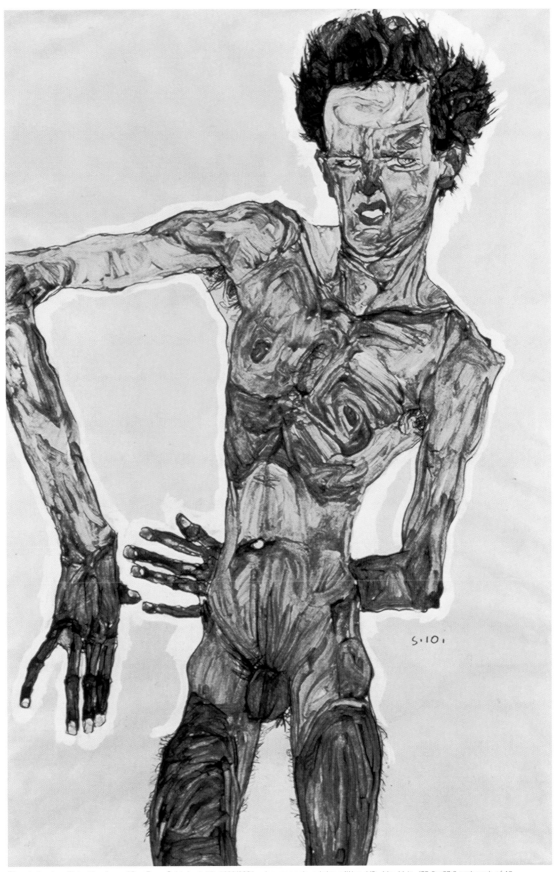

Sherrie Levine Selection from *After Egon Schiele: 1–18* 1982/2001 chromogenic prints; edition 1/2 14 x 11 in. (35.6 x 27.9 cm) each of 18
T. B. Walker Acquisition Fund, 2002 2002.6

discreetly outrageous way, entered the world of specta-
cle. A year later, she crafted another version at the
Menil Collection in Houston, this time with black glass
heads, allowing the sculptural edition to enter a sec-
ond, alternate life.

Levine has often chosen to speak about herself by
using quotations from a variety of, of course, unac-
knowledged writers. However, she has occasionally
also spoken of her work in a manner at once analytical
and heartfelt. One of the most telling statements con-
cerning her work was written for the publication mark-
ing her installation in Philadelphia: "Like Brancusi, I
am interested in the physical and the sensory. However,
I am also interested in the contingent and unstable. I
like the aura of happenstance. I like repetition, because
it implies an endless succession of substitutes and
missed encounters. . . . I would like you to experience
one of those privileged moments of aesthetic negation,
when high art and popular culture coalesce. I would
like high art to shake hands with its cynical nemesis—
kitsch, which in its sentimentality makes a mockery of
desire. I would like the meaning of this work to become
so overdetermined and congealed that it implodes
and brokers a new paradigm." [1]

R.F.

Notes
1. Sherrie Levine, Artist's statement, in Ann Temkin, ed., *Newborn*,
exh. cat. (Philadelphia: Philadelphia Museum of Art, 1993), 7.

Sherrie Levine *Skull* 2001 bronze; edition 11/12 5 x 4 3/4 x 7 1/4 in. (12.7 x
12.1 x 18.4 cm) T. B. Walker Acquisition Fund, 2002 2002.212

Sherrie Levine *Black Newborn* 1994 sand-blasted cast glass; edition 10/12 5 1/4 x 8 x 5 1/2 in. (13.3 x 20.3 x 14 cm)
Clinton and Della Walker Acquisition Fund, 2002 2002.233

Sherrie Levine *Fountain (after Marcel Duchamp: A.P.)* 1991 bronze; Artist's Proof 1 from an edition of 6 14 1/2 x 14 1/4 x 25 in. (36.8 x 36.2 x 63.5 cm) T. B. Walker Acquisition Fund, 1992 1992.153

Sherrie Levine *La Fortune (after Man Ray: 3)* 1990 wood, felt, resin; edition 3/6 33 1/4 x 115 x 65 1/4 in. (84.5 x 292.1 x 165.7 cm) T. B. Walker Acquisition Fund, 1992 1992.156

Sherrie Levine *Untitled (after Egon Schiele)* 1984 graphite, watercolor on paper 14 x 11 in. (35.6 x 27.9 cm) Gift of the artist, 1992 1992.151

On Sherrie Levine's *Untitled (after Egon Schiele)*

I've always found Egon Schiele's works difficult to look at, not only his embarrassingly emotionally raw self-por-traits but also the blatantly sexualized and exposed nudes that catalogue his neuroses and desires over and over again. I dislike most their theatricality, the sense that his fetishism already has a clientele, however small or select, in mind, the sense that they were made for me. What is uncomfortable about a work such as *Stehender weiblicher Akt mit über der Brust Verschränkten Armen (Moa)* (*Standing Female Nude with Arms Crossed Over Her Breast: [Moa]*) (1911) is how relentlessly it records his interest or, more technically, his scopophilia. The drawing's flat-tened, undulating contour owes as much to Gustav Klimt's *Jugendstil* as it does to the model's body; where Schiele pays attention—where I can see him looking—is in the dark scumble that occludes the figure's eyes and, even more obviously, in the calligraphic tangle of pubic hair, which is marked not only by the intensity or the density of his line, but also by a peculiar sort of mannerism. Schiele is at once a damaged and expressive subject—the very subject of Expressionism—and a performer, an impresario, even. He is too much there. "So I am creating more, seemingly endless new works out of myself," wrote Schiele to the collector Oskar Reichel in 1910. "I am so rich that I must give myself away." Maybe he has given himself away in a couple of senses, and perhaps he has given himself away to Sherrie Levine.

Her untitled watercolor after the Schiele drawing should be easier to look at; after all, she has, in a very partic-ular way, excised the artist's overbearing presence. Levine's watercolor is a fairly exacting copy, but she's left out Schiele's signature, which appears quite demonstratively in the original just to the right of the model's left shoul-der. I should feel less implicated in her version, or more shielded from its sexualized address, since her watercolor provides a cover, however transparent, for his drawing, or for my looking. Whatever libidinal energy it was that impelled the quickening and thickening of Schiele's line as he reached the pubis is, in the Levine, bound and cal-culated. The odd notation for the hair across the back of the neck, the way the right hand spreads out and disap-pears across the breast and under the left arm, the insouciant circles that designate curls of hair or the hollow of the throat: what had been serendipitous or discovered for Schiele is for Levine, quite literally, a trace. Looking should be free, detached, and yet one can get caught looking here, as well. It's hard to know where to look: if this image is not his, and not quite hers either, what does it mean to look at it and what does one look at it for? Her watercolor, too, is not proper, but it is improper around the issue of property rather than propriety.

Still, I find Levine's untitled watercolor a peculiarly touching work. Touching, in rather specific opposition to Schiele's looking, might be its theme. Levine's source, after all, isn't Schiele's drawing, but its reproduction in a catalogue, and her careful watercolor translation returns the sense of touch and the original that mechanical reproduction necessarily removes. The touch she returns isn't Schiele's, of course, but it's difficult to say that the picture is hers, that it "expresses" her the way we might imagine Schiele's drawing expresses him. If Levine is in the image, she's there precisely where Schiele is not—not only in his absent signature, but also in the pinkish-beige watercolor field that rests on the textured paper, palpably, like a cover. That field isn't in Schiele's original—his is a pencil drawing on a sheet of paper; hers is an image of that page as it appears in the catalogue, an image both of the drawing and its ground. Her work lies where the watercolor field fits up against or leaks through the pencil lines of its drawn border, or where that pencil line comes up to or just misses the dots made at each corner to measure out the rectangle. Her presence, then, is tenuous, almost invisible, or visible only at the surface and at the edge, but against the theatrical heat of Schiele's image that damping down of affect, that refusal to expose, is touching and effective nonetheless.

Howard Singerman

Sol LeWitt

American, b. 1928

Sol LeWitt's influential work bridges the Minimalist and Conceptual Art movements of the early 1960s. For more than forty years, he has remained extraordinarily prolific in a range of media that includes structural installations, wall drawings, photography, works on paper, prints, and artist's books. In 1967, he responded to an invitation from the editor of *Artforum* to contribute a statement on his work to the magazine. In "Paragraphs on Conceptual Art," LeWitt did more than simply outline the parameters of his artistic practice—he coined the term for a movement that would tip the scales from an orientation toward objects to an idea-based art. He radically proposed that "when an artist uses a conceptual form of art, it means that all of the planning and decisions are made beforehand and the execution is a perfunctory affair. The idea becomes the machine that makes the art." He went on to explain that "what the work of art looks like isn't too important. It has to look like something if it has physical form. No matter what form it may finally have it must begin with an idea. It is the process of conception and realization with which the artist is concerned." Neither manifesto nor dogmatic treatise, LeWitt's third-person proposition defined how this radical new mind-set and rational procedural framework could ultimately undermine the art world's obsession with authorship and render the formal necessities of design unnecessary, in order to eliminate "the arbitrary, the capricious, and subjective."[1]

In 1965, he showed several large wooden slab constructions painted with multiple layers of lacquer to achieve an uninflected, industrial-looking finish in his first New York solo exhibition at artist Dan Graham's short-lived John Daniels Gallery. LeWitt has recounted how he made the transition in 1964 from these early planar geometric formations to his first three-dimensional, open, modular structures: "Disturbed by the inconsistency of the grain of the wood in the Daniels Gallery pieces, and by the emphasis on surface (not only in appearance, but in the long hours of work needed to achieve the correct luster), I decided to remove the skin altogether and reveal the structure. Then it became necessary to plan the skeleton so that the parts had some consistency. Equal, square modules were used to build the structures. In order

to emphasize the linear and skeletal structure, they were painted black."[2] One of the first vertically oriented open structures, *Standing Open Structure Black* (1964), corresponded to a human scale, which was in keeping with the discourse on phenomenology circulating among fellow Minimalist artists such as Donald Judd. The field of perception concerned LeWitt briefly, but ultimately he moved beyond the body as a frame of reference toward a purely formal analysis stemming from basic arithmetic and numerical systems, permutations, and progressions.

By the end of 1965, LeWitt began painting the modular structures white, due to his concern that his use of black might be interpreted as harboring hidden content. He also believed that white allowed for greater integration of the object in space, specifically that of the white cube of the gallery. It was at this time that he also randomly established a ratio of 1:8.5 to dictate the correlation between line (matter) and space (interval) in his cubic structures.

By 1966, the cube would become the basic element in LeWitt's lexicon: "The most interesting characteristic of the cube is that it is relatively uninteresting. Compared to any other three-dimensional form, the cube lacks any aggressive force, implies no motion, and is least emotive. Therefore, it is the best form to use as a basic unit for any more elaborate function, the grammatical device from which the work may proceed."[3]

This was an important year for LeWitt as his white cubic structures were featured in a solo show at the Dwan Gallery and included in several seminal New York exhibitions, including the Jewish Museum's *Primary Structures*, which rather belatedly brought Minimalism to a broader public and endorsed LeWitt and other participating artists—Judd, Dan Flavin, Carl Andre, Robert Morris, and Anne Truitt—as serious practitioners of the new art. *Cubic Modular Piece No. 2 (L-Shaped Modular Piece)* (1966) is made up of five columns of six stacked cubes serially aligned in the shape of the letter *L*. The grid became a flexible medium through which a defined shape could take visible form in whatever scale he determined. Though the arrangements of his towerlike structures are conceptually simple, depending on the vantage point of the viewer, the cubes overlap, challenging depth perception and concentrating the overall intensity of the works.

In 1968, LeWitt enacted a significant breakthrough in the history of Conceptual Art: he drew a combination of vertical, horizontal, and forty-five-degree diagonal lines (left to right and right to left) directly onto one of Paula Cooper's gallery walls and called it *Wall Drawing #1*. Reasoning that it seemed "more natural to work directly on walls than to make a construction . . . and then put the construction on the wall,"[4] LeWitt, from that point onward, followed a carefully articulated system he later published as "Doing Wall Drawings."[5] In this text he states that the artist's responsibility for a drawing ends with the conception of the idea and providing a plan in the form of instructions (written, spoken, and/or drawn). After that point, an assistant or any other individual executes the work in any location, any number of times. By abdicating his claim to originality, forcing himself to deal with the architecture of a

given space and walls in varying states of disrepair, allowing for different skill levels on the part of his proxies, and accepting the work's inevitable destruction (painting over), LeWitt rendered his wall drawings contingent and provisional. Never in the history of art had drawings occupied such an ambiguous position.[6]

In 1980, the formula for the wall drawings changed to include more variety of shapes and media, including ink washes, inspired by his love of the Italian countryside surrounding his farmhouse near Spoleto. Warm earth tones reminiscent of frescoes and the Umbrian hills infiltrated his palette, resulting in increasingly sensual wall drawings.[7] The installation of *Four Geometric Figures in a Room* was commissioned by the Walker Art Center in 1984 for the entrance hall to two newly constructed galleries.[8] To create the piece, a special drawing ink saturated with pigment was rubbed on the slightly absorbent wall in layers—at least three for each color—then rinsed with clear water. Each area was carefully marked to produce a sharp, clear edge.

The 1980s also brought with it a new material for LeWitt's outdoor structures—concrete blocks, which he has openly acknowledged as having "an inherent ugliness."[9] He first considered using brick, but thought it was too steeped in architectural history, aesthetically loaded, and small in scale: "It suddenly dawned on me that I could also have the concrete block as a module. Concrete blocks were even more ubiquitous than brick, and an even more basic building material. Everything is built of concrete blocks. I preferred the larger module."[10] He has created walls, steps, triangles, towers, pyramids, and corner structures; the Walker's sculpture *X with Columns* (1996) is a variant of the latter. These structures continue to evoke LeWitt's early works through seriality and the use of the grid. And like his wall drawings, this monumental piece was conceived but not built by the artist—it was left to skilled construction workers to achieve its perfect alignment. To paraphrase LeWitt, Conceptual Art is good when the idea is good. And the idea was good.

E.C.

Notes
1. Quotations in this paragraph are from Sol LeWitt, "Paragraphs on Conceptual Art," *Artforum* 5, no. 10 (Summer 1967): 80.
2. Quoted in Alicia Legg, *Sol LeWitt*, exh. cat. (New York: Museum of Modern Art, 1978), 57.
3. LeWitt, "The Cube," in Legg, *Sol LeWitt*, 172.
4. Quoted in Gregory Battcock, "Documentation in Conceptual Art," *Arts Magazine* 44, no. 6 (April 1970): 45. Reprinted in Legg, *Sol LeWitt*, 169.
5. LeWitt, "Doing Wall Drawings," *Art Now: New York* 3, no. 2 (June 1971), unpaginated. Reprinted in Gary Garrels, ed., *Sol LeWitt: A Retrospective*, exh. cat. (San Francisco: San Francisco Museum of Modern Art, 2000), 376.
6. When acquiring a piece, a collector receives a diagram and a signed certificate of authenticity with a brief instructional description, designated media, date, and location of first installation, and draughtsmen's names if available. The Walker's certificate for *Wall Drawing #9A* (1969/1996) notes the fact that it was first executed by LeWitt and several assistants in black pencil at L'Attico Gallery in Rome in May 1969. The description reads: "Two-part serial drawing. The wall or rectangle is divided vertically or horizontally into two parts. One part with vertical and horizontal lines superimposed, the other part with diagonal left and diagonal right lines superimposed." The Walker also owns the companion piece, *Wall Drawing #9B* (1969/1996). It is identical to *Wall Drawing #9A* except that it is executed in colored pencil. *#9B* was first installed at the Walker in January 1996, and was executed by Kristin Hanson, Jeanne McGee, and Anthony Sansota.
7. This point was made by Michael Brenson, "Monuments in Time," in Susanna Singer, ed., *Sol LeWitt Concrete Block Sculptures* (Milan: Alberico Cetti Serbelloni Editore, 2002), 9.
8. LeWitt's certificate instructions for this drawing are: "Four geometric figures (circle, square, trapezoid, parallelogram) drawn with four-inch (10 cm) wide band of yellow color ink wash. The areas inside the figures are blue color ink wash, and the areas outside the figures are red color ink wash. On each side of the walls are bands of India ink wash." *Four Geometric Figures in a Room* was first executed in 1984 under the supervision of Sol LeWitt by Jo Watanabe, Kate Hunt, and Owen Osten. With the construction of the Herzog & de Meuron expansion to the Barnes building in 2004–2005, the hall was altered to such an extent that the piece by necessity was destroyed and will be resited.
9. Quoted in Brenson, "Monuments of Time," 15.
10. Ibid., 15.

Sol LeWitt *Four Geometric Figures in a Room* 1984 ink on latex paint on gypsum board installed dimensions variable Installation commissioned by the Art Center with funds provided by Mr. and Mrs. Julius E. Davis, 1984 1984.8

Sol LeWitt *Cubic Modular Piece No. 2 (L-Shaped Modular Piece)* 1966 baked enamel on steel 109 1/8 x 55 7/16 x 55 1/2 in. (277.2 x 140.8 x 141 cm)
Purchased with a grant from Museum Purchase Plan, the National Endowment for the Arts, and Art Center Acquisition Fund, 1974 1974.7

Sol LeWitt *Wall Drawing #9A* and *Wall Drawing #9B* 1969/1996 graphite, colored pencil installed dimensions variable Gift of the artist, 1996 1996.100

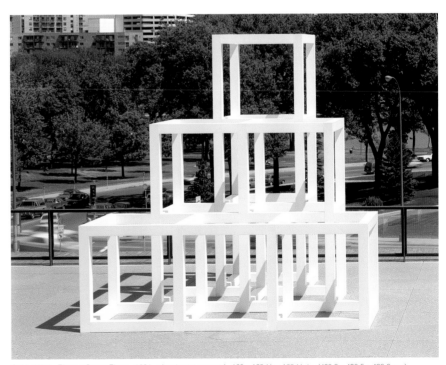

Sol LeWitt *Three x Four x Three* 1984 aluminum, enamel 169 x 169 1/2 x 169 1/4 in. (429.3 x 430.5 x 429.9 cm)
Walker Special Purchase Fund, 1987 1987.12

Roy Lichtenstein
American, 1923–1997

- - **Commissions**
Salute to Painting (1985–1986)
- - **Exhibitions**
Editions MAT 1964 and 1965 (1966), *Roy Lichtenstein* (1967; organized by the Pasadena Art Museum, California; catalogue), *Banners and Tapestries* (1967), *Eight Artists: Prints from Gemini G.E.L.* (1974; catalogue, tour), *20th Century Master Prints* (1975; tour), *Homage to Picasso* (1980), *Artist and Printer: Six American Print Studios* (1980; catalogue, tour), *Roy Lichtenstein as Sculptor: Recent Works 1977–1984* (1985; organized by the Columbus Museum of Art, Ohio; catalogue), *First Impressions: Early Prints by Forty-six Contemporary Artists* (1989; catalogue, tour), *The Cities Collect* (2000)
- - **Holdings**
1 painting, 1 sculpture, 2 unique works on paper, 178 edition prints/proofs, 7 multiples, 1 periodical, 1 model, 3 preparatory materials for works

After working through several experimental idioms, Roy Lichtenstein started scrapbooking advertising and comic art. Overnight he turned fuzzy pulp illustrations into Pop icons, becoming one of that movement's leading lights. It was 1961, and he was thirty-eight. Abstract Expressionism had founded New York School One; Pop Art and Minimalism initiated New York School Two.

The leap from One to Two took most collectors and curators by surprise. They failed to recognize that American innovation is not a conquering Cyclops but a Hydra whose several heads fight it out amongst themselves; there were, of course, winners and losers in the battle to be named most influential. Pollock's clotted tangles of puddles and drips, Rothko's sweeping fields of open color and unfocused form—these defined the extremes of Abstract Expressionism, and their utter eccentricity made a new American art but proposed no next step. Willem de Kooning's *Women* and *Abstract Landscape* canvases, though, were important to Rauschenberg, Johns, Oldenburg, and Lichtenstein— all of whom saw that de Kooning offered a way of working that did not exclude the possibility of linear structure. This is what we might call drawing, and what Lichtenstein called design.

Artist's Studio No. 1 (Look Mickey), an ambitious canvas from 1973, revisits several of Lichtenstein's earlier motifs: from 1961, a stretch sofa, Donald Duck painting, rotary telephone, and paneled door; a 1970 *Mirror* painting, which defines the side wall; a meager dentil molding from the 1971 *Entablature* paintings running along the ceiling. Quotes from his 1972 *Still Life* paintings litter the floor—a Matisse pewter jug, a gaggle of grapefruit and bananas, a sculptor's modeling stand, a wall-to-wall carpet of diagonal stripes. In a 1973 interview the artist said he took on two-tone stripes as nothing much more than an alternative to benday dots.[1] Both were mechanical devices for spreading a percentage of broken color on a white ground. Here, the carpet is fifty percent black, as is the verso of a painting leaning against the door (a take on the artist's 1968 *Stretcher Frame*). That's the tour.

The disorder of the composition is disconcerting. Objects are spread rather evenly but seem not to relate to one another. This reflects the painting's point of departure, Matisse's 1911 classic *Red Studio*. The central irony is that *Artist's Studio No. 1 (Look Mickey)* is both an homage to Matisse and a retrospective look at Lichtenstein's own career. This is an original but not difficult idea: Lichtenstein is not as philosophical as his fans think he is, and he never intended to redefine Western painting. Like Flemish masters of domestic interiors and still lifes, he paints what is familiar and what he likes. For Lichtenstein, as for Matisse and Picasso, using devices such as dislocation of scale, short-circuit of memory, or even the effete dogmas of abstraction does not diminish an obsession with the ordinary, the knowable, the comfortable. Like most artists of the 1960s, he assumes you already know this is a rogue's gallery of previous work. Matisse's assumptions were similarly solipsistic.

Always identified as a person of Pop, Lichtenstein sometimes dips in and out of Minimalism, a direction most exquisitely evident in his limited-edition graphics. Here we see pictorial reductivism, anonymous surface, industrial precision, even an occasional portfolio of variations on a single construct.[2] When interviewed about his 1969 *Haystack* and *Cathedral* portfolios, the artist dubbed the precision dot patterns "manufactured Monets," "an industrial way of making Impressionism . . . a machinelike technique."[3] The 1973 *Bull* prints make hash of the then-current notion that Minimalism, heir to the Cubist-Constructivist pontificate, is utterly intellectual because of its pure geometry. Inspired by Theo van Doesburg's four dairy cow paintings (which he'd seen illustrated in *Cubism and Abstract Art*),[4] Lichtenstein's bulls morph from realistic to abstract, beginning with an image of a Hereford steer he found in the Los Angeles Yellow Pages. Reversing van Doesburg, Lichtenstein's archetypal steers lead to progressively more complex Cubist-Constructivist concoctions.

Lichtenstein's 1965–1966 monster brushstrokes are like fluttering muses in the artist's career. They make only nominal reference to his own painterly abstractions of 1960 and present images more obviously invented than anything he'd done to that point. Most often he painted on acetate taped down to glass on an opaque projector, working the strokes into invented configurations.[5] The big brushstrokes in his 1967 show at the Walker Art Center deeply impressed then-Director Martin Friedman; nearly two decades later, when the museum planned to present an exhibition of his recent sculptures,[6] Friedman commissioned Lichtenstein to work up a four-stroke maquette as a proposal for a high-rise monument. The twenty-five-foot stack in painted aluminum was christened *Salute to Painting* (1985–1986). Here Abstract Expressionist gestures seem to lunge upward at one angle, then cascade down at another. A rotating motion is implied during daylight hours, when sunlight transforms its shape into an oddly totemic column, like a flagpole fully swaddled in bunting. *Salute to Painting*'s erratic weld joints give improbable upright gravitational balance and structural stability. Ah, the provoking irony: the artist transforms swaths of liquid paint into flat graphics, pops

out ridges and edges into shallow relief, then stacks
them up in assemblage fashion like a standing
Allegory of Painterly Painting: a kind of Pop paean
to the earlier generation of New York School artists.

Philip Larson

Notes
1. Lichtenstein, interview with the author, in Philip Larson, *Eight
Artists: Prints from Gemini G.E.L.*, exh. cat. (Minneapolis: Walker Art
Center, 1974), 16–18.
2. The Walker Art Center is fortunate to shelter many editions that
Kenneth Tyler shepherded at Gemini G.E.L. in Los Angeles, then later
at Tyler Graphics in Mount Kisco, New York.
3. Quoted in John Coplans, ed., *Roy Lichtenstein* (New York: Praeger
Publications, 1972), 44–45.
4. Alfred Hamilton Barr, *Cubism and Abstract Art*, exh. cat. (New York:
Museum of Modern Art, 1936), 145.
5. See Coplans, *Roy Lichtenstein*, 44–45.
6. The exhibition *Roy Lichtenstein as Sculptor: Recent Works 1977–1984*
was curated by Jean Robertson for the Columbus Museum of Art,
Ohio, and opened at the Walker in 1985.

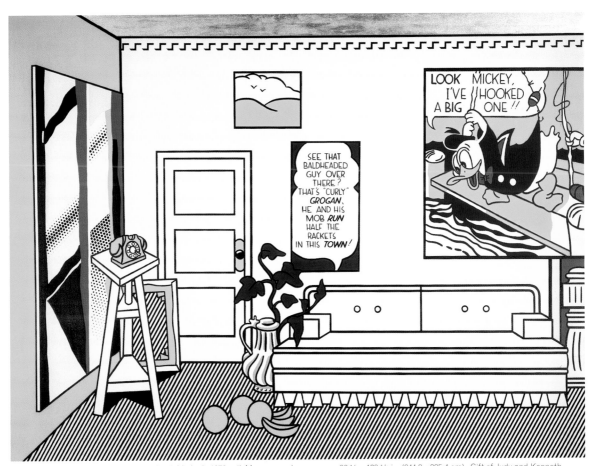

Roy Lichtenstein *Artist's Studio No. 1 (Look Mickey)* 1973 oil, Magna, sand on canvas 96 1/8 x 128 1/8 in. (244.2 x 325.4 cm) Gift of Judy and Kenneth
Dayton and the T. B. Walker Foundation, 1981 1981.3 ©Estate of Roy Lichtenstein

Glenn Ligon
American, b. 1960

- - **Exhibitions**
Viewpoints—Malcolm X: Man, Ideal, Icon (1992; publication, tour),
Duchamp's Leg (1994; catalogue, tour), *The Cities Collect* (2000),
Coloring: New Work by Glenn Ligon (2000; catalogue), *American
Tableaux* (2001; publication, tour), *The Squared Circle: Boxing in
Contemporary Art* (2003; publication)
- - **Residencies**
1999–2000
- - **Holdings**
2 paintings, 1 sculpture, 1 drawing, 22 edition prints/proofs, 1 book

Glenn Ligon troubles the waters with work that chal-
lenges assumptions about race, gender, sex, and citi-
zenship using history as his oar: "If I have a well to dip
into, it's filled with almost four hundred years worth
of permutations of what blackness has meant and
speculations on what it might mean in the future."[1]
Drawing on an art-historical lineage that includes
Andy Warhol and Adrian Piper, his practice is concep-
tually driven and embraces painting as well as print-
making, photography, and installation. He often
appropriates, reconfigures, and recontextualizes cul-
turally loaded materials, particularly literary excerpts
from the likes of Ralph Ellison, Zora Neale Hurston, and
James Baldwin. Making possible a sustained dialogue
across past and present, black and white, he stub-
bornly locates American history in the persistent now.

Ligon's series *Runaways* (1993) references the
unmistakable stain of American slavery while also
calling into question the nature of identity and the
power of language to capture it. On black-and-white
lithographs, in a style combining the format of run-
away slave posters with highly symbolic illustrations
of the abolitionist movement, the artist presents ten
distinct descriptions of himself supplied by ten friends
asked to pretend they were filing a missing persons
report. Each starts simply with the phrase "Ran away,
. . ." Surprisingly, these twentieth-century verbal
accounts mimic the text of actual fugitive slave posters,
offering physical descriptions that bring to mind auc-
tion blocks. One short piece ends with the racially and
historically weighted phrase "Nice teeth." Yet adequate
and stable definitions prove to be a moving target as
Ligon's skin color is described variously as "black,"
"pretty dark-skinned," and the nuanced "medium com-
plexion (not 'light skinned,' not 'dark skinned,' slightly
orange)." The power of language, oral and written,
often gives a visceral quality to his work, at once reve-
latory, inadequate, confining, and slippery. After all, he
seems to remind us, something as complex as a human
being cannot be captured in mere words, whether on
a slave poster or a modern-day newscast reporting a
criminal suspect.

Confronting race and its American twin obsession
of masculinity, Ligon collaborated with Byron Kim on
Rumble Young Man Rumble (Version #2) in 1993. It is a
standard-issue punching bag on which is stenciled a
poetic speech by champion boxer Muhammad Ali that
begins: "Everything that the so-called Negro do in

America seem to be the best, the greatest. So what's
wrong with him saying he *is* the greatest when every-
thing in America that has been made the greatest
has been painted and colored white?" It is a call to rhe-
torical arms that one can read in full only by circling
the sculpture, almost like a fighter dancing around the
ring. Language becomes image and performative cat-
alyst, the basic requirements of being black and male
in America, which are perfectly captured in the per-
sona of Ali. The metaphorical power of text is further
explored in Ligon's *Untitled (Stranger in the Village #16)*
(2000), a monochromatic painting with a layer of black
coal dust obscuring a passage from James Baldwin's
"Stranger in the Village." The 1953 essay relates
Baldwin's experience of being an American and an
African American in a foreign land. The painting's
dense and textured surface of luminescent black with
just a hint of warm red beneath—evidence of an aban-
doned work—alludes to the ever-shifting nature of
identity and race. As is his trademark, Ligon presents
language just on the edge of illegibility, playing hide-
and-seek with our ability to break the code and read
the script.

With *Malcolm X, Sun, Frederick Douglass, Boy with
Bubbles (version 2) #1* (2000), Ligon makes a radical
formal shift with a cacophony of colorful strokes differ-
ent from anything he's done before. This painting is
the end result of a multilayered process whereby the
artist gave young children coloring-book sheets to fill
in, which he then copied on a larger scale in his studio.
The images were collaged from various black-themed
coloring books from the 1970s, a time of immense
promise for black America. According to Ligon, the
paintings in this series "are about breaking free of con-
straints by using children's drawings and inhabiting
their casual, indifferent relationship to the images and
the whole project of liberation that those images were
about in the first place. The paintings are hovering in
that space between meaning a great deal and mean-
ing nothing."[2] This piece is a fascinating history lesson
spanning a great African American orator of the nine-
teenth century and a political martyr of the twentieth,
then veering into the seemingly trivial concerns of a
black child blowing bubbles and a vocabulary lesson
on the letter S. Thus, the playing field is leveled as
Ligon presents each element as equally relevant to
the full story of blacks in America. Perhaps rightly so,
since in the 1970s representations of blacks simply liv-
ing life—blowing bubbles, strolling—were as radical
and necessary as those of fiery revolutionaries, and
remain so. Again, the artist presents history as a com-
pelling force in contemporary times.

"People are trapped in history," Baldwin wrote,
"and history is trapped in them."[3] In Ligon's practice,
each work is a Rorschach test that drives us to reen-
gage with what we thought were stable moments and
meanings safely ensconced in the past. To encounter
his work is to enter an ambiguous yet metaphorically
rich space of unresolved questions swirling around
the complexity of humanity, which is colored, gen-
dered, and ever evolving. At first, we each see what
our own personal biographies and attendant limita-
tions allow us to see; then, he encourages us to look

shades

six
6

sun

S s

soul

Malcolm X

Glenn Ligon *Malcolm X, Sun, Frederick Douglass, Boy with Bubbles (version 2) #1* 2000 screenprint, oil crayon on primed canvas 96 x 72 in.
(243.8 x 182.9 cm) T. B. Walker Acquisition Fund, 2000 2001.18

past the familiar for those inevitable marks of transformation that bring history past into history present.

O.I.

Notes

1. Quoted in Byron Kim, "An Interview with Glenn Ligon," in Judith Tannenbaum, ed., *Glenn Ligon: Unbecoming*, exh. cat. (Philadelphia: Institute of Contemporary Art, 1998), 55.
2. Quoted in Olukemi Ilesanmi and Joan Rothfuss, "A Conversation with Glenn Ligon," in Olukemi Ilesanmi and Joan Rothfuss, eds., *Coloring: New Work by Glenn Ligon*, exh. cat. (Minneapolis: Walker Art Center, 2000), 32.
3. James Baldwin, "Stranger in the Village," in *James Baldwin: Collected Essays*, Toni Morrison, ed. (New York: The Library of America, 1998), 119.

Glenn Ligon *Untitled (Stranger in the Village #16)* 2000 acrylic, coal dust, oil stick, glue, glitter, gesso on canvas 48 1/16 x 56 1/8 in. (122.1 x 142.6 cm)
Butler Family Fund, 2000 2000.108

Artist-in-Residence, 1999–2000

Glenn Ligon's residency had two distinct elements that nevertheless shared a common theme of "sampling"—the contemporary method of cutting and mixing existing material and ideas to create something dynamic and new. Fascinated by the complicated histories—social, cultural, and political—that can be traced through the covers of books by and about African Americans, Ligon spent many hours exploring the stacks in the Archie Givens Sr. Collection of African American Literature at the University of Minnesota. He later assembled more than sixty of these covers in a small exhibition at the Walker. His display told a fascinating story of the changing representations of black subject matter from the 1950s to the 1970s, a time roughly parallel to the rise of the Civil Rights and Black Power movements, and then carried it forward with books from the 1980s to the close of the twentieth century. His selections and groupings, juxtaposed with his own commentary and quotes by writers such as LeRoi Jones, James Baldwin, and Oscar Wilde, were highly personal yet open to interpretation, and ranged from close-ups of black faces to the coding of blackness in typography and graphic layouts.

For the second part of his residency, Ligon asked Walker Art Center Teen Arts Council members to respond to various artworks in the Walker's permanent collection by sampling them to make their own individual pieces. Over a four-month period, the teens worked closely with Ligon to develop their ideas, gaining insight into the creative process. They drew on artists as varied as Lucio Fontana, Andy Warhol, Charles Ray, and Kara Walker. Their resulting works in a variety of media were also included in Ligon's in-residence exhibition.

O.I.

Glenn Ligon (center) with members of the Walker Art Center Teen Arts Council, 2000

Glenn Ligon and Byron Kim *Rumble Young Man Rumble (Version #2)* 1993
paint stick on canvas punching bag, metal 36 x 13 x 13 in. (91.4 x 33 x 33 cm)
Butler Family Fund, 1995 1995.148

Sharon Lockhart

American, b. 1964

- - **Exhibitions**
Stills: Emerging Photography in the 1990s (1997; publication)
- - **Holdings**
1 multimedia work, 2 photographs, 1 multiple, 1 book

The first thing one notices when confronted with the work of Sharon Lockhart is that she is neither a photographer nor a filmmaker. While the end results of her artistic process are indeed photographic prints and film projections, these are not the defining elements of her work. Her practice is much more akin to that of a choreographer or a musician, as her media of choice are space and time. Based in Los Angeles, the artist graduated with her MFA from the Art Center College of Design in Pasadena in 1993 and has subsequently become a central figure in a generation of artists who came of age in the 1990s. They are inheritors of what critic A. D. Coleman identified in 1976 as the "directorial mode" in photography, describing a new artistic strategy in which artists set up or stage their images. For the last decade, Lockhart has exploited the directorial mode in order to investigate the temporal gap between the stillness of photography and the dynamism of cinema.[1]

In Lockhart's *Untitled* (1996), for example, a single static image contains an entire world within the borders of its frame. Unlike some of her earlier work, it does not so much reference any specific instances in the history of narrative filmmaking as it describes a more general ontology of the cinematic. This extremely large, horizontally formatted color photograph is scaled to the aspect ratio of a cinema screen, confronting the viewer with what appears to be an ambiguously dramatic moment in the middle of an unknown or forgotten film. A young man finds himself in a hotel room, framed against the highly stylized backdrop of a floor-to-ceiling glass window that looks out into the twilight of an anonymous cityscape. As it turns out, the city is Los Angeles and the location is the Bonaventure Hotel, although we have no way of determining this visually as the picture recedes into a blurry depth of field constituted by the reflective surfaces of the glass. In its luminous shimmer, we catch a glimpse of a figure entering the room through a door that is in essence positioned in the off-screen cinematic space behind us. We are caught in the middle of the narrative created by this image, frozen in a fragment of time and trapped in a story with no promise of resolution, yet we are seduced into attempting to complete the open-ended fiction that has been so intricately constructed by the artist.

While Lockhart is well known for her photographic works, she has also worked in film since the very beginning of her career. In *Goshogaoka Girls Basketball Team* (1997), a work comprising both a film and a series of photographs, she moves away from a focus on storytelling in order to conduct a more sophisticated structural investigation into the nature of our physical relationship to cinematic space and time. The result of a residency in Japan in fall 1996, this project, featuring a junior high school girl's basketball team from the outskirts of Tokyo, enabled Lockhart to explore her interest in the experimental concerns of both the minimalist dance choreography and the structuralist filmmaking practices of the 1960s. In a nod to such filmmakers as Yvonne Rainer, Michael Snow, and Chantal Akerman,[2] who challenged the conventions of narrative cinema by focusing on the material structure and process of their medium, Lockhart employed a single stationary camera and divided the film into six sections of ten minutes each, a time determined by the length of a single commercially available reel of 16mm film. Working with American choreographer Stephen Galloway of the Ballett Frankfurt, Lockhart put these twenty-four young women through a set of highly structured movements in which their bodies weave in and out of our field of vision, defining the different areas of cinematic space created by her camera's constant gaze across the length of a gymnasium floor at the proscenium of a theatrical stage. As the film progresses through its six dramatic "acts," what at first appears to be a kind of rote documentation of a basketball practice begins to take on the character of a highly ritualized and abstract tale, leading Lockhart to suggest that "the proscenium defines the movement of the girls; it announces the film as a fiction, as staging, as theater."[3] This fictional staging stands in stark contrast to the film's structural influences. In the end, it becomes clear that in *Goshogaoka Girls Basketball Team*, the artist has managed to construct a hybrid exploration of bodily movement that paradoxically bridges the gap between the legacies of structural and narrative filmmaking, and in so doing, reveals her true fascination to be the mutable immateriality of dramatic performance.

D.F.

Notes
1. As the artist has suggested, "I think most of the time we see a photograph and we either are caught up in the flow of time—imagining the moments before and after the photograph was taken—or we see the image as existing completely outside of time. We never stop to consider the relationship, seeing both the flow of time and its arrest in the photograph." Quoted in Bernard Joisten, "Sharon Lockhart," *Purple*, no. 2 (Winter 1998/1999): 328–335.
2. Lockhart was especially influenced by Chantal Akerman's film *D'Est* (1993), which is also in the Walker Art Center's permanent collection.
3. Quoted in Joisten, "Sharon Lockhart," 329.

Sharon Lockhart *Atsuko Shinkai, Eri Kobayashi, and Naomi Hasegawa* from *Goshogaoka Girls Basketball Team* 1997 chromogenic prints, 16mm film (color, sound); photographs: edition 4/8; photograph dimensions vary film: Artist's Proof 1/3 63 minutes T. B. Walker Acquisition Fund, 2002 2002.211

Sharon Lockhart *Untitled* 1996 chromogenic print; edition 5/6 73 x 109 in. (185.4 x 276.9 cm) T. B. Walker Acquisition Fund, 1997 1997.109

Richard Long

British, b. 1945

The simple act of walking lies at the heart of Richard Long's sculpture. It is a simplicity that extends to all aspects of the artist's work: simple forms in simple materials, simple words in simple typefaces. The artist himself has used children's verse to characterize what he does: "Five six pick up sticks/Seven eight, lay them straight"— a not so tongue-in-cheek introduction to his love of "the simplicity of walking, the simplicity of stones."[1] But this surface simplicity is deceptive. By combining and recombining a limited array of forms and actions, Long achieves a wonderfully subtle complexity through which he expresses ideas about landscape in particular and the place of the individual in nature in general.

Long's walks have taken him all over the world and can entail anything from an hour to weeks of effort. The shorter walks are often determined by an abstract shape—a squared-off spiral, a circle—drawn onto a detailed survey map. In these cases the walk is the work itself; the only lasting evidence of it being the map, which, with a straightforwardly descriptive title— *Twelve hours twelve summits*, for example—permits the viewer to mentally reconstruct the artist's work. More often than not, the viewer comes away with the distinct notion that this would be "easier said than done." Maps are themselves an abstraction intended to allow individuals (or armies!) to negotiate *around* difficulties.[2] By imposing a further level of abstraction on the landscape, Long forces himself to confront and engage these difficulties. For longer walks, the artist usually follows established paths and along the way makes sculpture from nearby materials, which he then records with a photograph.[3]

Where the remote "walk sculptures" tend to blend in with their surroundings, their immediate offspring, the gallery sculptures, rely on contrast. By bringing rough-edged pieces of stone and wood—often secured locally—into pristine gallery spaces, simple, even mundane materials such as flint are suddenly imbued with qualities of extreme eloquence and elegance. Initially, each work is tailored for a specific place and, upon completion, the artist creates, on a single sheet of paper, an outline drawing, followed by a single paragraph written in simple block letters giving instructions on how to re-create it. Contingent factors, such as breakage and proportions, are recognized and accommodated. The instructions for *Minneapolis Circle* (1982) specify an exact twenty-two-foot diameter but allow "about ten spare stones left over at the end [to] make the selection of the last pieces to go in easier."[4] The drawing for *A Line of Flint* (1983), by contrast, permits

a two-foot variance in length ("depending on the particular placing") and, anticipating the friability of flint, stipulates that "any broken fragments less than 2 inches long should be thrown away." Both sheets end with this admonition: "N.B. This drawing shows procedure only; it cannot itself be 'copied.' It is not an artwork."[5] Such sentiments are in keeping with the artist's arm's-length relationship with the art world and the desire (now somewhat romantic-seeming) of many 1960s artists[6] to create work that exists largely outside a commercial framework and that rearranges rather than adds to the material world, bringing awareness and beauty to the everyday, the incidental, and the spurned.

Graham Beal

Notes

1. Richard Long, *Five six pick up sticks/Seven eight lay them straight* (London: Anthony d'Offay Gallery, 1980).
2. By an irony not of the artist's making, the very maps that Long uses for his walks in Britain owe their existence to the British Army's determination to pacify the Scottish Highlands following the uprising of 1745. Hence the name: Ordnance Survey Maps.
3. Long insists that the photographs are not works of art themselves, merely records of actual work, and deliberately inscribes them "in the public domain." To see the work itself, the would-be viewer must, to some degree, reproduce the artist's walk. In 1980, while discussing the possibility of the commission for *Minneapolis Circle*, the artist told the author that two long walks had been abruptly curtailed: one, by the Peruvian army, when Long was detained for his own safety to protect him from the guerrilla group Sendero Luminoso; a second when an amiable rancher in Wyoming advised him that his neighbor was prone to shooting "trespassers" before asking questions.
4. According to the author's memory, Long declined to use granite from the nearby Cold Springs Quarry for *Minneapolis Circle* because of the stone's particular decorative connotations. He had a favorite red slate shipped in from upstate New York.
5. Artist's statement, 1983 (Walker Art Center Archives).
6. This motivation (and aesthetic), widespread in European art circles in the 1960s and 1970s, also underlies work by artists associated with Arte Povera, Zero, and Fluxus.

Richard Long *Minneapolis Circle* 1982 red slate 264 in. (670.6 cm) diameter Justin Smith Purchase Fund, 1982 1982.161

Morris Louis
American, 1912–1962

-- **Exhibitions**
Morris Louis: The Veil Cycle (1977; catalogue, tour)
-- **Holdings**
1 painting, 2 drawings

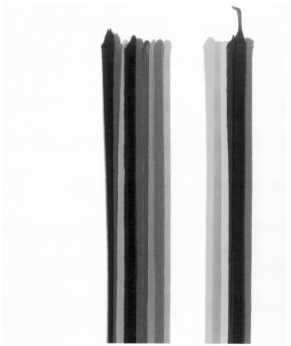

Morris Louis *#28* 1961 acrylic on canvas 91 1/8 x 78 5/16 in. (231.5 x 198.9 cm) Gift of the T. B. Walker Foundation, 1964 1964.9

Louis Lozowick

American, b. Russia, 1892–1973

-- Exhibitions
Art of the Print (1941), *American Prints Today* (1959),
The Precisionist View in American Art (1960; catalogue, tour)
-- Holdings
1 painting, 1 edition print/proof

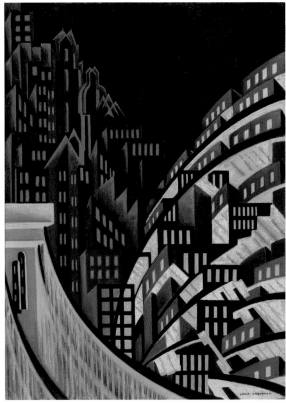

Louis Lozowick *New York* circa 1925 oil on canvas 30 3/16 x 22 3/16 in.
(76.7 x 56.4 cm) Gift of Hudson D. Walker, 1961 1961.17

George Luks

American, 1867–1933

-- Exhibitions
Watercolor—U.S.A. (1946; catalogue, tour), *John T. Baxter Memorial
Collection of American Drawings* (1949; catalogue), *John T. Baxter
Memorial Exhibition* (1959)
-- Holdings
1 painting, 1 drawing

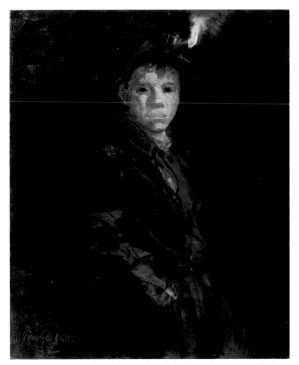

George Luks *Breaker Boy of Shenandoah, Pa.* 1921 oil on canvas 30 1/4 x
25 1/8 in (76.8 x 63.8 cm) Gift of the T. B. Walker Foundation, 1949 1949.13

Mark Luyten
Belgian, b. 1955

-- **Commissions**
On a Balcony (1993–1996)
-- **Exhibitions**
On a Balcony: A Cinema (Mark Luyten) (1997; catalogue)
-- **Holdings**
2 drawings, 1 multimedia work, 3 edition prints/proofs, 1 book

Mark Luyten was born and raised in Antwerp, the main metropolis in northern Belgium. The city is densely and vertically built, its elaborate architecture evidence of centuries of accumulated trade wealth. The surrounding landscape is low and wet, the local weather often gray. This strongly flavored visual environment has been important to Luyten's work, as has the Belgian obsession with language. The country has two official tongues (Flemish and French) and its citizens are schooled in those and two others (German and English). In Luyten's world, language is an ever-present signifier that can indicate one's religious, political, social, geographic, and even familial affiliations.

The relationship between man and nature, as mediated by the artificial construct of language, has been the focus of Luyten's work, which often takes the form of installations combining video, sculpture, text, and photographs. He likes to site his work in the interstitial spaces between indoors and out—balconies, porches, windows—or in landscape simulacra such as greenhouses, parks, and gardens. In 1990, he made a piece in the Hotel Furkablick, which sits at the Furka Pass high in the Swiss Alps (the hotel's name means "view of the Furka"). It consisted of phrases and words ("dream," "boredom," "storm," "music") rubber-stamped on windows throughout the building. As the artist has noted, windows serve as both access and barrier to the landscape, and here the texts function in the same way, both describing the view and suggesting that it will eventually be reduced to an abstraction in our memories. Later projects have been more complex, involving multiple sites and mediums, but each is more or less a lament on the difficulty of satisfying the desire for profound contact with nature. He has written, "Seeing is always linked with what has been seen, with descriptions, conventions, stories, memories, desires, etc. A landscape is always a landscape of words. . . . [Language] creates a distance between the subject and the object."[1]

In late 1993, Luyten was commissioned by the Walker Art Center to produce a series of installations in the museum building and the adjacent Minneapolis Sculpture Garden. He devised a working process in which he traveled from Antwerp four times a year—at each solstice and equinox—to create a new work somewhere on the site. Each installation remained in place until he returned to make something else. This evolving constellation of notations, ideas, and objects rarely appeared in the exhibition galleries proper, instead turning up unexpectedly in hallways, offices, stairwells, skylights, and other odd corners of the building, as well as in the Garden's conservatory and plazas and along the walkways. Between visits, Luyten corresponded with museum staff, who carried out instructions and made decisions as necessary; this working process became an important aspect of the final work, which was completed in early 1996. Its sixty-four components—videotapes, photographs, objects, drawings, letters, and films—were acquired for the Walker's collection under the umbrella title *On a Balcony*.

For all its procedural complexity, *On a Balcony* was ultimately as simple and richly varied as everyday life. Luyten traveled, packing his art in a suitcase and putting it in place when he arrived. He cheerfully incorporated the uncontrollable and accidental into his plans (objects were stolen, luggage was lost, weather turned sour). He invited the collaboration of the Walker's staff, providing a Super 8 camera for them to make films of trees in the Garden, or asking them to install his objects in their offices. He walked miles of the city's streets, then packed clay from a deposit in Collegeville, Minnesota, into his worn-out leather shoes (which promptly effloresced with a garden of mold). He brought things from home—shells from the North Sea, charcoal rubbings of his studio floor, videotapes of the view from his window—and left them in out-of-the-way spots throughout the building. He made a solo road trip into Minnesota's northernmost reaches, videotaping the view from inside his car. He mined the Walker's film collection for casual evening screenings in the Garden. And from the voluminous correspondence that accumulated over the course of the project, he made a simple, sculptural stack and displayed it in a vitrine—an acknowledgment that the project was based, in the end, on relationships among people.

All of this added up to an extended meditation on the specific yet paradoxically generic nature of concepts such as home, museum, and garden. In the book that documents the project, Luyten ended with an anecdote and a reflection that suggests one is never far from home: "During my last visit [Walker Director Kathy Halbreich] gave me a snowdome of the Minneapolis Sculpture Garden as a gift for my son. So it was around the corner. Everywhere. Portable."[2]

J.R.

Notes

1. Luyten, correspondence with Walker staff member Ernie Whiteman, December 17, 1993 (Walker Art Center Archives).
2. Mark Luyten et al., *On a Balcony: A Novel (Mark Luyten)*, exh. cat. (Minneapolis: Walker Art Center, 1997), 110.

Mark Luyten *What Is in between My Hands (Or Bob's or Randy's)* from *On a Balcony* 1995 unfired porcelain installed dimensions variable
Sculpture Garden Acquisition Fund, 1997 1997.66.53

Film screening curated by Mark Luyten for *On a Balcony*, Minneapolis Sculpture Garden, 1994

Stanton Macdonald-Wright
American, 1890–1973

- - **Exhibitions**
The Classic Tradition in Contemporary Art (1953; catalogue)
- - **Holdings**
1 painting

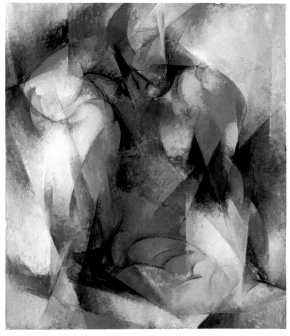

Stanton Macdonald-Wright *Synchromy in Green and Orange* 1916 oil on canvas 34 1/8 x 30 1/8 in. (86.7 x 76.5 cm) Gift of the T. B. Walker Foundation, Hudson D. Walker Collection, 1953 1953.49

Man Ray
American, 1890–1976

- - **Exhibitions**
The Classic Tradition in Contemporary Art (1953; catalogue), *Editions MAT 1964 and 1965* (1966), *The 20th-Century Poster: Design of the Avant-Garde* (1984; catalogue, tour), *Duchamp's Leg* (1994; catalogue, tour), *A Practical Dreamer: The Photographs of Man Ray* (2000; organized by The J. Paul Getty Museum; catalogue)
- - **Holdings**
5 edition prints/proofs, 1 multiple, 9 books

Man Ray *Cadeau* (*Gift*) 1921/1963 cast iron, tacks; edition 3/10 6 1/4 x 3 5/8 x 4 1/2 in. (15.9 x 9.2 x 11.4 cm) Bequest of Thomas H. Ruben, 2004 2004.55

Robert Mangold

American, b. 1937

-- **Exhibitions**
Artists' Books (1981)
-- **Holdings**
1 painting, 1 edition print/proof, 2 books

Robert Mangold *Pink X within X* 1980 acrylic, colored pencil on canvas
113 1/2 x 113 1/2 in. (288.3 x 288.3 cm) Justin Smith Purchase Fund, 1983
1983.199

"X marks the spot." This could be a label for Robert Mangold's *Pink X within X* (1980), a painting whose indexical function registers a striking presence on the wall. One may even be moved to see it as a kind of St. Andrew's Cross, only puzzlingly incomplete. But what kind of painting is it? This is the question Mangold shared with other New York–based artists of his generation. For Donald Judd and Sol LeWitt, Minimalism was a way out of painting, with which they had both aligned themselves early on in their careers. Frank Stella's shaped canvases and Ellsworth Kelly's multi-paneled monochromes incorporated sculpture into painting while severing the allusive relations between the picture and the world. The works of all these artists may be seen as efforts to destabilize what one might call strictures of flatness that had become a kind of rhetorical tyranny of opticality in painting.

While he has never disavowed painting per se, Mangold has always been more interested in the shape of the canvas than the act of painting *on* it. He acknowledged: "Shape is the first element in my work; I would not say that it is the most important, but everything starts there."[1] In 1980, he began making *X* and + paintings. These shapes represent perhaps Mangold's greatest departure from the conventional geometry of painting. As radical as the form in *Pink X within X* is, the work also unfolds a subtler drama of fixed modules and variations. No complex calculus is needed to analyze the lopsided construction, but it does require some time for a viewer to realize that the pencil-drawn *X* is a perfect equilateral cross. Though the four rectangular panels are identical, the resulting construction does not constitute another perfect cross, and it is because of this discrepancy between the two overlapping *X*s that a kind of optical trick, even pulsation, occurs. Both complementing and obfuscating this construction of proportion, equivalence, and disparity is the color. Whereas the monochromatic fleshy pink undoubtedly gives this painting a sensual quality, color, in Mangold's words, is "kept somewhat subdued to prevent it from dominating the piece since I want the work to be a total unity of color-line-shape."[2]

D.C.

Notes
1. Robert Mangold, "Interview with Sylvia Plimack Mangold," in
Richard Shiff et al., *Robert Mangold* (London: Phaidon Press, 2000), 62.
2. Rosalind Krauss, "Robert Mangold: An Interview," *Artforum* 12, no. 6
(March 1974): 37.

Piero Manzoni
Italian, 1933–1963

- - **Holdings**
1 painting, 3 books

Piero Manzoni's brief, incandescent, and boisterous career found a fitting context in the blossoming Italian economic climate of the late 1950s and early 1960s. Though often credited, along with Argentine-born Lucio Fontana, as a forerunner to the Italian Arte Povera movement of the later 1960s, Manzoni was a one-off, unable to be reduced to a single artistic sensibility. His association with Fontana has its origins in Albisola, an Italian seaside resort town renowned for its pottery, where the Milan-based Manzoni family often vacationed. Fontana had been visiting the locale since the 1930s to produce his ceramics and was among the first to notice Manzoni's earliest works, which included paintings with tar. Yet Manzoni's career would expand far beyond its parochial beginnings to become part of a rash of global conversations that included the Zero Group in Rotterdam, the international Cobra Group, Marcel Broodthaers, Yves Klein, and the Gutai Group in Japan.[1]

Often unfairly dismissed as something of a poor man's Duchamp, Manzoni received at best a lukewarm reception in the United States, where no solo shows were held until almost a decade after his death at the age of twenty-nine. Yet he was well aware of developments across the Atlantic, reproducing Jasper Johns' *Target with Plaster Casts* (1955) and Robert Rauschenberg's *Monogram* (1959) in the short-lived journal *Azimuth*, which he coedited with fellow artist Enrico Castellani in 1960.

Neither wholly ironic nor entirely cerebral, Manzoni invented the figure of the artist-trickster, whose acts assume profundity, heresy, and buffoonery all at the same time. As the archetypal artist who says he has nothing to say, his strategy was often to incarnate parts of himself as art—balloons of his breath, fingerprints, and most notoriously, cans of his own feces.[2] Yet at the core of his "act" is the body of work he called "Achromes," which he made throughout his short career.

The Achromes were first manifested around 1958 as things that mimicked white monochrome paintings in a shorthand for knowingly avant-garde or "difficult" art, but also role-played as flagrant targets for ridicule or skepticism. The Walker Art Center's example from this period, acquired from the Archivio Opera Piero Manzoni in Milan in 1999, is a petrified cummerbund of a painting made of kaolin, a pure clay used to make porcelain.[3] Manzoni would go on to make white objects from substances as haphazard as fiberglass, rabbit skin, straw, pebbles, and dinner rolls under the Achromes "brand." Each one is an operation of blank sorcery whereby commonplace materials are processed into works of art of the utmost reticence. Manzoni's invention of the Achromes mischievously trumps the hermeneutics of monochrome painting by changing the rules to his own form of mysticism. Not merely one color,

but achromatic, the Achrome defies common sense and instead incarnates pure substance and materiality at the sheer insistence of the artist.

M.A.

Notes
1. Manzoni had contacts in Japan as early as 1959, including Yamazaki Shozo, editor of *Geijutsu Shincho*, a journal that had published the manifesto of the Gutai Group in 1956 and would trade articles with Manzoni's *Azimuth*. See Anna Costantini's text in Germano Celant, ed., *Piero Manzoni*, exh. cat. (London: Serpentine Gallery; Milan: Edizioni Charta, 1998).
2. As Manzoni wrote, "There is nothing to be said. There is only to be, there is only to live." See his "Free Dimension" (1960), reprinted in Celant, *Piero Manzoni*, 130–134.
3. Manzoni may have discovered this material in the ceramic workshops of Albisola.

Piero Manzoni *Achrome* circa 1958 kaolin on canvas 37 x 29 1/4 x 1 5/8 in. (94 x 74.3 x 4.1 cm) framed T. B. Walker Acquisition Fund, 1999 1999.31

Franz Marc
German, 1880–1916

- - **Exhibitions**
Expressionism 1900–1955 (1956; catalogue, tour), *Franz Marc: Pioneer of Abstraction* (1980; organized by the University Art Museum, Berkeley, California; catalogue), *Franz Marc and the Blue Rider* (2001),
- - **Holdings**
1 painting

Die grossen blauen Pferde (*The Large Blue Horses*) (1911) is an acknowledged masterpiece by Franz Marc, a founding member of the avant-garde German group Der Blaue Reiter (The Blue Rider), which was active in the years just before World War I. One of the chief aims of this small cadre of artists was to make a radically new kind of art that conveyed transcendent, essential truths about the world. They hoped that their work, which incorporated current theories about the transformative power of abstraction, would reinvigorate the viewing public, whose senses had been deadened by the excessive materialism of the age.

Marc believed that animals dwell in a state of complete harmony with nature, and for much of his short career he turned to the natural world—in particular, horses—for his primary subject matter. Beginning in 1910, he used a symbolic color system that equated specific hues with characteristics or concepts. "Blue is the male principle, severe and spiritual," he wrote to fellow Blaue Reiter artist August Macke in 1910. "Yellow is the female principle, gentle, cheerful, and sensual."[1] These ideas are explored in *Die grossen blauen Pferde*, in which a triad of horses is built from a series of circles and diagonal lines and rendered in pure blue. The painting was shown in the first Blaue Reiter exhibition, which opened in Munich in 1911, and has since become emblematic of Marc's style.

Marc died on the front lines during World War I, having volunteered for service in a war that he believed would bring about the spiritual cleansing of Europe. Some twenty years later, in 1937, he was among the artists included in the exhibition *Entartete Kunst* (*Degenerate Art*), organized by the National Socialists as an object lesson on the corrupt nature of the avant-garde. In one of his many denunciations of the modern, Hitler—perhaps alluding specifically to Marc—spoke with derision of artists who presented their viewers with "blue meadows, green sky, clouds of sulphur-yellow."[2] Such pictures were unacceptable to the Reich, and therefore "un-German."

The Walker Art Center's acquisition of Marc's famous picture was enmeshed in events surrounding World War II. Final negotiations for the sale took place during the week in 1941 that Japanese planes bombed Pearl Harbor. Walker officials fretted about the possibility of additional air raids, and took pains to assure their trustees that no proceeds from the sale of the painting would benefit Germany.[3] Even so, they were immensely excited about the purchase and understood it to be momentous. "This is a very important acquisition for the collection, and a pioneering move in line with the spirit in which Grandfather originally opened the collection to the public," wrote Hudson Walker that year.[4] Press coverage heralded it as the museum's "initial step into the realm of modern art" and noted that, in contrast, Marc's groundbreaking work had been banned in Germany because of Hitler's retrograde views on the arts.[5] At that moment in the United States, an embrace of the avant-garde could also be read as an act of defiance and even patriotism; the acquisition of *Die grossen blauen Pferde* was promoted as just that sort of enlightened act. At the same time, it was a brilliant advance of the young institution's mission to present the most advanced art and design of its time in an open, populist, and educational setting.

J.R.

Notes

1. Letter dated December 12, 1910, cited in Frederick Levine, *The Apocalyptic Vision* (New York: Harper & Row, 1979), 57. During the same period, Marc's friend Wassily Kandinsky was exploring the theory of synesthesia, which related colors and sounds.
2. Quoted in Franz Roh, *"Entartete" Kunst: Kunstbarbarei im Dritten Reich* (Hannover, Germany: Fackelträger Verlag, 1962), 45. See also Stephanie Barron, *"Degenerate Art": The Fate of the Avant-Garde in Nazi Germany*, exh. cat. (Los Angeles: Los Angeles County Museum of Art; New York: Harry N. Abrams, 1991).
3. Letters from Hudson Walker (grandson of founder T. B. Walker) to his aunt, Mrs. Gilbert M. (Susan) Walker, December 11, 1941, and from the Walker's assistant director, J. LeRoy Davidson, to dealer Karl Nierendorf, December 10, 1941 (Walker Art Center Archives).
4. Letter from Hudson Walker to Mrs. Gilbert M. (Susan) Walker, December 5, 1941 (Walker Art Center Archives).
5. "Famous Modern Canvas Goes to Minneapolis," *The Art Digest* 16 (April 1, 1942): 21.

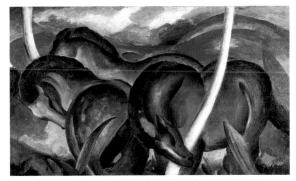

Franz Marc *Die grossen blauen Pferde* (*The Large Blue Horses*) 1911
oil on canvas 41 5/8 x 71 5/16 in. (105.7 x 181.1 cm) Gift of the T. B. Walker Foundation, Gilbert M. Walker Fund, 1942 1942.1

Christian Marclay

American, b. 1955

- - **Commissions**
Shake Rattle and Roll (fluxmix) (2004), Site-specific sound
installation (2004–2005)
- - **Performances**
New York Objects and Noise (1984; John Zorn, Christian Marclay, Arto
Lindsay, David Moss), *Dead Stories* (1986), djTrio (2004; Christian
Marclay, DJ Olive, Toshio Kajiwara), Two Turntables and a Saxophone
(2004; Christian Marclay, George Cartwright, Andrew Broder)
- - **Exhibitions**
Christian Marclay: Shake Rattle and Roll (2004)
- - **Residencies**
2003–2005
- - **Holdings**
1 video, 1 multiple, 1 book

Onstage or in the galleries, on screen or on turntables,
Christian Marclay's work methodically blurs the line
between what is to be heard and what is to be seen.
Since the early 1980s, he has honed his command of
production and distribution formats (sound tracks, film,
sculpture, installation, photography, publications). His
samplings of sounds and readymade images have—
with a loving disrespect for a tradition inaugurated by
Marcel Duchamp, the Futurists, and members of
Fluxus—eroded the validity of artistic disciplines and
challenged codes of representation.

The installation *Shake Rattle and Roll (fluxmix)*
(2004) reveals a critical and aesthetic practice that,
beyond its site- or collection-specific context, is abso-
lutely coherent with the program and the vocabulary
Marclay has developed during the past twenty years.
First, he identified hundreds of items from the Walker
Art Center's collection made by artists associated with
Fluxus: George Brecht's boxes, trick card decks, a green
violin by Henning Christiansen, Ben Vautier's chamber
pot, object poems by Yoko Ono—in other words, a col-
lection of mass-produced objects and performance rel-
ics that were intended to invade and humorously
subvert a somewhat stilted daily reality. The paradox
of their presence in a museum collection lies in the fact
that their very purpose is negated by the anesthetic
protocol of the vitrine, the "Do Not Touch" dictatorship,
and the neurosis of the registrar's white gloves. Marclay
counters this paradox by questioning, with both sar-
casm and subtlety, the validity of this kind of museo-
logical embalming.

To this end, he decided to make music with the
Fluxus works and to film himself handling each one
and revealing its potential for sound. As he caresses,
shakes, or drops the little relics of a past utopia,
Marclay is both reviving and desanctifying these
objects—desacralizing insofar as he attacks not only
the museum as institution, but also the physical integ-
rity of the items in question. But entwined with this is a
reactivating process, as evidenced by the quasi-clinical
aesthetic of Marclay's film (white background, white
gloves, white shirt), and the quasi-medical care with
which he manipulates these deaf and silent objects.

Deliberately touching on absurdity, Marclay reiter-
ates the urgent call to "stop making sense" reminiscent
of the historical avant-gardes as well as of the punk atti-
tude. By opening its doors to it, the museum had turned
Fluxus into the fossilized icon of a bygone freedom of
spirit, in spite of the fact that this movement always
seemed to prefer liberation (a process) over liberty (an
ideal). In the end, when Marclay extracts a plaintive
sound from Vautier's chamber pot, he may be inviting
us, through an absurdist detour, to stay alert.

P.V.

Christian Marclay *Shake Rattle and Roll (fluxmix)* 2004 16 DVDs (color,
sound); edition 1/5 continuous loop Justin Smith Purchase Fund, 2004
2004.61 top to bottom: installation view; stills from DVD

Brice Marden

American, b. 1938

- - **Exhibitions**
Painting: New Options (1972; catalogue), *Artists' Books* (1981),
Brice Marden: Cold Mountain (1992; catalogue, tour)
- - **Holdings**
1 painting, 6 edition prints/proofs, 2 portfolio of prints, 4 books

Since he began painting in the early 1960s, Brice Marden has been passionately committed to abstraction. His reductive wax-and-oil canvases of the 1960s have often been associated with the taciturn geometries of Donald Judd and Carl Andre, but Marden is no Minimalist. He has always been very clear that his paintings have content—both formal and expressive—that springs from his sensory and emotional experiences as well as his research into the limits and possibilities of pictorial space. In a statement written in 1963, while he was a graduate student at Yale's School of Art and Architecture, he explained: "The paintings are made in a highly subjective state within Spartan limitations. Within these strict confines . . . I try to give the viewer something to which he will react subjectively. I believe these are highly emotional paintings not to be admired for any technical or intellectual reason but to be felt."[1] Some forty years later, one could still apply this description to his work.

From his student days through the early 1980s, Marden's paintings evolved from single-panel monochromes to works of two, three, or more panels, each painted in one of his unmodulated but luminous colors. The wax he mixes with the pigments gives his paintings a dense, weighty tactility and a glowing translucence;[2] the colors evoke the visible world—water, skies, soil, plants, skin—and the scale is keyed to the human body. These references, while remaining generic for the viewer, are often very specific and personal for Marden: the yellow hue in *Summer Table* (1972–1973), for example, was suggested by the color of a glass of lemonade at a picnic.[3]

This expressive content is contained within a rigorous formal program. Until 1970, Marden had restricted himself to using vertical panels, although he had often combined several to make a horizontal work; in the Walker Art Center's *Untitled* (1971–1972) he experimented further. "I wanted to try a large three-panel horizontal painting," he has written. "I picked a deliberately awkward shape as [my] other horizontal paintings had an elegance and lack of confrontation. What I like about *Untitled* is that it confronts. I toyed with the idea of calling it *Barrier* but rejected it."[4] The warm, smoky tones of this work are related to those of his other paintings from this time, including the homage *Three Deliberate Greys for Jasper Johns* (1970).

During the mid-1980s, feeling the need for a fresh approach, Marden revamped both his method and his iconography after being introduced to Chinese calligraphy and poetry, especially that of the eighth-century hermit Han Shan (whose name means Cold Mountain). The resulting paintings, prints, and drawings are very different from the austere panels that preceded them.

Composed of interlocking skeins of oil paint that pulse with controlled energy, they appear to have as much to do with the legacies of Jackson Pollock and Willem de Kooning as with the discipline of the calligraphic arts. Making them, Marden says, is a quest. "One of the things about being a painter is that you're trying to make things that you want to see. The way I would define painting is to say that it's something we don't know about, and as artists we move toward that something along a visual path."[5]

J.R.

Notes
1. "Notes 1963," reprinted in Nicholas Serota, ed., *Brice Marden: Paintings, Drawings and Prints 1975–1980*, exh. cat. (London: Whitechapel Art Gallery, 1981), 54.
2. Although his paintings are often referred to as encaustics, Marden points out in a 1975 statement that this is not an accurate term because the primary binding agent in his formula is oil, not wax. Ibid.
3. Interview with John Yau in Eva Keller and Regula Malin, eds., *Brice Marden* (Zürich: Scalo, 2003), 49.
4. Artist's statement, September 22, 1974 (Walker Art Center Archives).
5. Quoted in Brenda Richardson, *Brice Marden: Cold Mountain*, exh. cat. (Houston: Menil Foundation, 1992), 74.

Brice Marden *1* from *Cold Mountain Series, Zen Studies 1–6* 1991 etching, aquatint, sugar-lift aquatint, spit-bite aquatint, scraping on paper; edition 21/35 27 1/2 x 35 1/4 in. (69.9 x 89.5 cm) Published by Matthew Marks Gallery, New York Gift of Harriet and Edson W. Spencer, 1992 1992.179

Brice Marden *Untitled* 1971–1972 beeswax, oil on canvas 90 x 96 in. (228.6 x 243.8 cm) Gift of the T. B. Walker Foundation, 1972 1972.10

Marepe (Marcos Reis Peixoto)

Brazilian, b. 1970

- - **Exhibitions**
How Latitudes Become Forms: Art in a Global Age
(2003; catalogue, tour)
- - **Holdings**
1 sculpture

The art of Marepe is steeped in the quotidian life of
Santo Antônio de Jesus, where the artist was born and
now lives and works, and cities just like it throughout
the Bahia region of northeastern Brazil. Bahia is the
country's most Africanized state, the hub of the slave
trade and sugar plantation economies until 1888, while
its capital, Salvador, is the rough diamond of what was
once the Portuguese empire. Although the complex heri-
tage and unabashed poverty of Bahia are inflected in
Marepe's practice, his works don't purport to offer a cri-
tique of what passed for globalized trade in the 1800s.
Instead, they are loyal to the particulars of workaday
objects, customs, and traditions, and to the innovative
and self-sufficient mercantile strategies of "making do"
and "getting by."

In the artist's works of the mid-1990s, mundane items
such as metal washbasins, water filters, and suitcases
became articulate sculptural elements. Typical of this
alchemy, his *Trouxas (Bundles)* (1995) reprise the kind of
ingenious folded-and-knotted cloth packaging used to
bundle up laundry or carry groceries,[1] while his *Bancas
(Itinerant Merchants)* engage with the varied methods
by which street vendors exhibit their wares. Marepe
made re-creations in the gallery of the work areas of, for
example, a vermin-poison seller or a wristwatch repair-
man, transforming the exhibition space into an uncan-
nily sparse marketplace.

Embutidinho (Small Embedded) (2001) was among
several works by Marepe included in the 2003 Walker
Art Center exhibition *How Latitudes Become Forms: Art
in a Global Age*. Made by a local carpenter in Santo
Antônio de Jesus, the model is a miniature version of
the type of full-scale housing units the artist exhibited at
the Venice Biennale that same year. The habitation can
break open on hinges and its walls can be reconfigured
and transformed to fulfill its imagined inhabitants' basic
domestic needs, like a rough-and-ready dollhouse for
a child with a penchant for experimental architecture.

Marepe *Embutidinho (Small Embedded)* 2001 (bottom: detail) wood,
hinges 27 9/16 x 27 9/16 x 31 9/16 in. (70 x 70 x 80.2 cm) Butler Family Fund,
2003 2003.59

M.A.

Notes
1. As Tadeu Chiarelli has pointed out, this series of shrouded anony-
mous forms can be seen as both a distant cousin of the wrapped
objects of Christo and Man Ray and a direct descendant of the fabric
works of the Brazilian Neo-Concretists of the 1950s and 1960s. See
Tadeu Chiarelli, "Weaving the Unraveled Thread," in Fatima Bercht,
O Fio da Trama/The Thread Unraveled, Contemporary Brazilian Art, exh.
cat. (New York: El Museo del Barrio, 2001–2002).

John Marin
American, 1870–1953

-- Exhibitions
Art of the Print (1941), *92 Artists* (1943; catalogue), *American Watercolor and Winslow Homer* (1945; catalogue, tour), *Reproductions: Own Your Favorite Painting* (1945; publication), *Watercolor—U.S.A.* (1946; catalogue, tour), *13 Marins from Keither Warner Collection* (1947), *John Marin: A Retrospective Exhibition* (1947; catalogue), *John T. Baxter Memorial Collection of American Drawings* (1949; catalogue), *Contemporary American Painting: Fifth Biennial Purchase Exhibition* (1950; catalogue, tour), *Contemporary American Painting and Sculpture: Collection of Mr. and Mrs. Roy R. Neuberger* (1952; catalogue), *Lowenthal Collection of American Art* (1952; catalogue), *The Classic Tradition in Contemporary Art* (1953; catalogue), *Expressionism 1950–1955* (1956; catalogue, tour), *First Annual Collectors Club Exhibition* (1957; catalogue), *Second Annual Collectors Club Exhibition* (1958; catalogue), *Art Fair* (1959; catalogue), *John T. Baxter Memorial Exhibition* (1959)

-- Holdings
1 drawing, 2 gouaches/watercolors

John Marin *Rocks, Sea and Boat, Small Point, Maine* 1932 watercolor on paper 20 3/16 x 25 1/2 in. (51.3 x 64.8 cm) Gift of the T. B. Walker Foundation, 1947 1947.56

Reginald Marsh
American, b. France, 1898–1954

-- Exhibitions
American Watercolor and Winslow Homer (1945; catalogue, tour), *Watercolor—U.S.A.* (1946; catalogue, tour), *Paintings to Know and Buy* (1948), *John T. Baxter Memorial Collection of American Drawings* (1949; catalogue), *Pictures for the Home* (1950), *Art Fair* (1959; catalogue), *John T. Baxter Memorial Exhibition* (1959), *The Cities Collect* (2000)

-- Holdings
1 painting, 2 gouaches/watercolors

Reginald Marsh *Coney Island* not dated oil on Masonite 17 15/16 x 24 in. (45.6 x 61 cm) Gift of the Estate of Felicia Meyer Marsh, 1979 1979.98

Kerry James Marshall

American, b. 1955

-- **Exhibitions**
American Tableaux (2001; publication, tour)
-- **Holdings**
1 painting, 6 edition prints/proofs

Recently, there has been a resurgence of interest in figurative painting. Among those who have contributed the most to this renewed appreciation is Chicago-based artist Kerry James Marshall. "I've always wanted to be a history painter on the grand scale of Giotto and Géricault," he once said.[1] Indeed, over the past decade he has created numerous mural-sized canvases interweaving heroic and everyday aspects of recent African American history. At the same time, like other artists he greatly admires—in particular, Leonardo da Vinci and Marcel Duchamp—Marshall embraces the freedom to depart from figurative painting as his inspiration dictates, exploring a wide variety of practices that include photography, sculpture, comics, installation, and printmaking.

Throughout his career, Marshall has commemorated individuals and ideas associated with the 1960s Civil Rights and Black Liberation movements. "When you talk about this obligation to articulate some socially relevant issue," he said in a 1998 interview, "a lot of that has to do with where I come from. You can't be born in Birmingham, Alabama, in 1955 and not feel like you've got some kind of social responsibility. You can't move to Watts in '63 and grow up in South Central near the Black Panther headquarters and see the kinds of things I saw in my developmental years and not be motivated to speak about it."[2] This series of prints depicts well-known slogans that the artist has referred to as "rallying cries to celebration and defiance."[3] In tone, they range from positive, constructive sentiments such as "Black Is Beautiful" and "We Shall Overcome" to confrontational exhortations such as "Black Power" and "By Any Means Necessary." When first exhibited, this series was accompanied by a matching set of five large-scale rubber stamps, the same ones used to make the prints themselves, along with large-scale ink pads holding red, green, and black inks, the colors symbolic of black nationalism.

Gulf Stream (2003) is a reimagining of the American artist Winslow Homer's well-known oil painting *The Gulf Stream* (1899). It belongs to a series of recent works in which Marshall has interpreted various iconic paintings from a contemporary African American perspective. Homer's original shows a black seaman alone on a broken vessel and adrift in a limitless, stormy ocean, surrounded by sharks that gnash their teeth in anticipation. Marshall's version of this theme presents a more serene and hopeful view. Here, a group of modern-day black companions relax as their sleek yacht sails over a placid sea. A dark cloud looms but at a comfortable distance, and there isn't a shark in sight. A pelican perched on a nearby mooring signals that the safety of shore is close at hand. The entire image is contained within a glittery decorative border in the form of a nautical rope and anchor. Uniting man and nature in harmony, the overall mood of the picture is one of meditative calm. By reinventing an iconic image of an African American subject, Marshall subtly critiques and transforms our inherited perceptions of race and class.

Lawrence Rinder

Notes
1. Kerry James Marshall, letter to Arthur Jafa, in Judith Russi Kirshner, Gregory Knight, and Ursula Prinz, eds., *Correspondences: Fourteen Artists from Berlin and Chicago* (Berlin: Berlinische Galerie; Chicago: Chicago Cultural Center, 1994), 95.
2. Kerry James Marshall in interview with Calvin Reid, "Kerry James Marshall," *Bomb* 62 (Winter 1998): 45.
3. Artist's statement, August 2, 1999 (Walker Art Center Archives).

Kerry James Marshall *"BLACK POWER"* 1998 relief print on paper; edition 1/5 25 5/8 x 40 in. (65.1 x 101.6 cm) T. B. Walker Acquisition Fund, 1999 1999.27

Kerry James Marshall *"BY ANY MEANS NECESSARY"* 1998 relief print on paper; edition 1/5 25 5/8 x 40 in. (65.1 x 101.6 cm) T. B. Walker Acquisition Fund, 1999 1999.29

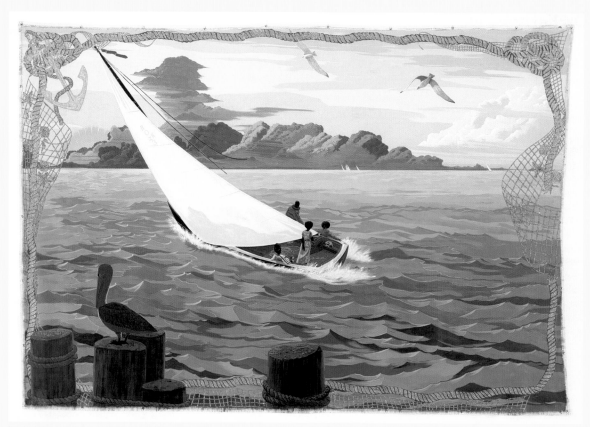

Kerry James Marshall *Gulf Stream* 2003 acrylic, glitter on canvas 108 x 156 in. (274.3 x 396.2 cm) T. B. Walker Acquisition Fund, 2004 2004.15

On Kerry James Marshall's *Gulf Stream*

Never mind the Afros. Check out the repose, for this is some serious chillin'. All of Kerry James Marshall's paintings, including *Gulf Stream* (2003), are an investigation and celebration of what he refers to as a "black aesthetic," the style in which black people do things, even the most mundane things such as relaxing. Hardly matters whether it's a sailboat or a Cadillac, the figures in *Gulf Stream* still find themselves "diggin' the scene with a gangsta lean." Yet, so strong are sailing's class connotations that depicting the activity in such a grand manner would probably elicit a similar response even if the figures were white.

Marshall's *Gulf Stream* is based on an 1899 painting of the same title by Winslow Homer. Homer's *The Gulf Stream* was executed well after the bulk of his acclaimed "Negro genre scenes," most of which were painted during the Reconstruction era. Debates as to whether the depiction of a black man aboard a sloop in shark-infested waters ought to be interpreted cynically or as a sign of hope have attended the painting since its unveiling. If anything, its failure to yield a clear, allegorical reading attests to the sense of uncertainty surrounding the fate of African Americans in the face of newly acquired freedom. While numerous critics focused on the drama of the sharks, as set against the young man's seeming indifference to his circumstances (having survived a storm only to find himself without mast or rudder), Alain Locke, a Harlem Renaissance intellectual, praised the work as the "emancipation of the Negro in American Art."[1] Other critics credit the painting with transcending the issue of race, reading it as a version of the timeless tale of man versus nature, or survival in the face of adversity. Homer himself offered little guidance, writing sardonically that "the unfortunate negro who now is so dazed and parboiled, will be rescued & returned to his friends and home, & ever after live happily," which is where Marshall's version of the painting begins.[2]

Marshall's *Gulf Stream* immediately announces itself as an allegory of liberation. In lieu of a lone survivor, Marshall depicts a quartet enjoying the day with nary a peril in the world as Homer's sharks have been replaced by an innocuous pelican and some seagulls. Marshall's Midas touch has been reserved exclusively for the rope bordering the painting, where he uses glitter to convert a symbol of bondage into a delightfully gaudy nautical motif cum framing device—though one which has been denied closure (in case one should find it too restrictive). To further dispel any sense of pessimism, he restores to the ship a steadfast sense of direction. In contrast to Homer's sloop, Marshall's sailboat is replete with mast and rudder, and its sail is filled with the same winds that have presumably pushed the storm off to the horizon. Whereas Homer provides a vantage point that only a seagull could obtain, Marshall's viewer is unambiguously positioned on a pier whose pylons are then used to order the space into foreground, middle ground, and background. The action takes place in the middle ground, an unusual focus for most of Marshall's paintings, in which the figures tend to be monumentalized toward the foreground. On the one hand, this corresponds to his desire to imbue *Gulf Stream*'s spatial ordering with symbolic meaning, as middle ground might refer to Middle Passage. On the other hand, the scale of the figures, whose poses are quite static in comparison to the sweep of the overall composition, speaks to the declining significance of race in relation to class. Under these circumstances, the forces of nature are hardly a threat to survival but are a source of conspicuous leisure; the painting arguably celebrates sailing more than its sailors.

Although leisure is a theme running throughout Marshall's work, it has never been so audacious as to rise above the middle-class variety. Whether it's gardening, camping, barbecuing, or having fun at the water park, these activities are for him tropes symbolizing African Americans' dignified participation in the whole of American life, which is often idealized through denial of class conflict. The resulting vision is of a homogenous middle-class society circa the Eisenhower presidency, which explains the taint of nostalgia prevalent throughout his work. His paintings are indeed conspicuous, bordering on Magic Realism, as accessibility to the American dream becomes more elusive for everyone, let alone blacks, the majority of whom are in the base of an "hourglass economy" characterized by a shrinking middle class.

In *Gulf Stream*, race and class are driven to hyperbolic extremes. As if being literally black were not enough, Marshall's characters are aboard the Sha Nay Nay; the female characters sport Afros; and the ubiquitous boom box reconfirms the integral role of music in black life. But the more strongly race is asserted as a cultural signifier, the greater is its relevance as an indicator of class, which sailing only throws into sharper relief, begging the question, "Does this group of blacks belong here?" It is a troublesome question, politically incorrect by most standards. It is not without rhetorical value for it is not a question of "belonging," but rather entitlement. If this painting is a species of Magic Realism, perhaps this group pooled its resources, using their reparations checks to purchase a sailboat. Would *Gulf Stream*'s hyperbole then be any different from that derived from, say, four young blacks riding around in a big white Humvee decked out with waist-high chrome wheels? Having achieved lifestyles worthy of celebration on the television show *MTV Cribs*, what's left to overcome? From Middle Passage to Livin' Large, a course that doubles as a treasure map has been charted. Mast and rudder intact, *Gulf Stream* isn't animated by wind, but by a force Adam Smith called "the invisible hand."

Hamza Walker

Notes

1. Quoted in Peter H. Wood, "Waiting in Limbo: A Reconsideration of Homer's *The Gulf Stream*," in Walter J. Fraser, Jr. and Winfred B. Moore, Jr., eds., *The Southern Enigma: Essays on Race, Class, and Folk Culture* (Westport, Connecticut: Greenwood Press, 1983), 77.

2. Ibid., 81.

Agnes Martin
American, b. Canada, 1912–2004

- - **Holdings**
2 paintings, 1 edition print/proof, 1 portfolio of prints

For more than five decades, Agnes Martin remained committed to a form of painting that strives for a purity of visual experience. Her spare, nonrepresentational canvases are concerned with timeless, universal subject matter. Though her use of a grid structure aligned her with the practitioners who ushered in the 1960s movement of Minimalism, her affinities lay with Abstract Expressionism, a movement she revered. As a young artist, she kept one foot in each world: in the Abstract Expressionist sense, her paintings are all-over compositions, with every area of the canvas given equal consideration. In her adherence to a resolutely spare surface, however, she formed an important bridge to the work of artists such as Frank Stella, who were concerned with erasing gesture from their work. Yet Martin never lost the sense of emotional content that was a hallmark of the New York School, even though her brand of Expressionism was removed from the heroic gestures of Franz Kline, Willem de Kooning, and Jackson Pollock that were filled with bravura, and often biography. Martin's subtle meditations were quietly contemplative—impersonal, but no less powerful.

Martin is in the company of artists drawn to the expression of the sublime through abstract means. The nonuniform, rectilinear grids of Piet Mondrian were a key precedent for her, and Ad Reinhardt, who espoused the teachings of Zen in his writings, was an important contemporary. Though influenced by Taoism and Zen, Martin did not consider her art to be religious, but rather inspirational, in the sense that it might invoke a transcendental state. Her extensive writings put forth a carefully articulated philosophy about her endeavors as an artist, which often bordered on poetry: [the paintings are] "not really about nature/It is not what is seen—/It is what is known/forever in the mind."[1]

After spending her early years in Vancouver, Washington, and New Mexico, Martin settled in New York in 1957 and moved to a studio space at 27 Coenties Slip.[2] Her early paintings and drawings embraced abstraction in the form of subtly toned, biomorphic compositions. She soon gained notice for her work, and presented her first solo exhibition in 1958.[3] Her admiration for Barnett Newman and Mark Rothko inspired her to consider using geometry as a way to attain a state of purity in her work. She became fascinated with the grid as a basis for her paintings. For Martin, the meaning of the grid was a metaphysical one—she sought to empty her work of ego, and saw "humble" lines delineating blank rectangles as a metaphor for a purer state of consciousness, as in the Buddhist notion of emptying of the mind in order to attain illumination.[4]

Her first mature paintings were initially received, however, in a more physical sense, since grids, as used by Sol LeWitt and others, were seen as the ultimate nonreferential construction. Her gridded canvases were exhibited alongside pioneering works of Minimalism by Carl Andre, Donald Judd, LeWitt, Robert Mangold, Robert Ryman, and Stella.[5] Having arrived at her new system, Martin painted prolifically in the 1960s, exploring myriad permutations of lines, grids, and subtle hues. In 1967, she abandoned painting to be closer to the land, and began to explore the American West. In 1968, she returned to New Mexico (where she lived and worked until the end of her life), and in 1974 resumed painting.[6]

The works that followed were fine-honed articulations of her earlier pieces. *Untitled #7* (1977) is fashioned from India ink and graphite. Like many of Martin's compositions, the painting is structurally divided around a central horizontal axis. Though the canvas is square, the grid is formed of two sizes of rectangles, her intention being, she had remarked in 1967, to make "a sort of contradiction, a dissonance. . . . When I cover the square with rectangles, it lightens the weight of the square, destroys its power."[7] Within the spare format of the painting, Martin subtly manipulated palette and structure to remarkable effect. In both the ruled graphite lines and veil of gray that is the ground, the artist's hand is visible throughout. The pencil marks hover on the canvas as ethereal tracings, creating a sense of expansiveness. *Untitled #1* (1980), also in the Walker Art Center's collection, exemplifies the delicately nuanced use of color that came to characterize her later work. The alternating, pale bands of bluish grays and creamy whites, barely there, evoke shimmering light. "The memory of past moments of joy leads us on," Martin wrote in 1977. "Reality, the truth about life, and the mystery of beauty are all the same."[8]

S.E.

Notes
1. Martin, unpublished notes, Institute of Contemporary Art, University of Pennsylvania, Philadelphia. Quoted in Lawrence Alloway, "Agnes Martin," in Lawrence Alloway and Ann Wilson, *Agnes Martin*, exh. cat. (Philadelphia: Institute of Contemporary Art, University of Pennsylvania, 1973), 12.
2. This lower Manhattan address housed a community of artists, including Ellsworth Kelly, Robert Indiana, and Jack Youngerman, and was a nurturing environment for Martin.
3. Her premier show was at the Betty Parsons Gallery, New York, which was among the first to champion the Abstract Expressionists.
4. For a thorough analysis of Martin's work in relation to her writings and philosophy, see Barbara Haskell, "Agnes Martin: The Awareness of Perfection," in Barbara Haskell, ed., *Agnes Martin*, exh. cat. (New York: Whitney Museum of American Art, 1992), 93–117.
5. Martin was included in the New York exhibitions *Geometric Abstraction in America* (1962) at the Whitney Museum of American Art and *Systemic Painting* (1966) at the Solomon R. Guggenheim Museum.
6. An impetus for resuming her activities in painting was the invitation from Parasol Press to make screenprints. The result was a portfolio of thirty prints, the only artwork Martin completed between 1967 and 1973. This portfolio, entitled *On a Clear Day*, is in the Walker's collection.
7. Quoted in Lucy R. Lippard, "Homage to the Square," *Art in America* 55 (July–August 1967): 55.
8. Agnes Martin, "What Is Real?" in Dore Ashton and Agnes Martin, *Agnes Martin: Paintings and Drawings 1957–1975*, exh. cat. (London: Arts Council of Great Britain, 1977), 17–39.

Agnes Martin *Untitled #7* 1977 India ink, graphite, gesso on canvas 72 x 72 in. (182.9 x 182.9 cm) Purchased with the aid of funds from The Butler Family Foundation, Mark B. Dayton, Roderick McManigal, Dr. and Mrs. Glen D. Nelson, Mr. and Mrs. Miles Q. Fiterman, Art Center Acquisition Fund, and the National Endowment for the Arts, 1979 1979.34

Matta (Roberto Antonio Sebastián Matta Echaurren)

French, b. Chile, 1911–2002

- - Exhibitions

Paintings to Know and Buy (1948), *Reality and Fantasy, 1900–1954* (1954; catalogue), *Matta* (1957; organized by the Museum of Modern Art, New York; catalogue), *Art Fair* (1959; catalogue), *Eighty Works from the Richard Brown Baker Collection* (1961; catalogue), *Matta: Recent Paintings* (1966; catalogue)

- - Holdings

2 paintings, 1 edition print/proof, 1 portfolio of prints, 1 multiple, 2 books

Matta *Cat for Piano* 1951 oil on canvas 48 3/4 x 59 in. (123.8 x 149.9 cm)
Gift of Mr. and Mrs. Donald Winston, 1977 1977.7

Alfred H. Maurer

American, 1868–1932

- - Exhibitions

Alfred H. Maurer 1868–1932 (1949; catalogue; tour), *Contemporary American Painting and Sculpture: Collection of Mr. and Mrs. Roy R. Neuberger* (1952; catalogue), *The Classic Tradition in Contemporary Art* (1953; catalogue), *Expressionism 1950–1955* (1956; catalogue, tour), *First Annual Collectors Club Exhibition* (1957; catalogue), *Second Annual Collectors Club Exhibition* (1958; catalogue)

- - Holdings

1 painting, 5 drawings

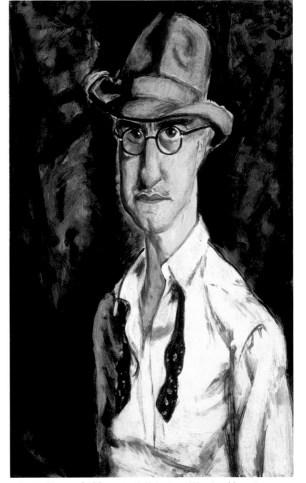

Alfred H. Maurer *Self-Portrait with Hat* circa 1927 oil on Masonite
39 x 24 in. (99.1 x 61 cm) Gift of the T. B. Walker Foundation, 1946 1946.50

Richard Maxwell

American, b. 1967

-- **Commissions**
Joe (2002)
-- **Performances**
Boxing 2000 (2002), *Joe* (2005)
-- **Residencies**
2005

Notes
1. See Margot Ebling, "Flat Land," *Village Voice*, November 17–23, 1998. Maxwell notes, "I'm not interested in the autobiographical, the personal, or the emotionally invested. I'm interested, as an audience member, in being able to project whatever I want onto a piece of theater. . . . It's about resisting a point of view."
2. From *Boxing 2000*.
3. Ebling, "Flat Land," 140.

Richard Maxwell *Joe* P.S. 122, New York City, 2002

Richard Maxwell is a playwright and director who expresses an aversion to acting but believes in the limitless power of the theater. A maverick even in the world of the experimental, his much-debated vernacular approach is a peculiar contrast of style and animus. He has developed an extreme form of neutrality for the stage: performers speak lines almost as if they were recitations, without discernible pacing or intent, and employ little to no blocking or movement.[1] Sets are generally minimal, consisting of perhaps a few chairs (*Showy Lady Slipper*, 1999), a drum kit (*Drummer Wanted*, 2001), or a white wall (*House*, 1998).

Maxwell's anti-aesthetic recalls the Beckettian quality of "nothing happens, twice" and prefers that its action be undistorted by manifest theatricality. Free of emotional overlay, the text asserts its primacy. The flat delivery leaves both the actors and the language so exposed that each utterance is like a weapon, no matter how innocuous ("You can find something beautiful. You can find it").[2] Maxwell often uses amateur actors, partly because of his affection for "bad acting," but mainly for the artless performance vocabulary they can engender.[3]

Although never overt, Maxwell's Midwestern roots are echoed in the treatment of his primary subject matter, American life in all its banal glory. The painstaking nonverisimilitude of his plays routinely conjures a (sub)urban pastoralism full of humor, tenderness, and longing. These common threads remain true, even when the driving incidents don't. The Walker Art Center–commissioned *Joe* (2002) uses five actors to portray the same character at different ages; *Burger King* (1997) shows a glimpse of the politics of working life with the generic Manager and Food Handler; while *House* deals with murder in the family. In *Boxing 2000* (2000), Maxwell's Walker debut performance in 2002, the ring stands as a quiet symbol of endurance for two brothers and their familial existence. Circular conversations, fractured silences, and general absurdity permeate his works, yet never does one suspect lurking parody or satire. Instead, the result is a sophisticated rendering of the human condition laid bare. It remains up to the viewer to mine this raw territory for meaning.

In the early stages of his career, Maxwell has already built a body of work that is individual in spirit, rigorous in execution, and beholden to no one. His violent antipathy to artifice operates like a low rumble of white noise within this milieu—a constant, if unconscious, reminder to the audience to remain in the immediate moment.

D.K.

Richard Maxwell *Joe* Southern Theater, Minneapolis, 2005

Paul McCarthy

American, b. 1945

- - **Exhibitions**
Let's Entertain (2000; catalogue, tour), *Painting at the Edge of the World* (2001; catalogue)
- - **Holdings**
1 photographic suite, 3 videos

To label Paul McCarthy's forty-odd years of artistic output as "a body of work" would strain the use of the phrase. With its presumptions of a neatly wrapped-up oeuvre, the phrase is hopelessly inappropriate to describe the breadth of forms his practice has taken: a hole in the wall that's a film, gagging-on-hot dogs performances, giant inflatable sculptures—let alone buffoonery about Osama bin Laden and the Queen of England. Yet the "body of work" metaphor would also be misplaced in suggesting a summary of the more literal corpora that inhabit McCarthy's world. Here bodies inexorably gush—puking, shitting, bleeding, ejaculating, and giving birth in clownish acts of debauchery and depravity, slapstick sex, and sordid secrets.

McCarthy studied at the University of Utah in the late 1960s, making door-size paintings with black oil, and using rags and his hands as surrogate brushes. Several of the thirteen short films collected as *Black and White Tapes* (1970–1975/1993)—made while continuing his studies in California—extend a kind of perverse painting practice. In *Face Painting—Floor, White Line* (1972), for example, the artist drags himself across his studio floor, pouring paint in front of him, while in another tape he petulantly flogs walls with a paint-soaked sheet. Of these films, *Ma Bell* (1971) is most prescient of what was to come in McCarthy's guise as a performer. While smothering each page of a Los Angeles telephone directory to make something resembling an oil-and-cotton wool lasagna, he began cackling and muttering, seemingly with no forethought, acting in character for the first time.

McCarthy's trademark live performances often become well-lubricated, penis-fixated, tragicomic epics—some would last five hours or more—through an increasingly fluent language of costumes, props such as rubber masks and dolls, and foodstuffs like ketchup, mayonnaise, and raw meat. Deranged, improvised, yet repetitive tableaux were tempered with feral desire, castration narratives, and Oedipal trauma. In works such as *Meat Cake* (1974), *Doctor* (1978), *Monkey Man* (1980), and *Popeye, Judge and Jury* (1983), gender-morphing grotesques that mashed up the human with the nonhuman drew as much on the no-budget teen "slasher" movie as on the ambivalent heritage of the clown. Unlike the real blood-and-guts of the Vienna Actionists—who were concerned with quasi-religious rituals of communion and redemption—McCarthy dredged below the veneer of the "perfect" family and "proper" behavior with a knowingly bankrupt symbolism. In this primordial semiotic universe, "Daddy's Sauce" was capable of representing both diaper-filling excrement and the taboos of incestuous desire.

McCarthy ceased live work in 1984, feeling that his performances had become too theatrical, too vaudevillian (he had preferred a small, invited audience). Focusing on the way in which history and folktales are framed by theme parks, television, and Hollywood, his vocabulary as a visual artist crystallized into a world in which kinetic mannequins depicted tree fornication and bestiality, and fluffy sculptures sported preposterous penises.

Documents (1995–1999) is a little-known photographic series prompted by an invitation to McCarthy to guest edit an issue of the French magazine *Documents sur l'art* and shown as part of the 2000 Walker Art Center–organized exhibition *Let's Entertain*. Like a visual scrapbook of installation works such as *Bavarian Kick* (1987), *Rear View* (1991), *Heidi* (with Mike Kelley, 1992), *Pinocchio Pipenose Householddilemma* (1994), and *Mechanized Chalet* (1999), *Documents'* eight panels of photographs abut apparent charm with latent malevolence. The work operates within a culture where the legacy of Nazi terror in World War II Europe can emerge as easily via the camp "Do-Re-Mi" of the movie *The Sound of Music* as it can in the defense of O.J. Simpson. A shot of a Bavarian castle, which might adorn a chocolate box, is put on the same visual field with one of a waxwork Hitler waving merrily from his car. The fiberglass peaks of Disney's Magic Kingdom clash with Tirolean postcard views, and giant busts of an aptly Wagnerian Siegfried and tiger-taming Roy encounter snapshots of Albert Speer's master plans or greet a Mickey mascot.

The status of the photograph as a document, as the unquestioned bearer of truth, becomes desperately muddled in these juxtapositions, which suggest that Disney's corporatization of childhood is just as tyrannical as Hitler's repurposing of Teutonic folklore. As the artist has written of this piece: "The initial premise was to investigate Hitler's Germany; the Paris, France, Exposition of 1900; Las Vegas, Nevada; and Disneyland, Anaheim, California, each location being a particular vision of Utopia and constituting a geographical straight line from East to West."[1] The pitch-perfect, pitch-black tone of *Documents* seems to elude, just barely, the impression that it has a lesson to teach—it is already too embroiled in conspiracy to parse any blame.

M.A.

Notes
1. Artist's statement, circa 2001 (Walker Art Center Archives).

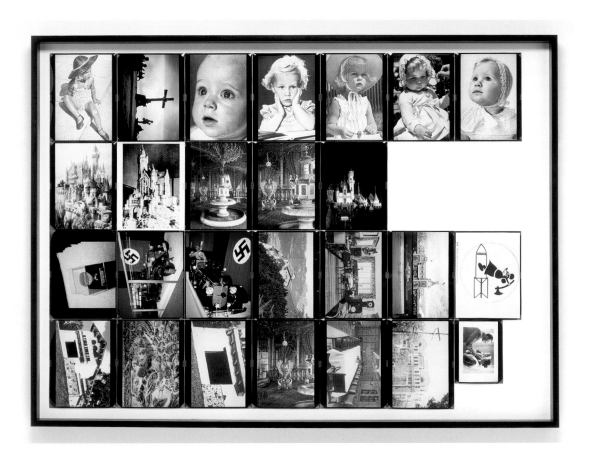

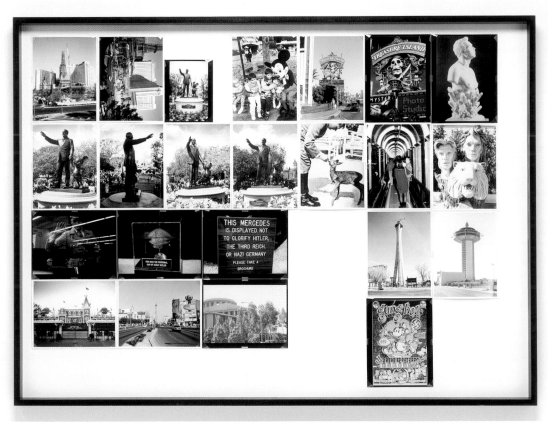

Paul McCarthy Selections from *Documents* 1995–1999 color photographs 61 1/8 x 85 1/8 x 3 1/4 in. (155.3 x 216.2 x 8.26 cm) framed, each of 8 panels
T. B. Walker Acquisition Fund, 2001 2001.147

Barry McGee

American, b. 1966

- - **Exhibitions**
Regards, Barry McGee (1998; publication), *American Tableaux*
(2001; publication, tour)
- - **Residencies**
1998
- - **Holdings**
1 multimedia work

Barry McGee is perhaps best known for his site-specific wall paintings that feature satirical figurative imagery, decorative script, floating heads, and simple tags rendered in black ink, aerosol paint, and white enamel on a ground of bright red house paint. Such works inventively call upon the attitudes, processes, and gestural elements of unsanctioned street art. Among his many influences, McGee cites the fearless energy of Mark Pauline and Survival Research Laboratories (SRL). He first encountered their urban performance events in the mid-1980s in the desolate lots below the I-280 freeway in the South of Market district of San Francisco. A burning effigy of Ronald Reagan, an overturned Volkswagen bus, warring machines, and cheering crowds served as McGee's first exposure to performance art, and he has since incorporated related elements of danger and destruction in numerous installations.

The indecipherable calligraphic marks, partially obscured monikers, and other discursive inscriptions that he utilizes also recall early twentieth-century works that engaged the explosion of print media, such as the assemblages of Kurt Schwitters. Like Schwitters, McGee incorporates banal graphic design and mass-produced typography that suggest a nostalgia for direct forms of communication, an insatiable appetite for discarded and recycled remains, and an ambivalent relationship toward consumer society. His narrative figuration is also closely linked to the influence of the Mexican muralists, including José Clemente Orozco, Diego Rivera, and David Alfaro Siqueiros, on the visual landscape of California.

Amidst a profound history of sanctioned and unsanctioned public art, McGee and cohorts— who have included Bill Daniels, Harrell Fletcher, Chris Johanson, Margaret Kilgallen, Alicia McCarthy, and Rigo 23—exacted a significant impact on art practice in the Bay Area through informal venues such as the Luggage Store Gallery, Adobe Books, and Clarion Alley in the 1990s. Together they advanced a socially conscious, uniquely San Franciscan punk aesthetic to the international art world. McGee has continued to test the limits of an uncontained practice, and since 2000, his installations have incorporated overturned or propped vehicles adorned with abandoned belongings, billowing smoke, small motorized elements, defaced surfaces, and flash movies that record acts of graffiti around the world. McGee has collaborated with Stephen Powers and Todd James, and most consistently with Josh Lazcano, to explore and document the lively character of informal creative practices in the urban space.

The hundreds of framed sketches, studies, logos, sewn paintings, and photos that make up the diaristic work *untitled* (1998) were amassed by McGee over several years' time. During a 1993 visit to the town of São Cristóvão, Brazil, he was moved by the installation of thousands of ex-votos in a small church. Silver hearts, wooden inscriptions, carved legs, and other likenesses recalled lost limbs, bodily ailments, loved ones. On another wall he saw small, framed photos and drawings of people, cars, families, a bridge. A third section featured braids and ponytails, all neatly arranged. Left behind by scores of the faithful, this unscripted, earnest chaos inspired McGee to assemble his own collection of images in installations such as this.

This collection of works was first installed at the Walker Art Center in the exhibition *Regards, Barry McGee* (1998). Housed in dime-store frames, many of the artist's small works were executed on found paper scraps such as musical score sheets, book endpapers, and aged newsprint. A significant example of McGee's wry sense of tragedy and skilled hand, *untitled* is part of his ongoing attempt to develop a destabilized art practice rooted in the incredible spontaneity of graffiti culture and other informal instantiations of visual expressivity. Although graffiti is often associated with vandalism and damage, for McGee and others it is a vital communicative record of the ebbs, flows, interruptions, and innovations to be found in the lived urban

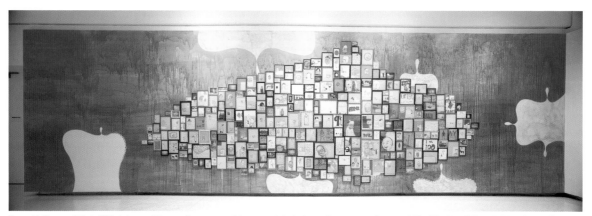

Barry McGee *untitled* 1998 ink, graphite, acrylic, commercial screenprint, photographs on paper, frames 115 x 280 1/2 in. (292.1 x 712.5 cm) overall
installed Miriam and Erwin Kelen Acquisition Fund for Drawings, 1998 1998.152

space. As he has explained, "The American Dream has nothing to do with criminality, but with a desire for independence and adventure, so escaping from any kind of control or definition also signifies not being identified, acting illegally, standing outside of every category of art and intervention on the streets."[1]

Eungie Joo

Notes
1. Quoted in the interview "Germano Celant_Barry McGee," Germano Celant, ed., *Barry McGee*, exh. cat. (Milan: Fondazione Prada, 2002), unpaginated.

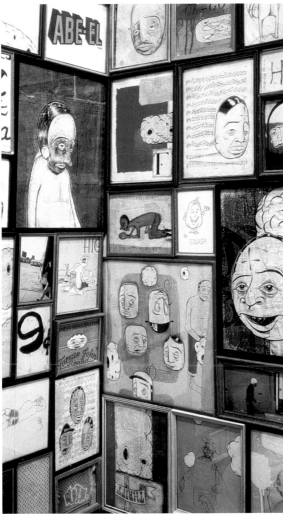

Barry McGee *untitled* 1998 (detail, alternate installation)

Artist-in-Residence, 1998

Barry McGee's residency brought the artist together with Minneapolis teenagers in a variety of activities intended to give expression to the energies of youth. Because his work is heavily influenced by "street art," it seems only fitting that one of his residency activities sent teens into the streets to wage a guerrilla marketing campaign for his 1998 exhibition *Regards, Barry McGee*. Working with the twelve members of the Walker Art Center Teen Arts Council (WACTAC), he created a sticker that was placed in public spots around the city. The project echoed many of the issues surrounding street art in general and McGee's work in particular: the use of public property as a venue for public discourse, the "interruption" that graffiti represents in the cityscape, and the underground network of communication that it nurtures.

WACTAC made further connections by creating a radio advertisement for the exhibition featuring the members' own voices blending and overlapping, reproducing sonically the layering and accumulation of images that marks McGee's work. They also asked the artist to teach a class to area teenagers. The result was Urban Messages, a series of workshops on painting, street art, and media literacy. Participants displayed their creations at a nearby exhibition space called the Soap Factory, and later shared their knowledge with others by leading tours of *Regards, Barry McGee* at the Walker's annual Student Open House event.

McGee's residency exemplified his passion for street art as a medium of expression for a younger generation as well as the energizing effect this unsanctioned art form has on youth culture. While society may view graffiti with a wary eye, as McGee says, "Kids are so into it. They love it. And I like that whole thing because it opens up possibilities for kids who don't normally have access to the arts, who aren't pushed creatively. That's how I feel; it opened me up to so many different things. I would hope every kid has that opportunity."[1]

L.D.

Notes
1. McGee, conversation with Eungie Joo, in Eungie Joo, *Regards, Barry McGee*, exh. publication (Minneapolis: Walker Art Center, 1998), unpaginated.

Participants in Barry McGee's Urban Messages graffiti workshop, The Soap Factory, Minneapolis, 1998

Julie Mehretu

American, b. Ethiopia, 1970

- - **Commissions**
Entropia (review) (2002–2004)
- - **Exhibitions**
Painting at the Edge of the World (2001; catalogue),
Julie Mehretu: Drawing into Painting (2003; catalogue, tour)
- - **Residencies**
2001–2002
- - **Holdings**
2 paintings, 1 edition print/proof

At the onset of a millennium defined by the twin forces of globalization and the legacy of September 11, Julie Mehretu is producing a new form of history painting that incorporates a wide range of formal, cultural, and personal references. Born in Addis Ababa, Ethiopia, she was raised in East Lansing, Michigan, educated in Rhode Island and Senegal, and currently lives and works in New York City. It is no surprise, then, that her work has a cartographic impulse in which a dynamic visual vocabulary of maps, urban-planning grids, and architectural forms stand in visually for a world that seems to be spinning out of control. By using elements extrapolated from recognizable references in our built environment, the artist creates paintings that blur the line between figuration and abstraction, fact and fiction, while also alluding to the world around us. The results are perfect metaphors for the interconnected and complex character of the twenty-first century.

Mehretu's paintings carry their own polymorphous history, almost like an archaeologist's dream site, by layering each stage between coats of acrylic paint. Marks build upon lines, which build upon colored shapes, creating an explosive collision of mythical history, architectural archives, and fictional landscapes. She says, "My aim is to have a picture that appears one way from a distance—almost like looking at a cosmology, city, or universe from afar—but then when you approach the work, the overall image shatters into numerous other pictures, stories, and events."[1] In *Babel Unleashed* (2001), the viewer is overcome by a swarming mass of shapes and lines—red, blue, green, pink, and black—as if the illusionistic space in a Renaissance system of perspective has been torn asunder. The most elemental forms are architectural, ranging from the anonymous (airports, stadiums, public plazas) to the celebrated, such as the Tower of Babel—a fabled site of cultural differentiation that remains a powerful symbol in a world where ethnic conflicts continue to shatter communities from Europe to Africa.

Hopeful visions for the future and the heartbreaking failures of humankind's utopian impulses constitute the underlying structure of Mehretu's *Transcending: The New International* (2003). Drained of all color and rendered in layers of black India ink and acrylic on an enormous stretched canvas, the painting has as its underlying structure the city plans of the major economic and political capitals in Africa. On the painting's surface, the artist has constructed complex line drawings depicting indigenous, colonial, and modernist architecture in the postcolonial period. For example, design schematics for a city plaza in Abuja, Nigeria, are submerged under a flurry of marks Mehretu calls her "characters," which stage battles, form alliances, and ravage her fictional cities. The painting is not, however, simply a nihilistic invocation of the derailed promises of African independence—it is at base a hopeful speculation on the futures of the real and imagined locations it depicts. In all her paintings, with their triumphant, expressive line, Mehretu charts a visual course that speaks not only to the tragic aspects of history but also to its moments of liberation and freedom.

D.F.

Notes
1. "Looking Back: E-mail Interview between Julie Mehretu and Olukemi Ilesanmi," in Douglas Fogle, ed., *Julie Mehretu: Drawing into Painting*, exh. cat. (Minneapolis: Walker Art Center, 2003), 13.

Julie Mehretu *Transcending: The New International* 2003 ink, acrylic on canvas 107 x 237 in. (271.8 x 602 cm) T. B. Walker Acquisition Fund, 2003 2003.42

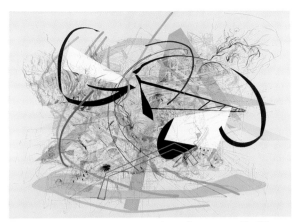

Julie Mehretu *Babel Unleashed* 2001 ink, acrylic on canvas 60 x 84 in.
(152.4 x 213.4 cm) T. B. Walker Acquisition Fund, 2001 2001.68

Julie Mehretu *Entropia (review)* 2004 lithograph, screenprint on paper;
Archive Proof 2 from an edition of 45 33 1/2 x 44 in. (85.1 x 111.8 cm)
Published by the Walker Art Center and Highpoint Editions, Minnesota
Acquired through commission, 2004 2004.54

Artist-in-Residence, 2001–2002

During her first visit to the Twin Cities in February 2001, Julie
Mehretu immediately noticed the sizeable population of East
Africans in the metropolitan area. Of Ethiopian descent
herself and familiar with the complex histories of the region,
she was curious about how these new immigrants were
adjusting to life in the American Midwest. For her residency,
she wanted to create a project that would be specific to
Minneapolis and St. Paul, yet relate to her own practice
and concerns as a painter: identity, personal and cultural
history, geography, and personal narrative. After much
research and in consultation with her brother, David Mehretu,
an urban planner, she designed *Minneapolis and St. Paul Are
East African Cities*, a self-ethnography project for thirty East
African teenagers at Edison and Roosevelt high schools
in Minneapolis.

She armed each participant, most of Somali, Eritrean, or
Ethiopian heritage, with two disposable cameras, a small dig-
ital audio recorder, a notebook, and a map of the Twin Cities,
and asked them to document their lives over a two-week
period. Opening a delicate window on their personal stories,
they recorded daily activities at the dinner table, on the soc-
cer field, at the local African supermarket, and at the mall.
Using both pictures and sound, they created rich and compel-
ling tapestries that explore themes of family history, social
and political upheaval, the individual and community in urban
space, and the mapping of the self within the larger whole.
Their personal and often moving stories were the basis for
a commissioned interactive Web site (http://tceastafrica.
walkerart.org), and their photographs, sound recordings,
maps, and notebooks joined the permanent collection of the
Hennepin History Museum in Minneapolis, where they were
on display during the summer of 2003.

O.I.

Julie Mehretu (left) at work with students from Edison High School,
Minneapolis, 2002

Fausto Melotti

Italian, 1901–1986

– – **Exhibitions**
The Cities Collect (2000)
– – **Holdings**
1 sculpture

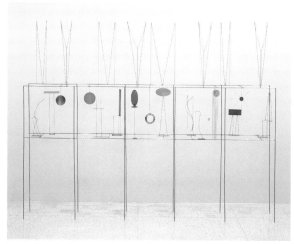

Fausto Melotti *Contrappunto Domestico (Domestic Counterpoint)* 1973
stainless steel 87 x 113 x 12 in. (221 x 287 x 30.5 cm) Gift of JoAnn and Gary
Fink, 2001 2001.215

Little known in the United States, Fausto Melotti created some of the most charming work of the last century. While "charming" might be perceived as an ideal word for damning with faint praise, that is anything but the case. His work is charming in the sense of an enchantment, an invitation to a world of sparkling harmonies and intricate choreography. Born in Italy in 1901, Melotti took a degree in engineering but eventually turned to sculpture, an occupation that proved in every way a perfect extension of his engineering studies. His earliest work in the 1930s was devoted to modestly scaled, abstract bas-reliefs in plaster. The very use of plaster as the end result was peculiar insofar as it was traditionally the means to an end, that is, something ultimately realized in marble or bronze. Thus, from the start, Melotti underlined his rejection of the monumental in favor of the intimate and the domestic.

While his early work was essentially investigating planar volumes, it also had an architectural presence that would continue into the 1950s. Indeed, the architectural nuance would slowly overtake the abstraction as Melotti increasingly turned to modeled Lilliputian interiors (or stage sets) that surely share the same strange air as Giorgio de Chirico's haunted cityscapes. Melotti's tiny "metaphysical theaters" suggest stories that are alternately heartening and tragic; they could easily exist as models for mise-en-scènes dedicated to such contemporaneous authors as Alberto Moravia or Jean-Paul Sartre. Working primarily in ceramic and terracotta, Melotti insistently saluted the craft of artisans just as several of the Arte Povera artists would do a decade later. Unlike the Arte Povera contingent, however, he also embraced narrative with the occasional metaphor or whimsical aside enhancing his miniaturized world.

The work that Melotti is arguably best known for emerged in the 1960s when he turned to metal. Inspired by his great passion for music, the artist's work exploded with glistening, effusive compositions in brass, copper, and steel that are three-dimensional scores for music of your own invention. Delicately wrought and responsive to their environment, these objects, including the Walker Art Center's *Contrappunto Domestico (Domestic Counterpoint)* (1973), possess an exquisite nervousness that resonates in the surrounding air. The best of the metal sculptures are balanced abstractions of unquestionable loveliness and brilliant engineering. As is the case with Alexander Calder, another artist who used air as just another material and understood the merits of craft, Melotti makes grace look necessary and beauty natural.

R.F.

Ana Mendieta
American, b. Cuba, 1948–1985

-- **Exhibitions**
The Last Picture Show: Artists Using Photography, 1960–1982
(2003; catalogue, tour)
-- **Holdings**
2 photographic suites

Born to a prominent Cuban family in Havana, Ana
Mendieta moved to the United States with her sister
at age thirteen, where she lived and worked in Iowa
until relocating to New York in 1978. In her best-known
works, the *Silueta* and *Fetish* series created in the open
air and preserved in photographic documentation,
Mendieta made impressions and reliefs of the contours
of her body in the ground with both arms raised as if
in prayer like an orant figure; these later developed
into more fully sculptural effigies. The series had clear
ties to the Earth goddess spirituality that feminists of the
1970s embraced as a critique of phallocentric, patriar-
chal religious ideologies and social structures. At the
same time, the works arose from the artist's particular
interest in the Afro-Cuban religion of Santería, likely
driven by her own ethnic and cultural identification.

Mendieta was greatly concerned with the marking
of the body with various categories of classification,
such as gender and ethnicity. In the 1970s, the field of
visual art was opened up by diverse new praxes, which
took it in various directions—away from commodifica-
tion and conventions of display, off the grid, and out into
open lands. With her body serving as a potent medium
interacting with the earth and by relinquishing her art-
making to the natural forces of entropy, she uniquely
combined contemporary concerns that were unfolding
in Conceptual Art, Earth Art, and Body Art.

Even before her "return to nature," however, the
body was at the center of Mendieta's artistic production.
In the series of performative works she created in 1972
as her MFA project at the University of Iowa, she sub-
mitted her (often nude) body to simulations of violation
and mutation: transferring shaved-off facial hair of a
male collaborator onto her face (*Facial Hair Transplant*,
1972); pressing sheets of glass on her face, breasts, and
buttocks to flatten and twist them out of shape (*Glass
on Body*, 1972); and perhaps most disturbingly, staging
scenes of sexual violence complete with fake blood
(*Rape Piece*, 1972). In *Untitled (Facial Cosmetic
Variations)* (1972/1997), two series of self-portraits in the
Walker Art Center's collection, she deploys a host of
rather simple devices—hosiery, makeup, wigs—to dis-
guise and distort her facial features. As much as her
face is "made up" to be ugly approaching on repug-
nant, it is also "unmade" beyond recognition. In her
resolute exploration of transformative possibilities that
lie in altering the body, Mendieta was in historical
league with the likes of Eleanor Antin, Adrian Piper,
and Hannah Wilke, among others, and laid the ground-
work for such artists as Cindy Sherman.

D.C.

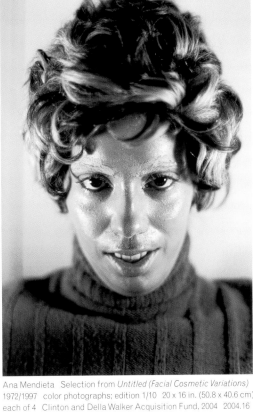

Ana Mendieta Selection from *Untitled (Facial Cosmetic Variations)*
1972/1997 color photographs; edition 1/10 20 x 16 in. (50.8 x 40.6 cm)
each of 4 Clinton and Della Walker Acquisition Fund, 2004 2004.16

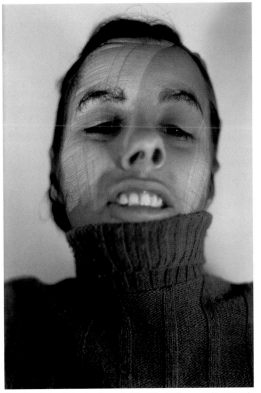

Ana Mendieta Selection from *Untitled (Facial Cosmetic Variations)*
1972/1997 color photographs; edition 1/10 20 x 16 in. (50.8 x 40.6 cm)
each of 3 Clinton and Della Walker Acquisition Fund, 2004 2004.17

Mario Merz
Italian, 1925–2003

--- **Commissions**
Untitled (1996–1997)
--- **Exhibitions**
Mario Merz (1972; catalogue), *Artists' Books* (1981), *Zero to Infinity: Arte Povera 1962–1972* (2001; catalogue, tour), *The Last Picture Show: Artists Using Photography, 1960–1982* (2003; catalogue, tour)
--- **Holdings**
2 sculptures, 7 drawings, 1 edition print/proof, 3 books

At the height of the student uprisings and social protests taking place across Europe in the spring of 1968, French philosopher Henri Lefebvre published his book *Everyday Life in the Modern World*, a critical study of capitalist urbanism that warned against the stultifying effects of what he termed "the bureaucratic society of controlled consumption." It was in the context of this widespread call to arms against the standardization of our lives according to the dictates of consumer culture that a new generation of Italian artists would emerge in the industrial centers of the postwar Italian economic miracle, loosely brought together in 1967 under the banner of Arte Povera by curator and critic Germano Celant. Among these artists was Mario Merz, who championed the infinite possibilities of human freedom by exploring the revolutionary social and material possibilities of sculpture.

Born in 1925, Merz was nearly ten years older than his Arte Povera cohorts, such as Giovanni Anselmo, Alighiero Boetti, and Giulio Paolini. Like his colleagues, he opposed the prevailing economic and cultural systematization of everyday urban life not by adopting an overt political stance, but by choosing to work with nontraditional art materials that often had an ephemeral or precarious nature, such as wax, cloth, wire mesh, glass, and earth. The contingent character of these media can be seen as providing an antiheroic and consciously humanist antidote to the oppressive uniformity of a world ruled by industrial mass production.

This emphasis on the positive value of contingency can be seen quite early in Merz's work in his iconic series of igloo structures, begun in 1968, which he fashioned out of such materials as metal, broken glass, and bags of dirt. He was attracted to the simplicity of this structure because of the organic connection of this architectonic form to the natural environment as well as its relationship to humanity through its function as a primitive shelter. *Igloo* (1971), for example, is made up of a series of simple metal tubes that define the hemisphere of a structure that is partially enclosed by two almost gossamer pieces of wire mesh. The entire work is held together rather precariously with carpenter's clamps, suggesting a delicate structural equilibrium that could collapse at any moment. In this work, spatial distinctions between interior and exterior break down as this object becomes simultaneously private and public, a closed shelter and an object open to the endless possibilities of the world. Its existence as an organic, habitable form stands in stark, poetic contrast to the harsh geometries of the modern industrial city, opening

it up as a site of oneiric reverie that asks us to contemplate the infinite.

Merz's obsession with the infinite can be seen most clearly in his conceptual adaptation to his work of the Fibonacci series, a theoretical progression of numbers discovered by the Italian mathematician Leonardo Pisano Fibonacci in 1202. Each number is the sum of the two preceding it, beginning with 1, 1, 2, 3, 5, 8, and theoretically continuing on into infinity. Based on observations of the quantity of seeds in fruit, petals on a flower, or offspring of an animal, the series describes a sequence of exponential natural growth whose mathematical progressions spoke to Merz of the unlimited potentiality of life in the face of the closed, systemic effects of modern society. In *Igloo*, he has affixed the beginning of the Fibonacci series to its surface with neon light fixtures that spell out the equation $1 + 1 = 2$. For Merz, Fibonacci is not simply an abstract mathematical system, but a method for creating relationships in the sculptural object between the physical materiality of the world and the possibilities offered by the immateriality of natural systems. As the artist has suggested, "Man loves trees because he feels that trees are part of the vital series of life. When man has this relationship with nature he understands that he is part of a biological series. The Fibonacci series is natural. If you put a series of trees in the exhibition, you have dead entities. But if you put Fibonacci numbers in an exhibition they are alive because men are like numbers in a series. People know that numbers are vital because numbers can go into infinity while objects are finite. Numbers are the vitality of the world."[1]

Merz's use of the Fibonacci series and his igloo sculptures were the centerpieces of the first solo museum exhibition of the artist's career, which took place at the Walker Art Center in 1972. Some twenty years later, the Walker commissioned and acquired its first major work by Merz, the untitled neon sculpture that resides on top of the Cowles Conservatory in the Minneapolis Sculpture Garden. Beaming out across the Garden in red light in the artist's handwriting are the words *città irreale* (unreal city), a phrase Merz has used repeatedly in his sculpture since the 1960s. His *Igloo* might also be seen as the physical embodiment of our own unreal city, an ephemeral and nomadic structure that migrates across a landscape caught in the liminal space between rationality and dreaming that is characterized by the infinite possibilities of human energy.

D.F.

Notes
1. Quoted in Richard Koshalek, "Interview with Mario Merz," in Richard Koshalek, *Mario Merz*, exh. cat. (Minneapolis: Walker Art Center, 1972), unpaginated.

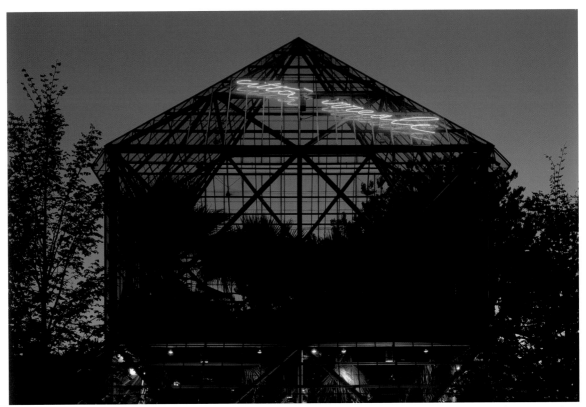

Mario Merz *Untitled* 1996–1997 neon tubing 240 x 480 in. (609.6 x 1219.2 cm) installed Anonymous gift from three local residents with appreciation for the Minneapolis Sculpture Garden and contemporary art, 1996 1996.178

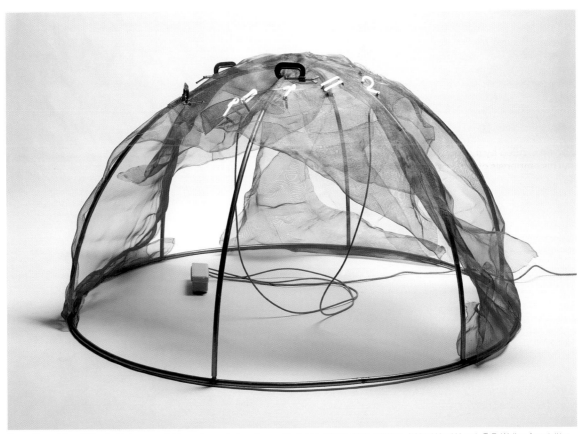

Mario Merz *Igloo* 1971 steel tubes, neon tubing, wire mesh, transformer, C-clamps 39 3/8 x 78 3/4 x 78 3/4 in. (100 x 200 x 200 cm) T. B. Walker Acquisition Fund, 2001 2001.64

Marisa Merz

Italian, b. 1931

- - **Exhibitions**
Zero to Infinity: Arte Povera 1962–1972 (2001; catalogue, tour)
- - **Holdings**
1 sculpture

Marisa Merz is the only woman artist associated with Arte Povera. During her long marriage to Mario Merz, one of the most bravura of the movement's progenitors, she resolutely managed her own career while rarely leaving his side and, occasionally, operating as his anonymous collaborator. Still, it is her tenacious personal vision that has resulted in a body of work that is both mystic and domestic. Knitting copper, draping aluminum, modeling clay, kneading wax, Merz has created a body of work that has the persuasiveness of myth, evoking as it does the transformational caprices of Calypso and the patient, heroic weaving of Penelope.

Merz's first three exhibitions all took place in Turin, Italy, in 1967. The range of creativity displayed was startling and culminated in the installation of her multipart *Untitled (Living Sculpture)* at the avant-garde Piper Club. The sculpture, a baroque, space-age fantasy of coiling aluminum shapes that drip from the ceiling like melting constellations, remains a work of great lyric muscularity and guaranteed Merz a reception quite independent of her famous husband. What followed was a sustained run of exhibitions in which she created dense installations filled with delicate moments of personal grace (what Germano Celant calls "a honeycomb of gestures"[1]), such as cups of salt, rolled and bound blankets, little slippers of copper, and the woven-nylon name of her daughter Bea. As the 1980s approached, more (and more complex) knitted copper webs began to appear, predicated on the Fibonacci numbering series her husband had made a key element in his work and which Merz utilizes as an homage to him. She also began drawing and sculpting heads that, in their explicit oddness and ceremonial solemnity, suggest nothing so much as votive offerings from a lost culture. The fist-size clay heads are totally mute but filled with a kind of cenotaphic energy that, combined with waxen cauls of pigmented color and veils of copper mail, achieve a riveting presence. With their blinded eyes, they also allude to the blind seers of antiquity, such as Tiresias, who foresaw the fall of Oedipus. Her drawings of heads, while obviously related, are direct descendants of the Italian Futurist line, seemingly spinning like planets yet resolutely calm in their orbit. Unlike the sculpture, they are often sly and flirtatious, almost giddy in their energized penciled coils.

Merz was invited to exhibit in Documenta 9 in 1992. The object she chose to display, a small fountain, could almost be read as a self-portrait. Exhibited in a room of its own, the beeswax form is that of a liquid square within a liquid square, creating four extended ovals surrounding a quiet, steady pulse of water. It is a work of contradictions and oppositions all formally aligned to provide a sensation that combines energy and peace as if they were one. It also echoes a reflection on Arte Povera that Merz once voiced: "The real power was to give reality to the imagination."[2]

R.F.

Notes
1. Germano Celant, "Marisa's Swing," in Catherine Grenier, ed., *Marisa Merz*, exh. cat. (Paris: Editions du Centre Pompidou, 1994), 246.
2. Marisa Merz, conversation with the author, Turin, Italy, October 3, 1997.

Marisa Merz *Fontana (Fountain)* 1992 beeswax, bronze, wood, electric pump, plastic reservoir 9 x 33 1/2 x 33 1/2 in. (22.9 x 85.1 x 85.1 cm)
Sculpture Garden Acquisition Fund, T. B. Walker Acquisition Fund, and the funds provided by the Frederick R. Weisman Collection of Art, 1995 1995.26

Joan Miró

Spanish, 1893–1983

– – Exhibitions

Unpopular Art (1940; catalogue), *136 American Painters* (1946; catalogue), *Joan Miró* (1952), *Art in Modern Ballet* (1953), *The Classic Tradition in Contemporary Art* (1953; catalogue), *Reality and Fantasy, 1900–1954* (1954; catalogue), *First Annual Collectors Club Exhibition* (1957; catalogue), *Art Fair* (1959; catalogue), *Miró Sculptures* (1971; catalogue, tour), *20th Century Master Prints* (1975; tour), *The Cities Collect* (2000)

– – Holdings

2 sculptures, 1 gouache/watercolor, 4 edition prints/proofs, 1 book, 2 posters

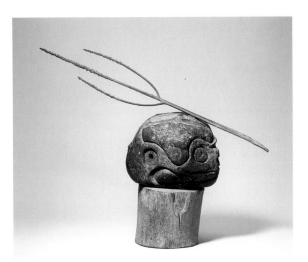

Joan Miró *Tête et Oiseau* (*Head and Bird*) 1967 bronze; edition 3/5
24 1/2 x 28 9/16 x 11 in. (62.2 x 72.6 x 27.9 cm) Gift of the T. B. Walker Foundation, 1970 1970.35

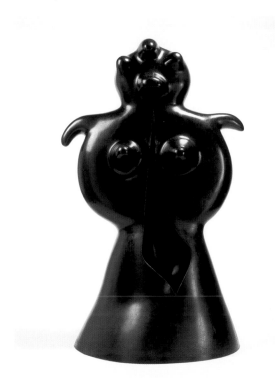

Joan Miró *Femme debout* (*Standing Woman*) 1969 bronze; edition 2/4
75 1/2 x 46 1/4 x 42 1/4 in. (191.8 x 117.5 x 107.3 cm) Gift of the Pierre Matisse Gallery and the T. B. Walker Acquisition Fund, 1973 1973.1

Joan Mitchell
American, 1926–1992

- - **Exhibitions**
Vanguard 1955 (1955; catalogue), *Second Annual Collectors Club Exhibition* (1958; catalogue), *60 American Paintings: Abstract Expressionist Painting of the Fifties* (1960; catalogue), *The Nature of Abstraction: Joan Mitchell Paintings, Drawings, and Prints* (1999), *The Cities Collect* (2000)
- - **Holdings**
3 paintings, 46 edition prints/proofs, 13 portfolios of prints, 1 book

Joan Mitchell was one of the most significant painters to emerge from Abstract Expressionism, a movement in American art at mid-twentieth century with few female proponents. Steeped in literature and the arts as a youth in Chicago, Mitchell moved to New York in 1950, where she soon became ensconced in the Greenwich Village art scene, associating with established painters of the New York School such as Franz Kline, Willem de Kooning, and Philip Guston as well as poets Frank O'Hara, John Ashbery, and others.

With her bold, gestural canvases and fiercely independent attitude, Mitchell quickly made an impact as one of the so-called second-generation of Abstract Expressionists (along with painters Sam Francis, Helen Frankenthaler, and Jules Olitski). Though her paintings shared the scale, exploded composition, and pure color associated with the period, Mitchell also had an abiding passion for the landscape. She devoted her artistic life to making resolutely abstract works that were her own reflections on the natural world, drawing inspiration as much from early modernists such as Paul Cézanne, Henri Matisse, and Vincent van Gogh as from her predecessors of the New York School.

Mitchell's confident, early paintings reflected her admiration for de Kooning, whose work she saw at the Whitney Annual in 1950, and Arshile Gorky, whose late style of abstraction was similar to her own. Though her feverish, densely marked surfaces often appear to have been painted spontaneously, she eschewed the term "action painting."[1] Her work was highly controlled, and she was sometimes known to spend months on a composition. *Painting 1953* was made the year she joined New York's Stable Gallery, at a time when her style was becoming fully mature. The painting shares a subdued palette of grays, greens, and yellows with several others made that summer in East Hampton, New York, and was one of the very few canvases Mitchell likely painted outdoors.[2] She preferred to execute her views of nature in her studio, often working at night. Her lyrical compositions of color and light were almost always derived from remembrances—"I carry my landscapes around with me," she remarked in 1957—rather than from visual cues.[3]

From 1968 until her death, Mitchell lived and worked in her adopted home of Vétheuil, a small town near Paris where the painter Claude Monet had resided from 1878 to 1881. While she observed the same surroundings as the French artist (sunflowers, trees, and wild grasses were among her favorite themes), she did not profess an affinity for his work, though she placed herself more within a French artistic tradition than an American one: "To me," she said, "painting is French."[4]

With her move to France, Mitchell began to work on a larger scale, often painting on multiple panels. Her love of poetry has often been cited in this context, her panels of painterly calligraphy sometimes compared to stanzas of verse or pages from an open book. In the late 1970s and early 1980s, her brushstrokes more closely began to suggest recognizable landscapes, and her surfaces, as in much of her work from the period, revealed an increased ordering of marks—mostly flat, vertical strokes densely applied with a palette knife.

Near the end of her life, Mitchell's paintings assumed a new clarity, marked by bold, distilled color (often taken directly from the paint tube), wide brushstrokes, and an increased sparseness. The assured clusters of blue, gray, and lavender in the diptych *Trees* (1990–1991) float amidst a diaphanous field of white, creating an arresting openness. "I like trees because a tree is not a person," she remarked the year this painting was finished. "It expresses things."[5] Mitchell remained prolific until her death from cancer in 1992. In her last years she produced some of her largest and most luminous canvases, pastels, and lithographs,[6] evincing her inventiveness as a colorist, her evolution as a painter, and her adherence to her own very personal vision.

S.E.

Notes
1. "The idea of 'action painting' is a joke," Mitchell remarked in 1991. "There is no 'action' here. I paint a little. Then I sit and look at the painting, sometimes for hours. Eventually the painting tells me what to do." Quoted in Deborah Solomon, "In Monet's Light," *New York Times Magazine*, December 1, 1991, 62.
2. Mitchell rented Rose Cottage in Three Mile Harbor, East Hampton, Long Island, that summer with Michael Goldberg, Paul Brach, and his wife, Miriam Schapiro. *Painting 1953* was made alongside two other canvases at that time, both titled *Rose Cottage*, which the artist painted in a studio space on an outdoor, covered porch. See Judith E. Bernstock, *Joan Mitchell*, exh. cat. (New York: Hudson Hills Press in association with the Herbert S. Johnson Museum of Art, Cornell University, 1988), 28–29.
3. Quoted in Irving Sandler, "Mitchell Paints a Picture," *Artnews* 56, no. 6 (October 1957): 45.
4. Quoted in Solomon, "In Monet's Light," 64.
5. Quoted in ibid., 62.
6. During the early 1980s, Mitchell became more active as a printmaker, and throughout her final years, she created a significant body of lithographs in collaboration with master printer Kenneth Tyler at Tyler Graphics Ltd. in Mount Kisco, New York.

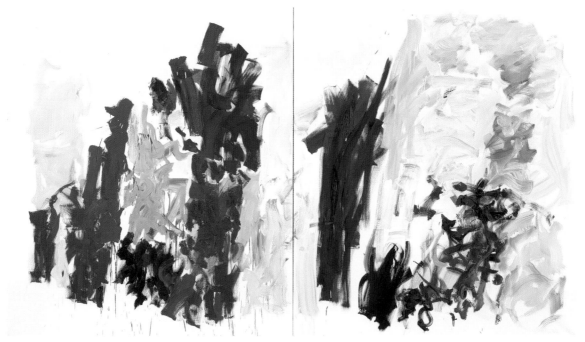

Joan Mitchell *Trees* 1990–1991 oil on canvas 78 1/2 x 142 in. (199.4 x 360.7 cm) installed Gift of Joanne and Philip Von Blon, 1995 1995.98
©The Estate of Joan Mitchell

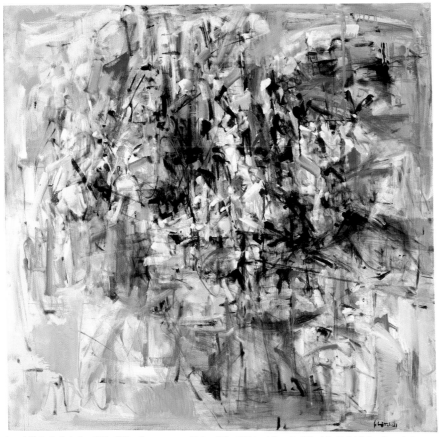

Joan Mitchell *Painting 1953* 1953 oil on canvas 52 1/2 x 55 in. (133.4 x 140 cm) Gift of the T. B. Walker Foundation,
1956 1956.2 ©The Estate of Joan Mitchell

Donald Moffett

American, b. 1955

- - **Holdings**
1 painting

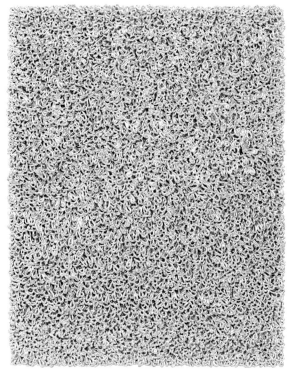

Donald Moffett *Lot 091195.03* 1995/2003 oil, enamel on canvas
20 1/8 x 16 1/8 x 2 1/4 in. (51.1 x 41 x 5.7 cm) Gift of the American Academy
of Arts and Letters, New York; Hassam, Speicher, Betts and Symons Funds,
2003 2003.55

Meredith Monk

American, b. 1942

In other cultures Meredith Monk would be called sha-
man, seer, healer; here we struggle to define her
interdisciplinary prowess. Singer/composer, dancer/
choreographer, actor/performer, director/playwright,
visual artist/filmmaker—even together, these catego-
ries cannot capture her resplendent achievements.
"I work in between the cracks, where the voice starts
dancing, where the body starts singing, where theater
becomes cinema," she says.[1] She creates visceral exca-
vations of abstracted gesture, sound, and tableau,
inviting audiences to experience archetypal, transfor-
mative rituals. Distilling idiosyncratic movement, three-
octave vocalizing, and luminous stage design to their
unadorned essence, she collages these elements into
transcultural dreamscapes. Via performance, record-
ing, and film, we journey through her clear-sightedness
into a vision of redemption.

A fourth-generation singer, Monk studied piano,
eurhythmics, lieder, and folk songs prior to enrolling
in a multidepartmental performing arts program at
Sarah Lawrence College in New York. She came of
age artistically in 1960s New York, performing in Fluxus
Happenings as well as studying, performing, and
collaborating at Judson Church. It was here, in one
of her first acclaimed solos, *16 Millimeter Earrings*
(1966), that she incorporated film and video into her
live performance.

From the beginning, Monk had dubious regard for
the proscenium. Audiences were ushered in and out
of her living space/loft as part of multivenue epics that
contained site-specific components in such locales as
the Solomon R. Guggenheim Museum (*Juice*, 1969) or
a parking lot in lower Manhattan (*Vessel*, 1971). Large-
scale events such as *Needle-Brain Lloyd and the
Systems Kid* (1969), with its one hundred fifty–member
cast, alternated with such intimate pieces as *Our Lady
of Late* (1971), created for solo voice and wine glass.

In 1974, the Walker Art Center invited Monk and her

ensemble to perform *Our Lady of Late* and involve
local artists in performances of *Education of the
Girlchild*, both of which were held in a converted
Masonic lodge. Since that initial visit, she has returned
nine times with film and video works, vocal recitals,
movement solos and duets, operas, and other music-
theater works.

Monk brought *Quarry*, her masterpiece set during
World War II, to the Great Hall of Coffman Memorial
Union at the University of Minnesota in 1977. In the
middle of this cavernous space, she portrayed a sick
child having nightmares as the Holocaust consumed
the world around her. In 1982, Monk spent five days
filming an adaptation of *Paris*, her "travelogue" collab-
oration with Ping Chong, in an abandoned grain ele-
vator along the Mississippi River in Minneapolis. Over
the next decade, the Walker presented two events: a
twentieth-anniversary retrospective of her polyphonic
vocal works and films at Hamline University in 1985;
and her opera of fantastical cultures, climates, and
landscapes, *ATLAS* (co-commissioned by the Walker,
Houston Grand Opera, and other national partners)
at the College of St. Catherine in St. Paul in 1991.

After working five years on the opulent *ATLAS*,
Monk challenged herself anew in the solo form. The
resulting *Volcano Songs*, premiering at the Walker
in 1994, was a tender rumination on the humor and
pathos of aging. The persona in *Volcano Songs*, mirror-
ing Monk's solitary figure some twenty years earlier
in *Education of the Girlchild*, joined a pantheon of her
unforgettable characters: Joan of Arc in *Vessel*, the
feverish child in *Quarry*, the madwoman in *Book of
Days*, and the intrepid truth-seeker in *ATLAS*.

Walker commissioning funds supported *Volcano
Songs*. Monk says, "They gave me the chance to do
what an artist strives to do: to create a new work without
knowing what the result will be; to take the risk of start-
ing from zero, cutting through preconceptions and artis-
tic habits to allow the piece to grow organically, so that
eventually it will have a life of its own."[2]

Monk and her ensemble returned in 1997 to the
College of St. Catherine with another Walker co-com-
mission, *The Politics of Quiet*. Excerpts of this work,
along with sections from *ATLAS*, were performed the

Meredith Monk *Education of the Girlchild* Cathedral of St. John the Divine,
New York City, 1973 Photo: Peter Moore

following year when the exhibition *Art Performs Life: Merce Cunningham/Meredith Monk/Bill T. Jones* was mounted in three Walker galleries. It documented the long relationship the institution has had with these artists, who in their multidisciplinary practice bridged both the dark and light spaces of the institution.

Monk's bountiful gallery included ephemera, performance photos, slides, posters, programs, scores, storyboards, drawings, sets, props, costumes, sound and film excerpts from her oeuvre, and newly created installations. A whimsical timeline featured thirty years of shoes worn by Monk and her performers beginning with *The Beach* (1965). As part of the opening festivities, Monk and ensemble, along with dozens of local performers, sang her *A Celebration Service* at the neighboring First Unitarian Society and at Mass at the Basilica of St. Mary in Minneapolis.

Monk returned to the College of St. Catherine in 2002 with another Walker copresentation, *mercy*. This hypnotic work was a collaboration with visual artist Ann Hamilton. Luminous projections from small pinhole cameras on the performers' fingertips and in their mouths drew the audience into the interconnectivity and interdependence of those onstage. Lilting melodies evolved from lullabies into guttural stutters, erupted into whispers, and then transformed into phrases, only to dissipate and fade away.

Buddhists have a term, *bodhisattva*, for one who single-mindedly seeks compassion for all living beings. Meredith Monk is a *bodhisattva* artist. The Walker and its audiences continue to be blessed in this ongoing relationship.

John R. Killacky

Notes

1. Jan Greenwald, "An interview with Meredith Monk," *EAR Magazine*, April–May 1981, 5.

2. Quoted in John R. Killacky, "Art and Life: Breaking Down the Walls—Meredith Monk, Merce Cunningham, and Bill T. Jones in the Twin Cities," *Lavender Magazine*, June 19, 1998, 42–43.

Meredith Monk *ATLAS* The O'Shaughnessy, College of St. Catherine, St. Paul, 1991

Meredith Monk *Volcano Songs* Walker Art Center Auditorium, Minneapolis, 1994

Jason Moran

American, b. 1975

--- **Commissions**
Milestone (2005)
--- **Performances**
Sam Rivers/Jason Moran Trio (2001), Jason Moran with Greg Osby
+ Strings (2002), Jason Moran and the Bandwagon: *Milestone* (2005;
world premiere)
--- **Residencies**
2004–2005

Composer and pianist Jason Moran reconciles jazz's
early traditions with the free experiments of the 1960s,
tempering them both with his generation's innate
understanding of hip-hop, pop, and new technologies
in production. His work also owes a debt to less visible
affinities—opera, painting, film, and design—as well
as the harmonic influence from such composers as
Maurice Ravel, Arnold Schoenberg, and Kurt Weill.
Like all significant jazz artists, Moran allows diverse
influences to coalesce around his own signature sound.
He plays with fluidity and a sense of funk, and wields
an arresting, clean attack that fuses instinctively with
the graceful playing of his mates in the Bandwagon,
Nasheet Waits (drums) and Tarus Mateen (bass).

Born in Houston, Texas, Moran relocated to New
York in 1993 to study with piano legends Jaki Byard,
Andrew Hill, and Muhal Richard Abrams. In 1997, he
began his tenure in the band of alto saxophonist and
composer Greg Osby after the pair met and recognized
an immediate affinity of shared intellectualism and
musicianship, especially related to the advancement
of jazz as a progressive medium.

Moran first appeared at the Walker Art Center in
the live premiere of his trio's collaboration with free-
jazz sax legend Sam Rivers. Although they'd played
together on Moran's highly regarded recording *Black
Stars* (Blue Note, 2000), the two had no plans for a live
rendition. With encouragement from the Walker (partic-
ularly to Rivers, who was initially reluctant to perform
live with a musician fifty years his junior, no matter how
brilliant), the rare collaboration was a historic and ser-
endipitous melding of sensibilities across generational
lines. Moran returned the following spring to perform
in Osby's chamber-jazz work *Symbols of Light*, which
united a string group with a jazz quartet.[1]

On these visits, Moran would spend every available
moment scouring the Walker galleries, indulging his
love of contemporary art. This led to an invitation for
Moran to create an evening-length work that would
musically and theatrically reinterpret elements of the
Walker's collection. A series of research trips and the
attendant two-year curatorial conversation across
departments resulted in *Milestone*, which premiered in
2005 in the Walker's new William and Nadine McGuire
Theater. Though *Milestone* was informed by artworks
ranging from sculptures by Louise Nevelson to a video
by David Hammons to paintings by Alice Neel and
Ellsworth Kelly, its central inspiration emerged as
Adrian Piper's *The Mythic Being; I/You (Her)* (1974)—a
progressive series of photographs with text additions.

Moran's fascination with this piece and his subsequent
examination of the artist's life and writing led to the con-
ception of a parallel creation in which he transferred
Piper's combination of the personal, political, and theat-
rical into the context of a jazz composition and concert
form. Moran, like Piper, interweaves his own journals,
personal history, and sociopolitical perspectives into a
flow of connected compositions. Also like her, he strives
to reframe his art form, designing a conceptual presen-
tation style that upends notions of the standard concert.

P.B.

Notes
1. The performers included Greg Osby (alto and soprano sax), Jason
Moran (piano), Peter Retzlaff (bass), Steve Kirby (drums), L. Chris
Howes (violin), Marlene Rice (violin), Judith Insell (viola), and
Catherine Bent (cello).

Jason Moran, Rome, 2003

Robert Morris

American, b. 1931

-- **Commissions**
Untitled (1969), *Observatory* (1971)
-- **Exhibitions**
Eight Sculptors: The Ambiguous Image (1966; catalogue),
14 Sculptors: The Industrial Edge (1969; catalogue), *Works for New Spaces* (1971; catalogue), *Artists' Books* (1981),
Duchamp's Leg (1994; catalogue, tour)
-- **Holdings**
1 sculpture, 2 drawings, 12 edition prints/proofs, 1 book,
2 periodicals

Robert Morris is widely known as one of the founders of Minimalism. This perception is both correct and incorrect. Some of his works from the early to mid-1960s were incontrovertibly at the forefront of the then-emergent movement, as attested to by his benchmark exhibitions at the short-lived but influential Green Gallery, New York (1960–1965). Furthermore, in February and October 1966, Morris published—like a one-two punch—"Notes on Sculpture" and "Notes on Sculpture, Part 2" in *Artforum*.[1] An openly polemical claim on Minimalism, the essays also constituted a thorough retort to the modernist naysayers who were virulently opposing the legitimacy of the new tendency. At the same time, the essays proposed a phenomenological reading of Minimalism, one that would be dominant for years to come.[2] However, Morris' art has always been too polymorphous—encompassing performance, texts, soft sculpture, and earthworks—and the artist himself too much of a polymath for either to be reduced to the label "Minimalist." One might say his Minimalism was, without imparting a value judgment, a soft version, as opposed to Donald Judd's hard version.[3]

The Walker Art Center's relationship with Morris goes back to a series of group exhibitions that began with *Eight Sculptors: The Ambiguous Image*, which opened in the same year his *Artforum* articles appeared. In an eclectic mixture of abstract and figurative, industrial and humanistic sculptures, Morris showed four works—*Untitled* (L-beams), two identical elements painted in a neutral gray; *Untitled* (Four Mirrored Cubes); *Untitled* (Ring with Light); and *Untitled* (Rope Piece)—made between 1961 and 1966 and all now canonical art-historical examples.[4] His untitled sculpture in felt, a medium he had started using the year before, entered the Walker collection in 1969. The work consists of eight differently colored felt layers with fourteen horizontal slashes through them. Hung on the wall with nails through the grommets at the two upper corners, it is pulled down by the force of gravity. Unlike his hard-edged, solid, industrial objects and constructions, which he was still making and exhibiting, his felt sculptures dealt with the plasticity of material. While called a "sculpture," this particular work mimics the form of a painting, a medium rejected by Morris early on in his career.

Two years after his two-part "Notes on Sculpture," Morris penned another essay, "Anti Form." In it, he says: "Recently, materials other than rigid industrial ones have begun to show up. . . . The focus on matter and gravity as means results in forms that were not projected in advance. . . . Disengagement with preconceived enduring forms and orders for things is a positive assertion. It is part of the work's refusal to continue aestheticizing the form by dealing with it as a prescribed end."[5]

By the end of the 1960s, Minimalism had established itself as arguably the most influential and enduring tendency in postwar American art. Already questioning its postulates, Morris was then moving on to diverse areas of exploration.

D.C.

Notes
1. "Notes on Sculpture, Part 3: Notes and Non sequiturs" and "Notes on Sculpture, Part 4: Beyond Objects" were subsequently published in *Artforum* 5, no. 10 (June 1967) and *Artforum* 7, no. 8 (April 1969). "Notes on Sculpture" and "Notes on Sculpture, Part 2" were published in *Artforum* 4, no. 6 (February 1966): 42–44 and *Artforum* 5, no. 2 (October 1966): 20–23.
2. For an excellent explication of the historical significance of the essays, see "Morris' 'Notes on Sculpture,'" in James Meyer, *Minimalism: Art and Polemics in the Sixties* (New Haven, Connecticut: Yale University Press, 2001), 153–166.
3. Morris' development in its early phase took place in lockstep with Judd's. Both showed at the Green Gallery, and later moved on to the Leo Castelli Gallery. See "The Emergence of Judd and Morris," in Meyer, *Minimalism*, 45–62.
4. For detailed descriptions of the works, see Rosalind Krauss et al., *Robert Morris: The Mind/Body Problem*, exh. cat. (New York: Solomon R. Guggenheim Museum, 1994), 2–17. The artist was subsequently included in *14 Sculptors: The Industrial Edge* (1969) and *Works for New Spaces* (1971).
5. Robert Morris, *Continuous Project Altered Daily: The Writings of Robert Morris* (Cambridge, Massachusetts: MIT Press, 1995), 46.

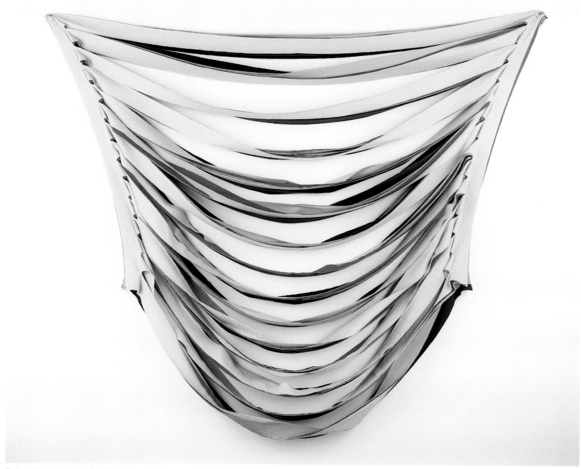

Robert Morris *Untitled* 1968 felt, metal 144 x 114 in. (365.8 x 289.6 cm) Gift of the T. B. Walker Foundation, 1969 1969.19

George Morrison

American, 1919–2000

– – Exhibitions

First Biennial of Paintings and Prints (1947; catalogue, tour), *Third Biennial Exhibition of Paintings and Prints from the Upper Midwest* (1951; catalogue, tour), *Fourth Biennial of Paintings and Prints* (1954; catalogue, tour), *George Morrison Paintings* (1955; organized by the Tweed Gallery, University of Minnesota, Duluth), *Biennial of Paintings, Prints, and Sculpture from the Upper Midwest* (1956; catalogue), *George Morrison Drawings* (1973; catalogue, tour), *Works by Minnesota Artists in the Walker Art Center's Permanent Collection* (1980; tour)

– – Holdings

4 drawings, 1 gouache/watercolor, 2 edition prints/proofs

George Morrison *Untitled* 1973 ink on paper 23 x 23 in. (58.4 x 58.4 cm)
Purchased with matching grant from the Museum Purchase Plan and the National Endowment for the Arts, 1973 1973.20

Robert Motherwell
American, 1915–1991

Robert Motherwell was the youngest member of the New York School of Abstract Expressionist painters, a group that included Willem de Kooning, Barnett Newman, Mark Rothko, and Jackson Pollock. His humanist approach to art, affinity for literature, and passion for writing made him the unofficial spokesperson for the movement. Unlike many of his peers, he had an extensive formal education, studying painting at the California School of Fine Arts, literature and philosophy at Stanford and Harvard, and art history at Columbia. His pictorial language took the form of drawings, collages, prints, and paintings ranging from intimate studies to monumental works on canvas. The Walker Art Center is home to a significant collection of Motherwell's achievements in all these media, including a complete archive of the prints—the largest public repository of this material in the world.[1]

Motherwell took pride in being a part of the lineage of modern painting, and embraced in his work the influence of Cézanne, Matisse, and Picasso. Of equal interest were Asian traditions of painting, drawing, and calligraphy; he also profited from the diverse ideologies of European artists living in New York in refuge from World War II, particularly the Surrealists Max Ernst, Yves Tanguy, and Roberto Matta. From them, he learned the concept of "psychic automatism," a form of doodling in which the artist allows an unconscious, spontaneous impulse to lead the way.[2] Motherwell used the technique with great success in developing his own brand of abstraction.

As a personal point of reference, it was the subject of Spain to which Motherwell returned time and again in his work. Two of his best-known series, the *Elegies to the Spanish Republic* and the *Iberia* paintings, were created in response to his intellectual and emotional involvement with Mediterranean culture. The *Elegies*, which eventually came to number more than one hundred canvases plus numerous drawings, prints, and studies, were intended not only to commemorate the loss of life and liberty marked by the defeat of the Spanish Republic in 1939, but to evoke Motherwell's belief that an era of enlightened humanism had died

with it. He once remarked, "The *Spanish Elegies* are not 'political,' but my private insistence that a terrible death happened that should not be forgot."[3]

The *Elegies* first appeared in Motherwell's work in 1948. Characterized by alternating ovoid and vertical bar shapes dominated by black, the motif soon became a seminal part of his visual vocabulary. *Elegy Study* (1953) shows the artist's interest in the impulse of automatism as well as the metaphorical permanence of black; in the late work *Elegy to the Spanish Republic #167 (Spanish Earth Elegy)*, the motif is placed on a field of ochre, a pigment the artist favored, in part, for its allusions to the sun-baked landscapes of Mexico and the Mediterranean.

The *Iberia* paintings, titled after the region named by the ancient Greeks that is now Spain, were initiated when Motherwell traveled there in 1958, an experience that proved pivotal. His many paintings and drawings made that year, such as the Walker Art Center's *Untitled (Iberia)*, moved away from figuration into a more pure and symbolic abstraction. Though critics have seen in the *Iberia* paintings such visual references as the body of a bull, in a formal sense these are paintings about black, the most persistent pictorial presence in Motherwell's work. He saw black as both a color and a structural element around which a work could visually and symbolically revolve.

Throughout his life, Motherwell explored the expressive potential of collage, a technique of assembling found papers or other materials on a flat surface. It was a means by which he could alternately explore issues of representation and abstraction. His collages were very personal statements and included ephemera— bits of torn rice paper, cigarette wrappers, sheet music, wrapping paper, wine labels, or postal packaging— that revealed his individual tastes and visual attraction to particular colors and textures. Through collage, Motherwell frequently resolved compositional problems he was investigating on canvas; likewise, the process of painting opened new possibilities for the artist to further his work in collage.

"For a painter as abstract as myself, the collages offer a way of incorporating bits of the everyday world into pictures," Motherwell once remarked.[4] The elegant *Histoire d'un Peintre (Diary of a Painter)* (1956) is composed of random fragments, such as pieces of brown wrapping paper at hand in his studio and paper removed from a blue package of French Gauloise cigarettes.[5] At the center of this work is a torn page from an art catalogue with text that reads *Réalité et abstraction* (reality and abstraction), words that allude to the two poles of artistic expression Motherwell actively explored. A second text appears on a scrap of rice paper on which the artist has written the phrase *Jour la maison, nuit la rue* (By day at home, by night on the town). Borrowed from the Surrealist writer Paul Éluard, these words might also have been included to poetically reference the life of a painter.

Throughout his activities in painting and collage, Motherwell returned to the practice of automatic drawing. He also had a fascination with Asian calligraphy, and often painted with ink and a calligrapher's brush. During the spring of 1965, he made a series of some six

Robert Motherwell *Untitled (Iberia)* 1958 oil on Masonite 22 x 30 in. (55.9 x 76.2 cm) Gift of Margaret and Angus Wurtele and the Dedalus Foundation, 1995 1995.54

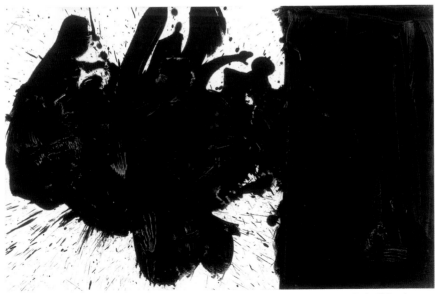

Robert Motherwell *Elegy Study* 1953 oil on paper mounted on rag board 22 3/4 x 28 13/16 in. (57.8 x 73.2 cm)
Gift of Margaret and Angus Wurtele and the Dedalus Foundation, 1995 1995.52

hundred ink drawings on Japanese rice paper.[6] He entitled these the *Lyric Suite*, named partly for a string quartet by Alban Berg that he had listened to repeatedly while he worked. Rapidly executed, each drawing has the resonant precision of Japanese haiku poetry and recalls Motherwell's interest in Zen. When grouped, the drawings amplify one another to form a strikingly vivid array of gestures. The artist once admitted that he was anxious at first that these ink studies lacked visual complexity, but many years later he was still astounded by their freshness.[7]

From early 1967 through the final years of his life, Motherwell devoted considerable time and energy to a series of works he called his *Open* paintings. Just as automatic drawing had led to the development of new forms in his work, serendipity also played a role. When one day he noticed two canvases leaning against each other in his studio, it led him to outline the shape of the smaller canvas onto the larger one, which resulted in a spare, rectangular design against a background of color. For Motherwell the effect recalled a window in the plane of a textured or colored wall, which in turn reminded him of the stark facades of Spanish houses.[8] The *Open* paintings, such as *Window in Sienna* (1968), allude to the presence of the window throughout the history of art, from Renaissance portraiture to the more abstract depictions of Henri Matisse to the psychological musings of René Magritte. Motherwell also spoke of the affinity between Japanese Zen painting and his own work, characterizing the *Opens* as analogous to the Asian concept of the void: "The amazing discovery is that it takes relatively little to animate the absolute void . . . [one discovers] that the void is beautiful in itself."[9]

S.E.

Notes

1. In 2003, the Walker published a definitive catalogue raisonné of Motherwell's prints to commemorate this acquisition. See Siri Engberg and Joan Banach, *Robert Motherwell: The Complete Prints 1940–1991* (Minneapolis: Walker Art Center, 2003).
2. It was Matta who introduced Motherwell to the technique in 1940.
3. Motherwell, "A Conversation at Lunch," address delivered at Smith College, Northampton, Massachusetts, November 1962, notes by Margaret Paul. Paul's notes were included in Robert Motherwell, *An Exhibition of the Work of Robert Motherwell*, exh. cat. (Northampton, Massachusetts: Smith College Museum of Art, 1963), unpaginated.
4. Quoted in Jack Flam, "With Robert Motherwell," in Douglas G. Schultz, ed., *Robert Motherwell*, exh. cat. (Buffalo, New York: Albright-Knox Art Gallery in association with Abbeville Press, 1983), 16.
5. The artist was known to keep "collage boxes" in his studio in which random materials could be collected for later use. Often, elements from a given collage fragment would appear in several works. The Gauloise package was a visual element the artist recalled being introduced to by a neighbor: " . . . one day we were sitting talking and he offered me one—I don't smoke them—but I said, 'God, that package is so beautiful and blue'—it probably was in August sitting by the sea—and about a week later he put in my mailbox an empty carton of these blue packages. One day in the studio I felt like making a collage, and among other elements, picked up this blue—well, it turned out to become an obsession, this blue package." Motherwell, interview with Martin Friedman, Walker Art Center, August 1972 (Walker Art Center Archives).

6. The series was initially meant to consist of 1,000 drawings: "On an impulse one day in a Japanese shop in New York City . . . I bought ten packets of one hundred sheets each of a Japanese rice paper called 'Dragons and Clouds.' Some weeks later—early in April 1965—it came to me in a flash: Paint the thousand sheets without interruption . . . and above all without revisions or additions upon critical reflection and judgement. . . . Anywhere from ten to fifty a day, on the floor, sweat dimming my spectacles on hot days. Each picture would change before my eyes after I had finished working on it." Motherwell, "Addenda to the Museum of Modern Art *Lyric Suite* Questionnaire—from Memory . . . with Possible Chronological Slips," August 8, 1969 (Museum of Modern Art Archives).
7. Ibid.
8. These recollections are quoted in Marcelin Pleynet, *Robert Motherwell* (Paris: Editions Daniel Papierski, 1989).
9. Quoted in Flam, "With Robert Motherwell," 23.

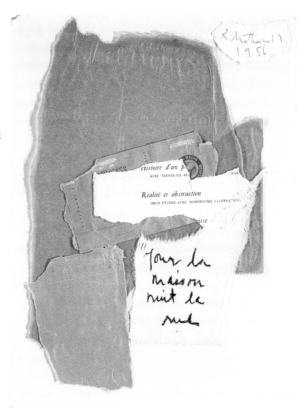

Robert Motherwell *Histoire d'un Peintre* (*Diary of a Painter*) 1956 crayon, paper on rag board 16 x 12 in. (40.6 x 30.5 cm) Gift of Margaret and Angus Wurtele and the Dedalus Foundation, 1995 1995.61

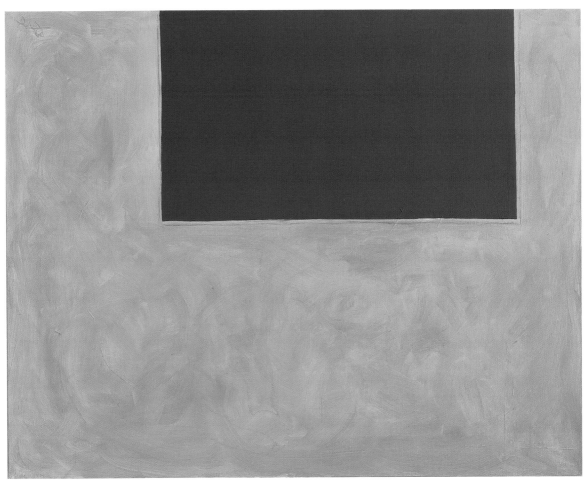

Robert Motherwell *Window in Sienna* 1968 acrylic on canvas 54 x 69 in. (137.2 x 175.3 cm) Gift of Margaret and Angus Wurtele and the Dedalus Foundation, 1995 1995.56

Reinhard Mucha

German, b. 1950

- - **Exhibitions**
Photography in Contemporary German Art: 1960 to the Present
(1992; catalogue, tour)
- - **Holdings**
2 sculptures

Reinhard Mucha rearranges and reconfigures commonplace furniture and hardware to create symbolic images. His sculptures and installations, combining concise constructions and subtle details, mix realism and abstraction to reveal allegories in the everyday. As a student at the Kunstakademie Düsseldorf in Germany in the mid-1970s, Mucha was steeped in the forms and theories of American Minimalist and Conceptual Art. But where his American counterparts emphasized rationality and anonymous materials, Mucha stressed intuition and found objects, viewing himself as a "craftsman tinkering in the gap where art ends and daily life begins."[1] Today, he compares his approach—a precarious feat of exacting control and imaginative play—to a circus act. He is both an impresario marshalling materials and a magician conjuring meaning from thin air.

The sculpture *O. T. (Oberer Totpunkt/Top Dead Center)* (1982), composed of two chairs—one right side up, the other inverted—sandwiching a white museum pedestal, exemplifies Mucha's speculative, investigative process. Conceived on the spot for an exhibition in Düsseldorf, it transforms generic museum fixtures into an emblematic sculpture. The title plays on the German abbreviations for *ohne Titel* (untitled) and *oberer Totpunkt* (top dead center), the apex of a piston's stroke. With its bracket of chairs echoing the Taoist yin and yang emblem, *O. T.* suggests the interplay between the viewer, the work of art, and the movement and balance in an engine. Its familiar ingredients, Mucha notes, lend the work the realism of one-to-one scale, which bolsters its less palpable associations.

Untitled (Oberhausen-Osterfeld Süd) (1986), a diptych consisting of an empty vitrine and a panel-mounted grouping of photographs, illustrates a more circular aspect of Mucha's method. The black-and-white images document an event in a Kunstakademie classroom near Düsseldorf's main railway station on Christmas Eve 1981. Aligning a writing desk and work cart to make a locomotive and a string of inverted tables to represent freight cars, Mucha constructed a three-dimensional diagram of a train. Above it, he built a pedestrian overpass using stepladders, tables, and a fluorescent tube lowered from the classroom ceiling to the underside of the bridge's span. Five years later, the artist combined these photographs with a glass-fronted case constructed from a discarded window. Resembling those displaying railroad timetables in German stations, the case is equipped with a handmade metal vent and an official-looking engraved plaque bearing the work's title, the names of two regional stations, and the year of the original installation. Two painted lines extending from either side of the nameplate, like the irregular mat surrounding the largest photographs, remind us this work is an artist's composition as well as the thing it represents.

As in many of Mucha's works, which since the 1980s have become larger and more intertwined with the spaces in which they are displayed, the layers of meaning and allusion in *Untitled* (Oberhausen-Osterfeld Süd) are intricate. For example, many critics have suggested that the gray felt lining the inside of the display case and the adjacent panel refers to Joseph Beuys, a legendary professor at the Kunstakademie, who used felt in installations and performances espousing art as a mystical force for social change. However, Mucha says the idea comes from childhood memories of shop windows in which colored felt formed backdrops for merchandise displays resembling tiny theaters. In fact, he views the heart of his work as a form of stage-dressing—using objects from the world to make images of the world and show ways that things work in it. Similarly, many have interpreted Mucha's interest in technology as having been inspired by Bernd and Hilla Becher (also teachers at the Kunstakademie), whose photographic typologies of industrial structures analyze form and function. Mucha shares the Bechers' interest in machine-age aesthetics (he has been a railroad buff since childhood), but also a fascination with what he calls "collective biography," the common experiences that shape us. The country's vast railroad network is so central to German life, Mucha notes, that there is even a common phrase—"I only understood 'train station'"—uttered as a non sequitur in a confusing conversation.

The palette of *Untitled* (Oberhausen-Osterfeld Süd)'s materials also evokes German landscapes, both physical and psychic. The work's gradient of grays suggests the drab landscape of the industrial Ruhr Valley, home to Düsseldorf as well as Oberhausen and Osterfeld, the latter two cities once important steel, coal, and railroad centers. Additionally, Mucha knows viewers see their own reflections in the blank vitrine, and that peering into it "creates a form of silence and emptiness and loneliness." This mood, he says, is appropriate for a work commemorating an event for a handful of students spending Christmas Eve in an empty classroom. It also is an apt memorial to the rail age, a shining achievement of nineteenth-century mechanical and social engineering—forever haunted in Germany by its role in the Holocaust—which is gradually being supplanted by less sensible and communal means of connecting people and places.

Toby Kamps

Notes
1. All direct and implied quotes taken from a telephone interview with Reinhard Mucha by the author, January 10, 2004.

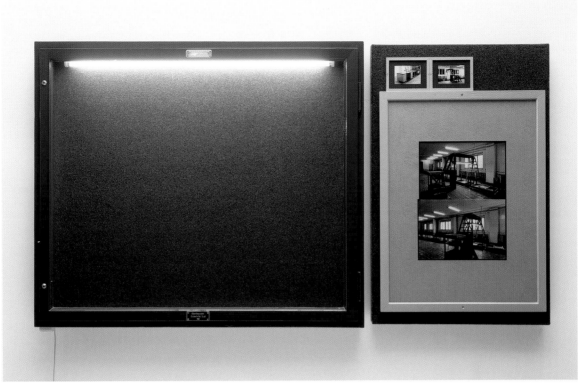

Reinhard Mucha *Untitled* (Oberhausen-Osterfeld Süd) 1986 wood, glass, felt, fluorescent light fixture, photograph, lacquer, paper, metal, plastic
left panel: 49 1/4 x 58 1/4 x 4 3/4 in. (125.1 x 148 x 12.1 cm); right panel: 48 x 31 3/4 x 4 3/4 in. (121.9 x 80.7 x 12.1 cm) T. B. Walker Acquisition Fund, 1992 1992.8

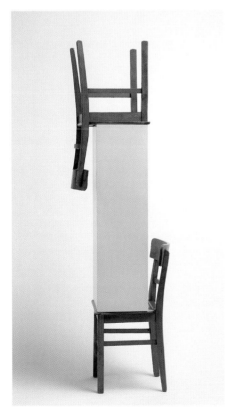

Reinhard Mucha *O. T. (Oberer Totpunkt/Top Dead Center)* 1982
wood chairs, pedestal 80 x 16 1/16 x 18 3/4 in. (203.2 x 40.8 x 47.6 cm)
T. B. Walker Acquisition Fund, 2002 2002.249

Otto Muehl

Austrian, b. 1925

-- Holdings
1 painting, 1 unique work on paper

Of the artists linked to Viennese Actionism, Otto Muehl may have been more closely aligned to the earlier Dada movement because of his subversive sense of aesthetic irreverence. A traditional figurative painter in the 1950s, Muehl radicalized his practice after meeting artist Günther Brus and becoming aware of the work of Jackson Pollock. Convinced that the accepted format of the picture could not remain intact, in 1961 Muehl proceeded to attack the surface of his paintings by ripping open the canvases, destroying the frames, setting them on fire, or working with the canvas on the floor, painting directly with his hands and literally "crawling" in paint. Simultaneously, he started to pour his pigments, adding cement as a thickening agent and pushing the pictorial space toward a relieflike, sculptural space. By removing the picture from the wall, Muehl developed painting in an "expanded field,"[1] one in which the materials become both the object and the subject of the work and in which the creative process assumes a continuing tension between construction and destruction: "In our painting we recognize materials as the real object of our works. It's a question of presenting material, matter itself. For us manufactured paint exists no more, we reject it as something aesthetic and degenerate. Our guiding principle is: matter = paint."[2]

Also in 1961, Muehl created the installation titled *Die Überwindung des Tafelbildes durch die Darstellung seines Vernichtungsprozesses (The Overcoming of the Easel Picture by Representation of Its Destruction Process)* in his Vienna apartment. The work represented his most radical move toward "junk sculptures," room-size works undoubtedly indebted to the process-oriented *Merzbau* by Dada artist Kurt Schwitters. The 1963 *Untitled* painting in the Walker Art Center's collection is an accurate (and rare) example of this moment in Muehl's career, and in the history of twentieth-century painting, when the urge to identify an alternative to dominant or academic aesthetic models pressed artists to stretch their medium to its ultimate limits. Within a very different cultural context, Muehl's practice can be seen as parallel to the "action collages" that Allan Kaprow was developing in the late 1950s in the United States.

If action collages led Kaprow to Happenings, then this liberation of painting into spatial installation was the departure point for Muehl's Material Actions. In the fall of 1963, Muehl organized his first action, *Degradation of a Venus*, which he described as: "Material action is painting gone beyond the picture surface: the human body [. . .] becomes the picture surface, time being added to the dimension of the body, of space."[3] Highly hedonistic and influenced by the writings of the Marquis de Sade and Antonin Artaud, Muehl's actions avoided the religious-liturgical flavor of those by his fellow Actionist Hermann Nitsch. Breaking every taboo, they evolved over time from wild orgies of material challenging the conventions of representation in painting and sculpture to a collective analytical, if not therapeutic, process challenging sexual, social, and political repression. The ultimate goal of the actions was to escape society and invent an alternative way of life. In 1972, as a logical extension of the ideas at play in his work, Muehl founded a commune in which free sexuality, collective property, mutual child rearing, and promotion of creativity ruled. The experience was interrupted in 1991, when a lawsuit resulted in a seven-year jail sentence for Muehl, who had assumed the agenda of Viennese Actionism to such an extreme that he crossed the boundary delineating society's ability to support a merging of art and life that implied a radical revolution in morals and politics.

P.V.

Notes
1. The term was first used by art historian Rosalind E. Krauss to describe the expansion of possible processes, sites, materials, and functions in sculptural practice after the 1960s. See "Sculpture in the Expanded Field," in Krauss, *The Originality of the Avant-Garde and Other Myths* (Cambridge, Massachusetts: MIT Press, 1986), 276–290.
2. Otto Muehl, letter to artist Erika Stocker, January 14, 1962, quoted in *Viennese Aktionism, Vienna 1960–1971: The Shattered Mirror*, ed., Hubert Klocker, trans. Dr. Alfred M. Fischer (Klagenfurt, Austria: Ritter Verlag, 1989), 188.
3. Quoted in *Otto Muehl—Ausgewählte Arbeiten 1963–1986*, exh. cat. (Friedrichshof, Austria: Archiv des Weiner Aktionismus, 1986), cited in *Viennese Aktionism*, 189.

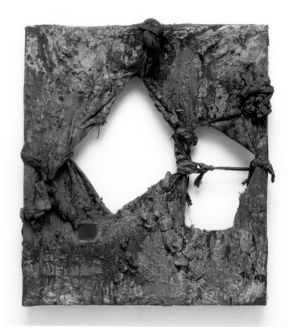

Otto Muehl *Untitled* 1963 sand, plaster, stockings, emulsion on sackcloth 30 3/8 x 28 1/2 x 4 in. (77.2 x 72.4 x 10.2 cm) T. B. Walker Acquisition Fund, 1999 1999.32

Elizabeth Murray

American, b. 1940

-- **Exhibitions**

Elizabeth Murray: Paintings and Drawings (1988; organized by
the Dallas Museum of Art and the Committee on the Visual Arts,
Massachusetts Institute of Technology; catalogue), *First
Impressions: Early Prints by Forty-six Contemporary Artists*
(1989; catalogue, tour)

-- **Holdings**

1 painting, 5 edition prints/proofs, 1 book

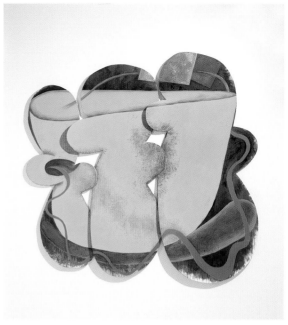

Elizabeth Murray *Sail Baby* 1983 oil on canvas 126 x 135 in. (320 x
342.9 cm) Walker Special Purchase Fund, 1984 1984.813

Elie Nadelman

American, b. Poland, 1882–1946

-- **Exhibitions**

Reality and Fantasy, 1900–1954 (1954; catalogue), *Art Fair*
(1959; catalogue)

-- **Holdings**

1 sculpture

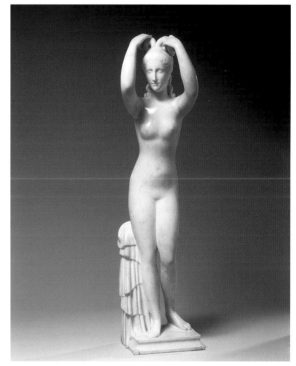

Elie Nadelman *Figure* circa 1925 marble 37 3/8 x 10 9/16 x 11 7/8 in.
(94.9 x 26.8 x 30.2 cm) Gift of the T. B. Walker Foundation, 1955 1955.12

David Nash
British, b. 1945

-- **Commissions**
Standing Frame (1987)
-- **Exhibitions**
The Garden in the Galleries (1994)
-- **Holdings**
1 sculpture, 3 drawings, 2 multimedia works

David Nash says that his work is about "the interface of mind and nature"[1]—a familiar coupling (or duality) that he explores through sculptures made entirely from trees. He saws, chops, and burns them into robust objects that remain clearly connected to the land while assuming machine-made, often geometrical shapes. By bringing the landscape indoors in this fashion, he means to assert the unity of the two realms— a worldview with roots (so to speak) in both Western Romanticism and Asian philosophy. His fascination with trees in particular has to do with their symbolic importance as a link between heaven and earth as well as their myriad real functions in providing shelter and food. Both mutable and sturdy, trees link the four elements of earth, air, fire, and water. "Damp and dry/ burnt and buried/wood is given/we do not make it," Nash writes. "In air it cracks/in fire it burns/in water floats/in earth returns."[2]

Nash found his footing early, while still a student at the Chelsea School of Art in London. There he constructed enormous, Tatlinesque towers in the cityscape, which he made from scraps of found wood—a bricoleur's practice that anticipated his current method of working in natural settings exclusively with dead or condemned trees. As his interest in the habits and properties of wood deepened, he began using as much of each tree as possible, even burning twigs to make drawing charcoal. Today he is associated with so-called British Land Art—modest, often ephemeral alterations of the landscape by artists such as Richard Long and Andy Goldsworthy—but Nash also has connections to the more assertive American traditions of Earth Art and Minimalism, and his sculptures seem to effortlessly blend all three approaches.

In 1987, the Walker Art Center commissioned Nash to make a piece for the Minneapolis Sculpture Garden. *Standing Frame* was fashioned from two white oaks cut near Taylors Falls, Minnesota. The sculpture is a witty cross between natural and man-made forms: three crooked tree limbs support a perfect, open square, a "nothing" described by the material "something," as Nash has suggested.[3] He made the work entirely at the site, as he prefers to do, cutting and assembling the parts in the forest near where the trees had stood; it was then trucked to Minneapolis and installed initially on an outdoor terrace, then in the Garden.[4] Some seven years later, feeling that time and weather had grayed the piece so much that its impact was diminished in the open expanse of its setting, Nash returned to char it soot-black, using slow-burning propane torches. "By charring, one changes the experience of wood—it's no longer wood, a vegetable, it's a

mineral experience and you see the form again . . . it changes the sense of scale and time."[5]

A second work in the collection, *Nature to Nature III* (1987), was made at the same time and on the same site as *Standing Frame*. A cube, a sphere, and a pyramid were measured and cut from the trunk of an elm, then charred in a bonfire. These objects were laid on sheets of paper, leaving "footprints" that were later enhanced with charcoal and made into drawings. Its title suggests Nash's project to reassert the elemental relationship between geometry and the flowing, organic forms of nature.

J.R.

Notes
1. Nash, correspondence with the author, June 22, 2004 (Walker Art Center Archives).
2. David Nash, *Wood Primer* (San Francisco: Bedford Press, 1987), 5.
3. Nash, correspondence with the author, June 16, 2004 (Walker Art Center Archives).
4. The piece was first sited on one of the Walker's terraces near the sculpture *Three x Four x Three* by Sol LeWitt. As Nash has recounted, then-director Martin Friedman envisioned "a shoot-out" between the emphatically Minimalist LeWitt and the more organic object by Nash. "I had long admired and had learnt a lot from LeWitt's work," recalls Nash, "so I made [my] frame exactly the same height, and the internal frame *space* is exactly the same size as the spaces in the LeWitt." Ibid.
5. Nash, lecture at the Walker Art Center, April 28, 1994 (Walker Art Center Archives).

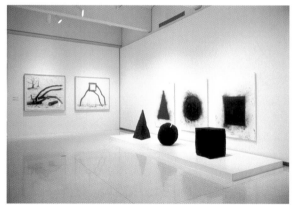

right: David Nash Installation view of *Nature to Nature III* 1987 charred white elm on paper, charred white elm pyramid: 32 x 21 x 19 1/2 in. (81.3 x 53.3 x 49.5 cm) sphere: 21 1/2 in. (54.6 cm) diameter cube: 19 3/4 x 17 1/4 x 17 1/2 in. (50.2 x 43.8 x 44.5 cm) drawings: 50 x 38 1/4 in. (127 x 97.2 cm) each of 3 T. B. Walker Acquisition Fund, 1987 1987.120

Charred and Powerful

The first time I saw photographs of David Nash pieces twenty-odd years ago (*Running Table* and *Three Dandy Scuttlers*), I felt a terrific rush. It was not just a case of "liking" the sculptures. They spoke deeply to me, made an immediate and powerful contact as if I had touched an electric fence. Perhaps because I lived then in heavily wooded northern New England, these tree works seemed hugely meaningful to me. Nash, for me, was a translator. Trees, which had always seemed to be straining toward sentience with their groaning branches and sussurating leaves, evolved, in Nash's hands, into woody creatures—running tables, rooty tripods and restless ladders, half-human, half-tree, witty and somehow larger than the sum of their parts.

Just as Magdalenean people scraped their pigments from the floors of caves, as the Lascaux artists used the natural protuberances and shapes of rock walls to give their painted animals lifelike appearances, just as their art came from the landscape around them, meaningful in the most intimate way, so I recognized in Nash's work art as an important connector to the natural world. No wonder the Japanese sense in his pieces the heart of Shinto, that old belief in nature spirits that predates Buddhism.

Standing Frame, once bare wood, now charred dark and powerful, like most of Nash's works, says several things. It speaks most immediately of the two Minnesota white oaks from which it is made and so has a commemorative quality. Its twisting tripod legs show a dynamic tension not entirely benign—this thing might kick out and race from the garden. Characterized by a sense of motion and vigor, the piece seems to be thinking over its next move. The burned, cracked appearance of *Standing Frame* reminds us that Nature has a forceful hand, always plucking away, rubbing, pushing over, flooding and shaking, ripping and worrying at, casting dust and sand, restlessly changing and rearranging the pieces of the world. Nothing is static, all is in flux. It illustrates human craftsmanship that has transformed it into something strange and beautiful. And its open square, a shape rare in nature, encloses drifting cloud, a confetti of snow, a jet's trajectory, a clump of city buildings, a bird momentarily perched on the lower cross member. It takes us to the center of that place where human culture and natural forms crisscross. It is of our world and of the very old world before humans came out of the leaves. *Standing Frame* is one of those rare pieces of art that frees and fires our imagination and changes the compass of our eyes.

Annie Proulx

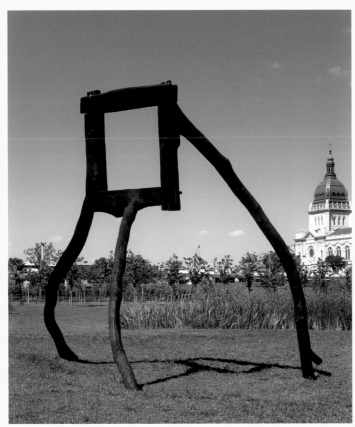

David Nash *Standing Frame* 1987 charred white oak 172 x 209 3/4 x 209 1/2 in. (436.9 x 532.8 x 532.1 cm) Gift of Star Tribune and Cowles Media Foundation, 1987 1987.75

Bruce Nauman

American, b. 1941

-- **Exhibitions**

Eight Artists: Prints from Gemini G.E.L. (1974; catalogue, tour), *Artists' Books* (1981), *First Impressions: Early Prints by Forty-six Contemporary Artists* (1989; catalogue, tour), *Bruce Nauman* (1994; catalogue, tour), *Duchamp's Leg* (1994; catalogue, tour), *Art Performs Life: Merce Cunningham/Meredith Monk/Bill T. Jones* (1998; catalogue), *The Cities Collect* (2000), *The Last Picture Show: Artists Using Photography, 1960–1982* (2003; catalogue, tour)

-- **Holdings**

2 drawings, 14 videos, 17 edition prints/proofs, 1 multiple, 5 books

If one wanted to argue that the major artistic innovations and breakthroughs in the second half of the twentieth century happened through sculpture, Bruce Nauman would be one of a small handful of artists on which to base the argument. Confronted with the question of what to do in the studio after he graduated from the University of California at Davis in 1966, Nauman made the following assumption: "If I was an artist and I was in the studio, then whatever I was doing in the studio must be art."[1] From this premise he has expanded the field of sculptural practice through confrontations with language (spoken, shouted, or written), with dance and performance, with film and video, with photography, and with architectural environments. He gives value to time and process.

Because his work resists categorization, it might be more convenient to define where Nauman does *not* stand, rather than where he *does*. He did not participate in Pop Art, he does not belong to Funk Art, he does not conform to Minimalism, he is not associated with Fluxus, he cannot be contained by the mantle of Body Art, and he demonstrates too much freedom to match the definition of Conceptual Art. Defying canonical definitions, he encompasses and overcomes all of them, showing less interest in what art is than in what art could be.

Since his earliest experimentation with painting and sculpture in the mid-1960s, Nauman has developed a complex body of work built on the assimilation and the digestion of models coming from a diversity of fields and disciplines. Though Marcel Duchamp and Jasper Johns found their rightful places in his genealogy, Nauman claims Man Ray as the artist who—through the versatility of his activities and his radical denigration of style—freed him to open the practice of sculpture to a wide range of media across the disciplines. Programmatically, Nauman imbibed Samuel Beckett's solipsistic sense of the absurd, Ludwig Wittgenstein's philosophical investigations of meaning and representation through the logic of language, and V. S. Naipaul's interpretation and denunciation of sociohistorical rage and grievance. From investigations of the individual body and its phenomenological perception, Nauman's work has increasingly addressed the body politic and its awareness. From a depiction of bodily functions to the experience of solitude, from psychology to profanity, from self-violence and humiliation to political torture and domination, Nauman's program has never ceased to capture primary emotions; avoiding the anecdote, he reaches the universality of an open work.

From his protean output, the Walker Art Center, in collecting his work, has focused on the moving-image genre in its diversity. Hence, a grouping of early videos provides a broad understanding of Nauman's experimentation with the potential of moving images. The fifteen or so films and videos that he produced in the late 1960s testify to both his recurring interest in representation of the body and his awareness of the avant-garde dance and music scenes. In front of a stationary camera set in the studio, he performed mundane and often obsessive activities, such as walking (*Walking in an Exaggerated Manner Around the Perimeter of a Square*, 1967–1968), bouncing (*Bouncing in a Corner No. 1*, 1968), pinching himself (*Pinchneck*, 1968), torturing himself (*Pulling Mouth*, 1969), or frantically playing an instrument he was unfamiliar with (*Violin Tuned D.E.A.D.*, 1970).

Exploring physical awareness and limitation, these performances, during which the camera is the audience's proxy, use redundancy and duration to exhaust and then liberate the body. His research, based on repetition and everyday gestures and behaviors, paralleled the work developed in the early 1960s in New York by the Judson Dance Theater (its movement-research performances) and choreographer Meredith Monk, whom he met in 1968. Through his friendship with Monk, his collaboration with Merce Cunningham,

Bruce Nauman *Art Make-Up* 1967–1968 16mm film transferred to videotape (color, sound); unlimited edition 40 minutes T. B. Walker Acquisition Fund, 2002 2002.86

Bruce Nauman *Poke in the Eye/Nose/Ear 3/8/94 Edit* 1994 video projection (color, silent) 52 minutes T. B. Walker Acquisition Fund, 1994 1994.146

and his acquaintance with musicians Steve Reich, Terry Riley, and La Monte Young, Nauman became aligned with a generation of artists who attempted to apply to their own practices the methodology of chance, the consideration of everyday sounds and gestures that John Cage employed in his own art and way of life.

When not questioning the status of the "artwork" itself, Nauman challenged the concept of the artist as an author. In *Art Make-Up* (1967–1968), he applies different colors of makeup (white, pink, green, black) to his face and upper body, successively erasing his identity, thus making the author more and more invisible, as Alain Robbe-Grillet did when he, with the other protagonists of the Nouveau Roman, challenged the traditional structure of the novel. Knowing the political context of the moment, it is difficult not to see in this portrait of the artist as a clown[2] an echo of Frantz Fanon's anticolonial, anti-xenophobic book *Peau Noire, Masques Blancs (Black Skin, White Masks)*.[3]

With *Poke in the Eye/Nose/Ear 3/8/94 Edit* (1994), Nauman continued to investigate intimate behaviors. A large video projection shows a slow-motion image of the artist poking his finger into his eye, nose, and ear. The nature of the image and its weird relationship to "real" time alter its narrative quality. It also stresses the thin line between pleasure and pain, as well as increases the discomforting spectacle of a finger poking into bodily orifices. These orifices are the conduits for sensible and cerebral perception, which Nauman attempts to awaken from a passive lethargy.

Challenging perception through time reaches an extreme degree in *MAPPING THE STUDIO II with color shift, flip, flop & flip/flop (Fat Chance John Cage) All Action Edit* (2001). The work consists of seven large video projections. The footage was shot at night over several months in 2000. Nauman installed seven infrared video cameras at different locations in his New Mexico studio and recorded the remnants of past works, tools, crates, detritus, and the night stillness interrupted by mice, insects, cats, noises from trains, horses, weather, and coyotes. From this databank of images—echoing his 1966 statement that "whatever I was doing in the studio must be art"—he produced several generations of works.[4] In the "All Action Edit," Nauman has edited the seven different tapes to only incidental, visual, and sound disturbances. The color of the images alternates from red to green to blue and back to red. The running time of each projection varies, and the images flip left to right or right to left and/or upside down.

With its meditative though uncanny relation to space and time, *MAPPING THE STUDIO II* crystallizes many elements that constitute Nauman's syntax, from his critical relationship to duration in film that he inaugurated in 1966 with *Fishing for Asian Carp*[5] to his interest in the technology of surveillance that became central to his work in the early 1980s. Also, as the subtitle suggests, tribute is made to Cage and his inclusion of chance, silence, and every single component of life in the making of his work.[6]

Meanwhile, by projecting the images on the walls all around the audience, Nauman has inverted our perceptual conventions. Whether in a museum, in a stadium, or in a movie theater, what we normally experience is frontal and disconnected from the work or the event. With *MAPPING THE STUDIO II*, the audience is at the center, surrounded by an oppressive panoply of media, controlled by the pace the artist has inflicted on the images. Whether an exercise in acute perception, absolute meditative escapism, or intense frustration, Nauman keeps it open. As with many of his works, *MAPPING THE STUDIO II*'s conciseness leaves us wanting—not more, not less, just wanting—triggering our desire to be fully alive, aware.

P.V.

Notes

1. Quoted in Ian Wallace and Russell Keziere, "Bruce Nauman Interviewed," *Vanguard* (Canada) 8, no. 1 (February 1979): 18.

2. The clown is recurrent in Nauman's cast of characters, appearing in such works as the neon sculpture *Mean Clown Welcome* (1985), the drawing *Clown with Video Surveillance* (1986), and the video *Clown Torture* (1987).

3. Frantz Fanon, *Peau Noire, Masques Blancs* (Paris: Edition de Seuil, 1952); *Black Skin, White Masks*, trans. Charles Lam Markmann (New York: Grove Weidenfield, 1967).

4. To date, Nauman has created four unique installations and two editioned works from the same source footage, all dated 2001. The unique works are *MAPPING THE STUDIO I (Fat Chance John Cage)*; *MAPPING THE STUDIO I (Fat Chance John Cage) All Action Edit*; *MAPPING THE STUDIO II with color shift, flip, flop & flip/flop (Fat Chance John Cage)*; and the Walker's work. The single DVD projections *Office Edit I (Fat Chance John Cage) Mapping the Studio* and *Office Edit II with color shift, flip, flop & flip/flop (Fat Chance John Cage) Mapping the Studio* were issued in editions of six.

5. Nauman filmed painter William Allan in the titular activity. The film lasts until a fish is caught: 2 minutes, 44 seconds.

6. Nauman discussed the subtitle of this piece: "'Fat Chance,' which I think is just an interesting saying, refers to a response to an invitation to be involved in an exhibition. Some time ago Anthony d'Offay [Gallery] was going to do a show of John Cage's scores, which are often very beautiful. He also wanted to show work by artists who were interested in or influenced by Cage. So he asked if I would send him something related. Cage was an important influence for me, especially his writings. So I sent d'Offay a fax that said FAT CHANCE JOHN CAGE. D'Offay thought it was a refusal to participate. I thought it was the work." From "A Thousand Words: Bruce Nauman Talks about *Mapping the Studio*," *Artforum* 40, no. 7 (March 2002): 121.

Bruce Nauman *MAPPING THE STUDIO II with color shift, flip, flop & flip/flop (Fat Chance John Cage) All Action Edit* 2001 7-channel video installation (color, sound) continuous loop T. B. Walker Acquisition Fund, 2002 2002.234

Alice Neel
American, 1900–1984

Exhibitions
Alice Neel (2002; organized by the Philadelphia Museum of Art; catalogue)

Holdings
1 painting, 1 edition print/proof, 1 book

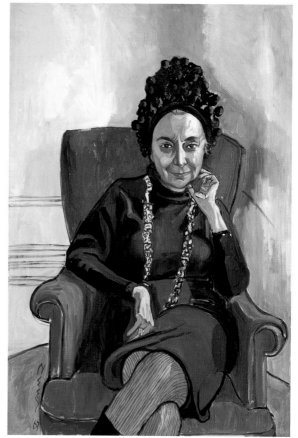

Alice Neel *Charlotte Willard* 1967 oil on canvas 40 7/8 x 30 7/8 in. (103.8 x 78.4 cm) Gift of Hartley S. Neel and Richard Neel, 2002 2002.255

Shirin Neshat

American, b. Iran, 1957

Shirin Neshat's renown has increased dramatically since her first solo exhibition of photographs in 1993. Both the form and the content of her work are based on stark contrasts and provocative oppositions that touch on questions of gender, exile and belonging, loss and memory, the particular and the universal. Though she is best known for her haunting trilogy of dual-screen, black-and-white short films—*Turbulent* (1998), *Rapture* (1999), and *Fervor* (2000)—the Iranian-born filmmaker originally came to the United States in 1974 to study painting. However, by the time she had completed her MFA at the University of California, Berkeley (1983), and moved to New York City, neither she nor her homeland bore any resemblance to what they had been nine years earlier. She had categorically ceased to paint, and Iran had been transformed from a secular-leaning monarchy to a conservative Islamic Republic. Neshat did not return to Iran until 1990.

After sixteen years of separation, she found the country of her youth profoundly changed. The economy was stagnating, public morale was flagging, and many basic freedoms had been severely curtailed. The burgeoning secular modernism Neshat had grown up with had been replaced by a forceful conservatism that, among other things, legally required all women to wear a veil in public. A highly charged symbol variously connoting Islamic identity, Iranian nationalism, Islamic feminism, and retrograde traditionalism, the veil and the centrality of women in the republic's legal and political discourse led Neshat squarely back to art-making.

Initially, she began a series of photographs that investigated the role of women in Iran. These images explored opposing notions of concealment and assertion, vulnerability and defense, motherhood and martyrdom. By 1997, however, Neshat began to find both medium and subject limiting: "When you have only a single image, the message you convey may be like propaganda, whereas when you use film, you can become a storyteller, choreographing ideas and images, creating nonlinear narratives. . . . I weave messages into my work that can't be pinned down, like a dream."[1]

As she shifted from still to moving images, the artist and her Iranian crew garnered increasing international acclaim. Her work has been featured in numerous solo and group exhibitions, including the Venice Biennale (1999), where *Turbulent* received the First International Prize. Lacking conventional elements such as plot line, character development, and dialogue, her films rely on the careful choreography of movement, physical environment, and soundscapes to simultaneously transfix and engage her audience. Dreamlike in their elusiveness, they aim to disarm, provoke, and give pause. Fielding questions about meaning and intent, Neshat dissociates her role as artist from that of interpreter: "I prefer raising questions as opposed to answering them."[2] Indeed, her films' dual-screen presentations reinforce audience engagement by placing viewers between the screens, forcing them to make the final decisions about where to look and when.

In what is perhaps her most personal film, *Soliloquy* (1999), the artist appears as protagonist in two stories that unfold in anonymous cities representing traditional and modern worlds. Filmed in Mardin, Turkey, and Albany, New York, this color, two-channel film is built upon controversial dichotomies—East versus West, Islam versus Christianity, and tradition versus modernity. On both screens, Neshat moves through imposing architectural and religious spaces, among people, and alone in nature. It is unclear whether she is running away from or to somewhere, whether the scenes are illusions or memories, or whether one place is more welcoming than the other. Neshat has said that "once you leave your place of birth, there's never a complete sense of center: you're always in the state of in between and nowhere completely feels like home."[3] With elegance and rigor, *Soliloquy* captures the artist's sense of displacement and loss while masterfully alluding to the ambiguities of identity, spirituality, and place that touch all people. As the two sound tracks merge toward the film's end, the viewer is left with an unforgettable sense of reconciliation.

Alisa Eimen

Notes
1. Quoted in "Art for the MTV Generation," *The Economist*, March 23, 2002, 80.
2. Quoted in Gerald Matt, "In Conversation with Shirin Neshat," in Gabriele Mackert, ed., *Shirin Neshat*, exh. cat. (London: Serpentine Gallery; Vienna: Kunsthalle Wien, 2000), 13.
3. Quoted in Arthur C. Danto, "Shirin Neshat," *Bomb* 73 (Fall 2000): 67.

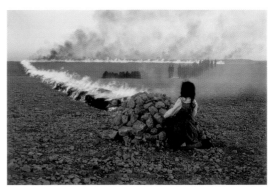

Shirin Neshat *Passage Series* 2001 Cibachrome; edition 3/5 41 7/8 x 63 1/8 x 2 in. (106.4 x 160.3 x 5.1 cm) framed Partial gift of Carol and Judson Bemis, 2002 2002.248 ©2001 Shirin Neshat

Shirin Neshat *Soliloquy* 1999 two-channel 16mm film (color, sound) transferred to DVD; edition 3/6 17:33 minutes Butler Family Fund, Justin Smith Purchase Fund, T. B. Walker Acquisition Fund, 2000 2000.100 ©1999 Shirin Neshat

Rivane Neuenschwander

Brazilian, b. 1967

-- **Exhibitions**
To/From: Rivane Neuenschwander (2002; publication)
-- **Holdings**
7 unique works on paper

The work of Rivane Neuenschwander is uncommonly poetic and beautiful yet tinged with a hint of the mortal. In works that range from installation and drawing to video and photography, she uses simple means, often taken from the natural and organic world—garlic husks, culinary spices, coconut soap, rice paper—for maximum magic. Growing up in Belo Horizonte, Brazil, she often played with the insects, arachnids, and other small animals that populated her childhood haunts, and they have now become a frequent component of her artistic process. Metaphorically charged, these collaborations across species are also based necessarily on principles of chance and negotiation.

The artist created *Carta Faminta* (*Starving Letters*) (2000) with the help of snails she collected at a church in Stockholm during a residency at the International Artists Studio Programme in Sweden. These seven drawings were produced as the snails, with some guidance by the artist, ate through pieces of Chinese rice paper, leaving behind trails of silvery slime on half-eaten sheets that suggest pages of a forgotten atlas.

In Portuguese, Neuenschwander's first language, *carta* means both map and letter. A frequent traveler, she speaks of the period just after arrival in a new place as a time of suspended animation while she adjusts to the new sensations of place, custom, and language.[1] She has to find her place on the map. Always somewhat imaginary, maps are often a form of wish fulfillment promising discovery, invention, conquest. From the comfort of our armchairs, they may evoke distant lands, foreign tongues, and exotic tastes, which can be both inviting and anxiety-provoking.

A world in our hands and our heads, these cartographic letters speak to that space in between our cravings and our fears, our feelings and our ability to express them, our impulse toward boundless exploration and our sometimes guilty search for that which is familiar. Each drawing, a poetic meditation on place, empire, and desire, is also a free-floating Rorschach test gnawing at that empty space in the belly of our imagination. A letter, a map, a destiny unfulfilled.

Rivane Neuenschwander Selections from *Carta Faminta* (*Starving Letters*) 2000 Chinese rice paper eaten by snails, paperboard, glass 19 1/2 x 18 7/8 x 5/8 in. (49.5 x 47.9 x 1.59 cm) framed, each of 7 Miriam and Erwin Kelen Acquisition Fund for Drawings, 2002 2002.218

O.I.

Notes
1. Neuenschwander, interview with the author, March 2001.

Barnett Newman

American, 1905–1970

- - **Exhibitions**

Contemporary American Painting: Fifth Biennial Purchase Exhibition (1950; catalogue, tour), *20th Century Master Prints* (1975; tour), *The Sublime Is Now: The Early Work of Barnett Newman* (1994; catalogue, tour)

- - **Holdings**

1 painting

Barnett Newman's signature canvases—vast fields of color punctuated by vertical stripes he called "zips"—are today counted among the great achievements of the Abstract Expressionists (or New York School), a storied group that included maverick artists Willem de Kooning, Arshile Gorky, Jackson Pollock, and Mark Rothko. But Newman's work was challenging in its time, and the artist himself was exacting about the conditions in which he would show it; these factors, combined with a relatively small output and his late start as an artist, meant that he didn't achieve critical and commercial success until 1958—well after many of his peers had been canonized by curators and critics.[1] But his uncompromising approach led him to produce a body of work that has proven as durable as that of any of his contemporaries, and was critical to the ideas of a younger generation that included Donald Judd and Frank Stella.

Newman was forty-five years old when he produced the canvas he considered his breakthrough, *Onement 1* (1948). In this modestly scaled painting, he finally resolved the use of zips, which he saw as "streaks of light" that unified the picture space rather than dividing it.[2] That same year, Newman—who was the prolific author of some of Abstract Expressionism's most articulate apologia—wrote a short essay entitled "The Sublime Is Now." In it he proposed that American artists no longer depended on an outmoded Greek ideal of beauty to communicate a sense of the exalted. "We are freeing ourselves of the impediments of memory, association, nostalgia, legend, myth, or what have you, that have been the devices of Western European painting. . . . The image we produce is the self-evident one of revelation, real and concrete, that can be understood by anyone who will look at it without the nostalgic glasses of history."[3] Turning away from the model of ancient Greek aesthetics, he looked instead to the arts of Africa, Oceania, and the Americas, in which he found a raw spirituality that was inseparable from form. His enthusiasm for "the primitive" was shared by many during the 1940s, when it was seen as closely aligned with the new modernist sensibility.

Newman's iteration of the spiritual reached its peak expression in *The Stations of the Cross* (1958–1966), a sequence of fourteen stark black-on-raw-canvas paintings. For him, Christ's lament on the cross—"Why have you forsaken me?"—was an "abstract cry" that represented the human condition and thus defined the task of painting. "That cry, that unanswerable cry, is world without end. But a painting has to hold it, world without end, in its limits."[4] During the eight years he labored on *The Stations*, he continued to produce other work,

including *The Third* (1962), a shimmering expanse of orange with yellow zips at either edge. The latter's title—like several other paintings from the early 1960s—refers to the sacred number of the Christian Holy Trinity and the Jewish mystical tradition.[5]

The Third was among several works by the artist that were included in the U.S. entry to the VIII Bienal de São Paulo in 1966. Its curator, Walter Hopps, wrote that Newman was the "key figure" of the show, which also included six artists who were his supposed inheritors: Judd, Stella, Larry Poons, Robert Irwin, Billy Al Bengston, and Larry Bell. For Hopps, these younger practitioners represented "a new sense of space and structure in American art" that could be directly attributed to Newman's radical explorations.[6] While this reading ignores the spiritual content that was so important to Newman, it aligns him with the next wave of American art as well as with his peers—a double role that his robust paintings have assumed with ease.

J.R.

Notes

1. After his first solo gallery exhibition in 1950 at his friend Betty Parsons' New York space, Newman was included in only three museum group shows—one at the Walker—until 1958. See Ann Temkin, *Barnett Newman*, exh. cat. (Philadelphia: Philadelphia Museum of Art, 2000).
2. He first used the term "zips" in an interview with filmmaker Emile de Antonio for the documentary *Painters Painting*. The interview is published in John P. O'Neill, ed., *Barnett Newman: Selected Writings and Interviews* (New York: Alfred A. Knopf, 1990), 306.
3. "The Sublime Is Now," originally published in *The Tiger's Eye*, no. 6 (December 1948): 51–53. Reprinted in O'Neill, *Selected Writings*, 170–173.
4. Newman articulated the metaphor of the "abstract cry" in an interview in *Newsweek*, May 9, 1966, 100. The second statement was published in *Artnews* 65, no. 3 (May 1966): 26–28, 57. Both reprinted in O'Neill, *Selected Writings*, 187–190.
5. The others are *Treble* (1960), *The Three* (1962), *Tertia* (1964), and *Triad* (1965). See Temkin, *Barnett Newman*, 248.
6. From Hopps' statement on the exhibition, printed in *Art in America* 53, no. 5 (October/November 1965): 82.

Barnett Newman *The Third* 1962 oil on canvas 101 1/2 x 120 1/4 in. (257.8 x 305.4 cm) Gift of Judy and Kenneth Dayton, 1978 1978.3

THIRD

Do what is right the voice from the left said.
I do not know what is right I said. The voice
Is a kind of light and comes always from the left.
Yes. Annunciation comes as a reading always from
Left to right—from where we stand.

I don't know where to start I don't think my face
in my hands is right Please don't let us destroy
Your world no *the* world I know I know nothing I know I
can't use you like this It feels better if I'm on
my knees If my eyes are pressed shut so I can see
the other things the tiniest ones which can still escape
us Am I human Please show me mercy no please show
a way If I look up all the possibility that you
might be there goes away I need to be curled up this
way my face pressed down my knees pulled up tight
I know there are other ways less protected more expressive of
surrender but here I can feel the whole crushing
emptiness on my back especially on my shoulders
I thought just now how that emptiness could be my wings
that you were maybe there laughing and that the room above
me here before dawn with its two windows black and this
bed pillow face pressed down hard on my hands how it, how all of it,
made up the wings There is a reason I
have to go fast I have to try to slip-in to some channel
I can feel the beginning of here in my pushed-down face right
where my face is pressed so sleep doesn't go there
anymore and the mirror—well that is another way if you wish, if you
look in for a very long time—but here, I did it
again (here)(I write the open parenthesis, press my face,
try again, then lift, close)(then this clause to explain)
(to whom?)(always wanting to be forgiven)(not *seen*—
no, no this thing I am in the dark rolled up is not a thing
for an eye—it wants to *be* an eye—it sees at the end
of the dark its face is pressing-towards a line, not a
going-in line but a line that stops one, a wall—See
it is already being lost here, the
channel is filling in, these words—ah—these, these—
How I don't want *them* to be the problem too there are
so many other obstacles, can't these be just a part of
my body, look (put my head down again)(am
working in total dark)(maybe this will not be
legible)—cover my ears to go further—
maybe if I had begun otherwise, maybe if I had
been taught to believe in You, I needed evidence,
others seem not to need it, they do not seem to me
graced but yesterday when I asked Don he said yes he
 was sure
everything was His plan so it was a lapse of faith
to worry, you will have noted I cannot say "Your
plan" and now, as if dawn were creeping in, the
feeling of the reader is coming in, the one towards which
this tilts like the plant I watched a
long time yesterday the head of and then the stem itself,
long, to see if it turned towards the light as the light arrived,
I would say it did, very slightly, and I
 could not *see* it

though I never lifted my gaze and tried very hard to blink only
when physically impossible not to, and yes, and yes, in the end it
was in a different direction, I had marked where we started
so I knew for sure, although of course I know nothing, I could
begin this story anywhere, maybe I will open my
eyes now, although I have gotten nowhere and will
 find myself
still just here, in the middle of my exactly given years, on
my knees naked in my room before dawn, the pillow
wet of course but what of it, nothing nothing comes of it,
they are all blind it seems to me out there where the
garbage truck will begin any second now, but I am supposed
to love, and also I must not care what others think, I
must be sure of myself—the knotted emissary of
wholesale murder—I can feel the whitening reefs which
I have only read about if that means anything (yes, no) under there where
they are, I put them in the space with the far wall, I see
the waters filtering through them all, the pH is wrong, the
terrible bleaching is occurring, the temperature—what
is a few degrees—how fine are we supposed
to be, I am your instrument if you would only use me, a
degree a fraction of a degree in the beautiful thin
water, flowing through, finding as it is meant to every
hollow and going in, carrying its devastation, but it looks so
simple, and a blue I have never seen, with light still in its
body, as light is in mine here I believe, technically,
yes light from a chemical point of view an
analysis would reveal, something which partakes of the same photons
which are in all matter, in this pillow, in the paint on the
wall which if I open my eyes will be five inches from my
face, the coral reefs having caverns I try to go in, I
can make myself very small is that a gift from you,
I think it might be one of the great gifts, that I can *make*
myself very small and go in, in from this room down into the
fibrous crenellations of the reef, which if you look close are formed
by one node clipping onto an other and then
the rounding-up as the damage occurs as the weight is lost. Now the coral
 is in with the
garbage trucks, pipeknock kicks in, it is beginning
again—when I open my eyes I see two white lines,
vertical, incandescent, I will keep all
knowledge away I think, I try to think, I will keep
the knowing away the lines seem to come out of nowhere
they do not descend nor do they rise but
just gleam side by side in the small piece of
glance my two eyes hold in their close-up
vision. There is a flood. There are these two lines.
Then the sun moves up a notch though still in the in-
visible, and I see it is the 12 ounce glass, its body
illumined twice, white strokes where the very first
light has entered, here, I look again, it gleams,
it seems to gleam, it is the empty glass.

Jorie Graham

Ben Nicholson
British, 1894–1982

Ben Nicholson *February 12, '52 (Carafe)* 1952 oil, graphite on canvas
34 1/16 x 18 1/16 in. (86.5 x 45.9 cm) Gift of the T. B. Walker Foundation, 1953
1953.6

Hermann Nitsch

Austrian, b. 1938

Holdings
1 painting

Hermann Nitsch is a leading figure of the controversial Viennese Actionism movement. Together with Otto Muehl, Rudolf Schwarzkogler, and Günther Brus, Nitsch struggled to challenge postwar Austrian society—with its religious taboos, political conservatism, and bureaucratic immovability—through the use of the human body as working material in a dramaturgy of the organic.

Educated as a painter of religious imagery, Nitsch first established the premises of a radical form of theater, the Orgien-Mysterien Theater (Orgies-Mysteries Theater), in 1957. The form was inspired by the rituals of the Catholic church, the Wagnerian model of the *Gesamtkunstwerk* (total work of art), Dionysian orgies, and Freudian psychology. In 1959, he visited the exhibition *Young Painters Today* at the Künstlerhaus, Vienna, which introduced him to Abstract Expressionism and its French equivalent, Tachism. The show included works by Sam Francis, Georges Mathieu, Pierre Soulages, and Yves Klein, while documenting in the catalogue works by Jackson Pollock and Franz Kline. His encounter with these movements encouraged Nitsch to incorporate painting into his concept of the Orgien-Mysterien Theater.

In November 1960, he began performing "painting actions," during which he transposed the basic ritual components of his theater onto the pictorial field, pouring red paint onto canvas and documenting the entire process through film and photography. Soon the actions grew more spontaneous. Nitsch would spread a canvas on the floor, splash paint on it, roll and step on it, involving his entire body in actions that often lasted only a few minutes and resulted in what he called *Schüttbilder* (poured paintings). *Schüttbild* (1963), in the Walker Art Center's collection, was realized during a painting action that took place on March 6, 1963,[1] a few months before Nitsch left Austria for Germany in order to avoid prosecution for alleged blasphemy and inflammatory activity.

Apparently dissatisfied with the limitations of painting, Nitsch decided in late 1963 to focus on and expand the range of his theater. Challenging and provocative, his new performances lasted several days; animal carcasses, entrails, blood, excrement, and stained religious garments were used in ritualistic ways to trigger every sense, push every limit. The steadfast importance of Viennese Actionism is attributable to the fact that its participants identified an alternative modern practice that questioned the limits of artistic freedom and broadened the connections between myriad disciplines: music, theater, literature, painting, sculpture, photography, and film.

P.V.

Notes
1. Nitsch, correspondence with the author, April 27, 2004 (Walker Art Center Archives).

Hermann Nitsch *Schüttbild* (*Poured Picture*) 1963 oil on canvas 72 1/2 x 112 1/4 in. (184.2 x 285.1 cm) T. B. Walker Acquisition Fund, 2002 2002.4

Isamu Noguchi
American, 1904–1988

- - **Exhibitions**
Reality and Fantasy, 1900–1954 (1954; catalogue), *Noguchi's Imaginary Landscapes* (1978; catalogue, tour), *Three Sculptors: Noguchi, Oldenburg, Segal* (1980), *The Garden in the Galleries* (1994), *The Cities Collect* (2000)
- - **Holdings**
6 sculptures, 1 drawing, 1 book, 2 models

Isamu Noguchi had a generous and expansive artistic vision. His considerable body of work encompasses not only sculpture, his main medium, but also interior design, landscape architecture, and public spaces. His peripatetic life encompassed numerous conflicts and dilemmas, and yet, he maintained an indefatigable pursuit of his utopian idealism.

Born to a Scottish-American mother and a Japanese father who was a renowned poet and literary scholar, Noguchi grew up shuttling across the Pacific. He spent part of his childhood in Japan and returned to the United States to attend school. After receiving initial artistic training in New York, he traveled to Paris in 1927 on a Guggenheim fellowship and worked as an apprentice in Constantin Brancusi's studio. From 1930 to 1931, he was again on the road, first to Paris, and via Moscow, on to China and Japan, where he studied ink painting and pottery. Back in New York, he made a living by making portrait sculptures, and at the same time developed his interest in art for public spaces, though many of his early proposals were not realized.

Noguchi, at this time, was inclined toward political activism, and it sometimes rendered him vulnerable to critique. A particularly egregious attack was made by critic Henry McBride on the occasion of the young artist's 1935 one-person show at the Marie Harriman Gallery in New York. The critic's comment on Noguchi's figurative work *Death*, an ad hominem denunciation rather than art criticism, greatly affected the young artist: "The gruesome study of a lynching with a contorted figure dangling from an actual rope, may be like a photograph from which it was made, but as a work of art it is just a little Japanese mistake."[1] Such prejudice would soon impact the artist's very freedom. In the wake of the Japanese surprise attack on Pearl Harbor, President Roosevelt signed Executive Order 9066 on February 19, 1942, authorizing a forcible evacuation of Japanese-American citizens in the western states into a handful of internment camps. Though he was residing in New York at the time and thus was exempt from the order, Noguchi chose to enter the camp in Poston, Arizona, with the intention of starting an art program. He soon found himself frustrated with the camp's bureaucracy and realized that his idealism faced insurmountable obstacles in harsh wartime reality.

After seven months, Noguchi returned to New York, vowing to dedicate himself exclusively to his art. A series of interlocking sculptures made from marble and slate sheets emerged out of intense work in seclusion, and some of them were included in the Museum of Modern Art's 1946 exhibition *14 Americans*. With evocative titles such as *Gregory-Effigy* and *Kouros*, his sculptures from this period maintain a liminal relationship with both figuration and abstraction and give form to the paradoxical notion of transformation in which stability and fragility are in strange coexistence. The easy construction and dismounting of these formally inventive works was also noted by the popular press.[2] *Avatar* and *Cronos*, both from 1947 and in the Walker Art Center collection, were made during this important period of transition and maturation in the sculptor's life and career. Crafted from pink Georgia marble and later cast in bronze, *Avatar* employs the same principle of construction as other interlocking sculptures. The joints carved into its compositional planes allow them to be quickly assembled into a whole. *Cronos*, carved out of balsa wood, an especially light material, consists of a set of rather turgid parts shaped like a boomerang, a bone, and an orb, which intersect, overlap, and penetrate one another, all suspended on a large central horseshoe-shaped support. Describing this work christened with the name of Zeus' father in Greek mythology, Noguchi wrote, "The image was that of the falling tears, or the limbs, of his sons devoured by the Titan."[3] The biomorphism of both works clearly links the new phase in Noguchi's art to Surrealism, which had been brought to New York by mostly French émigré artists. The ambiguous and richly suggestive curves, punctuations, and protrusions invite bodily and psychoanalytic readings, also highly relevant to Surrealist art.

The formal language developed in his sculpture from this period manifested itself in other fields as well. The permutable and recombinable shapes are found in the famed "Noguchi table," commissioned by George Nelson of the Herman Miller Furniture Company. Stage design was another major part of Noguchi's work. He collaborated with Merce Cunningham, Ruth Page, George Balanchine, and most prominently, Martha Graham, for whom he created more than twenty sets. "Holofernes' Tent," conceived for Graham's 1950 work

Isamu Noguchi Model for *Swimming Pool for von Sternberg* 1935/1980
bronze 6 3/8 x 14 1/4 x 15 1/4 in. (16.2 x 36.2 x 38.7 cm) Gift of the artist, 1980
1980.14

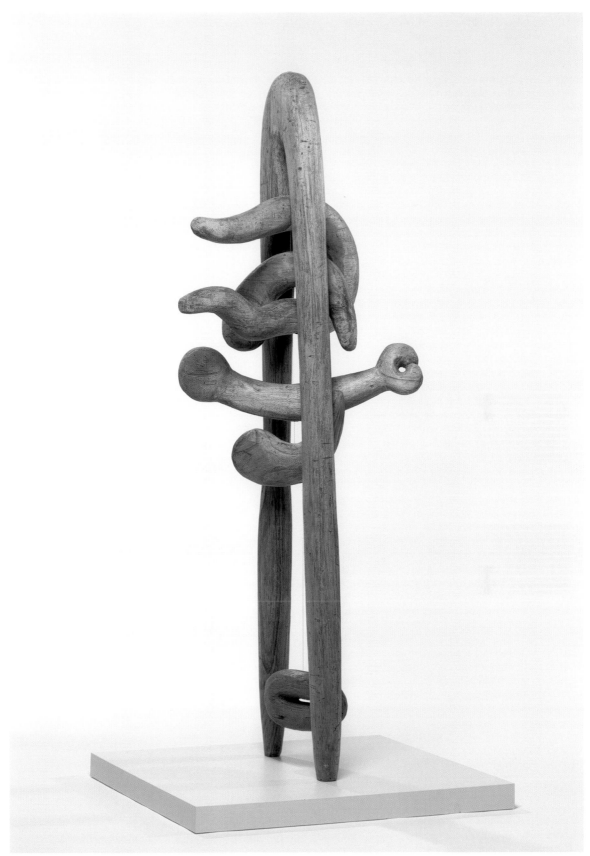

Isamu Noguchi *Cronos* 1947 wood, string, metal 86 1/4 x 22 x 31 in. (219.1 x 55.9 x 78.7 cm) Gift of the artist, 1979 1979.30

Judith, is a simple architectonic construction that consists of forms of a ferocious animal and archetypal symbols such as a phallus or a spear.[4]

Toward the end of this critical period, Noguchi felt that "the winds of imagination by now blew on me with force from the East."[5] He was awarded a Bollingen Foundation grant to write a book on leisure, which allowed him to travel to Western Europe, Egypt, India, and Southeast Asia. He arrived in Japan in 1950, his first visit in twenty years, returning as something of a cultural hero and herald in a country still under U.S. occupation. Exceptional opportunities awaited him. Solo exhibitions of his new works opened to considerable fanfare, and to his great personal fulfillment, he created a memorial lounge and a garden dedicated to his father at Keio University, where the elder Noguchi had been a respected professor. At the invitation of Kenzo Tange, the architect in charge of the memorial park in Hiroshima, he designed a bridge for the site. During this period he also created the Akari paper lanterns that are still in production today. In 1952, Noguchi built a studio in Kita Kamakura near Tokyo. There, he created an idealized country living space while working closely with master potter Kitaoji Rosanjin on a remarkable set of ceramic works.

Later that year, Noguchi's striking, sublime proposal for a sculpture to be called *Hiroshima Memorial for the Dead* was rejected for dubious reasons, since Tange had personally invited him to submit a design.[6] The episode highlighted the fact that Noguchi's place in postwar Japan was anything but secure, and made him recognize that his biracial identity cut both ways. Just as he had been deemed suspect in his own country, he could never quite be Japanese enough in his father's country. Despite such setbacks, his relationship with Japan and its cultures, material and aesthetic, would nevertheless deepen and last for the rest of his life.

Two works from this later period in the Walker collection, *Mortality* (1959) and *Shodo Hanging* (1961), show another stylistic turn taken by the artist. The formal ambiguity of the earlier biomorphic sculptures yields to a more restrained and austere balance, in which constancy and movement are suggested in vertical lines and masses. After establishing a studio in Shikoku in 1966, Noguchi split his time between New York and Japan for the next two decades.

The integration of sculpture with the landscape and the totality of environment had always been preoccupations in Noguchi's art. In the later period, his growing prominence enabled him to realize gardens and urban plazas around the world. Some of the better known examples include Unesco Garden, Paris (1956–1958), Sunken Garden for Beinecke Rare Book and Manuscript Library, Yale University (1960–1964), and Sunken Garden for Chase Manhattan Bank Plaza, New York City (1961–1964). The monumental stainless steel Horace E. Dodge Fountain at Philip A. Hart Plaza at Detroit Civic Center (1972–1979) is another celebrated public project.

Covering nearly the entire span of the twentieth century, Noguchi's life mirrored, often dramatically, the changing worlds in which he lived. Travel and exile, the representative tropes of the time, characterized his artistic passage. By nature and design, he was not confined in one culture, one place, or one country. What makes his art remarkable are not simply the specifics of his personal background but how he translated them into a rich and coherent body of work, a kind of holistic modernism in which tranquility and grandeur, ambition and delicacy, and utopian future and archaic past coexist in not so paradoxical ways.

D.C.

Notes
1. Reprinted in Isamu Noguchi, *Isamu Noguchi: A Sculptor's World* (New York: Harper & Row, 1968), 23.
2. "Japanese-American Sculptor Shows Off Weird New Works," *Life* magazine, November 11, 1946, 12–13, 15.
3. Noguchi, *A Sculptor's World*, 29.
4. A bronze cast of a balsa original, Theater set element from *Judith* (1950/1978) is installed in the Minneapolis Sculpture Garden.
5. Noguchi, *A Sculptor's World*, 29.
6. For a detailed examination of Noguchi's years in Japan, see Bert Winther-Tamaki, *Art in the Encounter of Nations: Japanese and American Artists in the Early Postwar Years* (Honolulu: University of Hawaii Press, 2000).

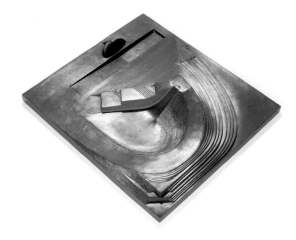

Isamu Noguchi Model for *Play Mountain, New York* 1933 bronze 4 x 29 3/16 x 25 11/16 in. (10.2 x 74.1 x 65.3 cm) Gift of the artist, 1980 1980.15

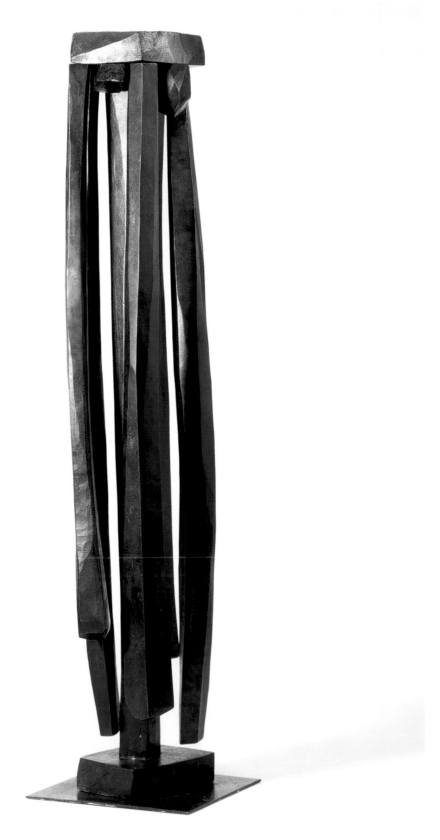

Isamu Noguchi *Mortality* 1959 bronze; edition 1/6 75 7/8 x 20 x 18 in. (192.7 x 50.8 x 45.7 cm) Gift of the T. B. Walker Foundation, 1964 1964.1

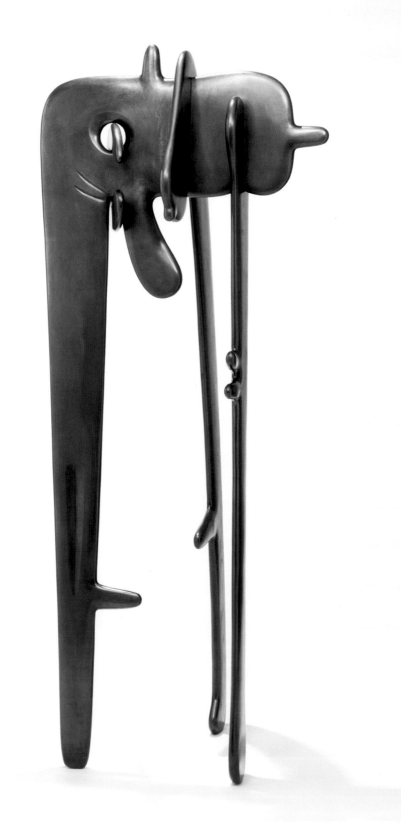

Isamu Noguchi *Avatar* 1947/1980 bronze; Artist's Proof from an edition of 8 78 1/2 x 33 x 23 in. (199.4 x 83.8 x 58.4 cm) Gift of the artist, 1980 1980.20

Kenneth Noland

American, b. 1924

-- **Exhibitions**

Artist and Printer: Six American Print Studios (1980; catalogue, tour),
Prints from the Walker Art Center's Permanent Collection (1980; tour),
Paperworks from Tyler Graphics (1985; catalogue, tour)

-- **Holdings**

2 paintings, 31 edition prints/proofs, 2 portfolios of prints,
1 periodical

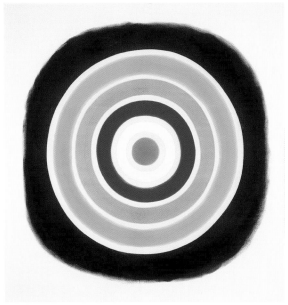

Kenneth Noland *Cantabile* 1961 acrylic on canvas 66 1/2 x 65 1/8 in.
(168.9 x 165.4 cm) T. B. Walker Fund, 1965 1965.35

Richard Nonas

American, b. 1936

- - **Exhibitions**
Viewpoints—Richard Nonas (1978), *Artists' Books* (1981)
- - **Holdings**
1 sculpture, 11 books

Richard Nonas turned to sculpture at the age of thirty, after abandoning a budding career in anthropology. Fieldwork in Mexico, Canada, and the American Southwest had left him deeply troubled about some of the methodologies used in ethnographic studies, and he also found it difficult to engage in "activity structured to end in conclusion."[1] But his anthropological work was a crucial early influence on his sculptural practice, fostering a deep curiosity about how experience shapes our perception of space. After two years in Mexico observing the Papago tribe, he began to wonder about "the subtle difference in how people perceive reality. The way those Indians, in a complete desert environment, felt spatial changes was very sensitive. To me, the desert was undifferentiated, but for them its spaces were like a series of familiar rooms."[2]

Nonas turned to art in the mid-1960s and soon began making work that referenced the then-current sculptural idioms of Earth Art, which focused on alteration of the landscape, and Minimalism, whose formal concerns included geometry and repetition. Most of his sculptures rest directly on the ground and suggest spatial markers: linear beams or timbers pick out perimeters; flat planes of steel or volumes of wood bring an area of the floor or room into focus. He often used modular forms and mathematical progressions only to interrupt them, suggesting flawed yet whole systems that perhaps echo the cultural structures he studied as an anthropologist. For he aspired to more than mere formalist investigation: "What interested me . . . was not minimalist 'specific objects' but rather the possibility of nonspecific charged ones: 'dangerous objects' whose power lay in their weird nonspecificity, their emotional slipperiness. . . . Tense, almost-vibrating objects were what I wanted, formal objects on the edge of becoming emotionally charged specific places."[3]

Razor-Blade, a steel floor piece whose five components form a symmetrical eight-foot cross, was made in 1977 for a solo show at P.S.1 Contemporary Art Center in Long Island City—a repurposed nineteenth-century school building whose rooms, with their wood floors, brick walls, tin ceilings, and radiators, feel rich with untold histories. The exhibition, entitled *Montezuma's Breakfast*, was part of an ensemble that included the installation space, a catalogue, an artist's book, an invitation card, and artwork titles; Nonas intended them to form a seamless but mysterious whole that would "create small, ongoing intrusions into the expectations of the audience."[4] Naming his P.S.1 project for Montezuma, the Aztec ruler who saw his empire devastated by the Spanish, is a clue (there are others) that the "intrusion" has something to do with the tangled narratives of conquest, colonialism, and missionary meddling that are a staple of human history. This unexpected content—history, war, life, death, home—is the stuff of epics: a powerful place for an artist to take his audience.

J.R.

Notes
1. See excerpts from his notebooks published in Donald B. Kuspit et al., *Richard Nonas: Sculpture/Parts to Anything* (Roslyn Harbor, New York: Nassau County Museum of Fine Art, 1985), 61.
2. Quoted in Grace Glueck, "Montezuma and the P.S.1 Kids," *New York Times*, April 15, 1977, sec. C, 20.
3. Richard Nonas, correspondence with the author, March 6, 2004 (Walker Art Center Archives). In a telephone conversation with the author on February 25, 2004, Nonas explained that the term "dangerous objects" is an allusion to the theory held by many Native healers that humans bring disease on themselves by disrespecting the dignity of powerful plants, animals, or objects.
4. Ibid. In a telephone conversation on February 25, 2004, Nonas told the author that titles for the sculptures in *Montezuma's Breakfast* were taken from the following passage in the eponymous artist's book: "A peddler in a wagon pulled by mules sells: razor blades, figs, cotton cloth, tin cups, live chickens, and tequila."

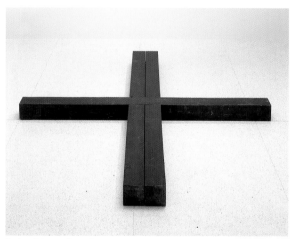

Richard Nonas *Razor-Blade* 1977 steel 6 x 96 x 102 in. (15.2 x 243.8 x 259.1 cm) Art Center Acquisition Fund, 1977 1977.45

Chris Ofili
British, b. 1968

- - **Exhibitions**
"Brilliant!" New Art from London (1995; catalogue, tour),
Painting at the Edge of the World (2001; catalogue)
- - **Holdings**
1 painting, 6 gouaches/watercolors, 1 edition print/proof,
1 portfolio of prints

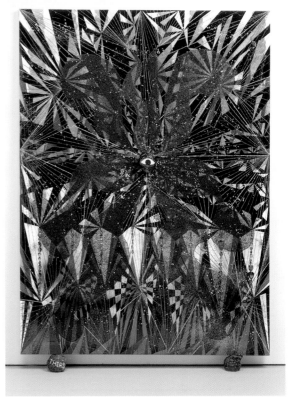

Chris Ofili *Third Eye Vision* 1999 acrylic, collage, glitter, resin, map pins, elephant dung on canvas 96 x 72 3/8 x 6 in. (243.84 x 183.83 x 15.24 cm)
T. B. Walker Acquisition Fund, 2000 2000.11

The paintings Chris Ofili made while studying at London's Royal College of Art owed an evident debt to the graffiti-influenced work of one of his heroes, Jean-Michel Basquiat. Yet Ofili had developed a deliciously decorative repertoire of his own by the time his paintings were first seen in an American museum as part of the Walker Art Center's 1995 exhibition *"Brilliant!" New Art from London*. In his fondness for absurd caricatures, he revels in an ethnically acute aesthetic realm opened up by David Hammons, whose 1983 *Bliz-aard Ball Sale*, in which he peddled snowballs on the street, even inspired Ofili to "sample" it, as he calls it, a decade later in his own *Shit Sale*. Attending street markets in Berlin and London in 1993, Ofili presented a display of the balls of elephant dung that he would begin to incorporate into his paintings later that year.

Ofili makes paintings that are rarely earnest or partisan but wily, confident, and playful. His canvases dazzle optically, caricaturing the look of a colonial textile or an aboriginal cave wall. But they also meddle with cultural stereotypes of ethnicity and sense of "political correctness," depicting, for instance, outrageous Afro-haired superheroes and supervixens. As the artist commented in 1995: "It's what people want from black artists. We're the voodoo king, the voodoo queen, the witch doctor, the drug dealer, the *magicien de la terre*. The exotic, the decorative. I'm giving them all of that, but it's packaged slightly differently."[1]

Third Eye Vision (1999) shares its name with a 1998 album by the San Francisco–based hip-hop act Hieroglyphics. With its apparent adoption yet gruff derision of racial archetypes, hip-hop culture is central to Ofili's lexicon. Irreverent rhymes, cheeky remixes, looped samples, and scavenged break beats are all concepts he has transcribed into his painting. The title recalls the supernatural powers of sight and psychic ability ascribed to the Hindu deity Shiva. Yet the painting seems to gently mock this conflation of faith and mysticism, as it perches on its support of two bead-festooned dung balls with a swagger, leaning against the wall with palpable cockiness.

M.A.

Notes
1. Chris Ofili, interview with Walker research fellow Marcelo Spinelli, "Decorative Beauty Was a Taboo Thing," in Richard Flood, ed., *"Brilliant!" New Art from London*, exh. cat. (Minneapolis: Walker Art Center, 1995), 67.

Georgia O'Keeffe

American, 1887–1986

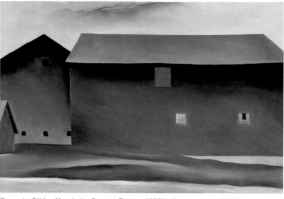

Georgia O'Keeffe *Lake George Barns* 1926 oil on canvas 21 3/16 x 32 1/16 in. (53.8 x 81.4 cm) Gift of the T. B. Walker Foundation, 1954 1954.9

- - **Exhibitions**

The Classic Tradition in Contemporary Art (1953; catalogue), *Reality and Fantasy, 1900–1954* (1954; catalogue), *Art Fair* (1959; catalogue), *The Precisionist View in American Art* (1960; catalogue, tour), *The Cities Collect* (2000), *American Tableaux* (2001; publication, tour)

- - **Holdings**

1 painting

Claes Oldenburg
American, b. Sweden, 1929

An artist who believes in the interpretation and inter-relation of art and life, Claes Oldenburg makes multimedia performances and artistic projects rooted in popular culture that have mirrored the human experience in surprising and sometimes unsettling ways. Continuing traditions begun by such movements as Surrealism and Art Brut, which emphasized the role of the unconscious, the unrefined, and the uncivilized in art, Oldenburg uncovers the mystery and power of commonplace objects by morphing their scale, shape, and texture, embracing what he calls "the poetry of everywhere."[1] The artist's inventive working process is cumulative. He orders his impressions of the world through sketches and writings in his ever-present note-books; models and drawings form another layer of thinking. Some ideas are realized as sculptures, ranging from the intimately scaled to the monumental, while others undergo a years-long period of study and change. The Walker Art Center is home to an in-depth collection of Oldenburg's work, ranging from early performance-related objects to large-scale outdoor sculpture to drawings, prints, multiples, and rare stud-ies. *Spoonbridge and Cherry* (1985–1988), a fountain-sculpture created with his wife and artistic collaborator, Coosje van Bruggen, is the centerpiece of the Minneapolis Sculpture Garden.

Born in Stockholm in 1929 and raised in Chicago by diplomat parents, Oldenburg moved to New York in 1956. In 1960, he staged his first major project, entitled *The Street*, at the Judson Gallery. Responding both to the urban environment where he lived and worked and to the flattened perspective of cartoon illustrations, Oldenburg covered the walls of the gallery with torn and crudely painted collages made from gritty, cast-off materials such as cardboard and burlap. The cutouts depicted inhabitants of New York's Bowery slums, including a Street Chick and an entity known as Ray Gun (also the artist's alter ego), characters that exempli-fied the seamy side of the city.

In 1961 Oldenburg presented *The Store*, an enter-prise combining sculpture and performance, on Manhattan's Lower East Side. He filled a vacant store-front, which he called the Ray Gun Manufacturing Co., with hundreds of plaster and papier-mâché replicas of common products such as shirts, shoes, slices of pie, and baked potatoes—all made in the back of the shop. These items were often larger than life, lumpy, mis-shapen, and garishly painted, and were sold as regular merchandise. *The Store* marked the first sounding of a main theme in Oldenburg's art—the exclusive use of inanimate objects to convey meaning. As he wrote in his now-famous manifesto of 1961: ". . . I am for an art that takes its form from the lines of life itself. . . . I am for U.S. Government Inspected art, Grade A art, Regular Price art, Yellow Ripe art, Extra Fancy art, ready-to-eat art . . . an art that is political-erotical-mystical, that does something other than sit on its ass in a museum."[2]

During his early years in New York, Oldenburg became involved with a close-knit group of artists, including Jim Dine, Allan Kaprow, and Lucas Samaras, who sought to create an iconoclastic form of "total art." Their projects, known as "Happenings," were one-time events that combined acting, painting, sculpture, music, poetry, dance, and film. Inanimate objects in the Happenings were on equal footing with the per-formers, with props salvaged from the events often emerging as sculptures in their own right, as in the case of Oldenburg's *Upside Down City*, a remnant from the 1962 performance *World's Fair II*.[3] The Happening began with two actors removing various objects from the pockets of an inert man and from a large trunk, then placing them on a table. Subsequent sections

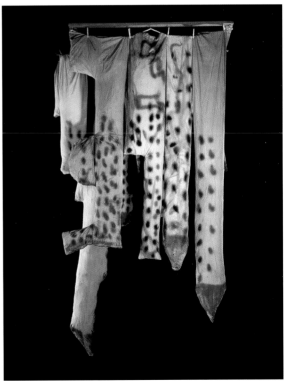

Claes Oldenburg *Upside Down City* 1962 muslin, latex and spray enamel, newspaper, wood, clothespins, wire hangers 118 x 60 x 60 in. (299.7 x 152.4 x 152.4 cm) Purchased with the aid of funds from the National Endowment for the Arts and Art Center Acquisition Fund, 1979 1979.24

Claes Oldenburg *Colossal Floating Three-Way Plug* 1965 graphite on paper 30 x 22 in. (76.2 x 55.9 cm) Gift of the T. B. Walker Foundation, 1975 1975.19

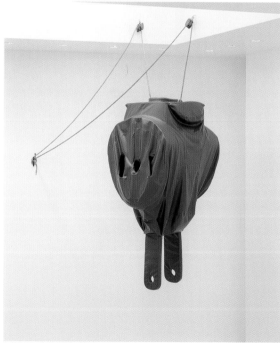

Claes Oldenburg *Three-Way Plug—Scale A, Soft, Brown* 1975 vinyl, polyurethane foam, Masonite, wood, wire mesh, rope, zipper, chain, cleat, pulleys 144 x 77 x 59 in. (365.8 x 195.6 x 149.9 cm) Gift of the artist, 1979 1979.120

focused on different areas of the room, and the event concluded with the performers suspending the inverted cityscape from the ceiling. Resembling hanging laundry, odd reptiles, or invented letterforms, the constructions of painted newspaper-stuffed fabric were key for Oldenburg in that they marked the beginnings of his work with "soft" sculpture, which would become an abiding interest and which he would explore with then-new materials (vinyl, fake fur, foam rubber) as well as traditional "painting" fabrics (canvas, and muslin).

Shoestring Potatoes Spilling from a Bag, a soft sculpture from 1966, was originally conceived as part of a grouping of soft fast-food items—french fries, ketchup, and cola—and was based on an advertisement the artist had seen in a 1965 issue of *Life* magazine. By inverting the shoestring potatoes and applying gravity, his "favorite form creator,"[4] Oldenburg produced a new entity that took on a life of its own and, as he had done with *Upside Down City*, he further challenged convention by creating sculpture from painted canvas.[5] Various relationships to the potatoes are examined in the pages of Oldenburg's notebooks, through drawings, clippings, and notations. In one drawing, the artist compares the french fries, ketchup bottle, and cola glass to a cathedral, a chapel, and the Leaning Tower of Pisa, respectively. Another page relates the potato forms to female legs, with a fan of miniskirts forming the edge of the bag.

It is this process of free association that is at the heart of Oldenburg's work. He has an innate inclination to classify and order forms, a tendency enhanced by his incisive visual memory and pliant imagination. "I like best," he noted in 1965, "an elementary idea which turns, by itself, into a surprising suggestive object, as through material action."[6] By systematically examining his spontaneous responses to his subjects, he recognizes both obvious and hidden relationships. Over the course of his career, he has charted the lineage of many leitmotifs—the clothespin, three-way electric plug, geometric mouse, or soft alphabet, for example—to which he returns time and again for inspiration.

Beginning in the mid-1960s, Oldenburg began to conceive of works that he termed "colossal monuments," familiar objects enlarged to Brobdingnagian proportions that could be seen as alternatives to traditional public sculpture. Often, the ideas arose from the artist superimposing an image of an object on a landscape, either in the form of a collaged study, as seen in the printed postcard studies for the 1968 multiple *London Knees 1966* (realized as a life-size object), or a drawing, such as the 1965 *Colossal Floating Three-Way Plug* (realized in a variety of scales and materials, including the Walker's 1975 Naugahyde version, *Three-Way Plug—Scale A, Soft, Brown*). The objects chosen for the proposed monuments are afforded the grand scale traditionally reserved for memorial architecture, though at the same time, the vast scale denies their reality. By proposing, for example, a museum building formed from a tobacco can and cigarette package or a hybrid "vehicle" made from a giant lipstick poised on the treads of a bulldozer, Oldenburg heightens his subject's abstract qualities to inspire a sense of wonder in forms usually overlooked.

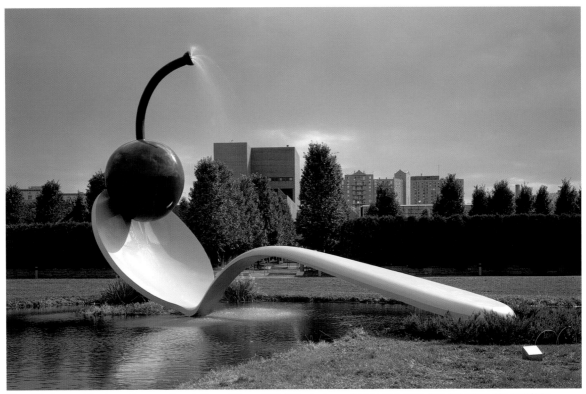

Claes Oldenburg and Coosje van Bruggen *Spoonbridge and Cherry* 1985–1988 aluminum, stainless steel, paint 354 x 618 x 162 in. (899.2 x 1569.7 x 411.5 cm) Gift of Frederick R. Weisman in honor of his parents, William and Mary Weisman, 1988 1988.385

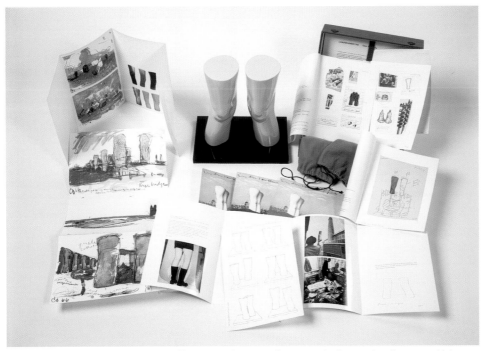

Claes Oldenburg *London Knees 1966* 1968 offset lithograph on paper, linen-covered suitcase, polyurethane on cast latex, acrylic; edition 74/120 box: 7 1/2 x 17 x 12 1/4 in. (19.1 x 43.2 x 31.1 cm) closed Published by Edition Alecto Ltd., London, in association with Neuendorf Verlag McKnight Acquisition Fund, 1999 1999.13

Since the mid-1970s, Oldenburg has made sculpture in collaboration with his wife, Coosje van Bruggen. The process behind the couple's proposals for what they term "large-scale projects" is integral to the work, regardless of whether a piece is realized. Over a period that may last years, an idea based on their impressions of a site is developed through drawings and models. *Spoonbridge and Cherry*, one of the artists' few fountain pieces, was commissioned by the Walker in 1985, during the planning of the Minneapolis Sculpture Garden. A number of associations about Minnesota played into the choice of subject.[7] The artists conceived of the sculpture as the focal point of the walk from the museum to the center of the Garden. Not wanting to overshadow the surrounding sculptures, however, the artists' aim was to create something that would "catch the eye and . . . lie down and be horizontal."[8] The spoon had been an element of Oldenburg's visual vocabulary since 1962, when he bought a novelty spoon that rested on an "island" of imitation chocolate. Drawings, prints, and unrealized proposals involving the spoon followed, including the idea of a Chicago pier extending into Lake Michigan, and a bridge near New York's Park Avenue. Oldenburg had continued to think of the spoon as being "something flung out over water."[9] It was van Bruggen who suggested the addition of the cherry, as well as the shape of the pool, which is inspired by the seed of the linden tree, a prominent planting in the Garden. The sculpture is now an iconic symbol for the Twin Cities.

S.E.

Notes

1. Oldenburg, "Extracts from the Studio Notes (1962–64)," *Artforum* 4, no. 5 (January 1966): 33.

2. Oldenburg, artist's statement for the exhibition catalogue for *Environments, Situations, Spaces* at the Martha Jackson Gallery, 1961; published in definitive form in Claes Oldenburg, *Store Days* (New York: Something Else Press, 1967).

3. *World's Fair II* was performed on May 25 to 26, 1962. The performers were Dominic Capobianco, Lette Eisenhauer, Claes Oldenburg, Pat Oldenburg, Lucas Samaras, and John Weber. See "World's Fair II: The Script," in Michael Kirby, ed., *Happenings: An Illustrated Anthology* (New York: E.P. Dutton, 1965), 220–222.

4. Oldenburg, "Extracts," *Artforum* 4, no. 5 (January 1966): 33.

5. "I discovered that by making ordinarily hard surfaces soft I had arrived at another kind of sculpture and a range of new symbols," Oldenburg wrote in his notebooks in 1966, ". . . the possibility of movement of the soft sculpture, its resistance to any one position, its 'life' relate it to the idea of time and change." Oldenburg, in "Selections from Oldenburg's Writings" in Barbara Rose, *Claes Oldenburg*, exh. cat. (New York: Museum of Modern Art, 1969), 194.

6. Oldenburg, from "Notes, New York, 1965–66," reprinted in *Claes Oldenburg: Dibujos/Drawings 1959–1989*, exh. cat. (Valencia, Spain: IVAM, Centre Julio González, 1989), 16.

7. These associations included the state's profusion of lakes and its Scandinavian heritage (the artists compared the raised spoon bowl to the prow of a viking ship). Oldenburg, unpublished interview with Siri Engberg and Toby Kamps, July 10, 1992 (Walker Art Center Archives).

8–9. Ibid.

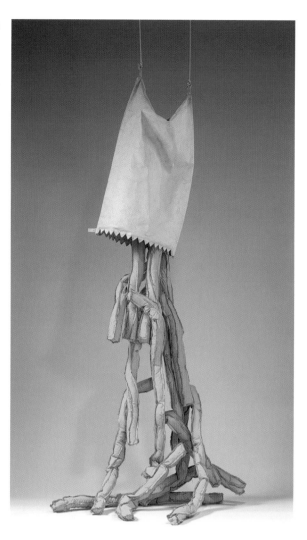

Claes Oldenburg *Shoestring Potatoes Spilling from a Bag* 1966 canvas, kapok, glue, acrylic 108 x 46 x 42 in. (274.3 x 116.8 x 106.7 cm) Gift of the T. B. Walker Foundation, 1966 1966.46

Yoko Ono

American, b. Japan, 1933

-- **Commissions**
Imagine Peace (2004)
-- **Exhibitions**
In the Spirit of Fluxus (1993; catalogue, tour), *Y E S YOKO ONO*
(2001; organized by the Japan Society, New York; catalogue)
-- **Screenings**
The Films of Yoko Ono: Collaborations with John Lennon,
Part One (1993), The Films of Yoko Ono (2001)
-- **Holdings**
1 sculpture, 1 multimedia work, 1 film, 1 video, 24 multiples, 6 books,
21 announcements, 1 periodical, 13 posters, 10 postcards

Since the early 1960s, Yoko Ono has been a seminal figure in avant-garde culture—her music, poetry, performances, films, sculpture, and paintings are inextricably linked to the development of Fluxus and Conceptualism. Her close associations with John Cage and La Monte Young led her to experiment with the "event score"—brief instructions that proposed mental and/or physical actions to be carried out by the reader. *Lighting Piece* (1955), one of her earliest Event Scores, directed the performer to "light a match and watch till it goes out." In the late 1950s, her practice extended to Instruction Paintings, which included traditional Japanese calligraphy and directions to the audience for completion of the work, such as walking or dripping water onto a canvas. Ono's notion of painting was twofold: instruction and realization, and enfolded audience participation and the use of language as a form of art. These innovations attracted the attention of George Maciunas, the founder of Fluxus and an important champion of her work.

The Walker Art Center's collection includes a version of Ono's *Painting to Hammer a Nail*, an Instruction Painting originally conceived in 1961. She made a number of realizations of this score, the first of which was exhibited in 1966 at Indica Gallery in London. The white-painted wood panel included a hammer that dangled from a chain along with a jar of nails placed on a chair. The directions for the piece asked the viewer to hammer a nail in the panel and then wrap a strand of hair around it. Although no hair remained on the piece, the work was deemed finished once the surface was covered with nails. The second version of the work, *Painting to Hammer a Nail In* (1961/1967), is made of stainless steel and glass and is inscribed to John Lennon, whom she had met in 1966 at the preview of her exhibition at Indica Gallery. The work can be read as a response to his suggestion that he hammer an imaginary nail into the panel, a conceptual proposal that echoed Ono's ongoing preoccupation with the importance of the idea of art over the physical object.

Performed as early as 1964 in Kyoto and as recently as 2003 in Paris, *Cut Piece* is an iconic work that unites Ono's conceptual practice with an immediate social event. A video of a 1964 performance at Carnegie Recital Hall documents Ono sitting motionless onstage as audience members take turns cutting off a piece of her clothing until she is stripped to her underwear. This work is as much a comment on collective responsibility as it is about the sexualized role of women in our society, exposing an intimate, and at the time unexplored, territory of the artist's own anguish in a public forum. In writing about this piece, Ono has said: "People went on cutting the parts they do not like of me finally there was only the stone remained of me that was in me but they were still not satisfied and wanted to know what it's like in the stone."[1]

In 1969, the newly married Lennon and Ono held the first in a series of antiwar demonstrations called *Bed-Ins for Peace*, in which they invited the media into their bedroom for a week to discuss their opposition to the Vietnam War. Because of their fame, their message of peace was wide-reaching, giving voice to what was on the minds of an entire generation at the height of this historic period. The *Bed-Ins* expanded Ono's practice to an international audience and transformed performance into a broad cultural and political statement. It also provided another layer to the artist's iconoclastic strategies of unifying her work in music, performance, and visual art. During the following year, the couple devised a multimedia campaign that included advertisements, billboards, posters, radio spots, and postcards that read: "War is Over! If you want it. Love and Peace from John & Yoko." Ono recently revisited their powerful public statement in a piece commissioned by the Walker: on a billboard in downtown Minneapolis she offered the simple message "Imagine Peace."

Sylvia Chivaratanond

Notes

1. Yoko Ono, "Biography/Statement" (1966), reprinted in Jon Hendricks and Alexandra Munroe, *Y E S YOKO ONO*, exh. cat. (New York: Japan Society and Harry N. Abrams, 2000), 301.

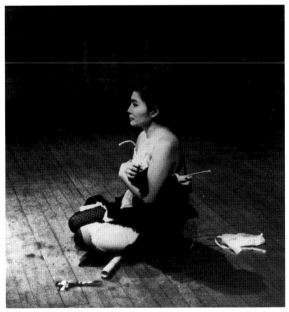

Yoko Ono *Cut Piece* 1965 DVD (black and white, sound); edition 6/10
9 minutes T. B. Walker Acquisition Fund, 2002 2002.210 pictured: Yoko Ono
performing *Cut Piece* at Carnegie Recital Hall, New York City, 1965
Photo: Minoru Niizuma/©Yoko Ono; courtesy Lenono Photo Archive

WAR IS OVER!

IF YOU WANT IT

Love and Peace from John & Yoko

Yoko Ono and John Lennon *War Is Over!* 1969 letterpress on paper 30 x 19 15/16 in. (76.2 x 50.6 cm) T. B. Walker Acquisition Fund, 2002 2002.205

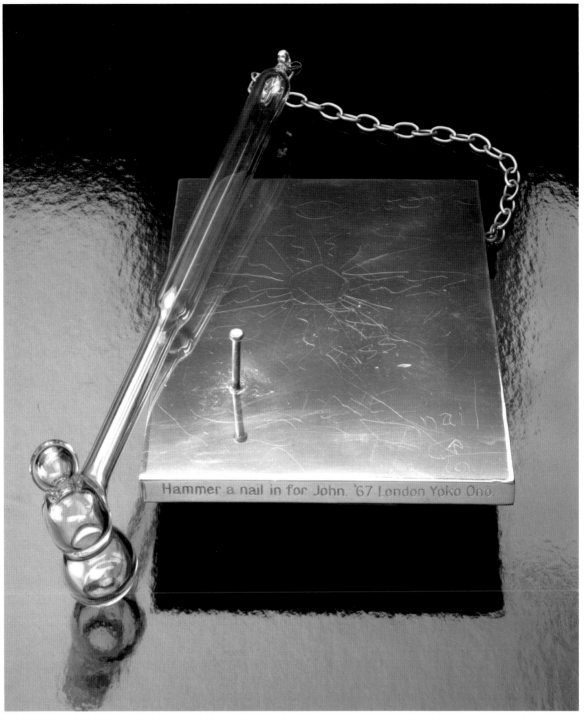

Yoko Ono *Painting to Hammer a Nail In* 1961/1967 glass, steel 12 x 8 x 4 in. (30.5 x 20.3 x 10.2 cm) T. B. Walker Acquisition Fund, 2002 2002.206

Catherine Opie

American, b. 1961

-- **Exhibitions**
Catherine Opie: Skyways & Icehouses (2002; catalogue)
-- **Residencies**
2001–2002
-- **Holdings**
2 photographs, 2 photographic suites

Catherine Opie's entire artistic career can be seen as one long photographic road trip across this continent in search not of the American dream but rather a dream of an idea of community. Her works—whether the extremely formal, color-saturated portraits of friends in the lesbian and gay leather community of Los Angeles that brought her to the art world's attention in 1993 or those documenting that city's ubiquitous concrete highway overpasses, mini-malls, and architectural facades—are each animated by a single question: How does one create a portrait of a community?

This question provides the motivating impetus behind Opie's *Domestic* series. These portraits of lesbian couples, families, and friends in their households, taken in 1998 as the artist embarked on a three-month odyssey in an RV to nine different cities across the country, were an attempt to "document the lesbian dream."[1] The catalyst for this series could be found in an earlier work, *Self-Portrait/Cutting* (1993), a color photograph of the artist isolated against a lush green backdrop with her bare back turned toward the viewer. This was, however, a self-portrait with a difference, as Opie's back became a surface for a naïve, childlike line drawing—cut into her skin with a razor—depicting two women holding hands in front of a house. It is paradoxically a heartbreakingly sweet image, notable for its ability to transform what might seem like a violent act into a beautiful one. As she suggests, this image is "about an idealistic view of what domesticity is, and what I want from it."[2] This desire became the basis for her *Domestic* series, which expands our understanding of how families can be constructed by presenting its lesbian subjects in a powerful and dignified manner in the realm of a profoundly recognizable American domesticity.

Communities can also be portrayed in terms of the architectural spaces they inhabit, as the artist demonstrated in 2001 when she began a yearlong residency project at the Walker Art Center. The resulting body of work was a series of fourteen large-scale color photographs of icehouses—indigenous, ad hoc architectural structures that populate the winter landscape of Minnesota. Like one of Italo Calvino's "invisible cities," these recreational fishing outposts manifest themselves organically on the frozen lakes, creating temporary, seasonal communities that cut across social distinctions. In the spring, these ice villages disappear as quickly as they had appeared, their citizens dispersing to their other lives. Under Opie's meticulous lens, the colorful shacks respirate from foreground to background along a horizon line that from image to image never wavers. Devoid of human presence, these almost abstract, minimal structures become anthropomorphic

markers of their inhabitants, who use them to fish, socialize, and while away the winter hours. Taken together, the two bodies of work present divergent, if complementary, methods for documenting their respective communities and can take their place in the documentary tradition in American photography dating back to the work of Robert Frank and Walker Evans, who both took their own road trips in search of America. Opie has adapted those formal techniques and social thematics to her own subjects, enlisting the genres of architectural and portrait photography in order to trace the diverse, shifting contours of the conceptual horizon line of the American community.

D.F.

Notes
1. Quoted in Russell Ferguson, "How I Think: An Interview with Catherine Opie," in Kate Bush, ed., *Catherine Opie*, exh. cat. (London: The Photographer's Gallery, 2000), 48.
2. Quoted in Rachel Allen, "Lesbian Domesticity: An Interview with Catherine Opie," *Los Angeles Forum for Architecture & Urban Design Newsletter*, Spring 1998, 2.

Catherine Opie *Norma & Eyenga, Minneapolis, Minnesota* 1998
chromogenic print; edition 1/5 40 5/8 x 50 5/8 in. (103.2 x 128.6 cm)
Clinton and Della Walker Acquisition Fund, 1999 1999.70

Artist-in-Residence, 2001–2002

When the Walker Art Center invited Catherine Opie to be an artist-in-residence, she immediately knew that she wanted to continue her investigation of American cites by photographing two vernacular architectural elements particular to the Twin Cities: ice-fishing houses and the downtown skyways. In two beautiful and haunting series, she captured not only the idiosyncrasies of each, but the psychological charge that these elements add to the Upper Midwestern landscape. To complement her photographs, Opie called for real-life stories, anecdotes, and poems from local residents who enliven those spaces every day and every winter. By turns funny, poignant, nostalgic, and revelatory of the manifold narratives that animate the Twin Cities, the seventy-six submissions she received from mostly nonprofessional writers cut across a wide demographic range yet shared a geographically defined experience. The writers' topics included being lost in a maze, a flying frozen fish, floating above Hennepin Avenue, a dancing fiddler, memories of Grandpa, echoes of Venice in Minneapolis, love in the sky, and an ice-fishing spirit. All the texts were collected on a Web site (http://www.walkerart.org/va/opie) and a selection were included in the exhibition catalogue for *Catherine Opie: Skyways & Icehouses*.

O.I.

Catherine Opie *Untitled #2* from *Untitled #1–#14* (*Icehouses*) 2001 chromogenic print; edition 1/5 50 x 40 in. (127 x 101.6 cm) each of 14 Published by Regen Projects, Los Angeles Gift of the Buddy Taub Foundation, Jill and Dennis Roach, Directors, and Justin Smith Purchase Fund, 2002 2002.214

Catherine Opie (left) with exhibition curator Douglas Fogle at the opening-day gallery talk, 2002

Catherine Opie *Untitled #1* from *Untitled #1–#14* (*Icehouses*) 2001 chromogenic print; edition 1/5 50 x 40 in. (127 x 101.6 cm) each of 14 Published by Regen Projects, Los Angeles Gift of the Buddy Taub Foundation, Jill and Dennis Roach, Directors, and Justin Smith Purchase Fund, 2002 2002.214

Gabriel Orozco

Mexican, b. 1962

- - **Exhibitions**
Unfinished History (1998; catalogue, tour), *Let's Entertain*
(2000; catalogue, tour)
- - **Holdings**
3 sculptures, 2 photographs, 1 book

The work of Gabriel Orozco is poetry in motion. He has spent his life traveling the world, and not surprisingly, his sculptures, photographs, videos, and installations have come to document his slight and often ephemeral interventions into his immediate surroundings. They convey, often with modest means and scale, the romance of daily life. As a result of his peripatetic lifestyle, Orozco has abandoned the notion of a traditional studio practice. In a 2003 interview he explained: "The post-studio practice in my case was to understand this studio on a temporal basis and not on a spatial basis. I took the word 'studio' literally, not as a space of production but as [a] time of knowledge. That time of knowledge can be generated in different places: outdoors or indoors. And the result of this . . . is unpredictable, because I don't own the means of production: I don't own a factory, I don't have a school, I have no assistants . . . I can use all of these models. But my favorites are the street, kitchen, and table."[1]

Orozco was born into a family of painters, and as is true with many artists emerging from Mexico during the second half of the twentieth century, he had to contend with the cultural legacy of the celebrated muralists Diego Rivera, José Clemente Orozco (no relation), and David Alfaro Siquieros (with whom Gabriel's father had studied and worked as an assistant). In 1993, Orozco burst onto the international art scene with solo exhibitions at the Kanaal Art Foundation in Kortrijk, Belgium; the "Projects" space at the Museum of Modern Art, New York; and Galerie Chantal Crousel, Paris, where he showed his now notorious work *La D.S.*, a French-made Citroën D.S. automobile which he cut lengthwise into three cross sections, removed the central portion, and seamlessly reconnected the remaining lateral pieces to form a shadow of its former self. The next year, he was offered his first solo New York show at Marian Goodman Gallery, where his exhibition of four blue-rimmed plastic yogurt container caps, one per wall, was spare, bordering on invisible. The controversial reception of this minimalist gesture in addition to the increasingly pronounced eclecticism of his practice made manifest in these exhibitions led to his subsequent meteoric ascendancy within the art world.

Orozco's privileging of found objects has been widely accepted as a poetic reinterpretation of Duchamp's use of the "readymade," but the artist has also freely acknowledged other influences, most notably Arte Povera's recycling of prosaic materials, Minimalism's strict geometries and seriality, and Earth Art's exploration of sites beyond the confines of the gallery. However, like Robert Morris and Bruce Nauman before him, the artist's body is perhaps the central reference point and unit of measure within Orozco's work.

In 1992, he created *Piedra que cede* (*Yielding Stone*), a pristine ball of plasticine modeling clay weighing the same amount as his own body (approximately 150 pounds). Like the tendency for travelers to accumulate impressions and souvenirs from a particular place, he rolled this malleable "stone" through the streets of New York City so it picked up all manner of detritus that became embedded in its surface.[2] Ultimately, the debris and inevitable indentations suffered by the piece reflect the geography of the urban environment and bear traces of time's passage.

E.C.

Notes
1. Cited in *Hans Ulrich Obrist: Interviews*, vol. 1, ed. Thomas Boutoux (Milan: Edizioni Charta, 2003), 646–647. Despite his theoretical protestations to the contrary, Orozco has established home bases in New York, Paris, and Mexico City.
2. Since its inception, the piece has become well traveled, having been rolled through the streets of Los Angeles and Mexico City on the occasion of a major survey of Orozco's work at the Los Angeles Museum of Contemporary Art (2000), which traveled to the Museo de Arte Contemporáneo Internacional Rufino Tamayo in Mexico City (2001), and to the Museo de Arte Contemporáneo de Monterrey, Mexico (2001). While the piece was in Los Angeles, the artist added shoe and finger marks. See documentation in the Walker Art Center Archives.

Gabriel Orozco *Piedra que cede* (*Yielding Stone*) 1992 plasticine, debris; edition 2/3 14 1/2 x 15 1/2 x 16 in. (36.8 x 39.4 x 40.6 cm) T. B. Walker Acquisition Fund, 1996 1996.166

Pepón Osorio

American, b. Puerto Rico, 1955

- - **Holdings**

1 sculpture

Pepón Osorio *100% Boricua* 1991 wood, glass, plexiglass, paper, fabric, metal, plastic 79 3/8 x 33 1/2 x 20 1/2 in. (201.6 x 85.1 x 52.1 cm) overall Gift of the Peter Norton Family Foundation, 1992 1992.180

Nam June Paik
American, b. South Korea, 1932

-- **Commissions**
Anti-Gravity Study (1976)
-- **Exhibitions**
Light/Motion/Space (1967; catalogue), *The River: Images of the Mississippi* (1976; catalogue, tour), *In the Spirit of Fluxus* (1993; catalogue, tour), *Duchamp's Leg* (1994; catalogue, tour), *Art Performs Life: Merce Cunningham/Meredith Monk/Bill T. Jones* (1998; catalogue)
-- **Holdings**
1 unique work on paper, 3 multimedia works, 1 photograph, 2 videos, 1 edition print/proof, 4 multiples, 6 books, 1 postcard

Nam June Paik's first use of television as an artistic material, in 1963, is a benchmark moment in the history of art. Since then, he has explored every corner of the vast aesthetic potential of television and video technology, an odyssey that has earned him the nickname "the Father of Video Art." But his first love—and the subject of his academic training during the 1950s—was musical composition. Paik wrote a thesis on Arnold Schoenberg and later studied with Karlheinz Stockhausen, who was experimenting with electronic sound at his studio in Darmstadt, Germany. His most important encounter was with John Cage, whose Zen-influenced, antimaterialist approach profoundly changed Paik's thinking as well as his art.

His performances of this period were intensely physical, visual, often shocking, and sometimes violent. Years later Cage recalled, "His work is fascinating, and often rather frightening. Now I would think twice about attending one of his performances. He generates a real sense of danger, and sometimes goes further than we are willing to accept."[1] Paik doused himself with water, banged his head on the piano keyboard, leapt, yelled, and drank water from his own shoe. This "action music," he explained, was an attempt to renew the ontological, or essential, nature of music rather than just its form.[2] He was in great demand on the avant-garde circuit, performing throughout Europe with the nascent Fluxus group. During these years he also made his first altered televisions by manipulating the horizontal and vertical hold controls to obtain distorted images, or hooking televisions to interactive radio controls to make sound "visible" on-screen.

Performance, music, video, and sculpture come together seamlessly in the objects Paik made for Charlotte Moorman, the cellist who became his chief collaborator after 1964. Two key works, *TV Bra for Living Sculpture* (1969) and *TV Cello* (1971), are in the Walker Art Center's collection. The former is an ungainly assemblage of two small picture tubes inside plexiglass cases, which was held on Moorman's body by an arrangement of clear plastic straps. The images on the monitors could be broadcast television, videotape, or closed-circuit views of the audience; at times the pictures were changed, modulated, and regenerated by the sounds produced by Moorman's cello as she played.[3] *TV Cello* is a stack of three picture tubes, also inside plexiglass boxes, that mimics the shape of a

cello. Paik fitted it with three strings and tuning pegs on a plexiglass neck; like *TV Bra*, its images changed with the performer's actions.

Moorman noted wryly that *TV Cello* was the first innovation in cello design since 1600,[4] and both objects were part of Paik's attempt to personalize the new technology. He claimed in 1969 that "by using TV as bra, the most intimate belonging of a human being, we will demonstrate the human use of technology, and also stimulate viewers . . . to look for the new, imaginative, and humanistic ways of using our technology."[5] He has since been at the forefront of experimentation with moving-image technology, making works that range from single-channel video collages such as *Global Groove* (1973) to monumental installations of dozens of television monitors to his recent *Transmission* (2002), an outdoor laser-beam projection controlled by his own performance on the piano.

In 1967, Paik was included in the Walker's exhibition *Light/Motion/Space*. He showed *Electronic Waltz* (1966), a color television set that displayed gyrating abstract shapes through the action of a magnet attached to its picture tube.[6] A decade later he produced *Anti-Gravity Study* (1976) for another Walker show, *The River: Images of the Mississippi*. This time, he suspended thirty monitors from the gallery ceiling and animated them with footage of steamboats, fish, shorelines, and other imagery evocative of river life. In 1987, when then–Walker Director Martin Friedman approached Paik about acquiring a new work, the artist suggested combining elements from the two earlier pieces to make a new one, which was eventually titled *66-76-89* (1990). At its base is the original blond wood set from *Electronic Waltz*, now retrofitted with electronic circuitry that simulates the original image. On it Paik placed a stack of thirty-two monitors showing footage from *Anti-Gravity Study* as well as newer video material. The installation provides a mini-survey of two decades of Paik's work, but also embodies his rich history with this institution.

J.R.

Notes
1. John Cage, *For the Birds* (Boston: Marion Boyars, 1981), 167.
2. Nam June Paik, "New Ontology of Music (PAIK)," reprinted in *Nam June Paik: Videa 'n' Videology 1959–1973*, exh. cat. (Syracuse, New York: Everson Museum of Art, 1974), unpaginated.
3. Edith Decker-Phillips, *Paik Video* (Barrytown, New York: Barrytown, Ltd., 1998), 124. For exhibition purposes, Paik has suggested that the monitors show tapes of broadcast television from 1969 (Curator's notes, 1991, Walker Art Center Archives).
4. She made the remark in Paik's video *Global Groove* (1973). See John Hanhardt, *The Worlds of Nam June Paik* (New York: Guggenheim Museum, 2000), 53.
5. Paik statement written in conjunction with the exhibition *TV as a Creative Medium* (Howard Wise Gallery, New York, 1969), reprinted in *Videa 'n' Videology*, unpaginated.
6. Paik got the set from Jasper Johns, who had found it left behind by the previous owners of a house he bought on Riverside Drive in Manhattan in 1963. He decided he didn't want it and gave it to Paik, whom he had recently met. According to Johns, Paik had not yet used color television in his work. Johns, conversation with the author, June 24, 2002.

Nam June Paik *TV Bra for Living Sculpture* 1969 (detail) video tubes, televisions, rheostat, foot switches, plexiglass boxes, vinyl straps, cables, copper wire installed dimensions variable T. B. Walker Acquisition Fund, 1991 1991.98

Nam June Paik *TV Cello* 1971 video tubes, TV chassis, plexiglass boxes, electronics, wiring, wood base, fan, stool, photograph installed dimensions variable Formerly the collection of Otto Piene and Elizabeth Goldring, Massachusetts T. B. Walker Acquisition Fund, 1992 1992.6

Nam June Paik *66-76-89* 1990 television cabinet, video monitors, laser disc players, steel 148 x 64 x 48 in. (375.9 x 162.6 x 121.9 cm) T. B. Walker Acquisition Fund, 1990 1990.194

Giulio Paolini

Italian, b. 1940

- - **Exhibitions**
Artists' Books (1981), *Zero to Infinity: Arte Povera 1962–1972* (2001; catalogue, tour), *The Last Picture Show: Artists Using Photography, 1960–1982* (2003; catalogue, tour)
- - **Holdings**
1 sculpture, 1 photograph, 3 books

Throughout his career, Giulio Paolini has been fixated on the act of seeing as well as the relationship between the seer and the seen. Emerging in the context of the Italian Arte Povera artists of the 1960s, he shared with his cohorts a profound mistrust of the commodity status assigned to traditional media such as painting. Working in a historical moment that saw the ascendancy of painting in the 1960s in the form of American Abstract Expressionism and the European Art Informel, Paolini took an iconoclastic position, suggesting that the medium was a "question without an answer." He chose instead to embark on a conceptual exploration of the parameters of painting's status within our culture as well as its physical structure, or what he has called "the space of painting."[1] His *Delfo* (*Delphi*) (1965) is a perfect example of the artist's early structural investigations into the nature of painting and its relationship to seeing. Taking its title from the oracle of Delphi, a "seer" in Greek antiquity who dispensed prophecies, the image is a photographic self-portrait of the artist wearing dark glasses and confronting the viewer from behind the wooden support bars of an unstretched painting. After he transferred this image to a piece of canvas through a photographic process, *Delfo* became a hybrid object that is both a photograph and a painting, yet at the same time is neither. It is paradoxically a work that refuses both the status and the act of painting while self-reflexively emphasizing the philosophical implications of the hidden physical support structure of that medium. In a very real sense then, Paolini has made painting the content of this work without ever putting brush to canvas.

If *Delfo* asks us to consider the implications of what lies physically beneath a painting's surface, it also brings into play a discussion of seeing and being seen. Is the artist himself the seer suggested by its title? Though he looks out at the viewer from behind the surface of a painting, neither artist nor spectator can fully meet the other's gaze, as their views are blocked by the conceit of the reproduced stretcher bars. This frustrating short-circuiting of the relational act of seeing and being seen raises issues regarding vision as well as painting. The question that is begged is how do we see the work of art, but more importantly, how does that work of art see us? This play of vision foreshadows future works by Paolini such as *Mimesi* (*Mimesis*) (1976–1988), a sculpture consisting of a pair of identical plaster copies of Praxiteles' Hermes that are turned to face each other, their eyes caught in a Narcissistic feedback loop of seeing and being seen. Both works invoke the legacy of art history's fascination with vision and looking that stretches back at least to Diego Velázquez's *Las*

Meninas (1656), a painting that is as much about the possibilities of making a picture as it is about the relationship between the seer and the seen. In light of this, Paolini's work looks toward the conceptual future of art-making as much as it does to its past.

D.F.

Notes
1. Quotes in this paragraph are from Paolini, conversation with Francesco Bonami, Richard Flood, and Kathy Halbreich in the artist's studio in Turin, Italy, September 27, 1997 (transcript, Walker Art Center Archives).

Giulio Paolini *Mimesi* (*Mimesis*) 1976–1988 plaster; edition 1/3 108 x 24 1/2 x 19 1/2 in. (274.3 x 62.2 x 49.5 cm) each installed T. B. Walker Acquisition Fund, 1996 1996.179

Giulio Paolini *Delfo* (*Delphi*) 1965 photographic screenprint on canvas 72 x 38 1/2 in. (182.9 x 97.8 cm)
Gift of the T. B. Walker Foundation, by exchange, 2003 2003.62

Philippe Parreno
French, b. Algeria, 1964

-- **Exhibitions**
Let's Entertain (2000; catalogue, tour)
-- **Holdings**
2 multimedia works

Since the early 1990s, Philippe Parreno has developed a body of works analyzing the codes of representation and the production of signs and content. In his practice, the exhibition—as a coded space, a format—has become a critical tool allowing an archaeology of our visual culture. What is the discursive role of an exhibition? How do exhibitions participate in knowledge formation? Can an exhibition be a film? What is an image? How do images affect the motion of the mind, of our memories? How do we find our way in an image-saturated culture? How do we discriminate among what Parreno calls "1,000 pictures falling from 1,000 walls"?[1]

This rigorous methodology is accompanied by an aesthetic of complicity, leading Parreno to multiple collaborations in which the notion of author is not so much questioned as exploded and atomized. The list of his collaborators includes artists Dominique Gonzalez-Foerster, Carsten Höller, Pierre Huyghe, Douglas Gordon, and Rirkrit Tiravanija; popular music icon Dave Stewart; scientist Jaron Lanier; and others who don't even know it: Jean-Luc Godard, René Daumal, Robert Rauschenberg, Edgar Varèse.

An installation conceived as a group exhibition, *Credits: Michel Amathieu, Djamel Benameur, Jacques Chaban-Delmas, James Chinlund, Maurice Cotticelli, Hubert Dubedout, François Dumoulin, Ebezeber Howard, M/M Paris, Pierre Mendès-France, Miko, Neyrpic, Alain Peyrefitte, Inez van Lamsweerde & Vinoodh Matadin, Anna-Léna Vaney, Angus Young* (1999) includes a film, a photograph and a sound track. The film reconstitutes a 1970s housing project in which the dream of reconciling urban life with countryside produced a polluted version of both nature and modernist architecture. The title names the residents consulted in the making of the film, the technical crew, influential figures from the period, including rock band AC/DC's lead guitarist and icon of teen discontent, Angus Young, former French politicians Michel Poniatovsky and Pierre Mendès-France, and the Miko ice cream company. A childhood memory unfolded in space and time, *Credits* borrows the structure of a film screening. The lights fade down at the beginning and fade up at the end focused on the photograph by Inez van Lamsweerde and Vinoodh Matadin, extending the time of the work into the space of the exhibition.

More an association than a collaboration, the video installation *Anywhere Out of the World* (2000) started in 1999 when Parreno and Huyghe purchased the copyright to a fictional character, Annlee, from a *manga/anime* design agency in Japan. Freed from the animation industry, remastered, and renamed, Annlee became a "deviant sign," a shell, available to whomever wanted to give her a context.[2] The name itself might refer to Mother Ann Lee, who founded the United Society of Believers in Christ's Second Coming (the Shakers), and who also figures in the video-documentary *Rock My Religion* by Dan Graham, an artist whom both Parreno and Huyghe consider a major antecedent.

Under the generic title *No Ghost Just a Shell, un film d'imaginaire* (1999–2000) (inspired by Mamoru Oshii's iconic 1995 *anime* film *Ghost in the Shell*), thirteen artists have adopted Annlee, giving her a plurality of identity within her own uniqueness. Parreno's *Anywhere Out of the World*, the first episode of Annlee's journey, introduces the character: "My name is Annlee . . . I was bought for 46000 yen . . . I was cheap . . . with no chance to survive . . . drop dead in a comic book . . . I am no ghost, just a shell." *Anywhere Out of the World* explores many issues that such a project raises: the economy and circulation of signs, the notion of the author, the concept of intellectual property, the debate on genetic memory and manipulation, and the controversy around euthanasia. In addition, Parreno asks us to consider the relationship between the model and the image; and the difference between iconoclasm and iconophilia.

Annlee was put to rest in December 2002, when she evaporated as a firework in the sky over Miami Beach. Emancipated from the realm of representation, she became an after-image, a ghostly collective memory, a public recollection, freed at last from any kind of commodification or fetishism and eventually offering a metaphysic of the art and the artist.

P.V.

Notes
1. This was the title of Parreno's 2000 exhibition at the Musée d'Art Moderne et Contemporain (Geneva, Switzerland).
2. Pierre Huyghe, excerpted from the sound track for the DVD *Two Minutes Out of Time* (2000), in the Walker's collection.

Philippe Parreno Selection from *Credits* 2000
chromogenic print by Inez van Lamsweerde and Vinoodh Matadin
66 5/8 x 52 3/4 x 2 in. (169.2 x 134 x 5.1 cm)

Philippe Parreno *Credits: Michel Amathieu, Djamel Benameur, Jacques Chaban-Delmas, James Chinlund, Maurice Cotticelli, Hubert Dubedout, François Dumoulin, Ebezeber Howard, MJM Paris, Pierre Mendès-France, Miko, Neyrpic, Alain Peyrefitte, Inez van Lamsweerde & Vinoodh Matadin, Anna-Léna Vaney, Angus Young* 2000 35mm film transferred to DVD (color, sound), dimmer device, chromogenic print by Inez van Lamsweerde and Vinoodh Matadin; edition 1/3 6:30 minutes installed dimensions variable T. B. Walker Acquisition Fund, 2000 2000.39

PDPal

Julian Bleecker, American, b. 1962; Scott Paterson,
Canadian, b. 1969; Marina Zurkow, American, b. 1966

- - **Commissions**
PDPal (http://gallery9.walkerart.org/pdpal/) (2003)
- - **Holdings**
1 net artwork

We all have mental maps of the places we live, which
are different than the road maps we use in unfamiliar
territory. They are usually circumscribed by where we
spend time and the routes we take, only sketchily repre-
senting the rest of the place. They are personal, reflect-
ing our preferences, such as favorite sites to eat or hang
out. They intersect with memories, such as a first kiss or
perhaps a mugging. And they are dynamic, as our life
experiences accumulate and change. The influential
urban planner Kevin Lynch called these mental maps
"images" and argued that they are an important way
to understand a city or place, from the perspective of its
inhabitants, not just its Cartesian coordinates.

PDPal (2003), a project by Julian Bleecker, Scott
Paterson, and Marina Zurkow, is like a drawing aid for
mental maps. To create it, the artists each brought a
particular set of skills to the collaboration. Bleecker is
an art technologist with a PhD in the History of
Consciousness, and he wrote the software code.
Paterson, trained as an architect, was responsible for
interface and interaction design and was, as he says,
"the linguistic glue between Marina and Julian because
I have both a design and technical background."[1]
Zurkow, with a background in animation and storytell-
ing, was the character developer and designed the
Urban Park Ranger, a chatty, animated "helper app"
whose gentle goading encourages would-be cartogra-
phers to invert the normal order of things and use the
city as a kind of mapping interface for their own psy-
chic geography.

To use *PDPal*, users either downloaded onto a PDA,
such as a Palm Pilot or other handheld digital organizer
(for in-the-field notes), or accessed via the Web site a
map of the area they are interested in annotating.[2]
Once selected, they can add personal "locales" and
routes to the map by choosing a rubber stamp to mark
and represent the spot. They then title it and select a
rating and attributes from predefined lists, which
include terms such as "prudishly," "tamely," "lustily,"
"faintly," "crowded," "comfortable," "lawless," "soggy,"
"haywire" ("My site is lustily haywire."). They can
then add a free-form description of the site.

Each map then becomes a highly individualized
image of the city, which collapses it to a kind of non-
geography of personal responses. As geographer
Denis Wood puts it, "*PDPal* . . . is all about the individ-
ual. It's *my* city it wants to let me write. It's *my* city it
wants to archive. It's *my* city it wants to exhibit."[3] At the
same time, however, it's possible to look at other peo-
ple's maps—to add them together into a "communicity,"
as the artists refer to it—which is a collective view but
from the bottom up, not the top down. In the Times
Square version of *PDPal*, viewers of maps can add their
own comments to the descriptions, as a way to gener-
ate a virtual conversation about the state of the commu-
nicity. *PDPal* is a creative tool that encourages users to
map a city—individually and collectively—in the same
ways that they interact with it: "through time, move-
ment, consumption, fantasy, memory, and projection."[4]

Steve Dietz

Notes

1. Paterson, artists' e-mail interview with the author, summer
2003, http://gallery9.walkerart.org/bookmark.html?id=624&type=
text&bookmark=1.
2. See http://www.pdpal.com for maps of the Minneapolis Sculpture
Garden and New York City's Times Square.
3. Quoted in Denis Wood, "*PDPal*," (published by Gallery 9/Walker
Art Center, 2003), http://gallery9.walkerart.org/bookmark.html?id=
599&type=text&bookmark=1.
4. Artists' interview with the author, 2003.

Julian Bleeker, Scott Paterson, and Marina Zurkow *PDPal* kiosk interface
2003 digital media Digital Arts Study Collection

Raymond Pettibon

American, b. 1957

Raymond Pettibon's iconoclastic, edgy ink drawings are reminiscent of underground comic-strip panels, pulp-magazine illustrations, or film-noir stills. They gained early recognition in the late 1970s when they appeared on album covers and other printed pieces produced by fringe rock bands such as Black Flag and Sonic Youth. These ventures led him to produce self-published books of his collated images, often crudely drawn, which he photocopied and distributed in small editions.

Since then, Pettibon's working process has continued to be a cumulative one. Though he received no formal art-school training, he nonetheless admits to learning much from the graphic styles of artists throughout history such as Francisco Goya, William Blake, John Sloan, and Edward Hopper. His pictorial subjects derive from an ongoing archive of disparate images culled from books, magazines, movies, television, and his own notes, which are then recombined or edited to visual fragments. Like frames from a comic strip, Pettibon's drawings are noteworthy for their economy. Some images appear alone, but most often they are paired with handwritten snippets of text, either the artist's own, or quotations from Henry James, John Ruskin, Christopher Marlowe, William Faulkner, James Joyce, and other writers to whom he is drawn. "You might consider my work a kind of pulling the writer out of his fictional closet, so to speak," Pettibon notes.[1] Many drawings feature recurring cartoon characters such as Vavoom[2] or Gumby, and images such as the book (especially the Bible), the train, the lightbulb, the phallus, the ocean, clouds, and other metaphorically loaded symbols that are significant to him. The convergence of image and language evokes themes ranging from the religious to the erotic to the metaphysical to the political, forming what the artist has referred to as "lyrical" fictions.[3]

Pettibon's invented vocabulary draws in part from the city of Los Angeles, where he has lived and worked for most of his life. The mystique of southern California—as a hotbed for popular culture, a surfer's paradise, a place emblemized as a land where dreams are fulfilled—weaves through much of his work. Like novelist Nathanael West or painter Edward Ruscha before him, however, Pettibon has turned his attention with equal fascination to the melancholia of Los Angeles—a curious microcosm of America itself—where the hyperbolical and utterly banal comfortably coexist.

Pettibon's works are typically exhibited in groups, sometimes of one hundred or more, and are often pinned directly to the wall. Though he works primarily on loose sheets of paper, he has also assembled groups of pen-and-ink illustrations in unique books, and since the 1990s has incorporated large-scale wall drawings into his installations that often serve as anchors for scatterings of smaller images on paper. The Walker Art Center's collection of his works forms a compendium of the artist's abiding interests. Executed on a variety of papers with materials ranging from bold pen and ink to aqueous fields of watercolor, the drawings are sometimes awkward and clumsy, at other times detailed and painterly. When viewed collectively, the pictures and texts form roving, disjointed narratives-by-association that provide an incisive and often illuminating commentary on the character of American culture.

S.E.

Notes
1. Pettibon, interview with Ulrich Loock, in Ulrich Loock, ed., *Raymond Pettibon*, exh. cat. (Bern: Kunsthalle Bern, 1995), 85.
2. Vavoom was a character from the Felix the Cat cartoons.
3. Quoted in Loock, *Raymond Pettibon*, 93.

Raymond Pettibon *No title (We almost made it out of Kansas)* 1989 ink on paper 13 7/8 x 11 in. (35.2 x 27.9 cm) Anonymous gift, 1998 1998.2

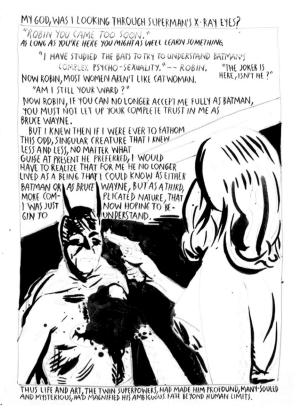

Raymond Pettibon *No title (My god, was)* 1990 ink on paper 14 x 11 in. (35.6 x 27.9 cm) T. B. Walker Acquisition Fund, 1996 1996.67

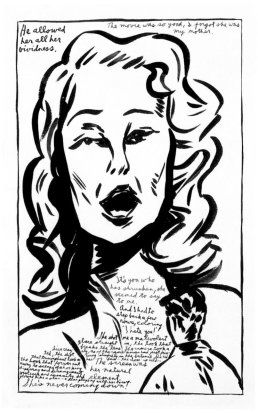

Raymond Pettibon *No title (He allowed her)* 1987 ink on paper 17 1/2 x 11 1/4 in. (44.5 x 28.6 cm) T. B. Walker Acquisition Fund, 1996 1996.61

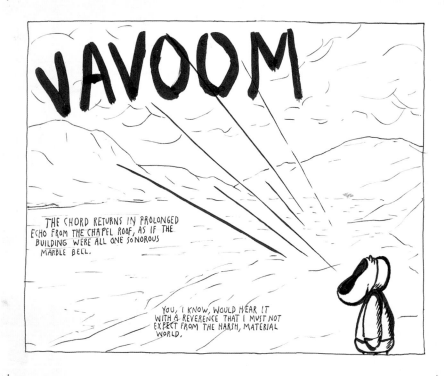

Raymond Pettibon *No title (Vavoom—The chord)* 1988 ink on paper 14 x 17 in. (35.6 x 43.2 cm) T. B. Walker Acquisition Fund, 1996 1996.64

On Raymond Pettibon's *No title (Why are we killing)*

1. Here, in this ink-on-paper drawing from 1988, we see four palookas having a *Reservoir Dogs*–style discussion—both crude and enlightened—while planning a hit on someone who's got it coming. The first line is the philosophical quandary of the hit man—why murder in a land of plenty? The second line is the throwaway laughter, and the third is the double-edged twist to leave us feeling raw and wounded. Change "control a" to "be" and it's a much simpler, sunnier, and far less interesting picture.

2. Pettibon's prose is rarely pointedly poetic. He doesn't seem to be trying too hard to impress. His drawings, too, have the feeling, at first glance, of having been thrown down with speed and a loose hand. In this one, notice that the hat of the man in the lower right was botched—the bill on it was added after the head had been drawn. But the seeming casual nature of the lines and the words give us the feeling that we want from Pettibon: that we're overhearing snippets of a conversation in progress inside someone's head—a passionate, grasping, but often dimly lit, head.

3. Questions left for us: Where is the rest of this conversation? Who are these guys? Pettibon only gives us these glimpses into seemingly complete worlds, like stills from movies—always movies from the '40s or '50s, always black and white. This is from an old noir film, about making things work during the Depression. Isn't one of those guys Peter Lorre?

4. Raymond Pettibon can be credited with kicking open the door to the acceptance of text in contemporary art. Were there others who incorporated text before him? Hundreds. But whole sentences? Sentences with narrative coherence? Not many, if any at all. Text in painting before Pettibon was almost always of the aphoristic (Kruger/Holzer), expressionistic (Nauman), or just iconic (Indiana) kind. No one dared to actually tell stories, which is what Pettibon does, much to the consternation of some: he's a storyteller. Having seen an entire show of Pettibon's work, we feel like we've read his diary, seen all of his films, read six or seven short stories and a chapbook of street poetry.

5. Last question: Why is "Spread like peanut butter." written in blue?

Dave Eggers

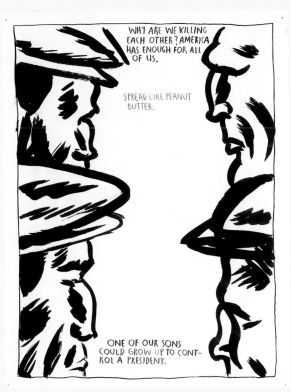

Raymond Pettibon *No title (Why are we killing)* 1988 ink on paper
13 15/16 x 10 15/16 in. (35.4 x 27.8 cm) Clinton and Della Walker Acquisition
Fund, 1995 1995.106

Elizabeth Peyton
American, b. 1965

- - **Exhibitions**
The Cities Collect (2000), *American Tableaux* (2001; publication, tour)
- - **Holdings**
1 painting, 3 drawings, 1 edition print/proof

Room 828 in New York City's Hotel Chelsea was the site of Elizabeth Peyton's 1993 breakthrough solo show of small-scale, monochromatic drawings depicting youthful visages of great historical figures such as Napoleon Bonaparte and King Ludwig II of Bavaria. Perhaps the "if these walls could talk" ambiance of this infamous hotel, which had housed the likes of Dylan Thomas in the early 1950s and Andy Warhol during the filming of his 1966 *Chelsea Girls*, contributed to the art-world buzz and critical response to her work. The faint suggestion of the impropriety of the gaze and the mastery of the artist over the model à la Matisse during his sojourns in Nice—all this was palpable despite the fact that Peyton was at the time a twenty-eight-year-old woman who had created her images from secondary source material.

By the time of her second solo show at Gavin Brown's enterprise, New York, in April 1995, Peyton had expanded her repertoire to include images of modern-day rock stars such as Sid Vicious and Johnny Rotten of the Sex Pistols. Kurt Cobain, lead singer of the 1990s grunge band Nirvana, also became a frequent subject and the first who was both a peer and an American.[1] It was not until late 1995 that she met artist Piotr Uklanski and invited him to pose for her, ushering in a body of work painted from life depicting her inner circle of friends, including Craig Wadlin and Tony Just.[2] What would become recognizable attributes of her portraits— Mannerist elongation, pale skin, and impossibly red lips—transported these images of consumptively thin and fashionable young men to the edge of androgyny. When asked if there was any difference for her between painting famous people and those whom she knows personally, the artist explained, "I think about how influential some people are in other's lives. So it doesn't matter who they are or how famous they are but rather how beautiful is the way they live their lives and how inspiring they are for others. And I find this in people I see frequently as much as in people I never met."[3] By distilling the essence of her subjects' lifestyles and life choices, the artist goes beyond representation to idealization. According to Peyton, "It's almost a nine-teenth-century idea that what's on the inside appears on the outside. Balzac was into the curve of your nose or mouth expressing some kind of inner quality that could be read on your face."[4]

In *Princess Kurt* (1995), Peyton depicts Cobain during a concert at the Praça da Apoteose Stadium in Rio de Janeiro on January 23, 1993, wearing a black lace dress and a crown, and looking to the artist "like an angel apparition."[5] The source was a still image taken from a 1994 video entitled *Nirvana: Live! Tonight! Sold Out!*, which includes live footage of the band performing the song "Dive." Peyton views Cobain through an unabashedly feminine lens, heightening his epicene quality and gender-bending sartorial statement through her use of transparent lipstick-red paint colors, which she characteristically allowed to run, drip, and stain the canvas. Here, Peyton's choice of medium goes hand-in-hand with her romanticized notions of history and permanence: "That's what oil paint's about. You know it'll last forever."[6]

E.C.

Notes
1. See Peyton, interview with Rob Pruitt and Steve Lafreniere, *Index Magazine* 4, no. 6 (June/July 2000): 57.
2. Peyton, correspondence with the author, March 17, 2004.
3. Francesco Bonami interview with Peyton, "Elizabeth Peyton: We've Been Looking at Images for So Long That We've Forgotten Who We Are," *Flash Art* 29, no. 187 (March/April 1996): 84–86.
4. Peyton, interview, *Index Magazine* 4, no. 6: 58.
5. Peyton, correspondence with Walker curatorial intern Rochelle Steiner, 1995 (Walker Art Center Archives).
6. Peyton, interview, *Index Magazine* 4, no. 6: 56.

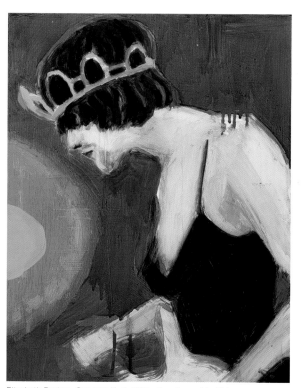

Elizabeth Peyton *Princess Kurt* 1995 oil on linen 14 x 11 in. (35.6 x 27.9 cm) T. B. Walker Acquisition Fund, 1995 1995.117

Pablo Picasso
Spanish, 1881–1973

-- **Exhibitions**
Art of the Print (1941), *Reproductions: Own Your Favorite Painting*
(1945), *A New Direction in Intaglio* (1949; catalogue, tour), *Goya
and Twentieth-Century Art* (1952), *Art in Modern Ballet* (1953), *The
Classic Tradition in Contemporary Art* (1953; catalogue), *Modern
Masterpiece: Picasso* (1953; organized by the Museum of Modern
Art, New York), *Reality and Fantasy, 1900–1954* (1954; catalogue),
Expressionism 1900–1955 (1956; catalogue, tour), *Drawings by Picasso*
(1957), *First Annual Collectors Club Exhibition* (1957; catalogue),
Second Annual Collectors Club Exhibition (1958; catalogue),
Paintings from the Stedelijk Museum, Amsterdam (1959; catalogue,
tour), *Art Fair* (1959; catalogue), *20th Century Master Prints* (1975;
tour), *Homage to Picasso* (1980), *Picasso: From the Musée Picasso,
Paris* (1980; catalogue, tour), *Picasso in Photographs* (1980; tour),
Vollard Suite (1980), *Je Suis le Cahier: The Sketchbooks of Picasso*
(1987; organized by the Pace Gallery, New York), *The Cities Collect*
(2000)

-- **Holdings**
1 painting, 1 sculpture, 6 edition prints/proofs, 1 book

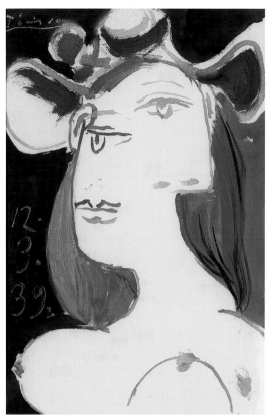

Pablo Picasso *Bust de femme au chapeau (Bust of a Woman in a Hat)*
1939 oil on paper mounted on canvas 17 1/16 x 11 1/2 in. (43.3 x 29.2 x cm)
Donated by Mr. and Mrs. Edmond R. Ruben, 1995 1995.76

Chloe Piene
American, b. 1972

-- **Holdings**
2 drawings

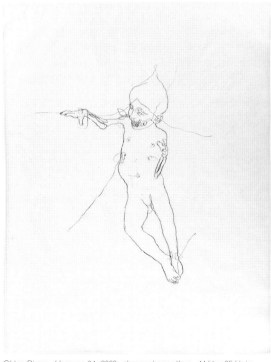

Chloe Piene *Homunc 04* 2003 charcoal on vellum 44 5/8 x 35 5/8 in.
(113.4 x 90.5 cm) T. B. Walker Acquisition Fund, 2004 2004.19

Otto Piene

German, b. 1928

-- **Commissions**

Proliferation of the Sun (1967), *Black Stacks Helium Sculpture* (1976)

-- **Exhibitions**

Light/Motion/Space (1967; catalogue), *Art and Technology* (1969),
Hennepin: The Future of an Avenue (1970), *The River: Images of the
Mississippi* (1976; catalogue, tour)

-- **Holdings**

1 sculpture, 2 gouaches/watercolors, 6 unique works on paper,
1 edition print/proof, 1 book

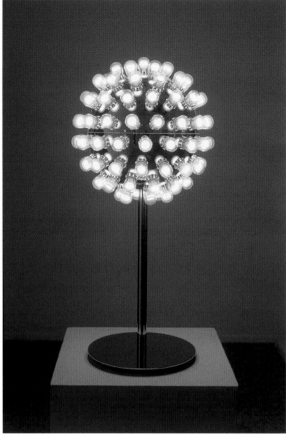

Otto Piene *Electric Flower* 1967 chromed steel, aluminum, lamps
41 1/2 x 18 x 18 in. (105.4 x 45.7 x 45.7 cm) Gift of Northern States Power Co.,
1968 1968.4

Jack Pierson

American, b. 1960

-- **Exhibitions**
Let's Entertain (2000; catalogue, tour); *American Tableaux*
(2001; publication, tour)
-- **Holdings**
1 painting, 2 sculptures, 2 books

Jack Pierson lives in a glamorous world. There are no gossip columns or paparazzi photos to prove this, but somehow viewers of his art are led to believe so. His diverse body of works—drawings, photographs, found-object sculptures, and installations—is autobiographical only in oblique ways, gently beckoning viewers to construct their own fantasies around them. Call it the glamour of the ordinary and prosaic, of anonymous scruffy young men, random landscapes infused with heart-achingly lurid colors, and textual scraps of unfinished sentences full of melancholy echoes. Though not entirely correct, there is a certain logic in the frequently drawn comparison between Pierson's art and the hustler's wanderlust in the writings of Jack Kerouac.

Silver Jackie with Pink Spot (1991), one of Pierson's early installation works, occupies a corner in the gallery. A simple combination of a black plywood platform and strips of silver Mylar, it conjures up a makeshift performance stage, no bigger than four-by-four and barely large enough to bust a move on. Christmas lights hiding behind the curtains emit little pings of reflection on the silver, and a pink spotlight adds a sense of titillation. Two cigarette butts have been casually left on the stage, jogging viewers' curiosity about the absent body: has she or he left for the night, or walked through the curtains never to look back? Although Pierson claims a post-Minimalist relevance for the work, calling it "a descendant of [Robert] Smithson or [Richard] Serra," it is difficult not to think of it as a Warholian creature. For the name "Jackie," in most people's minds, is automatically associated with that most recognizable cultural icon, Jacqueline Kennedy Onassis, whose sophisticated, revered public persona Andy Warhol immortalized in numerous silkscreen paintings. But "jackie" is another culturally specific reference: an older, derogatory street term for a gay man. Pierson remembered a scene in John Schlesinger's 1969 film *Midnight Cowboy* in which Ratso (Dustin Hoffman) says to Joe Buck (Jon Voight), "In that cowboy getup you look like every jackie out on 42nd Street."[1] When Pierson created the piece, his studio happened to be located on 42nd Street in Manhattan.

Photography, a medium he has employed regularly, creates equally rich associations, but in these works, the stories turn out to be even less revealing. Rather, they are fleeting moments of light, shadow, and hues that burn melancholy impressions on the negatives. *Frankie & Johnny* (1996), an enlarged photograph printed on canvas in acrylic lacquer, is a grainy, blurred image of a chain-link fence and ethereal foliage. The title is borrowed from an old folk song revived and reinterpreted over the years by singers such as Johnny Cash, Sam Cooke, and Van Morrison.

It is knowing muteness and insouciant detachment that are the source of Pierson's lyricism and that also make his work "insidious," as it manages to "get under your skin while pretending not to have any agenda." Another work in the Walker Art Center collection, *Beauty* (1995), is a sculpture made out of old marquee letters he scavenged in junk shops. Mismatched and scuffed, they literally spell the word without embodying any conventional vision of it. Pierson, claiming to be "inundated by the media," perhaps sees his polymorphous body of works as a tangent to, or an integral part of, the large mediated visual world in which we live, breathe, and fantasize.[2] What his art seeks to do, then, is to find dimensions of beauty that are utterly of the moment—casual, wispy, and unexpectedly enduring.

D.C.

Notes

1. All quotes in this paragraph are from Pierson's artist's statement, January 3, 1998 (Walker Art Center Archives). The line from *Midnight Cowboy* is as remembered by the artist.
2. All quotes in this paragraph are from Jack Pierson, interview with Veralyn Behenna, "Jack Pierson: Little Triumphs of the Real," *Flash Art* 27, no. 175 (March/April 1994): 90.

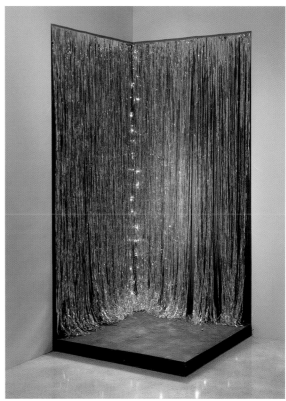

Jack Pierson *Silver Jackie with Pink Spot* 1991 plywood, silver Mylar, lights, cigarette butts, paint 100 x 48 1/4 x 48 in. (254 x 122.6 x 121.9 cm) installed Anonymous gift, 1997 1997.130

Howardena Pindell

American, b. 1943

- - **Holdings**
1 unique work on paper, 4 photographs, 1 video

In 1979, having resigned her position as Associate Curator of Prints and Illustrated Books at the Museum of Modern Art, New York, where she had worked for twelve years, and only months into her tenure as a professor at the State University of New York, Howardena Pindell was involved in a freak car accident that left her with partial memory loss. As she explains, "My work in the studio after the accident helped me to reconstruct missing fragments from the past. . . . Eight months after the accident I made *Free, White and 21* in my top-floor loft during one of the hottest summers in New York. . . . In the tape I was bristling at the women's movement as well as the art world and some of the usual offensive encounters that were heaped on top of the racism of my profession."[1] Narrating to the camera as herself, and made up as an accusatory "white woman," Pindell recounted autobiographical incidents of racism, including her experiences in New York following her graduation from Yale in 1967.

Free, White and 21 (1980)—clearly symptomatic of Pindell's role as a prominent antiracist, antisexist activist—remains her best-known work, despite the fact that the video is unrepresentative of a large part of her art practice. The reasons for this are enmeshed in the subject of the tape, namely the expectations and stereotypes of a black woman artist, from both inside and outside the art world. As photographer Dawoud Bey has suggested, despite the generalized authorization of diversity by cultural institutions since the proliferation of theories of race and representation during the 1980s, there has been a tendency to favor "an endless inspection of the forever beleaguered racialized self" at the expense of a whole other ecology of art practiced by artists of color, including conceptual, formalist, and decorative strategies.[2] Pindell's photographs, works on paper, and sewn canvases are an important component of this suffocated history.

Having worked through figurative painting and Abstract Expressionism, in the early 1970s Pindell had begun to create painted surfaces by using punched metal or paper as stencils. The piece *untitled #6* (1975) is made from thousands of tiny confettilike paper discs that the artist had saved from this process. Nearly every dot stuck on the graph paper is numbered in pen, though there is no perceivable logic to the arrangement. Pindell's father was a mathematician, and here she put the tools of his trade—numbers—to work on her own terms to summon a bewildering aesthetic equation of subtle complexity. In addition to *Free, White and 21* and *untitled #6*, the Walker Art Center's collection also includes four examples from the artist's photographic series *Video Drawings* (1973–1976), which further explore a form of unfathomable notation. By affixing clear acetate that she'd garnished with nonsensical annotations to a television screen, Pindell was able to photograph whatever was being broadcast at

that time—a high-diver preparing to jump, or a close encounter with a UFO, for example. The resultant frame-diagrams appear to be disconcertingly arcane interpretations of frozen moments in time, as if several permutations of what might happen next were being calculated, or Zeno's notorious "arrow paradox" were being explained away.[3]

M.A.

Notes

1. Howardena Pindell, "Free, White and 21," *Third Text* 19 (Summer 1992): 32. The video was first shown in *Dialectics of Isolation: An Exhibition of Third World Women Artists of the United States*, organized by Ana Mendieta at the A.I.R. Gallery, New York, in the fall of 1980.
2. Dawoud Bey, "The Ironies of Diversity, or the Disappearing Black Artist" (2004) on the Web site http://www.artnet.com/Magazine/features/bey/bey4-8-04.asp?C=1.
3. Zeno was a pre-Socratic mathematician; his "arrow paradox" is described by Aristotle: "If, says Zeno, everything is either at rest or moving when it occupies a space equal (to itself), while the object moved is always in the instant (in the now), the moving arrow is unmoved." See Thomas Heath, *A History of Greek Mathematics*, vol. I (Oxford, England: Clarendon Press, 1921), 276.

Howardena Pindell *Video Drawing* from *Swimmers* Series 1973–1976 color photograph 11 x 14 in. (27.9 x 35.6 cm) Gift of the Peter Norton Family Foundation, 1993 1993.51

Howardena Pindell *Video Drawing* from *Swimmers* Series 1973–1976 color photograph 11 x 14 in. (27.9 x 35.6 cm) Gift of the Peter Norton Family Foundation, 1993 1993.50

Adrian Piper

American, b. 1948

- - **Exhibitions**

Artists' Books (1981), *The Last Picture Show: Artists Using Photography, 1962–1980* (2003; catalogue, tour)

- - **Holdings**

3 drawings, 1 photographic suite, 3 books

"Dear Friend/I am black./I am sure you did not realize this when you made/laughed at/agreed with that racist remark." Thus read the opening lines of Adrian Piper's *My Calling (Card) #1* (1986–1990), a short message typed on a note card. Whenever the artist found herself in the presence of racist behavior by someone not cognizant of her mixed-race identity, she approached the perpetrator and silently handed over one of the calling cards. The "performance" was designed as a rational alternative to racial self-identification, which, Piper states elsewhere on the card, had caused people to perceive her as "pushy, manipulative, or socially inappropriate." But is such a textual act any less forceful than direct verbalization or protest?

Born in the Bronx, New York, in 1948, Piper came of age in the late 1960s and early 1970s, when Minimalism and Conceptual Art were irrevocably transforming the topography of artistic practice and providing the young artist with crucial lessons.[1] As exemplified in the aforementioned work, however, her art has always sought to transform the strategies of direct address and physical presence devised by the neo-avant-gardes into those of social criticism and political confrontation. And confrontation, as the artist has stated, is "therapeutic and also catalytic."[2]

In 1972, while a doctoral student in philosophy at Harvard, Piper began performing the "Mythic Being," a male alter ego with an afro, a pencil mustache, dark shades, a villainous grin, and an incessant cigarette in his mouth. In resulting performances, photographic documentation, and drawings, the Mythic Being enacted various masquerades of aggression and intimidation as well as philosophical reflection. *The Mythic Being: I/You (Her)* (1974), in the Walker Art Center's collection, consists of ten identical black-and-white photographs that show Piper's smiling face and a female companion in the lower left corner. Against chill black backgrounds are floating talk bubbles, filled in with the artist's soliloquy, which progresses from one photograph to the next. It narrates a friendship gone sour and obliquely suggests that the liaison between the two women had been quite intimate but met with a disastrous end. In one place, it is even implied that the artist's race might have been a factor in the relationship's demise. As a range of raw emotions—from regret, grief, and bitterness to rage—are revealed with an escalating intensity, Piper's face is gradually transformed with ink additions, ending as the full-blown, menacing Mythic Being.

The practice of drawing on preexisting imagery takes an especially visceral turn in the *Vanilla Nightmares* series, which Piper began in 1986 and continued until 1989.[3] In it, black figures drawn with charcoal and oil crayon emerge on the pages of the *New York Times* like spectres suddenly assuming physical forms to cross the threshold of visibility and invade the comfort zone of reason. They are summoned by headlines dealing with race and its perilous politics or by egregiously exoticist or sexist pandering to consumer desires in advertisements. In one work, a lone, black, "savage" male figure creeps up on an impassive female model featured in a Bloomingdale's ad titled "Street Safari," an urban fashion supposedly inspired by the romantic colonial imagination of wild nature. In another, a scowling and fist-waving mob appears next to the headline "Affirmative Action Upheld by High Court as a Remedy for Past Job Discrimination," and letters spelling "What if …?" are scrawled across the masthead. These disquieting, sometimes salacious, images tap into and give form to the enduring cultural fascination with slavery and black magic as well as racialized myths of miscegenation (consensual or otherwise) that are still seething just beneath the surface of our collective unconscious.

My Calling (Card) #1 closes with a twist: "I regret any discomfort my presence is causing you, just as I am

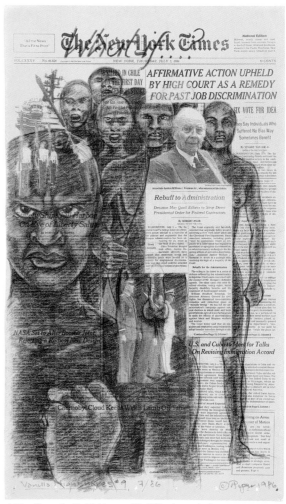

Adrian Piper *Vanilla Nightmares #9* 1986 charcoal, oil crayon on newspaper 22 x 13 3/4 in. (55.9 x 34.9 cm) T. B. Walker Acquisition Fund, 2004 2004.7

sure you regret the discomfort your racism is causing me." Irony and melancholia infuse the sentence, reminding us that it is precisely through discomfort that Piper's art cuts into the fortress of our injured consciousness, and such discomfort just might help to cure it.

D.C.

Notes
1. This point is argued in Maurice Berger's essay, "Styles of Radical Will: Adrian Piper and the Indexical Present," in Maurice Berger, ed., *Adrian Piper: A Retrospective*, exh. cat. (Baltimore: Fine Arts Gallery, University of Maryland Baltimore County, 1999), 12–32.
2. Maurice Berger, "The Critique of Pure Racism: An Interview with Adrian Piper," in *Adrian Piper: A Retrospective*, 80.
3. There are a total of twenty-one pieces in the *Vanilla Nightmares* series, and three (#3, #9, #10) are in the Walker collection.

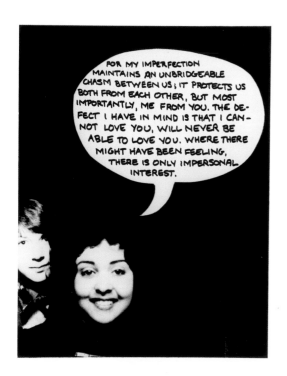
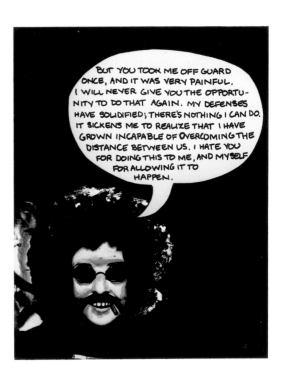

Adrian Piper Selections from *The Mythic Being; I/You (Her)* 1974 black-and-white photographs, ink 8 x 5 in. (20.3 x 12.7 cm) each of 10 T. B. Walker Acquisition Fund, 1999 1999.14

Keith Piper

British, b. 1960

Notes
1. Quoted in Caroline Smith, "The Sample Art of Keith Piper," *Creative Camera*, no. 335 (August/September 1995): 31–33.

- - **Exhibitions**
American Tableaux (2001; publication, tour), *The Squared Circle: Boxing in Contemporary Art* (2003; publication)
- - **Holdings**
1 unique work on paper, 1 multimedia work

Keith Piper has never shied away from complex provocations. In his early twenties, he helped form the BLK Group, an organization of black British students using art to respond to the collision of nation, history, identity, and culture in 1980s Thatcherite England. Echoing the practice of hip-hop that was just emerging at that time, Piper used his art to challenge assumed definitions of "British," "black," and "art" with installations that sampled and remixed various media, including text, photography, video, sound, and digital elements.

Race and masculinity, especially as embodied by sports heroes, have been recurring themes in his cultural excavations. In particular, he has repeatedly explored boxing, since this controversial sport has often served as a site of racially charged political struggle as far back as the eras of Jack Johnson and Joe Louis. In the installation *Transgressive Acts (A Saint Amongst Sinners/A Sinner Amongst Saints)* (1993/1994), Piper creates a chapel-like setting: a white pulpit on which the good book is opened to a quote from *Invisible Man*, Ralph Ellison's classic novel of racial allegory, faces two light boxes featuring life-size images of fighters Muhammad Ali and Mike Tyson seeming to rise out of the flames. Along either side wall are several softly illuminated texts ruminating on the themes of race, identity, and masculinity. More as provocation than declaration, Piper designates Ali the saint and the mind while Tyson is the sinner and the body, thus pitting these two boxing icons against one another in a battle of good versus evil. He remarks, "Both fighters stood out in opposition to what was seen as the acceptable behavior for the visible black male of the time."[1] Ali, now worshipped as a global sports hero and uncompromising political activist, was vilified in the late 1960s—despite his gift for dazzling poetry and lethal punches—when he joined the Nation of Islam and refused to fight in the Vietnam War. Tyson, on the other hand, emerged in the 1980s as a pure fighting machine. He was idolized for his supreme and brutal physicality, nothing more; that is, until his troubled personal life began to spill beyond the ring and he too moved from hero to villain.

Whereas Ali has risen in the public consciousness above his controversial past, Tyson remains a victim of his own bad choices. Yet each man is trapped by the limits of a public imagination that won't recognize him as a fully realized human being. Casting his twin icons in reverential yet confrontational light boxes, Piper ultimately allows them to stand side by side in sainthood, acknowledging the beauty and the beast in each. In this powerful work, redemption is the transgressive act.

O.I.

Keith Piper *Transgressive Acts (A Saint Amongst Sinners/A Sinner Amongst Saints)* 1993/1994 (detail) book, ink-jet images, dried flowers, wood podium, light boxes, Cibachrome transparencies, plexiglass, offset lithographs on tracing paper, wood shelves, lightbulbs, pendulum lamp installed dimensions variable Justin Smith Purchase Fund, 1995 1995.1

Steven Pippin

British, b. 1960

Steven Pippin Selections from *Laundromat/Locomotion (Walking without trousers) LL 08* 1997 black-and-white contact prints; edition 1/5 30 x 30 in. (76.2 x 76.2 cm) each of 12 T. B. Walker Acquisition Fund, 1998 1998.110

Michelangelo Pistoletto
Italian, b. 1933

- - **Exhibitions**
Michelangelo Pistoletto: A Reflected World (1966; catalogue), *Artists'
Books* (1981), *The Cities Collect* (2000), *Zero to Infinity: Arte Povera
1962–1972* (2001; catalogue, tour)
- - **Holdings**
2 paintings, 1 sculpture, 2 books

Michelangelo Pistoletto came of age in the 1960s as one
of a generation of artists radically exploring new aes-
thetic territories: reinventing a synthesis of art and life
in the context of postwar consumer culture. A multidis-
ciplinary approach informs his art with works ranging
from paintings, sculptures, and photographs to perfor-
mances and installations that often blur the boundaries
between media. Best known as one of the leading fig-
ures of Arte Povera, Pistoletto began his career as a
painter in the mid-1950s, focusing primarily on self-por-
traiture. He soon abandoned the post-Informel
approach that defines his early work—with its existen-
tial anxiety and debt to British artist Francis Bacon—
and in 1962[1] started working on a series of large works
combining photography, painting, and collage.[2] He
called them *quadri specchianti* (mirror paintings): life-
size images based on enlarged photographs, which are
rendered in oil and pencil on translucent tissue-paper
silhouettes and then glued onto stainless-steel surfaces
so polished that they become reflective.

The definition of *quadri specchianti* implies the idea
of process (*specchianti* literally means "mirroring/
reflecting"). Like the phenomenological "open work"
described by Italian theorist Umberto Eco, Pistoletto's
reflecting works are paintings whose "subject . . . is the
background, conceived as the possibility of continuous
metamorphosis."[3]

A key example of *quadri specchianti* is *Tre ragazze
alla balconata* (*Three Girls on a Balcony*) (1962–1964)—
viewed from the back, three women are portrayed
leaning on the rail of a balcony, their pose crystallized
in the memory of a photograph.[4] The figures belong to
the realm of the everyday, yet they remain mysterious
and enigmatic. They are fragments of an impossible
narrative whose linear continuity has been lost, just like
the estranged characters of a Michelangelo Antonioni
film. The motif of the balcony conveys the dialectics
between looking and being looked at, looking in and
looking out, thus functioning here as a metaphor for
painting: a space "in between" where presence and
absence, stasis and dynamism meet. While playing
with the Renaissance idea of a painting as a window
on the world, Pistoletto conceives of art as a *field* of
forces constantly in the making. Expressing his concep-
tual strategy, he has declared: "The entire system of
representation has been flip-flopped. The system has
arrived at a reflection of itself."[5] Art is potentially turned
from finished object into ever-changing *spectacle*.[6]

Inscribed in the context of postwar American and
European art of the late 1950s and early 1960s (repre-
sented in Italy by artists Lucio Fontana and Piero
Manzoni, among others), Pistoletto's *quadri specchianti*

participate in the reaction to Abstract Expressionism
by means of a gesture of erasure: the annihilation of
the painterly ego through the use of photography as a
source for the figure and the invention of a mirrorlike
background incorporating the viewer's physical pres-
ence. Contemplation is transformed into *con temp
l'azione* (with time action), to borrow the title of a
renowned Italian event-exhibition.[7]

The idea of painting as a space to inhabit is further
developed in another series of works known as the
Oggetti in meno (*Minus Objects*). Exhibited by Pistoletto
in his studio in 1966, these works obliterate the distinc-
tion between public gallery space and private living
space. *Quadro da pranzo* (*Lunch Painting*) from 1965 is
one of these minus objects. In the artist's words, "Unlike
the mirror paintings, my new objects do not represent:
they are . . . objects through whose agency I free myself
from something—not constructions, then, but libera-
tions. I do not consider them more but less, not pluses,
but minuses."[8] *Quadro da pranzo* consists of a wooden
structure containing in its "frame" two life-size wooden
chairs and a table in a simplified geometric design.
Part painting, part sculpture, part everyday object, this
work incorporates the white wall onto which it is posi-
tioned, challenging the very idea of art and its presen-
tation. The title itself expresses a provocative synthesis
of art and life by turning the idea of the tableau into an
object. As we entered and exited the mirror paintings,
now we are invited to live in the painting, sitting on it
and inside it. The conceptual aspect is integral to the
work. As Pistoletto has written, "To the idea of the wall
can be 'attached' the idea of painting, to which the idea
of the object can be 'attached,' to which the idea of the
subject can be 'attached.' "[9]

Francesca Pietropaolo

Notes
1. Pistoletto has retrospectively defined as his first mirror painting the
1961 work *Il presente* (*The Present*). Although realized in acrylic and
varnish on canvas, its luminous background projected his reflection
into the painting, thus suggesting to him the idea of mirrorlike
surfaces. See Michelangelo Pistoletto, "Gli oggetti in meno," in
Michelangelo Pistoletto, exh. cat. (Genoa: Galleria La Bertesca, 1966),
reprinted in Michelangelo Pistoletto, *A Minus Artist* (Florence:
Hopefulmonster, 1988), 12–14.
2. Martin Friedman has noted that the collaged photographic image
functions here as the "catalyzing force which makes the spectator
enter into new spatial and psychological relationships." Martin
Friedman, *Michelangelo Pistoletto: A Reflected World*, exh. cat.
(Minneapolis: Walker Art Center, 1966), unpaginated. The Walker
exhibition in 1966 was the first U.S. museum presentation of
Pistoletto's work.
3. Umberto Eco, *Opera aperta* (Milan: Bompiani, 1962), 136. (Trans.
Francesca Pietropaolo). Among the key sources for Eco's reflections
on art (painting, sculpture, literature, music, and film) are French
philosopher Maurice Merleau-Ponty and American philosopher John
Dewey, both crucial references in the cultural debate of the 1960s in
Italy. See also Corinna Criticos, "Reading Arte Povera," in Richard
Flood and Frances Morris, eds., *Zero to Infinity: Arte Povera 1962–1972*,
exh. cat. (Minneapolis: Walker Art Center, 2001), 67–88.
4. As philosopher Roland Barthes has noted, "Death is the *eidos* of
that Photograph." To Pistoletto, the photograph "has its origin in the

past; . . . but its life continues and is extended within . . . the mirror pictures." See Roland Barthes, *Camera Lucida: Reflections on Photography*, trans. Richard Howard (New York: Hill & Wang, 1981), 15; and Michelangelo Pistoletto's interview with Martin Friedman, 1966 (Artist correspondence, Walker Art Center Archives).

5. Michelangelo Pistoletto, *"L'immagine e il suo dop(pi)o"* ("The image and its double"), *Bit* 1 (December 1967): 9.

6. Pistoletto would subsequently develop the idea of art as spectacle through a series of performances. See Alanna Heiss and Germano Celant, eds., *Pistoletto: Division and Multiplication of the Mirror* (New York: Institute for Contemporary Art P.S.1 Museum, 1988), 32.

7. In 1967 critic Daniela Palazzoli organized a joint group show at the Stein, Sperone, and Il Punto galleries in Turin under the title *Con temp l'azione* (*with time action*), which plays in Italian with *contemplazione* (contemplation). Pistoletto participated by rolling, assisted by Maria Pioppi, his *Palla di giornali* (*Ball of Newspapers*) on the streets of the city, from one gallery to the next.

8. Pistoletto, "Gli oggetti in meno," reprinted in *A Minus Artist*, 12–14.

9. In the original text: "all'idea del muro può stare attaccata l'idea del quadro a cui può stare attaccata l'idea dell'oggetto, a cui può stare attaccata l'idea del soggetto." Trans. Francesca Pietropaolo.

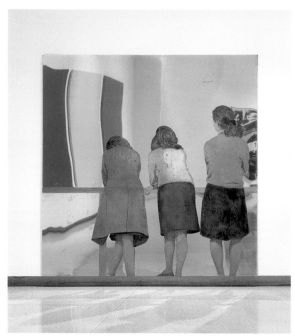

Michelangelo Pistoletto *Tre ragazze alla balconata* (*Three Girls on a Balcony*) 1962–1964 oil, graphite on tissue paper mounted to mirror-polished stainless steel 78 3/4 x 78 3/4 in. (200 x 200 cm) Gift of Mrs. Julius E. Davis, 1999 1999.33

Michelangelo Pistoletto *Quadro da pranzo (Oggetti in meno)* (*Lunch painting [Minus objects]*) 1965 wood 78 3/4 x 81 3/4 x 17 3/8 in. (200 x 207.7 x 44.1 cm) T. B. Walker Acquisition Fund, 2002 2002.217

Sigmar Polke

German, b. 1941

- - **Exhibitions**

Photography in Contemporary German Art: 1960 to the Present (1992; catalogue, tour), *Sigmar Polke: Editions, 1966–1995* (1995; tour), *Sigmar Polke: Illumination* (1995; catalogue), *The Cities Collect* (2000), *The Last Picture Show: Artists Using Photography, 1960–1982* (2003; catalogue, tour)

- - **Holdings**

1 painting, 1 drawing, 2 unique works on paper, 5 photographs, 78 edition prints/proofs, 1 portfolio of prints, 3 monoprints/monotypes, 6 multiples, 8 books, 1 periodical, 1 poster, 3 postcards

Sigmar Polke has constantly defied aesthetic boundaries in his work, extending the visual vocabularies of painting, photography, and printmaking through a mercurial working process. His investigations into the effects that can be achieved by embracing a vast range of materials, pictorial sources, and art practices have been highly influential to successive generations of artists. Within his wealth of material can also be found mystery—he is frequently called enigmatic, elliptical, obscure. Over the past forty years, he has created a body of work that continues to provoke and entrance, marking a significant bridge between the twentieth century and the twenty-first.

Polke was born in 1941 in Oels, Silesia (the eastern part of Germany at the time), now Olesnica, Poland. His father was trained as an architect and descended from ironworkers who had decorated Baroque churches. When Polke was twelve, his family immigrated to West Germany. At eighteen, he apprenticed with a glass painter, learning a centuries-old art form that was experiencing a revival due to the need for restoration after the war. From 1961 to 1967, he was enrolled at the Kunstakademie Düsseldorf, an environment rife with ideas.[1] The highly influential artist Joseph Beuys taught there from 1961 to 1972, and its students in the 1960s were eager to bring to their work a new sense of the social and democratic. Many felt the reverberations of American Pop Art, with its appropriation of commercial images, and the more international movement of Fluxus, which drew from performative impulses and pedestrian, often found materials. It was during this period that Polke, together with fellow students Gerhard Richter and Konrad Lueg,[2] cofounded a movement that was coined "Capitalist Realism" in 1963.[3] The term was a rhetorical play on Socialist Realism, then the official style of East Germany. Polke's paintings of the period embraced banal subject matter and verbal and pictorial clichés of advertising. His "dot paintings," or *Rasterbilder*, produced between 1963 and 1969, were hand-painted renditions of mechanically generated images (mainly found photographs), and were both a parody of and commentary on the slickness of mechanical reproduction appearing in American Pop.

Polke has always been an avid documenter, and has used photography as a tool to record both his surroundings and events performed for the camera. In his earliest photographs, such as *Bamboostange Liebt Zollstockstern* (*Bamboo Pole Loves Folding Ruler Star*)

(1968–1969), he continued to embrace the quotidian subject matter of his paintings. The series of fifteen deadpan black-and-white photographs was taken with a Rollei, a box camera that produces 120-millimeter square negatives. Polke's camera had a faulty shutter, which could yield somewhat hallucinatory double exposures.[4] Arrayed in three rows, the photographs depict a curious lexicon of commonplace objects—a ruler, a pitcher spilling paper "liquid," a pair of scissors suspended over a glass of water—that through the artist's deft staging appear to take on magical properties. The images are imparted with his signature merging of the playful and the serious, and though seemingly straightforward, emerge as eerily iconic. In the 1970s, Polke began an intensive exploration of photography and film, traveling in France, Brazil, Afghanistan, Pakistan, and the United States. The rich and innovative work from this period would influence his activities in other media as he explored the mutability of imagery via the chemical world of the darkroom.

As he matured as a painter, Polke increasingly began to draw upon allusion as subject in his work, invoking not only the here and now of contemporary life but also history, art history, allegory, and myth. His experimentation with photographic chemicals in the 1970s laid the groundwork for a body of paintings in the 1980s that were grandly scaled pictures made on a panoply of synthetic fabrics with metallurgic substances and chemicals that changed color with variances in temperature and humidity. He also began to explore the effects of painting on translucent surfaces, creating a tour de force body of large-scale paintings executed on skins of synthetic fabric in lieu of traditional canvas.

Sigmar Polke *Apparat, mit dem eine Kartoffel eine andere umkreisen kann* (*Apparatus Whereby One Potato Can Orbit Another*) 1969 wood, batteries, wire, screws, rubber band, battery-driven motor, potatoes; edition 9/30 31 1/2 x 16 1/4 x 16 1/4 in. (80 x 41.3 x 41.3 cm) Published by Edition Staeck, Heidelberg, Germany T. B. Walker Acquisition Fund, 1994 1994.131

His use of common textiles was not new: earlier paintings had combined representational imagery with the existing textures and patterns of such supports as tablecloths, upholstery fabrics, blankets, and dish towels. On the sheer polyester of the later paintings, which revealed the grid of wooden stretcher bars beneath, Polke layered washes of lacquer, artificial resin, and varnish. These abstractions became a veil for an arsenal of appropriated material—the artist is an omnivorous collector of images—ranging from early European engravings and illustrations to graphics drawn from contemporary print media and advertisements.

In 1994, the Walker Art Center acquired a comprehensive archive of prints and other editioned works spanning the first thirty years of Polke's career. This growing collection comprises a remarkable body of work, including prints, photographs, three-dimensional constructions, artist's books, and other special publications. Just as Polke's paintings have been a means for him to explore his experimental attitude toward materials, his editions are fashioned from an eclectic array of pigments on surfaces that include velour, imitation leather, and wallpaper. He has also made forays into sculptural editions, as in the 1969 multiple *Apparat, mit dem eine Kartoffel eine andere umkreisen kann* (*Apparatus Whereby One Potato Can Orbit Another*), an offhanded homage to Marcel Duchamp's iconic bicycle wheel, in which Polke affixed a found object—in this case a potato—to the underside of a stool, where it circles a second potato with the aid of a simple motor.[5] Many of his editions also incorporate photography, both in their imagery and in the use of photographically derived printing techniques, as in *Freundinnen* (*Girl Friends*) (1967), an early "dot" print based on an image enlarged from the newspaper, then commercially reprinted.

One of the artist's seminal print works is the photo-based series *Higher Beings Command* (1967). The images in the portfolio initially seem to suggest a narrative, though their relation to one another is ambiguous.[6] A number of the prints reference the palm tree, an image Polke cunningly constructs from such unlikely materials as cotton, glass, bread dough, buttons, a glove, and the human body. He appears in action in at least five of these prints, inviting the series to be read as both a performance and a fragmented self-portrait, one that might provide insight into the mind of an artist who has continued to elude, fascinate, and expand the possibilities of his craft.

S.E.

Notes

1. At the Kunstakademie, Polke studied primarily with Karl Otto Götz and Gerhard Hoehme. By the end of the 1950s, German art academies were dominated by German versions of post-Surrealist automatist movements such as Tachisme (exemplified by the 1953 Group, of which Hoehme was a part), and Art Informel.

2. Konrad Lueg (1939–1996), a painter, also had an illustrious career as an art dealer under the name Konrad Fischer.

3. In October 1963, Lueg and Richter staged a performance in a Düsseldorf furniture store, where they positioned themselves in lounge chairs perched on pedestals. The action was entitled "Life with Pop: A Demonstration for Capitalist Realism." See Karl Ruhrburg, "Revolt and Acceptance—Düsseldorf in the Sixties," in Klaus Schrenk, ed., *Upheavals, Manifestos, Manifestations: Conceptions in Art at the Beginning of the Sixties*, Berlin, Düsseldorf, Munich, (Cologne: DuMont Buchverlag, 1984), 86–97.

4. For a discussion of Polke's earliest photographic techniques and imagery, see Maria Morris Hambourg, "Polke's Recipes for Arousing the Soul," in Paul Schimmel, ed., *Sigmar Polke Photoworks: When Pictures Vanish*, exh. cat. (Los Angeles: Museum of Contemporary Art, 1995), 39–50.

5. Potatoes are a food whose generative capacity fascinated the artist. He used them as the subject of a number of early works, including *Kartoffelhaus* (*Potato House*) (1967), which he documented in photographs.

6. The images in the portfolio are based on photographs taken by Polke and Chris Kohlhöfer between 1966 and 1968.

Sigmar Polke *Freundinnen* (*Girl Friends*) 1967 offset lithograph on paper; edition 23/150 18 7/8 x 24 in. (47.9 x 61 cm) Published by Edition h, Hannover T. B. Walker Acquisition Fund, 1994 1994.93

Sigmar Polke *Bamboostange liebt Zollstockstern* (*Bamboo Pole Loves Folding Ruler Star*) 1968–1969 black-and-white photographs 23 7/8 x 19 13/16 in. (60.6 x 50.3 cm) each of 15 T. B. Walker Acquisition Fund, 1995 1995.77

Sigmar Polke *Frau Herbst und ihre zwei Töchter* (*Mrs. Autumn and Her Two Daughters*) 1991 artificial resin, acrylic on synthetic fabric 118 x 196 3/4 in. (299.7 x 499.8 cm) Gift of Ann and Barrie Birks, Joan and Gary Capen, Judy and Kenneth Dayton, Joanne and Philip Von Blon, Penny and Mike Winton, with additional funds from the T. B. Walker Acquisition Fund, 1991 1991.70

On Sigmar Polke's *Frau Herbst und ihre zwei Töchter*

What we see is remote and charming. It reminds us of the fairy tales we heard as children, about where snow comes from. The nineteenth-century lady and her two neatly dressed daughters sit on a cloud whose curves are the furbelows of her crinoline. It is all long ago and far away, black, white, and sepia. The image of Madame Autumn comes from J. J. Grandville's *Un Autre Monde* (*Another World*) (1844), which illustrates Dr. Puff's fantastic journey into an alternative world. Polke's Frau Herbst immediately also recalls Frau Holle, in the story collected by the Brothers Grimm. Frau Holle makes snow by shaking the feathers out of her mattress. In their *German Mythology*, the Grimms connect her with the old German goddess Holda, who rides with the Wild Hunt. Frau Holle is connected with spinning. It is worth remarking that Frau Herbst has neither featherbed nor spindle but a pair of shears, with which she is shredding paper or cloth. And the shears associate her with Atropos, the third Fate, Milton's "blind Fury with th'abhorred shears." We begin to notice that the facial expressions of the three ladies are grim.

Polke's visual world is made up of a web of allusions, puns, motifs, connecting threads. This is why he responds to Grandville, who plays games with shape-shifting animals and animated machines. In his *Laterna Magica* (*Magic Lantern*) (1988–1996), for instance, Polke juxtaposes Grandville's fantasy lizards with the modern mechanical toys, Transformers. Scissors—*schere*, shears—appear elsewhere in Polke's work. So do the falling squares of cut material. They appear, for instance, in *Radio aktiver Abfall* (*Radioactive Garbage*) (1992) where they blank out and partly obliterate hooded white figures with Geiger counters, cut out on a tartan cloth whose colors are dull fires. They appear like sprinkled tinsel on a painting called *Yggdrasil* (1984), where the Norse World-Ash is three bared wooden beams, a cross between a tree and a Cross.

The great slick of white paint against which the delicate fragments fall is related to Polke's very German abstract paintings of veils and clouds of color in which you are asked to see half-formed spectres and goblins, as in his lovely, cavernous *Apparizione* (*Apparition*) (1992). It is both threatening (nuclear winter? The Fimbul-Winter that precedes the Norse Ragnarok, the end of the world?) and beautiful. Beyond it are half-formed or forming shapes, like nebulae.

The visual beauty of the work depends on transparency and tricks of perspective. I have come to understand that Polke's use of old engravings and woodcuts is moving partly because he turns them into fine linear webs over transparent resin, behind which are the bare struts of the frame. The transparency of the detailed old images plays against the transparency of the resin, and against the translucent brushstrokes. It takes away the images' solidity. The mountain in the tiny landscape at the bottom left resembles the sectioned one in his *Die drei Lügen der Malerei* (*Three Lies of Painting*) (1994), with snow where the *Three Lies* has space. It is a vanishing Caspar David Friedrich world, its tiny inhabitants moving away from us into cold distance. The mountain is dwarfed by the echoing shape of the goddess on her neat cloud. Slowly we see that behind her is yet another rounded hummock, or storm cloud, or smear, evanescent and ambiguous. Nothing is stable. Everything can be read several ways. It is pure Polke, not innocent, and curiously exciting.

A. S. Byatt

Richard Pousette-Dart
American, 1916–1992

- - Holdings
1 painting

In 1951, *Life* magazine published a now-canonical photograph of fifteen artists of the New York School who had been dubbed "the Irascibles."[1] The picture includes most of the group's major figures—Barnett Newman, Ad Reinhardt, Willem de Kooning, Mark Rothko, Robert Motherwell, and Jackson Pollock. Among them, too, is Richard Pousette-Dart—in 1951, a key member of the avant-garde whose career was unfolding with great promise. Yet, as the *Life* photographer was composing the image that helped secure his role in a seminal art-historical moment, Pousette-Dart felt "fiercely by myself"[2] and was on the verge of abandoning New York because of commercial pressures that he felt were damaging to his work. As he explained later that year, "The artist must beware of all schools, isms, creeds, or entanglements that would tend to make him other than himself. He must stand alone, free and open in all directions for exits and entrances."[3] By the end of 1951, he had moved his family and studio to rural New York, where he remained for the rest of his life.

Although he chose to isolate himself from his contemporaries just as he was achieving widespread recognition, his work of the 1940s reflects their shared interests and beliefs. He studied Asian philosophy and read Carl Jung's work on archetypes and Mircea Eliade's writings on myth and totemic imagery in Africa, Asia, and other non-Western cultures. Through his parents—artist Nathaniel Pousette and poet Flora Dart, who hyphenated their surnames in an early gesture toward equality of the sexes—he was exposed to modernist works by Pablo Picasso, Paul Klee, and Joan Miró as well as the mystical doctrines of theosophy, of which Dart was a devotee. He also studied American transcendentalism in the paintings of Albert Pinkham Ryder and the writings of Ralph Waldo Emerson.

During the 1940s, these ideas and influences gelled in powerful, semiabstract paintings such as *Symphony Number 1, The Transcendental* (1941–1942), a cacophony of cosmic pictographic symbols that—at 7 1/2-by-10-feet in size—is now considered the first epically scaled Abstract Expressionist painting. It was made at a time when Pousette-Dart was an outspoken pacifist, and it communicates both the chaos of wartime and the artist's wish to transcend it. The Walker Art Center's painting, *Figure*, dates from the climactic war years of 1944 to 1945 and seems to be a more direct depiction of the evil that had spread in Europe. A grinning, flailing wraith is drawn in calligraphic flourishes of black and white over a colorful grid of abstracted fish, birds, and flowers—the figure is both palpable and diaphanous, like a puff of poison smoke that hangs over the natural world.

After the end of the war and his move to the country, Pousette-Dart's compositions became more ordered and quiet, eventually dematerializing into airy, pointillist fields of color. The evolution of his work from post-

Surrealist figuration toward pure abstraction is a familiar trajectory in the history of Abstract Expressionism, but he refused to embrace "the tragic," which Rothko and others considered an essential feature of the abstract sublime; in this, his work differs fundamentally from theirs.[4] In contrast, Pousette-Dart considered his art inseparable from religion—both constituted, for him, "the living adventure of the creative."[5]

J.R.

Notes
1. The photo was taken by Nina Leen in 1950 and published in the January 15, 1951, issue of *Life* with the article "Irascible Group of Advanced Artists Fight against Show." In May 1950, the Irascibles had protested what they saw as the anti-abstractionist bias of the Metropolitan Museum of Art in New York.
2. Quoted in Joanne Kuebler, "Concerning Pousette-Dart," in Robert Hobbs and Joanne Kuebler, eds., *Richard Pousette-Dart*, exh. cat. (Indianapolis: Indianapolis Museum of Art, 1990), 18.
3. Ibid., 16.
4. This has been pointed out by both Irving Sandler, in *Pousette-Dart: Paintings from the '40s and '50s* (New York: Knoedler, 1996), and Donald Kuspit, "Return to Aura: The Late Paintings," in *Richard Pousette-Dart*.
5. Quoted in Kuebler, "Concerning Pousette-Dart," 16.

Richard Pousette-Dart *Figure* 1944–1945 oil on canvas 79 7/8 x 49 7/8 in. (202.9 x 126.7 cm) Partial gift of Mary and Bob Mersky, 2003 2003.56

Richard Prince

American, b. Panama Canal Zone, 1949

- - **Exhibitions**

The Cities Collect (2000), *Let's Entertain* (2000; catalogue, tour), *American Tableaux* (2001; publication, tour), *The Last Picture Show: Artists Using Photography, 1960–1982* (2003; catalogue, tour)

- - **Holdings**

2 paintings, 1 unique work on paper, 2 photographs, 1 photographic suite, 1 portfolio of prints, 8 books

A simple joke, pirated from the archived recesses of the Borscht Belt humorists of the 1950s, plays a pivotal role in the career of Richard Prince. It goes something like this: "I went to see a psychiatrist. He said, 'Tell me everything.' I did and now he's doing my act." Since the late 1970s, Prince has made his mark in the contemporary art world by stealing the acts of the producers of consumer culture, whether they reside in the fashionable photographic world of magazine advertising or the cultural lowlands of jokes and cartoons. Working across a wide range of media that includes photography, drawing, sculpture, and painting, he has developed a strategy of appropriating images in his work in order to produce his own director's cut of the psychic landscape of desire and identification generated by the culture industry. In essence, Prince is a visual deejay who samples images rather than musical tracks, taking us on a trip into American advertising's heart of darkness. In fact, he emerged on the American art scene in the late 1970s at roughly the same time that a number of now-legendary deejays in New York, such as Grand Master Flash, were laying the foundations for the mix-and-dub culture that would become hip-hop. It is this liberating power of sampling, now so prevalent as to be ubiquitous, that lies at the heart of Prince's work.

Born in the Panama Canal Zone to American parents, Prince grew up in the vicinity of Boston and moved to New York in 1973. He took a job in the tear-sheet department at Time-Life, cutting articles out of magazines for the writers on staff. The remnants of these excisions—left on his desk like so much detritus—were magazine advertisements with glossy, overproduced, and anonymous photographs that heralded the good life of American consumer culture. It was here that Prince would experience his first breakthrough as an artist. As he contemplated these overwrought images of conspicuous wealth with their concomitant subliminal psycho-sexual dramas, he became interested in the ways in which their status differed from that of traditional art photography. Out of this experience was born Prince's strategy of rephotography, a practice that would become more widely referred to in the late 1970s and 1980s as appropriation.[1] This strategy allowed him to take an image of a fictional world of desire crafted for public consumption in a glossy magazine and return it to a realm in which the photograph itself is an object. He became a leading practitioner of a group of American artists loosely known as Picture Theorists, including Barbara Kruger, Sherrie Levine, and Cindy Sherman. This name was attributed to them in deference to the exhibition *Pictures*, curated by

Douglas Crimp at Artists Space in New York in 1977, which included the work of a number of these artists (although not that of Prince).

Though not the only artist practicing this technique, Prince is generally acknowledged to be one of its primary progenitors. His first foray into this new media landscape was the four-part photographic work *Untitled (living rooms)*, which he completed in 1977. The images were lifted directly from advertisements for high-end furniture found in the pages of the *New York Times Magazine*. Emptied of any extraneous denotative advertising language, the photographs radiate a strange ambivalence. Originally intended to invoke a longed-for world of luxury and leisure, they have become unmoored from the directives of Madison Avenue. Their ambiguity has launched them into a world where they might serve as sets for a vaguely familiar but not quite memorable sitcom or, better yet, an episode of the *Twilight Zone*. Instead of bringing us to a state of comforting narrative closure à la Rod Serling, though, Prince has set us adrift on a sea of endlessly proliferating signifying possibilities. Are they a critique or a celebration of consumer culture? Are these images even photographs in any traditional sense of the medium? These questions, paradoxically, are both generated by this work and held in a state of suspension.

Prince went on to use his technique of rephotography on other visual themes within the world of pop culture and advertising, shooting pictures of girls from biker magazines as well as male and female models from the pages of fashion publications. He would, however, become most identified with the figure of the cowboy, the subject of an ongoing untitled series of photographic prints that took its source images from the masculine world of American manifest destiny as seen through the mythic figure of the Marlboro man.

Richard Prince *Untitled (Hood)* 1989 oil, autobody compound, fiberglass on wood 57 x 31 1/2 x 4 in. (144.8 x 80 x 10.2 cm) T. B. Walker Acquisition Fund, 1996 1996.189

Similarly emptied of any determining graphic content, Prince's cowboys are not like John Wayne's boldly innocent character in John Ford's early western, *Stagecoach* (1939). They are much more akin to the dark antihero of Wayne's character in Ford's later film *The Searchers* (1956). These figures ride the range, wrangle stallions, and generally embody the rugged individualism of the epic foundation myths of the American frontier. Underlying their bravado, of course, is the nagging fact of their identification with the manipulative rhetoric of cigarette advertising. By isolating and reproducing these images in a systemic repetition, Prince empties them of their original content while making evident the ways in which they recirculate and reinforce this vision of American masculinity.

Another kind of American heroism would come into play as Prince added painting to his artistic repertory. In his series of car-hood reliefs and joke paintings, he took on two more aspects of America's self-imaging of its male identity. In his hoods, the artist practiced another kind of larceny parallel to that of his rephotography by employing the strategy of the sculptural "readymade" inaugurated by Marcel Duchamp. Ordering actual factory-made replacement hoods for American muscle cars (Mustangs, Challengers, Chargers) from automotive magazines, Prince repainted them and hung them on the wall. Installed in this manner, they are at once paintings and anti-paintings that resonate between the poles of adolescent male fantasies of automotive speed and sexual power and the equally heroic delusions of modernist abstract painting. The hoods shared this last aspect with Prince's

monochromatic joke paintings, such as *Was That a Girl* (1989). On a uniformly antimodernist purple canvas, a line of silkscreened text reads: "I met my first girl, her name was Sally. Was that a girl, was that a girl. That's what people kept asking." Mimicking the formal strategy of Barnett Newman's "zips" of paint, Prince's joke—itself a self-reflexive repetition of misogynist male culture—takes on the heroic, masculine romanticism of the legacy of American Abstract Expressionism by turning the vertical zips of Newman's monumental painting *Vir Heroicus Sublimus* (1951–1952) literally on their side into a Princely "vir antiheroicus ridiculous." In the end, perhaps his joke should read: "Was that a painting, was that a painting."

D.F.

Notes

1. As Prince has suggested, "They were like these authorless pictures, too good to be true, art-directed and over-determined and pretty much like film stills, psychologically hyped-up and having nothing to do with the way art pictures were traditionally 'put' together. I mean they were so off the map, so hard to look at, and rather than tear them out of the magazines and paste them up on a board, I thought why not rephotograph them with a camera and then put them in a real frame with a mat board around the picture just like a real photograph and call them mine. I mean 'pirate' them, 'steal' them, 'sample' them." See Jeff Rian, "In the Picture: Jeff Rian in conversation with Richard Prince," in Rosetta Brooks, Jeff Rian, and Luc Sante, *Richard Prince* (London: Phaidon Press, 2003), 12.

Richard Prince *Was That a Girl* 1989 acrylic, screenprint on canvas 75 x 116 1/16 in. (190.5 x 294.8 cm) T. B. Walker Acquisition Fund, 2002 2002.5

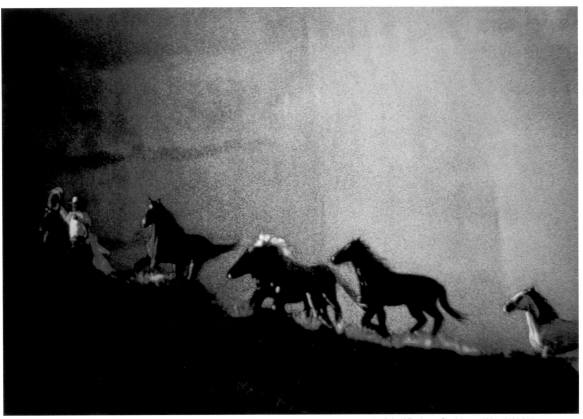

Richard Prince *Untitled (Cowboy)* 1992 Ektacolor photograph; edition 1/2 20 x 24 in. (50.8 x 61 cm) Gift of Barbara Gladstone, 2001 2001.214

Richard Prince *Untitled (living rooms)* 1977 Ektacolor prints; edition 5/10 20 x 24 in. (50.8 x 61 cm) each of 4 T. B. Walker Acquisition Fund, 2005 2005.3

Martin Puryear

American, b. 1941

- - **Commissions**
Ampersand (1987–1988)
- - **Exhibitions**
Sculpture Inside Outside (1988; catalogue), *The Garden in the Galleries* (1994), *The Cities Collect* (2000)
- - **Holdings**
2 sculptures, 1 model

Martin Puryear's art achieves a balance of homespun craftsmanship and refined abstraction. His remarkable body of work undeniably reflects the rich experiences of his early years. Upon graduating from college in 1963 as an art major with a concentration in painting, Puryear joined the Peace Corps and went to Sierra Leone, where he taught secondary school and also became acquainted with local carpenters and cabinet-makers. He then spent two years studying at the Royal Academy of Art in Stockholm, a decision that was in part impelled by his interest in Scandinavian design. Returning to the United States, he enrolled in the graduate program in sculpture at Yale University. There, Puryear found himself in the midst of a hotly contested art-historical turning point in which ideas reigned supreme, the traditional notion of "making" gave itself over to industrial manufacture and fabrication, and art-making per se was being retooled.

Instead of siding with one school of thought or the other, Puryear found an alternative—making art that refused to distinguish between "art" and "making." He pursued a sculptural methodology that incorporated everything from traditional carving and modeling to carpentry, furniture-making, joinery, cooperage, basketry, and even masonry and stonecarving. Each piece distinct from the next, Puryear's abstract sculpture brings up generously allusive associations with a range of natural or constructed forms: ship's prow, wheels, birds, conch shells, tendrils, and pea pods, among others. Though he rarely foregrounds his African American identity, he has at times expressed his admiration for and sense of connection to certain historical figures—most prominently, James Beckwourth, a little-known, late eighteenth-century mixed-race explorer who had an incredibly colorful life.[1]

In 1987, the Walker Art Center commissioned Puryear to create a piece for the new Minneapolis Sculpture Garden. *Ampersand* (1987–1988) is a pair of massive, almost identical columns made out of locally quarried granite. Each stands at more than thirteen feet, and together they guard the entrance to the park like totemic poles. At one end, each retains the texture of rough-hewn rock, while the other end is smoothed to form a rounded cone. They are oriented in opposite directions to create a kind of synthesis of antithetical energy, like yin and yang. Another of his pieces in the Walker collection, *To Transcend* (1987), represents an amalgamation of the various formal elements Puryear had explored in his earlier works. Simultaneously floor-based and wall-bound, it consists of a kidney bean–shaped base and a disk at the top that are connected

via a gentle arc. The severity of the disk's whetted rim and the blunt roundedness of the base produce a subtle contrast of geometric and organic form. The title is fitting, as the overall shape hints at a germination from the earth emerging into a rational Archimedean form reminiscent of the disk supporting the sacred flame in a Greek temple. On another level, this dynamic piece may very well be a formalist allegory of "transcending" ideological dualisms—of artisanship and art, tradition and modernism, and "underdeveloped and developed"—to which Puryear's art continues to aspire.[2]

D.C.

Notes
1. See Neal Benezra, "'The Thing Shines, Not the Maker': The Sculpture of Martin Puryear," in Neal Benezra, ed., *Martin Puryear*, exh. cat. (Chicago: Art Institute of Chicago, 1991), 29.
2. Robert Storr discusses this reconciliation of binaries in Puryear's work in "Martin Puryear: The Hand's Proportion," in Kellie Jones, *Martin Puryear*, exh. cat., 20th International Saõ Paulo Bienal (New York: Jamaica Arts Center, 1989), 25–34.

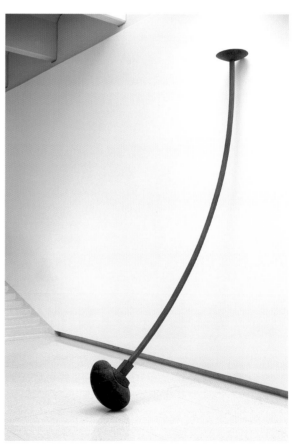

Martin Puryear *To Transcend* 1987 mahogany, poplar 169 x 13 x 90 in. (429.3 x 33 x 228.6 cm) Walker Special Purchase Fund, 1988 1988.4

radioqualia

Formed 1998
Adam Hyde, New Zealander, b. 1968; Honor Harger,
New Zealander, b. 1975

- - **Commissions**
Free Radio Linux (http://gallery9.walkerart.org/radioqualia/) (2002)
- - **Online Exhibitions**
CrossFade: Sound Travels on the Web (2002)
- - **Holdings**
1 net artwork

The term "qualia" has a significant history going back to the 1920s, when it appeared in debates surrounding the philosophy of mind.[1] Essentially, qualia are properties of sensory experience that are unknowable—and hence incommunicable—except through direct experience. The r a d i o q u a l i a collaborators are sound artists who are in the vanguard of "personal broadcasting," using the Internet and low-power radio as tools to transmit something that must be experienced to be properly apprehended.

In 2002, the Walker Art Center commissioned *Free Radio Linux*, which consists of a speech bot—a computerized, automated text-to-speech synthesizer—that reads all 4,141,432 lines of code used to create the open-source operating system Linux. Launched in Gallery 9 on February 3, 2002, the fourth anniversary of the coining of the term "open source," it took approximately 594 days to read the code.[2]

Through the everyday, visceral experience of listening, *Free Radio Linux* highlighted that which is normally hidden: the code that makes possible, literally and conceptually, so much of contemporary life. Most of this text, such as "struct sigframe underscore ia32," is incomprehensible to the nonprogrammer, but occasional Englishlike comments are inserted to help guide other coders: "Fork is rather simple, once you get the hang of it, but the memory management can be a bitch." As Larry Wall, creator of the programming language Perl, writes: "A language is not a set of syntax rules. It is not just a set of semantics. It's the entire culture surrounding the language itself."[3] And the culture surrounding *Free Radio Linux* is a combination of open-source software, community radio, and do-it-yourself (DIY) hacks to create meaningful experiences that are not about the technology per se.

As Micz Flor points out, "shifting the context alters more than the code's aesthetic quality. Putting code on the air stresses the fact that we are dealing with language after all. Software is not merely a combination of tools on a hard disk; software is language, an assumption with legal consequences."[4] In this way, *Free Radio Linux* gets to the heart of a matter crucial to the future of society. As code increasingly runs everything, not just our computers, but also our cars, our communications systems (even the human genome is a kind of code), what will be its status? Trade secret? Community resource? Esoteric knowledge? Merchandise? There is no single answer, but the question will not go away. Whose interests will be protected, and how? *Free Radio Linux* broadcasts the Linux kernel as a kind of urgent propaganda for open source to be viewed as a powerful model for a new set of societal relationships.

Steve Dietz

Notes
1. For more on the subject, see the online encyclopedia *Wikipedia* at http://en.wikipedia.org/wiki/Qualia.
2. These examples are taken from the essay by Micz Flor, "Hear Me Out," commissioned by the Walker. See http://netartcommons.walkerart.org/article.pl?slid=02/05/12/038213&mode=thread.
3. Ibid.
4. Linux, the brainchild of Helsinki native Linus Torvalds, is one of the largest and most successful open-source projects. Torvalds wrote the kernel of the Linux operating system in 1991, then posted it on the Web and asked other programmers to improve upon it. The term "open source" was coined in 1998 to refer to this type of software development process in which programmers work collaboratively and without financial compensation. To be considered open source, software must be distributed under a license that guarantees the right to read, redistribute, modify, and use the software freely.

r a d i o q u a l i a *Free Radio Linux* 2002 digital media Digital Arts Study Collection

David Rathman

American, b. 1958

- - **Exhibitions**
Dialogues: Amy Cutler/David Rathman (2002; publication)
- - **Holdings**
7 drawings, 6 edition prints/proofs, 1 portfolio of prints, 5 books

David Rathman *Every day above ground is a good one* 2002 ink on paper
22 x 25 in. (55.9 x 63.5 cm) Clinton and Della Walker Acquisition Fund, 2003
2003.3

David Rathman grew up in Montana, but he is not a
cowboy. He has never ridden a horse, nor has he roped,
rustled, or branded anything. He is, however, a story-
teller. Working on paper with sepia-toned inks, he takes
a very peculiar and particular look at one of the found-
ing myths of the American nation: the settling and
so-called taming of the Wild West. The story he tells is
not the glorious triumph of American manifest destiny
advocated by John L. O'Sullivan in 1845. Rathman's
West is more the poetic landscape of the literary works
of Samuel Beckett filtered through the lens of the revi-
sionist westerns of the 1950s and 1960s. In each case,
the artist's drawings are tinged with a dark, illogical
humor that subverts our national myth of the cowboy's
rugged individualism. In its place, he unveils a narra-
tive landscape of the Wild West that is one part existen-
tialist wasteland and two parts comic irony.

The first thing one notices about Rathman's draw-
ings is their minimalist figurative style. He draws his
cowboys, farmhands, gunfighters, prairie maids, and
rustlers in shadowy silhouette against wide open
expanses of cream-colored paper. They occupy eco-
nomically rendered and somberly suggestive vistas
that are as culturally iconic as any of the locations in
John Ford's films. In fact, Rathman culls his images
from a wide range of visual materials, including the
nineteenth-century landscape paintings of Frederic
Remington and Charles Russell, westerns by Ford and
other Hollywood masters of the genre, and their spa-
ghetti incarnations by Italian directors such as Sergio
Leone. Rathman's West, like Ford's and Leone's, is com-
plicated, morally ambiguous, and decidedly antiheroic.

Strangely enough, the crucial motor force of this
work is linguistic rather than visual. Rathman's draw-
ings manifest their absurdist effects through a juxtapo-
sition of these all-too-familiar images with bits of
appropriated language that the artist scrawls across
their surfaces. His characters spout droll aphorisms,
remorseful eulogies, and twisted bits of existential wis-
dom such as "Every day above ground is a good one,"
"I learned them sad songs early on," or "Wishin' all
these old things were new." These phrases—drawn
from sources that include the dialogue in western films,
song lyrics, and quotes by philosophers or politicians—
are mixed and matched with images to provoke odd
non sequiturs that undermine our common understand-
ing of the conquest of the West. As in Ford's revisionist
film *The Searchers* (1956), in which John Wayne plays
a cowboy of completely questionable character,
Rathman's protagonists are high plains drifters who
rewrite aspects of the Western lore by infusing it with
the artist's own desperate brand of black humor.

D.F.

Robert Rauschenberg

American, b. 1925

In 1959, Robert Rauschenberg included the following,
now-infamous statement in the catalogue for the land-
mark exhibition *Sixteen Americans*, organized by the
Museum of Modern Art in New York: "Painting relates
to both art and life. Neither can be made. (I try to act in
that gap between the two.)"[1] The importance of this
statement cannot be underestimated in terms of the
intellectual floodgates that it would open in the art
world of the 1950s, altering the discourse surrounding
the age-old question of what art is.

In 1973, critic Brian O'Doherty coined the term
"vernacular glance" to describe Rauschenberg's insa-
tiable appetite for collecting and reproducing visual
phenomena in the form of mass-produced images and
his ability to translate sensory overload into nuanced
juxtapositions within his works.[2] He was writing about
Rauschenberg's "combines"—which the artist began
producing in 1954—a body of work that straddled the
lines long established between painting and sculpture.
Considered neither one by the artist, but embodying
the characteristics of both, the combines would mark a
defining moment in the history of twentieth-century art.
They recalled Picasso's use of newspaper and bits of
wood as collage elements in his papier collé works as
well as the Surrealists' fascination with disjunctive
images born in the subconscious. He also reconsidered
the Abstract Expressionists' impassioned mark-making
and preempted the Pop artists' appropriation of mass-
media imagery. By attaching fabric, newspaper clip-
pings, photographs, magazine reproductions, articles
of clothing, street signs, taxidermied animals, mirrors,
and other found objects to his canvases, Rauschenberg
shifted the attention of the art world from the ivory tower
to the street and the gutter. The objects he selected were
not pristine items purchased off store shelves, but the
necessities and ephemera of life that boasted the patina
of everyday use. Impastoed and dripping gestural
brushstrokes as well as patches of bare canvas further
articulated the dissonant surfaces of the combines.

Around 1960, Rauschenberg was beginning to feel
constricted by this process—his choices and responses
had become too rote and predictable. For an artist
who had once said, "I am trying to check my habits of
seeing, to counter them for the sake of greater fresh-
ness. I am trying to be unfamiliar with what I'm doing,"
fluency was the death knell to his creativity.[3] He soon
transitioned from excess visual incident to relative
spareness by leaving larger expanses of canvas empty
and increasing the frequency of painterly gesture.
Trophy II (for Teeny and Marcel Duchamp) (1960), one
of Rauschenberg's most important combines from this
period, is one such work.[4] He created a total of five tro-
phy paintings from 1959 to 1962, paying homage to art-
ist friends who had had an impact on his artistic and
personal life: Merce Cunningham, Duchamp, Jean

Robert Rauschenberg *Booster* 1967 lithograph, screenprint on paper;
Gemini II from an edition of 38 71 7/8 x 35 7/16 in. (182.6 x 90 cm) Published
by Gemini G.E.L., Los Angeles Gift of Kenneth E. Tyler, 1985 1985.164

Tinguely, John Cage, and Jasper Johns. Although not personally acquainted with Duchamp prior to 1959, when poet and critic Nicolas Calas brought Duchamp to visit him and Johns at their Front Street studios, Rauschenberg felt an affinity for his "readymades" and deep respect for his lifelong tendency to go against the grain.[5]

Rauschenberg's nonhierarchical openness to all media is a hallmark of his practice. He has searched tirelessly for new formal means through which to bring the world into his art, including the production of transfer drawings, a self-taught technique he began exploring in earnest in 1958. One of his most celebrated bodies of work, the illustrations for *Dante's Inferno* (1958–1960), was created by soaking magazine images with a chemical solvent such as lighter fluid, placing them face down on a sheet of paper, and rubbing them with an empty ballpoint pen cartridge. In 1962, when he finally acquiesced to Tatyana Grosman's repeated invitations to make prints at her workshop, Universal Limited Art Editions (ULAE), in West Islip, Long Island, the result was several innovative (and award-winning) editions. Later that year, after a visit to Andy Warhol's studio, where he saw several very early examples of Warhol's silkscreen paintings, Rauschenberg adapted this process to his own practice, thus enabling him to transfer a single image ad infinitum on a much larger scale. Like his use of collaged elements in his combines, all of these print techniques granted the artist the flexibility to work in two dimensions as successfully as he did in three.

Booster (1967), a monumentally scaled lithograph and screenprint in the Walker Art Center's collection, was the first major project the artist produced at Gemini G.E.L. in Los Angeles, and the largest print that the pioneering lithography workshop had produced up until that point. Conceived as an autobiography, the central skeletal image derives from multiple X-rays of the artist's body. Named for the first-stage rockets that launch capsules into space, the print also includes numerous ancillary images forming modular units that overlap and butt up against one another, creating windows of perspectival depth. A small image of the launching pad at Cape Canaveral, Florida, in the upper right as well as a 1967 astronomy chart showing the orbits of Saturn and Jupiter screenprinted in red all point to the artist's lifelong obsession with space exploration.[6]

E.C.

Notes
1. Artist's statement in Dorothy C. Miller, ed., *Sixteen Americans*, exh. cat. (New York: Museum of Modern Art, 1959), 58.
2. Brian O'Doherty, *American Masters: The Voice and the Myth* (New York: Ridge Press, Random House, 1973), 197–198.
3. Quoted in William C. Seitz, *The Art of Assemblage*, exh. cat. (New York: Museum of Modern Art, 1961), 116.
4. *Trophy I (for Merce Cunningham)* and *Trophy II* were included in the exhibition *Robert Rauschenberg: Paintings 1953–1964*, organized by the Walker Art Center, May 3–June 6, 1965. Never one to concern himself with the permanence and ultimate legacy of his oeuvre, Rauschenberg painted over and reconfigured parts of a previous work—his seven-panel *White Painting* from 1951—to create *Trophy II*.
5. Barbara Rose, "An Interview with Robert Rauschenberg," in *Rauschenberg* (New York: Vintage Books, Elizabeth Avendon Editions, 1987), 63. In this interview, Rauschenberg mistakenly remembers meeting Duchamp for the first time in 1953 at his Stable Gallery exhibition opening, but the 1959 encounter with Duchamp was confirmed by the artist in Joan Young with Susan Davidson, "Chronology," in Walker Hopps and Susan Davidson, eds., *Robert Rauschenberg: A Retrospective*, exh. cat. (New York: Solomon R. Guggenheim Museum, 1997), 557.
6. Rauschenberg used the same set of images (except for the X-rays) in a series entitled *Test Stone #1–7* (1967), also in the Walker's collection. For more information on *Booster* and the artist's interest in space exploration, see Robert S. Mattison, *Robert Rauschenberg: Breaking Boundaries* (New Haven, Connecticut: Yale University Press, 2003), 36.

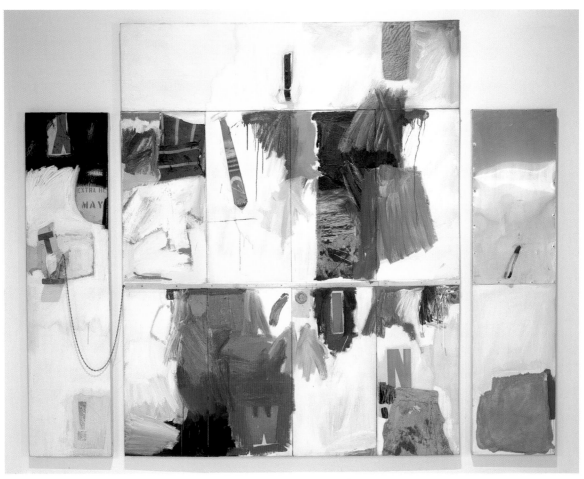

Robert Rauschenberg *Trophy II (for Teeny and Marcel Duchamp)* 1960 oil, charcoal, paper, fabric, metal on canvas, drinking glass, metal chain, spoon, necktie 90 x 118 x 5 in. (228.6 x 299.7 x 12.7 cm) overall installed Gift of the T. B. Walker Foundation, 1970 1970.1

Charles Ray

American, b. 1953

- - **Exhibitions**

Let's Entertain (2000; catalogue, tour), *The Last Picture Show:
Artists Using Photography, 1960–1982* (2003; catalogue, tour)

- - **Holdings**

1 sculpture

Los Angeles–based sculptor Charles Ray came to
prominence in the 1980s as he embarked on a quest to
find alternative routes to investigate abstract form. In
overtly "abstract" works such as *Ink Box* (1986), a decep-
tively minimalist-looking hollow cube filled to the top
with printer's ink, or in "figurative" works such as *Fall
'91* (1992), a female mannequin donning high-fashion
garb that has been enlarged to an Amazonian scale,
Ray enacted an aesthetic program that at its core
would navigate the anxious space between sculpture's
formal plane of existence and its more psychological, or
what he has called its hallucinatory, level. It is precisely
at this uncomfortable juncture between form and con-
tent, where abstraction and figuration collide, that we
can locate his *Unpainted Sculpture* (1997).

Nearly two years in the making, this work is a life-
size fiberglass cast of a 1991 Pontiac Grand Am that
had been totaled in a deadly accident. Like many of
Ray's works, *Unpainted Sculpture* was in part the result
of a chance occurrence. During a dinner conversation
with a student whose car had been repeatedly involved
in accidents, Ray suggested that he simply reconstruct
the car's bumper, cast it in fiberglass, and reattach it.
When another student pointed out that this would be a
good idea for one of Ray's sculptures, an idea was born.
The artist then spent more than two months searching
insurance lots, looking for wrecks in which fatalities
had occurred. He hoped to locate a vehicle that would
transcend the specificities of any particular accident
and would therefore attain the level of "a kind of
Platonic version of a wrecked car—one that was per-
fect."[1] Purchasing the wreck from an auction, Ray
painstakingly took the car apart, individually casting
each piece in fiberglass, and then reassembling the
cast elements piece by piece as if it were a model
hobby kit. The entire work was then uniformly covered
with two coats of gray primer paint, producing a uni-
fied, monochromatically flattened surface that tends to
partially neutralize the object's referential connection
to reality. We are left with an object that is on the one
hand Baroque in both the dynamism of its formal struc-
ture and in its ability to spatially fold together the inside
and the outside, and on the other hand disturbingly
hallucinatory in its rendering of the world at large.

Ray's sculptural resurrection of this automobile
transforms the original object into a kind of spectral
phantom of its former self, a transformation that moved
it, in the artist's mind, into the formal register of abstrac-
tion. As Ray suggests, "I don't believe in ghosts, but I
wondered that if there *were* ghosts, would the ghost
inhabit the actual physical molecules of the structure,
or would it be more interested in inhabiting the topol-
ogy or geometry of the structure? You know, if you were

to duplicate the geometry, would the ghost follow?"[2]
This is the crucial question posed by *Unpainted
Sculpture*. Did the ghost move into this fiberglass
object? Does it reference the real, much like Andy
Warhol's silkscreen paintings of car wrecks, or is it an
object that has been drained of all reference to the
tragic event that created its crumpled form? Is this work
a late twentieth-century version of Théodore Géricault's
The Raft of the Medusa that acts as a cautionary
marker of the perils of American consumer culture, or is
it a study in the relationship of the aleatory to abstract
sculptural form? In the end, like the best Baroque sculp-
ture, *Unpainted Sculpture* moves with us as we move
around it. Unlike the Baroque, however, this is a move-
ment that is both physical and conceptual, making the
work resonate between the poles of figuration and
abstraction. This is the contradiction at the heart of this
doppelgänger, the anxiety that glides across the sur-
face of its gray paint forcing our perceptions to vacillate
between the familiar and the uncanny. As the artist
himself notes, "In contemporary art, surface is an
expression of anxiety, and no one is as anxious about
surface as I am."[3]

D.F.

Notes

1. Quoted in Robert Storr, "Anxious Spaces," *Art in America* 86, no. 11
(November 1998): 106.
2. Quoted in Dennis Cooper, "Charles Ray," *Index Magazine* 2, no. 6
(January/February 1998): 38–46.
3. Quoted in Storr, "Anxious Spaces," 106.

Charles Ray *Unpainted Sculpture* 1997 fiberglass, paint 60 x 78 x 171 in. (152.4 x 198.1 x 434.3 cm) Gift of Bruce and Martha Atwater, Ann and Barrie Birks, Dolly Fiterman, Erwin and Miriam Kelen, Larry Perlman and Linda Peterson Perlman, Harriet and Edson Spencer with additional funds from the T. B. Walker Acquisition Fund, 1998 1998.74

Ad Reinhardt
American, 1913–1967

Ad Reinhardt is usually associated with the New York School of painters, especially Barnett Newman and Mark Rothko, whose spare, glowing abstractions were meant to kindle near-religious experiences for their viewers. Reinhardt's imagery is not unlike theirs, but his aims were completely different: he wanted to rid his work of all external subject matter, reducing his canvases to the sum of their component formal parts: line, color, and shape. "Art is art. Everything else is everything else," he quipped,[1] but looking at Reinhardt's work is a demanding assignment that belies the simplicity of his statement. His geometric forms, rendered in dry, matte oil colors that are close in hue, are on first glance barely perceptible; the shapes emerge and separate from one another only after an extended period of looking. As scholar Yve-Alain Bois observes, Reinhardt's paintings include very little optical incident, yet he is a completely optical painter, reducing the spectator to nothing more than an organ of vision.[2] It is impossible to see his work properly in reproduction; ideally, the viewer's experience should be similar to the artist's: a personal confrontation with an object over time.

Reinhardt began as an abstract painter in the 1930s and never swerved from that course. He studied art history and philosophy at Columbia College in New York, was inspired by the utopian abstractions of Kasimir Malevich and Piet Mondrian, and nurtured a lifelong interest in Asian and Islamic painting, sculpture, and decorative arts. His own work dipped in and out of the gestural and the organic until around 1954, when he purged asymmetry, irregular compositions, and bright tonalities from his paintings. The Walker Art Center's two blue-and-black canvases, *M* (1955) and *Painting* (1960), are typical of the nocturnal near-monochromes of this period.[3] After 1961, he followed an even more stringent regimen: each painting was a sixty-inch square in matte black on black that described a barely visible, symmetrical cruciform image. In these so-called *Black Paintings*, he reduced his practice to the "endless repetition of infinite sameness . . . not sameness but oneness."[4]

Like Barnett Newman, Reinhardt did not garner critical acclaim until the 1960s, and then it came from a younger generation who saw his work as a precursor to Minimalism. It is true that he was, like Frank Stella, Donald Judd, and others, committed to formalism, insisting that art's one true subject was art itself. But in light of his interest in Buddhism and Eastern thought, some scholars suspect he found formalism the purest means to achieve an essentially private spiritual encounter with the self.[5] For Reinhardt, the notions of unity and primary structures so basic to Minimalist dogma were related to an extra-intellectual state of being and a negation of content that suggested forms that were "Primary, unique, underivable from anything else . . . what is beyond utterance, 'unutterableness.'"[6]

J.R.

Notes

1. This is the first statement in Reinhardt's "25 Lines of Words on Art." Quoted by H. Harvard Arnason, "The Quest for Art-Is-Art," in Ad Reinhardt, *Ad Reinhardt: Black Paintings 1951–1967*, exh. cat. (New York: Marlborough Galleries, 1970), 13.
2. Yve-Alain Bois, "The Limit of Almost," in William Rubin, ed., *Ad Reinhardt*, exh. cat. (New York: Rizzoli, 1991), 28.
3. Reinhardt generally titled his works *Painting* or *Abstract Painting*. The unusual title *M* was probably first used by dealer Virginia Dwan, who needed a system of identification for her show of his monochromes in 1962. Because Reinhardt was essentially uninterested in titles, *M* was preserved as the name of this piece even though its verso bears the inscription "Painting 1955" in the artist's hand. For more information, see Bois, "Limit of Almost," and the Virginia Dwan Papers at Bard College, Annandale-on-Hudson, New York.
4. From Reinhardt's notes, in Barbara Rose, ed., *Art-as-Art: The Selected Writings of Ad Reinhardt* (New York: Viking Press, 1975), 77–78.
5. See Barbara Rose, "The Black Paintings," in *Black Paintings 1951–1967*, 19.
6. From "One," an undated text published in Rose, *Art-as-Art*, 93.

Ad Reinhardt *M* 1955 oil on canvas 48 x 12 in. (121.9 x 30.5 cm)
Donation of Virginia Dwan, 1987 1987.111

Robin Rhode

South African, b. 1976

--**Exhibitions**
How Latitudes Become Forms: Art in a Global Age
(2003; catalogue, tour)
--**Residencies**
2003
--**Holdings**
1 photographic suite

Robin Rhode's unconventional art practice channels the high energy of street inventiveness and youth culture through the lo-fi media of drawing, video, and performance. He recognizes no boundaries between the art gallery and urban space, high art and popular culture, as he transforms the quotidian into humorously narrative experiences. His work is laced with sharp commentary on the politics of leisure, global branding, and fetishized commodities and identities, and his visual and conceptual lexicon is built around issues of desire, loss, and dislocation in a capitalist world.

Rhode was born in Cape Town in 1976 and raised in Johannesburg, where he received a BFA from Witwatersrand Technikon and later took several filmmaking courses at the South African School of Film, Television, and Dramatic Arts. While his work is far bigger than his biography, he often draws on the specific indignities of growing up "colored" in apartheid South Africa. His technique of making drawings he then attempts to interact with was originally inspired by hazing rituals he endured as an adolescent and intended as a sly nod to the ancient cave drawings dotting the region.[1] As one who is always seeking the culturally subversive opportunity, Rhode infuses his work with a highly developed sense of play and an appreciation of the absurd that transcends mere politics.

In drawing-performance works such as *Upside Down Bike* (2000) and *Getaway* (2000)—which enact the scenes evoked by their titles—Rhode seeks energy and ingredients from the world around him, including sports, hip-hop, and action films as well as the legacy of graffiti art, Marcel Duchamp, and David Hammons. His "readymade" in *He Got Game* (2000) is a soiled city street on which he made a chalk drawing of a basketball stand and photographed his flawless execution of a somersault and slam dunk in just twelve easy steps. The title is taken from Spike Lee's 1998 film, which used the theme of basketball as a metaphor for hopes, dreams, and redemption. The work was completed in less than ten minutes in a busy urban setting, but the guerrilla style belies the careful forethought that went into laying out the scene. This storyboard-come-to-life approach—the images could easily convert into an animated flip book—is a Rhode signature and a holdover from his days as a film student. As physical feat and cultural metaphor, his work breaks down one of the world's most popular sports into a sum of its parts. Alluding to strategies of identity and identification, the artist comments, "Sports offer a means of emancipation, not only through a physical sense, but also through an emotional one. . . . It is an escape mechanism for people

geographically framed as third."[2] His fantastical rendering of a coveted shot highlights the superman status we too often assign to star athletes such as Michael Jordan and Kevin Garnett, leaving them little room for human foibles and complexities. With his simple rendering and simulation, Rhode lets a little air out of the inflated dream of physical perfection, wealth, and fame even as he gleefully assumes the role of protagonist in our collective fantasy of achieving just that.

O.I.

Notes
1. In Rhode's junior high school, older students would initiate younger ones by taking them into the boy's restroom, drawing various objects on the wall, and asking them to interact with them. For instance, they might be asked to ride a drawing of a bicycle, or blow out a lit candle. These early experiences became a creative springboard for Rhode's artistic practice.
2. Rhode, e-mail interview with the author, May 9, 2004 (Walker Art Center Archives).

Robin Rhode Selections from *He Got Game* 2000 color photographs
7 1/4 x 9 1/2 in. (18.4 x 24.1 cm) each of 12 Clinton and Della Walker
Acquisition Fund, 2003 2003.23

Germaine Richier

French, 1904–1959

-- **Exhibitions**
Sculpture by Germaine Richier (1958; catalogue), *The John and Dorothy Rood Collection* (1960; catalogue), *Faces and Figures* (1961)
-- **Holdings**
1 sculpture, 1 edition print/proof

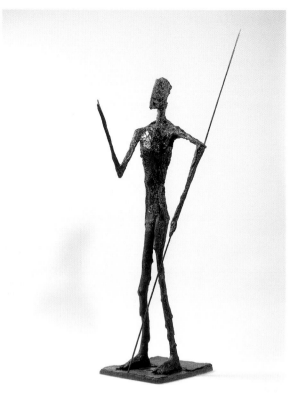

Germaine Richier *Don Quixote of the Forest* 1950–1951 bronze 93 x 35 x 25 in. (236.2 x 88.9 x 63.5 cm) John and Elizabeth Bates Cowles Foundation, 1956 1956.50

George Rickey

American, 1907–2002

-- **Exhibitions**
Kraushaar Galleries Exhibition (1958), *Obelisk without an Eye* (1966), *Recent Sculpture by George Rickey* (1967; catalogue)
-- **Holdings**
1 sculpture

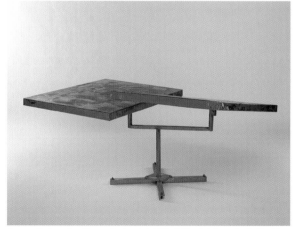

George Rickey *Two Planes Horizontal* 1966–1967 stainless steel 25 x 65 x 40 in. (63.5 x 165.1 x 101.6 cm) Gift of the T. B. Walker Foundation, 1967 1967.30

Bridget Riley

British, b. 1931

- **Exhibitions**

London: The New Scene (1965; catalogue, tour)

- **Holdings**

1 painting, 3 edition prints/proofs, 2 periodicals

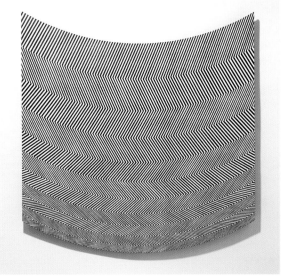

Bridget Riley *Suspension* 1964 emulsion on wood 45 3/4 x 45 7/8 in.
(116.2 x 116.5 cm) Gift of Mr. and Mrs. Julius E. Davis, 1981 1981.50

James Rosenquist

American, b. 1933

- **Exhibitions**

1958 Biennial of Paintings, Prints, and Sculpture (1958; catalogue, tour), *20th Century Master Prints* (1975; tour), *Artist and Printer: Six American Print Studios* (1980; catalogue, tour), *Prints from the Walker Art Center's Permanent Collection* (1980; tour), *Artists' Books* (1981), *First Impressions: Early Prints by Forty-six Contemporary Artists* (1989; catalogue, tour), *James Rosenquist: Time Dust/The Complete Graphics* (1993; organized by the University Art Museum, California State University; catalogue)

- **Holdings**

1 painting, 26 edition prints/proofs, 2 books, 1 periodical

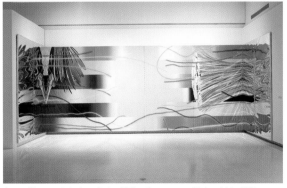

James Rosenquist *Area Code* 1970 oil on canvas, Mylar 114 x 276 in.
(289.6 x 701 cm) installed Gift of the T. B. Walker Foundation, 1971 1971.8

Dieter Roth

German, 1930–1998

- - **Holdings**
1 multimedia work, 4 portfolios of prints, 25 books

Living in Bern, Switzerland, in the early 1950s, Dieter Roth began his career working in a style of geometric abstraction influenced by Swiss Concrete artists, including Max Bill and Richard Paul Lohse. In 1960 he met Swiss artist Jean Tinguely in Basel, soon after Tinguely returned from New York, where he had staged the legendary *Homage to New York*, a large sculpture that self-destructed in the garden of the Museum of Modern Art. A profound change ensued in Roth's work thereafter, and his essential influences included not only Marcel Duchamp and Tinguely, but also Kurt Schwitters and Robert Rauschenberg.

Roth remains a singular and iconoclastic figure of contemporary art. During the last half of his career, he made many assemblage sculptures he called "material pictures," to which he would return many times over a number of years as they grew, mutated, and decayed. These works, among them *Tonbild* (*Sound Picture*) (1975–1988), are accretions of objects typically found in an artist's studio—various paints, brushes, and tools—as well as the miscellaneous flow of the materials of daily life. *Tonbild* began as a simple watercolor drawing, still visible in the upper right-hand corner, which Roth mounted on a wooden support; he then added a frame, and periodically attached various objects to the surface and to the frame.

Music became an integral part of his assemblage sculptures, adding another dimension of time to the experience of the work. In *Tonbild*, a small, simple child's music box was added to the upper left corner. Roth then recorded on a tape player the sounds of the music box, and the tape player was hung from the frame. On another recorder, he made a tape of the first recorder, including the sound of the recorder itself and the sound of the music box. And so on. He intended that the tapes could be rewound and replayed by viewers, but expected that all of these devices for making sound would fail over time; in one case, the German word "kaput" was written by Roth on one of the players. In its current state, the sound of each of the tape players has been preserved as originally recorded, so that initially one hears the single tune of the music box; with each rerecording overlaid one on top of the other, the sound builds to a final crescendo as a harrowing screech.

Transience and order, destruction and creativity, playful humor and critical inquiry, the abject and the beautiful—all these qualities maintain an unrelenting balance in Roth's work. A sense of the imminently tragic but boundlessly open distinguishes both his art and his life.

Gary Garrels

Roth Books

The Walker Art Center Library contains books and catalogues from every phase of Dieter Roth's career. The earliest, an alphabet book from 1964, shows the influence of Swiss Concrete artists, while the last, a catalogue from his 1997 retrospective in Marseilles, France, consists of 219 unbound pages comprising a handwritten diary account punctuated with Polaroids and printed by a color Xerox machine. In the thirty intervening years, Roth's bookworks took a range of formats, many in eccentric categories of his own invention: the world's smallest books, comic books, "complete shit" books, and volumes with "speedy drawings" that were made using a two-fisted pencil technique. There are those with specially designed limited-edition covers, others whose pages are perforated like so much Swiss cheese, books stapled shut that defy the reader to open them, and some that are the result of collaborations with Richard Hamilton and Emmett Williams.

When the Walker acquired Roth's sculpture *Tonbild* (*Sound Picture*) in 1995, the Library celebrated with an exhibition of his books. Word of the installation reached the artist, who responded with a letter ("Dear Art Center Walkers") that documented his reaction, complete with Polaroids and a self-portrait showing him giving the project his benediction.[1]

All of this artist's vigor and imagination are reflected in his books. Roth validates the dictum of Stéphane Mallarmé: "Everything exists in the world in order to become a book."

R. Furtak

Notes
1. Correspondence with the author, postmarked July 12, 1996 (Walker Art Center Library).

Dieter Roth Selection of artist's books and correspondence, 1964–1996
Walker Art Center Library Collection

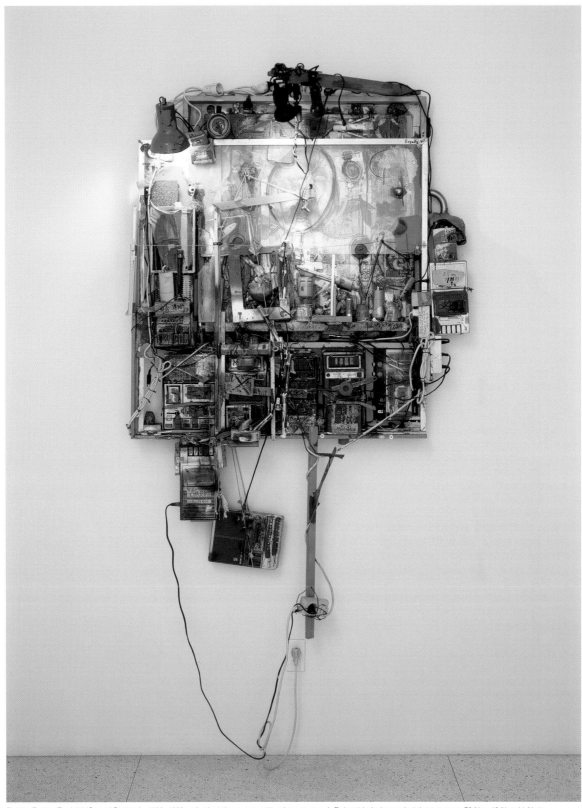

Dieter Roth *Tonbild* (*Sound Picture*) 1975–1988 oil, plexiglass, cassette players, wood, Polaroid photograph, ink on paper 78 3/4 x 40 3/8 x 11 3/4 in.
200 x 102.6 x 29.9 cm) T. B. Walker Acquisition Fund, 1995 1995.10

Susan Rothenberg
American, b. 1945

-- **Exhibitions**
Viewpoints—Susan Rothenberg (1978), *Images and Impressions: Painters Who Print* (1984; catalogue, tour), *First Impressions: Early Prints by Forty-six Contemporary Artists* (1989; catalogue, tour)
-- **Holdings**
2 paintings, 2 unique works on paper, 3 edition prints/proofs, 1 monoprint/monotype, 2 multiples, 1 book

Susan Rothenberg *Tattoo* 1979 acrylic, flashe on canvas 67 x 103 1/8 in. (170.2 x 261.9 cm) Purchased with the aid of funds from Mr. and Mrs. Edmond R. Ruben, Mr. and Mrs. Julius E. Davis, the Art Center Acquisition Fund and the National Endowment for the Arts, 1979 1979.50

Two of the important threads that run through all of Susan Rothenberg's work are the human touch and the nature of human engagement. The Walker Art Center is fortunate to have in its collection prime examples from her long and productive career that reveal an increasing comfort in allowing these elements to come to the fore.

Rothenberg achieved prominence in the mid-1970s for her paintings of horses. Initially composed of flat, uninflected outlines or silhouettes, these paintings evolved into works such as *Tattoo* (1979), whose milky white field, languid movement, and silent narrative offer greater evidence of humanity than earlier versions. The artist has said the horse was a surrogate for the self. The title refers to the animal's head drawn inside the inverted outline of a leg, "a tattoo or memory image," as she describes it.[1]

The image of overlapping head and hand that followed the horses was first introduced in *Pinks*, a series of unique hand-painted woodcuts. The familiar elements of the heavy outline and the contrast between solid and hollow link these works to earlier efforts such as *Tattoo*. In *Pinks*, Rothenberg moves from animal to human image, albeit a disembodied one. But the handprint on the left side of the image and the hand-coloring on the right side underscore the human touch. The artist says of this series, "I was thinking that all I have is a head and a hand to paint with and eyes in my head."

Painted almost a decade after *Tattoo* and *Pinks*, *Night Ride* features what is unmistakably a human figure on a bicycle. Rothenberg has moved from symbol to reality and added new dimensions of sound and movement. Full figures in motion and a signature thicket of brushstrokes—she terms it "the weather"—now define her painting. Like the horse, the cyclist appears ready to burst through the picture plane. The ghostly image in motion calls to mind the photographic motion studies of Eadweard Muybridge, but Rothenberg is aiming for something different: the unconscious memory of moving through space and time and of negotiating life that has always been in her work.

Marge Goldwater

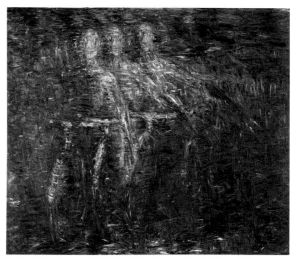

Susan Rothenberg *Night Ride* 1987 oil on canvas 93 3/8 x 110 5/16 in. (237.2 x 280.2 cm) Walker Special Purchase Fund, 1987 1987.78

Notes
1. All quotations are from the artist in conversation with the author, 1990.

Mark Rothko

American, b. Russia, 1903–1970

- - **Exhibitions**

60 American Painters: Abstract Expressionist Painting of the Fifties
(1960; catalogue), *Mark Rothko, 1903–1970: A Retrospective* (1979;
organized by the Solomon R. Guggenheim Museum, New York;
catalogue), *Mark Rothko: Seven Paintings from the 1960s* (1983)

- - **Holdings**

5 paintings, 1 gouache/watercolor

Mark Rothko's journey toward a signature style has
been characterized as one of struggle and ambiguity
that, after two decades of effort, resolved itself in the
simplest possible way: luminous, pure abstractions
that are now benchmarks in the history of postwar
American art.[1] His earliest works, made during the
1930s, were muted, often melancholy urban scenes and
landscapes. These were colored by his involvement in
left-wing political committees and activist groups such
as the Artists' Union in New York; equally important
were his studies with Max Weber at the Art Students'
League and his long friendship with Milton Avery.
Both his mentors painted in a figurative style heavily
informed by the ideas of Pablo Picasso and Henri
Matisse, but during the 1930s Rothko also encountered
Surrealism, which was to prove the more salient influ-
ence for the next decade. He was especially captivated
by the automatist abstractions of Joan Miró, and (along
with fellow New York School artists Barnett Newman
and Adolph Gottlieb) cultivated an interest in myth,
Greek drama, tribal arts, and the art of children.

For a time Rothko attempted to bring all these inter-
ests together in canvases that communicated both the
grim social reality of the day and the irrational, tragic
nature of the human condition. But around 1938,
as Hitler's troops began stirring in Europe and the
Depression continued in the United States, Rothko
turned away from current events and committed him-
self to "the forms of the archaic and the myths from
which they have stemmed."[2] Believing fervently that
"there is no such thing as good painting about noth-
ing,"[3] he set out to embed the messages of his own time
within a new semiabstract idiom. His canvases were
filled with amorphous shapes swirling in shallow
space, allusions to vast skies and oceans, musical nota-
tions, microscopic life, and fragmented human and ani-
mal forms. Typical of this period is the Walker Art
Center's *Ritual* (1944), in which a figure—with truncated
limbs and an oversized ear that doubles as a head—
floats mysteriously in an undefined space. Delicately
painted in thin washes of magenta, ochre, and black,
this lilting composition suggests ancient rituals and
myths involving music and its often-hypnotic power—
the irresistible song of the Sirens, or Orpheus, who lulls
the Furies with his lyre.[4]

Rothko's fervent desire to make his art the vehicle for
transcendent experience led him to systematically elim-
inate representation and even allusion from his images.
He forced his Surrealist-inspired forms of the 1940s to
gradually dematerialize until, by 1950, he had distilled
them into soft blocks and bands of luminous color

arranged in simple, flattened compositions. He aban-
doned evocative narrative titles and began simply
numbering his works, letting the content reside com-
pletely within the visual information. After 1950 he also
ceased publishing statements about his aims and
ideas, confiding to Newman that he had "nothing to say
in words" about what he was doing on canvas.[5] But he
made it known that he was not a formalist: his paintings
were experiences and ideas in their own right, not illus-
trations of experiences and ideas, and certainly not
mere experiments with color and space. What Rothko
was after were visceral, emotional, intimate encounters
with objects that offered no less than complete physical
and emotional immersion.

Rothko wanted his paintings to convey a sense of
place, and he was extremely attentive to their scale and
proportion as well as to the lighting, architectural set-
ting, and context of their display. He also preferred that
his paintings be seen in groups, isolated from the work
of others. Given these preferences, it isn't surprising
that three mural commissions, with their distinct but
related challenges, collectively occupied him for much
of his last decade. The first, an invitation to make a
group of murals for the Four Seasons Restaurant in
New York's Seagram building, was never completed,
but he did finish five panels for a campus building at
Harvard University in 1962.[6] Perhaps his consummate
achievement is the suite of fourteen black-and-blood-
red canvases made for a chapel in Houston, Texas.[7]
With this commission, Rothko had the chance to create
the transformative spiritual experience he had always

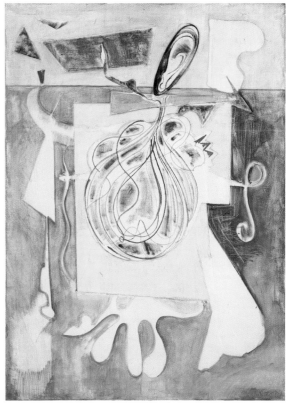

Mark Rothko *Ritual* 1944 oil, graphite on canvas 53 7/16 x 39 in.
(135.7 x 99.1 cm) Gift of The Mark Rothko Foundation, Inc., 1986 1986.1

envisioned for his audience. These brooding works, which were installed in the chapel in 1971, after Rothko's death, are a kind of endpoint in the exploration of the sublime in abstraction—the enterprise that had brought Rothko and the New York School into the forefront of the avant-garde twenty years earlier.

J.R.

Notes

1. See David Anfam, *Mark Rothko: The Works on Canvas* (New Haven: Yale University Press; Washington, D.C.: National Gallery, 1998), 71.

2. From Rothko's notes for a letter (cowritten with Adolph Gottlieb) to Edward Alden Jewell, quoted in Dore Ashton, *About Rothko* (New York: Oxford University Press, 1983), 75.

3. From the letter referenced in note 2, reprinted in Diane Waldman, ed., *Mark Rothko: 1903–1970* (London: Tate Gallery, 1987), 77–78.

4. *Ritual* was one of fifteen oils Rothko included in a 1945 solo exhibition at Peggy Guggenheim's Art of This Century Gallery, which had opened in New York three years earlier with a mission to show work in difficult modern styles such as Surrealism.

5. Quoted in Michael Compton, "Mark Rothko: The Subjects of the Artist," in *Mark Rothko: 1903–1970*, 50.

6. Nine of the Seagram paintings were given by Rothko to the Tate Gallery, London, where they were installed in a room of their own. The five Harvard canvases are installed in the university's Holyoke Center.

7. The Rothko Chapel was commissioned by Dominique de Menil for a new chapel for the University of St. Thomas, Houston. Rothko worked closely with the project's original architect, Philip Johnson, on plans for the building, which was intended to be a Catholic chapel but is now described by its administrators as a "modern meditative environment" open to "people of every belief."

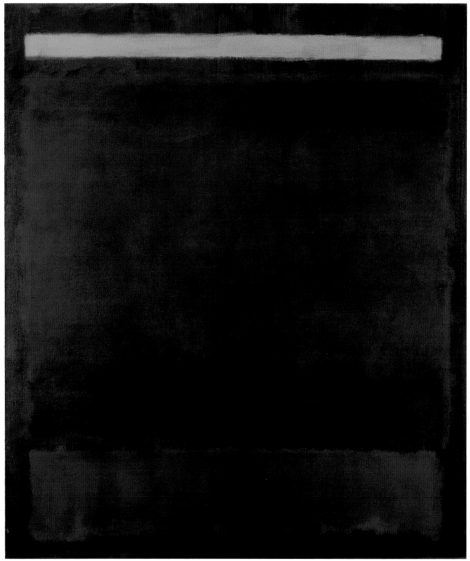

Mark Rothko *No. 2* 1963 oil, acrylic, glue on canvas 80 1/4 x 69 1/8 in. (203.8 x 175.6 cm) Gift of The Mark Rothko Foundation, Inc., 1985 1985.16

Edward Ruscha

American, b. 1937

Edward Ruscha has long been an influential voice in postwar American painting as well as one of contemporary art's most significant graphic artists. Born in Omaha, Nebraska, in 1937 and raised in Oklahoma City, Ruscha left for Los Angeles in 1956 to study commercial art.[1] He abandoned this discipline for painting soon after, but nonetheless found the techniques of layout, lettering, and illustration to be a significant influence on his work. As an Oklahoman, he was able to see Los Angeles through the eyes of an outsider, and to document in his art the ethos of this modern, sprawling metropolis that has a vernacular all its own. To many, his work epitomizes aspects of a Los Angeles sensibility, thriving on popular culture, illusionism, and a sense of nostalgia. Though Ruscha emerged at a time when a number of art movements were appearing on the American scene, he developed to the side of any particular group, bringing to his work a synthesis of the ideas behind Surrealism, Pop, and Conceptual Art.

Ruscha's paintings, drawings, and prints blend the humorous with the odd, the beautiful with the unexpected, the clever with the mundane. Language is always a point of departure. Many images portray words as curious physical entities, or present bits of language that stand as provocative texts on their own. Others feature common objects floating in enigmatic voids of lush color, or depict archetypal emblems culled from film and fiction. He is also known for experimentation and has used such substances as chocolate, gunpowder, or spinach in place of traditional pigments.

Ruscha first gained attention in the early 1960s for his paintings and drawings depicting popular icons, including the Hollywood sign, and single words such as "flash," "boss," and "ace." By this time, he had also begun to make books, including *Twentysix Gasoline Stations* (1963), a series of no-frills black-and-white photographs documenting twenty-six filling stations along Route 66 between Oklahoma City and Los Angeles. This book, and the fifteen small paperbacks that followed, were like nothing the art world had seen before. With deadpan titles such as *Every Building on the Sunset Strip*, the books catalogued some of the many banal items and locations that dot the American landscape. These works are now considered pivotal to the history of the artist's book and to the beginnings of contemporary conceptual photography.

Ruscha has continued to use pointed, isolated words as visual subjects. "I love the language," he remarked in 1969. "Words have temperatures. . . . When they reach a certain point and become hot words, then they appeal to me."[2] He first rendered letters as three-dimensional entities in the 1962 painting *Large Trademark with Eight Spotlights* (which featured the 20th Century Fox logo), and later used this device to create the illusion of words made from ribbon or folded paper. In 1967, he began exploring the notion of "liquid words." The Walker Art Center's painting *Steel* (1967–1969), like others from this period, such as *Jelly* (1967) and *Rancho* (1968), uses a single word chosen as much for its evocative power as for its phonetic qualities. In *Steel*, the word functions as a found object, made more palpable by the trompe l'oeil rendering of the letterforms, which seem to have emerged from a viscous substance resembling motor oil.[3] An image of an unexpected, ball bearing–like object (perhaps made of steel), painted at actual size, drifts into the left edge of the picture field as if to provide instant scale. Ruscha has always embraced the non sequitur, remarking that "often when an idea is so overwhelming, I use a small unlike item to 'nag' the theme."[4]

Since 1959, works on paper have also been a central part of Ruscha's practice. He has made an extensive body of drawings in pastel and various powdered materials, such as the dry pigment drawing *Double Hear Me?* (1986), and has published editioned prints both independently and with a wide range of international graphics workshops. A significant concentration of the prints resides in the Walker's collection, ranging from the iconic *Standard Station* (1966), the artist's first silkscreen; to *News, Mews, Pews, Brews, Stews & Dues* (1970), a pivotal portfolio in which the artist used such ingredients as coffee, squid ink, axel grease, and caviar in place of traditional printing inks; to a 1999 series of editioned photographs based on his 1967 book *Thirtyfour Parking Lots in Los Angeles*.

Through his paintings, drawings, prints, books, and occasional forays into multiples and narrative film, Ruscha has created works uniquely American in both subject and sensibility. He has found language and its visual and psychic repercussions to be a forum for prolific innovation, and in his work continually offers unexpected ways by which to examine our culture.

S.E.

Notes

1. Ruscha studied industrial and graphic design at Chouinard Art Institute (now CalArts) in Los Angeles from 1956 to 1960.

2. Ruscha in "Words with Ruscha," interview by Howardena Pindell, *The Print Collector's Newsletter* 3, no. 6 (January–February 1973): 126.

3. "My 'romance' with liquids," Ruscha remarked in 1982, "came about because I was looking for some sort of alternative entertainment for myself—an alternative from the rigid, hard-edge painting of words that had to respect some typographical design. These didn't—there were no rules about how a letter had to be formed. It was my sandbox to play in. I could make an 'o' stupid or I could make it hopeless or any way I wanted and it would still be an 'o.'" Quoted in Patricia Failing, "Ed Ruscha, Young Artist: Dead Serious about Being Nonsensical," *Artnews* 81 (April 1982): 80.

4. Ruscha, in Barbara Radice, "Interview with Ed Ruscha," *Flash Art* 54–55 (May 1975): 49.

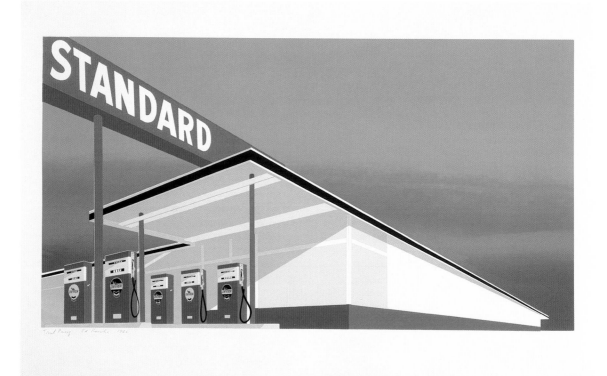

Edward Ruscha *Standard Station* 1966 screenprint on paper; Trial Proof from an edition of 50 25 5/8 x 40 in. (65.1 x 101.6 cm) Published by Audrey Sabol, Villanova, Pennsylvania T. B. Walker Acquisition Fund, McKnight Acquisition Fund, 2002 2002.122

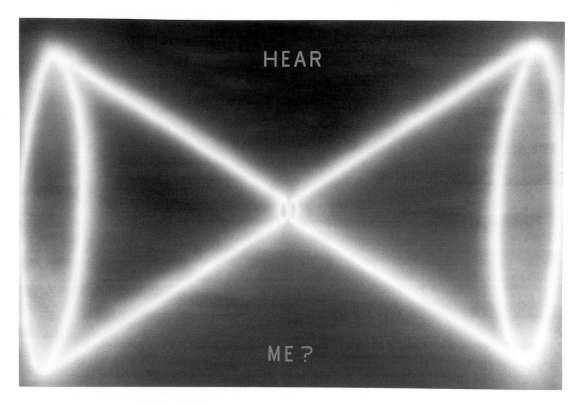

Edward Ruscha *Double Hear Me?* 1986 dry pigment, acrylic on paper 40 1/8 x 60 in. (101.9 x 152.4 cm) Walker Special Purchase Fund, 1988 1988.5

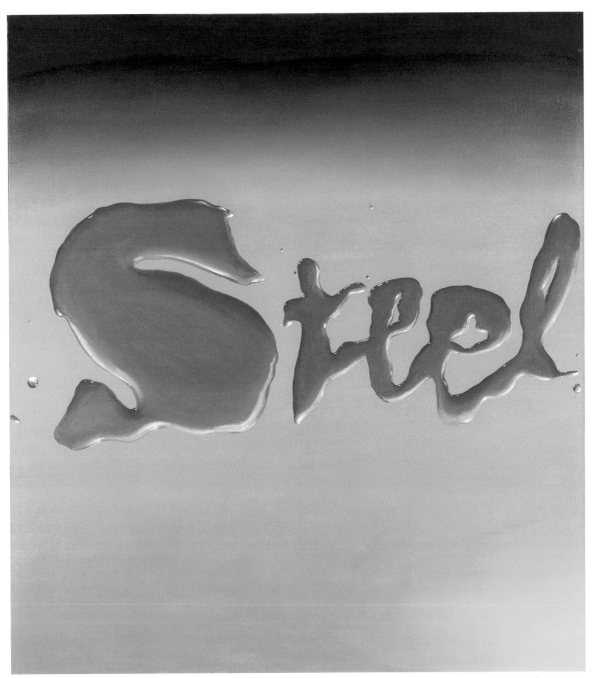

Edward Ruscha *Steel* 1967–1969 oil on canvas 60 x 54 in. (152.4 x 137.2 cm) Purchased with the aid of funds from the Clinton and Della Walker Acquisition Fund and the National Endowment for the Arts, 1980 1980.24

Anne Ryan

American, 1889–1954

-- **Exhibitions**
Vanguard Group (1947), *Kraushaar Galleries Exhibition* (1958)
-- **Holdings**
23 unique works on paper

Anne Ryan *No. 226A* 1948/1954 fabric, paper, string collage 6 x 4 3/4 in.
(15.2 x 12.1 cm) Gift of Elizabeth McFadden, 1979 1979.8

Alison Saar

American, b. 1956

-- **Exhibitions**
The Cities Collect (2000)
-- **Holdings**
1 sculpture, 1 edition print/proof

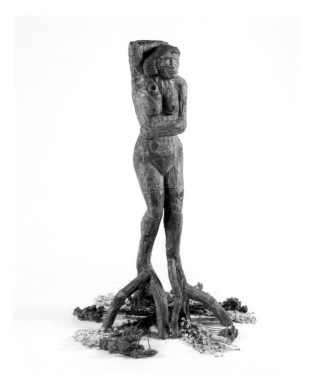

Alison Saar untitled from *Crossroads* 1989 wood, copper, flowers, tin
70 x 20 x 28 in. (177.8 x 50.8 x 71.1 cm) T. B. Walker Acquisition Fund, 1993
1993.125

Kay Sage
American, 1898–1963

- - **Exhibitions**
The Classic Tradition in Contemporary Art (1953; catalogue),
Reality and Fantasy, 1900–1954 (1954; catalogue), *American Tableaux*
(2001; publication, tour)
- - **Holdings**
2 paintings

Notes
1. See Judith D. Suther, *A House of Her Own: Kay Sage, Solitary Surrealist* (Lincoln and London: University of Nebraska Press, 1997).
2. This is proposed by Whitney Chadwick in *Women Artists and the Surrealist Movement* (London: Thames & Hudson, 1985).
3. Suther, *House of Her Own*, 156. (Suther's book incorrectly dates the painting as 1954.) It was purchased for the collection in 1953 after its inclusion in the Walker exhibition *The Classic Tradition in Contemporary Art*.
4. Ibid., 213.

Kay Sage, one of the few prominent women associated with Surrealism, was born to a wealthy family in upstate New York but spent much of her youth traveling in Europe with her restless mother. Their peripatetic lifestyle resulted in a desultory artistic education for Sage, who maintained throughout her life that she was self-taught as a painter. This is not quite the case, but it is certainly true that she did not find her mature artistic voice until after 1937—the year she left behind both her Italian husband and their life of languorous but aimless privilege. In Paris, she rented a garret studio overlooking the Seine and began to paint in earnest.

Like the other women associated with the mostly male Surrealist group, Sage was only grudgingly accepted by them as an artist, and never as their equal. According to her biographer, Sage's affiliation with them was strained, and came at a price of internalized misogyny and self-loathing that was exacerbated by her stormy second marriage to preeminent French Surrealist Yves Tanguy.[1] Her sense of autonomy was further damaged by critics' constant dismissal of her as merely "the wife of," and she struggled with a fear that her work was derivative of her husband's.

Sage had no reason to worry: her mature style was unlike anything else in Surrealism. She rejected biomorphism and instead developed her own austere iconography of wide open vistas and architectonic structures rendered in muted tones. Human presence is suggested but rarely revealed, and in her canvases there is a sense of both unlimited freedom and impending doom. She admitted to being strongly influenced by the work of Giorgio de Chirico (she owned his 1914 painting *The Torment of the Poet*), but her style also likely comes out of her alfresco study, in the 1920s, of the open, light-filled Roman countryside.[2]

Typical of her strongest works is the painting *On the Contrary* (1952), one of the first of Sage's canvases to enter a museum collection.[3] Completed in her barn studio in Woodbury, Connecticut, where she and Tanguy had settled in 1941 after fleeing the war in Europe, the painting depicts a still life of boxes, boards, drapery, and rope in an apparently unfinished architectural space. Like the best Surrealist images, it is an unsettling mix of parts that don't add up to an understandable whole. Sage embraced this kind of mystery. One of her poems, written in 1961, ends with the lines "two and two do not necessarily make four/If that is a scientist at my door please tell him to go away."[4]

J.R.

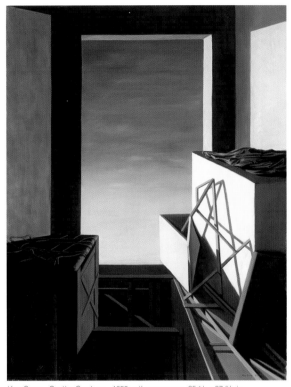

Kay Sage *On the Contrary* 1952 oil on canvas 35 1/2 x 27 3/4 in.
(90.2 x 70.5 cm) Gift of the T. B. Walker Foundation, 1953 1953.9

Lucas Samaras
American, b. Greece, 1936

-- **Exhibitions**
Eight Sculptors: The Ambiguous Image (1966; catalogue), *20th Century Master Prints* (1975; tour), *Viewpoints—Ray Herdegen/ Lucas Samaras* (1978), *Lucas Samaras Pastels* (1982; organized by the Denver Art Museum; catalogue), *Vanishing Presence* (1989; catalogue, tour)
-- **Holdings**
3 sculptures, 4 photographs, 3 books

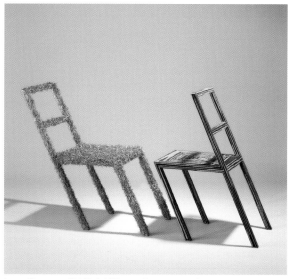

Lucas Samaras *Untitled* 1965 wood, pins, yarn, glue pin chair: 35 3/8 x 19 1/4 x 35 3/4 in. (89.9 x 48.9 x 90.8 cm) yarn chair: 35 3/8 x 18 x 26 5/8 in. (89.9 x 45.7 x 67.6 cm) Art Center Acquisition Fund, 1966 1966.2

Fred Sandback
American, 1943–2003

-- **Exhibitions**
Artists' Books (1981)
-- **Holdings**
4 sculptures

Fred Sandback was resolute in considering his work to be sculpture; and yet his signature style—strands of wool or acrylic yarn, elastic cord, or wire drawn tautly to outline polygons in space, sometimes creating polyhedrons in suspension—seems hardly sculptural. It is tempting to see his work as heir to a particular modernist approach to sculpture as "drawing in space," a concept instigated by Vladimir Tatlin's Constructivist reliefs and realized fully in the works of Alexander Calder and Anthony Caro. However, Sandback's work occupies a place somewhat independent of these complex webs of art-historical references and inheritances.

In his notes, Sandback had a way of defining his sculpture via a series of negations, which he did with careful and sensitive exactitude.[1] Pronouncing his skepticism about such constructs as surface and interior, and the binarism they necessarily suggest, he seemed to share a common belief with the Minimalists, who advocated making gestalt objects, or immediately recognizable shapes, which can be experienced spatially and phenomenologically by the viewer's *embodied* eye.[2] But he clearly wished to distinguish his work from the obduracy of Minimalist objects and the totality they create, stating: "My work isn't environmental. . . . It doesn't take over a space, but rather coexists with it." He also objected to Minimalism's overly verbal, theoretical bent. He called it an "illustrative quality" and said the "notion of executing an idea is the same as giving form to material." For him, "ideas are executions."

It would appear, then, that Sandback would have been a natural candidate and advocate for Conceptual Art, which, developing in the wake of Minimalism, questioned art-making and the art object through linguistic and analytical means. Critic Lucy R. Lippard characterized this exceedingly rich and complex period in art history as "the dematerialization of the art object."[3] Although his art was in gestation precisely during this time, he later insisted, "I don't make 'dematerialized art.'" Nor did his work bridge Minimalist and Conceptual Art, as did Sol LeWitt's by employing geometry and logic. "What I'm doing really doesn't have anything to do with geometry," he said, "and it doesn't have anything to do with deductive reasoning."

Ultimately, Sandback's artistic intention was pure and simple: he wanted to make sculpture "without a composition of parts, or . . . without positive and negative spaces."[4] While the fate of sculpture became deeply polarized in his lifetime between uncompromising objectness and cerebrally willed disappearance, Sandback simultaneously wished his sculpture to coexist with the continuum of life and felt "a continuing need to disrupt that permanence."

D.C.

Notes
1. Fred Sandback, "Notes, 1975," in Hermann Kern, ed., *Fred Sandback*, exh. cat. (Munich: Kunstraum München, 1975). Unless otherwise noted, all statements by the artist in these paragraphs come from the same source.
2. While attending the graduate program at Yale University, Sandback studied with Donald Judd and Robert Morris, who were visiting instructors in 1966 and 1967, respectively.
3. Lucy Lippard, *Six Years: The Dematerialization of the Art Object from 1966 to 1972* (New York: Praeger, 1973).
4. Fred Sandback, "Remarks on My Sculpture 1966–86," in Aisha Jahn and Jens Jahn, eds., *Fred Sandback, Sculpture 1966–1986*, exh. cat. (Mannheim, Germany: Kunsthalle, 1986).

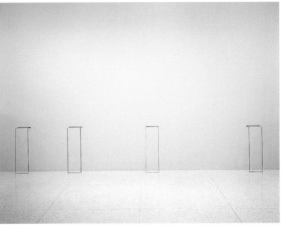

Fred Sandback *Untitled* 1968 steel, paint 30 x 171 x 6 1/4 in. (76.2 x 434.3 x 15.9 cm) installed Donation of Virginia Dwan, 1985 1985.760

Fred Sandback *Yellow Corner Piece* 1970 elastic cord 72 x 72 x 1/4 in. (182.9 x 182.9 x .6 cm) installed Donation of Virginia Dwan, 1986 1986.126

Egon Schiele
Austrian, 1890–1918

– – **Exhibitions**
Expressionism 1900–1955 (1956; catalogue, tour), *Art Fair*
(1959; catalogue), *The Cities Collect* (2000)
– – **Holdings**
1 watercolor

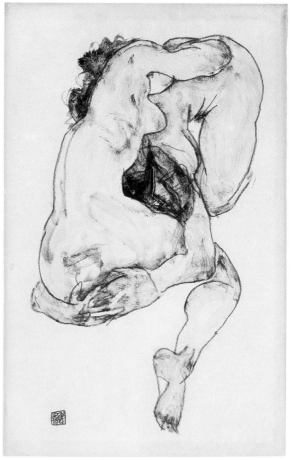

Egon Schiele *Two Figures* 1917 watercolor, charcoal on paper 17 3/8 x
11 1/8 in. (44.1 x 28.3 cm) Gift of Elizabeth and Donald Winston, Los Angeles,
1973 1973.29

Thomas Schütte

German, b. 1954

-- **Exhibitions**
Unfinished History (1998; catalogue, tour), *The Cities Collect* (2000),
Painting at the Edge of the World (2001; catalogue)
-- **Holdings**
2 sculptures, 2 photographs, 1 portfolio of prints, 2 books

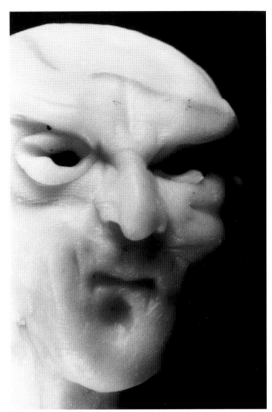

Like the lone figure in Caspar David Friedrich's painting *Wanderer in the Sea of Fog* (circa 1818), Thomas Schütte is an aesthetic itinerant. His incredibly diverse body of work is difficult to categorize in that it encompasses a wide spectrum of media, form, scale, and approach. As he himself has suggested, "Doing my work is like hiking through the Alps and getting lost every ten minutes. It's important to have different perspectives opening up all the time."[1] One could say that Schütte is a sculptor, but that wouldn't tell the whole story. He is, rather, an artist who has spent his entire career interrogating the monumental in its various incarnations, moving deftly from the realm of the architectural to that of the figure.

In fact, for the past fifteen years or so, figuration has become a central concern for Schütte. By the early 1990s, after having spent the previous decade making functional architectural projects, sculptures resembling architectural models, and large-scale installations, he turned his attention almost exclusively to sculpting the human form. Although early on in his career he inserted small figures into his architectural models (ranging from store-bought *Star Wars* action models to his own handmade versions), this practice became the centerpiece of his *United Enemies* series, a breakout body of work begun in 1993. Subtitled "a play in ten scenes," these sculptures consist of puppetlike forms whose heads are rendered in Fimo, a children's modeling clay. Each figure features a distorted, hairless face reminiscent of a medieval gargoyle or a mask for carnival. They are individually wrapped in material taken from the artist's discarded clothing and are then bound together with wire before being placed under a glass dome mounted on top of a tall, cylindrical plinth.

The Walker Art Center's example from this series, *Untitled*, dates from 1995 and includes three of Schütte's homunculi mercilessly bound together as if being prepared for an uncomfortable voyage to some level of Dante's Inferno. What exactly is uniting these enemies? Are their grotesque visages the karmic results of some unknown historical misdeeds? These are strangely mute antimonuments, presenting their contents as if they were abducted from a display case in an anthropological museum or from a cabinet of curiosities. The theatrical impact is only heightened by Schütte's decision to photographically reproduce the faces of these characters in his *Innocenti (The Innocents)* series. In these large black-and-white images, the faces of the so-called innocenti completely fill the frame, their chiaroscuro lighting accentuating every wrinkle, line, and corrupted fold of flesh. Always hung high on the gallery wall, these figures stare down defiantly, smirking at us with a knowing arrogance. Of what exactly

Thomas Schütte *Untitled* 1995 gelatin silver print 36 5/8 x 28 3/4 x 3/4 in. (93 x 73 x 1.9 cm) framed T. B. Walker Acquisition Fund, 1997 1997.4

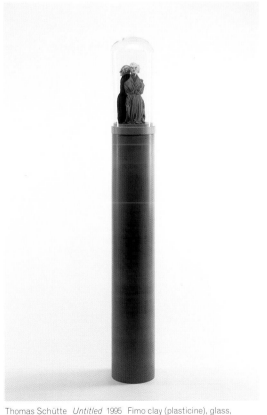

Thomas Schütte *Untitled* 1995 Fimo clay (plasticine), glass, wood, plastic, fabric, wire 73 3/4 x 10 x 10 in. (187.3 x 25.4 x 25.4 cm) T. B. Walker Acquisition Fund, 1997 1997.7

are they innocent? One is reminded of Adolf Eichman or of Slobodan Milošević, another breed of self-proclaimed innocenti of the twentieth century. In the end, however, these figures are simply puppets. They are mute containers that are open to our own projections, becoming a kind of screen on which memory and forgetfulness (both personal and historical) play out their duet.

As he has done so often to great effect, Schütte radically shifted his scale in a subsequent series of bronze sculptures that includes *Bronze Woman IV* (1998/2000). Here the artist also moves effortlessly from the register of the monumentality of history to that of modernism. Originally cast in steel, this series consists of nine heroically scaled but formally altered female nudes that each in its own way refuses to function within the traditional framework of monumental, figurative sculpture. Each figure rests on top of an oxidizing steel table whose brute materiality calls to mind the abstracted sculptural planes of Richard Serra's work. The rigid geometries of these self-immolating, minimalist platforms stand in direct contrast to the biomorphic curves of the women's bodies. Although these women

emerged out of Schütte's fascination with the heavy and at times brutal sculptures of Aristide Maillol and Henri Matisse, they resist that modern figurative tradition. One body flows over itself in great folds as it makes its way off the table, while another reclines in a supine position only to reveal a strange multiplication of her breasts. *Bronze Woman IV* lies flattened on her steel table unable to move under the weight of some unknown force. Perhaps her flatness is due to the gravitational pull of the monumental. It is the event horizon of that black hole that Schütte has spent his entire career trying to escape.

D.F.

Notes
1. From James Lingwood, "James Lingwood in conversation with Thomas Schütte," in Julian Heynen, James Lingwood, and Angela Vettese, *Thomas Schütte* (London: Phaidon Press Limited, 1998), 24. Schütte's diverse approach to his work is in part the result of having studied at the famed Kunstakademie Düsseldorf in the 1970s under the tutelage of sculptor Fritz Swegler and painter Gerhard Richter.

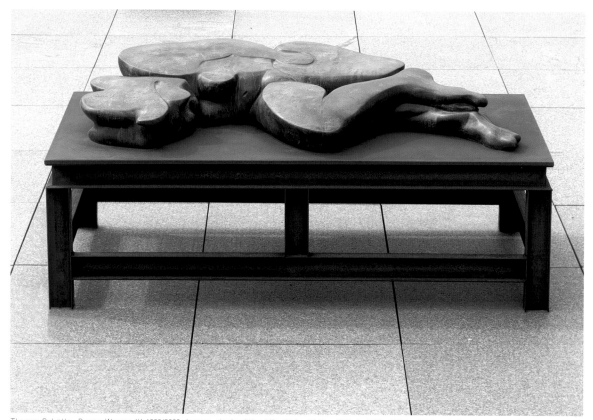

Thomas Schütte *Bronze Woman IV* 1998/2000 bronze, steel; edition 1/2 42 1/2 x 98 1/4 x 49 1/4 in. (108 x 249.6 x 125.1 cm) Purchased with funds provided by the Frederick R. Weisman Collection of Art, 2000 2000.405

Rudolf Schwarzkogler

Austrian, 1940–1969

– – **Holdings**
1 photographic suite

Along with Hermann Nitsch, Günter Brus, and Otto Muehl, Rudolf Schwarzkogler was a prominent member of the Viennese Actionism movement. Officially founded in July 1964, it placed the body at the center of the artwork both for its empirical potential for cognition and its power to confront and oppose the taboos of the conservative postwar, post-Fascist Austrian society.

Schwarzkogler might have been the most conceptually oriented member of the Vienna Actionists. His abstract monochromatic paintings from the early 1960s already reflect a theoretical rigor that linked him to such artists as Piero Manzoni and Yves Klein, while his interest in the body is demonstrated by works like *Untitled "Tableau-Sigmund-Freud"* (circa 1965), a white monochrome whose surface is interrupted by a razor blade.

Schwarzkogler conceived and realized only six performances (or "actions"), all taking place between 1965 and 1966. He considered the actions an extension of his paintings, or a differently developed form of painting, and described them in his manifesto *PANORAMA I* (1965) as "painting in motion." He explained that "the construction of the image on a surface has been superseded by the construction of conditions of the act of painting."[1] He differentiated himself from the violently expressive public actions of the other members of the movement by avoiding any kind of confrontation with an audience. With the exception of the very first action, to which some of his intimate friends were invited, all of his actions were staged expressly, and solely, for a photographer. They were all characterized by an absolute control of content and a radical, austere, and clinical aesthetic. During the actions, which were staged in a white, diaphanous environment, Schwarzkogler or an actor would be either naked or wrapped in medical bandages and surrounded by objects that included scissors, razor blades, test tubes, electrical wires, lightbulbs, and eviscerated fishes.

His first two actions were conceived as an attack on religious rituals—namely, the institution of marriage and the Catholic mass—in which the artist stands as the celebrant. The four other actions choreographed a secular, suffering, mutilated body. Schwarzkogler's highly disturbing experimentations all led to a reflection on the vulnerability of the human being in the face of alienating forces such as the state, the church, and the challenges of everyday life. His philosophy was one of liberation through a spiritual and corporeal asceticism.

After his final action in 1966, Schwarzkogler focused exclusively on a series of conceptual drawings and the writing of manifestos. He died in 1969, after falling from the window of his apartment. None of his works was ever publicly exhibited during his lifetime. The portfolio *Actions, Vienna 1965/66* (1975–1982) documents the incredibly short career of an artist who understood early on the potential of photography as an autonomous medium, and whose work has been influential for subsequent generations of artists, including Paul McCarthy, Mike Kelley, and Matthew Barney.

P.V.

Notes
1. Schwarzkogler's manifesto was published in *Le Marias*, *Special Edition* (Vienna: Günter Brus, 1965), quoted in *Viennese Aktionism*, *Vienna 1960–1971: The Shattered Mirror*, ed. Hubert Klocker, trans. Dr. Alfred M. Fischer (Klagenfurt, Austria: Ritter Verlag, 1989), 352.

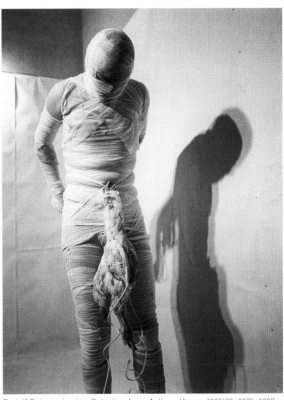

Rudolf Schwarzkogler Selection from *Actions, Vienna 1965/66* 1975–1982 black-and-white photographs mounted on board; edition IX/X from an edition of 40 25 3/8 x 19 11/16 in. (64.5 x 50 cm) each of 60 Published by Galerie Krinzinger and Edith Adam, wife of the artist Justin Smith Purchase Fund, 2001 2001.211

George Segal

American, 1924–2000

- - **Commissions**

Walking Man (1988)

- - **Exhibitions**

Ten American Sculptors (1964; catalogue, tour), *Figures/Environments* (1970; catalogue), *George Segal: Sculptures* (1978; catalogue, tour), *Homage to Picasso* (1980), *Three Sculptors: Noguchi, Oldenburg, Segal* (1980), *American Tableaux* (2001; publication, tour)

- - **Holdings**

5 sculptures, 1 multimedia work, 2 books

In early 1961, George Segal hadn't yet found his signature sculptural style. He was still attempting to forge a path as a painter, making work that was equally indebted to the languid figuration of Matisse and the bravura brushwork of the Abstract Expressionists. In the late 1950s, he had tried three-dimensional work, constructing rough-hewn, expressionistic figures from burlap, plaster, and chicken wire—all materials readily available on his farm. The sculptures were always conceived in relation to his paintings, but it wasn't until the summer of 1961 that he serendipitously found the material that would change everything for him. One of his students, the wife of a chemist at Johnson & Johnson laboratories, brought to class some cloth bandages newly developed to aid in setting broken bones. "Immediately, I knew what I wanted to do," Segal recalled.[1]

What he thought to do was dip the bandages in plaster and wrap them around live models, making casts that refined his earlier sculptures into more convincing volumes with a great deal more detail. He served as his own first model, but soon began casting friends and relatives and placing the forms in theatrical environments assembled from found objects. In these installations, the figures become ghostly presences whose individual features pale in the face of the resolutely real objects that surround them. Critics immediately saw that they had something in common with the work of Andy Warhol, Roy Lichtenstein, and Claes Oldenburg—artists who were first dubbed "New Realists," but soon would be rechristened as Pop artists. Like them, Segal drew his imagery from the real world; but if Pop Art is at bottom a tongue-in-cheek celebration of consumer products, images, and advertising, then Segal was not at heart a Pop artist. His works are tributes to Everyman and the everyday, and most are quietly reflective and even melancholy in mood. They are also strongly narrative—so much so that Mark Rothko once remarked to Segal that his sculptures were like "walk-in [Edward] Hoppers."[2]

Hopper's great lunch-counter vignette, *Nighthawks* (1942), certainly seems to be the emotional forebear of Segal's *The Diner* (1964–1966).[3] Two figures avoid eye contact under the glare of a fluorescent tube; they are alone, with only a shabby green counter between them, and the sexual tension is palpable. Segal described the work as a self-portrait of sorts: "In the years that I was farming . . . I was extremely restless, running into New York all the time, seeing friends and driving home at midnight. I almost invariably stopped at a diner for coffee. . . . Walking into a diner after midnight when you're the only customer, there's both fatigue and electricity. The waitress behind the counter is always sizing you up, wondering if you're going to rob her or rape her."[4] Segal also pays close attention to the formal aspects of his work—color, mass, volume, and the interplay of positive and negative spaces. An expansive red panel against the back wall—the only element that did not come from the failed New Jersey diner that was the source for the other props—frames the action and also is an homage to the great Abstract Expressionist Barnett Newman, whose work Segal had long admired.

Though best known for multiple-figure, theatrical environments like *The Diner*, Segal was also fascinated by single-figure motifs like "woman at her toilette," a theme familiar from the work of Impressionist painters such as Edgar Degas and Auguste Renoir. Segal treated it with similar reverence, using it to explore the intimate everyday world of women in an unflinching but affectionate way. The precipitous posture and ample proportions of the figure in *Woman Brushing Her Hair on Green Chair* (1964) recall Degas, but the technique is pure Segal: thick layers of bandages, with handfuls of wet plaster slapped on them, emphasize the woman's fleshiness.[5] As in all his work, the juxtaposition of a cast figure with found objects is a surreal mix of illusion and reality that nonetheless speaks volumes about our real human relationships.

J.R.

Notes

1. Quoted in Phyllis Tuchman, *George Segal* (New York: Abbeville Press, 1983), 23.

2. Cited in Graham Beal, "Realism at a Distance," in Martin Friedman, *George Segal: Sculptures*, exh. cat. (Minneapolis: Walker Art Center, 1978), 68.

3. *The Diner* was made in 1964 and first shown in 1965, after which it was returned to Segal's studio. In 1966 he changed its arrangement substantially, moving the male figure much closer to the waitress in order to "increase the psychic distance between them." This change is the reason the piece has been assigned an extended date. See Segal's "Commentaries on Six Sculptures" in Friedman, *George Segal*, 36–39.

4. Ibid., 37.

5. Friedman, *George Segal*, 12.

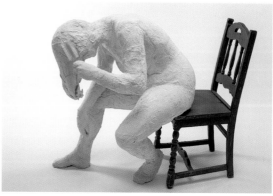

George Segal *Woman Brushing Her Hair on Green Chair* 1964 plaster, chair, hairbrush 40 x 43 x 28 in. (101.6 x 109.2 x 71.1 cm) Gift of Mrs. Julius E. Davis, 2000 Given in memory of George Segal 2000.110

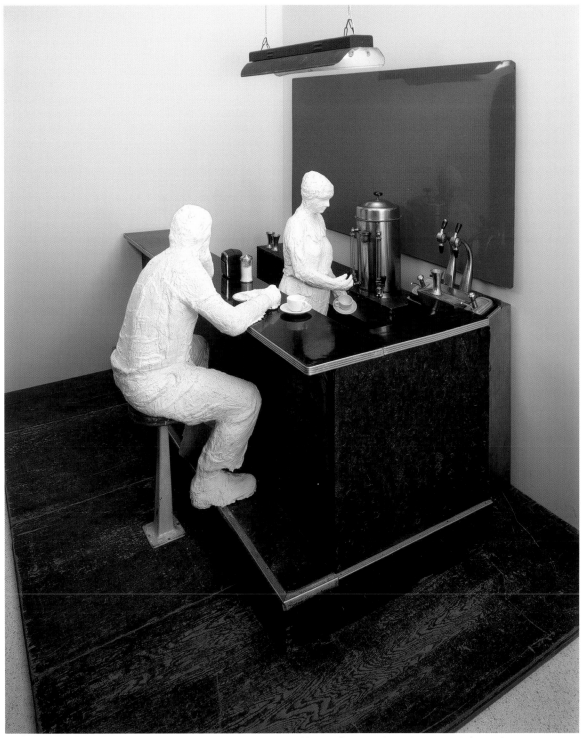

George Segal *The Diner* 1964–1966 plaster, wood, chrome, laminated plastic, Masonite, fluorescent lamp, glass, paper 93 3/4 x 144 1/4 x 96 in. (238.1 x 366.4 x 243.8 cm) installed Gift of the T. B. Walker Foundation, 1966 1966.47

Richard Serra
American, b. 1939

- - **Commissions**
Joplin (1971)
- - **Exhibitions**
Works for New Spaces (1971; catalogue), *Eight Artists: Prints from Gemini G.E.L.* (1974; catalogue, tour), *The Garden in the Galleries* (1994)
- - **Holdings**
2 sculptures, 1 unique work on paper, 1 film, 21 edition prints/proofs, 2 monoprints/monotypes, 1 multiple, 1 book, 1 periodical

As a young artist eking out a living and trying to find his niche in the fertile and frenetic New York art world of the mid-1960s, Richard Serra composed a list of transitive verbs—"to roll, to crease, to fold . . . to bend . . . to splash," which he interspersed with phrases such as "of tension, of gravity, of entropy, of inertia, of equilibrium" —describing various forces acting on matter.[1] This concrete poem of sorts became a lifelong "to do" list for Serra that would lay the conceptual groundwork for his sculptural practice, one shared by artists such as Robert Morris and Eva Hesse, who privileged the physical over the metaphysical, process over product, the literal over the abstract. According to Serra, "I was very involved with the physical activity of making. It struck me that instead of thinking about what a sculpture is going to be and how you're going to do it compositionally, what if you just enacted those verbs in relation to the materials, and didn't worry about the result? So I started tearing and cutting and folding lead."[2]

In 1968, he began exploring the formal possibilities of this previously nonart material, which he favored over other metals for its weight and malleability. With composer Philip Glass, who for a time had become Serra's studio assistant, he began splashing molten lead with a large ladle into and against the angle of intersection between his studio wall and the floor.[3] It was at this moment of discovery that he began to create his first "props," works of raw psychological power based on the fear of collapse. These cantilevered, completely self-supporting sculptures were created in perfect balance and counterbalance based on the artist's calculations, testing the laws of physics without recourse to clipping, gluing, or welding.[4] Each element was integral to the integrity of the form, as is the case with a house of cards, the subtitle of the artist's *One Ton Prop (House of Cards)* (1969). In this piece, four lead plates were placed in an upright position and inclined toward the other, overlapping by two and one half inches to form an irregular cube. When discussing this body of work produced in the wake of Minimalism, a movement by which he is often co-opted, Serra explained, "The perception of the work in its state of suspended animation, arrested motion, does not give one calculable truths like geometry, but a sense of presence, an isolated time."[5]

The previous year, the artist had begun to create "wall props," for which he hand-rolled massive sheets of lead into poles and leaned them up against flat sheets. The Walker Art Center's *Prop* (1968) is one such

work. In a 1980 interview, Serra recalled the genesis of this and other pieces like it: "I realized that I was making one form, the lead roll, and I wanted to combine it with the other form, which was the sheet. It occurred to me that the roll could be used as a pole and the sheets could be propped from and off the wall without utilizing a joint. These pieces utilizing the floor and the wall retained a memory of pictorial concerns even though their content was predicated on their axiomatic building principles."[6]

At the end of 1969, Jasper Johns commissioned Serra to produce a splash piece in his Houston Street studio, and Serra was happy to oblige. He used one small, freestanding steel plate placed perpendicular to a wall and one wedged into a corner as the backdrops for his piece, and in so doing, had an epiphany regarding the use of the existing architecture as the sole means of structural support. This was the genesis of his next body of work, which also represented a pivotal shift in his practice. For his next major piece, *Strike* (1969–1970), Serra hired a professional rigging crew for the first time to place an eight-foot-high, twenty-four-foot-wide plate of hot-rolled steel so that it bisected a ninety-degree corner. From this point onward, he turned almost exclusively to steel, which in turn prompted him to abandon the studio for the steel mill, the locus of his sculptural production to this day.[7]

The artist has recalled that the works from 1970 to 1971 represented "a real sea change for me. I began to think about declaring or dividing the space of a room, and about the spectator walking through and around a piece in time, rather than just looking at an object. The spectator became part of the piece at that point, not before."[8] Another important work from this period, the Walker's *Five Plates, Two Poles* (1971), was created to function equally well indoors and out. The massive Cor-Ten steel plates appear to have been shuffled off axis as they lean precariously against one another in a rhythmic dance of mass and space. Its height, taller than the average person, frustrates sight lines, which creates the need to constantly move around the piece in order to comprehend its gestalt. *Five Plates, Two Poles* is experienced by many as confrontational and intimidating, and by others as perversely playful, but Serra does not concern himself with psychological readings. For him, it is enough simply "to continue."[9]

E.C.

Notes
1. This list was first published in Grégoire Müller, *The New Avant-Garde: Issues for the Art of the Seventies* (New York: Praeger Publishers, 1972), 94.
2. Quoted in Calvin Tomkins, "Profiles: Man of Steel," *New Yorker*, August 5, 2002, 57.
3. The risk and sheer muscle involved in this performative process were captured in a series of photographs by Gianfranco Gorgoni, which for their theatricality and the machismo they reveal might be compared to Hans Namuth's well-known pictures of Jackson Pollock hurling paint from a stick onto a canvas on the floor of his East Hampton studio. One of Gorgoni's photos serves as the cover image for Müller's *The New Avant-Garde* (1972).
4. Their fully interdependent parts were assembled by art handlers,

not by industrial aids such as forklifts or cranes. In addition to Philip Glass, Serra turned to his friends and fellow Yale art students, including painter Chuck Close, musician Steve Reich, writer Rudy Wurlitzer, and monologuist Spalding Gray, to help assemble the early prop works.

5. Richard Serra, "Play It Again, Sam," *Arts Magazine* 44, no. 4 (February 1970): 25.

6. "Interview: Richard Serra & Bernard Lamarche-Vadel," in Richard Serra and Clara Weyergraf, *Richard Serra: Interviews, Etc. 1970–1980* (Yonkers, New York: The Hudson River Museum, 1980), 142.

7. During his high school and college summers, Serra worked in a steel mill, an experience that proved to be as formative as his formal education at the University of California at Berkeley and Santa Barbara, and at Yale University.

8. Quoted in Tomkins, "Profiles," 58. The artist's intention to engage with the whole body invites a phenomenological reading, linking perception and bodily encounters with forms. French philosopher Maurice Merleau-Ponty's 1945 book *The Phenomenology of Perception* was first translated into English in 1962 and was widely read by the artists of the time. See Rosalind Krauss, "Richard Serra: A Translation," in Alfred Pacquement, ed., *Richard Serra*, exh. cat. (Paris: Centre Georges Pompidou, Musée National d'Art Moderne, 1983), 29–35.

9. "To continue" was the last entry on Serra's 1967–1968 verb list.

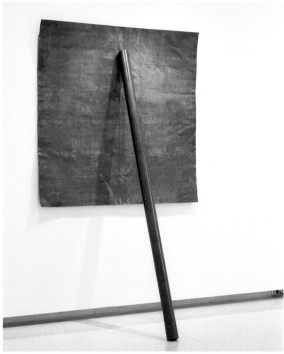

Richard Serra *Prop* 1968 lead antimony sheet: 60 x 60 in. (152.4 x 152.4 cm); roll: 95 1/2 x 4 x 4 in. (242.6 x 10.2 x 10.2 cm) Gift of Penny and Mike Winton, 1977 1977.44

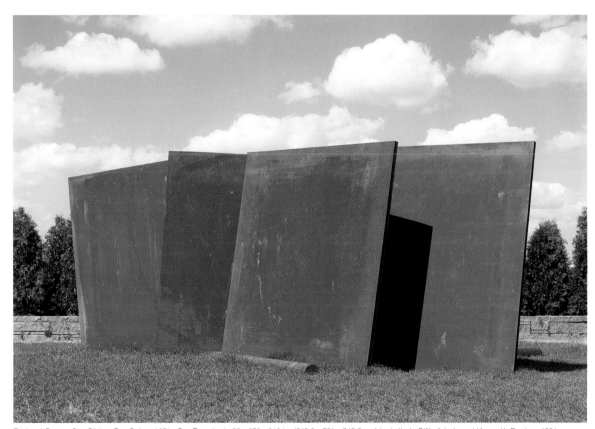

Richard Serra *Five Plates, Two Poles* 1971 Cor-Ten steel 96 x 276 x 216 in. (243.8 x 701 x 548.6 cm) installed Gift of Judy and Kenneth Dayton, 1984 1984.1147

Paul Shambroom

American, b. 1956

-- **Exhibitions**
Paul Shambroom: Hidden Places of Power (1995; publication),
American Tableaux (2001; publication, tour)
-- **Holdings**
2 photographs

Paul Shambroom *Untitled* (Minuteman II Missile, Air Force Transporter
Erector Vehicle, Ellsworth Air Force Base, South Dakota) from *Nuclear
Weapons* 1992 color coupler print 48 x 60 15/16 x 2 11/16 in. (121.9 x 154.8 x
6.8 cm) framed Clinton and Della Walker Acquisition Fund, 1995 1995.100

Joel Shapiro

American, b. 1941

-- **Exhibitions**
Scale and Environment: 10 Sculptors (1977; catalogue), *Joel Shapiro:
Outdoors* (1995; catalogue), *The Cities Collect* (2000), *American
Tableaux* (2001; publication, tour)
-- **Holdings**
1 sculpture

Joel Shapiro *Untitled* 1975 iron, wood 20 x 22 x 29 1/2 in. (50.8 x 55.9 x
74.9 cm) Purchased with the aid of funds from the National Endowment for
the Arts and gifts from Mr. and Mrs. Edmond R. Ruben, Mr. and Mrs. Julius
E. Davis, Suzanne Walker and Thomas Gilmore, 1976 1976.4

Paul Sharits
American, 1943–1993

- - **Commissions**
Synchronousoundtracks (1973–1974)
- - **Screenings**
Paul Sharits: Visiting Filmmaker (1974), Paul Sharits: Visiting Critic (1979), Filmmakers Filming (1981; catalogue), Ruben Cinematheque: Hollis Frampton and Paul Sharits (1994)
- - **Exhibitions**
Projected Images (1974); *In the Spirit of Fluxus* (1993; catalogue, tour)
- - **Holdings**
7 films, 2 multiples, 1 book

A leading member of the American avant-garde cinema of the 1960s and 1970s, Paul Sharits was also a teacher, critic, and proponent of "structural film," as it was termed by P. Adams Sitney in 1969. Intrigued by the physical properties of the filmstrip, its development and projection, Sharits created a series of films examining the boundaries of physical perception. His advocacy helped launch experimental filmmaking at numerous colleges and universities in the United States.

Sharits' work is part of an essential history of experimental film. Exploring what makes up the nature of cinema, he utilized the basic elements of the medium while steering away from traditional tropes of narrative storyline and dramatic tension. Seven of his films are in the Walker Art Center's Edmond R. Ruben Film and Video Study Collection, including the definitively structuralist *T,O,U,C,H,I,N,G* (1968). He wrote: "Premise: there is the possibility of synthesizing various, even contradictory concepts of perception-consciousness/knowing-meaning into a unified, open (self-organizing) systems model through a close analysis of the most fundamental level of what I am calling 'cinema.'"[1] Sharits found his realm of experimentation at this fundamental level.

Early in his career, while still a painter, he noted that he was looking through the frame to see the painting, but with film he was looking at the frame. Discounting film abstraction as too closely related to painting, he wanted to take away the sense of illusion offered by cinema and "enter directly into the higher drama of celluloid, two-dimensional strips; individual rectangular frames; the nature of sprockets and emulsion; projector operations; the three-dimensional light beam; environmental illumination; the two-dimensional reflective screen surface; the retinal screen; optic nerve and individual psycho-physical subjectivities of consciousness."[2]

In 1966, when Sharits perceived that traces of narrative tainted his early avant-garde films, he destroyed them. By 1968 when he made *T,O,U,C,H,I,N,G,* he was already working with the pure substructure of film and the montage of the single frame. Even the title's punctuation is the ultimate exercise in editing to provide the synthesis he was striving for—physical perception and consciousness. Yet, as critical as he was of narrative structure, this synthesis links the eye and the ear in linear perception. Images of a man's face (poet David Franks, whose voice is heard on the sound track) and of extended fingers scratching into the film's surface are repeated, in varying order, interspersed with a close-up of an eye—an homage to Luis Buñuel's *Un Chien Andalou* (*An Andalusian Dog*) (1929)—and a shot of the male and female sex organs in coitus, photographed at extremely close range and thus hard to identify. Pain, sex, the tension of being scratched or maimed—this is drama.

Images in this film were sequenced as if Sharits were composing a musical score. Yet the sound track consists of one word, "destroy," voiced repeatedly. The human mind can not, does not, hold on to the word's meaning over the twelve minutes of the film's duration, but lets it evolve into other sounds, other words, and new ideas put into effect by the images. The fast repetition of sound and imagery assaults perception like photonic bullets. Sharits said about his work, "In my cinema flashes of projected light initiate neural transmission as much as they are analogues of such transmission systems, and the human retina is as much a 'movie screen' as is the screen proper."[3]

S.M.

Notes
1. Paul Sharits, "Cinema as Cognition: Introductory Remarks," *Film Culture* 65–66 (August 1978): 76.
2. Paul Sharits, "Notes on Film/1966–1968," *Film Culture* 47 (Summer 1969): 13.
3. Ibid.

Paul Sharits *T,O,U,C,H,I,N,G* 1968 16mm film (color, sound) 12 minutes
Edmond R. Ruben Film and Video Study Collection

Charles Sheeler

American, 1883–1965

-- **Exhibitions**

Paintings to Know and Buy (1948), *Contemporary American Painting: Fifth Biennial Purchase Exhibition* (1950; catalogue, tour), *Pictures for the Home* (1950), *Charles Sheeler* (1952), *Contemporary American Painting and Sculpture: Collection of Mr. and Mrs. Roy R. Neuberger* (1952; catalogue), *Lowenthal Collection of American Art* (1952; catalogue), *The Classic Tradition in Contemporary Art* (1953; catalogue), *Reality and Fantasy, 1900–1954* (1954; catalogue), *The Precisionist View in American Art* (1960; catalogue, tour), *American Tableaux* (2001; publication, tour)

-- **Holdings**

1 painting, 1 unique work on paper

Charles Sheeler *Buildings at Lebanon* 1949 tempera, graphite on pressed board faced with sized paper 14 5/16 x 20 1/4 in. (36.4 x 51.4 cm) Gift of the T. B. Walker Foundation, 1952 1952.5

Charles Sheeler *Midwest* 1954 oil on canvas 17 7/8 x 32 in. (44.1 x 81.3 cm) Gift of the T. B. Walker Foundation, 1955 1955.6

Cindy Sherman
American, b. 1954

"Here is a picture: It shows a young woman with close-cropped hair, wearing a suit and hat whose style is that of the 1950s. She looks the part of what was called, in that decade, a career girl, an impression that is perhaps cued, perhaps merely confirmed by the fact that she is surrounded by the office towers of the big city."[1] It was these sentences, published in 1979, that introduced readers of the then-nascent yet already unashamedly highbrow journal *October* to the work of Cindy Sherman. The words served as a suitably partial description of the artist: not only was she herself at the very beginning of a career in a big city, having moved to New York City from Buffalo only two years earlier, but she was, and continues to be, the only actor in her photographs.

Today the sixty-nine photographs that comprise Sherman's *Untitled Film Stills* (1977–1980) have become one of the most written-about bodies of work in the short history of contemporary art. Douglas Crimp's "Pictures" essay, from which the above quotation was taken, has become a marker of its time as well—it is included in many an anthology and college curriculum.[2] At least in retrospect, Sherman's small black-and-white prints were a smoldering fuse for the explosion of critical theory that would also come to circulate around the term "postmodernism" in the visual arts of the 1980s.[3]

The ambivalent, nostalgic female types that Sherman portrayed in her *Untitled Film Stills* continue to attract a plethora of critical readings—psychoanalytic, feminist, formalist—but it was her second major group of works, the imposing color *Centerfolds* series of 1981, which convinced skeptics (who might have been suspicious of dormant narcissism) of the genuine innovation of her work. The Walker Art Center's holdings of Sherman's work span diverse episodes of her career, and the earliest photograph in the collection, (*Untitled*, 1981), is from this series. The *Centerfolds* were conceived in response to an invitation from *Artforum* magazine, though they were not ultimately published. Unlike the modesty of previous work, these prints were executed in high-gloss Cibachrome that, at two-by-four-feet, were unwaveringly large in scale. Using a mirror to pose herself for the first time, the artist, now playing cinematographer/director, conjured finely tuned, claustrophobic scenes in her studio. Whether depicting a gawky adolescent waiting for the phone to ring or a terrified, doe-eyed gamine, the artist uses the horizontal format to engender a desperate defenselessness that seemingly exacerbates a rape-fantasy, woman-as-prey psychology. As Sherman says, "It was kind of a problem to think of different situations where someone is horizontal . . . this person is reclining or in some elongated position like that and I guess that to me signifies something that's vulnerable or sexual perhaps . . . the person could be sick in bed, it could be a person who is drunk, a person could be thrown down. . . . I guess I was more interested in the vulnerable ones, the ones that looked like you feel sorry for them."[4]

Six years after these pictures, in 1987, Sherman produced the *Disgust* series. Here her actual presence in the photographs is slight, occurring in reflection or at the very edge of the frame, for example; often the body is represented instead by its formless, visceral excreta, with vomit and fecal matter abjectly mingling with foodstuffs, decay, and grime. These pictures charted landscapes of monstrous disdain for hygiene at a time when the world was newly fearful of contamination through HIV and AIDS. *Untitled* (1987) is particularly pointed in its addressing of body politics; a teenager sits on a sordid mattress that's littered with condoms, apparently "practicing" safe sex with bananas and carrots, the penis euphemisms of high-school sex education. Sherman conceived of this series as a deliberate about-face: "At some point I felt I was the art world's flavor of the month, and I didn't like the idea that these nouveau collectors were going to be buying up my work because it was the thing to do, so in the mid-'80s I made the works that people call the 'disgusting series'—photos with vomit in them, et cetera. 'Put that over your sofa!' I thought."[5]

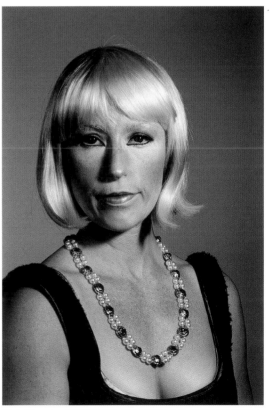

Cindy Sherman *Untitled* 2000 color photograph; edition 2/6 31 1/8 x 24 3/16 x 1 in. (79.1 x 61.4 x 2.5 cm) framed T. B. Walker Acquisition Fund, 2001 2001.19

Having dealt with sex, history, fashion, fairy tales, and horror, among other subjects throughout the next decade, Sherman would, in a new series begun in 2000, self-consciously ape the most generic form of portraiture, the kind of head-and-shoulders studio pose set against a graduated backdrop. *Untitled* (2000) torments the faith of private collectors once more, as Sherman inhabits an affluent woman who has, we might imagine, commissioned the portrait as a frantic commemoration of her perceived "good taste." Weathered by the leisure of salons and charity soirées, she is betrayed by the vulgar necklace, patchy panda-eye tan, and wobbly makeup that reveal a social disguise in ruins. In a *mise en abyme* of what we might term the "Sherman-function" itself, the artist plays a woman who is defined by the very game of keeping up appearances.

M.A.

Notes

1. Douglas Crimp, "Pictures," *October* 8 (Spring 1979): 75–88.
2. Crimp's text was an elaboration on his catalogue essay for a show he had organized for Artists Space in 1977. Sherman was not in the show, though, incidentally, she did at one time work at the venue's front desk. Crimp followed up his championing of Sherman, Prince, and other "Pictures" artists in, among other essays, "The Photographic Activity of Postmodernism," *October* 15 (Winter 1980): 91–101.
3. Though, as she has explained, setting a philosophical agenda is never the issue: "I have never been a fan of criticism or theories, so that actually none of that affected me and still doesn't." See "True Confessions: Cindy Sherman Interviewed," *Creative Camera* (February–March 1991): 36.
4. Sherman, interview with Lisa Lyons (former Walker curator) in conjunction with the Walker exhibition *Viewpoints—Eight Artists: The Anxious Edge*, 1982 (transcript, Walker Art Center Archives).
5. "Cindy Sherman Talks to David Frankel," *Artforum* 41, no. 7 (March 2003): 55.

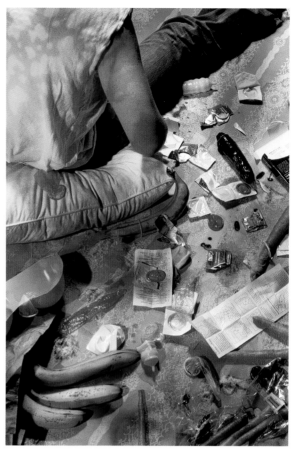

Cindy Sherman *Untitled* 1987 color photograph; edition 1/6 73 1/8 x 49 1/4 x 2 1/2 in. (185.7 x 125.1 x 6.4 cm) framed Gift of Barbara Gladstone, 2000 2000.409

Cindy Sherman *Untitled* 1981 chromogenic print; Artist's Proof 1/2 from an edition of 10 24 x 48 in. (61 x 121.9 cm) Art Center Acquisition Fund, 1982 1982.40

Shimamoto Shozo

Japanese, b. 1928

- - **Holdings**
1 painting

Shimamoto Shozo was one of the original members of the Gutai Art Association (*Gutai bijutsu kyokai*) founded in Osaka, Japan, in 1954 under the leadership of Yoshihara Jiro, the group's teacher and an imposing presence. Gutai, which literally means "concrete," lasted until 1972, the year of Yoshihara's death, but its most original works arguably were made during the late 1950s and early 1960s. International recognition came rather quickly and widely for Gutai, and the self-promotion and networking built into the movement's strategies attest, in retrospect, to the ambition of a group situated away from the center of the Japanese art world in Tokyo. Gutai's accomplishments were especially remarkable given the historical circumstances of postwar Japan: the country was defeated and devastated by World War II and subsequently rebuilt under the American occupation (1945 to 1951).

In the *Gutai Manifesto* published in 1956, Yoshihara wrote: "Gutai art does not transform matter. Gutai art gives life to matter. In Gutai art, the human spirit and matter remain in confrontation as they shake hands. . . . Bringing matter to life fully is the means for bringing the spirit to life. The raising of the spirit is the introduction of matter into a highly creative place."[1] Reflecting the *Manifesto*, albeit never slavishly, Gutai artists indeed tended to use materials as a means for achieving sometimes unpredictable possibilities rather than preconceived visions. Shimamoto had already made a series of paintings (circa 1949 to 1952) in which he punctured layers of glued newspaper. They were roughly contemporaneous with Lucio Fontana's famous *Concetto Spaziale* (*Spatial Concept*) paintings, in which the artist made cuts, holes, and slashes.[2]

Soon after joining Gutai, Shimamoto began his signature painting experiment—hurling and shattering glass bottles filled with pigments on canvas. In *Untitled* (1961), a chaotic melange of colors—white, scarlet, maroon, pinkish orange, and black—is accreted in thick impasto in the center of the canvas, its round mass and fleshy folds giving it a rather disconcertingly visceral feel. On top of and around it are thinner stains, splatters, rivulets, and eddies of paint, which add a further dimension to the optical push-and-pull dynamic of volume and motion. Shards of glass encrusted on the surface enhance the painting's tactile sensation amidst the vortex of chromatic collision. Made without a brush or any of the usual tools of painting, the work majestically testifies to an action forceful in its execution and dauntless in its abandonment of creative control to the caprices of chance and physics.

D.C.

Notes
1. Reprinted in *Document Gutai 1954–1972* (Ashiya, Japan: Ashiya City Culture Foundation, 1993), 8. Originally published in Japanese as *Gutai*

bijutsu sengen in *Geijutsu shinchō* 7, no. 12 (December 1956). The English translation is a reprint of the text in Barbara Bertozzi and Klaus Wolbert, *GUTAI, Japanische Avantgarde/Japanese Avant-Garde 1954–1965* (Darmstadt, Germany: Mathildenhöhe, 1991), 364–369.
2. For a discussion of Shimamoto and Fontana in the same context, see Paul Schimmel, "Leap into the Void: Performance and the Object," in Paul Schimmel, ed., *Out of Actions: Between Performance and the Object, 1949–1979*, exh. cat. (Los Angeles: Museum of Contemporary Art, 1998).

Shimamoto Shozo *Untitled* 1961 mixed media on canvas 76 3/8 x 51 15/16 x 1 1/2 in. (194 x 131.9 x 3.8 cm) framed Anonymous gift, 2000 2000.214

Shiraga Kazuo

Japanese, b. 1924

- - **Holdings**
1 painting

From photographic documentation of the Japanese Gutai artists' early actions, it is quite clear that Shiraga Kazuo was the most enterprising, even macho, of the pack. *Challenging the Mud* (1955), in which the artist, dressed only in a pair of boxers, jumped on top of a mud pile and kicked, punched, and wrestled with it, remains an iconic Gutai work. A practice that has earned him more enduring recognition, however, is his "foot painting," which he had begun shortly before joining Gutai in 1955. To create a piece such as *Untitled* (1959) in the Walker Art Center's collection, he would swing back and forth from a rope attached to the ceiling and push paint with his feet across canvas or paper laid on the floor. The artist's performative physicality exemplifies, with a powerfully dramatic flair, the Gutai group's manifest practice of translating action into painting.

Michel Tapié, the French critic who formulated the theory of *art autre* (also known as Art Informel) in relation to postwar gestural painting, was introduced to Gutai early on and became the conduit between the Japanese avant-garde and the Western art world. When Tapié arrived in Japan in 1957 with his compatriot Georges Mathieu, a practitioner of rather histrionic action painting and no stranger to swaggering self-promotion, the latter allegedly said: "That man named Shiraga, I hear, paints with his feet. Why does he paint with feet when he's got hands? He should cut his hands off then!"[1] As soon as they encountered one of Shiraga's paintings, however, both Tapié and Mathieu became avowed backers of their Japanese contemporary's work.

Shiraga's method of painting on a horizontal surface invites an obvious comparison with Jackson Pollock's "dancing" and "dripping" over a canvas laid on the floor, which was famously captured in Hans Namuth's 1950 documentary film and photographs. However, even when hung on the wall as a painting, Shiraga's work denies the sublimation of base materiality into pure opticality that one experiences in Pollock's.[2] The thick accumulation of pushed paint and the registration of splashes in Shiraga's paintings pulsate with an uncontainable preconscious—perhaps even preperceptual—energy. The artist, who became an ordained Buddhist monk in 1971, has commented numerous times on the calligraphy of Nantembo, the early twentieth-century Zen monk and artist known for his energetic brushwork. By linking his art to another tradition in which horizontal mark-making is practiced for the explicit purpose of self-awakening, Shiraga intimates that his gesture is able to elevate matter to a level beyond the optical, perhaps to that of the spiritual sublime.

D.C.

Notes
1. As recalled by Murakami Saburo in "Gutai-teki na hanashi" (Concrete Talk: Interview with Murakami and Shiraga Kazuo), in *Gutai I•II•III* (Ashiya, Japan: Ashiya City Culture Foundation, 1994), 211. Trans. Doryun Chong.
2. For an in-depth discussion of horizontality and the idea of sublimation in painting, see Rosalind Krauss in *The Optical Unconscious* (Cambridge, Massachusetts: MIT Press, 1993), 242–308.

Shiraga Kazuo *Untitled* 1959 oil on canvas 70 7/8 x 110 in. (180 x 279.4 cm) T. B. Walker Acquisition Fund, 1998 1998.109

Yinka Shonibare

British, b. 1962

- - **Holdings**
1 sculpture, 1 multiple

Born in England to parents of Nigerian descent, Yinka Shonibare explores the cultural duality of his upbringing through work that is informed by the complex and contradictory history of colonialism and the attendant dynamics of power, race, and class. His multidisciplinary practice, which includes painting, photography, sculpture, and installation, converges with his relentless fascination with the politics of representation. Through cultural symbols such as the batik, a type of textile with colorfully patterned motifs, Shonibare uncovers the often murky territory of authenticity.

Used widely throughout the African diaspora for everything from head wraps to tablecloths, the batik is a loaded subject. Although typically associated as a marker of African culture and usurped in modern times as a symbol of nationalism and empowerment, its history reveals something quite different. The cloth actually originated in Indonesia, where it was exported to Holland during the Dutch colonization of that country. Via these colonial trade routes, the fabric was introduced throughout Europe and then appropriated in Africa in the early nineteenth century. This is where Shonibare's work begins.

In his elaborate installations and sculptural works, he creates tableaux of Victorian proportions, taking period parlor rooms and characters straight out of Thomas Gainsborough paintings and literally dressing them up with batik cloths. Shonibare's signature works are physical manifestations of cultures clashing. In *Dysfunctional Family* (1999), he uses the textile to mask a group of figures resembling aliens. The title plays off and destabilizes bourgeois definitions of the family unit and the enterprise of acceptance and alienation. The artist deals with the perversity of norms and deconstructs the binary relationships between high and low, race and class, the colonized and the colonizer. In doing so, Shonibare eloquently expresses the layered and often overlapping experiences that constitute the self-consciousness of a postcolonial world.

Clara Kim

Yinka Shonibare *Dysfunctional Family* 1999 wax-printed cotton, polyester, wood, plastic installed dimensions variable Butler Family Fund, 2000 2000.99

Paul Sietsema

American, b. 1968

-- **Holdings**
1 film

The films of Los Angeles–based Paul Sietsema are meditations on artifice and absence. For his two major projects to date, he has filmed elaborately detailed, handmade sculptural elements and models rather than selecting preexisting objects and architectural spaces. Sietsema's entrée into the art world came while he was still an MFA student at the University of California, Los Angeles, with the 1998 debut at the Brent Petersen Gallery of his nineteen-minute silent film *Untitled (Beautiful Place)*.[1] The work consists of a series of slow camera pans of eight floral and botanical specimens— images the artist collected initially from advertisements, textbooks, and other photographic sources before crafting them meticulously out of wood, plastic, clay, glue, paint, foam, fabric, and paper. Sietsema then captured them on a film stock that supersaturated the color of the flowers, resulting in a hyperrealistic effect.

He used a similar tactic in his next work, *Empire* (2002), although this time his interest was almost entirely phenomenological. The concept that subtly informs each of the six segments of the film is the exploration of ways that geometric and organic forms are represented and visually perceived in two- and three-dimensional space, specifically within the context of art history, and more precisely, that of the avant-garde.[2]

The film opens with a fuzzy gray, blank screen that slowly comes into focus. A grasshopper balanced on a leafy branch appears and then disappears again into an overexposed flash of light. The second segment reveals a craggy, hivelike form—which the artist has revealed is a hybrid reinterpretation of Louise Bourgeois' 1963 sculpture *Fée Couturière (Fairy Dressmaker)* and a little-known early sculpture by Jackson Pollock—through which the camera weaves in and out, leaving the viewer at certain moments in complete darkness.[3] In segment three, a transparent, polyhedronic form seems to tumble in space, as the camera scans the triangular planes created at the intersecting points of what the artist ambiguously calls "black sticks." A rotating crystalline structure in segment five harkens back to this purely geometrical moment in the film.

The interiors of two vastly different living spaces in the fourth and sixth segments serve as conceptual anchors for the work as a whole. A filmic image of a model created from a photograph of critic Clement Greenberg's art-filled Manhattan living room as illustrated in a 1964 article in *Vogue* magazine[4] is paired with another trompe l'oeil facsimile of the extravagantly ornamental "Salon de la Princesse" in the Hôtel Soubise in Paris, a masterpiece of Rococo architecture. What these two vastly different interiors share is that, stylistically, they were resolutely of their time and serve as canonical touch points along an ever-unfolding historical continuum. The art objects, furniture, and decorative architectural details and the way they are displayed betray a particular conception of art history.

Sietsema's interest in cultural anthropology inflects our view of these uninhabited spaces as proxies for the individuals who resided in them.

E.C.

Notes
1. As an MFA student at the University of California, Los Angeles, Sietsema studied with artists Chris Burden, Paul McCarthy, and Charles Ray, all of whom aided him in clarifying his artistic identity as a sculptor who doesn't produce sculptural objects for display. Correspondence with the author, March 31, 2004 (Walker Art Center Archives).
2. In correspondence with the author, April 13, 2004, Sietsema explained, "The bridge between the development of early film and the avant-garde was perception. . . . I began to think of the parallel worlds of film and imagination (as it relates to perception) as empires." Sietsema also identified other possible sources for his choice of this title: Andy Warhol's iconic 1964 film of a single continuous shot of the Empire State Building, and London's Empire Theater, which in 1896 became the first public "moving picture" house.
3. See Chrissie Iles, *Empire: Paul Sietsema*, exh. cat. (New York: Whitney Museum of American Art, 2003), unpaginated.
4. Clement Greenberg, "Private Lives—With Art: The Greenberg Collection," *Vogue* 143 (January 15, 1964): 92–95.

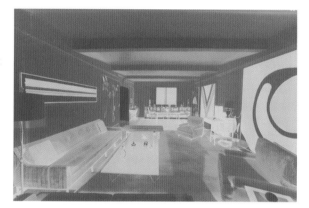

Paul Sietsema *Empire* 2002 16mm film (color/black and white, silent), modified projector; edition 6/7 24 minutes T. B. Walker Acquisition Fund, 2003 2003.30

Lorna Simpson

American, b. 1960

-- **Commissions**
Recollection (1998)
-- **Exhibitions**
Duchamp's Leg (1994; catalogue, tour), *Scenarios: Recent Work by Lorna Simpson* (1999; publication, tour)
-- **Residencies**
1997–1998
-- **Holdings**
1 photograph, 1 film, 1 edition print/proof, 3 multiples

Brooklyn-based artist Lorna Simpson is best known for provocative photographic works that address issues ranging from racial and sexual identity to conceptions of the body to interpersonal communication and relationships. Trained at the School of Visual Arts in New York City, she received her MA in 1985 from the University of California, San Diego, where she studied film and fine arts. She began her career as a documentary photographer but soon found herself more interested in investigating the role of the viewer. Part of a larger movement of feminist-inspired conceptual artists in the 1980s, including Cindy Sherman, Adrian Piper, and Barbara Kruger, who were concerned with the way a photograph is "read," Simpson began in the mid-1980s to create compositions pairing minimalist black-and-white images with short texts. Presented with cool detachment and sometimes caustic humor, her images were often grouped to create large-scale tableaux of visual fragments—the human figure, objects, and words—that coalesced into quietly confrontational narratives.

Simpson came of age in the late 1970s, and acknowledges that the feminist movement—particularly her exposure to black feminism—was intrinsic to the shaping of her work.[1] Her earliest photographs pictured an African American female model in a simple dress, frequently photographed in partial view or from behind. In presenting an anonymous subject coupled with disparate objects and words bearing cultural, social, or metaphoric weight, Simpson challenged the viewer to interpret meaning through personal experience. *Queensize*, a work from 1991, consists of three parts. The top image depicts the back of an African mask against a rich field of black. A second photograph portrays an African American female figure, clothed in a dark dress and shown from the waist down, the curve of her hip emerging from the shadows as her hands rest upon it. The diptych is joined by a wall-mounted plastic plaque—like those labeling the doors of corporate offices—engraved with the italicized word *Queensize*. The juxtaposition of the images and text, each part occupying a discrete visual space, creates a fractured yet powerful narrative surrounding notions of black feminine beauty.

In the mid-1990s, Simpson began creating works in which photographic imagery and text were printed on dense felt. The prints in the multipart *Wigs (portfolio)* (1994) were made by transferring twenty-one photographic images to felt panels using waterless lithogra-

phy.[2] The edition marks a period when Simpson was interested in eliminating the figure in favor of objects that could "indicate the body rather than actually using the body itself."[3] Hair and its cultural indicators had occupied a central place in her work since 1988. *Wigs (portfolio)* presents a taxonomy of hairstyles in varying lengths, shapes, and textures that signify differences of race, gender, and age, while emphasizing the wig as a masquerading device. The images are juxtaposed with texts, such as "the wig produced the desired effect" and "first impressions are the most lasting," that underscore the unstable nature of social identities and question cultural assumptions associated with appearance.[4]

Simpson's early concentration on the figure evolved in the late 1990s into an interest in working with physical space and recognizable human characters, a shift that led her to explore narrative film. Her lush black-and-white films are often manifest as dual or multiple projections, and are intended to be screened in a darkened room within a gallery context. Just as her multi-image photographic tableaux are "built," so too are the film composites, weaving images and dialogue into compelling, open-ended scenarios. Stylistically, the sense of mystery, intrigue, and romance in these works nods to film noir; Simpson's focus on details and objects recalls the classics of Alfred Hitchcock, whom she acknowledges as a strong influence, though the contemporary subject matter is very much her own.[5]

The Walker Art Center invited Simpson to make *Recollection* (1998), her third film, as an artist-in-residence from 1997 to 1998. Shot in the Twin Cities, the project presents what the artist has called a "disjointed,

Lorna Simpson *Queensize* 1991 black-and-white silver prints with plastic plaque; edition 3/3 102 x 50 1/2 in. (259.1 x 128.3 cm) installed Rollwagen/Cray Research Photography Fund, 1991 1991.100

linear narrative" that focuses on characters who attempt to reconstruct past events through memory.[6] In this single-projection installation, she employs a film-within-a-film device, calling into question the parts that are "real" and those that are fictitious. One scene presents two women in a movie theater speaking in hushed tones as they try to recall the details of a crime, their memories triggered by images they see on-screen. Several scenes involve telephone conversations ranging from a lovers' quarrel to a case of mistaken identity. By layering snippets of dialogue, evocative vignettes, and enigmatic characters, the artist suggests that memory is at best selective. The experience of viewing Simpson's films is one of tension; the verbal and visual cues she presents are challenging—at times disturbing—yet we remain drawn to the evocative power of her moving images.

S.E.

Notes

1. Lorna Simpson, telephone interview with the author and Sarah Cook (former Walker Visual Arts intern), March 9, 1999 (Walker Art Center Archives).

2. The felt in Simpson's wall works is a variety commonly used to cushion the beds of printing presses. Thematically, her choice of felt for this piece is particularly apt: this material, traditionally used for clothing and hats, is produced through an industrial process that combines animal hair and water.

3. Simpson, interview with Engberg and Cook.

4. The texts in *Wigs (portfolio)* are a combination of aphorisms, bits of dialogue, and narratives. One text is an excerpt from the slave narrative of William Craft, which describes his plan for escaping to freedom by having his wife masquerade as his white master.

5. Simpson also acknowledges a stylistic debt to Constantin Costa-Gavras, Jean-Luc Godard, and Jean-Pierre Gorin. Simpson, interview with Engberg and Cook.

6. Ibid.

Lorna Simpson *Recollection* 1998 16mm film transferred to laser disc (black and white, sound) 9 minutes Clinton and Della Walker Acquisition Fund, 2000 2000.111

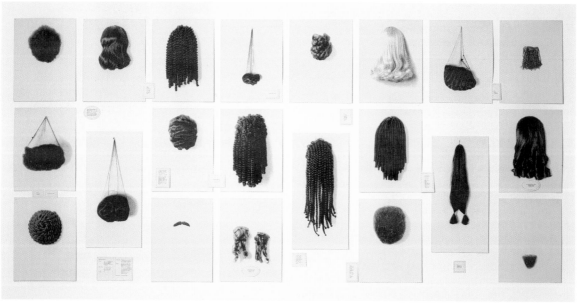

Lorna Simpson *Wigs (portfolio)* 1994 waterless lithograph on felt; edition 2/15 72 x 162 x 3/8 in. (182.9 x 411.5 x 1 cm) installed T. B. Walker Acquisition Fund, 1995 1995.22

David Smith
American, 1906–1965

- - **Exhibitions**

Contemporary American Painting and Sculpture: Collection of Mr. and Mrs. Roy R. Neuberger (1952; catalogue), *David Smith Sculpture* (1952), *The Classic Tradition in Contemporary Art* (1953; catalogue), *Expressionism 1900–1955* (1956; catalogue, tour), *The John and Dorothy Rood Collection* (1960; catalogue), *The Cities Collect* (2000)

- - **Holdings**

3 sculptures, 1 drawing, 1 unique work on paper, 2 periodicals

It has been said of David Smith that "he came into the inheritance of all the modernist impulses of European art simultaneously and without having to commit himself to one over another."[1] The impulses in question are Constructivism, Surrealism, and Cubism, all of which deeply imprinted his sculptural work. After seeing Vladimir Tatlin's Constructivist reliefs in the late 1920s, Smith—who began as a painter—added objects to the surfaces of his canvases, engaging the space in front of them as well as the flat plane of the wall. Surrealist interest in myth and legend suffused his early works, but Cubism was his most important discovery—especially the iron sculptures of Pablo Picasso and Julio González. He first saw such works in the early 1930s, in the French art journal *Cahiers d'Art*; by then, he was already familiar with steel, having worked as a welder at a Studebaker factory while he was a student. But he hadn't thought to use it as a material for his work. "[Seeing] the Picasso-González iron constructions of 1931 . . . was the liberating factor which permitted me to start with steel, which before had been my trade, and had until now only meant labor and earning power for the study of painting."[2]

Smith's early welded sculptures—the first was made in 1933—were open, linear constructions that suggested animals, figures, and totems, all familiar Surrealist motifs. *The Royal Bird* (1947–1948), purchased for the Walker Art Center's collection in 1952, the year the Walker organized a solo exhibition of his work, is based on the skeleton of *Hesperornis regalis*—the regal western bird, a prehistoric diving carnivore.[3] When Smith made the piece, World War II had not been over for long, and his vehement antiwar views surely informed his rethinking of the bird's body as an aggressive knot of spikes and talons. His decision to model it after a bird that kills in order to live may also be a specific indictment of profiteering through death—the particular variety of warfare he most abhorred.[4]

Smith made *The Royal Bird* at his studio in Bolton Landing, a town in the Adirondack Mountains of upstate New York. He had set up shop there permanently in 1940, naming it Terminal Iron Works for the Brooklyn business where he had previously rented studio space. There he planned and constructed his welded steel and iron objects, installing many of the finished pieces in the surrounding fields. Smith, the painter-turned-sculptor, worked his ideas out in two dimensions: he made hundreds of drawings that were studies for forms in the round, and he also used the floor of his work space to move fragments of scrap

metal around until he had a composition he liked. His last series, the *Cubis*, were mostly mocked up using discarded cardboard cartons such as liquor and cigar boxes. The process of manipulating real materials to arrive at the meaning and structure of a work had been the basis of Picasso's collage technique and, through him, became central to New York School artists, including Smith and his close friend Robert Motherwell.[5]

Cubi IX was made in October 1961, the first of twenty-eight works in this series created before Smith's death in a car accident in 1965. A radical departure from the essentially flat or linear work he had made up until that time, the *Cubis* are composed of stacks of blocky shapes that seem both architectural and dynamic. As described by poet and curator Frank O'Hara, the *Cubis* are "stainless-steel volumes balancing one on another, signaling like semaphores, climbing into the air with the seeming effortlessness and spontaneity of a masterful drawing, while retaining the sobriety of their daring defiance of gravity."[6] Their stainless-steel surfaces were finished with an electric buffing machine fitted with a Carborundum disk, which left swirling patterns that shimmer and reflect the light and colors around them.[7] Smith's engagement with surface inflection dates from his beginnings as a painter and remained a lifelong concern—in fact, about a third of his sculptures are polychromed. "My sculpture grew from painting. My analogy and reference is with color," he said simply.[8]

By the end of his prolific career, Smith had almost single-handedly imagined a new idiom for modernist sculpture. He refused to explain his work, only asserting time and again that it had been created out of necessity and as an expression of his identity. "I haven't named this work nor thought where it would go. I haven't

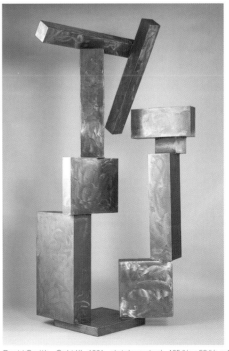

David Smith *Cubi IX* 1961 stainless steel 105 3/4 x 58 5/8 x 43 7/8 in. (268.6 x 148.9 x 111.4 cm) Gift of the T. B. Walker Foundation, 1966 1966.20

thought what it is for, except that [it] is made to be seen. I've made it because it comes closer to who I am than any other method I can use. The work is my identity. . . . Why should you expect understanding when I do not?"[9]

J.R.

Notes

1. Hilton Kramer, quoted in Frank O'Hara, *David Smith*, exh. cat. (London: Arts Council of Great Britain, 1966), 9.
2. Smith in Cleve Gray, ed., *David Smith by David Smith* (New York: Holt, Rinehart, and Winston, 1968), 68.
3. Smith saw the specimen in the collection of the American Museum of Natural History, New York, and owned at least one photograph of it.
4. See Robert S. Lubar, "Metaphor and Meaning in David Smith's *Jurassic Bird*," *Arts* 59 (September 1984): 78–86. Lubar also suggests that we might read in the sculpture's title an allusion to monarchy and, by extension, to colonization and slave trade, brutalities that were motivated in large part by economics.
5. This point was made by E. A. Carmean, Jr., in *David Smith*, exh. cat. (Washington, D.C.: National Gallery of Art, 1982), 36.
6. Frank O'Hara, quoted in *David Smith* (London), 46.
7. See Carmean, *David Smith* (Washington), 46. Smith intended the *Cubis* to be installed outdoors, but doing so has caused some to develop small rust pocks due to iron inclusions in the impure grade of stainless steel he used. In addition, the surfaces of the *Cubis* are easily scratched but difficult to restore because of their swirling patterns. See conservation documents on *Cubi IX* (Walker Art Center Archives).
8. Smith, statement of 1960, quoted in *David Smith* (London), 13. His painted metal sculptures were not always well received—modernist critic Clement Greenberg, for example, considered the addition of paint to be an aesthetic mistake on the artist's part. Greenberg, one of the executors of Smith's estate, drew criticism in 1974 for his extraordinary decision to strip the paint from several sculptures that were still part of the estate. See Hilton Kramer, "Altering of Smith Work Stirs Dispute," *New York Times*, September 13, 1974, 28.
9. Smith, quoted in Gray, *David Smith by David Smith*, 164.

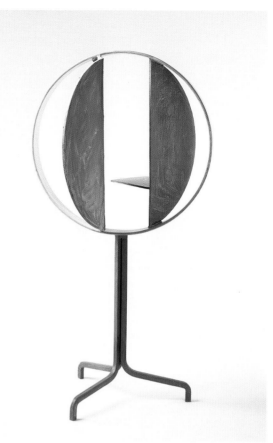

David Smith *Circle and Arcs* 1961 steel, paint 74 1/8 x 37 5/8 x 35 in. (188.3 x 95.6 x 88.9 cm) Gift of Judy and Kenneth Dayton, 1999 1999.61

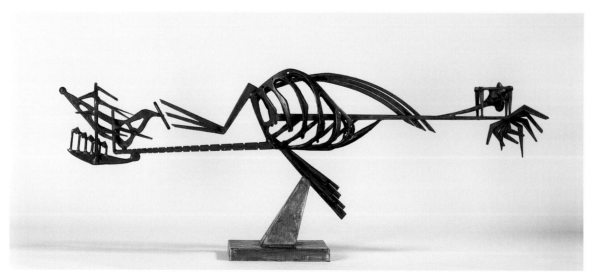

David Smith *The Royal Bird* 1947–1948 steel, bronze, stainless steel 22 1/8 x 59 13/16 x 8 1/2 in. (56.2 x 151.9 x 21.6 cm) Gift of the T. B. Walker Foundation, 1952 1952.4

Kiki Smith

American, b. Germany, 1954

- - **Exhibitions**
Duchamp's Leg (1994; catalogue, tour), *Kiki Smith* (2005; catalogue, tour)
- - **Holdings**
1 video, 4 edition prints/proofs, 1 portfolio of prints, 1 multiple, 6 books

Since she emerged in the early 1980s, Kiki Smith has been a fascinating and inventive presence. Her provocative meditations on the human body and the realms of myth, spirituality, nature, and narrative have resulted in works of extraordinary power and uncommon beauty. Smith's attitude toward working methods and materials is decidedly nonhierarchical. She has explored an eclectic array of media, including sculpture, multimedia installations, prints, drawings, photographs, multiples, artist's books, and film and video works. Her influences are rich, from Edgar Degas to Eadweard Muybridge to Lewis Carroll, and her work falls in the lineage of artists such as Lee Bontecou, Louise Bourgeois, Eva Hesse, Carolee Schneemann, and Nancy Spero, all of whom advanced feminist ideas in their work.

Born in Nuremberg, Germany, in 1954, Smith and her family returned to the United States in 1955 to reside in New Jersey. Art was central to her childhood: her grandfather had been an altar carver; her mother was an actor; her father, sculptor Tony Smith, encouraged her participation in his work; and family friends included Jackson Pollock and Mark Rothko. Despite these influences, it would be years before she would consider herself an artist in her own right. In 1976, after a brief enrollment at the Hartford Art School, she settled in New York City and turned to art wholeheartedly.

Her work in the early 1980s was concerned with themes of mortality and regeneration—a response, in part, to her father's death and to the rapidly growing AIDS crisis.[1] In the years that followed, she began to develop an elaborate visual vocabulary around the forms and functions of the human body and its metaphorical and physical relationship to society. Her visceral sculptures in plaster, paper, and wax as well as intricately constructed drawings of ink and collaged paper explored the body both as a whole and as fragments, internal and external.

Banshee Pearls, a tour de force print series made in 1991, shows Smith's dual interest in the body and narrative. The work is a fragmented self-portrait, a quiltlike composition of twelve printed sheets. Most of the imagery derives from photographs and photocopies of the artist's face, transferred in positive and negative, in a range of scales and orientations.[2] Also woven through the work are childhood photographs and enlarged details of body parts, such as hair and teeth. Prior to printing, the artist embellished the lithographic plates with her own drawings and gestures, resulting in a remarkably personal, almost diaristic work with a powerful presence.

By the mid-1990s, Smith was engaged with themes of a more religious and mythological nature, creating sculptural works related to the imagined physical bodies of such biblical figures as the Virgin Mary, Mary Magdalene, and Lilith. More recently, she has considered fairy tales (*Little Red Riding Hood*), legends, (the French tale of Sainte Geneviève), and stories (Lewis Carroll's *Alice's Adventures Underground* of 1864) as subject matter, and has developed a growing menagerie of work concerned with animals and natural phenomena. Her fascinatingly varied body of work has established her as a virtuoso printmaker, an explorer of the startling possibilities of paper, and a reinventor of figurative bronze sculpture. Above all, she is an artist who revels in an exploration of the human condition.

S.E.

Notes

1. Smith's underground reputation in New York in the early 1980s grew alongside her involvement with the artists' collective Collaborative Projects, Inc. (Colab) and exhibitions of her work at such alternative spaces as the Kitchen, where she presented her first solo exhibition in 1982.
2. This print was made in collaboration with Universal Limited Art Editions, a workshop with which Smith has forged a long and productive relationship. For a discussion of her activities in printmaking throughout her career, see Wendy Weitman, *Kiki Smith: Prints, Books and Things*, exh. cat. (New York: Museum of Modern Art, 2003).

Kiki Smith Selections from *Banshee Pearls* 1991 lithographs on paper; edition 30/51 22 1/2 x 30 1/2 in. (57.2 x 77.5 cm) each of 12 Published by Universal Limited Art Editions, Inc., West Islip, New York T. B. Walker Acquisition Fund, 1991 1991.138

Robert Smithson
American, 1938–1973

Part postmodern cynic, part Beat wanderer, Robert
Smithson attempted to comprehend the world in
geological time, as a system verging on dissolution,
dereliction, and decay and over which man seeks sov-
ereignty in vain. Through his engagement with maps
and minerals, prehistory and archaeology, and culmi-
nating in his most iconic work, *Spiral Jetty* (1970), in the
Great Salt Lake of Utah, Smithson's art unfolds like the
fascinated narrative of a shamanic journey. Coming to
prominence in the mid-1960s, the artist produced a
uniquely influential body of work and writings that elu-
cidate an art strategy straddling both Conceptual and
environmental, Minimalist and activist concerns while
becoming increasingly hostile to curators and muse-
ums' "cultural confinement" of his art.[1] Smithson was
killed in a plane crash while surveying the site for his
posthumously completed *Amarillo Ramp* in 1973; yet
he still looms over the field of contemporary art with a
charismatic presence.

A major piece by the artist in the Walker Art
Center's collection, *Leaning Strata* (1968), dates from
an early phase in his mature work when he was still
producing what has often been characterized as self-
contained geometric sculptures.[2] As evidenced by
correspondence and works on paper in the collection,
Smithson's inclusion in the Walker exhibition *6 artists
6 exhibitions* came at a pivotal point in the develop-
ment of his practice, as he was departing from
Minimalist-looking series toward "indoor earthworks"
that included actual rocks and minerals.

Two months before the Walker show, Smithson had
held his second solo exhibition at the Dwan Gallery
in New York, showing a series of affiliated sculptures,
including *Leaning Strata*, executed in white metal,
fiberglass, or plastic.[3] Oriented around invisible points
in space, each is made up of compound geometric
wedges that are stacked into structures resembling
immaculate fun-house staircases or crystalline geologi-
cal formations. *Leaning Strata* was planned out in a
series of working drawings that conflate two schematic
systems of spatial representation—a cartographic pro-
jection and a perspectival grid. Smithson mentioned
Leaning Strata in a letter to then–Walker Director
Martin Friedman on May 30, 1968: "I plan to travel
throughout the west this summer looking for sites with
interesting rock and mineral deposits, such as volcanic
cinders, fragments from lava flows, obsidian (black
volcanic glass), broken granite, different types of sand-
stone, fossil agglomerates, shale, limestone, all kinds of

pulverized rock. This geologic or anti-geologic sense
has always been in my work to a certain degree. From
the 'Tar pit and gravel' model of 1966 [*Tar Pool and
Gravel Pit*, 1966] to the stratigraphic *Leaning Strata*.
Geologic time has a way of diminishing 'art history' to
a mere trace."[4]

Though *Leaning Strata* was not included in *6 artists
6 exhibitions*, works on paper in the collection reveal
that Smithson had considered a number of different
options for the installation. In what would have been an
elaboration on *Pointless Vanishing Point* (1968), he had
contemplated the fabrication of a series of sequentially
smaller three-dimensional works painted in progres-
sively lighter shades of "an *evanescent* greenish-blue."
However, on a picture-postcard of the moon from the
Hayden Planetarium, New York City, he wrote that he
had "decided to make only the largest unit of the 5 units
(the 8-foot one), and it will be white."[5]

Smithson did create his second "non-site," *Non-Site
#2*, for the Walker presentation, though this piece was
later destroyed at the artist's suggestion.[6] As in related
work, a dialogue was activated between an outdoor
location many miles away (the Site, on this occasion an
area close to the Lincoln Tunnel exit near Weehawken,
New Jersey) and an "artificial topographical structure"
in a gallery (the Non-Site).[7] Smithson drew on top of a
map of the area, dividing it into twelve pie-slice seg-
ments that themselves corresponded to a flattened-out
projection of the Earth's hemisphere. This companion
map (*Entropic Pole*, 1967) was reflected in the three-
dimensional iteration: nine feet in diameter, *Non-Site #2*
was specially fabricated by Walker staff and took the
form of twelve analogous white wedges with mirror
strips that indicated lines of longitude.

M.A.

Robert Smithson Working Drawing for *Non-Site #2 (with mirror latitudinal
degree)* 1968 graphite on tracing paper 23 x 18 1/2 in. (58.4 x 47 cm)
Walker Art Center Study Collection S1994.48

Notes

1. Robert Smithson, "Cultural Confinement" (1972), in Jack Flam, ed., *Robert Smithson: The Collected Writings* (Berkeley, Los Angeles: University of California Press, 1996), 154–156.

2. Smithson would, however, retroactively dispute that works from this period were self-contained, commenting of a related work, *Gyrostasis* (1968), "GYROSTASIS is relational, and should not be considered as an isolated object." Robert Smithson, "Gyrostasis" (1970), in Flam, *Collected Writings*, 136.

3. The Walker's *6 artists 6 exhibitions* included one piece from the March 1968 Dwan Gallery show, *Pointless Vanishing Point* (1968), as well as *Vortex* (1967), *Alogon #2* (1966), *Mirage #1* (1967), and *Non-Site #2* (1968). The other artists in the show were Larry Bell, Chryssa, Will Insley, Robert Irwin, and Robert Whitman. See *6 artists 6 exhibitions*, exh. cat. (Minneapolis: Walker Art Center, 1968). The main space at the Dwan Gallery show included *Leaning Strata*, *Shift*, *Sinistral Spiral*, *Gyrostasis*, and *Pointless Vanishing Point*. See Ann Reynolds, *Robert Smithson: Learning from New Jersey and Elsewhere* (Cambridge,

Massachusetts: MIT Press, 2003), 125–127.

4. Letter from Robert Smithson to Martin Friedman, May 30, 1968 (Walker Art Center Archives).

5. Postcard from Robert Smithson to Martin Friedman, n.d., post-marked February 1968 (Walker Art Center Archives).

6. Robert Hobbs speculates that "probably the reason he had this piece destroyed is that it appeared too decorative and abstract and was not a totally satisfactory mirroring of the site." Robert Hobbs, *Robert Smithson: Sculpture*, exh. cat. (Ithaca, New York: Cornell University Press, 1981), 104. However, in subsequent correspondence with Martin Friedman, Smithson only mentions that *Non-Site #2* could be destroyed, as he agreed it was not needed for the tour of *6 artists 6 exhibitions* to the Albright-Knox Art Gallery, Buffalo, in September 1968. Letter from Martin Friedman to Robert Smithson, May 24, 1968; letter from Robert Smithson to Martin Friedman, May 30, 1968 (Walker Art Center Archives).

7. Letter from Robert Smithson to Martin Friedman, May 30, 1968 (Walker Art Center Archives).

Robert Smithson *Leaning Strata* 1968 aluminum, paint 49 1/8 x 105 x 30 in. (124.8 x 266.7 x 76.2 cm) Donation of Virginia Dwan, 1985 1985.761

Michael Sommers

American, b. 1955

- - **Commissions**
Passionate Journey (with Myron Johnson/George Sand) (1993),
A Prelude to Faust (1998)
- - **Performances**
Bad Jazz (with Kevin Kling, Loren Niemi) (1986), Bad Jazz and
Broodthaers: A Celebration (with Kevin Kling, Loren Niemi) (1989),
A Prelude to Faust (1998; world premiere)
- - **Exhibitions**
*Viewpoints—Michael Sommers/Susan Haas: The Question of
How* (1993)
- - **Residencies**
1998

Puppetry's extensive history as a vital, often sacred, art form is due in part to its simultaneous ability to convey hard truths while propagating the fantasies and myths that have long sustained cultures across the globe. It also has a distinct tradition of social subversion couched in comic barbs and double entendres. Michael Sommers, together with partner Sue Haas, has played a vigorous role in the development and sustenance of the Twin Cities' puppetry/performance community, jointly directing Open Eye Figure Theatre and other independent theatrical projects with a sensibility that makes the static kinetic. Of particular importance to the artists are the sociopolitical possibilities of performance, and the belief that communities benefit from simple but profound ideas introduced via artistic practice.[1]

The Walker-commissioned *A Prelude to Faust* (1998), Sommers' prequel to Goethe's paradigmatic tale of the ultimate conflict—whether to make a deal with the devil or not—is no exception. The outer and inner worlds of the human condition are embodied, respectively, in the sly machinations of Kasper, Faust's comedic servant, and the existential struggle of Gilgamesh, a contemporary Everyman. Sommers' rendering takes a populist approach to the heady debate on the existence of free will, using the rapid-fire meter of ribald vaudeville and satiric musical interludes performed live. The artist's scopic knowledge of theatrical, musical, and visual arts is evident in this hybrid of marionette puppetry and experimental object-theater that reads more gestalt than postmodern. Ingeniously compact, yet decadent set/figure design is marked with signs of crumbling decay, a visible meditation on humanity's perpetual materialism and the fragile spiritual state in which it mires us. Poignantly illustrated by the mortal Everyman, this conflict is manifested through archetypal Western symbolism: the apple, the quill, the egg. Not unlike the painter's hand made visible through the brushstroke, the marionettes are vitalized by the clear manipulations of the puppeteers, conscious breaks in verisimilitude acting as deliberate reminders that philosophy (as well as theater) is also the construct of man.

It may seem incongruous to claim that bits of painted wood effectively convey the very essence of what makes us human, but this contradiction feeds Sommers' narrative and visual style. In the Walker's 1993 exhibition *Michael Sommers/Susan Haas: The*

Question of How, the gallery was divided: one half of it featured the interactive *Kopfspiel*, an arcade with numerous portals whose hidden contents could only be revealed by human hands; the other was a laboratory of live performance, music, and various creative activities. Because the role of the viewer is essential, the exhibition's final content was ultimately determined by the visitor's experience.

These dichotomies end in a collision of forms that are inanimate and sentient, age-old and modern, and cannot be traced through a direct creative lineage. Sommers creates machine poems for a new era, returning repeatedly to classic allusions in a continual search for universality. His work bears the imprimatur of an artist captivated first by visual poetry, but who holds fast to the potentiality of the human heart.

D.K.

Notes
1. Open Eye Figure Theatre annually presents *Driveway Tours*, a traveling puppet play able to be mounted anywhere a given host requests. In exchange for a guaranteed audience of fifty, the artists accept donations rather than a set fee.

Michael Sommers *A Prelude to Faust* Patrick's Cabaret, Minneapolis, 1998

Song Dong

Chinese, b. 1966

- - **Exhibitions**
How Latitudes Become Forms: Art in a Global Age
(2003; catalogue, tour)
- - **Holdings**
1 video

In 1997 Song Dong was the main organizer of a year-long project involving twenty-seven artists from seven cities in China. These artists, including Song, created a number of site-specific works following his guidelines of using "nonexhibition space" and "nonexhibition form." Of particular interest to him was the fact that these presentation strategies would force the audience to encounter a work of art by chance (*bu qi er yu*): "A passerby might accidentally see something strange, which could have an earth-shattering impact on him, or he might ignore it completely and just walk on by."[1]

The concerns of that exhibition—site-specificity, process, time, and *bu qi er yu*—can now be recognized as hallmarks of his work. *Jump* (1999) is a video projection of the artist jumping in place in Tiananmen Square as people mill about, largely ignoring him. His pieces are often set at sites fraught with personal, cultural, and political meaning. By choosing Tiananmen Square as a location, Song places his work within the history of that space—a history that includes the protest against the terms of the 1919 Treaty of Versailles that launched the May Fourth movement, the declaration of the People's Republic of China, and the tragic killings of hundreds of pro-democracy demonstrators in June 1989. An earlier piece, *Breathing* (1996), also took place in Tiananmen Square. The temperature was 16 degrees Fahrenheit; Song was lying face down, breathing onto the ground for forty minutes. A small patch of ice formed around his head. He then repeated the action on the frozen Hou Hai Lake in Beijing, where the effect was imperceptible. Other pieces have been created in the apartment he shares with his wife, artist Yin Xiuzhen, and *Touching My Father* (1997) literally takes place on the surface of his father's body as Song projected a video of his hand onto his father's skin in an ethereal caress.

The artist says that self-expression is at the root of his art and life. As such, his works are deeply personal and exist in a field beyond everyday logic. The full Chinese title of *Jump* can be translated as "No reason not to jump/No reason to jump/Without a reason, still must jump," highlighting Song's take on art-making as something beyond the rational.

Aimee Chang

Song Dong *Jump* 1999 video projection (color, sound) 16 minutes
Butler Family Fund, 2003 2003.61

Notes
1. Wu Hung, *Exhibiting Experimental Art in China* (Chicago: University of Chicago Press, 2000), 144.

Alec Soth

American, b. 1969

- - **Holdings**

2 photographs

Alec Soth *New Orleans, LA* 2002 chromogenic print 40 x 50 in. (101.6 x 127 cm) T. B. Walker Acquisition Fund, 2003 2003.34

Pierre Soulages

French, b. 1919

- - **Exhibitions**

Expressionism 1900–1955 (1956; catalogue, tour), *School of Paris 1959: The Internationals* (1959; catalogue), *Eighty Works from the Richard Brown Baker Collection* (1961; catalogue)

- - **Holdings**

1 painting, 3 edition prints/proofs

Pierre Soulages *Painting, 26 December 1955* 1955 oil on canvas 38 3/8 x 51 3/8 in. (97.5 x 130.5 cm) Gift of the T. B. Walker Foundation, 1956 1956.16

Daniel Spoerri

Swiss, b. Romania, 1930

– – **Exhibitions**
Editions MAT 1964 and 1965 (1966), *Artists' Books* (1981),
In the Spirit of Fluxus (1993; catalogue, tour), *Duchamp's Leg*
(1994; catalogue, tour)
– – **Holdings**
1 sculpture, 1 unique work on paper, 2 multiples, 4 books,
1 announcement, 3 newspapers

Daniel Spoerri's career has been connected to both
Fluxus and Nouveau Réalisme, two of the many groups
that emerged in the 1960s whose stated goals included
nudging "high art" and everyday life a little bit closer
together. Their art required viewers to pay attention to
activities and objects that are often overlooked or taken
for granted, and even to think of them as artful (that is,
valuable and beautiful)—things such as eating a meal,
sweeping the floor, shaving, or walking. This type of
work is built on two concepts that had provoked radical
shifts in twentieth-century artistic practice: Marcel
Duchamp's proposal that context is a key factor in des-
ignating something as art, and John Cage's abdication
of total artistic control through the use of chance.
Spoerri united all these ideas in his best-known body of
work, the *Snare Pictures*—sculptural works made by
"snaring," or fixing in place, chance arrangements of
objects (in drawers or boxes, on tables), then displaying
them on the wall as paintings. One waggish reviewer
described them as the kind of things that might have
resulted from a meeting between Pierre Bonnard and
the garbageman,[1] an apt joke that suggests their con-
nection to the pleasures of domestic life, their position
as both sculpture and (still-life) painting, and the axiom
that one man's trash might be another man's treasure.

Spoerri made his first *Snare Picture* in 1960 and
soon after began focusing his work on food, especially
the preparation and consumption of meals—activities
that are fundamental to life but also often sensual,
sociable, and pleasurable. Many *Snare Pictures* were
made from the remnants of meals he cooked and
served to friends, including a group of thirty-one that
resulted from a series of dinner parties he threw for
New York artists and art-world figures. Shown in 1964
under the title *31 Variations on a Meal*, the series
included a piece made from the leftovers of a meal
eaten by artist Bruce Conner, who later recalled the
evening: "The settings had the same silverware, dishes,
and glasses, napkin on each one. . . . I chose to eat
bread and red wine and refused all the enticing, well-
prepared delicacies that Daniel prepared. I did not use
any glass on the setting except for the wine glass. . . . I
did take the heart-shaped ashtray/candle holder from
the center of the table and move it to my setting. I kept
changing everything and then stopped when everyone
had finished eating. I left the apartment immediately."[2]

Conner's story hints at the self-consciousness
imposed by the knowledge that your meal might end
up as someone else's work of art, but clearly chance
played a large role: Spoerri began the work, but it was
completed by the diner. The contrast between the

immobility of the objects and the vitality of the activity
that had produced them was, for Spoerri, the source of
a certain "malaise" or tension, which he enjoyed.[3]
Above all, he cautioned viewers, "Don't take my *Snare
Pictures* as works of art. They are information, provoca-
tions, indications for the eye to see things it normally
doesn't notice. Nothing more. . . . And anyway, what is
art? Maybe a way and a possibility of living."[4]

J.C.P. with J.R.

Notes
1. "Daniel Spoerri," *Artnews* 64, no. 5 (September 1965): 19.
2. Bruce Conner, correspondence with Joan Rothfuss, February 3, 2001
(Walker Art Center Archives).
3. Daniel Spoerri, "À propos des Tableaux-Pièges" (1960), reprinted
in Daniel Spoerri, *Hommage à Isaac Feinstein*, exh. cat. (Amsterdam:
Stedelijk Museum, 1971), 13. Trans. Joan Rothfuss.
4. Ibid.

Daniel Spoerri *31 Variations on a Meal: Eaten by Bruce Conner* 1964
bread, dishes, flatware, ashtray, wrappers, cloth napkins, cigarette
butts, match, plastic plant, wood 21 1/4 x 25 3/16 x 11 in. (54 x 64 x 27.9 cm)
T. B. Walker Acquisition Fund, 2001 2001.126

Theodoros Stamos
American, 1922–1997

- - **Exhibitions**
Paintings to Know and Buy (1948), *Art Fair* (1959; catalogue),
*60 American Painters: Abstract Expressionist Painting of the
Fifties* (1960; catalogue)
- - **Holdings**
2 paintings

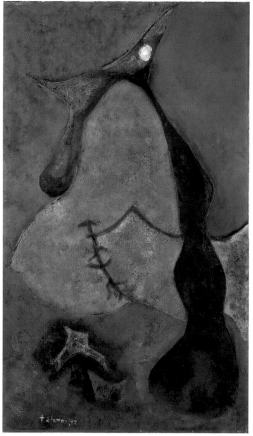

Theodoros Stamos *Archaic Release* 1947 oil on Masonite 47 15/16 x
28 1/4 in. (121.8 x 71.8 cm) Gift of the T. B. Walker Foundation, 1948 1948.28

Richard Stankiewicz
American, 1922–1983

- - **Exhibitions**
Eighty Works from the Richard Brown Baker Collection (1961;
catalogue), *Stankiewicz and Indiana* (1963; catalogue), *Prints on
Art Fabric: The 3M Collection* (1964; catalogue)
- - **Holdings**
2 sculptures, 2 edition prints/proofs

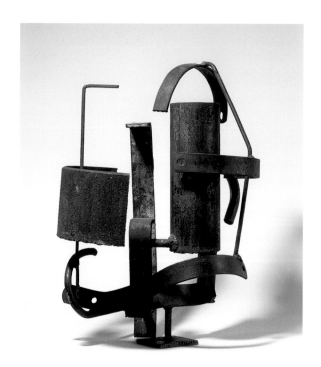

Richard Stankiewicz *untitled* 1962 iron, steel 27 15/16 x 13 1/2 x 20 1/4 in.
(71 x 34.3 x 51.4 cm) Art Center Acquisition Fund, 1963 1963.46

Georgina Starr

British, b. 1968

-- **Exhibitions**

"Brilliant!" New Art from London (1995; catalogue, tour)

-- **Holdings**

1 multimedia work, 1 video

Georgina Starr Selections from *The Nine Collections of the Seventh Museum* 1994 214 chromogenic prints, color photograph mounted on Sintra, offset lithograph on paper, ink on paper mounted to foam board, videotape (*The Making of Junior [+ Entertaining Junior]*) (color, sound), CD-ROM, computer with touch-screen monitor installed dimensions variable Butler Family Fund and Justin Smith Purchase Fund, 1995 1995.17

Frank Stella

American, b. 1936

– – Exhibitions

Eight Artists: Prints from Gemini G.E.L. (1974; catalogue, tour), *20th Century Master Prints* (1975; tour), *Artist and Printer: Six American Print Studios* (1980; catalogue, tour), *Prints from the Walker Art Center's Print Collection* (1981; tour), *Paintings from the Des Moines Art Center* (1984), *Paperworks from Tyler Graphics* (1984; tour), *Frank Stella: The Circuits Prints* (1988; catalogue, tour), *First Impressions: Early Prints by Forty-six Contemporary Artists* (1989; catalogue, tour), *Frank Stella at Tyler Graphics* (1997; catalogue, tour)

– – Holdings

2 paintings, 2 sculptures, 333 edition prints/proofs, 15 preparatory materials for works

Frank Stella emerged as part of a generation of American artists challenging the established style of postwar Abstract Expressionism. In his earliest work, he de-emphasized painterly gesture in favor of an exploration of materials and architecturally inspired, flat geometric forms. The *Black Paintings*, for which he first gained recognition—and notoriety—in the late 1950s, soon catapulted the young artist into the canon of modernist painting. When they were shown in New York at the Museum of Modern Art's *Sixteen Americans* exhibition in 1959, the shaped stretchers and unmodulated, rectilinear black bands interspersed with "pinstripes" of raw canvas were received as a flippant affront to the heroics of the Abstract Expressionists. And it was: Stella's Pollock-like use of house paint, applied to bare canvas on a mural scale, was no accident. While the New York School artists had embraced such notions as automatism and the impassioned immediacy of paint put to canvas, Stella's work by contrast appeared cool, calculated, almost mathematical in its precision. His self-stated goal "to do something about relational painting, i.e., the balancing of the various parts of the painting with and against each other" with "symmetry—making it the same all over" and with attention to color density, which could force "illusionistic space out of the painting at constant intervals by using a regulated pattern."[1] These groundbreaking works are widely considered to have ushered in the 1960s movement of Minimalism.

Throughout his career, Stella has made paintings in series, arriving at a solution of "what to paint and how to paint it," and exploring the possibilities of that particular problem in a number of variations before moving on to the next idea.[2] By 1962, the artist had begun his fifth cycle of works, which he called the *Concentric Squares and Mitered Mazes*.[3] Pictorially, these were more complex than any of the paintings that had come before. The majority share the same square format and the essential design of either a series of progressively larger squares radiating from the center of the canvas, or a "maze" made by adding diagonal lines drawn from the exterior corners of the painting to the center band.

Sketch Les Indes Galantes (1962)[4] is from the latter group, and is painted in grisaille. It was originally intended to be one half of a diptych, a pendant to a colored version of the design, an idea that was abandoned.[5] The painting has a strong optical quality, its high-contrast darks and lights creating a sense of movement, or "meander," as Stella characterizes it. His idea was that the viewer's eye "started from one edge of the canvas and ended up in the center . . . the traveling of the color and the progression of the color is what was really important" as was "the flatness of the terrain."[6] As he had with his *Black Paintings*, Stella again separated the bands of paint in the *Concentric Squares and Mitered Mazes* series by leaving bare strips between them. He has explained that key to this work was "the notion of painting on raw canvas," and what most interested him was "the medium and its relationship to the canvas itself—to the surface it was working on."[7] Like his earlier works, *Sketch Les Indes Galantes* is made with house paint, which he found to be a practical and pedestrian complement to his design formula.

By the end of the 1960s, Stella had made seven more paintings series. The last of these was the *Protractor* series—made between 1967 and 1969, and mostly named after Near Eastern and Islamic cities with circular plans—which marked a culmination of his investigations into shape and surface pattern. The series introduced an increasingly complex color palette of pastels and fluorescents, as well as the first curves—varying patterns of half-circles—to be seen in his work. In every way, these paintings exploded the scale of Stella's earlier series and were his most architectural. At twenty-five feet in length, *Damascus Gate Stretch Variation* (1968) is among the largest and most aggressively horizontal of these canvases. The complex interweaving of the semicircles shows Stella's fascination with ornamentation in art and architecture,[8] as well as his well-documented admiration for Henri Matisse. In 1970, he told curator William Rubin, "My main interest has been to make what is popularly called decorative painting truly viable in unequivocal abstract terms. . . . I would like to combine the abandon and indulgence of Matisse's *Dance* with the overall strength and sheer formal inspiration of a picture like his *Moroccans*. . . . Maybe this is beyond abstract painting . . . but that's where I'd like my painting to go."[9]

The 1970s saw a dramatic transition in Stella's work from a minimalist aesthetic to a more expressionistic one. He began to move beyond simple paint and canvas toward the creation of painted wall constructions in wood and various metals. His technique at this time became one of collage, and the building of a surface through form and heightened color. As the work became more structurally intricate, his imagery continued to gain in complexity, with each series borrowing elements from the one that preceded it. It was also at this time that he became increasingly involved with printmaking, a practice that would begin to influence his work in all media. His prints made since 1974 in collaboration with master printer Kenneth Tyler at the workshop Tyler Graphics Ltd. are housed as a complete archive at the Walker Art Center.[10]

By the late 1980s and early 1990s, the artist's additive process had resulted in a practice that allowed full parity between painting, sculpture, and printmaking. *Loomings 3X* (1986), a sculptural wall relief, is part of a large program of works in a variety of media related to

Frank Stella *Sketch Les Indes Galantes* 1962 oil on canvas 71 5/8 x 71 5/8 in. (181.9 x 181.9 cm) Gift of the T. B. Walker Foundation, 1964 1964.26

Herman Melville's *Moby Dick*. Combining honeycomb aluminum (from his sculptures) that has been etched (like his printing plates), then painted on (like his earlier wall reliefs), the work is an amalgam of Stella's techniques. Certain allusions to his earlier practice are also metaphoric: he sees the central ribbonlike form as a brushstroke, pushed from the picture plane.[11] The maquette for this work was made by first creating a three-dimensional paper construction, a practice he had also been using by that point in his printmaking. His prints of the 1990s, many of them also based on the *Moby Dick* theme, were "built," as Stella describes them, by making collages of discarded proofs, then dissecting and re-creating the collages as elaborate matrices of etched and shaped metal printing plates. These were then printed using multiple techniques in myriad colors—arguably some of the most complex printmaking ever conceived—to explosive effect.

As Stella's work has become, as he calls it, increasingly "baroque," his prints, paintings, and sculptural works have begun to share the same templates, many of which are drawn from his industrial collaborators: engravers, foundries, and other commercial fabricators. At first glance, his recent work conjures images of pure fantasy. The aggressive supermarket colors, dynamic shapes, and interstices of sculptural line form an energized abstraction quite unlike anything that has preceded it. Of his most recent paintings, he says, "The canvas, by the time I'm through, is gone. The paint takes over."[12] The title of one of his most recent series, *Imaginary Places*, further alludes to a kind of fantastical composition. But the pictorial origins of the recent work can be traced back to surprising derivations that are not only entirely consistent with Stella's practice so far, but also a natural continuation of it, part of the cumulative vocabulary of imagery he has translated across all the media in which he works.

S.E.

Notes

1. These remarks were part of a now-famous address to art students at the Pratt Institute, New York, in 1960. Transcript of the lecture text reprinted in Brenda Richardson, *Frank Stella: The Black Paintings*, exh. cat. (Baltimore: Baltimore Museum of Art, 1970), 78.
2. Ibid. "There are two problems in painting," Stella said in his Pratt lecture. "One is to find out what painting is and the other is to find out how to make a painting. The first is learning something and the second is making something."
3. The series that preceded the *Concentric Squares and Mitered Mazes* were the *Black Paintings* (1959–1969), the *Aluminum* series (1960), the *Copper* series (1960–1961), and the *Benjamin Moore* series (1961).
4. The title of this work refers to an opera-ballet, first performed in 1735, by composer Jean-Philippe Rameau. Stella has described the composition as "a Frenchman's idea of the new world." He was interested in the "ordered sense" of Rameau's harpsichord music, and liked the way the painting's high-contrast palette alluded to the instrument's keyboard. Stella, interview with Martin Friedman, February 22, 1982 (transcript, Walker Art Center Archives).
5. Whereas the paintings in his previous series had been monochrome, this series was the first in which Stella investigated a multicolored palette in some of the canvases, using either six colors (the primary colors and their secondaries) or painting the bands in varying values of gray.
6. Quoted in Calvin Tomkins, "Profiles: The Space Around Real Things," *New Yorker* 60, no. 30, September 10, 1984, 84.
7. Stella, interview with the author, Mount Kisco, New York, July 9, 1996 (transcript, Walker Art Center Archives).
8. Stella's senior thesis at Princeton had been on the decorative tradition of Hiberno-Saxon manuscript illumination. He was also influenced by his travels, particularly a 1963 trip to Iran. In 1984 Stella recounted: "The trip was a very big experience for me. . . . There's all that interlacing, or interweaving . . . things doubling back on themselves, like snakes swallowing their tails. This came out in the *Protractor* pictures." Tomkins, 84.
9. Quoted in William S. Rubin, *Frank Stella*, exh. cat. (New York: Museum of Modern Art, 1970), 149.
10. For a full discussion of Stella's printmaking development and his more than thirty-year collaboration with Kenneth Tyler, see Siri Engberg, *Frank Stella at Tyler Graphics*, exh. cat. (Minneapolis: Walker Art Center, 1997).
11. Stella, conversation with Martin Friedman, February 1987, in Martin Friedman, ed., *Walker Art Center: Painting and Sculpture from the Collection* (Minneapolis: Walker Art Center; New York: Rizzoli International Publications, 1990), 501.
12. Stella, interview with the author, 1996.

Frank Stella *Damascus Gate Stretch Variation* 1968 acrylic on canvas 60 x 300 3/4 in. (152.4 x 763.9 cm) Gift of Mr. and Mrs. Edmond R. Ruben, 1969 1969.6

Frank Stella *Loomings 3X* 1986 ink, oil paint on etched magnesium and aluminum 142 1/8 x 162 1/2 x 44 in. (361 x 412.8 x 111.8 cm) Gift of Joan and Gary Capen, 1987 1987.8

Joseph Stella

American, 1877–1946

-- **Exhibitions**

Contemporary American Painting and Sculpture: Collection of Mr. and Mrs. Roy R. Neuberger (1952; catalogue), *The Classic Tradition in Contemporary Art* (1953; catalogue), *Art Fair* (1959; catalogue), *The Precisionist View in American Art* (1960; catalogue, tour), *American Tableaux* (2001; publication, tour)

-- **Holdings**

1 painting

Joseph Stella *American Landscape* 1929 oil on canvas 79 1/8 x 39 5/16 in. (201 x 99.9 cm) Gift of the T. B. Walker Foundation, 1957 1957.15

Florine Stettheimer

American, 1871–1944

-- **Exhibitions**

Reality and Fantasy, 1900–1954 (1954; catalogue), *American Tableaux* (2001; publication, tour)

-- **Holdings**

1 painting

Florine Stettheimer *Still Life with Flowers* 1921 oil on canvas 26 3/8 x 30 1/4 in. (67 x 76.8 cm) Gift of Mrs. Ettie Stettheimer, 1955 1955.19

Clyfford Still

American, 1904–1980

-- **Exhibitions**

60 American Painters: Abstract Expressionist Painting of the Fifties
(1960; catalogue)

-- **Holdings**

1 painting

Clyfford Still *untitled (1950—C)* 1950 oil on canvas 116 5/16 x 81 5/8 in.
(295.4 x 207.3 cm) Art Center Acquisition Fund and Gift of Mr. and Mrs.
Kenneth N. Dayton, Suzanne Walker and Thomas N. Gilmore, Mr. and Mrs.
Richardson B. Okie, and Mr. and Mrs. Hall J. Peterson, 1972 1972.9

Elizabeth Streb

American, b. 1950

-- **Commissions**

Rebound (1989), *Impact* (1991), *Across* (1997), *Fly* (1997)

-- **Performances**

Wall; *Rebound* (1989; world premiere), *Impact* (1992),
Across (world premiere); *Bounce*; *Fly* (world premiere); *Surface*;
Up! (1997)

Elizabeth Streb *Fly* Minneapolis Sculpture Garden, May 1997

Thomas Struth
German, b. 1954

- - **Exhibitions**
Photography in Contemporary German Art: 1960 to the Present
(1992; catalogue, tour), *Unfinished History* (1998: catalogue, tour),
The Cities Collect (2000)
- - **Holdings**
1 photograph

Thomas Struth is an artist who makes pictures that do not simply show us the world but also question how we see that world. He began his studies at the Kunstakademie Düsseldorf in 1973 as a student of painter Gerhard Richter. On Richter's advice, in 1976 he became a student of photographer Bernd Becher, who, in conjunction with his wife, Hilla, had provoked something of a conceptual revolution in photographic practice in the 1960s with their analytic typologies of anonymous industrial buildings.[1] While Struth's work has certain affinities with the photographic projects of 1920s and 1930s German photographers Karl Blossfeldt, August Sander, and Albert Renger Patzsch, he was particularly influenced by the Minimalist sculpture and the conceptual practices of the 1960s with their respective emphases on the physical relationship between the work of art, the architectural space, and the spectator on the one hand and the attention to the historical and social specificity of aesthetic practice on the other.[2]

Struth went on to produce numerous series of photographic cityscapes, family portraits, museum pictures, and landscapes that emphasized an approach at once phenomenological and historical. In his work, the camera is not a godlike, objective, and passive recording device that is somehow located outside history and the relationships of the world it records. For him, the medium of photography is bound up with a complex set of overdetermined relationships between the camera, its subject, the artist, and most importantly, the spectator. Each of his images self-reflexively acknowledges this complicated matrix and calls for the active engagement of the viewer within this network. As critic James Lingwood suggests, "Struth's concern is not only with what we see, but how we see it—because the way we see is a key to the way we are, with ourselves and with others."[3]

Monreale, Palermo (1998) embodies precisely this self-reflexive attitude toward the act of looking, with all its social and historical implications. This large-scale photograph of the twelfth-century church Santa Maria la Nuova, with its Byzantine apse mosaic of Christ Pantocrator, is from a series of works by Struth of great cathedrals throughout Europe. The image highlights a complex web of overlapping gazes: those of the photographer, the visitors to the cathedral, the images on the walls, and all of us viewing the work. When we stand in front of this picture, it becomes clear that Struth's camera is positioned within the space at a height that suggests the photographer himself is located within the field of vision. As a group of tourists listens to a lecture about the cathedral, their attention is directed along multiple sight lines that emphasize a precipitous movement between stability and dynamism. As the immobile and controlling gaze of the gigantic Christ figure looks down on the crowd, for example, a single woman in the left-hand corner of the image looks back over her shoulder at both the photographer and, by implication, the viewers of this photograph. That is Struth's strength: he presents us with a phenomenological view of photography that puts both our bodies and his into the picture, breaking down the traditional distance between the camera and the world around it.

D.F.

Notes
1. In the 1970s, Struth was a contemporary at the Kunstakademie of sculptors Thomas Schütte and Reinhard Mucha. After taking up the large-format camera in 1976, he would become identified with a generation of German photographers that emerged in the 1980s, including Andreas Gursky, Candida Höfer, and Thomas Ruff, all of whom studied with the Bechers. Both Ruff and Struth were featured in the Walker's 1992 exhibition *Photography in Contemporary German Art: 1960 to the Present*, curated by Gary Garrels.
2. For a larger discussion of Struth's work, see Charles Wylie et al., *Thomas Struth 1977–2002*, exh. cat. (Dallas: Dallas Museum of Art, 2002).
3. James Lingwood, "Open Vision," *Parkett* (1997): 137.

Thomas Struth *Monreale, Palermo* 1998 chromogenic print; edition 4/10 73 1/4 x 91 1/4 x 2 1/4 in. (186.1 x 231.8 x 5.7 cm) framed Partial gift of Carol and Judson Bemis, 2000 2000.216

Catherine Sullivan

American, b. 1968

-- **Holdings**
1 video

Konstantin Stanislavski and Vsevolod Meyerhold—directors working in Russia at the beginning of the twentieth century—each founded his own grammatical concept of theater. Whereas Stanislavski's "System" sought to distill the correlation between physical and psychological action, Meyerhold's coaching imbued actors with an even more acute sense of the repertoire of behaviors that their bodies could enact, conceiving productions around accumulations of scripted movement. The legacy of these analyses of theater—and one could also cite the work of Bertolt Brecht, Jerzy Grotowski, or Peter Brook—runs throughout the live performances and video installations of Catherine Sullivan.[1]

That being said, knowledge of these theatrical luminaries is not needed to appreciate her art; the transformative potential of acting that she works through in her practice is apparent to anyone who has ever been to the cinema. Sullivan's work operates around what she terms "economies," the cloak of behavioral tropes and emotional dynamics that distinguishes a performer from a character.[2]

Sullivan studied acting at the California Institute of the Arts in Valencia and art at the Art Center College of Design in Pasadena. She garnered wide attention with an exhibition that premiered at the Renaissance Society in Chicago in 2002, and was included in the 2004 Whitney Biennial with a piece based on the October 2002 siege of a Moscow theater by Chechen separatists. *Little Hunt* (2002) was first presented as one part of the Chicago exhibition, which was entitled *Five Economies (big hunt/little hunt)*.[3] *Big Hunt*, a five-screen installation, interweaves restaged scenes from films such as Robert Aldrich's *Whatever Happened to Baby Jane* (1962) and Ingmar Bergman's *Persona* (1966) with other vignettes. Continuously transposing and recasting parts throughout, the action runs through permutations of the five "economies" of the exhibition's title—five different registers, or acting paradigms, from the minimal to melodramatic.

Also silent, *Little Hunt* is its more modest companion, presented on a single monitor, in which acting overlaps with choreography. The Steadicam glides around a portly man and a curly-haired woman who move about a tennis court in contrasting dance movements—a gliding, partnerless waltz for the gentleman, a kind of gestural interpretative dance-cum-Tai Chi for the lady. Largely oblivious of each other's presence, the two interact with a set of props borrowed from a musical production of *Les Miserables*, including gallows and a table and chair, that are clustered throughout the court. The woman goose-steps, stag leaps, and stomps with a musket or a scythe; the man sashays around a coffin or pirouettes with candelabra. Mid-gesture, the action may cut from a sunny day to a floodlit night, further disrupting an already disassembled continuity.

Perhaps quoting the final scene of Michelangelo Antonioni's film *Blow-Up* (1966), in which mimes play tennis with no rackets or balls, *Little Hunt* dissects the mise-en-scène of the stage through the language of cinema and dance and with the absurd logic of an eccentric sport.

M.A.

Notes

1. Observation made by Hamza Walker, "Action, Minus Paint," in *Catherine Sullivan: Five Economies (big hunt/little hunt)*, exh. cat. (Los Angeles: UCLA Hammer Museum; Chicago: The Renaissance Society, 2002), 51.

2. In this regard, Sullivan has referred to the phenomenon of "Oscar material" roles that involve contemptible or disabled characters. Ibid., 4.

3. The hunt titles were inspired by a former teacher of Sullivan's, who described an actor's preparation for a demanding role as "big-game hunting." See Margaret Sundell, "Repeat Performance: The Art of Catherine Sullivan," *Artforum* 42, no. 2 (October 2003): 139.

Catherine Sullivan *Little Hunt* 2002 DVD (color, silent); edition 3/6 15:30 minutes Butler Family Fund, 2003 2003.46

Sarah Sze

American, b. 1969

-- **Commissions**
Grow or Die (2002; publication)
-- **Holdings**
1 sculpture, 1 book

Throughout her childhood in Boston, Sarah Sze was an attentive observer of her father's work as an architect. This fascination, as well as her undergraduate study of art and architecture at Yale, fostered her appreciation of the conceptual, material, and practical complexities of the design and construction of buildings. Having lived in two of the world's most densely populated cities (Tokyo and New York), Sze experienced firsthand the tenuous connections between people and the places in which they live and work, observing that there are structures "ever present in daily urban life that . . . both support and threaten us. I experience both a general comfort and fear that comes with my complete dependence on [them]."[1]

Sze's site-specific installations reflect this tension. Since 1996, she has created finely attenuated sculptures, often on a monumental scale, constructed out of a wide array of brand-new, domestic commodities of everyday life, including lightbulbs, thermometers, breakfast cereal, cotton swabs, and pushpins. Metastasizing from walls and ceilings, her works also inhabit random or underutilized spaces such as corners or windowsills. All of her installations to date are interventions with the existing architecture; she "doesn't fight the building but tickles it."[2]

Over a period of twelve days in May 1992, Sze created the Walker-commissioned *Grow or Die*, a three-part site-specific work in the Cowles Conservatory on the grounds of the Minneapolis Sculpture Garden.[3] For this project, she cut into the subterranean spaces beneath the floor usually reserved for the mechanical innards of a modern building's basement or foundation. Each of the three windows looking into her unique handcrafted land- and cityscapes is meant to be a surprise encounter: "I wanted the sites to seem as if they had been discovered, rather than placed."[4] By impeding the viewer's ability to determine depth and breadth, Sze reinforces the idea that each window provides a glimpse of a single, expansive system.

The first part of *Grow or Die* resembles an archaeological dig in a canyon or eroded river bed. Blue pushpins and small rocks balance on top of swirling geological outcroppings carved in Styrofoam. The snowy white formations of the second part undulate downward to an icy abyss. Sze wanted the viewer of this piece to experience a powerful gravitational pull into the void. In contrast to the organic infrastructure of these installations, the third is organized in an irregular architectonic grid. Rather than evoking a natural environment staving off the encroachment of human development, the preponderance of rectangular forms signals a bird's-eye view of a lost cityscape. In Sze's art, human creativity, ingenuity, and progress face off against the inevitable natural and biological imperatives of birth, growth, death, and evolution, securing the timeless struggle for survival.

E.C.

Notes
1. Quoted in an interview with Hans-Ulrich Obrist in John Slyce and Hans-Ulrich Obrist, eds., *Sarah Sze*, exh. cat. (London: Institute of Contemporary Arts, 1998), unpaginated.
2. Sze, artist talk at the Walker, May 19, 2002 (videotape, Walker Art Center Archives).
3. The visitor's encounter with Sze's microcosmic worlds parallels the experience of entering the Conservatory, which is itself a contrived environment. In the same way that the Conservatory is a shelter for tropical trees and botanical specimens that could never survive in the northern climate outside its protective structure, Sze's artificial eco-system is safe from the elements and contains things that appear to be growing and dying out, hence her choice of title.
4. Sze, correspondence with the author, July 2, 2002 (Walker Art Center Archives).

Sarah Sze Selection from *Grow or Die* 2002 mixed media 24 x 24 x 24 in. (61 x 61 x 61 cm) each of 3 Purchased with funds donated by Department 56, Inc., in honor of its founder, Edward R. Bazinet, and the Frederick R. Weisman Collection of Art, 2002 2002.7

Piotr Szyhalski

Polish, b. 1967

-- **Commissions**
Ding an sich (The Canon Series) (http://gallery9.walkerart.org/szyhalski) (1997), *Harvest* (1997), *Dolphin Oracle II* (with Richard Shelton) (2004–2005)
-- **Online Exhibitions**
Beyond Interface: net art and Art on the Net (1998), *Art Entertainment Network* (2000)
-- **Performances**
Combat Reality: Politprop Lecture Nr. 3 (2002)
-- **Holdings**
2 net artworks, 1 interactive multimedia work

Piotr Szyhalski works with many media because he believes "there is only one right way of expressing every idea."[1] He has degrees from the Academy of Visual Arts in Poznan, Poland, in drawing and poster design; he has exhibited photographs and mural paintings; his work is often installation-based; he has collaborated on multimedia performances with the Atlanta Symphony Orchestra and the Minneapolis choral arts group VocalEssence; he frequently stages scripted solo performances; he teaches a political propaganda class; and he is perhaps best known for his computer-based, interactive works such as *Ding an sich (The Canon Series)* (1997).

What is common to all of Szyhalski's work is his unswerving commitment to the audience as co-creator. As he says in a short video entitled *Poem to My Audience* (2002), "You are my everything." It is a provocatively sentimental statement that reflects his allegiance to the ideals of Joseph Beuys, particularly the notion that "information (the creation of the work) and exformation (the act of perception/comprehension of the work) are equally important in art."[2] For example, with *Harvest*, which was commissioned for the Walker exhibition *Joseph Beuys Multiples* (1997), visitors to the Web site can add their own texts about the nature of democracy, becoming actual creators of the work. Szyhalski provides only the starting point or platform.

Ding an sich was the first artwork commissioned for the Walker's online Gallery 9 of net art. Taking his cue from symphonic structures, Szyhalski designed ten movements plus a prelude and coda that he calls canons, a reference to the well-established musical canon, which did not have an equivalent at that time for digital media work, especially online. The voices of artists such as Martha Graham, John Cage, and Susan Sontag, sampled from the Walker's archival materials, are part of each canon. The look of each piece is Szyhalski's trademark high-contrast black and white combined with sinuous type, line diagrams, and elegantly stylized figures, which refer to but subtly undermine the heroic style of Soviet-inspired propaganda with which he grew up. Each canon involves a different interaction, which the audience must decode through exploration and then "complete," although there is generally no specific goal, and a canon will loop infinitely until the participant launches the next one. In this way, the timing of the symphony is completely audience-driven, as is, of course, the interpretation of these hermetic pieces, which only hint ambiguously at any particular meaning. Yet Szyhalski, borrowing from Immanuel Kant's *Critique of Pure Reason*, named the series *Ding an sich* —"the thing in itself"—because he believes that this fluidity is "precisely what remains constant in all the possible readings/experiences that may occur on the Web."[3] For him, the essence of so-called new media lies in its variability, particularly as activated by audience participation—Beuys' exformation of the artwork.

Steve Dietz

Notes
1–3. Szyhalski, interview with the author, September 1997, http://gallery9.walkerart.org/bookmark.html?id=149&type=text&bookmark=1.

Piotr Szyhalski Selections from *Ding an sich (The Canon Series)* 1997 digital media Digital Arts Study Collection

Rufino Tamayo
Mexican, 1899–1991

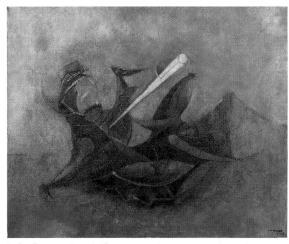

Rufino Tamayo *Wounded Beast* 1953 oil on canvas 31 5/8 x 39 3/8 in. (80.3 x 100 cm) Gift of the T. B. Walker Foundation, 1958 1958.13

-- Exhibitions

Modern Art in Advertising: Designs for Container Corporation of America (1948; catalogue), *Paintings to Know and Buy* (1948), *Pictures for the Home* (1950), *Contemporary American Painting and Sculpture: Collection of Mr. and Mrs. Roy R. Neuberger* (1952; catalogue), *Rufino Tamayo* (1952), *Reality and Fantasy, 1900–1954* (1954; catalogue), *Expressionism 1900–1955* (1956; catalogue, tour), *First Annual Collectors Club* (1957; catalogue)

-- Holdings

1 painting

Tanaka Atsuko
Japanese, b. 1932

Holdings
1 painting

Tanaka Atsuko's *Electric Dress* (1956) is very possibly the most emblematic action/object in the history of Gutai. It consisted of approximately ninety lightbulbs and one hundred tubes that were daubed in nine different hues of enamel paint. The light fixtures were connected via tangled skeins of electric cords to an electric gear, which switched them on and off at irregular intervals and also generated loud whirring sounds. The anthropomorphic contraption—vaguely reminiscent of a nascent cyborg—was meant to be worn, and that is exactly what Tanaka did. At the Second Gutai Art Exhibition in 1956, risking burns and electric shocks, she entered the oversize armor and activated it on stage. Two more versions soon followed and were shown in the exhibition-cum-performances in which early Gutai works were presented. In 1957, the object was dismantled and reassembled into a new composition, with light fixtures mounted on a flat, wall-based work.[1] Recent scholarship has recognized the significance of *Electric Dress*, and the work is now considered a pioneering benchmark in postwar art.[2]

Tanaka joined the Gutai group in 1955, a year after its founding, and remained a member until 1965. She stood out in an environment undeniably structured by the hierarchical relationship between the leader and teacher Yoshihara Jiro, and his younger followers and students, who were mostly male (such as Shiraga Kazuo and Shimamoto Shozo). Intensely productive, she was undaunted by the hierarchical and gendered context; in quick succession, she made a series of works in the form of architectural clothing that tread the boundaries between spatial installation, object construction, and bodily performance and suggest the transformative and mutable potential of human skin. During two short, intense years that followed her entry into the group, she also made drawings in crayon, ink, and watercolor on paper that derive from her original studies and plans for the objects.

Around 1957, Tanaka started using more stable materials, such as permanent markers and vinyl paint, and the first group of paintings emerged. Circles and lines, previously the simplified symbols for lightbulbs and electric circuitry, assumed a more autonomous character and began to function as a language for abstract painting. The two simple geometric forms proved to be an extremely fertile ground that the artist would plumb and develop in the following four decades.

D.C.

Notes
1. A particularly detailed description of *Electric Dress* is found in Mizuho Kato, ed., *Atsuko Tanaka: Search for an Unknown Aesthetic, 1954–2000* (*Tanaka atsuko: michi no bi no tankyu 1954–2000*), exh. cat. (Ashiya, Japan: Ashiya City Museum of Art and History, 2001), 63.

2. Although a more accurate translation of the original Japanese title *denki-fuku* would be "Electric Clothes" rather than "Dress," the latter title is used here as it is now widely circulated and accepted in English-language publications. The work's representative status is well illustrated by the fact that it was chosen as the cover image for two recent exhibition catalogues, Françoise Bonnefoy, Sara Clément, and Isabelle Sauvage, eds., *Gutai*, exh. cat. (Paris: Galerie Nationale du Jeu de Paume, 1999) and Paul Schimmel, ed., *Out of Actions: Between Performance and the Object, 1949–1979*, exh. cat. (Los Angeles: Museum of Contemporary Art, Los Angeles, 1998). The version presented in these shows and others was reconstituted in 1986 for the exhibition *Japon des avant-gardes 1910–1970* at the Centre Georges Pompidou, Paris.

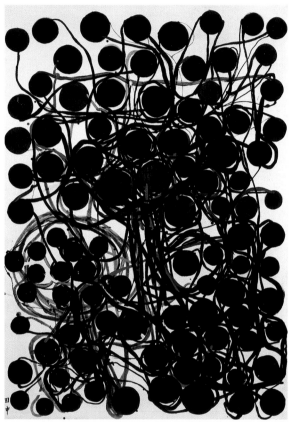

Tanaka Atsuko *Untitled* 1961 oil on canvas mounted to wood 52 3/8 x 36 7/8 x 1 7/16 in. (133 x 93.7 x 3.7 cm) framed T. B. Walker Acquisition Fund, 2000 2000.215

Mark Tansey

American, b. 1949

- - **Exhibitions**
Mark Tansey: Art and Source (1990; organized by the Seattle Art Museum; catalogue), *American Tableaux* (2001; publication, tour)
- - **Holdings**
2 paintings, 524 preparatory drawings and source materials

Painting suffers from no lack of interpretive theory. The Renaissance notion of painting as a mirror reflecting or a window opening out to the world went through numerous historical revisions to arrive at repeatedly proclaimed deaths and equally frequent returns in the twentieth century.[1] What does this apparent impasse in painting's progress mean—that it is ever lively and vigorous, or that it can do no more than await a true end? For painters who are necessarily informed and enlightened as well as burdened and haunted by this history, the act of painting continues to require that they contend with tradition as well as with the tradition of antitraditions. As painters' struggles grow with time, the weight of interpretation seems to do the same.

If there were a painting about the theory of painting, or simply about theory, it might look something like Mark Tansey's work. He takes art history, philosophy, critical theory, and key terms and buzzwords as the subject and content of his art. A pantheon of twentieth-century thinkers and artists appear as actors in the theaters of his paintings. Even a quick survey of Tansey's titles reveals how much he is embroiled in, even obsessed with, the particular phraseology of his trade. They often refer to painting itself and discourses surrounding it (*A Short History of Modernist Painting*, *End of Painting*) or to crucial cultural concepts or artistic theorems (*Modern/Postmodern*, *Myth of Depth*). Another group of titles—*Archive*, *Reader*, *Close Reading*, and *Under Erasure*—derive from the bibliographic tropes familiar in the "textual turn" effected by deconstruction, represented by the literary critics Jacques Derrida and Paul de Man. (The last phrase on the list is the English translation of *sous rature*, one of Derrida's better-known ideas.) Tansey's dramatis personae, besides the two deconstructionists, include other French (post)structuralists, such as Roland Barthes, Michel Foucault, and Jacques Lacan, and modernist giants from both the School of Paris and the New York School.

As specialized and self-involved as such references are, their manifestations into painting, in Tansey's deft hands, take surprisingly nostalgic forms: heroic or Romantic landscapes like those of Albert Bierstadt and Caspar David Friedrich or more intimate interior scenes reminiscent of Edward Hopper. Such staging of modern painting might suggest that the artist looks askance at the notorious self-absorption of the medium of his choice and the jargon-ridden, secret society–like academe that was perceived as increasingly dominating contemporary art. Indeed, when conservative critic Daniel Bell launched one of his many attacks on what he saw as "the decay of American intellectual life," he chose to illustrate the point with a reproduction of Tansey's *Constructing the Grand Canyon* (1990), in

which the incursion of the French deconstructionists into American universities was paradoxically depicted as a reversal of the process of natural erosion whereby an accumulation of textual strata reaches a height as improbable as the depth of the natural wonder itself.[2] The irony, however, lies not in the artist's subject but in his ability to turn an intellectual dilemma into narrative imagery by strategically marshaling anachronisms.

Tansey paints subtractively on gessoed canvas in a race of time against the drying process. The speed with which he executes a painting is contrasted with and enabled by long, extensive studies and preparations. For all his works, Tansey collects various sources—an extensive bibliography and dossier of notes, photographs, popular magazine illustrations, drawings, and film stills—which he cuts and pastes to develop final motifs. *White on White* (1986) refers to Kasimir Malevich's series of works of the same title (circa 1918), one of the Russian Suprematist's revolutionary propositions to return painting to its zero degree. In Tansey's late twentieth-century rejoinder, however, people from two distant parts of the world and climatic zones—desert-dwelling Bedouins with camels and fur-clad Inuits with huskies—come to an unlikely rendezvous. The broad-stroked washes of white paint across the canvas seem to depict at once a sirocco and a blizzard. The sense of disorientation is caused, on the one hand, by the narrative impossibility of this encounter and on the other, by the encroachment of figures materializing on the supposedly dematerialized surface of the purest form of painting. The image Tansey concocts, then, may be a nightmare for those believers of painting's destined passage of self-purification toward some Hegelian telos. But for many others, it just might be a delightful reverie.

D.C.

Notes

1. This thesis is argued most eloquently by Yve-Alain Bois in "Painting: The Task of Mourning," in Yve-Alain Bois, *Painting as Model* (Cambridge, Massachusetts: MIT Press, 1990).
2. Daniel Bell, "The Cultural Wars: American Intellectual Life, 1965–1992," *Wilson Quarterly* 16, no. 3 (Summer 1992): 7.

Mark Tansey *White on White* 1986 oil on canvas 78 x 138 in. (198.1 x 350.5 cm) Gift of Charles and Leslie Herman, 1991 1991.99

Mark Tansey *Constructing the Grand Canyon* 1990 oil on canvas 85 x 126 1/2 in. (215.9 x 321.3 cm) Gift of Penny and Mike Winton, 1990 1990.193

Deconstructing Deconstruction

In the early 1970s, a body of academic writing, originating primarily in France, entered the American thought stream like a virus, inflecting the discourse initially of professors of literature, but spreading with great rapidity through most departments devoted to what the French designate as *les sciences humaines*—anthropology, art history, and a range of newer disciplines, such as film studies, gender studies, black studies, and the like. A new canon was established, designated Theory, consisting centrally of the writings of Jacques Derrida and Michel Foucault, but also Jacques Lacan and Louis Althusser, and certain earlier figures from whom these drew inspiration—Walter Benjamin, Ferdinand de Saussure, and the philosophers Hegel, Marx, and Heidegger. None of this was in what one might consider the American grain, but the immense upheavals of the 1960s, centered in American universities, created an atmosphere hospitable to the idea of deconstruction, which was Theory's chief concept. Since everything within Theory's range was up for deconstruction, everything was in effect a construction—improvised, arbitrary, subject to revision and ultimately to abandonment. It was a very liberating vision of the matrices that shape—or distort—our lives. And for a time, criticism was moved from the sidelines of culture to its heart.

The extent to which Theory inflected the practice of art, as against the language of art writing, is an interesting art-historical question in its own right, but Mark Tansey must count as unique among artists in assimilating it into his own concept of painting and, via his extraordinary gift for irony, into the subject matter of his art. His earlier work ironized the critical views of Clement Greenberg, which he flatly (no pun intended) rejected. But Tansey found himself deeply attracted to deconstruction, with its vision of layers beneath layers of meaning, which corresponded in spirit to his own philosophy of painting. He could not, however, resist the ironic opportunity of deconstructing Theory itself, as in his 1990 masterpiece, *Constructing the Grand Canyon*, inspired by a metaphor in Foucault's *The Archaeology of Knowledge*, which Tansey, tongue in cheek, deliciously pretended to take literally. In a way, the painting serves to criticize criticism—even if the artist really accepted the premises of Theory himself.

Theory's controlling metaphor was the idea of the text, and one of Derrida's boldest assertions was that the world itself is a text: *Il n'y a pas de hors-texte* (Nothing is outside the text). Objects and events must thus be related to one another not, as science supposes, as cause and effect, but through the kinds of frictions that fuse words and sentences into, say, narrative wholes. This must entail, contrary to our intuitions, that the Grand Canyon is in some sense a piece of writing, and this is what Tansey mischievously shows, even if we are unable to read the lines of text which, rather than stone and dirt, is what this natural wonder is built or constructed of. The painting itself is a text about texts. The Yale School of Literature—which was the portal through which Derrida's philosophy entered America—corresponds to the position occupied by the School of Athens in Raphael's painting, turned upside down. Derrida, Paul de Man, Harold Bloom, and Geoffrey Hartman are overseeing a vast illegible project. Foucault is precariously seated on an outcropping to the left. A buffalo has been rubbed off an American nickel, alluding to an essay on metaphor by Derrida. The scene is shown as if in a fading photograph, from a forgotten archive, memorializing an epistemological excavation by solemn investigators, raising clouds of dust, changing everything while leaving it all the way it was.

Arthur C. Danto

Sam Taylor-Wood

British, b. 1967

- - **Exhibitions**
"Brilliant!" New Art from London (1995; catalogue, tour),
Stills: Emerging Photography in the 1990s (1997; publication)
- - **Holdings**
1 multimedia work, 1 video, 1 book

Sam Taylor-Wood is a filmmaker, photographer, videographer, set designer, art director, writer, and producer of what she calls "dysfunctional social situations."[1] Upon completion of the fine arts program at London's Goldsmiths College in 1990—the launching pad for the careers of other YBAs (young British artists) such as Angus Fairhurst, Damien Hirst, and Sarah Lucas—Taylor-Wood took a short break from the art world to work in the costume department of the Royal Opera House in Covent Garden. Attending the nightly performances, she was swept up in "the theater, the drama, the explosion of emotion."[2] This experience completely reoriented her previously minimalist artistic practice toward a prolonged engagement with narrative and the representation of what she has referred to as "states of being."[3]

By 1993 she had garnered critical attention for two photographic self-portraits: *Fuck, Suck, Spank, Wank* (1993), in which she is both confrontational and vulnerable with her pants down around her ankles; and *Slut* (1993), an unseemly head shot in which a constellation of love bites is dramatically revealed through chiaroscuro. The following year she finished *Killing Time* (1994), her first major video project. For this installation piece projected onto four screens, Taylor-Wood asked four friends to lip-synch the libretto (in German) from Richard Strauss' opera *Elektra*, which they take turns "performing" without feeling or expression. The disjointed effect is one of extreme ennui coupled with a crescendo of tension and passion embodied by the music.

In 1995, Taylor-Wood created *Five Revolutionary Seconds*, a series of fifteen twenty-five-foot-long panoramic photographs that she would return to for the next five years. The word "revolutionary" in the title had as much to do with the mechanics of production as a self-conscious identification that she was breaking new ground. Through the use of a camera that rotates 360 degrees on the axis of a stationary tripod, the artist was able to capture (in the five seconds it took to come full circle) the mise-en-scène of a highly choreographed, fictional nonevent. Each of the photographs is a study in social alienation and self-absorption as her dramatis personae—friends of the artist, professional actors, and occasionally celebrities—go about

their highly ambiguous business in stylish if not decadently affluent domestic spaces. She elaborated on the images with a sound component—ambient noises and conversational fragments taped during the shoot are emitted from speakers installed at both ends of the photograph. Although the viewer is inevitably enticed to construct a coherent narrative or rationalization for the presence and actions of the characters peopling the photographs, Taylor-Wood does not have any one story line in mind. The artist's job, as she sees it, lies not in providing closure but in "ungluing the setting."[4]

The Walker Art Center's piece, the first in the series, depicts six people in a well-appointed apartment with requisite art collection, library, and grand piano.[5] According to the artist, "the idea was to have four different states of being within one room—creativity, boredom, eroticism, and passion."[6] In a discussion of the series in a 2002 interview, she explained that "it's like encapsulating one person in one room but within . . . different bodies, each one not communicating with the others. It was also about all those different ways of removing and isolating yourself from other people. And all this takes place in five seconds; it's a momentary thing, isolated in time. When you look at it you don't know what happened before or after it, you only have this moment and from that you can invent whatever you want."[7]

E.C.

Notes
1. Taylor-Wood, interview with Bruce Ferguson, in *Bomb* 65 (Fall 1998): 48.
2. Taylor-Wood, interview with curator Douglas Fogle, "He Had to Have a Nervous Breakdown and It Had to Last Ten Minutes," in Richard Flood, ed., *"Brilliant!" New Art from London*, exh. cat. (Minneapolis: Walker Art Center, 1995), 78–79.
3. Taylor-Wood, interview with Clare Carolin, in Clare Carolin, ed., *Sam Taylor-Wood*, exh. cat. (London: Hayward Gallery, 2002), unpaginated.
4. Taylor-Wood, interview with Germano Celant, in Germano Celant, ed., *Sam Taylor-Wood*, exh. cat. (Milan: Fondazione Prada, 1999), 210.
5. The artist has revealed that the work was photographed in the private residence of the London art dealer Richard Salmon.
6. Artist's statement, March 2, 1997 (Walker Art Center Archives). She goes on to identify the figures as follows: "The pianist was a friend, the arguers were actors, one a friend, naked man a friend, and the two boys on a sofa I picked up at a party of Damien's [Damien Hirst]."
7. Carolin, *Sam Taylor-Wood*, unpaginated.

Sam Taylor-Wood *Five Revolutionary Seconds I* 1995 color photograph on vinyl with audiocassette tape photograph: 23 3/8 x 298 in. (59.4 x 756.9 cm)
T. B. Walker Acquisition Fund, 1997 1997.2

Sam Taylor-Wood *Five Revolutionary Seconds I* 1995 (details)

Diana Thater

American, b. 1962

- - **Exhibitions**
Diana Thater: Orchids in the Land of Technology (1997; publication)
- - **Holdings**
1 video, 1 model

Diana Thater is a Los Angeles–based installation artist who creates works that prompt viewers to contemplate the age-old nature/culture divide. Since her first solo exhibition in 1991, Thater has established herself as a provocative female voice in the once male-dominated world of video art with her largely site-specific, environmental projections. At the outset of her career, she broke radically from the tyranny of the pedestal-bound monitor by projecting her images directly onto the existing walls, doorways, and windows of a given space, while also placing the necessary hardware—projectors, monitors, laser-disc players, and cables—directly on the floor, in plain view. This strategy of making the viewer aware of the apparatus of filmmaking stemmed in part from her interest in the history of video, specifically the first wave of 1960s Conceptual artists such as Peter Campus, Dan Graham, Joan Jonas, and Bruce Nauman. Their structuralist concern with real time and the medium's raw technology is updated in Thater's oeuvre with a distinctively contemporary emphasis on the way in which our vision of the world has been mediated through a culture saturated with images.

Beyond the formal issues associated with the politics of exhibition display, the relationship between architecture, human subjectivity, duration, and narrative is of central importance to her practice: "I'm interested in transformation. With each new work I ask how can I reconfigure the space/time continuum and what kind of space does that make for the subject to reconsider herself?"[1] Indeed, the audience is implicated as the primary subject in Thater's work. Physically negotiating one of her installations means occasionally stepping in front of the light of the projectors, which in turn throw exaggerated silhouettes that ultimately provide the viewer with the awareness and experience of being in the work.

In 1998, Thater produced perhaps her most complex work to date, *The best animals are the flat animals—the best space is the deep space*.[2] Shot in both film and video, it consists of six different installations and three monitor editions composed of numerous parts, together constituting a total artwork.[3] In the process of creating the piece, the artist posed the question "How is it that one goes about constructing a point of view?" and also provided the answer: "All of the things that make up the work—those who are depicted (objects); how they relate to their space (the field); how the image of them relates to our space (real space); and those who watch (subjects)—are made equivalent."[4]

Conceived specifically for the Walker Art Center as "a tribute to a great female artist," *Bridget Riley made a painting* (1998) is one of the components of this larger body of work. Riley's trademark use of black-and-white, optically vibrant patterns in her early work provided

an obvious visual counterpoint to Thater's use of zebra imagery.[5] The film, presented as two wall projections and three monitor pieces, was shot on location at Hedrick's Exotic Animal Farm in Nickerson, Kansas. For the projections, Thater edited a series of close-ups of the zebras, so all that is discernible is a bold (albeit hairy) black-and-white graphic design, shifting and shuttering as the animals graze. The monitors show footage of the herd frolicking in the paddock and the camera crew at work with their vehicles and equipment. Again, the exposure of the "behind the scenes" action is in keeping with Thater's overall practice—her interest in breaking down the illusion of the fourth wall heightens the self-conscious act of looking.

E.C.

Notes
1. From Melinda Barlow, "In Dialogue: A Conversation with Diana Thater," *Sculpture* 20, no. 8 (October 2001): 39.
2. This title was inspired by an enigmatic quotation from French theorist Gilles Deleuze's text *The Logic of Sense*. The quote reads: "The old depth having been spread out became width. 'Depth' is no longer a complement. Only animals are deep, and they are not the noblest for that; the noblest are the flat animals." It serves as the epigraph to Thater's essay "Skin Deep," in Peter Noever, ed., *The best animals are the flat animals—the best space is the deep space*, exh. cat. (Los Angeles and Vienna: MAK Center for Art and Architecture, 1998), 29.
3. Thater's proposition was to have each of the works arranged and rearranged out of its separate parts in different venues simultaneously. See Lynne Cooke, "Diana Thater: On Location," *Parkett* 56 (1999): 177–182.
4. Thater, "Skin Deep," 30.
5. In correspondence with the author, July 18, 2004, Thater revealed that as a longtime admirer of Bridget Riley's optical conceits, she was inspired by Riley's *Suspension* (1964) in the Walker's collection, which she had the opportunity to view during trips to the Twin Cities in preparation for her Walker solo exhibition *Diana Thater: Orchids in the Land of Technology*.

Diana Thater *Bridget Riley made a painting* 1998 videotape (color, silent) continuous loop installed dimensions variable T. B. Walker Acquisition Fund, 1996 1996.160

Paul Thek
American, 1933–1988

-- **Exhibitions**
Figures/Environments (1970; catalogue), *Painting at the Edge of the World* (2001; catalogue)
-- **Holdings**
2 paintings, 3 sculptures, 2 drawings, 1 portfolio of prints

A self-described "mystic showman," Paul Thek imbued his work with an idiosyncratic personal symbolism that was deeply rooted in his uneasy relationship to Catholicism and his preoccupation with death, ritual, and the symbolic function of objects and images. After graduating from Cooper Union in New York City in 1954, Thek worked for ten years before achieving his first critical success with the *Technological Reliquaries* series (1964–1967), the earliest of which were plexiglass-entombed wax sculptures depicting freshly cut flesh with all the layers of sinewy muscle, hair, and fat intact. One of these visceral objects, *Hippopotamus* (1965), was inspired by the fabulist rantings of Sylvia Kraus, who launched public tirades against communism and environmental dangers, claiming that "hippopotamus poison" was being used to oppress and control the American public. The tubing in Thek's sculpture suggests a bizarre life-support system for the tainted flesh, vaguely hinting at Kraus' medical science fiction, a "poetic misunderstanding of the world" Thek found beautiful for its fervor and imagination.[1]

The *Technological Reliquaries* inscribed the body, in all its stinking, rotting, grotesque reality, into the midst of Minimalism's coolness and the slick branded imaging of Pop Art. They also espoused an aesthetic of immediacy with a firm basis in reality; as the artist said, "Everything is beautiful and everything is ugly simultaneously."[2] Thek had a constant concern for the themes of body, death, spiritual redemption, and rites of passage, but he also ascribed to a kind of material pragmatism in which artworks are not so much discrete objects as they are parts from which to construct elaborate scenarios. *The Personal Effects of the Pied Piper* (circa 1975), for example, is a group of bronze objects that seem to be the postmortem remains of the Piper's belongings. They include pieces related to the tale—a burnt-out campfire, a folding kit of implements, several mice, and a loaf of bread and some books the rodents have hollowed out—commingled with references to other narratives, including the Bible and *Uncle Tom's Cabin*. As a whole, Thek's *Pied Piper* is a cautionary tale of power, technological progress, and the potential consequences that may arise when humanity plays games of follow the leader too naively.

The idea of "Procession" lies deep in the heart of all of Thek's work and life, which were conjoined in an always-evolving experience that was ephemeral or nomadic, unfixed, collaborative, full of ritual, and anti-concrete. An early work, *Pyramid/A Work in Progress* (1971–1972), is a room-size encampment of sorts in which multiple sculptures and found objects were connected by elaborate ad hoc walkways and passages. Begun as a monthlong process of environmental cre-ation with the loose cadre of artists known as Artist's Co-op, the work was called by Thek both a "time temple" and a "life theatre"[3] and exemplified his approach to mythic, personal art as well as camp theatricality, sensual spirituality, and communal creativity.

In 1980, Thek realized an installation of paintings that, through lighting, seating, and decor, consciously created a humanizing situation for viewing art. Commonly known as the Picture Light Paintings due to their presentation in kitschy gold frames with picture lights, the works exorcise the demons of twentieth-century painting with quirky charm and strange wit. From serene landscapes to the brushy abstraction of the Walker Art Center's *Bambi Growing* (circa 1980) to garish abstraction, raw expressionism, and sight gags, the paintings were variously about, according to Thek, theology, psychology, philosophy, art, beauty, and humor. *Bambi Growing* was a sentimental reference to the Disney movie, a favorite of the artist's, and the patient constancy of Bambi's mother.

The representative sampling of Thek's work in the Walker's collection situates itself easily within art-historical trajectories from Joseph Beuys and Arte Povera to later international developments in Conceptual and Process Art. His sincerely poetic works, intended as meditations and healing environments, are also witty provocations that confront the blunt realities of the world while reaching for answers about life beyond it on both mental and spiritual planes.

Elizabeth Thomas

Notes
1. Richard Flood, "Paul Thek: Real Misunderstanding," *Artforum* 20, no. 2 (October 1981): 49.
2. Quoted in G. R. Swenson, "Beneath the Skin," *Artnews* 65, no. 2 (April 1996): 35.
3. Thek, correspondence with Martin Friedman, October 6, 1973 (Walker Art Center Archives).

Paul Thek *Bambi Growing* circa 1980 acrylic on canvas, wood frame, embossed plastic, picture light 11 x 13 1/4 x 6 1/4 in. (27.9 x 33.7 x 15.9 cm) T. B. Walker Acquisition Fund, 2001 2001.60

Paul Thek *2 Birds* 1975 oil on newspaper 22 3/4 x 33 7/16 in. (57.8 x 84.9 cm) Justin Smith Purchase Fund, 2003 2003.64

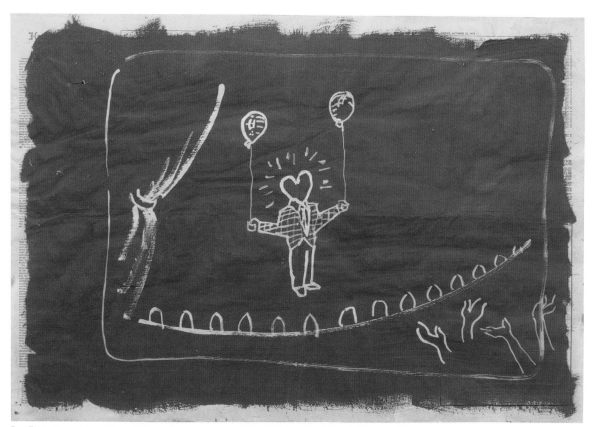

Paul Thek *Untitled (Heartman)* 1974 acrylic on newspaper 22 7/8 x 33 1/4 in. (58.1 x 84.5 cm) Miriam and Erwin Kelen Acquisition Fund for Drawings, 2003 2003.63

Paul Thek *Hippopotamus* from *Technological Reliquaries* 1965 beeswax, plexiglass, metal, rubber 11 3/8 x 19 3/4 x 11 1/2 in. (28.9 x 50.2 x 29.2 cm)
T. B. Walker Acquisition Fund, 1994 1994.196

Paul Thek Selections from *The Personal Effects of the Pied Piper* circa 1975 bronze installed dimensions variable
T. B. Walker Acquisition Fund, 2003 2003.45

Wolfgang Tillmans
German, b. 1968

Notes
1. Quoted in Lynn Barber, "The Joy of Socks," *The Observer Magazine* (London), January 5, 2003, 14.

- - **Holdings**
22 photographs, 1 book

Wolfgang Tillmans' photographic career began in Hamburg, Germany, in the late 1980s, when the rhythm of his life resulted in photographs of the local club scene that found their way into such pivotal British lifestyle publications as *The Face* and *I.D.* From the start, there was something remarkably personal in his images; it would have been impossible to imagine such photographs being taken by anyone other than a participant or an intimate. The private moments shot by Tillmans rebuff any sense of the documentary; they are simply too involved to be neutralized as coverage. From the club work came fashion assignments that exploded notions about appropriate models, hip styling, and product display, which remain influential more than a decade later. When these pivotal images were first published, Tillmans was a student at Bournemouth Art College, where he studied from 1990 to 1992.

As his career moved steadily from commercial assignments to exhibitions, Tillmans did not differentiate between works past and present. What changed were groupings and image scale. A constantly evolving family of photographs continued to tell new stories through the artist's creation of a shifting hierarchy of relationships. This highly edited approach led away from traditional photographic display into nuanced, emotionally dense installations in which works of differing print sizes are push-pinned into conversations both abstract and emotional. He is also one of the foremost book designers in the art world.

Over the years, Tillmans has held very close to his world, which includes friends and lovers, parties that are very over, sex (mostly gay but maybe not), landscapes (often with animals), streetscapes, and increasingly, abstractions that are lovely and liquid and look like they live in our veins. Speaking of his work, shortly after winning the Turner Prize in 2003, Tillmans attempted to define his mission: "At age ten I found this little book on astronomy, and for the next four years I was totally driven by astronomy—each year I had to get a bigger telescope. I was counting the sunspots every day, and going to amateur astronomical conventions. And it was this sense of positioning myself that has been my most fundamental interest. It gives me a feeling of not being alone, of being grounded. And looking at the truth, and finding comfort in truth. You were asking the essence of my work—maybe to find comfort in truth."[1]

The title for Tillmans' 2003 retrospective at the Tate Britain was *if one thing matters, everything matters* and, indeed, looking at the body of work, one can see his attention to knowing the essence of what is being photographed; it may well be a world of randomness, but this artist is loitering with intent.

R.F.

Wolfgang Tillmans *Aids, General Idea* 1991 chromogenic print, edition 5/10 12 x 16 in. (30.5 x 40.6 cm) Butler Family Fund, 1995 1995.127

Wolfgang Tillmans *domestic scene, Remscheid* 1991 chromogenic print, edition 9/10 12 x 16 in. (30.5 x 40.6 cm) Butler Family Fund, 1995 1995.128

Wolfgang Tillmans *burnt tit* 1994 chromogenic print, edition 2/10 12 x 16 in. (30.5 x 40.6 cm) Butler Family Fund, 1995 1995.141

Rirkrit Tiravanija

Thai, b. Argentina, 1961

- - Commissions
Catalogue (Back of Postcard Reads) Memories (1997)
- - Exhibitions
Economies: Hans Accola and Rirkrit Tiravanija (1995; publication)
- - Residencies
1996–1997
- - Holdings
1 multimedia work, 13 multiples, 2 books

Rirkrit Tiravanija was born into a diplomat's family in Buenos Aires, raised in different parts of the world, and settled in Bangkok to attend high school. Upon graduation, he continued his studies in Canada and the United States, and now divides his time between New York, Berlin, Bangkok, and everywhere in between. Peregrination—touted as the defining condition of our "global" age in which inhabitants lead "nomadic" lives—comes naturally for the artist. Constant motion, however, does not constitute a raison d'être in itself, but rather suggests a state of being. In his art, mobility is a catalyst for the formation of communities, networks of acquaintances, and lasting friendships within them.

It is only to be expected, then, that "convivial" is an adjective that appears so frequently in writings about Tiravanija's art. Defined as "relating to, occupied with, or fond of feasting, drinking, and good company,"[1] the word finds its etymological origin in the Latin word *convivium*, meaning a banquet, which is in turn a compound of "com" (with) and "vivere" (to live). Cooking performances, which the artist has done for more than ten years in galleries and museums around the world, are open to interested viewers, art world workers, total strangers, and friends, and indeed create experiences that resemble a banquet. But in a more fundamental way, his work reframes the experience of art per se. It is no longer posited as a solitary, meditative relationship between an object and a viewer, but as a situation in which audience participants are reminded that they are social entities coming into completion *only* in relation with one another. In that sense, the work is especially representative of the aspect of interpersonal connectivity in 1990s art, which French art critic Nicolas Bourriaud has named "relational aesthetics."[2]

If a new kind of aesthetics is in fact expressed in Tiravanija's art, it did not come out of a vacuum. His work and the larger aesthetic matrix of which it is part are intimately tied and deeply indebted to the conceptual lineage of postwar and contemporary art, which includes such figures as Carl Andre, Vito Acconci, Gordon Matta-Clark, Felix Gonzalez-Torres, and Andy Warhol. Though wildly divergent from one another, these artists, between the 1960s and the early 1990s, collectively critiqued originality and auteurism in modernism, formulated the notions of dematerialization, interactivity, and communalism, and reconceptualized the economy of art and artistic labor. One concrete art-historical precedent for Tiravanija's approach can be found in the work of Michael Asher. For his 1974 solo show at the Claire Copley Gallery, Los Angeles, Asher removed the physical, visual barrier between a pristine exhibition space and an office behind it, exposing the separation between a purely perceptual and reflective experience of art and the attendant fiscal transactions.[3] Almost two decades later, Tiravanija's rejoinder, *Untitled (Free)* (1992), presented at the 303 Gallery, New York, used a similar trick. He transplanted into the exhibition space what usually stays in the back room—inventoried artworks, custodial supplies, sundry electronic equipment—as well as the gallery owner. The emptied room was then turned into a place for the artist's cooking and "conviviality."

In that Tiravanija engages in a sort of social catalysis, an even more pertinent historical model for his art would be German artist's Joseph Beuys, whose concept of "social sculpture" redefined art as various activities geared toward positive social change. Beuys' utopianism was interwoven with his unique understanding of the artist's role as a spiritual medium, an idea that approached something akin to shamanism. In his one-person exhibition at Migros Museum in Zurich in 1998, Tiravanija installed in the galleries a bar, an automobile body shop, and a supermarket, all fully functioning despite the displacement. Coming to the museum for a rarified experience, visitors were instead invited to be the social beings that they already are. The title of the exhibition, *Social Capital*, operated as a quip on Beuys' social sculpture and may well describe Tiravanija's larger project in general. Described as "human networks and institutions that constitute social cohesion" by the World Bank, the United Nations agency that oversees worldwide economic development, "social capital" as appropriated by Tiravanija is rendered specially relevant for a practice that is acutely conscious of the far-reaching dynamics of globalization.[4] His work is distinct from Beuys' for its lack of gravitas, however. His seemingly lighthearted art may not address the precarious condition of civilization at peril that concerned Beuys so greatly in the wake of a catastrophic war, but it makes its own political commentary on capital's latest colonization of the everyday.

The artist's works in the Walker Art Center's collection include *Untitled, 1995 (Back of Postcard reads:)*, a multimedia installation he created for the 1995 exhibition *Economies: Hans Accola and Rirkrit Tiravanija*. Multiples, being especially well-suited for experiential multiplication and accessibility, are prominent in his body of work. Always having to do with specific actions and events that constitute his art, these objects are born out of memories and are reminders rather than remainders. *Catalogue (Back of Postcard Reads) Memories*, an editioned work that he produced and the Walker published, brings together various images and items related to the exhibition and maps, like an atlas, the memories associated with it.

Many of his multiples make reference to food or cooking, an integral element in his art-making. *Young Man, if my wife makes it . . .* (2000) is a fabricated plastic-and-wax model of a plate of pad thai. The title comes from an interaction he once had with a senior Thai artist, who on the occasion of the younger artist's lecture on his earlier cooking performance "Pad Thai," uttered those derisive words to question its status as art.

Tiravanija recalls: "There were at the time questions concerning the authenticity of my Thainess, and [whether] I was using Thainess (culture) as an exotic flavour, for which [it] became in the Western context a successful work of art."[5] The question—a dilemma shared by many non-Western contemporary artists—stayed with him. A few years later, the artist encountered fake food models so ubiquitously displayed in restaurant shop windows in Japan. After a cooking performance at a gallery in Tokyo, he had an artisan fabricate multiple model copies of the pad thai he had made.[6] With the production of this edition, the particular memory he had carried around materialized as "a playful return to the question asked many years back!"[7] The manner in which he uses multiples in relation to his ephemeral, often cerebral art resonates yet again with Beuys, for whom such objects functioned as "props for the memory" and "kernel[s] of condensation upon which many things may accumulate."[8] *Young man, if my wife makes it . . .* also contains Tiravanija's idiosyncratic idea of what art is and what its social meaning is, and conveys it from the time and place of its origin to the present. The "playful" object—a pair of chopsticks picking up strands of sweet noodles from a plate—jogs viewers' minds with the philosophical questions and idle thoughts that had occupied the artist's mind. Or, it tells them simply that life is a banquet.

D.C.

Notes

1. *Merriam-Webster's Collegiate Dictionary*, 10th edition (Springfield, Massachusetts: G. & C. Merriam Company, 1994), 254.
2. Nicolas Bourriaud, *Relational Aesthetics* (Paris: Presses du Réel, 2002).
3. Jerry Saltz makes a comparison between Asher and Tiravanija in "A Short History of Rirkrit Tiravanija," *Art in America* 84, no. 2 (February 1996): 84–85.
4. See the World Bank's Web site: http://www1.worldbank.org/prem/poverty/scapital/index.htm (accessed January 18, 2005).
5. Tiravanija, e-mail correspondence with Walker curatorial intern Aimee Chang, December 27, 2001 (Walker Art Center Archives).
6. Junko Shimada, director, Gallery Side 2, Tokyo, e-mail correspondence with the author, April 25, 2004.
7. Tiravanija, e-mail correspondence with Chang.
8. Quoted in Jörg Schellmann and Bernd Klüser, "Questions to Joseph Beuys," in Jörg Schellmann, ed., *Joseph Beuys, The Multiples* (Cambridge, Massachusetts: Busch-Reisinger Museum, Harvard University Art Museums; Minneapolis: Walker Art Center; Munich and New York: Edition Schellmann, 1997), 9.

Rirkrit Tiravanija *Catalogue (Back of Postcard Reads) Memories* 1997 mixed media; Artist's Proof 1/4 from an edition of 16 box: 13 x 9 1/2 x 2 1/2 in. (33 x 24.1 x 6.4 cm) closed Published by the Walker Art Center Commissioned with funds provided in part by the Surdna Foundation, 1997 1997.97

Rirkrit Tiravanija *Young man, if my wife makes it . . .* 2000 wooden chopsticks, plastic, metal bowl; edition 12/27 7 1/4 x 12 x 9 1/2 in. (18.4 x 30.5 x 24.1 cm) T. B. Walker Acquisition Fund, 2001 2001.16

Rirkrit Tiravanija *Untitled, 1999 (the power of cheese)* 1999 resin, enamel paint; edition 5/5 13 x 17 3/4 x 13 3/4 in. (33 x 45.1 x 34.9 cm) T. B. Walker Acquisition Fund, 2000 2000.106

Rirkrit Tiravanija *Untitled, 1992 (Red, Yellow, Green Curry)* 1992 canned curry paste; edition 10/10 1 1/2 x 3 x 3 in. (3.8 x 7.6 x 7.6 cm) each of three T. B. Walker Acquisition Fund, 1996 1996.45

Artist-in-Residence, 1996–1997

Residencies often precede an exhibition of the artist's work and feature the piece(s) created during that period of time as the basis for the show. Sometimes the opposite is true. In July 1996, more than a year after the exhibition *Economies: Hans Accola and Rirkrit Tiravanija* had closed, Tiravanija returned to Minneapolis to participate in a yearlong artist residency. He proposed to have local teens document the memories of those who saw his installation *Untitled, 1995 (Back of Postcard reads:)* in *Economies*.

Beginning in the fall of 1996 and continuing throughout the school year, students from the Minnesota Center for Arts Education interviewed people who had viewed the exhibition. Gallery guards, curators, and local and national visitors shared their impressions of the opening-night party and/or interacting with the detritus from the festivities and the blanket-and-pillow-strewn tent that was the centerpiece of Tiravanija's installation. The interviews became the basis for the students' project *Catalogue (Back of Postcard Reads) Memories*, an artist's book that consists of a series of thirty-two postcards enclosed in an envelope. The cards present the teens' reflections on the residency and document themes raised during their research and discussions with the artist.

This book was incorporated into Tiravanija's own response to his residency and the *Economies* exhibition: a limited-edition multiple of the same title that includes photographs, drawings, maps, notes, audio, video, and other documentation. Often residencies provide an artist with opportunities for reflection and investigation that inspire a new creation. In this instance, the artistic process came full circle from creation to reflection to creation anew.

L.D.

Rirkrit Tiravanija during the installation of the exhibition *Economies: Hans Accola and Rirkrit Tiravanija*, Walker Art Center, 1995

George Tooker

American, b. 1920

– – **Exhibitions**

Reality and Fantasy, 1900–1954 (1954; catalogue), *American Tableaux* (2001; publication, tour)

– – **Holdings**

1 painting

George Tooker *Window I* 1955 egg tempera on composition board 28 7/16 x 22 9/16 in. (72.2 x 57.3 cm) Gift of the T. B. Walker Foundation, 1955 1955.16

Arthur Tress

American, b. 1940

– – **Holdings**

47 photographs

Arthur Tress *Women in Pet Cemetery, Stockholm* 1967 selenium-toned gelatin silver print 11 x 13 15/16 in. (27.9 x 35.4 cm) Gift of Steven Rifkin, 2002 2002.266

Anne Truitt

American, 1921–2004

-- **Holdings**
1 sculpture

Anne Truitt *Australian Spring* 1972 wood, paint 72 x 24 x 24 in. (182.9 x 61 x 61 cm) Gift of Mrs. Helen B. Stern, 1973 1973.16

Tseng Kwong Chi

Chinese, 1950–1990

-- **Exhibitions**
Art Performs Life: Merce Cunningham | Meredith Monk | Bill T. Jones (1998; catalogue), *The Cities Collect* (2000)
-- **Holdings**
3 photographs

Tseng Kwong Chi *Mount Rushmore, South Dakota* 1986 gelatin silver print; edition 2/9 38 x 37 5/8 in. (96.5 x 95.6 cm) T. B. Walker Acquisition Fund, 1999 1999.68

James Turrell

American, b. 1943

‐ ‐ **Commissions**
Sky Pesher (2005)
‐ ‐ **Exhibitions**
First Impressions: Early Prints by Forty-six Contemporary Artists
(1989; catalogue, tour)
‐ ‐ **Holdings**
1 sculpture, 1 drawing, 2 portfolios of prints, 1 book

James Turrell is the master of light. Early in his career, he was part of a Los Angeles cadre of artists (Robert Irwin and Doug Wheeler, primarily) who were drawn to the phenomenology of light and space, to realms where things were experienced, not simply perceived. Over the years he has created a variety of environments in which the holistic merger of light and color provides hypersensualized contexts for human experience. There are *Wedgeworks* and *Skylights* and *Skyspaces* and *Perceptual Cells*, all of which offer a kind of total immersion associated more with the landscape than with a gallery. Turrell has also created spaces that offer a permanent alternative to the torpor of the known and, instead, invite the visitor into minimalist environments that are baths of real light and gelled light and real space and illusionistic space, combined to create an experience of almost spiritual transcendence.

Since 1977, Turrell has been working on his *Gesamtkunstwerk*, the Roden Crater. Situated northeast of Flagstaff, Arizona, the now-dead volcanic crater is one in a gigantic field of eleven such formations. Each year he draws ever closer to an almost impossible dream wherein "the visitor will be guided through a system of guided paths, corridors, and steps to several rooms that all have a specific light quality of their own. Not only did the artist arrange the rooms and their apertures on the basis of natural light and its rhythmic change according to the time of day and the season of the year, he also took into account the astronomical constellation of the sun, moon, and stars."[1]

In a 1990 interview about the project, Turrell was asked if, ultimately, his romance is really with painting. His reply tells it all: "At the crater, I'm moving a lot of earth, but actually I'm affecting huge amounts of sky. It really changes the shape of the sky. . . . The crater's spaces will be filled with starlight. For me this has a very elegant quality because there are stars that are billions of years old and there is starlight that is fairly recent, maybe only twenty light-years old. Other starlight has taken millions or billions of light-years to get here. So you can mix this light of different ages that has a physical presence, which speaks of its time. That's the content I work with."[2]

In 2003, Turrell was commissioned to design a *Skyspace* for the new garden on the Walker Art Center's expanded campus. A square chamber open to the elements and only visible above ground as a simple cube, *Sky Pesher* (2005) is entered through a ramp that gently descends underground. Once inside, visitors experience the changing appearance of the sky as it is framed by an approximately 16-foot-square aperture in the ceiling. The work responds to the ambient light outside, transforming the sky into a living painting that is just out of reach.

R.F.

Notes
1. Jiri Svestka, with Alison Sarah Jacques and Julia Brown, eds., *James Turrell: Perceptual Cells*, exh. cat. (Düsseldorf: Kunstverein für die Rheinlande und Westfalen, 1992), 55.
2. Richard Flood and Carl Stigliano, "Interview with James Turrell," *Parkett* 25 (1990): 98.

James Turrell Sketch for *Sky Pesher* 2003 ink on paper Walker Art Center Study Collection, 2004 S2004.1

Richard Tuttle
American, b. 1941

- - **Exhibitions**
Artists' Books (1981)
- - **Holdings**
1 unique work on paper, 1 edition print/proof, 1 multiple, 17 books

Richard Tuttle's approach to art since the early 1960s has been subtle, idiosyncratic, and intimately poetic. Born in Rahway, New Jersey, in 1941, he studied literature and philosophy at Trinity College in Hartford, Connecticut. Perhaps it's this nontraditional training that allows him to create art that crosses boundaries between drawing, sculpture, and painting while using materials as humble as paper, rope, string, cloth, wire, nails, and plywood. Line, form, and material are his holy trinity. His work—on the floor, the wall, in space—takes the practice of Minimalism and imbues it with human nuance and expressivity. He is an antiheroic poet and philosopher with an inclination toward the spiritual, and art is his primary form of communication. An Eastern sensibility, in particular, seems to pervade his practice.

Since his first show at the Betty Parsons Gallery, New York, in 1965, it has been clear that Tuttle prefers the path less ventured. Ten constructed paintings or "drawings" of painted plywood shapes were placed on the gallery walls and floor. Each of the handmade forms—suggesting sickle, wishbone, mushroom, alphabet letters, and so on—displayed a sensitivity of touch and an emotional core that only gained force with the passage of time. Time is a key element in his work, which tends to reveal its power slowly, like a finely crafted verse. "It's a job for the scientist to find a new idea for time," he says, "but it's a job for the artist to show what the experience of time would be like."[1]

Time is often read by the change of light, from intense to fading, overhead to just out of sight. Noting that "paper has the capacity for every expression and dimension,"[2] Tuttle has created a work that adopts light as a mercurial partner in seeing and being. Each time *Eighth Paper Octagonal* (1970) is displayed, an original template drawn by the artist is used to create an exhibition version from white paper. The octagon, which measures five feet across, is then pasted directly onto a white wall. This modest white-on-white installation is determinedly elusive and delicately subtle. Depending on the time of day, the illumination of the room, or the angle from which we view it, the piece may disappear altogether or appear brighter or darker than the wall, seeming to gain volume or remain flat. The resulting interplay of light and shadow creates a poem in time, Tuttle's gift to us.

O.I.

Notes
1. Quoted in Jochen Poetter, *Richard Tuttle: Chaos, Die, or the Form*, exh. cat. (Baden-Baden, Germany: Kunsthalle Baden-Baden, 1993), 172.
2. Quoted in Paul Gardner, "Odd Man In," *Artnews* 103, no. 4 (April 2004): 103.

Tuttle Books

Richard Tuttle has been making artist's books since 1965. They range from high-end volumes employing techniques associated with letterpress printing to modest productions done in large editions with offset lithography. A critic once described Tuttle's art as both "sophisticated and infantile,"[1] a paradoxical linking, but true enough. He manipulates the simple stuff of art-making—line, color, shape, and texture—to make it lyrically and whimsically his own. His quirky minimal forms force viewers to get close to his work, something easily accomplished in the book format.

The Walker Art Center Library has built a collection of seventeen books by Tuttle, including one of his earliest, *Two Books* (1969). Each of its two volumes is bound in black felt and contains stark imagery: white against black in one, and black on white with white-on-white die-cuts in the other. The changing position of the goalpost image as it dances over the pages in Book One contrasts sharply with the repetition of a slowly diminishing box shape in Book Two. An extension of this idea is apparent in *Hiddenness* (1987), a continuous fold of five panels of handmade paper on which vibrantly colored paper pulp images are woven around a text.[2]

One of the most significant works by Tuttle in the collection is *Lonesome Cowboy Styrofoam* (1989). This volume includes many precious bits—satin ribbon, handmade paper, a painted swatch of earth pigment—but also mundane materials such as a stapled foam wrapper, a balloon, and some grass from New Mexico. The impetus for the book was an eponymous exhibition at Gallery Casa Sin Nombre in Santa Fe, at which Tuttle exhibited shaped painted panels made from Styrofoam he had found abandoned in an attic. The book is a record of that show in that it includes the visual account of work done as well as what the artist calls, in the introduction, "verbal and informational stock." Measuring only six-by-six inches, it is a treasure chest of revelatory fragments, testing the boundaries of the book format and trying, as Tuttle says, to make one world out of disparate parts.[3]

R. Furtak

Notes
1. Holland Cotter, "Richard Tuttle," *New York Times*, October 30, 1992, sec. C29, 1.
2. Made in collaboration with poet Mei-mei Berssenbrugge, published by the Library Fellows of the Whitney Museum of American Art, New York, in 1987.
3. Bob Holman, "Richard Tuttle," *Bomb* 41 (Fall 1982): 30–35.

Richard Tuttle Selection of artist's books, 1969–1995
Walker Art Center Library Collection

Richard Tuttle *Eighth Paper Octagonal* 1970 paper 46 x 60 in. (116.8 x 152.4 cm) Anonymous gift, 2002 2002.61

Günther Uecker

German, b. 1930

Günther Uecker *White Field* 1964 paint, nails on canvas on wood 34 1/2 x 34 1/2 x 2 3/4 in. (87.6 x 87.6 x 7 cm) Gift of the T. B. Walker Foundation, 1964 1964.41

Ben Vautier

Swiss, b. Italy, 1935

- - **Commissions**
Ben's Window (1992–1993)
- - **Exhibitions**
Artists' Books (1981), *The 20th-Century Poster: Design of the Avant-Garde* (1984; catalogue, tour), *In the Spirit of Fluxus* (1993; catalogue, tour), *Duchamp's Leg* (1994; catalogue, tour)
- - **Holdings**
2 sculptures, 3 unique works on paper, 1 multimedia work, 1 photograph, 26 multiples, 11 books, 12 announcements, 1 newspaper, 14 posters, 7 postcards

Ben Vautier was described as 100% Fluxman by George Maciunas, self-appointed founder of the Fluxus movement, which was considered by many to be the most radical and experimental art movement of the 1960s. Intentionally positioning themselves outside mainstream art and art institutions, Fluxus artists created their own venues for performances, exhibitions, and sale of their work. Vautier—often referred to simply as Ben—played a central role in the early evolution of the Fluxus movement and was one of its most active international participants.

In the early 1960s, Maciunas organized a number of performances throughout Europe that carried the hallmarks of what would become classic Fluxus. These events, often presented as "concerts" or "festivals," brought together a range of experimental artists whose performance activities combined music, poetry, the visual arts, and actions. In 1962 in Nice, Maciunas worked for the first time with Ben, organizer of the "Festival Ben Vautier," who expanded the format to include street performances in addition to events presented in theater and staged settings. Ben was particularly interested in the techniques of Dada and the ideas of Marcel Duchamp and John Cage. "Without Cage, Marcel Duchamp, and Dada, Fluxus would not exist . . . ," he wrote. "Fluxus exists and creates from the knowledge of this post-Duchamp (the readymade) and post-Cage (the depersonalization of the artist) situation."[1]

In his Fluxus performances, Vautier used his own body as the primary medium for his art. His events in the streets of Nice included gestures and actions that were surprisingly literal. While writing on a wall, for instance, he inscribed on a large placard "Ben ecrit sur les murs" (Ben is writing on walls). In another performance, he seated himself on a chair in the middle of a street, with a placard at his feet that read "regardez-moi/cela suffit/je suis art" (look at me/that's enough/i am art). In a later performance, titled *Mystery Food* (1963), Vautier—dressed in a suit, overcoat, and bowler hat—opened and ate the contents of a can of food whose label had been removed, then ceremoniously brushed his teeth. In subversive disregard of any conventional approach to art, Fluxus humor resided in the incongruities between expectation and presentation. His self-exhibitions abandoned conventional aesthetics, mocked the self-importance of the artist, and encouraged laughter at the self.

In the late fall of 1962, Fluxus-associated artists Daniel Spoerri and Robert Filliou organized an event in London called the Festival of Misfits. During the week-long festival, Vautier presented himself and his environment as the ultimate Duchampian readymade—a living aesthetic object for the viewer's contemplation. Calling his work *Living Sculpture* (1962), he took up residence in the small display window of London's Gallery One, where he lived for fifteen days, putting himself on view and offering himself for sale for £250. Acting on "the stage of life," he surrounded himself with everyday objects, including a bed, a table and chair, a gas cooker (for heating food), a television set, a wine glass, a meat grinder, a hand drill, and a teddy bear, along with created objects such as a "potatoes on a wire" sculpture and numerous plaques with Ben's text. In his trademark cursive handwriting, these text panels consisted of rhetorical questions and whimsical comments, giving equal importance to everything from the kitchen table to a container of dirty water. "Everything that I touch and look at is a work of art," reads one of his plaques. As the artist engaged in a direct exchange with the audience, this quintessential Fluxus piece bypassed the elitism of the museum and gallery system and blurred the lines between art and everyday life.

"It was real life," he wrote about *Living Sculpture* more than thirty years later. "When I did the window, Fluxus was supposed to turn into life and fun. Today, it is art archaeology."[2] In 1993, the Walker Art Center mounted the exhibition *In the Spirit of Fluxus*. Invited to re-create his Gallery One window, Vautier found a number of vintage objects from the original piece, to which he added numerous replicas based on old film footage and photographs of the 1962 event. He also inserted several new objects, including a boombox and a slide projector that displayed original and updated texts in the window, such as "Does anybody have an idea?" and "Art is a dead story."

A number of the objects and ideas for objects presented in Ben's window were later produced by Maciunas as Fluxus multiples, and the Walker's collection includes key examples of many of these publications as well—from his books and broadsides to the multiplicity of small things such as his *Flux Mystery Food* (1967), *Flux Missing Card Deck* (1967/1969), and *A Flux Suicide Kit* (1967/1969). Taking the notion of Duchamp's readymades to its logical conclusion, Vautier made up certificates that could authenticate as art such mundane objects as empty wine bottles, dirty water, dust, blank postcards, holes, and even himself. As produced by Maciunas in large editions from inexpensive, easily obtainable materials, these objects reflect one of the most distinctive aspects of Fluxus, the "free license" that artists gave one another in interpreting their work. In the process, they undermined the status of art as a valuable commodity and rewrote the notion of artistic sovereignty and originality.

Elizabeth Armstrong

Notes

1. Ben Vautier, "What Is Fluxus?" *Flash Art* 84–85 (October–November 1978): 52.

2. Artist's statement, 1993 (Walker Art Center Archives).

Ben Vautier *Ben's Window* 1962/1992–1993 mixed media 125 1/2 x 178 1/2 x 108 in. (318.8 x 453.4 x 274.3 cm) installed T. B. Walker Acquisition Fund, with additional funds from Lila and Gilbert Silverman, 1993 1993.126

Kara Walker

American, b. 1969

- - **Commissions**

Slavery! Slavery! presenting a GRAND and LIFELIKE Panoramic Journey into Picturesque Southern Slavery. or "Life at 'Ol' Virginny's Hole' (sketches from Plantation Life)" See the Peculiar Institution as never before! All cut from black paper by the able hand of Kara Elizabeth Walker an Emancipated Negress and Leader in her Cause (1997)

- - **Exhibitions**

no place (like home) (1997; catalogue), *The Cities Collect* (2000), *American Tableaux* (2001; publication, tour)

- - **Holdings**

7 drawings, 1 suite of drawings, 1 video, 1 edition print/proof, 2 books

History, or the underbelly of history, is at the heart of Kara Walker's work. She plays out her own version of the past on an epic scale, in fragmented visual narratives told through simple paper silhouettes, using as a backdrop one of America's darker historical locations (the antebellum South) and more recently, the linear narrative that underlines the history of modernism. The silhouette aspect of her work finds its roots in nineteenth-century, middle-class Southern "ladies' art" as well as the kitsch, mass-cultural icons and emblems that circulate widely in our society. The protagonists of her minstrel shows, however, owe much to the visceral writings of the Marquis de Sade and Steve Cannon. They lick, suck, dig, poke, shit, or copulate in a series of acts ranging from sexual voracity to outrageous sadism and auspicious indolence.

Walker's use of the silhouette is part of a strategy. Her work aggressively expands the debates on race and its representation beyond the notion of good or bad iconography and imagery. She is pushing her art to a very specific level of narrative cohesion, using seductive visual effects to comment sarcastically, ribaldly, on the history of race relations, slavery, and sexual exploitation. She appropriates and twists the code of the constructed national memory that is American History. And she does it in such a way that no one is let off the hook. In her silhouettes, she says a lot with very little information, which is both the virtue and the vice of stereotyping.

One cannot pretend that the stereotypes she uses—most of which were created in the early nineteenth century—are no longer with us. We cannot pretend that we do not know what they mean and how they make us feel. Her appropriation of history, her historicization of the past, and her narrativization of society force her viewers to confront the idea of a collective memory that still resides in the present moment—that resides in the awareness that black bodies in pain for public consumption have been, and still are, a European/American spectacle. We are not only talking about basketball or boxing, but about Emmett Till, Rodney King, and Amadou Dialou.

Walker's work triply implicates viewers in social guilt: the guilt surrounding the history of slavery, the guilt surrounding the use of stereotypes, and the guilt

associated with witnessing sexual and scatological functions. She deliberately uses the narrative authority of the novel—which during the nineteenth century was a cultural form tied to bourgeois society and imperialism—as a system of social reference refining and articulating the authority of a sociohistorical status quo. And in order to make her critique more complex, beyond good and evil, beyond morality, she reveals a sense of humor that allows her to perpetuate stereotypes as she debunks and critiques them. At the end she leaves us conflicted, laughing ourselves to tears.

Walker's intensely charged imagery, a broad institutional recognition and patronage of her work, and a prestigious MacArthur Foundation Grant in 1997 triggered a violent criticism and boycott campaign that year. Led by an older generation of African American artists, including Betye Saar and Howardena Pindell, the campaign attacked the relevancy and the true intent of her work. The criticism targeted Walker's motivation, ability, and freedom (if not morality) to use black stereotypes and to assume responsibility for their cultural and political implications when representations of blackness/whiteness are paired with those of masculinity/femininity and class. The work was labeled "visual terrorism," too "sexist and derogative" to be suitable for the audience's gaze and judgment, and as perpetuating, through negative sexualized images, American racism and its sources.[1]

Created between August and December 1997, *Do You Like Creme in Your Coffee and Chocolate in Your Milk?*, a series of sixty-six drawings in various media, was conceived by Walker as a diaristic response to the controversial campaign.[2] Often including the artist's writings, the work shares a traditional, though visceral, aesthetic that seems indebted to Francesco Goya, Egon Schiele, and Antonin Artaud. With often abrasive language and iconography, this series echoes Walker's usual preoccupation with the sexualized self and racialized flesh and addresses frontally her feelings about the letter-writing campaign initiated by a "Finger Pointing Matron" against a "27 year old African-American Cunt (with a MacArthur Grant)."[3] By attempting to identify the larger issues that the controversy raised—on one of the pages of the work she writes, "The Merits of Arguing over Representation: I mean—you can't please everyone and why *should* you anyway!? Pindell's argument—that this (My) work is not accepted by *ALL* Black People is Right . . . What ARTWORK actually *Does* that?"—Walker does not deny the necessity of the debate and allows herself to publicize her sarcastic, humorous, and sometimes angry and indignant voice, refusing a monolithic interpretation of her work.

Codes of representation—the ones that have shaped most of twentieth-century modernity—are at the center of *Endless Conundrum, An African Anonymous Adventuress* (2001). Commissioned by the Fondation Beyeler in Basel, Switzerland, for its exhibition *Ornament and Abstraction*, which brought together non-Western, modern, and contemporary works from the Fondation's permanent collection, *Endless Conundrum* follows the same confrontational structures. The cut-paper composition is dominated

Kara Walker *Testimony* 2004 DVD (black and white, silent), boxed with paper silhouette 8:49 minutes Clinton and Della Walker Acquisition Fund, 2004 2004.62

Kara Walker Selections from *Do You Like Creme in Your Coffee and Chocolate in Your Milk?* 1997 watercolor, colored pencil, graphite on paper 11 5/8 x 8 3/16 in. (29.5 x 20.8 cm) each of 64; 8 3/16 x 11 5/8 in. (20.8 x 29.5 cm) each of 2 Justin Smith Purchase Fund, 1998 1998.100

by a silhouette evoking Josephine Baker—the "black Venus," the "black pearl," the "Creole Goddess"—being stripped of the banana skirt that took Europe by storm in the 1920s and 1930s. Baker, the Missouri-born singer, dancer, and actress who faced a violent racist reaction in America, embodies a fascination with the "other," and in Walker's composition she is swallowed in an epic, sexualized, dramatic, and historical narrative.

The other protagonists of this narrative are silhouettes of Constantin Brancusi's modern icon, the *Endless Column*, and the figure of the colonizer who is by turns drawn, attacked, seduced, and devoured by the object of his own covetousness, lust, and ultimate misunderstanding: the exotic "others," fetishes, and sculptures. The most memorable one might be a Gabonese fang ladder, easily mistaken for the *Endless Column*, or the other way around, and a Congolese *Nkisi N'kondi* nail figure waving at a fleeing colonizer, echoing its original purpose to "honor" departed ancestors. Part Dante's *Inferno* and part Jacob's Ladder, Walker's *Endless Conundrum* pokes at the debate around primitivism as a Eurocentric construction, in which the "primitives," trapped between savagery and a state of grace, between diabolical rites and superstitions, between darkness and enlightenment, have been stripped from any cultural, religious, and social background and instrumentalized in order to assess the European cultural and historical hegemony.

By expatriating a century of modern art history, *Endless Conundrum* echoes the critique that Thomas McEvilley articulated against *"Primitivism" in 20th-Century Art*[4] and questions the ideology of the Kantian aesthetic theory that champions pure form and the universality of the modernist canon. "My works are erotically explicit, shameless. I would be happy if visitors would stand in front of my work and feel a bit ashamed—ashamed because they have . . . simply believed in the project of modernism."[5] As she whispers these words, Walker attempts to reclaim a history, both individual and collective, that has never overcome what W. E. B. Du Bois identified as the problem of the "color line."[6]

P.V.

Kara Walker Selection from *Do You Like Creme in Your Coffee and Chocolate in Your Milk?* 1997 watercolor, colored pencil, graphite on paper 11 5/8 x 8 3/16 in. (29.5 x 20.8 cm) each of 64; 8 3/16 x 11 5/8 in. (20.8 x 29.5 cm) each of 2 Justin Smith Purchase Fund, 1998 1998.100

Notes
1. For a succinct description of the controversy—the events, the issues, and the persons involved—see "Extreme Times Call for Extreme Heroes," *International Review of African American Art* 14, no. 3 (1997): 3–15.
2. The work consists of sixty-six drawings and watercolors on notebook paper and includes the artist's musings on the controversy.
3. Both phrases are written on pages of the work.
4. Thomas McEvilley, "Doctor, Lawyer, Indian Chief: *'Primitivism' in 20th-Century Art* at the Museum of Modern Art in 1984," *Artforum* 23, no. 3 (November 1984): 54–61.
5. Kara Walker, interview with Samuel Herzog, "Die schwartze Seele wird von der Moderne verbraucht," *Basler Zeitung*, June 9, 2001, 55. Trans. Lynn Dierks.
6. See W. E. B. Du Bois, *The Souls of Black Folk* (Chicago: A. C. McClurg & Co., 1903).

Kara Walker Selection from *Do You Like Creme in Your Coffee and Chocolate in Your Milk?* 1997

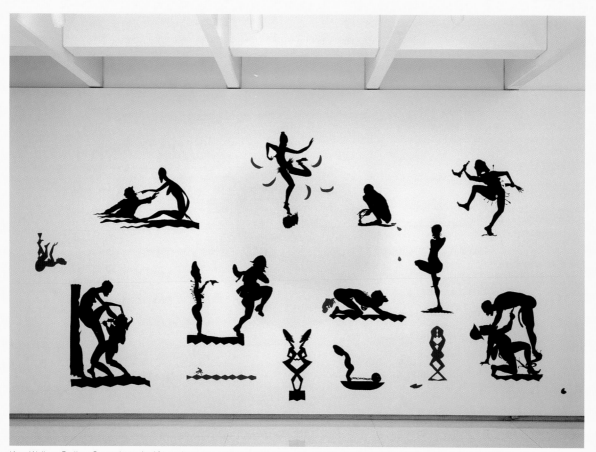

Kara Walker *Endless Conundrum, An African Anonymous Adventuress* 2001 paper 180 x 420 in. (457.2 x 1066.8 cm) installed T. B. Walker Acquisition Fund, 2002 2002.21

On Kara Walker's *Endless Conundrum, An African Anonymous Adventuress*

Of Kara Walker's works to date, *Endless Conundrum, An African Anonymous Adventuress* (2001) is among the most unusual and distinctive. One reason for this is that, in formal and political disposition, it is a direct response to *Océanie, le ciel (Oceania, the Sky)* (1946), a mural-size screenprint by Henri Matisse.[1] *Oceania* comprises a field of unbleached linen that supports an open yet disciplined arrangement of oversized, opaque white forms enclosed within an ornamental border. This sparse, light composition is more decorative than most from Matisse's productive final period, during which he refined the cutout technique that is now his thumbprint. At this point, Matisse was also visited regularly by memories of a 1930 holiday in Tahiti, whose flora and fauna inspired *Oceania*'s forms, which a designer translated from Matisse's hand-cut versions.

In the late nineteenth and early twentieth centuries, Tahiti was among several locales whose foreignness fed many modern artists' hunger for essences, providing material for both their work and their claims of avant-gardism. The artistic and literary products of these sojourns helped to secure not only the fiction of the Western artist "gone native" but also the privilege that artist enjoyed at home. More damaging, of course, were the social effects of the deep cultural narcissism cultivated by those who conferred upon themselves the unique perception needed to represent the essence of humankind by briefly steeping themselves in societies they barely knew. After visiting Tahiti, Matisse remarked that it was "a deep goblet into which you look" and, from this distance, praised its color, light, and the relief his eye and mind enjoyed while "the natives wallowed in animal pleasures."[2]

Naturally, such chauvinism has generated harsh criticism ever since. But with *Endless Conundrum*, Walker appears to regard it somewhat more judiciously. This imposing work presents a daringly theatricalized, alternative vision of the historical encounter between so-called Continentals and "the native." In a way, it is a leveling view: one suggesting that such exchanges may not have always been one-sided perpetrations of racism and/or sexism, that even the most patently ridiculous cultural projections can engender desire. For one thing, Walker's uncharacteristic use of brown (for the bananas, feces, and baby) softens the drama of black and white while also humanizing their interplay. She disturbs the order of Matisse's exotic modernism in the process of evoking it: by denying *Endless Conundrum* a framing element or restful balance, she forces us to take in the space her work fills, shattering Matisse's "goblet" precisely by stressing the experiential aspect of looking. This *opening* of the work facilitates a related effect, namely in passages whose action reminds us that formal relationships between form and ground, positive and negative, and interior and exterior also have cultural counterparts, that these relationships are never fixed, and that both kinds are as elemental to the "big picture" of modern art as they are to Matisse's panel.

Elsewhere in the space of *Endless Conundrum*, diverse characters drawn from grammars of racial and sexual exoticism partake in various retributions and pleasures. Among them are a Harlem Renaissance Nubienne, a Congolese nail fetish, a Josephine Baker type, and a colossal, feminized Pygmalion. Perhaps this last is Walker's remark on the cumbersome precedent of modern artistic genius; or perhaps not. In any case, her use of figuration here is particularly shrewd: in a boundless field, it engages abstract art opportunistically and thus repositions modern art as a *cultural* project, a two-sided engagement having a profound contemporary resonance.

The riffs on Constantin Brancusi's *Endless Column* (1938), which is both *Endless Conundrum*'s namesake and central motif, make this explicit. That work—a monumental zigzagged pillar that is overwhelmingly phallic and also resembles a trope in African art—is alternately toppled, miniaturized, fragmented/castrated, and ecstatically, sexually engaged in *Endless Conundrum*. It is fitting that *Endless Conundrum*'s exploded, emphatically postmodern framework harbors a position on the politics of modernism that is so pointedly vague. Walker and her silhouetted cohort need such a space of expanded possibility in order to bypass the passive role that is habitually assigned to nonwhite, non-male subjects of art—and to create in a way that is equally commemorative *and* critical.

Darby English

Notes

1. Kara Walker, correspondence with the author, October 2004.

2. See "Interview with André Vernet," in Jack Flam, ed., *Matisse on Art*, rev. ed. (Berkeley: University of California Press, 1995), 209–216.

Jeff Wall

Canadian, b. 1946

- - **Exhibitions**
The Last Picture Show: Artists Using Photography, 1960–1982
(2003; catalogue, tour)
- - **Holdings**
1 photograph

Jeff Wall's photographs invite staring. His monumental, dramatically staged narratives revolve around seemingly ordinary events, such as businessmen caught in a windstorm, custodians carrying out chores, or pedestrians eyeing one another on the street. These scenarios are played out on an epic scale, with the kind of luminous color, compositional structure, and authority more typically associated with painting. His visual language may borrow broadly from eighteenth- and nineteenth-century painting traditions, but the imagery is expressed photographically, utilizing the medium's capacity for documentation and fragmentation to construct spectacular fictions. In Wall's handling of the medium, the photograph proves the perfect vehicle for such contemporary allegories—somewhat gritty, but sumptuous tales of everyday life.

His images tend to re-create events that might actually have occurred, but passed without notice, producing what he describes as "near documentary" photographs. He utilizes actors and props to reconstruct these scenes, taking great care to present fantastic, chaotic, or even exceptionally banal imagery as plausible records. In the camera's absorptive retelling of such events, they emerge as strangely compelling bits of cinema; despite their realism, there is the lingering sense that these are not actual occurrences at all, but perfectly inscribed fabrications, pulled from a larger narrative.

In *Morning Cleaning, Mies van der Rohe Foundation, Barcelona*, a scene that opens onto the pavilion designed by Ludwig Mies van der Rohe for the 1929 Barcelona International Exhibition, the image is suspiciously devoid of fanfare for what is one of the most emblematic structures of modernist architecture and design. The interior space is exquisitely spare, attended only by a pair of iconic so-called Barcelona chairs, several ottomans, and a custodian who is unceremoniously cleaning the window. His presence immediately alters the reading of the space as an architectural monument, and recalibrates it to include the human presence of the staff that maintains the place. Suddenly this anonymous figure becomes the focal point of the narrative. He is, of course, like all of Wall's characters, a fictional figure, posed and directed to give the appearance of a custodian at work. The unlikely juxtaposition is comical, a sly comment on the constant scrubbing and maintenance of modernist ideologies.

Diana Gaston

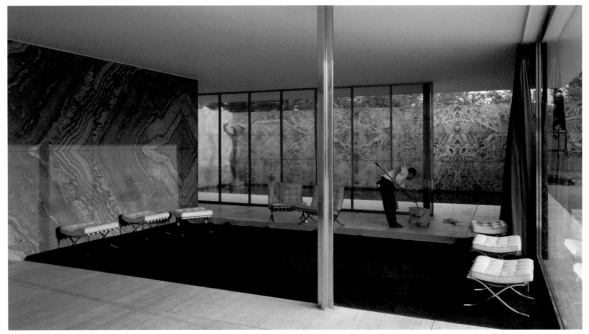

Jeff Wall *Morning Cleaning, Mies van der Rohe Foundation, Barcelona* 1999 Cibachrome transparency, fluorescent bulbs, aluminum display case
81 1/8 x 145 3/4 x 10 1/4 in. (206.1 x 370.2 x 26 cm) T. B. Walker Acquisition Fund, 2000 2000.109

Nari Ward

American, b. Jamaica, 1963

-- **Commissions**
Rites-of-Way (2000; publication)
-- **Residencies**
2000
-- **Holdings**
1 sculpture, 1 edition print/proof

Artists frequently salvage society's forgotten objects, images, and memories. They reorder these humble elements, finding the redeemable within the abject. To create his enigmatic sculptural ensembles, Nari Ward gleans our remnants, acting as a modern-day archaeologist unearthing the dreams and nightmares that undergird our daily lives. In his hands, everyday items—oven pans, baby strollers, plastic beads, shopping carts—are transformed, imbued with poetry, emotion, and spirit before being re-presented in unexpected ways. He considers his artistic interventions to be an "activation" of the objects and the memories they carry.

Born in Jamaica, Ward moved with his family to New York City at the age of twelve. For more than two decades, the neighborhood of Harlem—for generations a hotbed of artistic, cultural, and intellectual pursuits—has served as incubator for his creative impulses. He gathers materials and ideas in the least likely places, and is more often "interested in the things that don't fall into place, that fall outside the guidelines you are supposed to follow."[1] He purchased the carpet used in the Walker Art Center's sculpture *Den* (1999) from a street salesman who was demonstrating the quality of his vacuum cleaner. The sculpture was later completed with the addition of a twisted tree trunk onto which Ward added carved lion-claws legs from an old chair. Ward has remarked that *Den* carries a specific reference to *Daniel in the Lion's Den* (1865) by African American painter Henry Ossawa Tanner, whose painterly homage to the Old Testament tale of a prophet trapped in a den of timid lions has often been read by critics as a meditation on slavery, persecution, and martyrdom.[2] Ward adds a touch of the surreal in this psychologically explosive commingling of the majestic and the ordinary, the synthetic and the organic, the spiritual and the profane. The work is a series of transformations as the fence cuts into the tree, which in turn seems to morph into a declawed and splayed animal. It is a dark and moody piece, but the artist offers a ray of light in the small, cleaned corner of the carpet that seems to suggest a glimmer of redemption, of hope. By shining a light on the darker corners of our existence, Ward creates work that is, inescapably, a part of us.

O.I.

Notes
1. Quoted in Alessandra Pace, "Nari Ward: In the Inside of a Sunshower," *Flash Art* 29, no. 190 (October 1996): 76–79.
2. Ward, correspondence with Walker curator Elizabeth Carpenter, January 3, 2002 (Walker Art Center Archives).

Artist-in-Residence, 2000

As a Walker artist-in-residence, Nari Ward held storytelling workshops over the course of six months with people from several different Twin Cities communities and asked them to describe "home." The answers he received—from Hmong immigrants, African American and Korean seniors, homeless teenagers, college students, and local writers, among others—wove stories of memory, dislocation, community, and ritual. Ward assembled these tales against the backdrop of his detailed research into local history and customs. He was especially fascinated with Minnesota's ice-fishing "villages," the grand ice palaces of the early twentieth century, and the old Rondo neighborhood of St. Paul that was bisected by highway construction in the late 1950s. Lastly, he was drawn to the life and work of Clarence Wigington (1883–1967), an African American municipal architect and designer of several ice palaces in the 1930s and 1940s who had ties to Rondo.

Ward pulled all these disparate elements together in a beautifully evocative sculpture, *Rites-of-Way* (2000), which stood in the Minneapolis Sculpture Garden for two years. During his community visits, he asked attendees to donate an object that meant "home" to them. These items—ranging from clothing, record albums, and toys to banknotes, kitchen utensils, and a slice of a sacred bur oak tree—were then ceremoniously wrapped and mailed to no-longer-existing Rondo addresses. This gesture made references to a post office in Wigington's 1940 ice palace, the building on which the artist based his sculpture's floor plan. Once returned through the postal system, these packages were suspended in the work's towers (made to resemble ice-fishing shacks). The installation's series of passageways were outlined with strings of large clear beads, evoking the light and translucence of ice and water while acting as a metaphorical threshold between homes real and remembered.

O.I.

Nari Ward (left) with workshop participants at the Hallie Q. Brown Community Center, St. Paul, 2000

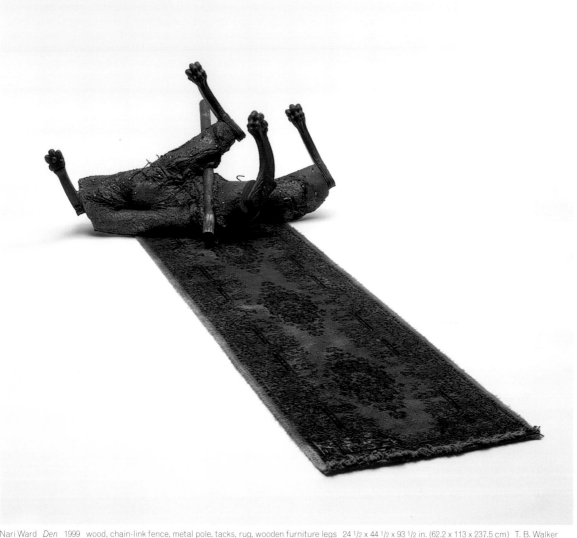

Nari Ward *Den* 1999 wood, chain-link fence, metal pole, tacks, rug, wooden furniture legs 24 ¹/₂ x 44 ¹/₂ x 93 ¹/₂ in. (62.2 x 113 x 237.5 cm) T. B. Walker Acquisition Fund, 2002 2002.30

Andy Warhol

American, 1928–1987

Exhibitions

Banners and Tapestries (1967), *20th Century Master Prints* (1975; tour), *Prints from the Walker Art Center's Permanent Collection* (1980; tour), *First Impressions: Early Prints by Forty-six Contemporary Artists* (1989; catalogue, tour), *Duchamp's Leg* (1994; catalogue, tour), *Art Performs Life: Merce Cunningham/Meredith Monk/Bill T. Jones* (1998; catalogue), *Andy Warhol Drawings: 1942–1987* (1999; organized by the Andy Warhol Museum, Pittsburgh, and Kunstmuseum Basel; catalogue), *The Cities Collect* (2000), *Let's Entertain* (2000; catalogue, tour), *The Last Picture Show: Artists Using Photography, 1960–1982* (2003; catalogue, tour)

Holdings

5 paintings, 9 sculptures, 1 drawing, 3 photographs, 1 video, 10 edition prints/proofs, 7 portfolios of prints, 1 multiple, 6 books, 1 periodical

Today, Andy Warhol's name is as widely recognizable as those of Marilyn, Elvis, Jackie, Liz, Campbell's Soup, and Coke, some of his most famous subjects. For many people, the name Warhol is also synonymous with glamour, fame, hucksterism, money, and all the excesses of postwar American consumer culture. His life traces the classic American dream: he was born in Pittsburgh to working-class immigrant parents, and built a successful career in the 1950s as a New York commercial artist. He reinvented himself in the 1960s as a Pop painter and avant-garde filmmaker, then transcended the art world to become a wealthy international celebrity who was pursued by groupies and paparazzi. Warhol's work, too, transgressed categories and pushed at the boundaries that defined what art could be, ultimately transforming the aesthetic landscape through the unlikely agency of trashy, offhand films and deadpan paintings of banal subjects. Many of his works were made by committee, with the artist directing a band of cronies in the studio he called the Factory. Critic Edmund White called him a "brilliant dumbbell,"[1] and he was not alone in wondering if Warhol's success was attributable to a serendipitous combination of intuition, timing, savvy, and ambition more than simply to native intelligence and talent. But the artist insisted there was no mystery. "If you want to know all about Andy Warhol, just look at the surface: of my paintings and films and me, and there I am. There's nothing behind it."[2]

Warhol had his first New York solo exhibition in 1962 at the Stable Gallery. The eighteen works presented gave viewers a look at what would become his signature devices: a compositional structure based on the grid, and the use of silkscreen to apply photographic imagery to his canvases. The grid had figured in his earlier pictures of airmail stamps and S&H Green Stamps, but these were "painted" using stencils cut from balsa wood or rubber stamps carved out of gum erasers. Warhol first used photo-silkscreening for *Baseball* (1962), a repeating grid of news photos showing Roger Maris hitting a home run. Subsequently, he relied on newspaper photos as well as celebrity head shots, advertisements, comics, and all manner of found images as sources for his pictures, and silkscreening

was a quick, inexpensive, and accurate way to transfer them onto canvas. The smudges, missed alignments, and inconsistencies were always accepted, and give the works a handmade appearance despite the industrial process. There are clear connections between these works and Jasper Johns' flags, targets, and alphabet grids, and Robert Rauschenberg's embrace of newspaper imagery,[3] but Warhol had found his own very modern voice by privileging mechanical techniques and serial imagery over the gestural brushwork and personal content favored by Johns and Rauschenberg.

Repetition as a condition of modern life is perhaps most pervasive in the mass media, where iconic images, faces, and slogans appear again and again and again, moving from print to television to billboards, changing scale and color, being copied, cropped, degraded, and enhanced—but always remaining the same. Warhol brilliantly exploited this monotonous barrage, lining images up so that the profusion could be understood, then freezing them in place. The melancholy, black-and-blue *Sixteen Jackies* (1964) quotes from the incessant television coverage of President John F. Kennedy's assassination in 1963, after which footage of the same events (inauguration, motorcade, funeral) was repeated for weeks. The Jackie canvases followed other death and disaster series, including the *Car Crashes*, *Suicides*, *Electric Chairs*, and *Race Riots*, which were based on photos from tabloids and movie magazines. Even his *Marilyns*, painted after her death, might be seen as portraits of a suicide. Perhaps Warhol was attempting with these pictures to quiet his own purported fear of death through familiarity and repetition. "When you see a gruesome picture over and over again, it doesn't really have any effect," he told an interviewer in 1963.[4]

In 1964, when *Sixteen Jackies* was painted, Warhol's Factory was in full swing, populated each day with various assistants, friends, visitors, and hangers-on. Many were there to work on his films, a medium with which he was becoming increasingly involved; others helped him produce the paintings and sculptures. Some of these were on view in his second solo show at the Stable Gallery, in early 1964, which featured a profusion of grocery-carton sculptures—hand-painted and silkscreened facsimiles of boxes for Brillo soap pads, Kellogg's Corn Flakes, Heinz Ketchup, and other products. Warhol stacked the boxes in towers so that the gallery resembled the back room of a supermarket, and priced them inexpensively at $200 to $400 each.[5] They sold poorly, but the show was a critical success, and the boxes—quintessential Pop objects—have become an important part of a larger conversation about appropriation that begins in the 1910s with Duchamp's "readymades," includes Johns' painted bronze beer cans of 1960, and continues into the 1980s, when Richard Prince rephotographed magazine advertisements.

In 1968 Warhol was shot and nearly killed by Valerie Solanis, a sometime Factory denizen and actress who had had a bit part in one of his films. Most observers mark the event as a turning point in his work as well as his life. Post-shooting, he hired himself out as a portraitist to the rich and famous, turning out idealized likenesses based on his own Polaroids rather than the mass-media images he'd used during the previous

decade. He produced new images of Marilyn, Mao, and others, but in negative (the *Reversals*), and began sprinkling glittery diamond dust (a powder obtained during the manufacture of industrial diamonds) on his canvases.[6] Toward the end of the 1970s, he returned to self-portraiture, but the blank cool of his 1960s canvases is gone; the late self-portraits include haunting images of Warhol's disembodied head, with gaunt face and fright wig, floating on dark fields of color; expressionistic memento mori featuring a human skull; and poignant photographs of the artist in skewed drag, wearing provisional makeup and cheap wigs and looking very mortal indeed.

Finally, Warhol turned to abstraction—Warhol, whose soup cans and *Marilyns* had helped end the dominance of Abstract Expressionism, and whom de Kooning had accused of killing art, beauty, and even laughter.[7] The *Oxidation*, *Shadow*, *Rorschach*, and *Camouflage* series of the late 1970s and 1980s approach the sublime in spite of banal sources and abject materials. The majestic, phantom *Shadows* were based on photographs of dramatically lit pieces of paperboard, and the *Oxidations* are canvases prepared with copper metallic paint on which the artist and others urinated, turning piss into cash in an alchemical revision of action painting.

Warhol's immense body of work includes thousands of paintings, sculptures, drawings, prints, films, photographs, multiples, and books—a cornucopia whose bounty hasn't dimmed the appetite or enthusiasm of his public. Increasingly, he seems a crucial part of our focus on the proliferation of images and spectacle in contemporary culture, and the increasing overlap of art, consumption, entertainment, and information. Warhol understood long ago that the distinction among these realms would not hold. "I believe media is art," he said, and he made it so.[8]

J.R.

Notes

1. Quoted in Arthur C. Danto, "The Philosopher as Andy Warhol," in Callie Angell et al., *The Andy Warhol Museum* (New York: D.A.P., 1994), 81.
2. From a 1967 interview, quoted in Kynaston McShine, *Andy Warhol: A Retrospective*, exh. cat. (New York: Museum of Modern Art, 1989), 457.
3. Rauschenberg was unfamiliar with the photo-silkscreening technique when he visited Warhol's studio in September 1962. After querying Warhol about it, Rauschenberg began using it himself the following month. Warhol was dismayed, fearing that he would be accused of stealing the idea from the older, better-known artist. See Walter Hopps and Susan Davidson, eds., *Robert Rauschenberg: A Retrospective*, exh. cat. (New York: Solomon R. Guggenheim Museum, 1997), 561, and David Bourdon, *Warhol* (New York: Harry N. Abrams, 1989), 131–132.
4. Interview with G. R. Swenson, quoted in Bourdon, *Warhol*, 142.
5. Ibid., 186.
6. Ibid., 380. The Walker's collection includes an example of the latter: *Diamond Dust Joseph Beuys* (1980).
7. Danto, "The Philosopher," 77–78.
8. Quoted in Christoph Heinrich, *Andy Warhol Photography*, Candace Breitz, ed., exh. cat. (Hamburg: Hamburg Kunsthalle; Pittsburgh: Andy Warhol Museum, 1999), 6.

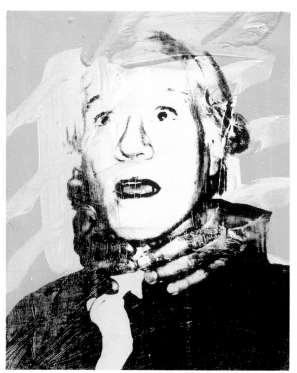

Andy Warhol *Self-Portrait* 1978 acrylic, silkscreen ink on canvas 16 x 13 in. (40.6 x 33 cm) T. B. Walker Acquisition Fund, 1993 1993.187

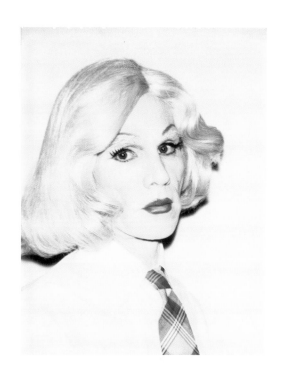

Andy Warhol *Self-Portrait in Drag* circa 1981 Polaroid 4 1/4 x 3 5/16 in. (10.8 x 8.4 cm) Butler Family Fund, 2003 2003.12

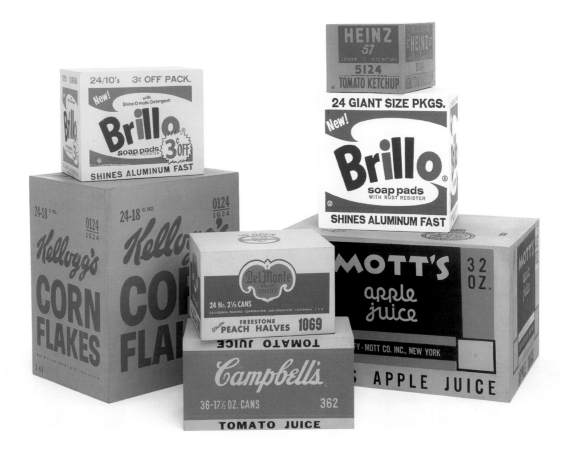

Andy Warhol *Campbell's Tomato Juice Box*; *Del Monte Peach Halves Box*; *Heinz Tomato Ketchup Box*; *Kellogg's Corn Flakes Box*; *Mott's Apple Juice Box*; *White Brillo Box*; *Yellow Brillo Box* 1964 synthetic polymer paint, screenprint on wood various dimensions Gift of Kate Butler Peterson, 2002 2002.305–311

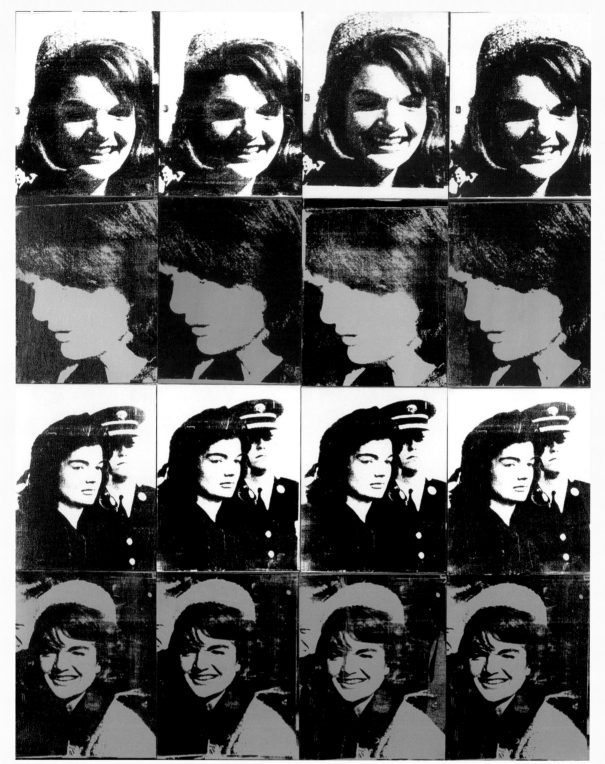

Andy Warhol *Sixteen Jackies* 1964 acrylic, enamel on canvas 80 3/8 x 64 3/8 in. (204.2 x 163.5 cm) Art Center Acquisition Fund, 1968 1968.2

Jackie and Repetition

Jackie recurs: her specialty is repetition. Mass media's adoption of Jackie as slogan and image ensures that no sighting of her can ever claim to have been the first: it will always rest upon a prior occasion. Thus Jackie, as image, is necessarily cliché and revenant.

Events recur in Jackie's life: her narrative depends on erotic and morbid déjà vu. Black Jack returns as Jack Kennedy, and then again as swarthy Ari; Lee is Jackie's double. After Jackie almost dies in childbirth, and baby Patrick dies (the second of her children to die), then her husband is shot, a death itself echoed in 1968 with Bobby's assassination. A 1973 *Photoplay* headline summarizes Jackie's connection to repetition: DEATH IN JACKIE'S LIFE AGAIN: GOD, NO MORE!

The Jackie look repeats itself. Every mock Jackie echoes the original, as homage or unintended parody; every new photograph of Jackie repeats the foundation we've already seen, the progenitive Jackie, whose good taste mandates a fawning series of imitators.

Andy Warhol, in such silkscreens as *Gold Jackie*, *Round Jackie*, *Jackie (The Week That Was)*, *Three Jackies*, *Nine Jackies*, and *Sixteen Jackies*, was the first intellectual or artist to reflect on Jackie's status as repeated icon. These Jackie portraits, some pre-assassination, some post-assassination, borrowed the format of his electric chair, car crash, Liz, and Marilyn series. All of these subjects are spectacles associated with disaster and shock: Liz, Marilyn, and Jackie faced disasters (illness, suicide, assassination); witnessed electrocutions turn death into spectacle, just as a car wreck attracts voyeurs and photographers. Furthermore, as critic Richard Meyer has observed, Warhol conflated celebrities and criminals: John Waters would do much the same with Divine, who achieves apotheosis, in such films as *Multiple Maniacs*, when she goes on killing sprees. Fabulousness lies in Divine's imagined likeness to Liz Taylor, as well as in her theatrical, overplayed monstrousness. Jackie, Marilyn, electrocuted convict: the silkscreened figure, in the Warhol oeuvre, is (like Divine) interchangeably a glamorous female star, a criminal, or a victim.

Warhol rendered Jackie—celebrity/victim—in his standard grid, repeating images as if they were mug shots, frames of documentary film footage, or a fan's clippings. Repetition implies mourning: the Dallas scene is a trauma, and mourning takes the form of recycling and recall, a process that unsettles chronology (images of Jackie before and after JFK's death get jumbled). Repetition implies commodification: Jackie no longer has control over her own image, nor do we, as consumers, for it is dispersed in culture with a rapidity and vehemence that do not obey the laws of individual desire. And repetition implies obsession: the Jackie photos are cropped—narrowing the focus onto Jackie alone, myopically isolating her from context. In Warhol's *Sixteen Jackies*, she's alone in a hall of mirrors, like Rita Hayworth in the final scene of *The Lady from Shanghai*; lonely Jackie is trapped among reflections of herself, without companion. Though the Warhol silkscreen announces no individual or psychological point of view—it seems to erase individuality, its technique underscoring the "inhuman" processes of mass media reproduction—it betrays the emotions of a saintmaker. To repeat Jackie sixteen times requires energy, momentum, and love: Andy evidently cared enough about Jackie to multiply her. Or else her aura was tenuous, and it needed bolstering through multiplication. One would never get deeper into her experience; one could only repeat the faint glow, and hope to acquire a vivid Jackie through stolid accretion.

Camille Paglia, arguing that Warhol's "Jackie" silkscreens emerge from his lapsed Catholicism, considers them images of a *mater dolorosa*. True: but they were also a gay fan's cutouts, images from a "pervert" scrapbook. What's remarkable about Warhol's *Sixteen Jackies* isn't any specific emotion that accrues to the images. We don't know what the spectator feels, the spectator who repeated and tinted Jackie. All we know about Jackie worship from *Sixteen Jackies* is that the procedure has sixteen stations; that this fan desires sixteen copies; that her value increases with each repetition.

Warhol not only silkscreened celebrities: he also befriended them. He knew Jacqueline Onassis; they even went to the Brooklyn Museum together. He describes the visit: "Being with her is like walking with a saint. . . . It was like she was in a trance." Jackie told him about a Haitian artist who charged according to how many figures or objects a painting contained. Warhol remembers: "The first three are included—cows, dogs, and chickens. Sheep and goats are extra, and if you throw in some people and houses it gets really expensive. Jackie thought that was an interesting concept of art." It's odd to think of the real Jackie having a conversation about aesthetics and value with the artist who, in his silkscreens, commented on (and perpetuated?) her commodification. She also asked him, "What's Elizabeth Taylor really like?" Onassis gave Warhol credit for knowledge of the "real" Liz, even though he was famous instead for repetitions of a "false," silkscreened Liz. This scene—Onassis discussing iconicity with Warhol—suggests that Jacqueline Onassis, living in a world saturated with images of Jackie and Liz, may have looked toward "Jackie" or "Liz" as the type of alluring stranger about whom ordinary people might ask, "What's Jackie really like?"

The images in *Sixteen Jackies*, however, are not identical copies of each other. For example, the four smiling Jackies in the top row are the same photo, but the third from the left is not level with the others (like a TV with a vertical-hold problem). Although the image of Jackie doesn't change, our angle of vision might; the picture may fade, or be artificially brightened; it may fall off-center, or drop below the line of visibility. Each time Jackie gets repeated, she alters. A narrative emerges, and it is not the story of Jackie's life or the growth of Jackie's soul—but the narrative of the image and of our relation to the image.

Wayne Koestenbaum

Robert Watts
American, 1923–1988

- - **Exhibitions**
In the Spirit of Fluxus (1993; catalogue, tour), *American Tableaux*
(2001; publication, tour), *The Last Picture Show: Artists Using
Photography, 1960–1982* (2003; catalogue, tour)
- - **Holdings**
4 sculptures, 13 multiples, 3 books, 1 announcement, 2 newspapers

Robert Watts is one of the many freewheeling thinkers
whose work was associated with Fluxus but not con-
tained by it. A mechanical engineer by training, he
turned to art during the late 1940s, focusing on abstract
painting only to abandon it, in 1958, for the multidisci-
plinary hijinks of what would soon be known as Fluxus.
He was a core member of the Fluxus cadre over the
next two decades—a composer, performer, visual artist,
and filmmaker with an incisive mind and clownish wit.
His scientific bent was balanced by a metaphysical
streak that led him to such extra-Fluxus activities as the
observation of seasonal rhythms and energy fields.
Toward the end of his life, he mused to a friend that if he
had it to do over he might like to spend his life as a "sci-
entific monk"—one who balances an active spiritual
life with the unhurried exploration of physical phenom-
ena.[1] In fact, he seemed always willing to see the pro-
found within the unremarkable.

Although Watts didn't consider himself a Pop artist,
he was included in important Pop exhibitions at the Leo
Castelli and Bianchini galleries during the 1960s on the
strength of his droll sculptural works: rows of plaster
casts of bread painted in a graduated gray scale; a box
of chocolates filled with chrome-plated bronze bon-
bons; and a mock supermarket display of multicolored
wax eggs and chromed fruits. These are clever visual
puns, but also meditations on the collision of desire and
illusion. Often they depend on photography—the lid
of a wooden fruit crate bears a shot of a dozen perfect
apples in waxed paper, and *TV Dinner* (1965) is a group
of laminated images (with the exception of the cast-
plastic peas) depicting a classic frozen turkey dinner in
an aluminum foil tray, accompanied by cutlery and
wine glass all arranged on a pedestal as formally as if
they were crystal, silver, and filet mignon.[2] Eventually,
though, Watts' constant sampling of media and
approaches couldn't sustain an association with Pop,
which became as slick and predictable as the products
it parodied.[3]

The erotic appears in various degrees and guises
throughout Fluxus; Watts' taste ran to images of the
naked female body, from girlie pix to classical nudes.
Portrait Dress (1965) put a semiotic spin on the theme:
a transparent vinyl shift is covered with pockets, each
containing a photograph of a female body part. Our
assumption that a portrait should present a holistic,
psychologically penetrating image of an individual is
completely upturned by this collection of desultory,
anonymous fragments. Images of skin adorn a gar-
ment—a second skin—while also revealing portions of
the wearer's (nude) body. More pointedly fetishistic is
the punningly titled *Chest of Moles (Portrait of Pamela)*

(1965–1985), composed of sixteen photographs picturing
skin with moles, which are embedded in plastic and
displayed in a lighted cabinet.

Among his many other activities, Watts taught for
thirty years at Rutgers University, where he developed
the Experimental Workshop, an interdisciplinary semi-
nar. According to the artist, their work was "limited only
by the equipment we can find or buy, what you have
on hand, who you are, and what you want to do."[4] An
apt description, in fact, of Watts' own blend of curiosity,
humor, and pragmatism, and the surprising range of
his art.

J.C.P. and J.R.

Notes
1. Larry Miller, "Robert Watts: Scientific Monk," in Benjamin H. D.
Buchloh and Judith F. Rodenbeck, eds., *Experiments in the Everyday:
Allan Kaprow and Robert Watts—Events, Objects, Documents*, exh. cat.
(New York: Miriam and Ira D. Wallach Art Gallery, 1999), 85.
2. Among Watts' numerous ideas for Fluxus editions (some of which
were realized) were tabletops and place mats laminated with photo-
graphs of meals. See Jon Hendricks, ed., *Fluxus Codex* (Detroit: The
Gilbert and Lila Silverman Fluxus Collection, in association with Harry
N. Abrams, New York, 1988).
3. Benjamin H. D. Buchloh has written extensively on Watts, Pop Art,
and postwar commodity culture. See especially his essays in Miller,
Experiments in the Everyday, and Benjamin H. D. Buchloh, *Robert
Watts*, exh. cat. (New York: Leo Castelli Gallery, 1990).
4. From Watts' course description, quoted in Larry Miller and Sara
Seagull, "Grounds for Experiment: Robert Watts and the Experimental
Workshop," in Geoffrey Hendricks, ed., *Critical Mass: Happenings,
Fluxus, Performance, Intermedia, and Rutgers University, 1958–1972*,
exh. cat. (New Brunswick, New Jersey: Rutgers University Press,
2003), 26.

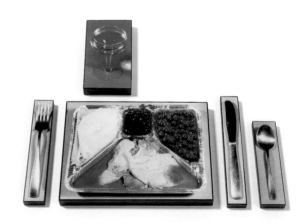

Robert Watts *TV Dinner* 1965 black-and-white photographs laminated
on wood, cast plastic 1 3/8 x 20 x 11 in. (3.5 x 50.8 x 27.9 cm) installed
T. B. Walker Acquisition Fund, 1993 1993.128

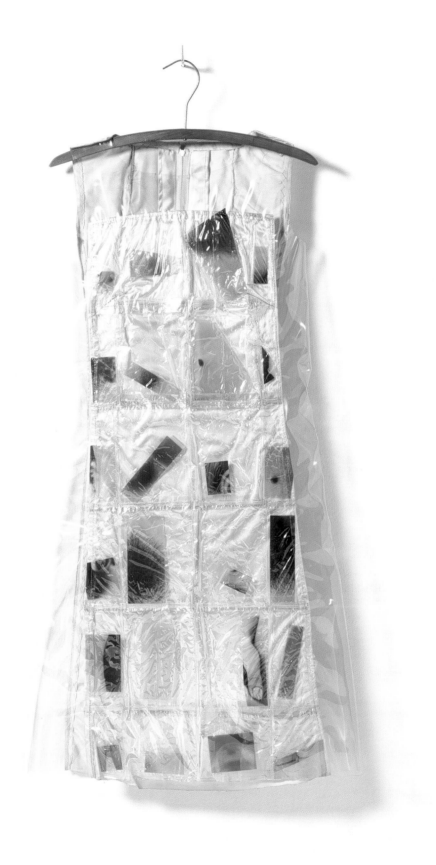

Robert Watts *Portrait Dress* 1965 black-and-white photographic transparencies, cloth, vinyl, zipper 39 1/2 x 19 3/4 x 2 1/4 in. (100.3 x 50.2 x 5.7 cm)
T. B. Walker Acquisition Fund, 2003 2003.15

Carrie Mae Weems

American, b. 1953

- - **Exhibitions**
Carrie Mae Weems (1994; organized by the National Museum of Women in the Arts, Washington, D.C.; catalogue), *The Cities Collect* (2000)
- - **Holdings**
1 multimedia work

In Carrie Mae Weems' *Untitled* (1990), the viewer sees a triptych of black-and-white photographs showing a woman and a man seated at a kitchen table in a sparsely furnished room illuminated by overhead, interrogation-room lighting. The camera inches from left to right along the progression of the images, as the narrative develops from an emotional alienation to an intense stand-off to a tentative reconciliation between the two protagonists. Yet, despite the range of emotions expressed by the woman (played by the artist), her lover, with his eyes constantly affixed on a newspaper, remains seemingly detached. The triptych is part of a larger suite of twenty photographs, grouped in twos and threes and accompanied by thirteen text panels. The photographs are broken into chapters, relating the tale of a doomed romance that in the end leaves the woman alone, but not defeated. The text, spun out breathlessly with poetic, melancholic cadences in colloquial black English, tells another story involving a woman, a man, and their child from a third-person standpoint. The two narrative strands have no clear one-to-one correspondence but instead run parallel to each other, with a few moments of convergence.

Weems had a late start as an artist. She entered the photography program at California Institute of the Arts (CalArts) at the age of twenty-seven and received her MFA at the University of California, San Diego. Both schools emphasized a rigorous conceptual, theoretical approach, and the photo-text method that would become Weems' signature style resonates closely with the works of Allan Sekula and John Baldessari, both teachers at CalArts.[1] In her earliest complete series,

Family Pictures and Stories (1978–1984), begun while she was still a student, Weems intimately portrays bonds as well as pathologies within her own family, effectively complicating one-dimensional depictions of the "black family." Through this extended engagement with both the medium of photography and her blood relations, she examines the problems inherent in documentary photography and its alleged capacity for impartial inquiry, particularly when applied to black subjects.

In subsequent series, Weems skillfully pried apart the mechanisms of signification that operate in photography and language. In the interstices that develop in her jolting and powerful juxtapositions of images and texts, she shows that these two most common means of knowledge and information are fraught with potential fallacies and violence, especially when the subject is race. The successive series of works—*Ain't Joking* (1987–1988), *American Icons* (1988–1989), and *Colored People* (1989–1990)—explore ways that stereotypes propagate and reinforce themselves in multifarious dimensions, such as jokes and material culture. After more than a decade of making works in investigative modes, it was perhaps necessary for Weems to turn to a more familiar form that intentionally traffics in clichés. Unlike her earlier projects, *Untitled* is determinedly not about recuperating the vanished and misrepresented. Returning the power of embodiment back to its maker through self-portraiture, the work gives the viewer, as well as the artist herself, no less than a human drama—with no qualifiers.

D.C.

Notes
1. For discussions of the affinities between Weems' work and those of other artists of her generation, see Andrea Kirsh, "Carrie Mae Weems: Issues in Black, White and Color," 13–14, and Susan Fisher Sterling, "Signifying: Photographs and Texts in the Work of Carrie Mae Weems," 26, both in Andrea Kirsh and Susan Fisher Sterling, eds., *Carrie Mae Weems*, exh. cat. (Washington, D.C.: National Museum of Women in the Arts, 1993).

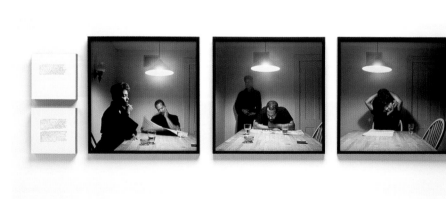

Carrie Mae Weems *Untitled* 1990 gelatin silver prints, paint on wood photographs: 26 1/2 x 26 1/2 in. (67.3 x 67.3 cm) each of 3; 28 1/8 x 131 9/16 in. (71.4 x 334.2 cm) overall installed; edition 4/5 Rollwagen/Cray Research Photography Fund, 1991 1991.101

William Wegman

American, b. 1943

-- **Commissions**

What Goes Up Must Come Down (1970)

-- **Exhibitions**

1968 Biennial of Painting and Sculpture (1968; catalogue), *9 Artists/
9 Spaces* (1970; catalogue), *Wegman's World* (1982; catalogue, tour),
The Last Picture Show: Artists Using Photography, 1960–1982 (2003;
catalogue, tour)

-- **Holdings**

1 drawing, 2 photographs, 2 videos, 2 books

William Wegman *Before/On/After: Permutations* 1972 black-and-white
photographs 9 1/2 x 7 3/4 in. (24.1 x 19.7 cm) each of 7 Art Center
Acquisition Fund, 1983 1983.3

Lawrence Weiner

American, b. 1942

- - **Exhibitions**
Artists' Books (1981), *Duchamp's Leg* (1994; catalogue, tour),
Lawrence Weiner Posters (1994; organized by the Nova Scotia
College of Art and Design, Halifax)
- - **Holdings**
1 sculpture, 1 drawing, 1 unique work on paper, 1 video, 33 books,
1 periodical

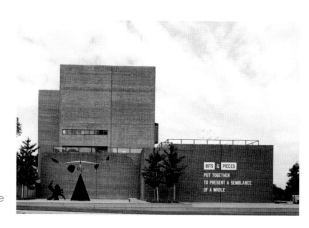

Frequently referred to as a Conceptual artist, Lawrence
Weiner is perhaps more accurately described as a
sculptor who considers his medium to be "language
and the materials referred to."[1] His work developed
within the context of the so-called dematerialization
of the art object[2]—when, in the late 1960s, artists began
with the premise that a work of art need not be a mate-
rial object but rather could be ephemeral. Art could be
an idea, a journey, a sentence, or even a page printed
in a catalogue. By 1967, sculptural practice had moved
well beyond the use of traditional bronze, stone, wood,
and other three-dimensional materials to encompass
such elements as photographs, film, video, perfor-
mance, texts, maps, imaginary sites, travel to specific
locations, artists' books, and audiotapes.

 In the early 1960s, before Weiner began working
with language, he created sculptural works in the land-
scape, including setting off explosions to form craters in
Northern California. Later, in Vermont, he set posts into
the ground to form the outline of a rectangle, stringing
twine from them to form a grid pattern.[3] However, he
soon realized that it was not possible to build many of
the large-scale, site-specific pieces he envisioned and
so he began presenting them in language that signified
such intentions. In 1968, he wrote his "Statement of
Intent," the overarching philosophy that articulates the
ways in which his work functions:

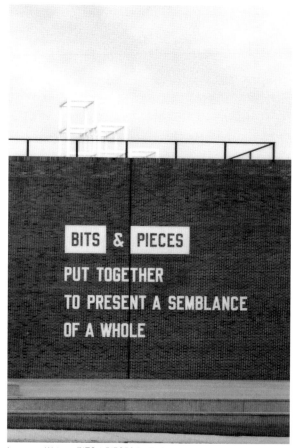

> 1. THE ARTIST MAY CONSTRUCT THE WORK
> 2. THE WORK MAY BE FABRICATED
> 3. THE WORK NEED NOT BE BUILT
> EACH BEING EQUAL AND CONSISTENT WITH
> THE INTENT OF THE ARTIST THE DECISION AS
> TO CONDITIONS RESTS WITH THE RECEIVER
> ON THE OCCASION OF RECEIVERSHIP

In accordance with these conditions, Weiner constructs
linguistic phrases and declarations that describe con-
structions, actions, and processes, such as ONE QUART
EXTERIOR GREEN INDUSTRIAL ENAMEL THROWN
ON A BRICK WALL (cat. #002); states of materials such
as IGNITED (cat. #081); and "equations" such as BITS &
PIECES PUT TOGETHER TO PRESENT A SEMBLANCE
OF A WHOLE (cat. #690) in the Walker Art Center's
collection.[4] Each work references a sculptural entity
or process, which is signified in language and notated
in uppercase, sans serif type.

 These phrases may have more than one format,
determined either by the artist or the "receiver" as out-
lined in the "Statement of Intent." Frequently, they are
painted or applied with vinyl letters directly onto the

Lawrence Weiner BITS & PIECES PUT TOGETHER TO PRESENT A
SEMBLANCE OF A WHOLE 1991 anodized aluminum installed
dimensions variable T. B. Walker Acquisition Fund, 1993 1993.177

walls of interior exhibition spaces, but have also been permanently installed in public areas, architectural settings, and other spaces. BITS & PIECES PUT TOGETHER TO PRESENT A SEMBLANCE OF A WHOLE, for example, was installed in 1991 on the Walker's facade and reformatted by the artist in 2004 for the cover of this book.

Along with such artists as Dan Graham and Vito Acconci, Weiner has moved the practice of sculpture away from the tradition of autonomous objects, making works that involve the viewer as well as the situation or context to realize, interpret, and give them meaning. He also has been a pioneer in developing artist's books, videos, audio works, and music as well as designing such ephemera as T-shirts, badges, announcement cards, and posters (a full archive of which the Walker exhibited in 1994). Weiner's bold use of type has become a consistent aspect of his work, and has influenced the possible forms of contemporary art and the field of graphic design.

Rochelle Steiner

Notes

1. The artist began describing his medium as "language and the materials referred to" in the mid- to late 1970s. Lawrence Weiner, correspondence with the author, July 2004.

2. See Lucy Lippard, *Six Years: The Dematerialization of the Art Object from 1966 to 1972* (New York: Praeger, 1973); reprinted Berkeley and Los Angeles: University of California Press, 1997), 5. Lippard notes: "It has often been pointed out to me that dematerialization is an inaccurate term, that a piece of paper or a photograph is as much an object, or as 'material,' as a ton of lead. But for lack of a better term, I have continued to refer to a process of dematerialization, or a deemphasis on material aspects (uniqueness performance, decorative attractiveness)." However problematic, her term nonetheless serves to mark the difference between traditional art forms and the more ephemeral forms that developed at the end of the 1960s.

3. This work was included in an exhibition of outdoor work by Weiner, Carl Andre, and Robert Barry at Windham College in Putney, Vermont, in 1968.

4. Weiner prefers not to date his works. As curator R. H. Fuchs has explained, "Notations are never dated. Dating them would not concur with Weiner's wish to let them exist as objective facts within the culture that in many different ways, in many different places may materialize. Only actual executions (or presentations in books, records, exhibitions) are dated." (From Rudolf Herman Fuchs, ed., *Lawrence Weiner*, exh. cat. (Eindhoven, Netherlands: Van Abbemuseum, 1976), unpaginated. Instead, Weiner assigns each work a number as it is completed. In the above text, these numbers are given in parentheses after each artwork title. See Weiner's *Specific & General Works* (Villeurbanne, France: Le Nouveau Musée, 1993).

Weiner Books

Much of Lawrence Weiner's art-making activity has centered on books, and the Walker Art Center Library contains some forty examples. One of the earliest, STATEMENTS (1968), describes twenty-four works the reader can construct. Using few words and no illustrations, the artist provides general directions for manipulating a group of very pedestrian materials: plywood, Masonite, a dye marker, plastic sheeting, wooden stakes, steel nails, and twine. These items and their instructions are hardly the stuff of high art; for example, a work can be made of "one sheet of plywood secured to the floor or wall," and another from "one standard dye marker thrown into the sea." Weiner's egalitarian text puts the formula for making art into the hands of anyone willing to spend $1.95, the book's original retail price.

In STATEMENTS, as in Weiner's work overall, language itself is the core component in the making of art. A later volume, LA MARELLE OU PIE IN THE SKY (1990), places equal emphasis on his drawings. Diagrams of hopscotch (*la marelle*) supplement the bold red and orange texts, and the grace needed to play the game is reiterated in its lilting language: "Pebbles moved here & there between sky & earth." While it is dedicated to the artist's wife, Alice, "who plays between heaven and earth," this book is one with which children can immediately identify. Perhaps Weiner is saying that childhood is utopia or the "pie in the sky" of the title.

Linguistic underpinnings also figure prominently in TRACCE/TRACES (1970). Spare in its design, each page offers a verb, in Italian and English, in the past tense: "schiacciato/mashed" or "fermentato/fermented." Is the reader meant to act on these words, consider them reflections on Conceptual Art, ponder them as design, see them as insightful commentary on the artist's oeuvre, or read them aloud? Quite possibly, all of the above.

R. Furtak

Lawrence Weiner Selection of artist's books, 1968–1999 Walker Art Center Library Collection

Tom Wesselmann

American, 1931–2004

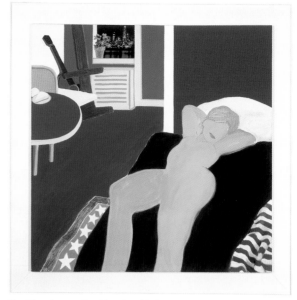

Tom Wesselmann *Great American Nude #32* 1962 oil, polymer enamel, pigments on gelatin silver print on wood 56 3/4 x 56 3/4 x 1 1/8 in. (144.2 x 144.2 x 2.9 cm) framed Gift of Fred Mueller, New York, 1966 1966.22

Franz West

Austrian, b. 1947

- - Holdings
4 sculptures, 1 multiple, 1 book

Franz West belongs to a generation of Viennese artists who had to acknowledge the incredible importance of the Vienna Actionist movement of the 1960s and at the same time learn to forget about it in order to establish their own autonomous practices. Building on the Actionists' political and aesthetic engagement of the body (its presence and its fluids) in postwar art-historical discourse, West has since the early 1970s built an oeuvre that has privileged the value of the haptic experience.

Starting in 1976, West initiated a sculptural series titled *Pass-stücke* (*Adaptives*) that does not so much invite or suggest the viewers' participation as it demands it. The *Pass-stücke*, made of papier-mâché, plaster, and gauze coagulated over metal armatures, are in general oddly shaped, evoking weird body extensions or tumors. On occasion, discarded domestic items such as bottles, sticks, wires, or brooms are recycled within the works, providing some compositional variation on the primal, libidinous, and always humorous impetus that generated them. They are frequently displayed insouciantly against a wall or fortuitously leaning on rough-and-tumble pedestals; West often includes photographs or videos to encourage audiences to pick up the objects and adopt any pose that comes to mind.

The name *Pass-stücke* is a multilayered pun. The German word *pass* could refer to the way something fits or harmonizes with something else, or could mean being attentive. As a noun, its meanings range from "gait" or "pace" to "passport" or "permit," depending on the context. West himself suggests a translation by using the word "adaptives:" inscrutable objects meant to be adapted to a body, they are human limbs as well as social prosthetics.

3 Pass-stücke (*3 Adaptives*) (1997) asserts the vitality of the series as the recurrent backbone of West's practice. Meant to be manipulated to reveal both the user and the object's ergonomic potential, the work's clumsiness does not ignore a critical debate on the relationship between the sculpture and the pedestal, between form and mold, stasis and motion, and the phenomenological conversation among sculpture, space, and the spectator. The piece provides a clear analysis of the sculptural condition through a criticism of classical representation and passive contemplation.

The same could be said of the *Sitzwuste* (2000), colorful sculptures meant to be used as tables or benches whose title—a made-up word—is a play on the German words for seating (*sitz*) and sausage (*wurst*). Slightly grotesque and a bit scatological, they relieve the artist and his audience from the rigidity of "public sculpture" and playfully translate or stage the language of sculpture into a language of the body.

West's ambition is to relocate, or liberate, the aesthetic experience at the limit of art through the development of relational objects affecting the psychological or physical structure of the subject. With a smile, without didacticism, West questions the nature of the space between the body and the artwork as a way to interrogate the space between the body and the world, the space between us all. He is part of a history of alternative modernism that stretches from André Breton to Gilles Deleuze and Felix Guattari, from Otto Muehl to Felix Gonzalez-Torres, from Yayoi Kusama to Mike Kelley, all of whom have refuted what Antonin Artaud identified in *The Theater of Cruelty* as a "body without organs."[1]

P.V.

Notes
1. See Antonin Artaud, *The Theater and Its Double* (New York: Grove Press, 1966).

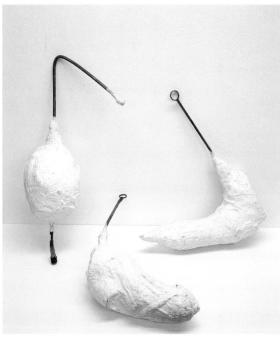

Franz West *3 Pass-stücke* (*3 Adaptives*) 1997 iron, epoxy, gauze, paint 3 elements: 25 5/8 x 11 3/4 x 11 3/4 in. (65.1 x 29.9 x 29.9 cm); 31 1/2 x 10 5/8 x 10 5/8 in. (80 x 27 x 27 cm); 24 3/8 x 9 x 9 in. (61.9 x 22.9 x 22.9 cm) T. B. Walker Acquisition Fund, 2001 2001.65

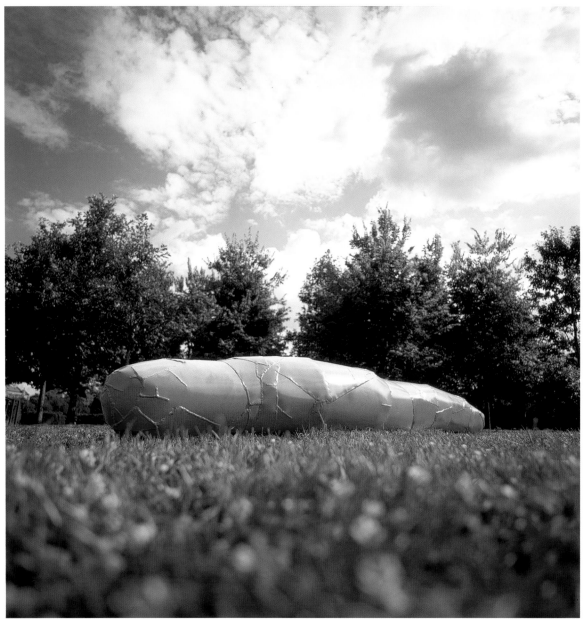

Franz West *Sitzwuste* 2000 aluminum, lacquer 21 5/8 x 29 1/2 x 161 7/16 in. (54.9 x 74.9 x 410.1 cm) Purchased with funds provided by the Frederick R. Weisman Collection of Art, 2002 2002.209

H. C. Westermann

American, 1922–1981

- - **Exhibitions**

Eight Sculptors: The Ambiguous Image (1966; catalogue, tour)

- - **Holdings**

1 sculpture, 1 book

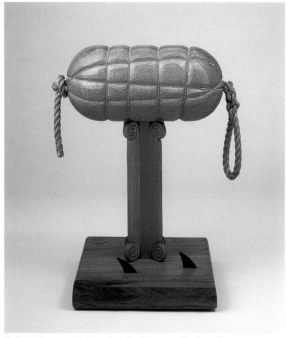

H. C. Westermann *A Piece from the Museum of Shattered Dreams* 1965
cedar, pine, ebony, rope, twine 28 7/8 x 23 1/2 x 15 1/2 in. (73.3 x 59.7 x 39.4 cm)
Gift of the T. B. Walker Foundation, 1966 1966.45

Rachel Whiteread

British, b. 1963

- - **Exhibitions**

"Brilliant!" New Art from London (1995; catalogue, tour), *The Cities
Collect* (2000), *Strangely Familiar: Design and Everyday Life*
(2003; catalogue, tour)

- - **Holdings**

1 portfolio of prints, 1 multiple

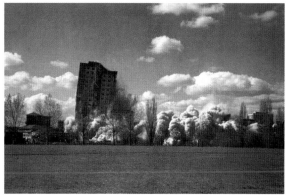

Rachel Whiteread Selection from *Demolished* 1996 screenprints on
paper; edition 12/35 19 1/4 x 29 1/4 in. (48.9 x 74.3 cm) each of 12 Published
by Paragon Press, London T. B. Walker Acquisition Fund, 1997 1997.67

Hannah Wilke

American, 1940–1993

After studying at the Tyler School of Art in Philadelphia and holding a number of high-school teaching posts, Hannah Wilke careered into the early 1970s New York art scene, which seemed to be in flux. However, with the art market consolidating the achievements of Jasper Johns, Robert Rauschenberg, and their Abstract Expressionist progenitors; the ascendance of heavy metal Minimalism; and the fashion for going out West and tearing up the desert, it was a resolutely boys-only club. Wilke's emergence into this male subculture was all the more extraordinary in that it simultaneously confounded puritanical women's lib agendas. Her striking looks and her relationships—including those with Claes Oldenburg and Richard Hamilton—were integral to an artistic practice that fused the flirtatious with the feminist and art with (love) life. She explored "Venus envy" with a desire to respect the objecthood of the body, and redressed classical art's devaluation of female sexuality with a series of vaginalike sculptures, provocative self-portrait photographs, live performances, and sassy wordplay.

Wilke came to wider attention when her latex sculptures were exhibited at the 1973 Whitney Biennial. Pinned to the wall with layered delicacy, each sensuous work recalled ornamental flowers, diaphanous lingerie, or the blushing folds of vaginal skin. She would go on to employ a range of off-beat materials, such as lint, putty erasers, and chewing gum, to create her signature layered motifs, yet she had started out with a most traditional artists' material, namely clay.

Teasel Cushion (1967) is one of her earliest ceramic works, an abrupt sculptural shorthand of pinkish, liquitex-dipped terra cotta for the pudenda and coarse plastic grass for pubic hair. "Nobody cringes when they hear the word phallic" she said. "You can say that Cleopatra's Needle outside the Metropolitan Museum of Art is a phallic symbol and nobody will have a fit. You can say a Gothic church is a phallic symbol, but if I say the nave of the church is really a big vagina, people are offended."[1] Sans fig leaf, Wilke's portrayal evokes what is often literally veiled and gives it transcultural, emblematic status.

Like many of her artworks, *Teasel Cushion* is in dialogue, directly or indirectly, with those by Marcel Duchamp—a riposte, perhaps, to his *Female Fig Leaf* (1950) or *Wedge of Chastity* (1954). Yet, as with her striptease behind his *The Bride Stripped Bare by her Bachelors, Even (The Large Glass)* (1915–1923), Wilke infused Duchamp's aberrant sexual universe with social, personal, and political agendas.[2] Like Gustave Courbet's explicit *Origin of the World* (1866), *Teasel Cushion* discards the morbid peep-show gaze of Duchamp's *Etant Donnés . . .* (1946–1966), replacing

it with an aggressively cropped assertion—perhaps parody—of pornographic availability.

M.A.

Notes
1. Wilke quoted in Thomas H. Kochheiser, ed., *Hannah Wilke: A Retrospective*, exh. cat. (Columbia, Missouri: University of Missouri Press, 1989), 48.
2. This striptease performance at the Philadelphia Museum was made into a film called *Through the Large Glass* (1976). Wilke preferred to use male cameramen to document her performances, underscoring the scopophilia of the act of filming.

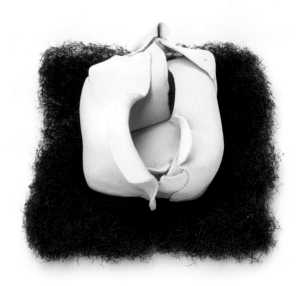

Hannah Wilke *Teasel Cushion* 1967 terra cotta, acrylic, plastic
4 x 12 x 12 in. (10.2 x 30.5 x 30.5 cm) T. B. Walker Acquisition Fund, 2002
2002.69

Christopher Wool

American, b. 1955

Holdings
1 painting, 3 books

Although Christopher Wool abandoned painting in 1978—briefly studying film at New York University—he returned to it in 1981 with a renewed engagement in picture-making as a process. Affected at once by European art, including Yves Klein's *Anthropometries* and the surly abstractions of Arnulf Rainer as well as post-Minimalist American landmarks such as Richard Serra's splashed molten-lead works, Wool fabricated a new lexicon of "all over" painting.

Wool designated two bodies of work known as the "silver" and "drip" paintings (1984–1986) as acts of covering a surface—in his case, slablike rectangles of sheet aluminum backed by wood. Their abused and weathered appearance—pitted, etched, graffitied, scarred—gives them the demeanor of squatted and marked territories. By rejecting any colors other than black and white, he began to treat painting more like wayward printmaking, as the work resembled vast fouled-up intaglio plates or lithographic stones splashed with acid. In 1986, the artist began to employ actual printing techniques, using rubber rollers to create floral or ornamental patterns that look like botched and moldering wallpaper. However, it is his "word paintings," begun a year later, for which he has become best known. These elaborate the dispossessed language of his mark-making—though they're arguably no less "abstract"—as awkward letters are crammed into the space, disconcertingly breaking across lines or omitting letters. Some words, such as FEAR, AMOK, RIOT, are blunt iterations that evoke turbulent mental states or a claustrophobic sense of degradation, while others, SELL THE HOUSE SELL THE CAR SELL THE KIDS, draw on popular culture (such as this line from the 1979 film *Apocalypse Now*) or slang expressions and insults.

Drunk II came into the Walker Art Center's collection as a gift from artist Robert Gober, with whom Wool has produced collaborative exhibitions on several occasions. At 303 Gallery, New York, in 1988, Wool showed his *Apocalypse Now* painting together with three of Gober's uncanny urinal sculptures. Amplifying this disquieting juxtaposition was a co-authored, modestly proportioned black-and-white photograph: an image of a demure white dress hanging from the branches of a tree in a clearing of an anonymous woodland. Printed with a repeating pattern of black leaves that Wool had deployed on his roller paintings, the decorated garment almost looked like it had been viciously slashed. A tall mirror mounted on the wall and a short story by writer Gary Indiana completed this suffocating *parcours* of works. The two colleagues worked together once more at Documenta 9, in 1992, with Gober designing forest wallpaper against which Wool's paintings were displayed.

Drunk II was first exhibited in *Strange Abstraction* in 1991—an exhibition that featured, in addition to Gober and Wool, two other artists with whom Wool has a deep affinity, Philip Taaffe and Cady Noland.[1] Redolent of the slurred obnoxious bark of a veteran drinker, the hiccupping expression of the work pays dismal homage to a condition of intoxication familiar to painters throughout history, not least as part of the armory of another artist who emerged in the 1980s to engage with the latest declared demise of painting, the German Martin Kippenberger.

M.A.

Notes

1. The exhibition *Strange Abstraction*, curated by Jeffrey Deitch, was presented at the Touko Museum of Contemporary Art, Japan, in 1991.

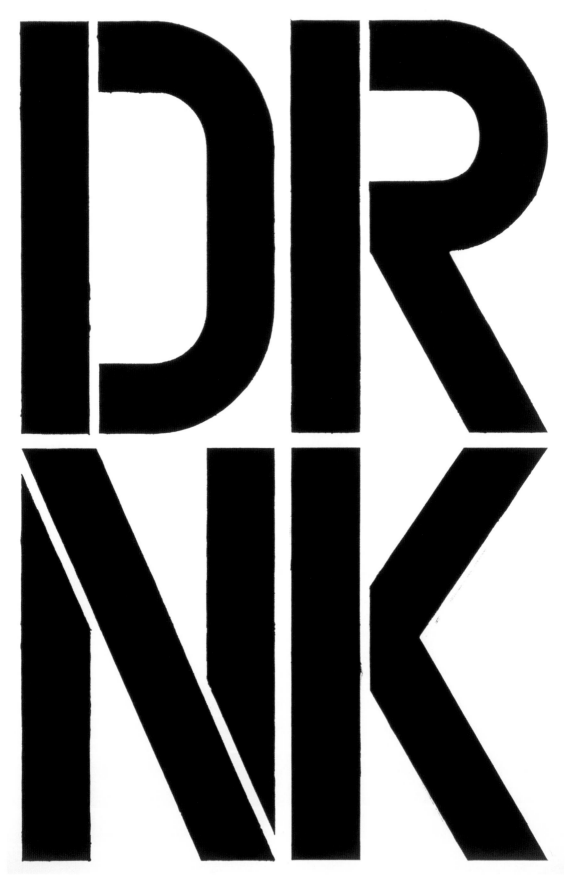

Christopher Wool *Drunk II* 1990 alkyd, acrylic on aluminum 96 x 64 in. (243.8 x 162.6 cm) Gift of Robert Gober, 2003 2003.75

The Wooster Group

Formed 1975

Founding members: Jim Clayburgh, American, b. 1949;
Willem Dafoe, American, b. 1955; Spalding Gray, American,
1941–2004; Elizabeth LeCompte, American, b. 1944; Peyton
Smith, American, b. 1948; Kate Valk, American, b. 1957;
Ron Vawter, American, 1948–1994

--- **Commissions**
BRACE UP! (1991)
--- **Performances**
BRACE UP! (1991), *House/Lights* (1997), *North Atlantic* (2000)

The list of founding members of this tenacious collective
of theater radicals reads like a roster of American
performance luminaries. The modest, nearly hidden
garage space on Wooster Street in New York's SoHo
district that serves as home and laboratory gives little
indication of these artists' international stature or the
depth of their influence on the generation that followed.

Among the first to fully integrate video, film, and
multitrack sound design in performance, the Wooster
Group creates revolutionary restagings of the classics
and fully invented assemblages of diverse, new mate-
rial. The incorporation of found objects, dance/move-
ment, and architectural theater design are other
Wooster trademarks. The group's dismissal of naturalist
storylines and its psychology-based acting, deconstruc-
tion of text, and raw performance power still set it apart
from others. Its aesthetically and politically confronta-
tional work can feel like a nightmare of information
overload, yet somehow retains its clarity of vision and
purpose. Emanating from Richard Schechner's
Performance Group of the 1960s, director LeCompte
and Gray started the company with a close-knit group
of friends in 1975,[1] intent on keeping a low profile to pro-
tect an idiosyncratic practice in which the development
of each new piece spanned months, sometimes years.

Despite critical acclaim, the Wooster Group rarely
tours in the United States; its work is considered too pro-
vocative[2] and unwieldy in scale for most American pre-
senters to even consider. It was thus newsworthy when
the Walker Art Center, On the Boards (Seattle), and the
Wexner Center for the Arts (Columbus, Ohio) commis-
sioned *BRACE UP!*, the group's eerie deconstruction of
Anton Chekhov's *The Three Sisters*.[3] The piece com-
bined selections from obscure postwar Japanese fiction
and film, Noh theater's comedic Kyogen interludes, and
some of the troupe's own history and personal stories.
This approach was standard—LeCompte felt the forced
collision of seemingly random source materials
reflected the realities of modern life. *House/Lights* (1997,
copresented with the Guthrie Theater and Northrop
Auditorium, Minneapolis) found Gertrude Stein's *Dr.
Faustus Lights the Lights* in bed with the 1960s camp
soft-core film *Olga's House of Shame*. *North Atlantic*
(2000, copresented with the Guthrie Theater) mixed
military jargon, cowboy songs, analog tape material,
over-the-top dance numbers, and a wide range of film
references to create a paranoid, sexually obsessed,
pre-digital-age work of startling cohesion.

The Walker has also presented solo work of the
group's core members, commissioning Vawter's
Roy Cohn/Jack Smith in 1991, which contrasted the
wildly differing lives of two gay men in 1950s and
1960s America. The relationship with Gray includes
eight Walker presentations, beginning in 1980 with
the heralded *Sex & Death to the Age of 14*. Turning
autobiographical stories into evening-length mono-
logues, Gray single-handedly invented a new per-
formance genre.

Considering the quality and dominance of work
by the current crop of young performance ensembles
owing an aesthetic debt to the group—Elevator Repair
Service, Big Dance Theater, Gob Squad, Radiohole,
Needcompany, 33 Fainting Spells, the Builders
Association, and dozens of others—the impact of this
singular collective becomes apparent. Surviving the
tragic deaths and departures of key members and the
Hollywood stardom of others, the Wooster Group has
defied the odds for more than three decades, persever-
ing as a vital and intrepid producing collective.

P.B.

Notes
1. They did not legally assume the name the Wooster Group until 1980.
2. David Savran, *Breaking the Rules: The Wooster Group* (New York:
Theater Communications Group, 1988), 1. "It has consistently
addressed pressing social issues, including the victimization of
women, racism, and the multifarious processes of dehumanization. . . .
Eschewing the certitude of the liberal critic or the authoritarianism of
the proselyte, it questions from a position of doubt."
3. Though the Wexner remained committed to the original commis-
sioning of *BRACE UP!*, only On the Boards and the Walker were able to
present the work. William B. Cook, associate director, Wexner Center
for the Arts correspondence to the Wooster Group, January 29, 1991
(Walker Art Center Archives).

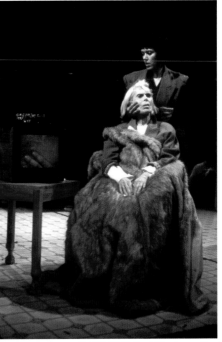

The Wooster Group *BRACE UP!*, St. Ann's Warehouse, Brooklyn, 2003

John Zorn

American, b. 1953

-- **Commissions**

Houdini/de Sade (1991)

-- **Performances**

New York Objects and Noise (1984); *Godard/Spillane* (1986); *The Way I Feel* (1988); John Zorn's Naked City (1989); *The Grand Guignol* (1991; world premiere), *Houdini/de Sade* (with Arto Lindsay) (1991; world premiere); Masada (2001)

Maverick composer/musician John Zorn was a lightning rod in the New York City Downtown scene during the 1980s. He joined like-minded renegades excited equally by notions drawn from free-jazz loft sessions, young composers such as Rhys Chatham and Glenn Branca cooking up fresh ideas at the Kitchen, and no-wave players such as the Contortions and DNA, who held court at the Mudd Club. In 1984, Zorn was invited to the Walker Art Center with skronk guitarist Arto Lindsay, proto-turntablist Christian Marclay, and untethered drummer David Moss. Billed by Moss (to Zorn's chagrin) as New York Objects and Noise, they ripped it up with a raucous zeal that was characteristic of Zorn's guiding spirit, then and now.

Working with blocks of sound arranged cinemati-cally, complete with fierce jump cuts, they played with a neo-expressionist verve that paralleled the current energy in the world of painting. Zorn was a standout wearing a Pac Man sweater knitted by his mom and extending his sax lines by playing duck calls, a gambit that attracted scorn from staid jazz critics. He was a lit-mus test for where you stood in the world of jazz at the time. On one side were the Uptown, commercially via-ble, neo-conservative "young lions" led by Wynton Marsalis; on the other, underground sounds that would coalesce around Zorn at the first Knitting Factory on Houston Street. Sharp-witted, strong-willed, and wild, he plunged provocatively ahead, a perfect candidate to be invited back regularly.

In addition to Walker dates with soul-jazz organist Big John Patton[1] and with his Downtown supergroup Naked City,[2] Zorn premiered ambitious compositions for larger ensembles as tributes to inspirational figures. In 1986, he performed two instrumental works: *Godard*, his salute to the iconic filmmaker Jean-Luc Godard; and *Spillane*, which signaled his mature cinematic style with its shadowy noir passages and hard-hitting musi-cal mayhem. These works were based on his method of amassing score fragments on index cards detailing musical motifs that were then arranged in genre-collid-ing sequences for performance. Always balancing notated ideas with the need for improvisational room to highlight the specific musical voices of his ensem-bles, Zorn and company would arrive at the Walker for intense rehearsals prior to their edgy and exciting pre-miere. Walker audiences had the visceral sense of see-ing pieces take shape, and avidly looked forward to their next encounter.

For the debut of *Houdini/de Sade*,[3] Zorn composed subversively captivating musical settings for collabora-tor Lindsay's S&M-themed libretto. The lurid lyrics, sung by hyperexpressive Mike Patton of Faith No More, upped the shock value of the show to the nth power. The bicoastal band kept pace through Zorn's intricate accelerations and dark moodscapes, though many had never met until they arrived the day before the per-formances. The Walker premiere of *Houdini/de Sade* and its notorious subsequent show in Paris (augmented by performers in bondage gear) have since been ana-lyzed in lengthy academic papers. It did seem like his-tory was being made that night, with Zorn delivering the essential magic that invoked Houdini as much as Arto summoned the Marquis.

Charles R. Helm

Notes

1. The impromptu combo, whose program was billed as *The Way I Feel*, included Frisell, Big John Patton, and Bobby Previte.
2. Naked City featured Frisell, Fred Frith, Wayne Horvitz, and Joey Baron.
3. *Houdini/de Sade* was co-commissioned with the American Music Theater (Philadelphia) and the Kitchen (New York City).

John Zorn's Naked City, Walker Art Center Auditorium, 1989

Contributors

Elizabeth Alexander is a poet, essayist, and playwright whose recent books include a collection of essays entitled *The Black Interior* (2003) and the book of poems *American Sublime* (2005). She teaches at Yale University.

Max Andrews (M.A.) is special projects curatorial assistant to the director, Tate Collection, London. At the Walker Art Center, he was curatorial intern, visual arts, from 2003 to 2004.

Elizabeth Armstrong is deputy director for programs and chief curator at the Orange County Museum of Art, Newport Beach, California. She held various positions at the Walker Art Center from 1982 to 1996, most recently head of visual arts.

Graham Beal is director of the Detroit Institute of Arts. He was chief curator, visual arts, at the Walker from 1977 to 1983.

Doug Benidt (D.B.) is assistant curator, performing arts, at the Walker Art Center, where he has worked since 1996.

Philip Bither (P.B.) is the William and Nadine McGuire Senior Curator, Performing Arts, at the Walker Art Center, where he has been on staff since 1997.

Andrew Blauvelt (A.B.) is design director at the Walker Art Center, a position he has held since 1998.

Peter Boswell is assistant director for programs/senior curator at the Miami Art Museum. He held various positions at the Walker Art Center from 1986 to 1995, most recently associate curator, visual arts.

A. S. Byatt is the Booker Prize–winning author of *Possession: A Romance* (1990) as well as *Angels and Insects: Two Novellas* (1992) and several collections of short stories. Her critical works include *Degrees of Freedom* (1965), a study of Iris Murdoch. In 1999, she was appointed Dame Commander in the Most Excellent Order of the British Empire.

Steve Cannon is a poet, playwright, and novelist. In 1991, he founded A Gathering of the Tribes, an arts and cultural organization in New York City dedicated to excellence in the arts from a diverse perspective. He publishes a magazine of the same name that combines poetry, fiction, reviews, essays, interviews, and visual art.

Elizabeth Carpenter (E.C.) is assistant curator, permanent collection, at the Walker Art Center, where she has been on staff since 2001.

Aimee Chang is curatorial assistant at the UCLA Hammer Museum, Los Angeles. At the Walker Art Center, she was Curatorial Intern for Diversity in the Arts, visual arts, from 2001 to 2002.

Sylvia Chivaratanond is curatorial director, Perry Rubenstein Gallery, New York. At the Walker Art Center, she was curatorial/education intern, visual arts, from 1998 to 1999.

Doryun Chong (D.C.) is curatorial fellow, visual arts, at the Walker Art Center, where he has worked since 2003.

Joshua Clover is a poet and the author of *Madonna anno domini* (1997), *The Matrix* (2005), and *The Totality for Kids* (forthcoming in 2006). He teaches at the University of California, Davis.

Arthur C. Danto is Johnsonian Professor Emeritus of Philosophy at Columbia University, and art critic for *The Nation*. He is an editor of the *Journal of Philosophy* and consulting editor for *Artforum*. His books on the philosophy of art include *The Transfiguration of the Commonplace* (1983), *The Philosophical Disenfranchisement of Art* (1986), *After the End of Art* (1998), and *The Abuse of Beauty* (2003). A collection of critical pieces, *Encounters and Reflections: Art in the Historical Present* (1990) won the National Book Critics Circle Prize for criticism.

Deepali Dewan is associate curator at the Royal Ontario Museum, Toronto, and assistant professor at the University of Toronto. She was Lila Wallace Curatorial Intern at the Walker Art Center from 1995 to 1997.

Lynn Dierks (L.D.) is visual arts administrator at the Walker Art Center, where she has worked since 1999.

Steve Dietz is an independent curator. At the Walker Art Center, he was curator, new media initiatives, from 1996 to 2003.

Robin Dowden is director of new media initiatives at the Walker Art Center, where she has been on staff since 1997.

Dave Eggers is the author of *A Heartbreaking Work of Staggering Genius* (2000), *You Shall Know Our Velocity* (2002), and *How We Are Hungry* (2004), and the editor and founder of *McSweeney's*, a journal and book publisher. In 2002, he established 826 Valencia, a nonprofit writing lab and tutoring center for San Francisco youths. He writes periodically about art and music for *Parkett*, *Frieze*, *Blind Spot*, *Spin*, and other magazines.

Alisa Eimen is a PhD candidate in art history at the University of Minnesota. At the Walker Art Center, she was curatorial intern, visual arts, from 2002 to 2003.

Siri Engberg (S.E.) is curator, visual arts, at the Walker Art Center, where she has been on staff since 1990.

Darby English teaches postwar American art at the University of Chicago. He has written on a variety of subjects in contemporary art and art history, and his most recent publication is *Kara Walker: Narratives of a Negress* (2003).

Richard Flood (R.F.) is deputy director and chief curator at the Walker Art Center, where he has been on staff since 1994.

Douglas Fogle (D.F.) is curator, visual arts, at the Walker Art Center, where he has been on staff since 1994.

Martin Friedman was director of the Walker Art Center from 1961 to 1990, during which time he oversaw the extensive development of its collection and artistic programs, the construction of its 1971 building, and the inauguration of the Minneapolis Sculpture Garden in 1988. He is a past president of the Association of Art Museum Directors and was awarded the National Medal of the Arts in 1989. His most recent project is a book on Chuck Close (Harry N. Abrams, 2005).

Mildred S. Friedman was editor of *Design Quarterly*, an international forum for architecture, design, and design theory, from 1969 to 1991 and design curator at the Walker Art Center from 1979 to 1991, in which capacity she organized numerous exhibitions and oversaw all museum publications. She recently curated the exhibitions *Vital Forms* (2001), *Frank Gehry, Architect* (2001), and *Carlo Scarpa, Architect: Intervening with History* (1999). She received a Chrysler Design Award in 2002.

Rosemary Furtak (R.Furtak) is librarian at the Walker Art Center, where she has worked since 1983.

Gary Garrels is the Robert Lehman Foundation Chief Curator of Drawing and curator of painting and sculpture at the Museum of Modern Art, New York. At the Walker Art Center, he was senior curator, visual arts, from 1991 to 1993.

Diana Gaston is associate curator at Fidelity Investments, Boston. At the Walker Art Center, she was National Endowment for the Arts Curatorial/Education Intern from 1988 to 1989.

Marge Goldwater directs a private educational foundation in New York City and is an art consultant with a special interest in contemporary Israeli art. At the Walker Art Center, she was curator, visual arts, from 1983 to 1990.

Jorie Graham has published numerous collections of poetry, including *The Dream of the Unified Field: Selected Poems 1974–1994* (1994), which won the Pulitzer Prize for Poetry in 1996. She has also edited *Earth Took of Earth: 100 Great Poems of the English Language* (1996) and *The Best American Poetry 1990* (1990). She is currently the Boylston Professor of Rhetoric and Oratory at Harvard University.

Kathy Halbreich is director of the Walker Art Center, a position she has held since 1991.

John G. Hanhardt is senior curator of film and media arts at the Solomon R. Guggenheim Museum, New York. At the Walker Art Center, he was coordinator, film, from 1973 to 1974.

Charles R. Helm is director of performing arts at the Wexner Center for the Arts, the Ohio State University, Columbus. At the Walker Art Center, he was music consultant from 1984 to 1991.

Irene Hofmann is curator of contemporary art at the Orange County Museum of Art, Newport Beach, California. At the Walker Art Center, she was National Endowment for the Arts Curatorial/Education Intern from 1993 to 1994.

Bill Horrigan is curator of media arts at the Wexner Center for the Arts, the Ohio State University, Columbus. He held various positions at the Walker Art Center from 1981 to 1985, most recently assistant director, media.

Olukemi Ilesanmi is grants coordinator at Creative Capital, New York. She held various positions at the Walker Art Center from 1998 to 2004, most recently assistant curator, visual arts.

Bruce Jenkins is dean of undergraduate studies at the School of the Art Institute of Chicago. At the Walker Art Center, he was curator, film/video, from 1985 to 1999.

Eungie Joo is gallery director and curator at REDCAT (Roy and Edna Disney/CalArts Theater), Los Angeles. She held various positions at the Walker Art Center from 1996 to 1998, most recently curatorial assistant, visual arts.

Toby Kamps is director of the Institute of Contemporary Art at Maine College of Art, Portland. At the Walker Art Center, he held various positions from 1991 to 1994, most recently curatorial assistant, visual arts.

John R. Killacky is program officer, arts and culture, at the San Francisco Foundation. At the Walker Art Center, he was curator, performing arts, from 1988 to 1996.

Clara Kim is assistant curator at REDCAT (Roy and Edna Disney/CalArts Theater), Los Angeles. At the Walker Art Center, she was the Lila Wallace-Reader's Digest Curatorial Intern for Diversity in the Arts, visual arts, from 1997 to 1998.

Diana Kim (D.K.) is assistant program manager, performing arts, at the Walker Art Center, where she has been on staff since 2000.

Wayne Koestenbaum has published five books of nonfiction, including *The Queen's Throat* (1993), *Jackie Under My Skin* (1995), *Cleavage* (2000), and *Andy Warhol* (2001); four books of poetry (most recently, *Model Homes*, 2004); and the novel *Moira Orfei in Aigues-Mortes* (2004). He is a professor of English at the Graduate Center of the City University of New York.

Richard Koshalek is president of the Art Center College of Design, Pasadena, California. He held various positions at the Walker Art Center from 1967 to 1973, most recently curator, visual arts.

Philip Larson is a professor of art and architectural history at the Minneapolis College of Art and Design. At the Walker Art Center, he was curator, visual arts, from 1970 to 1976.

James Lingwood is codirector of Artangel, a London-based organization that commissions and produces projects by contemporary artists. He publishes widely and has curated exhibitions and projects for museums in Europe and the United States.

Elizabeth Mangini is an independent critic and curator. At the Walker Art Center, she was curatorial intern, visual arts, from 2000 to 2001.

Elizabeth Wright Millard is an independent curator. At the Walker Art Center, she was curatorial/education intern from 1985 to 1986.

Sheryl Mousley (S.M.) is curator, film/video, at the Walker Art Center, where she has worked since 1998.

Linda Nochlin is the Lila Acheson Wallace Professor of Modern Art at the New York University Institute of Fine Arts, New York. Among her writings are the landmark essay "Why Have There Been No Great Women Artists?" (1971), and the books *Women, Art, and Power: And Other Essays* (1988) and *Representing Women* (1999).

Dean Otto (D.O.) is assistant curator, film/video, at the Walker Art Center, where he has been on staff since 1995.

Richard Peterson is director of programming at the Christopher B. Smith Rafael Film Center, San Rafael, California. At the Walker Art Center, he was curator, film, from 1977 to 1985.

Jennifer Case Phelps (J.C.P.) is assistant archivist at the Walker Art Center, where she has worked since 2004.

Francesca Pietropaolo is curatorial assistant, Department of Drawings, at the Museum of Modern Art, New York. At the Walker Art Center, she was curatorial intern, visual arts, from 2000 to 2001.

Jenelle Porter is associate curator at the Institute of Contemporary Art, University of Pennsylvania, Philadelphia. At the Walker Art Center, she was curatorial intern, visual arts, from 1997 to 1998.

Annie Proulx lives and writes stories, novels, and essays in Wyoming and Newfoundland-Labrador, Canada. Her novels include *Postcards* (1992) and *The Shipping News* (1993), which won the Pulitzer Prize and the National Book Award in 1994.

J. Fiona Ragheb is an independent curator. At the Walker Art Center, she was curatorial intern, visual arts, from 1992 to 1993.

Lawrence Rinder is dean of graduate studies at the California College of the Arts, San Francisco. At the Walker Art Center, he was National Endowment for the Arts Curatorial/Education Intern from 1987 to 1988.

Joan Rothfuss (J.R.) is curator, permanent collection, at the Walker Art Center, where she has been on staff since 1988.

Sarah Schultz is director, education and community programs, at the Walker Art Center, where she has been on staff since 1992.

David Shapiro has published nine volumes of poetry, most recently *A Burning Interior* (2002). He has written books on artists Piet Mondrian, Jim Dine, and Jasper Johns. His critical writings have appeared in the *New Yorker*, the *Partisan Review*, and the *Paris Review*. His poem for Czech national hero Jan Palach inspired a monument by architect John Hejduk, which was dedicated in Prague in 1991 by Vaclav Havel. Shapiro was nominated for the National Book Award by age twenty-three and has received many awards and honors for his work.

Charles Simic is a poet, essayist, and translator. He teaches American literature and creative writing at the University of New Hampshire, Durham. He has published sixteen collections of his own poetry, five books of essays, a memoir, and numerous books of translations. Simic is the recipient of many awards, including the MacArthur Fellowship in 1984 and the Pulitzer Prize in 1990. His recent works include the volume *The Voice at 3:00 A.M.: Selected Late and New Poems* (2003).

Howard Singerman is associate professor of art history at the University of Virginia, Charlottesville, and the author of *Art Subjects: Making Artists in the American University* (1999). His essays on Sherrie Levine have appeared in the journals *October*, *Parkett*, and *Res: Anthropology and Aesthetics*.

Daniel Smith (D.S.) is collection researcher, film/video, at the Walker Art Center, where he has worked since 2002.

Rochelle Steiner is chief curator at the Serpentine Gallery, London. At the Walker Art Center, she was the National Endowment for the Arts Curatorial/Education Intern from 1994 to 1996.

Claire Tancons is an independent curator and writer. At the Walker Art Center, she was Curatorial Intern for Diversity in the Arts, visual arts, from 2002 to 2003.

Elizabeth Thomas is assistant curator of contemporary art at the Carnegie Museum of Art, Pittsburgh. At the Walker Art Center, she was curatorial intern, visual arts, from 1999 to 2001.

Jan van der Marck was chief curator of the Detroit Institute of Arts until 1995. At the Walker Art Center, he was curator, visual arts, from 1963 until 1967.

Philippe Vergne (P. V.) is director of the François Pinault Foundation for Contemporary Art, Paris. He held various positions at the Walker Art Center from 1997 to 2005, most recently senior curator, visual arts.

Jill Vetter (J. V.) is archivist at the Walker Art Center, where she has worked since 1994.

Hamza Walker is associate curator/director of education at the Renaissance Society, University of Chicago. He has written numerous articles and reviews for such publications as *Trans*, *New Art Examiner*, *Parkett*, and *Artforum*.

Suzanne Weil is an independent producer based in Santa Monica, California. At the Walker Art Center, she was coordinator, performing arts, from 1968 to 1976.

Index

Page numbers in **bold** refer to illustrations.

Reproduction Credits

The Wooster Group. Directed by Elizabeth LeCompte. Pictured (left to right): Emily McDonnell and Koosil-ja Hwang 40 (top left)
©Estate of Maya Deren 42 (top left)
©2005 Jenny Holzer/Artists Rights Society (ARS), New York 82
Art ©Louise Bourgeois/Licensed by VAGA, New York, NY 83
©2005 Sol LeWitt/Artists Rights Society (ARS), New York 83
©2005 Richard Serra/Artists Rights Society (ARS), New York 89
Vito Acconci. *Theme Song*, 1973. Courtesy Electronic Arts Intermix (EAI), New York 94
©2005 The Josef and Anni Albers Foundation/Artists Rights Society (ARS), New York 99
Art ©Carl Andre/Licensed by VAGA, New York, NY 102–103
©2005 Estate of Alexander Archipenko/Artists Rights Society (ARS), New York 105
Jean (Hans) Arp. Art ©2005 Artists Rights Society (ARS), New York/VG Bild-Kunst, Bonn 111
©2005 Richard Artschwager/Artists Rights Society (ARS), New York 111
©2005 Milton Avery Trust/Artists Rights Society (ARS), New York 113
©2005 The Estate of Francis Bacon/ARS, New York/DACS, London 114
Rudolf Belling. Art ©2005 Artists Rights Society (ARS), New York/VG Bild-Kunst, Bonn 125
Art ©Lynda Benglis/Licensed by VAGA, New York, NY 126

Joseph Beuys. Art ©2005 Artists Rights Society (ARS), New York/VG Bild-Kunst, Bonn 127–130
Dara Birnbaum. *Technology/Transformation: Wonder Woman*, 1978. Courtesy Electronic Arts Intermix (EAI), New York 134
Bernhard Blume. Art ©2005 Artists Rights Society (ARS), New York/VG Bild-Kunst, Bonn 134
Alighiero Boetti. Art ©2005 Artists Rights Society (ARS), New York/SIAE, Rome 136–137
Marcel Broodthaers. Art ©2005 Artists Rights Society (ARS), New York/SABAM, Brussels 141–142
André Cadere. Art ©2005 Artists Rights Society (ARS), New York/ADAGP, Paris 148
©2005 Estate of Alexander Calder/Artists Rights Society (ARS), New York 150
©2005 John Chamberlain/Artists Rights Society (ARS), New York 156
Art ©The Joseph and Robert Cornell Memorial Foundation/Licensed by VAGA, New York, NY 170–172
Joseph Cornell. All rights held by The Museum of Modern Art, New York 171 (bottom)
Henry Darger. Art ©2005 Kiyoko Lerner, All Rights Reserved 181
©2005 The Willem de Kooning Foundation/Artists Rights Society (ARS), New York 184-185
Thomas Demand. Art ©2005 Artists Rights Society (ARS), New York/VG Bild-Kunst, Bonn 186
©Estate of Maya Deren 187
©2005 Jan Dibbets/Artists Rights Society (ARS), New York 191

©Estate of Burgoyne Diller/Licensed by VAGA, New York, NY/Estate represented by the Michael Rosenfeld Gallery 193
©2005 Jim Dine/Artists Rights Society (ARS), New York 194–195
©Gaumont, SA [1996 Gatt/URAA copyright restoration] 197 (top)
Jean Dubuffet. Art ©2005 Artists Rights Society (ARS), New York/ADAGP, Paris 197
Marcel Duchamp. Art ©2005 Artists Rights Society (ARS), New York/ADAGP, Paris/Succession Marcel Duchamp 198
Lyonel Feininger. Art ©2005 Artists Rights Society (ARS), New York/VG Bild-Kunst, Bonn 210
Peter Fischli and David Weiss. Images courtesy the artists and Matthew Marks Gallery, New York 211–213
©2005 Estate of Dan Flavin/Artists Rights Society (ARS), New York 214–215
Katharina Fritsch. Art ©2005 Artists Rights Society (ARS), New York/VG Bild-Kunst, Bonn 227–228
Alberto Giacometti. Art ©2005 Artists Rights Society (ARS), New York/ADAGP, Paris 232
Felix Gonzalez-Torres. Art courtesy Andrea Rosen Gallery, New York 241
Arshile Gorky. Art ©2005 Artists Rights Society (ARS), New York 242
Art ©Adolph and Esther Gottlieb Foundation/Licensed by VAGA, New York, NY 242
Dan Graham. *Rock My Religion*, 1982–1984. Courtesy Electronic Arts Intermix (EAI), New York 245

©2005 Andreas Gursky/Artists Rights Society (ARS), New York/VG Bild-Kunst, Bonn Courtesy Matthew Marks Gallery, New York and Monika Sprüth/Philomene Magers, Cologne/Munich 250
Thomas Hirshhorn. Art ©2005 Artists Rights Society (ARS), New York/ADAGP, Paris 269–270
©2005 Estate of Hans Hofmann/Artists Rights Society (ARS), New York 275
Craigie Horsfield. Art ©2005 Artists Rights Society (ARS), New York/ADAGP, Paris 277
Huang Yong Ping. Art ©2005 Artists Rights Society (ARS), New York/ADAGP, Paris 278
Michael Hurson. Courtesy Paula Cooper Gallery, New York 280
Robert Indiana. Art ©2005 Morgan Art Foundation Ltd./Artists Rights Society (ARS), New York 283
©2005 Robert Irwin/Artists Rights Society (ARS), New York 285
Alexej Jawlensky. Art ©2005 Artists Rights Society (ARS), New York/VG Bild-Kunst, Bonn 289
Art ©Jasper Johns/Licensed by VAGA, New York, NY 291–296
Art ©Judd Foundation/Licensed by VAGA, New York, NY 305–308
©William Klein 323–325
Yves Klein. Art ©2005 Artists Rights Society (ARS), New York/ADAGP, Paris 327
Art ©Estate of Yasuo Kuniyoshi/Licensed by VAGA, New York, NY 332
©2005 Sol LeWitt/Artists Rights Society (ARS), New York 347–349
©2005 Man Ray Trust/Artists Rights Society (ARS), New York/ADAGP, Paris 364

Photography Credits

Courtesy
0100101110101101.org 91
Christi Atkinson 355
(right), 383 (right)
Mike Barich 33 (bottom)
Tom Berthiaume 34
Image courtesy James
Coleman 164
©Paula Court 591
Rolphe Dauphin 15 (top),
17 (bottom), 32 (top), 50
(top left and bottom), 59
(top and bottom)
Clark Dean 9, 32 (bottom
right), 59 (middle)
Arno Declair ©dumb type
38 (bottom)
Dan Dennehy 11, 27 (top
right), 28 (bottom), 30
(top and bottom left), 38
(bottom), 46 (bottom
right), 48 (top), 54
(top right and bottom),
56, 67 (top), 72 (top), 130
(right), 177 (bottom),
202, 254, 300, 397, 443
(right), 535 (bottom), 555
(right), 571
©Estate of Maya Deren 42
(top left)
Sally Dixon 45 (top right)
Barbara Economon 27
(bottom), 28 (top)
©T. Charles Erickson 39
(bottom)
©Mary Gearhart 40
(top left)
Boyd Hagen 35 (top,
middle, and bottom left),
145 (bottom), 176
Glenn Halvorson 25 (top
right and bottom), 27 (top
left), 36 (right), 37
(bottom left), 38 (top
left), 45 (top left), 46 (top
and bottom left), 53 (top
left and bottom right), 63
(bottom right), 64, 65, 132
(right), 140, 150 (bottom),
160, 226, 272, 273 (top),
301, 592
Knut Klaßen 135
©James Klosty 175
Nathalie Matteucci 398
Alan McAteer 40
(top right)
Dan Merlo 339 (top)
Minnesota Historical
Society 84 (top left)

Peter Moore ©Estate of
Peter Moore/VAGA,
New York 395
Don Neal 36 (left)
Keith Pattison, courtesy
Pomegranate Arts 282
Gene Pittman 268 (top),
379 (bottom)
Michael Schmelling,
courtesy New York City
Players 379 (top)
David Smith/University
Musical Society 38
(top right), 302
Eric Sutherland 10, 19, 20,
22, 23, 24, 25 (top left), 33
(top), 44, 51, 52, 63 (top
and bottom left), 116
John Szarkowski 17 (top),
32 (bottom left)
Walker Art Center Archives
13, 33 (middle), 37 (top
and bottom right), 45
(bottom), 145 (top), 149,
177 (top), 233, 396
Courtesy Robert Wilson 35
Cameron Wittig 30
(bottom right), 40
(bottom), 48 (middle and
bottom), 55 (bottom), 57,
67 (bottom right), 72
(bottom), 73 (top right
and bottom), 80 (bottom),
201 (right), 268 (bottom),
339 (bottom), 385 (right)

Unless otherwise credited,
all photographs by
Dan Dennehy, Barbara
Economon, Glenn
Halvorson, Peter Latner,
Gene Pittman, and
Cameron Wittig for the
Walker Art Center.

Acknowledgments

A catalogue of this magnitude and complexity by necessity requires the contributions and talents of numerous individuals, both inside and outside the walls of the Walker Art Center. We wish to thank the following people who assisted us in the conception and production of this catalogue.

A resounding thank you to:

Joan Weinstein and the Getty Grant Program for their extraordinary faith in this project and their generous financial support, which made it all possible

Lawrence Weiner for his marvelous cover design

All the artists and their studio assistants who corresponded with us during the research phase of this project

Martin and Mildred Friedman for sharing their seemingly limitless institutional memory with us and for their contributions to this catalogue

Elizabeth Alexander, A. S. Byatt, Steve Cannon, Joshua Clover, Arthur C. Danto, Dave Eggers, Darby English, Jorie Graham, Wayne Koestenbaum, James Lingwood, Linda Nochlin, Annie Proulx, David Shapiro, Charles Simic, Howard Singerman, and Hamza Walker, whose exceptional essays expand the dialogue around artworks in the Walker's collection

All the former Walker staff members who contributed texts to this book

The staff members at the archives, estates, foundations, galleries, and libraries (too numerous to mention by name) who assisted with our research, and shared their time, knowledge, images, and collections with us

At the Walker Art Center our gratitude goes to:

Director Kathy Halbreich for her unwavering support every step of the way

The Walker Art Center Board of Directors for their assistance in building these remarkable collections and for their support of our research

Deputy Director and Chief Curator Richard Flood for his creative vision and guidance

All contributing writers from the Walker Art Center programming departments: Design, Education and Community Programs, Film/Video, Library/Archives, New Media Initiatives, Performing Arts, and Visual Arts

Special projects fund-raiser Kathryn Ross for her creativity and resourcefulness

Librarian Rosemary Furtak, archivist Jill Vetter, assistant archivist Jennifer Case Phelps, and researcher Natilee Harren for their creative and extensive mining of Walker history that informs all aspects of this catalogue

Registrars Dave Bartley, Gwen Bitz, Ann Gale, Elizabeth Peck, Evan Reiter, Noah Wilson—and particularly Joe King and Heather Scanlan, who were unfailingly collegial and patient—for their stewardship of the permanent collection and their flawless attention to detail

Photographers Dan Dennehy, Barb Economon, Glenn Halvorson, Peter Latner, Gene Pittman, and Cameron Wittig for the beautiful images that grace these pages

Program services staff Cameron Zebrun, Jon Voils, and Randy Reeves for making the collection available at a moment's notice for research and photography

Administrative assistants Kate Dowling and Michelle Klein for managing the innumerable demands we made on them, which they handled with ease

Design fellow Emmet Byrne and production specialists David Naj and Greg Beckel for their tenacious and timely completion of their duties

Special recognition and appreciation must go to:

Visual arts administrator Lynn Dierks for her dedication to the myriad tasks this project entailed, from organizational minutiae to editing and writing

Curatorial interns Max Andrews, Aimee Chang, Alisa Eimen, and Claire Tancons, and curatorial fellows Doryun Chong and Yasmil Raymond, for their camaraderie and many long hours of writing, researching, fact-checking, and proofreading

Freelance editor Michelle Piranio and proofreader Sharon Rose Vonasch, whose awe-inspiring attention to detail ensured the accuracy of this catalogue

Finally, we would like to express our boundless gratitude for the commitment and extraordinary talents of designers Andrew Blauvelt and Chad Kloepfer, publications manager Lisa Middag, and editors Kathleen McLean and Pamela Johnson, who have been equal partners on this project from day one.

Joan Rothfuss and Elizabeth Carpenter